THE IMAGE OF THE BLACK IN WESTERN ART

PUBLICATIONS OF MENIL FOUNDATION, INC.

THE IMAGE OF THE BLACK IN WESTERN ART

I
FROM THE PHARAOHS TO THE FALL OF THE ROMAN EMPIRE

II
FROM THE EARLY CHRISTIAN ERA TO THE AGE OF
DISCOVERY

III
FROM SIXTEENTH-CENTURY EUROPE TO NINETEENTH-
CENTURY AMERICA

LADISLAS BUGNER General Editor

THE IMAGE OF THE BLACK
IN WESTERN ART

I
FROM THE PHARAOHS TO THE FALL OF THE ROMAN EMPIRE

JEAN VERCOUTTER

JEAN LECLANT

FRANK M. SNOWDEN, JR.

JEHAN DESANGES

Foreword by AMADOU-MAHTAR M'BOW
DIRECTOR GENERAL OF UNESCO

WILLIAM MORROW AND COMPANY, INC. NEW YORK

Designed by Hanspeter Schmidt.
Studio S + T, Lausanne.

Printed in Switzerland.

ISBN 0-688-03086-6
LC 76-25772

TABLE OF CONTENTS

FOREWORD

For fifteen years the Menil Foundation, with a group of scholars, has been conducting a thorough investigation of the iconography of blacks in the Mediterranean and Western world, from the origins through the nineteenth century.

This volume and the two others which are to follow are the first result of this work. Needless to say, neither the Foundation nor the authors have attempted to write a history of Africa or a comprehensive study of how whites have regarded blacks throughout the ages. Much work is still necessary to allow a deeper understanding of the material assembled during the investigation. For the time being, the Foundation and the scholars entrusted with the work have tried first and foremost to outline the most promising themes for future studies. These themes have been presented in iconographic series, logically and chronologically organized according to the methods of the history of art, as L. Bugner points out in the Introduction. Some authors have nevertheless attempted to establish a closer correlation between these series of images and the general history of Africa, which they reflect in some respects. But none of them claims to have written an exhaustive history, drawing upon all the possible sources, of the period he studies in the iconography of the white man's view of the black. While reading these texts and pondering over these numerous and remarkable images patiently gathered by the Menil Foundation, we should keep in mind their preliminary character.

Readers familiar with African history might wonder why certain "burning issues" have been approached from a seemingly remote standpoint. We may regret, for example, that certain hypotheses about the ancient population of Egypt have not been mentioned, since the subject dealt with was in fact "ancient Egypt and the blacks." We cannot blame the authors for not going into the substance of the problem, since that was not the purpose of this publication; but a simple mention would have acknowledged the

importance of this question to the many people dedicated to such research.

Again, the informed reader might, at a first glance, be shocked by the way the slave trade was approached. It should be recalled that the slave trade itself, and for good reason, gave rise only to a very modest iconography; images became abundant only with the propaganda of the abolitionists, and they were aimed primarily at moving Europeans, revealing to them the fate to which blacks were condemned. Besides, the authors who have worked on these iconographic documents have dealt with them first and foremost as historians of art.

This is certainly not the place to open a debate on the validity of an autonomous history of art. Today, many historians are convinced that art is only one of the ways in which societies express themselves, and thus it should be treated as any other form of human production, within a total and integrated view of history.

But, as they are presented, the volumes of this publication are of prime importance: first, by the seriousness of the work, and also because for the first time, they offer a synthetic vision of an often little-known iconography. Readers will find information which will better enable them to understand certain attitudes of contempt which whites have held toward blacks, as well as the causes of some tragic historical misunderstandings. Obviously, these volumes do not constitute, nor can they, an anti-racist manifesto, but they provide material for reflection on some historical roots of the white man's bias against the blacks. In this respect, these books naturally take their place in a perspective which is UNESCO's own—a perspective of mutual respect by all people and all cultures, and the eradication of racial prejudice.

UNESCO, whose interest in the African continent is increasingly confirmed at every session of its General Conference (publication of a *General History of Africa*, studies of African languages and oral traditions, studies of African art and of the civilizations of black Africa and the Diaspora), can only rejoice at the publication of these volumes, *The Image of the Black in Western Art*, which will contribute to better understanding among peoples, the essential basis of any true international cooperation.

A. M. M'Bow

The decision in 1960 to launch a systematic investigation of the iconography of blacks in Occidental art did not proceed from any clear plan. It was an impulse prompted by an intolerable situation: segregation as it still existed in spite of having been outlawed by the Supreme Court in 1954.

Many works of art contradicted segregation. A sketch by a master could reveal a depth of humanity beyond any social condition, race, or color. So why not assemble these art works in an exhibition or a book?

With such a naïve approach, a serious enterprise was started. It brought to light a wealth of artistic treasures and uncovered the breadth and complexity of problems which had their roots in history, in myths, in the collective unconscious.

It took fifteen years to bring the project to completion, and it took the exceptional gifts of a young art historian totally dedicated to the task. We salute here the emergence of Ladislas Bugner.

It also took the cooperation of eminent scholars who gave the project the benefit of their personal research. The contributions of Jean Vercoutter, Jean Leclant, Frank M. Snowden, Jr., Jehan Desanges, Jean Courtès, Jean Devisse, Michel Mollat, Jacques Thuillier, Jacques de Caso, and John McCoubrey are gratefully acknowledged here.

The advice and encouragement of Jean Devisse, in the early days, and his unfailing interest in the project have been crucial. The collaboration with Frank Snowden was invaluable. His research in Greek and Roman antiquity antedated our own: for twenty years he had investigated the museums of Europe and America, gathering references to blacks in the classical period. *Blacks in Antiquity*, published in 1970, presents the sum of his work.

Exceptional credit goes to Monique Bugner, who assumed heavy responsibilities. Her background in art history, her stamina, and her devotion

to the work overcame all difficulties. Deep thanks go to her and to the other collaborators, Marie-Dominique Perlat-Daudel and Anne Poidevin in Paris, Karen Coffey and Geraldine Edwards in Houston; also to Virginia Camfield who was the correspondent in Houston during the initial phase of the project. Let us also mention here the students and researchers who, with great patience, have surveyed the photo archives, libraries, museums, and churches: Anne-Françoise Bonnardel in Paris, Paola Dettori in Rome, Sérgio Guimarães de Andrade in Lisbon, and Gude Suckale-Redlefsen in Munich.

Jean Malaquais's vision and encouragement were a stimulating factor. He agreed to translate into French the texts of Frank Snowden and John McCoubrey, bringing to the work the prestige of his talent. The translations into English were masterfully done by W. Granger Ryan. We express here deep gratitude to both translators, and to Laura Furman, who edited the English text and checked all the references.

We cannot thank individually here the many scholars who became interested in the work and helped it in one way or another, yet we must mention Bernard V. Bothmer, Herbert Hoffmann, Jean Mallon, and Charles Sterling for their trust and their friendly support.

We wish to thank also the directors and curators of the museums and libraries who have generously opened their files to us. We are particularly grateful to the curators who consented to let our photographers work in their departments.

The large photographic program executed in Egypt and in the Sudan was made possible by Gamel Mokhtar and Negm ed Din Mohammed Sharif. We are most grateful for their kind interest and their efficient help.

Finally, let us recognize the superb achievements of the photographers, Mario Carrieri, Blaine Hickey, and Ogden Robertson, artists in their own right. The photographic campaigns were skillfully organized by Francesco Orefici.

Such a large effort and such an abundance of collected material bring sobering reflection.

Undeniably, we are confronted with a gallery of blacks. A great variety of people: some plain, some beautiful, some even quivering with life. Yet all have been cast in roles they did not choose. They are actors in plays written by whites. Though whites are invisible, their presence is felt everywhere. It is their customs, their tastes, their prejudices, their phantasms, and their romanticism that have been captured in these images.

These voiceless blacks, these ghosts, have carried nevertheless one of the longings of mankind. They were a symbol of universality and of the equality of men before God. On twelfth-century enamels the apostles address themselves to a white man and a black man who signify humanity in all its variety. Pale skins have no monopoly on the earth.

When Orient and Occident were swept by the high winds of Christianity and Islam, ideals of fraternity blossomed. There was a time when the West adopted a black knight as its patron saint, a time when artists did not neglect to include an African among the resurrected, a time when a white King Solomon embraced a black Queen of Sheba. Reality might have followed in the footsteps of dream: it was in the arms of the Pope that the

first ambassador of the Congo died. His bust is still in Santa Maria Maggiore. But the dream of an authentic cooperation between Europe and Africa, of a sharing of ideals and knowledge, was shattered by crimes so atrocious that they left no images.

The past is heavy. To face it, to assume it, facts must be brought candidly to light. The making of a more human world requires rigorous studies. It is the hope of the Menil Foundation to work toward this goal.

DOMINIQUE DE MÉNIL

"When they turned to the east, their shadow fell to the south and to the right."

The *Liber Chronicarum*, written by Hartmann Schedel, thus reports the disorientation of the Portuguese sailors after they crossed the equator in 1484. The Occident was discovering new stars, a new sky, a "New World." That year an "old" world tottered; the fact of entering the southern hemisphere did away with the paralyzing paradox of the antipodes. It happened along the African coasts. Diogo Cão went ashore in the Congo. There he met black people.

At the present time we are witnessing Portugal's abandonment of the last remnants of its ancient colonial empire. Symbolically, at this same time the fall of the Ethiopian monarchy has brought down with it the prestigious heritage of the traditions of the Queen of Sheba and Prester John.

Again a "New World" is coming into view. A new "discovery"—but what is to be sought? Other stars in Space? Should we not rather look into another revelation—the revelation of Man? The time has come to reconsider the opposition of the "white man" and the "black," which History has made a vehicle of opprobrium. Slave trade, racism, and colonialism have loaded the word *Negro* with a virulence so invidious that it came to stand for an antipode to be shunned.

If this word now expresses nothing but an outmoded pattern of oppression and dependency, one may decide that it ought to be dropped from common use. Then analysis can proceed more freely, in order to deal with more complex relationships, and to develop perspectives that will be fairer to all concerned. African universities, Black Studies programs in American universities, and Africanists have set themselves to bring about this conscientious examination of history.

But can the word *Negro* be discarded out of hand? As long as it conveys

an intention to degrade or is so understood, it retains the force of an insult, and this derives from a history that must be fully and consciously taken into account. Following the initiative of *Présence Africaine* and of Léopold Sédar Senghor, an entire school has reconsidered *négritude* as a positive value and invested it with a new reality. Rejection of the condition of servitude does not necessarily lead to rejecting the word *Negro* but presupposes that it be exorcised. The insult beclouds five thousand years of history. Like the Greek word *aithiops* and the Latin *niger*, the word *Negro* described the individual by the simple extension of a distinctive peculiarity, and the designation was progressively transformed until it assumed its modern comprehensiveness, more and more conventional, and, by that fact, more and more useful to the cause of prejudice. The term accounted for a difference before it came to signify the default born of the disappearance of neutrality. How far does this phenomenon of inversion characterize the attitude of "whites"? Do not they also bear witness to a certain permanency by the constant renewal of the desire for knowledge through so many and such diverse situations? It is indeed on this unaccustomed scale, with variations covering several centuries, that the perspectives can most profitably be made clear, once the three volumes of this work have presented a coherent sequence of representations of the black in Occidental art. What we have done, in effect, is this: instead of following the words we have followed the image. In comparison with simple nomenclature, art offers its own resources, its own way of naming. It is a field apart which has still another advantage: plastic figuration is not as adaptable as the written language of generic terms, such as *Ethiopian* or *Moor*—terms which often designate widely diverse types and which in the course of time can acquire widely divergent meanings. For an expression such as "a demon black as an Ethiopian" the words come naturally enough, but its transposition into a plastic image leads to a rupture of the balance between the two terms, and the artist has to choose between the representation of the fantastic demon and that of the real African.

The first task the Menil Foundation entrusted to us was to establish as general and complete a documentation as possible—this before bringing together the essays to be contained in the three volumes of the present work. As this inventory has provided the basis for the collective study, it is worthwhile to set forth the principal options we decided upon. After that we shall try to define their limits and their import.

The inventory of works of art related to the Occidental representations of the black African takes us back not to the person of the African nor to a particular aspect of African history, but to the cultural phenomenon implied by the term *Negro*. More precisely, it is concerned with the plastic expression by which the white man has marked the state of difference, of "otherness," in which he situates the black man in relation to himself. The nuances of this otherness run the gamut from out-and-out exaggeration to the almost total attenuation of the marks of opposition—a formal gamut which has its own historical determination. From the start, therefore, the study excluded any a priori assumptions regarding the definition of the African "black" and of the homologous Occidental "white" as well.

Thus, at this stage, we are led to dispense with any preliminary defini-

tion of the "Negro" based on anthropological or ethnological data. An artist depicts a black when he intends to make the black *recognizable*, through a certain number of signs, to a public that constitutes his audience, in the midst of a society to which he himself belongs. As we face the ambiguities discerned in the approximate figures of blacks, what will hold our attention is not the more or less certain degree of cross-breeding, but the reticence of the artist who chose to suggest the black type without going so far as to express it completely, thus producing a "pseudo-Negro." In this area there is no clear boundary line, but rather a zone that can be extended as desired, which enables us to observe all the gradations discoverable in the artistic treatment of the theme. For instance we will not select a given portrait in which identification of the model as a member of the black race cannot be determined by his general appearance but solely by a technical criterion belonging to the field of anthropology. The presence of the specialized indications shows the painter's concern for realistic exactness, but does not suffice to negate the *prima facie* evidence dictated by the artistic structure in accordance with which the meaning of the representation is organized. Let us say immediately that the absence of anthropological definition affects only the initial phase of the choice of documents. This in no way diminishes the interest such a definition may have in further stages of the research. It will find various applications in the papers that follow.

We have also avoided being limited in our study by a definition of Occidental (or Western) art. What geographical boundaries should we adopt? Nothing could be more vague. The word *Occidental* is here intended to cover an area of civilization which we may call Christian, heir to and inseparable from Greco-Roman antiquity, the latter owing much to Egyptian civilization, particularly in what concerns the black. The contraposition of Orient and Occident has no place here, as is proved by the interesting surveys of Byzantine and Islamic art already carried out. Moreover we stress the fact that the use of the word *Occidental* is in no sense normative; otherwise Egyptian art would certainly seem a questionable appendage. We would be ready to abandon the term altogether, provided it was not replaced by such an expression as "white art" with its complement "black art," thus putting two ethnocentrisms back to back.

The resources provided by existing catalogues and inventories have not proved to be of much use. The descriptions given (some detailed, others consisting merely of a title) cover only recognized subjects, whereas there was no compelling reason to include the black in most of the themes of art, and it was never obligatory. A subject as distinctive as the *Baptism of the Ethiopian Eunuch by Philip the Deacon* was sometimes depicted with an exclusively white cast of characters. Hence an inquiry of this sort depends on direct examination of the work or a photograph of it. It requires that the search be pushed as far as possible, and this was made feasible through the facilities offered by the photograph archives. We have done our best to make systematic use of their resources.

By our estimate, which the nature of the work makes reasonably accurate, we have gone through 6.5 million photos in some forty institutions. Let us now express our appreciation of the admirable achievements which these photo archives represent and our thanks to their directors and

research staffs. Had it not been for their generous welcome and professional competence, our results would not have amounted to much.

The content of the photo archives imposes a certain extrinsic order upon the number and distribution of the works of art: in other words the analysis of the photograph holdings is to some extent governed by the degree of activity in a given country in the compiling of inventories, and by the centralization or decentralization of this activity. Some notably large collections of representations are the product of an organized and active inventory effort, which assures an exceptionally complete survey of existing examples; or else they are due to the progress, admittedly irregular, made in establishing corpora of mosaics, manuscripts, stained glass.... Most of the photo archives have increased their holdings since we visited them, filling some gaps but leaving others. It is not surprising that we have found a clear majority of reproductions of easel paintings, a fact that reflects a dominant tendency in art history as well as the ease with which movable, well-preserved objects can be photographed at moderate cost. The decoration of churches and palaces is very inadequately represented. If scaffolding was needed we would have to await the start of a hypothetical program of restoration to get our pictures. The very idea of a large photo archive collecting reproductions of prints would strike many people as paradoxical if not utopian. The extravagance of photographing each page of a manuscript (as is done for every picture in a gallery), not to mention the alarming paucity of manuscript cataloguing, make this the area which had had the least attention: yet for many periods this is one of the essential sectors, where omissions often risk leading to errors and contradictions. Moreover the descriptive information accompanying the photos is inevitably second-hand. Chronology, provenances, and attributions reflect the state of art history in general, where a few areas of order and clarity stand out in a vast expanse of confusion. In these circumstances one may question the validity of conclusions drawn from this documentation. What reality does it represent? Might we reply—not entirely in jest—the reality of the photo archives!

We were aware of this problem as we embarked on the present investigation. A very large volume of material has been collected, the main elements of which we present here. We have our own photo archive and card index covering some ten thousand works of art of every kind over a period of almost five thousand years of history. We are confident that the coverage makes it possible to follow closely the broad lines of the subject as it developed: they stand out clearly. We have succeeded in giving direction to the analysis, defining the problems, and classifying the documents. Special attention has been given to the concurrence of catalogue indications and the reciprocal confirmation resulting therefrom, and complementary research has enabled us to go deeper into certain aspects of this information and to correct the major distortions. The subject henceforth is recognized. A framework is now available for use in research.

In the field of art history few conclusions can be considered final. For most periods, dates and attributions are always subject to revision. Much still remains to be done in order to arrive at the satisfactory systematization of a theme. Further projects define themselves: the Menil Foundation is planning a series of publications in which historical studies and contribu-

tions coming from other disciplines will take their place beside inventories of the works catalogued. But what is most urgently needed is an in-depth examination of the literary sources in relation to our theme: a comprehensive, methodical study of this kind has not yet been made. The main obstacle we have met in the artistic area is the discouragingly wide scope of the field of research—whence the temptation to present too hasty conclusions from too limited a segment. Now that an ensemble of problems has been drawn up thanks to the documentation established on the basis of the plastic arts, this complementary approach will be less hazardous, and partial conclusions may be arrived at more quickly. We can even dream of a synthesis of the two fields, which in fact are inseparable. Such a synthesis would be the only guarantee of the soundness of the iconographic approach.

We are filled with admiration for our ten collaborators and friends who were willing to address themselves to the reality of a wordless documentation. To them goes the credit for having cast it in a new form, and for having given the black a positive image that emerges from the transformations to which history has subjected it.

The studies dealing with the successive chronological phases mark the over-all evolution of the theme, bringing out a series of representative aspects, like so many "facets" that illuminate and complement each other while retaining their autonomy. In this way they avoid giving the impression of a general synthesis. We consider this a capital point. Not only would this synthesis be premature in view of the work still to be done, given the range of the historical phenomena under consideration, it simply could not be achieved. In the present state of the question it is healthier to allow some divergence of opinion than to aim for general agreement. We are equally firm in our opinion that the theme must be worked on through a variety of methods. Each of these has been applied here in the study of a limited period or of a particular aspect of the subject, and if for practical reasons each cannot be extended to the totality, it may be to a larger phase of the development. The juxtaposition of different points of view indicates an obvious complementarity: to set aside the formulation of a general synthesis and to put on view a variety of possible approaches. These two aims clearly define a structure of work which we find promising. In the present situation, however, and depending on the period under study, one approach may prove to be preferable to another. At times the research has drawn upon earlier works, thus enjoying the advantage of starting from an already high level of acquired knowledge. In other instances, it has been necessary to reinterpret a mass of disparate elements in accordance with new and untested hypotheses.

Egyptology, to begin with, is well organized. Its terrain is relatively limited, the material in large part inventoried, precisely known and situated. The historical data and the literary sources complement the monuments. Thus the archeological approach was obviously the way to establish a first image of the black, up and down the Nile Valley (the outlet to the Mediterranean world of the interior of Africa). Later on the Kushites, dominating a large part of Egypt during the Twenty-fifth Dynasty, adopted the canons of Egyptian art and with them its themes. Aside from a

few differences of detail, interesting in themselves, the ruler was extolled by being portrayed in the traditional form of the Egyptian pharaoh, with the same image of the conquered enemy, including the black, at his feet.

How did this image evolve in the Greco-Roman art of the Mediterranean Basin? Instead of tackling this question directly, we must begin by considering the way society in the period of classical antiquity dealt with the black, now no longer a "neighbor," but regarded as an exotic, "distant" element.

It is in this area that publications bearing on our subject have been the most numerous. Following on G. H. Beardsley's indispensable repertory, brought out in 1929, and several articles that presented the principal series of objects, F. M. Snowden, Jr. published his synthesis, *Blacks in Antiquity*, in 1970. This work is based on an exhaustive analysis of classical literature, but it also supplies abundant illustrations. His contribution in our first volume complements his book, and much of the illustrative material is revised and brought up to date. The study is not limited to examples where blacks were placed in frank contrast to whites, but explores the fringe areas where the distinguishing traits, while not completely disappearing, came very close to doing so. Snowden examines the farthest areas to which black people penetrated in antiquity, along with the extent of their integration. Carried too far, the argument would lead to the paradoxical situation in which one can no longer identify the subject of one's study among a range of examples; but by the coherence of his classification and distribution of types, the author leaves it to be understood that those who deny the relevance of a piece of evidence should produce their own proof.

From beginning to end of the classical period Egypt continued to disseminate the image of the black. Naukratis and Alexandria were two important sources of diffusion in the Nile Delta. "Alexandrianism" even became a style, and the word came to be descriptive of works whose connection with Alexandria itself was sometimes rather vague. A careful examination of North African monuments shows that the contrasted, precisely characterized image of the black was not widely used there, and confirms the preponderant role of the Delta in the diffusion of the theme down to the end of the Roman Empire.

The testimonies coming from classical antiquity are presented accompanied by all the iconography previously developed in the Nile Valley. Seeing all this together, we are made aware of an original aspect of the Negro subject matter, which is that when the Greeks and the peoples of the Roman Empire wanted to represent a far-off, prestigious but different land, they used the black as the sign of differentiation: he became one of the forceful images in the "stylized" way of picturing Egypt, as the Egyptians had used his figure just as forcefully to symbolize their opposites.

Research on that image in the Christian art of the Occident from its origins to the fifteenth century—the subject of our second volume—presents quite a different situation. Properly speaking, the theme hardly goes back further than the twelfth century, when the figure of the African was separated from that of the Devil; this distinction occurred much earlier in Byzantine art, which thus forms a transition with antiquity. But from the very beginning the commonplaces on the blackness of the Ethiopian

stocked the patristic writings, and more particularly the commentaries written on them; they must of necessity serve as our introduction.

There has been no previous effort to assemble a documentation on the representation of blacks in Christian art. What we present in the second volume, with all the limitations and inadequacies we have already noted, is therefore a really fresh contribution, which will have to be judged by the art historian. But working from religious iconography ran the risk of narrowing the point of view too much as long as the black had not found his proper place in it. From the Crusades to the Great Discoveries, it seemed that the purely historical perspective was best suited to shape up the principal aspects of the subject, to bring out the mythic values of the representations, and to outline an approach to ideas and social attitudes.

The development so presented might be entitled "from myth to human reality." The two chapters dealing with these two extremes do not describe a simple phenomenon of transition. The beginning of the fourteenth century may well be considered a turning-point. But between the twelfth and the fourteenth century a certain discovery of the black African had already taken place—a process of humanization, of recourse to the data of experience, which progressively took the black out of his purely symbolic role. As time went on, the desire to free themselves from traditional ways of thinking is certainly evident in the view Europeans ventured toward their expanded horizons; a view nonetheless weighted with the old symbols rooted in fantasy. Those who were grappling for the first time with the unknown felt that mythic knowledge was "truer than nature" and furnished keys for the interpretation of the new reality.

From the sixteenth century onward, historical ideas about the blacks were shaped by the development of the Triangular Trade and the growth overseas of a slave-holding society. The revolt in Santo Domingo, sparked by revolutionary ideals, got enmeshed in the progress of the abolitionist movement before colonial imperialism, renewing the connection with Africa, opened the history of our own time.

The slave trade can be viewed as being the dominant phenomenon of this period. The works dealing with it are still insufficient; we would hope to see it treated with a scope worthy of the size of the subject. However, the chapters composing our third volume make no pretense of being a major contribution to the field. True, there is artistic material more or less directly related to it, such as illustrations in accounts of travel, popular prints, and devotional images which we will consider in a later publication; giving it space here would hardly be justified. If the phenomenon is of prime importance historically, the fact remains that art did not concern itself with the slave trade as long as it was generally accepted in Europe. Art approached the Negro theme according to specific rules governing the nature of its testimony. Slavery began to appear as a problem from the moment the new ideas of happiness and liberty were introduced by the philosophical literature of the mid-eighteenth century. Revolutionary proclamations subsequently spread them abroad, and a constant interaction between these two currents is observable. At the same time a sharp distinction was established between subjects suitable for treatment in "Great Art" on the one hand, and "popular" themes on the other, with the result that

the content of "academic" works was without significance. Neoclassicism and Jacques-Louis David's "dictatorship" certainly did as much as the suppression of rebellion in Santo Domingo to exclude the image of the black from the painting of the time. It is therefore mostly in illustrative prints for poems, novels, and historical accounts that the abolitionist inspiration shows up. The important paintings (Morland's, Turner's) were done in England, where anti-slavery ideas were particularly strong and sympathy for Santo Domingo was all the deeper because it could at the same time be directed against Napoleon. Moreover the pressure of David's influence was not felt in England. In France the reaction came from Géricault. When, in 1819, he put a black at the peak of the human pyramid of castaways in his *Raft of the Medusa*, he was certainly pleading for the human dignity of slaves; but his picture also puts a subject illustrating a current news item over against the grandiose historical compositions that glorified only the heroes of antiquity. Géricault's black man is exalted as the anti-hero, in defiance of a certain conception of the "dignity" of art.

A final chapter is devoted to the image of the man transplanted to the other end of the chain. In America even more than in Europe the freedom of the black might have been central to the concerns of art, since the driving force of the idea led to a civil war. But one would look in vain for such a concern. Here and there amidst the copious artistic production a moving accent of truth is discernible, but most often portraits and genre scenes emphasize the picturesque. The art of the time is mainly narrative in content, reflecting the black man's situation through the spectacle of daily life.

This survey will draw no conclusions. Many witnesses have not been called, others are still unknown. What we have is only a first meeting with the image of the black, not yet clearly discernible but already so revealing! Of all ways of discovering the past, art is the one that enables us to go the furthest; outdistancing all analysis, it brings us the fundamental quality of a presence. The attentive beholder cannot remain insensitive to the strength of this bond between the artist and his model, dependent on one another down through the generations. On the other hand art eschews certain kinds of conclusions: it states but does not reason. Development, causality, relationships—here these necessarily constitute the essential factors in the work of analysis by which scattered elements are organized into a comprehensible sequence. It must be borne in mind that in the end these thought processes betray a deviation from descriptive discourse. No law, unless it be the law of chance, can "explain" the presence of the black in a work of art or account for his absence; otherwise it would be necessary to explain the presence or absence of the masterpiece, whereas the answer to this falls within the domain of genius, which can in no way be reduced to a formula. The part of creativeness contained in the image of the black will ever bear witness to an encounter, an exchange in their true element, which is freedom.

LADISLAS BUGNER

INTRODUCTION

Turned inward upon itself, cut off from the Mediterranean Basin by the Sahara desert and from Europe for hundreds of years by the barrier of Islam, and in more recent centuries isolated by the system of the Triangular Trade, black Africa was an unknown land until the end of the nineteenth century. When an evaluation of the place of the black in Occidental art in general is undertaken, one is forced to conclude that his role is marginal. One is tempted to regard this low status as the sign of an unreasoned but deep-seated aversion toward the African on the part of the white. What we are about here is not only to review this summary interpretation but to show that the problem should be stated in quite different terms.

Works of art depicting the black are rare, and, generally speaking, not of high quality, and the insertion of a black image within a given theme was entirely optional. Hence we are always compelled to evaluate the relativity of his representation; taken in isolation, its unusual appearance might seem to have an originality or a significance which in fact it does not have. The representation of black torturers and executioners in scenes of the *Passion* is so frequent as to illustrate, by spectacular examples, a long period of xenophobia—as long as we disregard the still more frequent appearance of white headsmen. The evocation of Christ's sufferings had such appeal, and the taste for realism and the picturesque was so strong, that little room is left for the interpretation of the figure of the African himself. Speaking more generally, a history of art would not be written exclusively on the basis of works related to this theme. On the other hand one written without mentioning them would leave out a nuance, although it would not constitute a serious omission.

So much being said, we must emphasize the remarkable permanence of the subject through five millennia rather than limit its scope. Themes have taken form with a consistency such that the image of the African, though not obligatory, came to be normal and expected. Some of

these even confer a specific role on this image, and integrate it into the iconography of the Occident. Examples are the St. Maurice of the Holy Roman Empire, the *Baptism of the Eunuch*, the *Miracle of the Black Leg*, St. Benedict of Palermo, and above all the black Wise Man, the diffusion and durability of which cannot be minimized.

In the Occident the description of the Negro inevitably involved a certain realism: he was a particular type. Most often this differentiation was excluded as a matter of course from the most ambitious works, which aimed, through a certain degree of idealization, to express the human condition in general. We will not look for the black in the pediment of the Parthenon, but we find him in the main portal of Notre-Dame de Paris and in the cathedral of Magdeburg, invested with the highest spiritual significance that realism could confer. His importance was recognized by Maecenases as prominent as the Emperor Charles IV of Luxemburg, the Duke of Berry, and Cardinal Albert of Brandenburg. We might cite great artists' names, the Limbourgs, Grünewald, Dürer, Memling and Hieronymus Bosch, Mantegna and Veronese, Velázquez, Rubens, Rembrandt, Watteau, Pigalle, Houdon, Géricault, Delacroix, Turner, Cézanne ... the roll would make a "pantheon" which proves at least that the image of the black was not without interest to European artists of the highest distinction. Despite the fact that the Occident knew so little about the African continent, despite the weight of pejorative themes which Africa inspired, this image was able to take its place in a gallery of European masterpieces.

Should we wish to press the analysis further and take the frequency and distribution of the works into account, it would be possible to establish a curve of the variations of interest aroused by the African over the centuries, to set forth a topography of his presence and influence, and to compare these patterns with what history additionally attests regarding the waxing and waning of relations with Africa. But how are we to decide whether there was not more contact with Africans in the periods when art had only a limited "figurative" significance—for instance in the ninth and eighth centuries of ancient Greece? What shall we say about the European idea of the Negro as expressed in Romanesque art? The fickle chance that governs the preservation or discovery of the testimonies often makes such comparisons illusory. Exceptional cases of preservation (Pompeii), of destruction (the Lisbon earthquake), or of periods of iconoclasm (the Reformation, the French Revolution) are of less importance here than the normal situation of regions subject to cycles of regeneration. Loss or destruction of works in the busiest centers of communication (where traditionally artistic production is most active), while not so readily perceived, is often all the more sweeping. In Paris, for example, not a Romanesque, nor even a fourteenth-century stained-glass window left, nor a fresco earlier than the seventeenth century ... the losses are immeasurable.

The identification of the black in a work of art is possible only when the design or the modelling is executed with a certain degree of precision. Generally this is not verified in the case of archaic art forms, nor of works that are badly preserved, eroded, broken, or restored. We would hesitate to make so banal a statement if we were not aware that its obviousness is not always perceived. The fact that the work is "readable" often rules the efforts made to isolate the oldest-known example of the appearance of a

theme. This kind of mention is then none other than a disguised case of frequency interpretation: the single example surviving from a given period can seldom be precisely situated within a continuum of development in accordance with the conditions of formation and appearance of the theme, conditions which are deduced afterwards. Did the black Wise Man first appear in the twelfth century, as a certain number of literary sources would suggest? All examples of this figure from before 1400 fall short stylistically of a decisive individualization, or else may well be repaints. In the fifteenth century, when the theme reached its greatest popularity, or again in the nineteenth, when large programs of restoration were undertaken, three white Magi might have seemed an anomaly. We know of several instances where the people responsible for the protection of art works gave the restorers the job of removing a coat of paint from a statue; but can it be said that the "whitened" Balthasar has recovered his original appearance? Is it not a mistake to wipe away an alteration which, even though today it is regarded as an abuse of the original, has its own historic authenticity?

Once these reservations are noted, it is interesting to observe the absence of the black in the major works produced in periods of high-level artistic activity—e.g., by Raphael in Renaissance Italy or by Poussin in seventeenth-century France—whereas he is present in secondary works, and the most insignificant images, such as that of the little servant, increase in number. In this regard it might be asked whether, and to what extent, the black's reduction to these minor themes may reflect the effects of slavery, which developed in this period. It would be risky to say. The progress and ultimate success of abolitionist propaganda were echoed hardly at all in "Great Art," and found their most fertile ground and another medium of diffusion in popular engravings and prints.

Only objects cast in the same mold, taken from the same model, copies, and replicas add up. Those things give us useful indications of the success of a motif or the propagation of a theme, but they have nothing to do with artistic creation. For a given period, the difference between a large bronze and a small terracotta, both Hellenistic, is not simply a matter of size, but, more precisely, bears on the nature of the testimony. In a given category of objects, a statue will not have equal importance in the Sixth Dynasty and in the Eighteenth, or in a Gothic portal and a Baroque decoration. The artist turns progressively away from what a work signifies and toward formal considerations. Therefore, from its purely material and technical aspect to the factor of inventiveness and even of spirituality discerned in its production, every work constitutes a unique moment and an original equilibrium which demand recognition.

The importance of the evidence depends also on the place assigned to the black within a representation. If he is there only as an "extra" in a scene in which the white man is the principal actor, it is clear that his part is secondary. Even if his role is not degrading, and he is not added simply for contrast, his insertion in a composition shows that his image is subordinate to other factors in which he is only indirectly concerned. It may be thought that the periods during which such insertions occur most frequently thus seem the most unfavorable to the image of the black: instances would be the art of pharaonic Egypt and Christian Europe before the fifteenth century.

On the other hand the representation of the black may be isolated and stand alone as a consummate artistic form. This formal isolation seems to correspond to a more direct approach to the African. Contrast does not play a deciding role: attention is given first to the peculiarities of the type, and then of the individual. There is a large proportion of isolated figures in Greco-Roman art. The hazards of preservation may be in large part responsible for this; yet the major examples left by Hellenistic, Alexandrian, and Roman art give eloquent testimony to the favor in which the image of the black was held. In one case the isolation of the figure amounts, in all probability, to the identification of an individual. The Berlin museum has a marble head from the second century A.D. which portrays a black, noble of visage, calm, marvellously expressive. There is no question of the individuality of the figure. It was discovered among several busts with bases intact, and these give us the names of the models—Herodes Atticus, the wealthy Sophist and patron of the arts, and two of his disciples. These are mentioned by Philostratus along with the name of a third, Memnon—the name recalls the legendary king of Ethiopia. Thus everything seems to prove that this reference gives us the key to the identity of the personage portrayed by the sculptor. But for one fortunate find, how many names lost!

The problem of the portrait was elaborated in Western art from the fifteenth century onward with the more precise and limitative notion of genre. The privilege of having one's portrait "done" was certainly extended beyond the upper social classes. The impression created by the samples which have come down to us is a deceptive one. Doubtless an individual did not need to be rich or prominent to have his likeness done, but the same cannot be said of the reasons for preserving it. Who can carry around a family tree? Because Dürer was celebrated even during his lifetime and his least work sought after by his contemporaries, and because he made notes during his sojourn in the Low Countries, we can determine the decisive moment when he became interested in a black person, individualized and named: this was the servingmaid of an agent of the king of Portugal. On the drawing that fortunately has been saved for us, the artist inscribed the name and the age of the model. In 1521, Catherine was twenty years old.

Between the isolation of the form and the individuality of the portrait there is at times a basic gap. Certain figures do indeed present the black as he was, but are intended only as a representative, general type— witness the polychrome marble busts and the *porte-flambeaux* of the eighteenth century. Frequently the representation is coupled with a utilitarian object in which its isolation—due to the function of the object—loses its main importance and becomes in fact, the pseudo-isolation of the Negro-accessory.

For the most part, the representations of blacks made in the Roman period of antiquity are found in small hand-held objects such as tableware, lamps, and various utensils. Despite the quality of some of them, these pieces put the theme in the category of "minor" arts and limit its significance; but it is this lowering of status—no feeling of being threatened or of xenophobia, no reaction of fear vis-à-vis the unknown—that makes the approach to the image easier, more relaxed, amounting to a certain anecdotal familiarity.

There are times when art consents to take anecdote and raise it to the

level of style; at other times concern for style excludes the anecdote, and the theme has to have receded into history before the black is represented. The passing of generations can lead to sudden changes. Thus Rogier van der Weyden did not portray a black in any of his known compositions. In his great *Adoration of the Magi* in the St. Columba triptych, painted about 1460, the Three Kings are white, although the work was destined for Cologne, where the theme of the black King was first propagated. In 1464, the year of Rogier's death, his pupils, beginning with Memling, adopted the black Wise Man with a sort of predilection, and put him in large compositions which must have been painted in the master's studio. It is also possible that the desire to manifest a newly awakened sensibility partly explains the popularity of the Negro image among the Mannerists, among the painters of the third generation after Caravaggio, or among the Romantic artists who turned against neoclassicism. Such reactions are less easily discernible in antiquity when, taking longer to develop, they spread over several generations. Yet by analogy we can identify periods that were more favorable than others to exotic, or simply unusual, inspiration. Such trends appear in the art of the end of the Eighteenth Dynasty, in Hellenistic art (in which Alexandria played a central part), or again in the Roman art of the second and third centuries of our era. Decreases of creative tension may have the effect of favoring an eclectic approach, which in turn clears the way for exoticism. The disciple turns toward novelties in order to prolong for his own advantage the masterpiece he cannot surpass, by bringing in what is singular and strange.

Faced with the complexity of a decorative system or the endless resources that allow two figures to be placed in relation to each other, the spectator himself introduces the notion of isolation, which is simply a convention, a way of seeing. Once out of the artist's hands the work lives its own life, and a new setting creates or destroys relationships that modify its pristine situation. Yet isolation can be considered from another point of view, valid for all works of art, which takes us back to the moment when the form emerges, guided and controlled by its creator. Then we are aware of a kind of attention, of observation—we might say simply of effort and time the artist devotes to this figure in particular. We must be careful to avoid an anachronistic subjectivity which would read into this a personal, favored relationship to the model; but the understanding of the theme of the black in Occidental art is essentially based on an intuitive grasp of the dialogue.

The meaning of this dialogue interests us here insofar as it concerns a black model before a white artist. Furthermore this black model is chosen from among a number of white models. His image is more than a contrast: it represents the dissonant minority. Hence in Europe the relation between white man and black man cannot be communicated as it would be in African societies. On the other hand the dividing lines appear less clearly. Egypt was the first to give expression to a sense of the antagonism inherent in ethnic difference: there can be no doubt that Egypt saw a distinction between her own people and the black populations farther south, quite as much as Ethiopia did. Yet the "dwarf-Pygmies," the Nubians, and the Kushites pose the problem of the presence, in greater or lesser numbers, of

Negroid elements in these regions. In fact this question concerns all of North Africa, the Nile Valley as far as Meroë, and the northeastern horn of the continent; but admittedly it belongs to another set of problems, and we touch upon it very indirectly. In the Christian era Ethiopian and Coptic art do not seem to furnish guidelines that would allow us to judge whether black-white contrasts followed from particular, consistent attitudes at the ethnic or symbolic level.

To make the representation of the black man an index of ethnic differentiation is to put it into a much wider scope of meanings, these being determined by the symbolism inherent in blackness itself. The opposition involves not only the color white but light and brightness, and does not exclude the positive aspect of a real valuation. We shall deal only partially with this question, through art and in function of some of the most telling effects of the symbol upon the image of the African.

In ancient Egypt blackness was a sign of fecundity, related to the color of the fertilizing silt. Certain allegorical representations of the Nile carved in dark or black stone induce us to recognize, in the choice of the material, an allusion to the Ethiopian source of the river, although the figure has no Negroid traits. The same method of treatment applies to "Isis the Black," and careful studies should be made regarding its probable application to other divinities, where the notion of fertility is again associated with black color, both in Egypt and in Greece. The European Black Madonnas and alchemical symbolism are connected with the same kind of positive evaluation.

The Christian metaphor of the Ethiopian as a symbol of sin certainly established a relationship between the image of the African and that of the Devil, and the association of blackness with Death and Hell followed from the repulsion aroused by the blackness of Evil independently of any direct reference to concrete experience. It is nevertheless beyond question that this pejorative extension of the symbolism of black color reflected unfavorably on the person of the African. How far is this responsible for the degradation of his image? In this regard it seems to us that art may not have played a determinative role. The symbolism of blackness was generally used without calling upon Negroid features to represent the demon. A remarkable thing about this iconography is that we find so few demons with the features of a black, whereas from the earliest times of the Church the texts make such abundant use of this comparison. It would be an exaggeration to say that blackness constituted the demoniac attribute *par excellence;* the infernal world appears in all the colors of the rainbow. Sometimes violent hostility led to the blackening of the Jewish torturer, but such examples are not numerous. The same process was used more widely to caricature the Saracen, but in this case the artist also based his portrayal on features he had observed.

Another theme in which art followed literature only sporadically and in minor variations is that of Night. The terrors awakened by obscurity, the phantasms emerging from darkness, nocturnal themes in general are mostly literary. The Byzantine personification of Night is white, with the attributes of the moon and the stars: only exceptionally do we find her represented as black or blue with a veil over her head. In Occidental art the black Night—the night of sin—appears in a rare thirteenth-century document,

where it illustrates the liturgy of the Easter vigil. Otherwise it is hardly ever present until the sixteenth and seventeenth centuries in allegorical themes of an erudite, scholarly character.

From another point of view, art constantly made use of black without the slightest ethnic or symbolic significance. Before it is seen as a color, it is simply the obvious response to a piece of white paper. In black, the distinction between the two basic elements of painting, tone and color, fades in and out, allowing an interplay of subtle resonance. Materials present their own properties from which artists seek to produce the best result. Works can be adapted to bitumen, black glaze, basalt, or dark marble without constraint. The sculptor makes brilliant use of the limitless metamorphoses of black: shadow to substance; light gently absorbed or harshly reflected.

By the deliberate exploitation of a kind of "elective affinity" between medium and motif, the artist aims to convey the illusion that the material "summons forth" the image. When this image is as strange and exotic as that of an African, the meeting is all the more appealing. Greek head-vases, Alexandrian and Roman statues, provide many examples of this appearance of a pre-established harmony. The possibilities of the charcoal pencil in the hand of Dürer or Watteau give their portraits of blacks the charm of a rich counterpoint between medium and style.

Pictorial illusion is obtained by the use of gradations of masses and colors, superimposed planes, spatial depth conveyed by modelling light and shadow. In all these instances the use of black pigment is necessary. The figure of the African can even come in directly. May not the main reason for painting so many little black servingboys into pictures, around the eighteenth century, have been to create a dark area which is not a shadow?

The diffusion of our theme is linked to times and places in which a certain consensus on the three points we have been making is historically conceivable: we refer to the black-white contrast as a sign of ethnic differentiation, the extension by which this sign assumed symbolic significance, and the relative freedom of plastic expression from external constraint. The adoption of these points makes it possible to reduce the African to a conventional pattern that calls upon only a limited group of distinguishing signs. The convergence of a number, deemed sufficient, of the elements commonly called "Negroid features" is enough to identify the figure, at times with the help of a context that emphasized the differences and contrasts.

In fact the coordinates which dictate the image of the black are extremely malleable and unstable. Each element, taken separately, assumes meanings which go beyond simple racial characterization. On the other hand, one element can be suppressed or transformed within the system of representation without causing the identification of the black to be questioned.

By representing him with broad nose and everted lips, Egypto-Roman art recalled the African origins of the god Bes, while giving him the form of a grotesque, comic dwarf quite different from the Ethiopian type. This same kind of approximation is often used in the representation of satyrs, and, like the god Bes, these may show white or black coloration, as well as others. Lastly, in the numerous Nilotic scenes of Alexandrian origin, Pygmies, despite their dark skin, generally show only slightly Negroid features.

In the margins of manuscripts, in the profusion of sculpture in cathedrals, and in countless decorative patterns, the artist liberated, juxtaposed, or crossed forms accepted but turned from their ordinary function. Then the use of Negroid features takes on a playful aspect; precise reference to the African is absent or is recalled incidentally, as an added touch. These features are often gathered together in what are called the "grotesques": what we must see there is mostly a gesture of homage to the plasticity of their forms. Or the artist, inspired by entirely different motives, could use the flat nose, thick lips, and sometimes an exaggerated prognathism, without black color, as a conventionl vocabulary for expressing instinctive brutality in contrast to "noble" spiritualization or "feminine" grace. The realistic figure of the black already served this purpose. But it was not necessary to go so far. The snub, turned-up nose suited any figure, white or black, that the artist wanted to vilify. Rabelais called this the "ace-of-clubs" nose.

The element of color has always been used as the principal sign of differentiation, yet it is the most superficial and the one that can be most readily omitted. Pure, opaque black color, resistant as it is to modelling or shading, is seldom used excepting for two special applications, namely the shiny glaze on Greek vases and the black paint on fifteenth- and sixteenth-century polychrome statues in wood. In these objects, the conventional use of an artificial equivalent for the black man's skin color is allowed, whereas such equivalents are generally rejected for the white man, who was never represented as pure white.

Transposition of color probably disturbs least the identification of the subject. Rubens, in his famous study in Brussels, used modulations of silvery blue, brown, and red to render the color of four heads of blacks, producing, as it were, an inversion of a *grisaille*. Before and after him many artists, in painting the African, found opportunities for displaying the rich, vibrant tonalities of their palettes.

Ordinarily the black man is brown, most often dark, although a swarthy tone is sometimes hard to distinguish from a ruddy suntan. According to technical demands or the artist's fantasy the African can be red, green, or blue. No single color belies the black. Indeed the convention of the complete elimination of color can be observed without creating the impression that the work is unfinished: neither white marble nor ivory nor line drawings detract from the reality of the identification. In these cases, as in that of stone statues which have lost their polychrome, the absence of the too obvious sign of color is felt as a better approximation of the true appearance of the individual, as though he is no longer seen through a mask.

No one Negroid feature is in itself sufficient or indispensable to the identification of the black. Plastic characteristics, however, are far more clearly indicative than color. Long, wavy strands of hair, replacing the usual tightly curled crop, basically changes the representation. The same can be said of any other feature: a relatively small modification is enough to render it incompatible with the other signs, although these are still clearly recognizable. Furthermore the signs will be deemed strong or weak to the degree they can throw the image of the black out of balance if they are altered. Woolly hair thus counts among the strongest elements. Its absence does not affect the image—the black need not be bareheaded—but change

it and the image is destroyed. This is the process that makes it so easy to adapt Negroid features to "grotesques" and other "expressive" figures. Inversely, the nose and lips are less telling but cannot be supressed. Moreover they read as different, stronger signs when they are shown in profile, not frontally, partly because of the more distinctive contour, partly also thanks to the possibilities offered by changing the facial expression, which process attenuates the peculiarity of features seen full-face. A broad smile stretches the lips, flares the nostrils, accentuates the prominence of the cheekbones. The artist grasps these subterfuges by which he can assimilate the black type to the white. Considerations of style complement the choice of a model amidst the real variety of ethnic types, pure or mixed-breed. A straight, slender nose and thin lips either describe the Nilotic type or conform to the rejection of realism in favor of formalization of the sign or idealization of the figure.

Each plastic element demands an effort of analysis on the artist's part and sets up a problem of formal transposition. We can watch the creative imagination at work as it makes its way through the various treatments of the black's hair in Greco-Roman art, where we find incised diamond shapes in relief, little "peppercorn" lumps, spiral cones, tight ridged curls, or vermiculate grooves. Frizzy hair challenges the sculptor's chisel. Prognathism, however, is most often forgotten. When it is rendered faithfully it manifests a sharpness of observation that is out of the ordinary because it necessitates departing from the "canons" usually adhered to, in order to reconstruct the architecture of the face completely. This is why we find that trait more often in Egypt than in Rome, Egypt having been more familiar with the appearance of the black.

The ways artists worked to bring realistic representation of the African into harmony with their style or with the public's taste imply a veritable doling out of Negroid features. Throughout the second half of the fifteenth century we often find series of representations of the *Adoration of the Magi*, some of them quite long, stemming from the same composition and produced in studios that worked for a variety of publics. Their diffusion called for variations dictated by regionalisms, which might take the form of resistance to innovation or to the strangeness of the black Wise Man. To establish the necessary distance from the prototype, the evocation of the black conformed to a precise approximation; the lightening of the color and the attenuation of racial characteristics are school traits that correct the model. This reticence is noted even when in the same picture a servingman in the retinue of the Magi must be the portrait of an African carefully characterized—so much so that in certain cases one suspects that the figures are played off against each other in compensation. On the other hand the reduction of racial peculiarities may simply be due to the deterioration of a provincial style that drew upon an already stereotyped model without renewed observation of its source; in a word, the bankruptcy of the image.

We see, therefore, how the notion of artistic representation of the black goes beyond an approach to the African inspired by ethnology both as to symbolism of color and as to form. A Greek plastic vase from the fifth century B.C. illustrates this point perfectly, presenting back-to-back two contrasting heads, one of a white man, the other of a black. The contrast is

achieved by coloration, incisions, and other surface applications; underneath this dressing the two heads are identical, cast from the same mold. Between analogy and similarity, the mirror of resemblance projects its reflections *ad infinitum*.

The constancy of the representations of the black in the civilizations that developed around the Mediterranean Basin is inescapable. When the nineteenth-century explorers made their way into the heart of Africa, the expression "the Virgin Forest," which stirred the dreams of the children of Europe, gave rise to the idea that relations between Africa and the Western world were at their beginnings. The so-called "New World" of the fifteenth-century navigators had created the same impression. But these explorers and navigators were latecomers. Artistic evidence shows that the appearance of the African dates from no one event or time; his image is present in the continuous history of the Occident from the remotest legacy of Egypt onward.

Two fundamental aspects of the black man's status emerge from the variety of the themes of art and reveal the concrete relationships established with the whites: the man-at-arms, image of his status as a warrior, and the servitor, image of his servile or domestic status. The two images are already present in Egypt. The Assiut bowmen (Eleventh Dynasty) confirm the traditional employment of Nubian mercenaries, but these direct testimonies are rare. It is the image of the conquered warrior, the foreigner overpowered by Egyptian arms which recurs most frequently. On the other hand statuettes of concubines, toilet articles, and tomb paintings provided many opportunities to reflect the charm of servingmaids or the tall stature of men carrying offerings. In the Greco-Roman world there existed above all a black labor force made up mostly of young men whose task it was to follow the master to banquets or to the baths, and of dancers, musicians, acrobats, and jugglers for his entertainment; and fairly numerous representations of grooms and chariot-drivers seem to prove some specialization in circus performances and also in the care and training of animals. In the art of the Christian Occident, beginning in the twelfth century, the image of the man-at-arms predominates. Representations of St. Maurice, of executioners, of black "Saracens," and later of the black Wise Man, belong in this category. The servitor appears in the same period as a member of the caravan escort or the retinue, or as exhibitor of exotic or familiar animals. The image of the servant becomes more and more frequent after the fifteenth century: his integration into European society propagated the type of the young lad which was characteristic of Alexandrian art. In the eighteenth century this was diversified with the figure of the adult manservant whose devotion to his master is evident, and that of the faithful maidservant whom the colonials brought back with them to the home country.

Yet even when it is rounded out and its nuances are taken into account, this over-all image of warlike and servile status remains a bare outline. Above all, it leaves out the originality of the artistic evidence. Always keeping in mind the precautions to be exercised in estimating the value of a work, we must go further and try to determine the accomplishments and stimulations in function of which the production of this image

took an active role in history. Let us then pose this question: "Why the Negro?"

No one will doubt that the question calls for more than one answer; even to attempt this approach may be thought foolhardy. Anyway we shall not try to outline a general interpretation of the theme; we shall be satisfied to offer one thread which, among many others, may lead us through its successive phases.

We have been considering the black man in Occidental art as a figure that most distinctly and clearly expresses the differentiation of the foreigner. By his presence he brings in a relationship with a far-off land, an origin so remote that it poses a problem of reception and assimilation. Situated in an exotic setting, he transports one toward an "elsewhere," stirs a dream of accessibility and, by that fact, a dynamism of expansion and retreat. Let us pose as a premise that the black is *other*, that the black is *space*. These two terms will perhaps help us to evaluate better the significance of his representation.

These images—warlike or domestic—insert the black in the neighborhood of the white, and therefore denote a way of experiencing nearness. In Egypt we have a subject matter of defensive polemic against the invaders. To express his power, the pharaoh awarded himself the titles of Chief of the North Country and Chief of the South Country. The Kushite, broken and in chains, was the one who was trodden underfoot, like the Syrian, the captive from the North; but the fact that the Kushites adopted for their own use the Egyptian theme material of the fallen black captive shows perfectly the autonomy of the symbol. On the enclosures of temples and palaces and on the bases of statues, the North and the South, crushed prisoners of war, support the glorious king—a throbbing, rhythmic litany, like the sudden alternations of light and shadow at the sharp edges of the colossal walls. The symbolism of color, the opposition of black and white, and exoticism play only a minor part in the decorative aspects of the theme; the effigy is accompanied by a cartouche indicating the homeland of the conquered, like a placard of infamy cut deep into the stone.

The frequency of representations of prisoners and the constancy of their pejorative significance in pharaonic Egypt naturally lead us to see in them a manifestation of the fear aroused by pressure from the peoples to the South, as well as a proof of their strength and their organization, verified in time by their successful invasion and the establishment of the Twenty-fifth, or "Ethiopian," Dynasty. Much later also, in the thirteenth century of our era, the blackness of the headsman and the Saracen recalls, through the image of hatred, the power of the warrior, and the iconographic testimonies confirm the presence of black Africans in the Muslim armies. Christian Spain, which kept alive the fear of the invader, spontaneously retrieved the figure of the victorious king grinding down his enemies, so widespread in Egypt. From the pharaoh carved upon a pylon of the Great Temple at Medinet Habu to the archangel Michael painted on a fifteenth-century Catalan retable, the symbol has lost none of its reassuring eloquence. There is scarcely any need to modify the belligerent gesture. The painter has once again made use of the plastic effectiveness of the tense body solidly planted on spread legs, slashing through the mass of caricatured Saracens and blacks trodden underfoot, thrust down into the army of Satan.

The Medicis assured the fortune in the Occident of Cosmas and Damian, two saints of Oriental origin who worked miraculous cures. A legend attributes to them the *Miracle of the Black Leg:* they graft this leg onto a sick man while he sleeps, in place of his gangrenous limb. He awakens to discover the miracle. Strange alchemy by which the blackness of the gangrene is regenerated thanks to the sound member of a dead Negro! The theme did not spread much in Italy: Fra Angelico saw only its pictorial novelty, and serenely depicted the engrafted leg, half white, half black. In Spain, on the contrary, representations of the miracle abound: could it be that blacks were mingled with the population in greater numbers? The image of "domestic" polemics emerges when the cadaver from which the sound limb was taken is brought into the foreground of the scene instead of being sketched summarily in the background. With the aid of realism and a sense of the pathetic, this inspiration is pushed to the limit in an example in which the black, in the foreground, has had his leg amputated but is still alive.

When the threat turns to calamity and the blame is put on fate rather than on men, it becomes possible, in the same regions and the same period, to encounter the expression of a feeling of solidarity among all those faced with death. The diversity of races is sometimes joined with the difference of social status in a theme which can be regarded as one of the most beautiful illustrations of nearness; and even if there are no masterpieces to point to, it is remarkable to recognize the head of a black man among the figures huddled together beneath the mantle of *Our Lady of Mercy.*

Because for the Occident Africa was always the Unknown Land and constituted, so to speak, the inaccessible mystery closest at hand, the meaning of the image of the black in opposition to the white will to some extent be determined by a dialectic of distance, of which nearness is only a particular term. By the representation of the black the Occidental also expresses his situation as he perceives it: he places himself in a mental space which is subject to considerable variations both on the level of reality and in the realm of the imagination. The nature of the image is also a symptom of a way of coming to terms with this dimension, and reveals the conditions under which the Occidental determines his own situation. The memory of Egypt can always be recalled when the black is introduced in a polemical illustration of nearness. On the other hand one must turn to the heritage of classical antiquity to find prototypes of the black image that transport toward an "elsewhere," and translate otherness by a distance which is at the same time remoteness.

First, absolute distance: the impassable. The ancient world did not lack these marvelous projections into the Elysian fields which allowed the imagination to go beyond the norms of experience. Homer makes Ethiopia the ideal place for the banquets of the gods. Thus he confers on the black a power of evocation that prompts the embellishment of an "inaccessible" accepted as such. Between gods and men there is indeed a relation, a bond, but as though inverted—a bond of separation. The black, the pious guardian of the gods' retreat, stands for the contrary equivalent of the white man in a place to which the white will never have access.

The image the Greeks formed of the black has in it as much of the

"Egyptian mirage" as of the "Ethiopian mirage." In it the inaccessible is replaced by a distance bridged, the black representing both the forbidden crossing and the terminus. The most derogatory iconography to be found in the decoration of sixth- and fifth-century ceramics has as its theme the expedition of Heracles against Busiris the man-eating pharaoh. At times the painters pictured the episode without including the figure of the king, and showing opposite the hero only the wretched Egyptian servants in flight. Their Negroid features emphasize the pejorative image so strongly stamped upon the black in Egypt itself, an image separated in a way from its origin by the distance introduced by the Greeks. The crocodile is so closely connected with the Nile that we cannot help seeing the same sort of opposition used by the potter Sotades (with the distance of parody perhaps added?). He depicts a reptile so unrealistic that it suggests a figure in a pantomime, and a black urchin in a pitiable situation (the figure might also be a Pygmy), held in an "amorous" grip by the crocodile before the beast devours him. The Egyptian motif of the trampled black comes to mind before this Attic adaptation of a Nilotic theme, blending the lachrymose and the fantastic in an object which itself is so improbably "barbarous" in form.

The theme is renewed in depth in Alexandrian art. The black is sharply distinguished from the Pygmy and presented in the widest variety of forms, from terracotta figurines of the famished servant to large statuary in black marble. Once more the Nile Delta became the center of the world, but this time of a Hellenized world laid out on an East-West axis: Alexander's conquests thus led to seeing the black in a distance encompassed within a united and governed whole, at the farthest limits of an extended neighborhood. In Lower Egypt his features were repeated into the Christian era: the medallion stamped on the St. Menas phials is evidence of the strength and durability of this relationship. When Rome became the new center of empire, the Alexandrian themes underwent an important prolongation that amounted to a new flowering of exoticism: the image of the black, diverted anew from Africa, continued to spread a reminder of Egypt, but the reappearing mirage was now that of the Orient.

Classical antiquity treated the subject of the Ethiopian as "the different," utilizing the contrasts of near and distant, large and small, black and white, but not giving them an overt value of opposition or attaching a univocal symbolism to blackness. When we follow the successive dynamics of distantiation and of envelopment, we perceive that the inaccessible occupied a place restricted on the whole but still eminently favorable. On the contrary the Occident readily invested the black with a "mobilizing" function, thus to some extent continuing the polemical tradition of Egypt. But there were no longer any precise geographical boundaries to limit the extension of the poles of opposition. Black and white were fitted into a cosmological dualism, conveying not only contrast but fundamental antagonism—Hell versus Paradise. The flaw is in the world and in the heart of man: nearness and inaccessibility merge together. The inaccessible brightness is experienced as an aspiration and, as a consequence, blackness as a rejection. Recalling the African supports the metaphor. The black man—reality, color, symbol—comes into the dialectic of the repulsive, the repugnant, and arouses against him an instinctive urge for self-justification.

Aversion toward the black purifies and whitens. The inaccessible now "moralized" and blackened, thus became a preponderant element in the inspiration of the Christian Occident, to which it appeared as the world of the non-human.

Yet every man, however black he may be, always keeps a certain whiteness, for he is called to salvation. Only the Devil is totally black. The whole dialectic of the black-white symbolism was developed out of an unrealism based upon the sense of salvation which allowed the possibility of passing from black to white as well as that of falling back from white to black. The black Ethiopian illustrated the state of sin insofar as the literary metaphor supported the image of an Ethiopian turned white by the grace of repentance and baptism. Could art follow the concept? Could the metaphor become metamorphosis? Was not the only way to render the image of the black Ethiopian, the figure of sin, to deny him any sort of human face in order to recognize in him the horned, fantastic creature of the Devil? On the other hand an Ethiopian purified by conversion and relieved of his blackness would no longer be distinguished from a white man. The sarcophagi of the early Christian centuries show us the Ethiopian Eunuch converted by Philip without any distinctive ethnic feature, whereas, in a parallel way, the images of demons eliminate all precise reference to a particular human type. In this case we would have the invisible "Negro" at the center of the debate, but passed over and denied from either side by the white man, in function of his idealized image on the one hand and his phantasmal image on the other.

The Muslim expansion cut down the Byzantine Empire step by step. The threatening wall raised by Islam in Africa reinforced the barrier of the Sahara desert, and inevitably screened any knowledge of the depths of the continent that might get through to the Mediterranean Basin. An assimilation like the one that connected the black with Egypt in antiquity now associated him closely with Islam. The transfer of the symbolism of the black demon to the infidel set Occidental imagery on an unfavorable path. Over a long period black Saracens and torturers prolonged the repulsive image of the demon in more or less stereotyped forms. However, this "specialization" in excess did not prevent the African from playing a positive role, no longer based on a process of abusive assimilation but on a creative effort to differentiate.

As soon as the Christian Occident broke with Byzantium and assumed the autonomous and irreducible traits of its own personality, the Bible became a permanent encouragement to exoticism, although this was not always felt to the same degree. In any case the distance from Rome to Jerusalem stood as a fundamental separation deeply impressed upon the collective consciousness by the Crusades, an ideal dimension expressing the tension between Good and Evil. Here the image of the African played no part at the outset, either to sustain the polemical mobilization of feeling or to signify the opposition of the East.

Although anti-Jewish iconography made its appearance in the year of the first Crusade, the real insertion of the African image only occurred a century later, about 1180, with the *Queen of Sheba*, who figures in the typological retable at Klosterneuburg; of course the black kingdom is depicted among the Old Testament types and prefigures the *Adoration of the*

Magi, where the Three Kings are white. The symbolic structure is maintained, since the blackness that marked the Old Law is whitened in the New; but the concrete manifestation of the symbolism is no longer the absolute alternative of rejection by damnation or election by grace. Now it expresses the difference between the gropings of the man in search of the truth and the happy state of him who bows before the Revelation. The line of demarcation has shifted: it no longer separates the human from the non-human, but true goods from false. Man is posted on either side: a ford crosses the brook Kedron. It might be thought that the distance has been embellished to suggest the deceptive charms of the world not yet touched by the word of God; but such is not the fact. On the contrary, distance here serves to deny the very existence of this other world, since the apostles have been called to preach the Gospel to the ends of the earth. The *Pala d'Oro* in the basilica of St. Mark, Venice, is approximately contemporary with the Klosterneuburg retable: its enameled Byzantine plaques present an equally erudite iconography. The *Pentecost* scene is repeated twice. The apostles are ranged around a horseshoe table, inside of which are two men, one white, the other black. By this simple pictorial contrast the totality and diversity of the world's peoples are summed up. The black man also symbolizes the ends of the earth, the limit considered as a goal. St. Thomas preached to the Indies, St. Matthew converted Ethiopia: according to this logic, only distance and the Muslim barrier make it impossible to come upon the descendants of the people the apostles evangelized. Bonds were woven between the legends of the Magi and of Thomas the Apostle at the same time as the rise of the myth of Prester John, guardian of the gates of Paradise, the sovereign ruling beyond the frontiers of the known world, in whom all the virtues of priesthood and empire were united. The mysteries of Africa were so deep that that ideal figure for the medieval Occident, after a long series of tentative localizations, was finally drawn toward the fabled regions of the sources of the Nile. In spite of its failures the Occident did not give up its crusade dimension, and continued to cast its eye beyond the lines which the driving force of its faith had not succeeded in breaching.

On the main portal of Notre-Dame de Paris the symbolism of the non-human black was refuted. In a setting admirable in its grandeur, the idea of a threshold replaced that of distance. The threshold is the ultimate one, that of the *Last Judgment*, and the Ethiopian fits perfectly into the dialectic of sin and salvation: summoned by the angels *before* the Judgment, the African, his features nobly idealized but with clearly recognizable ethnic traits, is at this moment neither white nor black, and he can be redeemed just as any other man can.

The development continues with the creation of the St. Maurice of Magdeburg, about 1245. This is a local type but a prestigious one, which results from a complete reversal of the dialectic of repulsion. Magdeburg represents the fortress of Christianity at the border of the Eastern Marches. Symbol of the crusade mounted against the Slavs, white and pagan, the sainted black knight of the Theban Legion presents an image precisely the inverse of that of his opponents. The fright that the representation of the black might arouse in these regions, where he probably had never been seen, may well have heightened the effectiveness of this remarkable adaptation of the patron saint of Agaune. The cult of St. Maurice, it is true, had

spread throughout Europe, and his iconography was abundant; but the black St. Maurice is found only in the lands of the empire.

About the year 1268 Nicola Pisano finished the marble reliefs on the pulpit in the cathedral of Siena. He sculpted two blacks perched on camels in the cortège of the Three Kings, giving them a modest place but one perhaps not devoid of hidden intentions. The artist was breaking with the classicizing style of the studio that had a few years earlier produced the sober pulpit in the Baptistery of Pisa. Is there a desire to include something picturesque and exotic? To accentuate the rustic character of the escort in order to focus attention on the noble bearing of the Wise Men? Even so, the importance of another aspect of the work would be undiminished: for the first time we see the black integrated into a New Testament scene, without a trace of hostility, whereas previously his role had been exclusively that of the executioner.

The latter role was not abandoned forthwith, however, and even took on an increasing brutality; but in the figures of this whole period, at Rouen, at Chartres, at Strasbourg, quality of observation and nobility of style are always in evidence. The distance suggested by the representation is also a kind of drawing together, thanks to the progressive humanization of the black: nothing points up this ambiguity between the degradation of the role and the grandeur of the figure better than Giotto's executioner in the Arena Chapel of Padua, painted at the beginning of the fourteenth century.

Removed little by little from the polemical images of the Crusades and aided by the tortuous evolution of the Prester John legend, the black had a part in illustrating a re-evaluation of the diversity of nations and of the knowledge of mankind. Between 1360 and 1420 the flowering of the court art of International Gothic placed him in one of his richest iconographies. It was in those years that one of the Three Kings was first represented as a black, but it took a half-century for his image to be accepted and commonly used. The beginning of its period of wide diffusion coincided with the painting of the *Last Judgment* triptych in Rogier van der Weyden's studio (most art historians agree that Memling participated in its execution). In this triptych blackness was not reserved for the demons: it also identified, this time *after* the sentence, an African among the elect and another among the accursed. At that date, about 1464, the Occident had achieved its "Great Discovery" with regards to black people, and this means that, in the period which elapsed from the opposition of the angel and the demon to the equal distribution of Africans among the saved and the damned, the widest leap from one to another of the diverse conceptions of the black in the West had probably occurred.

The distance spanned denotes the success of the attempt made to overcome, without ever eliminating it, the tension inherent in the polemic of nearness and the myth of inaccessibility. This bridge legitimized the black man's place both under the mantle of Mercy and at the right hand of God. On the rare occasions when the Occident was not involved in a theme of domination but aimed at a broader, more political expression of universality, it was by the rejection of any exclusion of other peoples, in the name of human solidarity, that it conferred the deepest significance upon its encounter with the black. As for the Holy Roman Empire, it found there

material to illustrate the true dimension of its temporal vocation, and this in various forms, of which some, notably the St. Maurice of Magdeburg, are rooted in the oldest traditions of chivalry. For this purpose the empire did not need to wait upon the progress of the maritime voyages, which at first led only to the multiplication of concrete images for the renewal of old symbols.

The black King has been interpreted in many ways. One of the very earliest, developed around Cologne, was to suggest the universal import of the message of "peace on earth to men of good will." In the course of its development the theme of the *Adoration of the Magi* brought together the Virgin and the aged King kneeling at her feet in a single formal unit. Thus the group composed of the other two Kings, the white and the black, is set apart, and makes a new use of the most ancient symbol of the diversity of peoples, already found in Byzantine representations of Pentecost.

The as yet implied universality which defines one aspect of the *Adoration of the Magi* adds only a specific element to the much more general and traditional meaning of the act of allegiance. The linking of homage with signs denoting the range and outreach of a center of power constitutes one of the oldest and most widespread dialectics. In this sense the Egyptian scenes of tribute prefigure the gifts offered by the Magi. In particular, this interpretation relates less to the symbolic import than to the tangible value of the offerings, including an accumulation of goldsmithery and heaps of precious stones, as seen in the Manueline art of Portugal. Among these "tributaries" we find some of the most sumptuous figures of blacks, their importance enhanced at times with a real sense of nobility and elegance, or, more often, with a factitious overload that slips into the extravagant. But the ornaments of the Magi always heighten the glory of the One they come to adore. In the dialectic of All and Nothing the magnificence of the king, contrasted with the poverty of the Infant in the crib, creates a counterevidence which immediately implies the superlative opposition between the "more than all" and the "less than nothing," and here the role of the black fits in easily. But an excessive homage may well be crushing, and, despite the tricks of composition, the transfer of importance and value will be all the more difficult as, for its part, the image of the "sovereign" is impoverished in order to emphasize the contrast. In the end the antithesis as used in art is seen to be relatively ambiguous, and suitable only for a very limited range of applications.

When Africa had been rounded and its physiognomy recognized, Europe entered into direct contact with Ethiopia and the Congo. For the first time the traditional route of approach from the east was seen in relation to the newly discovered western route, and the continent was placed in the perspective of its true coordinates. This unique occurrence explains the remarkable popularity of the black Wise Man until the beginning of the sixteenth century.

Such excellent opportunities for encounter with Africans were compromised by the momentum of success as the Europeans saw it. The circumnavigation of Africa was in reality a trial run for the immense expansion both toward the Indian Ocean and toward the Atlantic. The extended thrust of the Great Discoveries went far beyond the African continent, whose image was dissipated between the poles of the glory of the maritime

empire and the exploitation of the slave trade. Africa was marooned and lost for exoticism, and the American Indian took over the black man's role in feeding the themes of "primitivism," the nostalgia of the Golden Age, the praise of the Noble Savage, and the myths of Eldorado.

Thereafter America took over a prominent place in exotic imagery and held it for a long time. Moreover Europe was unable to carry its exploration of the African interior beyond a few coastal enclaves. These two facts sharply limited the effects of the discovery of the black continent. Yet a new era opened in the history of its relations with Europe. Continuous contacts, though mostly connected with the growing importance of the slave trade, created a new framework that had only few analogies with the traditional space of the eastern Mediterranean. Art adopted the figure of a Western black which represented distance spanned within the framework of a modern world.

In the wake of European expansionism the expression of the Church's spiritual radiation and the exaltation of its missionary role called for the creation of themes more directly connected with current developments. The Jesuits fostered the image of St. Francis Xavier baptizing in India and Japan. So far as Africa is concerned, the most remarkable testimony is the tomb of Antonio Nigrita, ambassador of the Congo, in the church of Santa Maria Maggiore; a fresco showing the Pope at the bedside of the dying man is still to be seen in the Vatican. But the case remained unique. In fact the continent gave rise to the creation of no original themes, and its penetration by the West had practically no direct reflection in religious iconography. The crisis that shook Europe during the Reformation and the orientations dictated by the Council of Trent explain in large part this loss of interest. The slave trade gave the Church no occasion to play an important role. The Trinitarian Order did indeed devote itself to the ransoming of captives, and its emblem, as seen by the founder in an apparition, shows an angel between two prisoners. An important early example (beginning of the thirteenth century) already depicts the two as a black and a white. The angel of the Trinitarians reappears in seventeenth-century examples, with or without the contrast between the rescued men. In fact the Order worked not on the Guinea coast but in North Africa, negotiating the ransom of Christians carried off by the Barbary pirates.

There is no evidence of triumphalism in the iconography of St. Benedict of Palermo, a black and the son of freed slaves, who lived in Sicily in the sixteenth century. His cult spread somewhat due to the existence of confraternities of blacks in Spain and Portugal. There is still a local devotion to him in our time.

It is in non-religious art that we find the major appearances of this new figure of the Western African, unburdened of the weight of old myths, and removed from behind the distorting screens interposed by conflation with Eastern types. Velázquez's *Mulata* and the musician in Matthieu Le Nain's *Leçon de Danse* show an astonishing new frankness of imagery. Rubens and Rembrandt prove that these masterpieces are no exception. Others were painted in France and Italy, and, along with the work of lesser artists in which studies and portraits are numerous, they exemplify a mainstream that persisted into the 1660s and 1670s.

The heightened interest extended to viewing the African in his own milieu, in his nudity, with his customs, amidst his luxuriant natural surroundings whose age-old reputation for exoticism is confirmed. This discovery, which heralded the philosophers' anthropological concerns in the following century, began with accounts of travel: those by Theodor de Bry and Dapper were the most widely read, and their illustrations the most often copied. The new view came into art because Maurice of Nassau took a group of painters with him on his expeditions against the commercial settlements the Portugese had established at São Jorge da Mina on the Gold Coast and in Brazil. Their task was to reproduce in detail the flora and fauna and the landscape they encountered. Two of these painters, Frans Post and Albert Eckhout, have been especially remembered.

Among the pictures brought back by Maurice of Nassau, the *Portrait of a Congolese* dressed in European fashion—lace, rich doublet, huge felt hat with a red feather—and the *Negro from the Gold Coast*—nude, muscular, armed with assegais and arrows—represented the two types most sought after by Europeans: the noble presence of Othello and the naturalness of the "Savage." But already the eight pictures which Maurice presented to Louis XIV direct the viewer's interest to Brazil itself, and the black appears simply as an appropriate exotic element in the decorative scheme later exploited in the famous Gobelin series, the *Tentures des Indes.*

Maurice of Nassau recommended Albert Eckhout to Frederick William of Brandenburg, and the painter spent from 1653 to 1663 at the court at Dresden. On the banks of the Oder, he laid out his Brazilian scenes "taken from nature," without changing them much, as decoration for the Prince Elector's two residences.

Following Frederick Augustus's accession to the throne of Poland, Dresden enjoyed a period of magnificence in the early eighteenth century. One of its most original achievements in the realm of art is the *Grüne Gewölbe*, a treasure so rich and various that it claims to withstand any comparison. The chief pieces, in which rare materials and precious stones are combined, were the fruit of close collaboration between the goldsmith Dinglinger and Permoser the sculptor—a sumptuous display of "curiosities" which conjured up China and Egypt as well as Africa. Here, then, in the heart of the European continent, much more than in Venice, the infatuation excited by the exoticism of the black man, now associated with the New World, reached its most extraordinary expression. This same region had been the area where the black St. Maurice was most favorably received. Thus two of the most representative adaptations of the black image to the European mentality took shape in the same milieu, far from the maritime routes and without direct contact with Africa or the slave trade.

Permoser's exoticism had nothing in it of the black saint. Yet the heaping up of riches at the Dresden court and the unbridled prodigality of Cardinal Albert of Brandenburg, with his enormous collection of relics at Halle, manifest the same style of patronage of art. Both princes strove to tie Saxony more closely to Western Europe. They imposed a new scale of distance by producing out of this remote province a *nec plus ultra* that could neither be ignored nor bypassed, and would thereafter necessarily be reckoned within the compass of the achievements of European culture. But Cardinal Albert drew upon a tradition borrowed from the spiritual values

of the empire and the Crusades; even though it was near the end of its decline, this tradition endowed the black image with a wealth of significance. On the contrary, Augustus II merely seized upon the trends of fashion.

In Permoser's scintillating theater the black's role is clearly that of a bit-player. The artist uses him to transpose to this fairyland world the fashion of the little black page, popular in all the princely courts of the time: so he turns up, gorgeously attired, in innumerable state portraits. In other pictures he introduces a note of strangeness intended to add piquancy to scenes of daily life, highlighting the rarity of exotic products or animals—coffee or chocolate, monkeys and parrots. Then the theme develops to contrast the woman and her Moor, the one as white and beautiful as the other is black and ugly. In this period of masques and court ballets the burning heat of the African sun, the even brighter gleam in the eyes of Beauty, the fires of Love, and the burns of Passion are woven into a tissue of courtly metaphors. In Carmontelle's exact sketches we see the black as an object of amusement for the society of the Ancien Régime: Messieurs de Caumartin, artists to the best people, posed their Negro Telemachus. The facetious choice of names—Narcisse, Auguste—and the eccentricity of the costuming situate the little plumed hussar between the buffoon and the clown. We find the phenomenon everywhere, from Madrid to Stockholm, from London to St. Petersburg.

Toward the end of the eighteenth century, the arrival in Europe of a growing number of servants accompanying their masters home from the colonies, and the gradual perception of a more human psychological reality as rendered by Watteau, Quentin de La Tour, and some others, helped to lessen the popularity of this fashion without undermining it altogether. Drawings, pastels, and paintings, from Rigaud's to Madame Benoist's, display a mounting and varied gamut of sensitive portraits. In this series Pigalle's terracotta bust of *Le Nègre Paul*, servingman to Desfriches the colonial administrator, deserves special notice. The features are marked with a subtle nobility and vivacity, the model still being dressed in a picturesquely exotic style with a plumed turban on his head. Among portraits of blacks in the round this figure is the third one to bear a name. Memnon, Nigrita, Paul, three names that are anything but African . . . a certain kind of baptism is always required.

The new, Occidental figure of the black corresponds to the rising importance of the Atlantic and the far-reaching routes of modern maritime trade. It is part of a truly world-embracing geographical vision. The notion of universality comes out clearly and distinctly. The expression of homage by the oblique device of recalling the diversity of peoples reached its fullest development during the sixteenth century in the *Allegory of the Four Continents*. This turning-point is important, and in a way indicates the autonomy of distance.

The traditional notions of catholicity and empire are related to the unity of the Creation and constitute the affirmation of a pre-established cosmological order, refuting in advance any circumscription and, by right, annihilating any extension. The image of the variety of nations and classes represents a common human nature, in a collective rather than generic way: it is associated with an already explicit symbol in such a way that the

two terms mutually illustrate and determine the generalization of their import. To assure its autonomy, the artistic representation of universality must no longer draw its meaning from the symbol to which it is applied; in other words its form must be independent of the nature of the power whose outreach it indicates. Moreover it must rid itself of the accidental character of realistic detail, which an effect of accumulation only tends to stress; from this point of view the picturesque details of exoticism introduce a determination which is always too precise. With the allegory, universality is dealt with directly in its abstractness, outside of any concrete situation, instead of being suggested as a simple presentation of variety, and so is made available for an indeterminate series of applications, like a part of speech. The personification of *Africa*, filling the role of an ideogram, is integrated into a purely Occidental formal system—the last great structured and homogeneous theme in which the image of the black finds its regular place.

As it was codified by Ripa, about the year 1600, allegory establishes a system of conventional interpretations which transposes the evidence of direct observation to the level of abstraction, but avoids contradicting the same evidence at the level of the elaboration of the sign. Ripa justifies the choice of attributes by a disingenuously naïve appeal to common sense and tradition. The flowering branch and the urn overturned should be self-explanatory. The *Iconologie* presents itself as a "dictionary of accepted ideas." When the human figure personifies an abstract idea it shares in the nobility of the concept and supports the attributes, but initially must not have individual peculiarities. In principle the female figure had to be as idealized as, for instance, the personification of *Strength*, which was never portrayed with the muscular physique implied by the title. But how could blackness be omitted? If we continue our analysis, blackness is a mask, the most external of the Negroid features, and so is all the more appropriate as an attribute. Very quickly the figure of an African woman came to be used as the personification of *Africa*. The figure has a function which is the exact opposite of that of the portrait. The image of the African woman in the allegory often shows a high degree of observation and a precise rendering of features and expression; it is obvious that the artist used a model. But the truth of the figure is negated by the signification it is meant to transmit, and its merit is in direct proportion to the degree to which it does not draw attention to itself.

Several of the factors that contributed so much to the popularity of the *Adoration of the Magi*, and assured the spread of the black King, exhausted their effectiveness toward the end of the sixteenth century. The picturesque tended to be used less in the treatment of religious subjects; the homage rendered by the *Four Continents* replaced the implicit universality of the Magi with the more versatile, more up-to-date allegory. The Church, of course, made use of it, even giving it its broadest and richest sense. Bernini's *Fountain of the Four Rivers* expressed the radiation of the power of the popes: the Jesuit Andrea Pozzo spread a vertiginous apotheosis of his Order across the vaults of the Church of St. Ignatius in Rome. Yet the black King kept his place in Western iconography. But if we pay strict attention to the quality of the distance he embodies and the nature of the sense of danger he conjures up, we find him caught in a new dialectic which puts him between two neighboring but opposed forces. After the fall

of Constantinople the image that Europe formed of the Orient was dominated by the Turk—or at least this was one of the Orients, because imagination vested the East in different colors depending on whether it appeared near, middle, or far. The Turkish East, moreover, was subject to the fluctuations of a distance felt, from the too-near to the too-far. Its wealth and prestige were on display, while its menace was one of the great constants of the period. The Orient of costumes and arms, with the turban as the distinguishing sign. The *Adoration of the Magi* became one of the privileged themes of this exoticism. But was it solely a matter of exoticism?

The frequency of the theme falls in regularly with the rhythm of European concern as the Ottoman peril rose and subsided. If this parallelism has meaning, it may be thought that the Three Kings illustrate, or at least serve to evoke, the aspiration toward an ideal of unity put above the rivalry of particular interests. Except for a few times of crisis the Eastern frontier was in fact the only one really exposed, and amidst their intrigues the Occidental nations were content to see the Hapsburgs bear that pressure alone. But it was always regarded as proper to proclaim the solidarity of Christendom facing the hereditary enemy. Thus the black King confirms his place as the turban on his head gets larger and larger.

A return to the oldest orientation of Africa as the traditional land of evangelization is revealed, however, by the renewed popularity of the biblical episode of the *Baptism of the Eunuch*. The theme was widespread in the seventeenth century, particularly in the Low Countries: it was used in the decoration of baptismal chapels including the one in St. Peter's in Rome. The maritime expansion indirectly linked it to the present, and the Eunuch often becomes a pendant of St. Frances Xavier. One of its first appearances in the Occident is in a Book of Hours made for the Emperor Charles V, in which the servitor of the mysterious Candace is shown standing and bowing, clad only in a loincloth. Obviously it is the Africa of the Discoveries that was taking its place in Christendom. Orientalism rapidly recovered its rights, whereupon cortège, costumes, and landscape came, as usual, to be pretexts for transposition, and exoticism lost all its precision. Artists like Blomaert, Cuyp, and Rembrandt made much of the fervent piety of the black who was touched by the Revelation. Above all they glorify the sacrament in the name of which Christians were called to convert the world. The theme hardly outlived the Ancien Régime. We would be tempted to rediscover the *Eunuch*, as the distant continuation of an art pattern, in the image of the "grateful" kneeling black, when slavery was abolished.

Once the Turkish danger was dispelled and the themes of Christian unity stifled by nationalistic progress, the Magi themselves began to look like lost tributaries. The splendor of their multicolored costumes, the gold of their gifts, the pomp of their entourage, all were drawn into the crèches of Bavaria and Naples; the meaning of their homage became less and less distinguishable from the joyous celebration of the Christmas feast, at which time the world laid aside its everyday garb and put on its make-believe finery. What did the black then evoke, unless it was the improbable transformation by which for one night the slave could be a king?

If we borrow the perspectives of exoticism and look eastward or westward, we find, at the end of the eighteenth century, an image of the black,

infinitely available, but which no cause any longer had need of. The role of art in society no longer supported the grand iconographic themes that had kept the image so vigorously alive. Neither the Wise Man nor the Ethiopian Eunuch nor the allegory of Africa henceforth inspired real creative effort. The Orientalism which in many ways was a deeper probing of exoticism—a quest for values to complement European aspirations— brought forth nothing particularly new so far as the black was concerned. His last transformation put him to use as heightening "local color." The attraction of the Orient was revived, but also modified, by Bonaparte's campaign in Egypt. The mere fact that the Nile thus became a goal of conquest is in itself extremely significant, without precedent since St. Louis's siege of Damietta. Moreover, the new ambition took satisfaction in marching in the traces of the empires of Augustus and Alexander. Finally, recalling the ancient glory of the land of the pharaohs brings us back to the origins of our theme. In his picture commemorating the *Battle of the Pyramids*, Gros put in the foreground the body of a fallen black trampled under the horses' hooves, as on Tutankhamun's painted box. How could we do better, after contemplating forty centuries of history!

The only concrete, familiar image surviving at the end of the Ancien Régime is that of the black domestic, who is connected with life in the colonies, and even this reflects the end of the journey, the reassuring return to the home country. He makes it possible to evoke the distances traversed and the tangible bonds between the fatherland and the lands across the sea. But the bonds were beginning to wear out, and with American independence all bridges were in danger of being destroyed. As for Europe, the slave trade remained the only important business in which it was involved with Africa, and the abolitionists were attacking the trade and scoring their first successes.

We must clearly understand this decline in the evocative power of the black if we are to gauge the efforts the abolitionists had to put forth in order to awaken public opinion to the realities of slavery. Their testimony took the form of a bill of particulars presented in the metropolis, the arena where the trial was unfolding. The description of the cruel treatment inflicted on the slaves had the counter effect of radically altering the current idea of the black—not necessarily to his advantage.

The fight was waged in the name of principle—of a restoration of the moral values of Western society. Oppression and tyranny were the big words against which the ideal of Liberty was raised in the French Revolution. Slavery was a last Bastille, but its dismantlement in no way authorized the rebellion in Santo Domingo. Toussaint Louverture's success considerably slowed the progress of abolitionist ideas in France; the movement got under way again only after Toussaint died. From Egypt to Santo Domingo Bonaparte sensed that the value of the Empire-Liberty couplet depended on the existence of the couplet Negro-Slave. What could not be allowed was that the black man be free and the author of his own freedom.

Most of the black images that the Occident had developed had become obsolete. Those not in accord with the argument fell into oblivion; only the most pejorative were revived. The fusion of the terms *Negro* and *Slave* resulted in reducing the age-old relations of the black with the Occident by

placing prime importance on the relatively short period during which the Triangular Trade was thriving. A sort of backdrop was thus draped across the sixteenth century and disguised the more distant past. It is understandable enough that the abolitionist propaganda should have imposed this double limitation, both of nature and of duration, on the European image of the black; the propagandists had to stick to their immediate objective. But they had not foreseen that the realization of their humanitarian ideas would lead to the continuance of these narrowed perspectives. The trial ended with the victory. Time stood still at the "supreme" moment when the black had only to chant his deliverance. His image was confused with that of the slave; and once slavery was abolished he saw his past, his future, his very person enveloped in a single negation. On this negation white supremacy was erected.

An uneasy conscience is, for Occidental images of the black, the chief source of their energy. The serene appreciation that marks both the zone of equilibrium of the dialogue, from exchanges to fusion, and the measured, geometric distance which is related simply to travel, is rarely illustrated in a significant way in the subject matter of the black, particularly since the equilibrium (when it is achieved at all) is quickly called in question. Exoticism is evasion, and man, besieged, discovers that he is his own assailant. Does he not need to set the reassuring image of exteriorized terror over against the hidden threats he carries in himself? According to the strength or fragility of the sentiment of internal cohesion, individual or collective, all the variations on this theme of otherness present themselves. One of the major interpretations of the theme developed by the Occident is that of the black man who acknowledges neither faith nor law nor king. This would explain how the black image attained such complete availability before the abolitionist debate began. We do indeed see sanctity and majesty and justice embodied in the Theban knight, the Eunuch of Ethiopia, or the king "of Tarshish and the Isles." But more usually the black, as symbol of the forbidden, of transgression, or as the object of terror or nostalgia, has presented himself as the figure chosen for transposition— demon, hereditary enemy, good savage or bad. Whether he is portrayed as Egyptian, Saracen, Turk, or Indian, he is torn away, figuratively and then literally, from his South, where in the beginning the Occident found him.

The most evident transposition is that of blackness. The image becomes exemplar by its eclipses: eclipse of the Ethiopian between the angel and the demon; eclipse of Africa between Liberty and slavery. The obliterated image comes out in full sharpness when it is turned over: Pharaoh, Hero, Angel, Saint, Emperor, all then appear in relief—an image gloriously enhanced, deserter from the depths in which it is rooted. As Africa surreptitiously conceals itself behind the mask of the Negro, the white man senses his own secret blackness, and exalts its apotheosis through a black more black than the Black.

LADISLAS BUGNER

I

THE ICONOGRAPHY OF THE BLACK IN ANCIENT EGYPT: FROM THE BEGINNINGS TO THE TWENTY-FIFTH DYNASTY

JEAN VERCOUTTER

Egypt's geographical location in the Lower Nile Valley gives her a privileged position in Africa. From the earliest times, even before the climate changed to what it is at present, the valley of the longest river on Earth has been a route of communication between the subtropical and equatorial world south of the Sahara—in other words the black world—and the Mediterranean Basin, birthplace of the civilizations which were among the first to practice sculpture, drawing, and writing.

Egypt is the link between Africa, Europe, and the Middle East, all densely populated regions. It is therefore to be expected that the oldest representations of Africans would be found on Egyptian soil. This is exactly what happened; and it is not unlikely that the canons adopted by the Egyptians for the iconography of the black determined, at least partially, those of the Western world at large.

Since the appearance of an epoch-making article by H. Junker,[1] Egyptologists generally agree that it was not until the Eighteenth Dynasty, about 1450 B.C., that the pharaohs came into direct contact with the blacks, in the sense in which we understand this term; i.e., with the populations which, by their physical features, were very close to the present inhabitants of Chad, Niger, Kordofan, and even of the Congo basin. Junker, after defining the word *Negro* from the ethnic point of view—dolichocephaly, breadth of face and nostril, prognathism, type of hair, and shape of skeleton, notably the length of the lower limbs—concluded that nothing indicated the presence of true "blacks" in the vicinity of Egypt from 5000 to 3600 B.C. There was no definitive indication of a particular ethnic group that could be described as "Negro" in the texts nor in figurative representations—archaic painting or sculpture. Moreover, the skeletons found in the Nubian tombs of the Upper Nile Valley (between the First and Second Cataracts) all belonged, according to Junker, to populations who had no black blood at all. Discussing the position adopted

by historians like J. H. Breasted and E. Meyer on the period 3600 to 2700 B.C., Junker showed that it was inaccurate to hold that blacks had at that time invaded the Nubian valley of the Nile: except for their very dark pigmentation, the foreigners depicted in the art of the Old Kingdom could not be considered Negro, since the other characteristics were missing. From 2000 to 1700 B.C., the inhabitants of Nubia (Group C in the nomenclature adopted by G. A. Reisner)[2] were still pure "Hamites" (*sic*).[3] The same holds true (still according to Junker) for the people of the civilization called "of Kerma," between the Third and Fourth Cataracts. The Nubian mercenaries appearing in Egyptian mural paintings or in the "models" placed in tombs were all "Hamites."

To continue Junker's analysis, it was not until after 1600 B.C. that genuine Negroes appeared in the Nile Valley, arriving there by two distinct routes. Some may have come in by moving along the eastern coast of Africa and the Red Sea: there are blacks among the inhabitants of the "Land of Punt" who are represented in the bas-reliefs of Hatshepsut at Deir el Bahari (c. 1480 B.C.).[4] They may also have followed the course of the Upper Nile. Until the reign of Tuthmosis III (1490-1436), at any rate, the peoples who lived in Upper Nubia, and who are depicted in the Theban tombs of the first half of the Eighteenth Dynasty, were still essentially "Hamites": there are few, if any, Negroes among them. It is only after Tuthmosis III's reign that the true black appears in Egyptian representations. At the end of the Eighteenth Dynasty—during the reigns of Tutankhamun and Horemheb—Negroes formed the majority of the population in the Nubian valley of the Nile, to judge by the representations found in the Egyptian tombs.

After the appearance of Junker's article, which I have just analyzed, historians of ancient Egypt stopped translating the word *Nehesyu*, which certainly goes back to 2300 B.C. and is probably older, by *Negro* or *black*, as they had done previously, and adopted the translation *Nubian*. The fact is that the word *Nehesyu* would seem to be derived from a place name. It designates all the settled inhabitants of the Nile Valley south of Egypt, and the texts show that it can apply to different peoples and tribes.[5] It is not therefore a genuine ethnic term, and it could mean blacks, if there were any in the Nile Valley at that time, as well as the indigenous non-black population which it most often designates.

If therefore Junker's reasoning is followed to the end and his conclusions are accepted, the Egyptians, before the fifteenth century B.C., were in contact only with the so-called "Hamitic" populations settled in the Nubian valley of the Nile, south of Assuan, and in the adjacent deserts— populations related to the Berbers, the Libyans, and the nomads, now Muslims, of northeast Africa, Beja, Bisharin, Hadendoa, and Somali—all of these, though African, different from the blacks in Africa south of the Sahara. These latter, in Junker's view, were completely unknown to the Egyptians of the Old and Middle Kingdoms.

What is certain is that there is no known representation of an indisputably "Negro" person in Egyptian art dating from before 1600 B.C. Yet on the one hand we must keep in mind the stylization of the art of the Old Kingdom: a given head, which looks to us like the classic representation of an Egyptian, may just as well belong to a genuine black. On the other

hand I think it would be dangerous to conclude, from the absence of likenesses of unquestionably black persons in Egyptian iconography, that the Egyptians had not yet had any contact, at that early period, with black African peoples.

In reality, as I see it, the probability that the Egyptians could have and must have known the blacks is indicated by an analysis of the problem, both curious and complex, of the presence of "Pygmies" under the pharaohs of the Old Kingdom. If it be granted that the Egyptians of that remote time knew this typical people of Central Africa, then it is at least probable that they also had contact with the other black populations south of the Sahara. A frequently quoted text,[6] and a very important one, may well allude to the arrival of a Pygmy in Egypt: the text is the story carved on the walls of the tomb of the Egyptian explorer Harkhuf, at Assuan.

Harkhuf, the governor of Elephantine, who lived about 2300 B.C., at the end of the Sixth Dynasty, brought back a "dwarf" from Upper Nubia (the Land of Yam). Once back in Elephantine, Harkhuf dispatched a messenger to King Pepy II, who was still very young, to inform him that he had returned from the lands to the South. The king replied immediately with a message which Harkhuf ordered carved on his tomb. Here are its essential passages (the king is addressing the explorer directly):

You said ... that you have brought back a dwarf from the land of the horizon, a dancer of the god, like the dwarf that the god's treasurer Bawerdjed brought back from the Land of Punt in the days of King Isesy. You wrote me: "Never has anyone else brought a dwarf like this one from the Land of Yam." ... Come straight to the Residence and bring the dwarf with you ... Choose some trustworthy men to be with him ... Make certain he does not fall in the water ... My majesty desires to see this dwarf more than the other marvels of Punt.

The problem lies in the translation of the word *deneg*, which in the text designates *the dwarf dancer of the god*. The general opinion, based on the fact that the usual word for dwarf is *nemu*, is that *deneg* should be translated *Pygmy*.[7] If this translation is accepted—and the arguments in its favor are very strong—it should also be granted that the Egyptians were very early in contact with the Pygmies, and consequently with the populations of Central Africa. The word *deneg* does indeed appear in the *Texts of the Pyramids* (No. 1189),[8] in which the dead pharaoh, in a magical incantation, declares: "I am the Pygmy-*deneg* of the dances of the god, who amuses the god at the foot of his great throne."

Even if the collection of funerary formulas known as the *Texts of the Pyramids* is not as old as was thought until recently, the fact remains that the incantations contained in it go back at least as far as 2400 B.C., and that many of them are older than that. This implies on the one hand that the Egyptians were in contact with the remote African world as early as 2400, and on the other that the Pygmies, who at the present time live in the great equatorial forest, in the third millennium probably occupied lands farther north, toward the Nile basin. Thus the Egyptians of Isesy's time (about 2450) could come across a Pygmy on the Red Sea coast, in the neighborhood of Eritrea; and some years later Harkhuf brought one back from

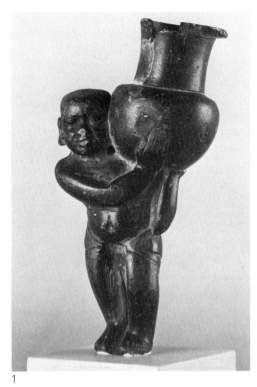
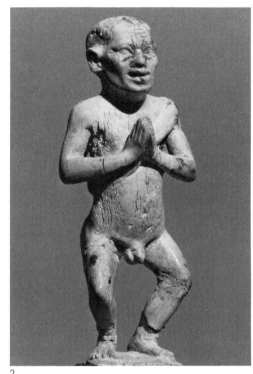

1

2

1. Pygmy (?) carrying an ointment jar. Dynasty XII, about 2000 B.C. Steatite. H: 10.2 cm. London, British Museum.

2. Statuette of a Pygmy (?), part of a "mechanical" toy. From Lisht. Dynasty XII, about 1970-1930 B.C. Ivory. H: 6.5 cm. New York, Metropolitan Museum of Art.

3. Statue of an African prisoner. From Saqqara. Late Dynasty VI, about 2400-2200 B.C. Limestone. H: 84 cm. Cairo, Egyptian Museum.

Upper Nubia. Be that as it may, it seems evident that the Eritrean coast did not belong to the Pygmies any more than Upper Nubia did, and that in both instances cited above it was through intermediaries that the Egyptians got their Pygmies. Thus we are led back to the problem of the relations between black Africans and Egyptians.

If, as the analysis of the Pygmy problem indicates, the Egyptians were in contact with the black world as early as the third millennium B.C., why do we find no trace of the blacks in Egyptian iconography? My feeling is that we have to take a very close look before declaring that there is no representation of a *true* black in the Egyptian art of before the Eighteenth Dynasty. That opinion, which stems from Junker's article, is based on a comparison: in the Egyptian art of the Old and Middle Kingdoms there is no representation of human beings who *resemble* those depicted in the Theban tombs, particularly in the characteristics of accentuated prognathism and very dark skin. But does that mean that there is no representation of a black African from an earlier period? Assuredly not. We have figures of individuals who are very short in stature and very dark of skin, who might be Pygmies, among them a statuette in the Louvre, and more particularly the figure of an individual carrying a very fine ointment jar, this one belonging to the British Museum.[9] Also to be noted are four ivory statuettes found at fig. 1
Lisht in Middle Egypt, in a tomb dating from the reign of Sesostris I (1970-1930 B.C.). These figures represent dancers, and look strangely like Pygmies. They belonged to a "mechanical" toy.[10] fig. 2

These objects date from the Middle Kingdom; but among the prisoners' heads found by G. Jéquier at Saqqara South, in the funerary temple of Pepy II,[11] and more recently by the French Archeological Mission for figs. 3, 4
Saqqara in Pepy I's tomb, some are African.[12] Of course the bas-reliefs of figs. 5, 6
the Fifth Dynasty and the beginning of the Sixth also showed African prisoners, but the bad condition of the monuments obscures the ethnic

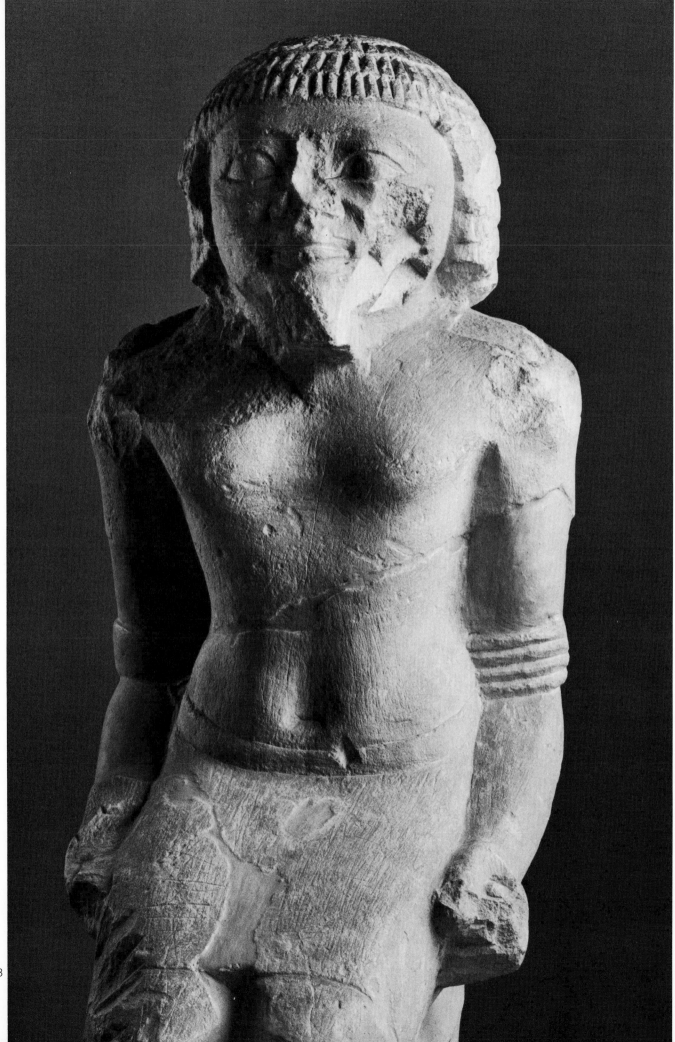

3

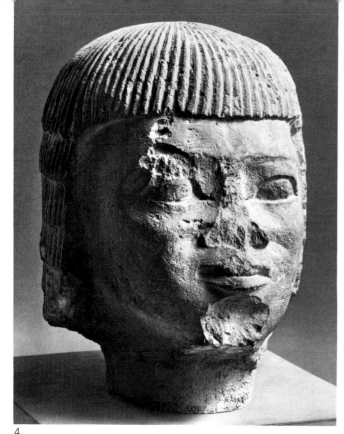

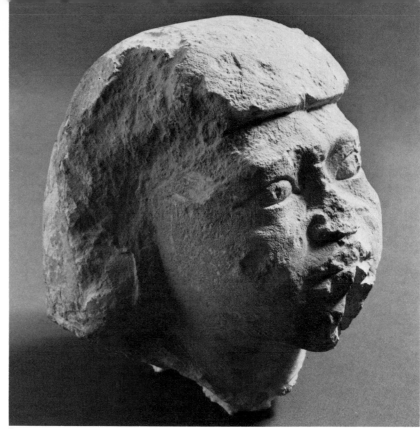

4 5

4. Head of an African prisoner. From Saqqara. Dynasty VI, about 2400-2200 B.C. Limestone. H: 19 cm. Cairo, Egyptian Museum.

5. Head of an African prisoner. Dynasty VI, about 2423-2300 B.C. Limestone. H: 19 cm. Saqqara, *in situ*.

6. Head of an African prisoner. Dynasty VI, about 2423-2300 B.C. Limestone. H: 16 cm. Saqqara, *in situ*.

characteristics of the individuals represented. At Saqqara the heads, although mutilated, give a clearer idea: the hair, notably, is arranged in parallel rows of short, tight braids, no doubt to represent its kinky or woolly texture—a trait which persisted in the iconography of the black throughout the era of the pharaohs in Egypt. cf. fig. 3

The appearance of Africans in Egyptian iconography coincides with the deeper and deeper penetrations made by pharaonic expeditions up the Nile Valley. Harkhuf, who brought back a Pygmy to Pepy II's court, advanced far into Upper Nubia: we may assume that sometime in the reign of Merenre he got into the area between the Second and Third Cataracts, and may have gone beyond the Third.[13] Now these are the regions in which terminate both the trails coming from Darfur and Kordofan toward the Nile Valley, and those which cross the Bayuda and join the Upper Nile directly at the Middle Nile of Dongola. Moreover, this is why Harkhuf was able to find a Pygmy there on the occasion of his second expedition. The appearance of black Africans in Egyptian iconography can therefore be dated from about 2500 B.C. Either these blacks are Pygmies, or they are individuals whose ethnic group cannot be determined solely by iconographic criteria, but whose African character is certain. To describe them systematically as Nubian Hamites is an a priori position which it is hard to justify.

Furthermore, if representations of Africans become numerous during the second half of the third millennium, it is quite possible that they are already present in earlier iconography. I am thinking especially of the admirable "reserve head" (belonging to the reign of Cheops, about 2600) found by G. A. Reisner in 1913 in a mastaba at Giza.[14] It is difficult not to fig. 7 see this head as that of a Negress, as Reisner himself did. The important thing is that these heads, which form "a veritable gallery of portraits of the time of Cheops," (J. Vandier)[15] all belong to personages of rank in the

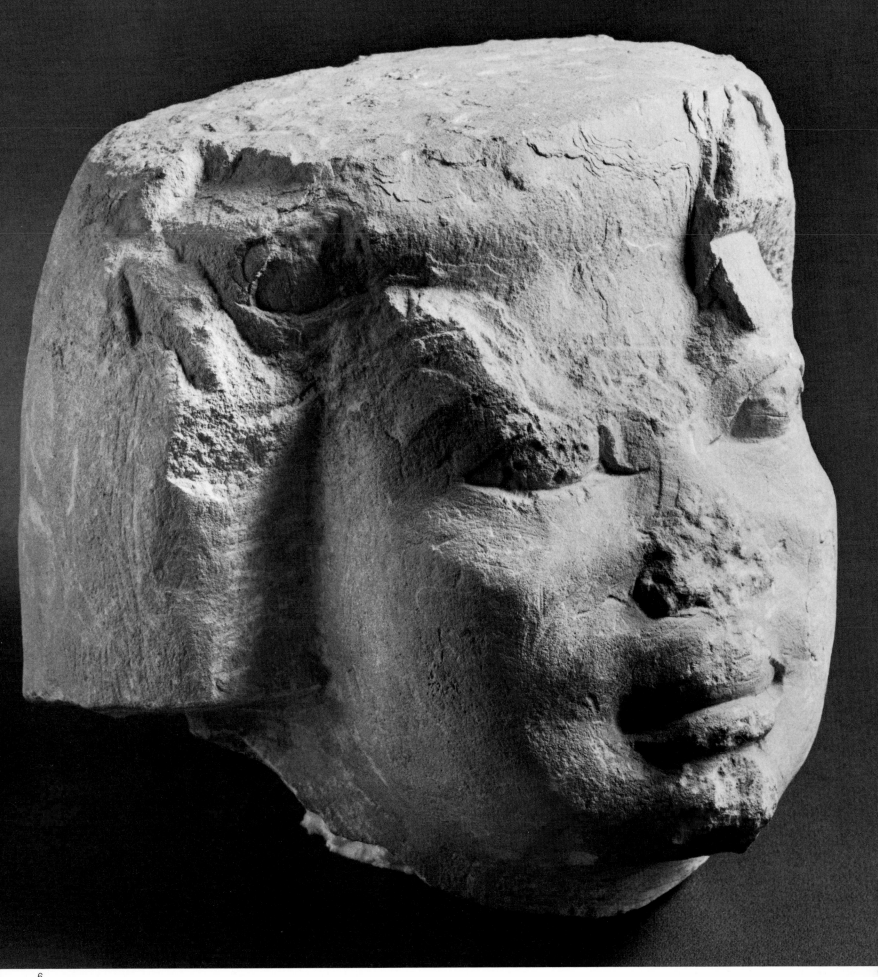

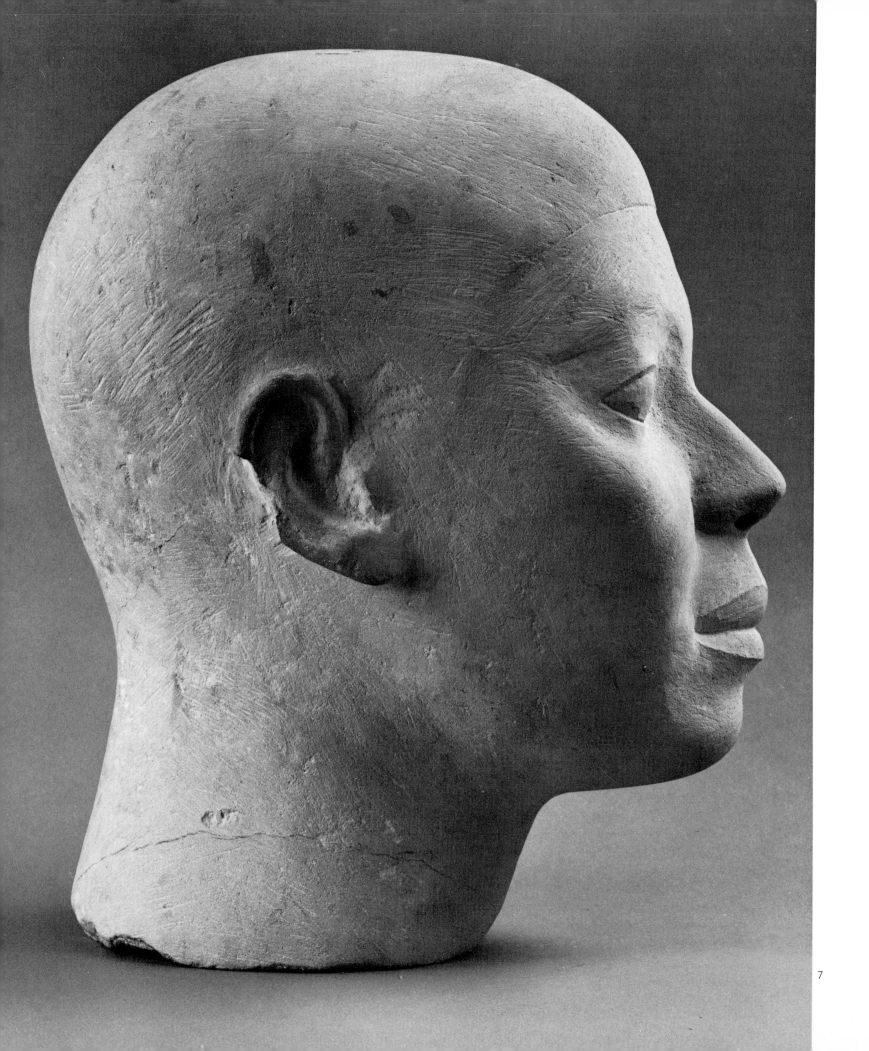

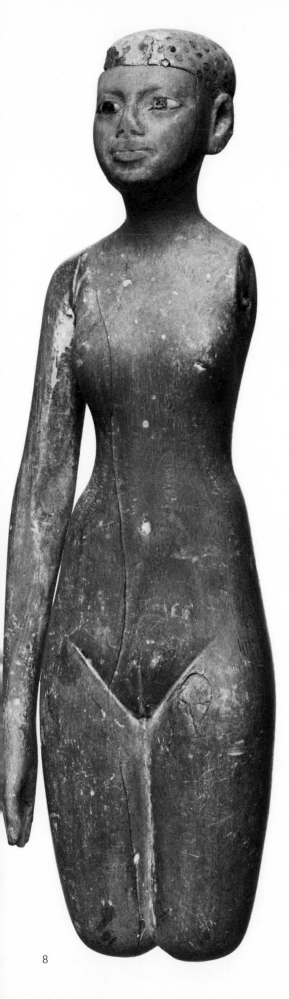

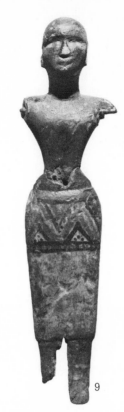

court of the Fourth Dynasty. They certainly come from the royal sculpture workshops at Memphis, and they prove that at that early period the nobles of the court of Memphis did not hesitate to marry African women, who at that time held equal rank with women of Egyptian birth.

Representations of blacks appear in Egypt, therefore, from the beginning of the third millennium, multiplying in number during the second half of the same millennium. All of them, or very nearly all, are unknown to us. Apart from those which have disappeared during the four thousand years since the Fifth and Sixth Dynasties, we must keep in mind the fact that the pyramids and solar temples of that era, rich as they must have been in pictures and statues of peoples foreign to Egypt, have not all been excavated. The representations of Africans dating from the Old Kingdom that have come down to us, often in a wretched state of preservation, are but a small fraction of those that must have existed, and no doubt still exist, buried in the sands of the desert plateau of Giza and Saqqara. We may hope for further discoveries in that area.

Figurations dating from the Middle Kingdom seem to have enjoyed no happier fate. The texts—notably the "Texts of Execration" or "Magical Texts"[16]—show that the Egyptians had exact knowledge of the Upper Nile Valley and its geographic and political divisions, and even of the names of the local rulers. Yet the representations dating from that period are rare, if we except some few statuettes of Africans who lived in Egypt. Such are the figure of a very beautiful "concubine" in wood, coming from El Bersheh,[17] a work which shows that the Egyptians were then, as they continued to be, sensitive to the beauty of African women, and the "dolls" (?) representing blacks, found in a tomb dating from the Eleventh Dynasty (2050-2000 B.C.) at Deir el Bahari.[18] The scarcity of figurations of Africans in the sculpture and painting of the Middle Kingdom is the more surprising since, as is well known, people from the South came into Egypt in large numbers from the

fig. 8

fig. 9

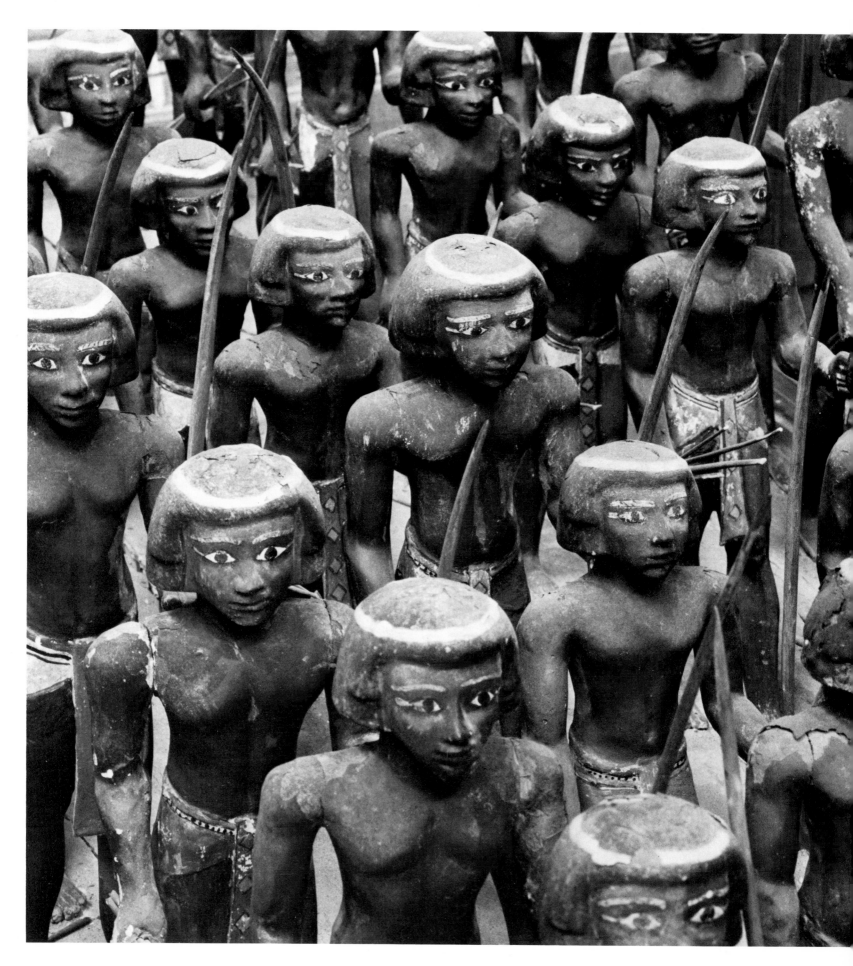

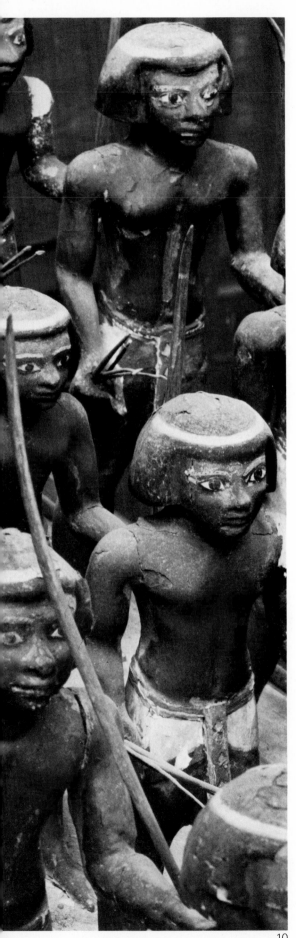

year 2000 on: it is noteworthy that from 2200 to 2000 B.C. they formed the majority of mercenaries who took part in the internal struggles of the First Intermediate Period.

After the conquest of Nubia between the First and Second Cataracts in 2000 B.C., the Egyptian armies had access to the Upper Nile Valley, and entered into close contact with the indigenous populations as far south as the Third Cataract and beyond. Even if most of these peoples were not Negro, it is certain that as in the previous period they were also in contact with others still farther to the south. Therefore it should be possible to find in Egypt representations of people who must have made their way into the Lower Nile Valley. We have some few figurations of Africans then living in Egypt, but unfortunately either they are in very bad condition or their artistic quality is so poor that they give no precise idea of what the persons represented looked like. Still, as in the Old Kingdom, the portrayals indicate that Egyptians, both men and women, were not averse to mixed marriages. It is characteristic that only soldiers are shown[19]—the archers in the famous wooden model from Assiut, in which the Nubians are seen reduced in size,[20] the warriors of the tomb at Mi'alla near Thebes[21] and of the pyramids of Sesostris I and Sesostris III,[22] and the archers on stelae dedicated by mercenaries.[23] Female figures are much rarer. Examples are the statuettes found by H. E. Winlock at Deir el Bahari, which we have already seen,[24] and a few representations of African women who went to Egypt with their husbands, which can be seen on the stelae of the mercenaries of the First Intermediate Period.[25]

figs. 10, 11

fig. 12

Whether the lack of documentation is due to the random chance of excavations or to the destructive effect of time, representations of blacks in Egyptian iconography are relatively rare, as we have seen. With the coming of the New Kingdom a double phenomenon is observed: on the one

10

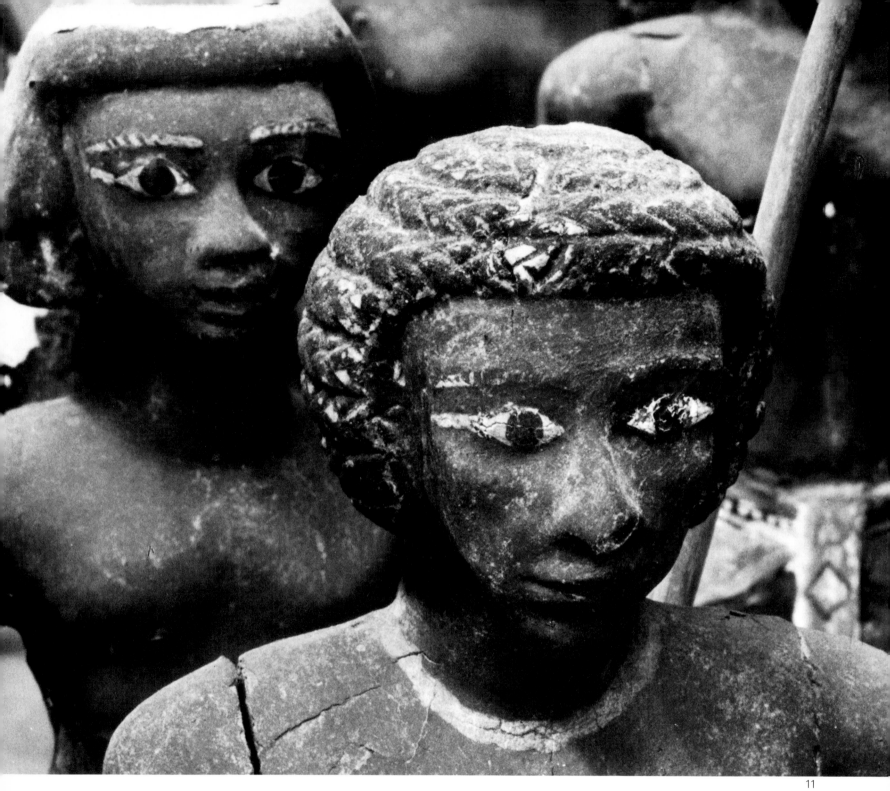

11. Troop of Nubian archers (detail). From Assiut. Dynasty XI or XII, about 2000 B.C. Model in painted wood. Cairo, Egyptian Museum.

12. Nubian mercenary and his wife, detail of a stela. First Intermediate Period, about 2180-2040 B.C. Limestone, with traces of paint. Leiden, Rijksmuseum van Oudheden.

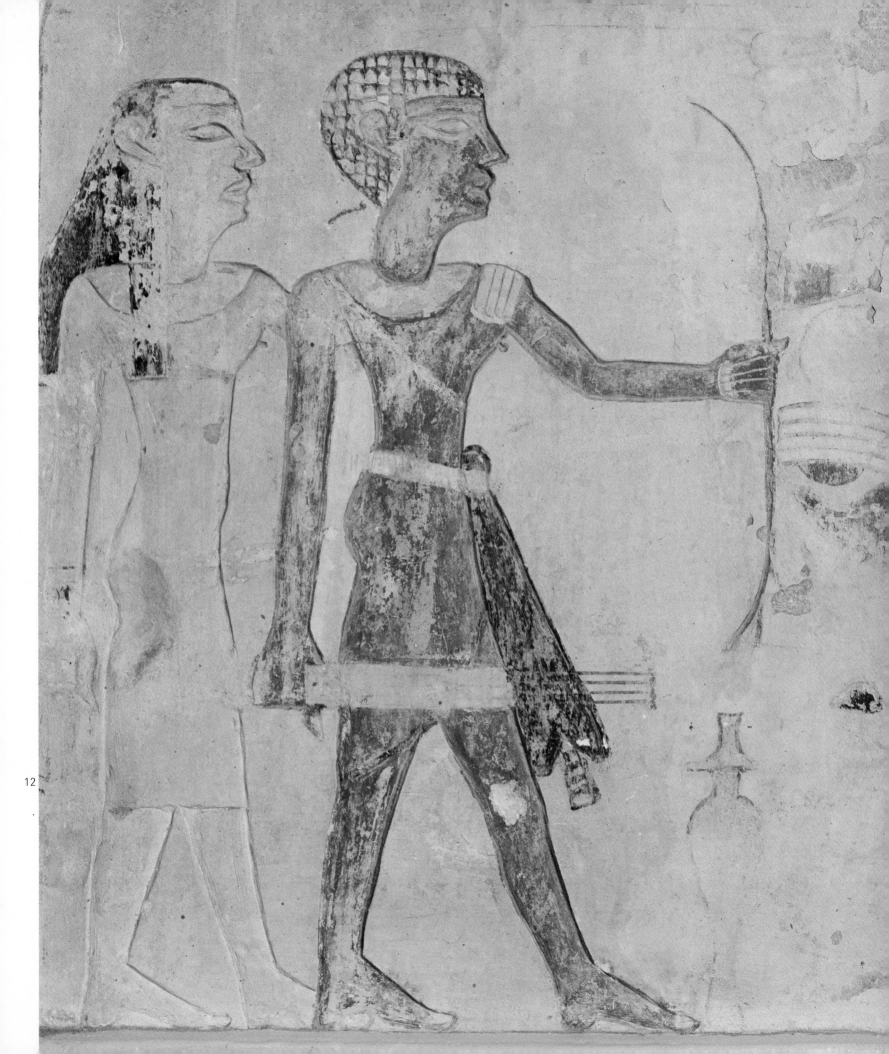

hand the representations of Africans become numerous, and on the other they become extremely schematic. While in the best ancient figurations the individual traits of the blacks come out clearly, under the New Kingdom they quickly become stylized, and there appears in Egyptian art a Negro "type" which was handed down to Greek and later to Roman Egypt.

What had happened? From 1730 to 1580 Egypt was under the domination of the foreign Hyksos. No doubt taking advantage of Egypt's internal difficulties, the peoples of the Upper Nile Valley organized themselves into independent kingdoms.[26] These kingdoms may not have been fundamentally hostile to Egypt, since archeology proves that they were at least partially Egyptianized, but in the nature of things they constituted a danger to the pharaoh. This comes out in a recently discovered text, in which Apophis, the Hyksos ruler, addresses the king of Kush, a new African kingdom, exhorting him as follows:

Come, fare north at once [into Egypt]. Do not be timid. See, he [Pharaoh Kamose] is here with me... I will not let him go until you arrive. Then we will divide the towns of this Egypt between us.[27]

There is no indication that the African ruler gave a favorable response to the Asian's urgent summons, but the pharaoh saw the danger of being caught in a pincers movement between Asia to the north and an organized Africa to the south. The new Theban dynasty, the Eighteenth, did not rest until it had destroyed the African political power that had arisen along the Upper Nile. The Egyptian dynasty found this move doubly profitable: it protected Egypt against the incursions of very bellicose peoples, and, not less important, it gave access to the African resources which were indispensable for the planned intervention in Asia.

That whole episode has never, to my knowledge, received the emphasis it deserves. Misled by the pejorative used in the Egyptian texts to designate the African kingdom, *Kush-Khesyt*, "Kush the Contemptible," as the expression was usually translated, or "Kush the Defeated," as it is now understood,[28] historians of ancient Egypt have underestimated the power of Kush. Yet it took campaign after campaign by the first pharaohs of the Eighteenth Dynasty, Ahmose, Amenhotep I, and Tuthmosis I, to put an end to African resistance, which still flared up sporadically under Hatshepsut, Tuthmosis III, Amenhotep II, Tuthmosis IV, and Amenhotep III.[29] Only military occupation of Nubia from the First to the Fourth Cataract finally allowed Egypt to keep its hold on the Upper Nile and to put the resources of Africa to use in its wars in Asia.

In fact it is from the Eighteenth Dynasty on that we see the annual tribute from Kush play a decisive role in the Egyptian economy. It was thought, and it is still too often thought, that Egypt's policy with regard to the Upper Nile was one of colonization, whereas in reality it was nothing more than intensive exploitation. The sole function of the Royal Son of Kush, or Viceroy of Nubia (an officer of very high rank, equal if not superior to the vizier himself),[30] was to gather up and send on to Egypt every year the livestock, wood, gold, tropical products, and above all the manpower—servants and recruits for the army—needed by the pharaoh for his wars in Asia. Beginning with the reign of Tuthmosis III (1490-1436),

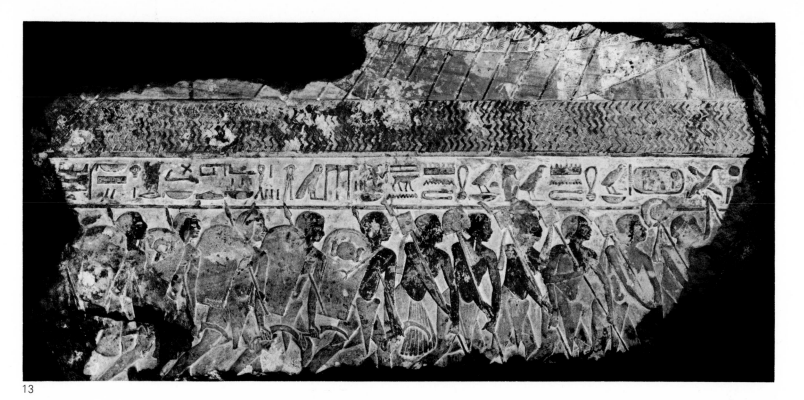

13

13. Military procession including a black standard-bearer; fragment of painted relief. Dynasty XVIII, about 1490-1436 B.C. Cairo, Egyptian Museum.

Sudanese blacks were recruited into the regular army, as we learn from a bas-relief in Cairo,[31] in which the third standard-bearer is a black. Recent fig. 13 excavations have shown that the Egyptian "occupants" or colonists were always relatively few in number.[32]

The appearance of a large number of black Africans in Egyptian iconography, beginning with the New Kingdom, is the direct result of the African policy of the Theban pharaohs. The military campaigns of the first pharaohs of the Eighteenth Dynasty, which were carried out in sparsely settled territory, had the inevitable effect of emptying the land of a large percentage of its population, still mostly non-black (the same thing happened in Lower Nubia between 2700 and 2300). What was the result? The sources that might give us a sure answer are lacking, but two possibilities are worth considering. The first is that, taking advantage of the exodus created by the Egyptian troops, black peoples coming from the plains of the White Nile, the foothills of Ethiopia, or the plateaus of Darfur and Kordofan, moved down into the Nile Valley: established thenceforth in Nubia, they would then have furnished the contingents brought together annually by the viceroy. Or perhaps the Egyptians, having control of the African routes which opened into the Nile Valley between the Second and Fourth Cataracts, may themselves have launched raids either toward the Upper Nile Valley or toward the lowlands of Chad and contiguous areas. It would be in the course of this penetration in depth that they may have come across blacks of different races.

In either case the result is the appearance in Egyptian iconography of a new type of black, distinct from the Nubian. Furthermore this shift from the African type conventionally called *Hamitic*, although the term itself is subject to question, to the subtropical type took place progressively. Thus in the Rekhmire tomb,[33] where a whole tier is devoted to the tributaries from Nubia, the physical type of the bearers of tribute is still in conformity

47

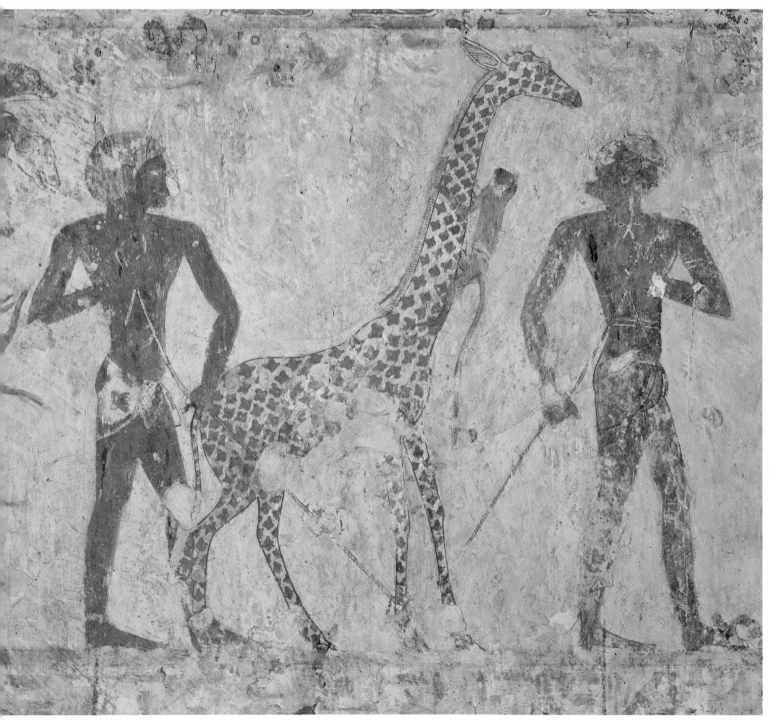

Procession of Nubian tribute-bearers
(details): Nubian tributaries bringing offerings.
Dynasty XVIII, about 1504-1450 B.C. Mural
painting. Thebes, tomb of Rekhmire.

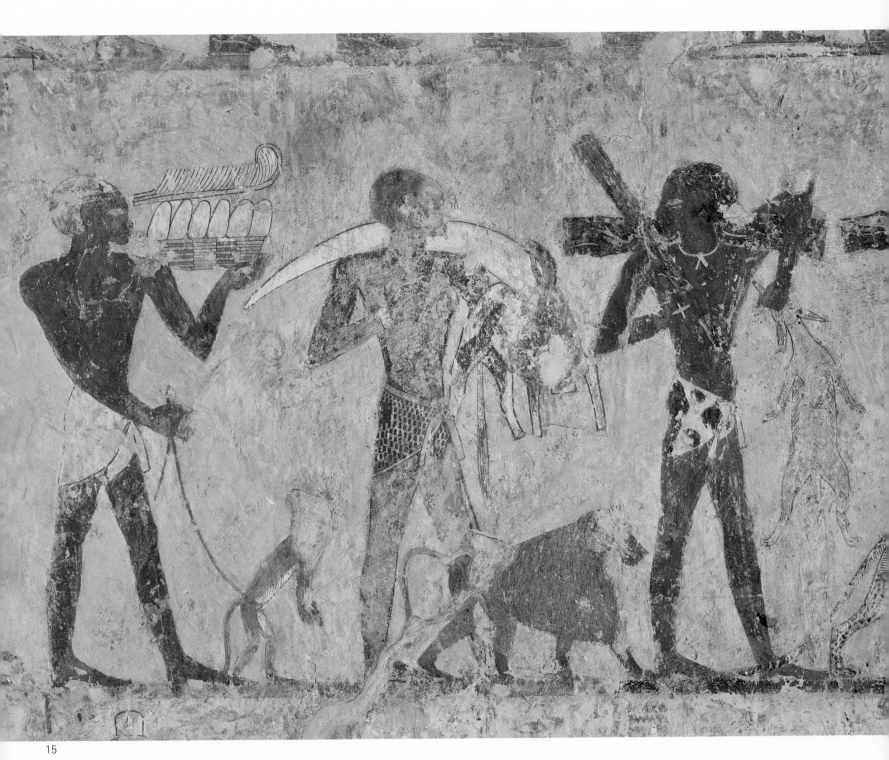

15

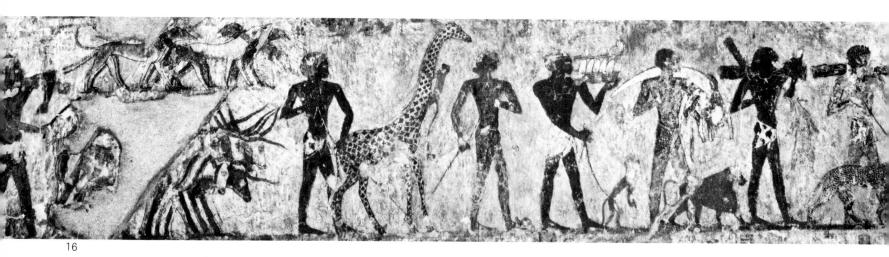

16

16. Procession of Nubian tribute-bearers. Dynasty XVIII, about 1504-1450 B.C. Mural painting. Thebes, tomb of Rekhmire.

with the "Hamitic canon," so to speak—slender body, prognathism absent or barely suggested. Only the very dark color of the skin shows us that these are blacks;[34] and this is confirmed by the inscription above the group: figs. 14-16 "Peaceful arrival of the Chieftains of the Lands of the South, of the Iuntiu-Ta-Seti and of the Khent-hen-nefer." The products they have brought are piled in front of them, and include ostrich feathers and eggs, pieces of ebony, elephant tusks, sacks of gold and gold ingots, leopard skins, semi-precious stones, and a monkey. The porters bring the same products, as well as live animals—cheetahs, baboons, monkeys, and a giraffe with a monkey clinging to its neck. Behind the line of porters is a pack of dogs and a herd of long-horned cattle (the horns are certainly distorted), led by a young black carrying a piece of ebony, with a monkey perched on his right shoulder. It should be noted that one of the porters wears the leather loincloth which is characteristic of soldiers, as if he had already signed up to join the Egyptian army.

The text, which mentions only the *Ta-Seti*—the Land of the Bow—and uses the vague term *Khent-hen-nefer* (probably meaning Nubia), is archaic in flavor. It is all the more surprising not to find the place-name *Kush*, this being the word used from the beginning of the Eighteenth Dynasty to designate the remote South, and particularly the group of African lands administered by the *Sa-nesut-en-Kush*—the "Royal Son of Kush"—a title often interpreted as "Viceroy of Nubia."

The ambiguity of the scene is obvious. To judge by the color of their skin and the products they bring, in particular ebony, ivory, leopard skins, and certain live animals such as the giraffe, cheetah, and baboon, the Rekhmire tributaries come from the great tropical savanna, the habitat of true blacks. On the other hand, gold, cattle, and dogs are more characteristic of Lower Nubia. It has been noted (by N. de G. Davies)[35] that the lowest tier of this scene in the Rekhmire tomb, showing the procession of

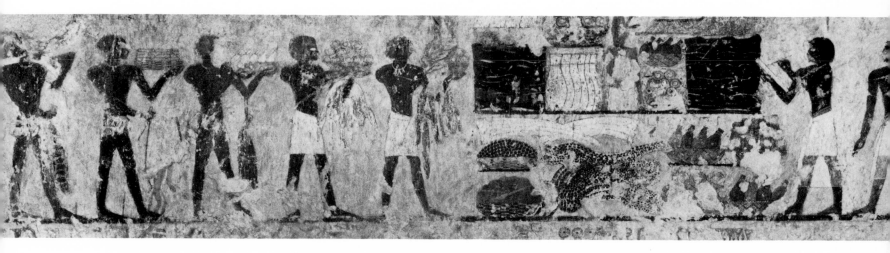

the "children of the Chieftains of the Lands of the South ... brought away as the pick of the booty of His Majesty ... to fill the workshops and to be serfs of the Temple estate of Amun," represents women and children who are more Nubian than Negro.

Anyway the ambiguity is there, but it may be that it exists only in our minds. Following H. Junker we have established formal distinction between Nubians and Negroes. In fact, the Egyptians may well have had ideas different from ours; and being both more realistic and better ethnologists, they represented individuals with "Hamitic" features mixed with Negro traits. It might even be supposed that they had noted, and quite rightly, the gradual infiltration of the black element into a different milieu during the first half of the Eighteenth Dynasty (from about 1580 to about 1480). Thus, in the tomb of Rekhmire, as in other Theban tombs of the period, we find two of the characteristics which, from the second half of the Eighteenth Dynasty to the very end of the New Kingdom, mark the iconography of the black, viz., the quality of the hair and the earrings. Two of the Rekhmire tribute-bearers, the one holding the cheetah on a leash and carrying a piece of ebony, and one of those tending the giraffe, show a curious arrangement cf. fig. 14 of the hair which apparently indicates an effort to represent the kinky hair of the blacks. Moreover, six out of ten of the same African bearers wear a circular earring.

We should note that this is the very period in which blacks appear in Minoan and Mycenaean art. Is it not remarkable that in this same tomb at Rekhmire are shown a line of typical pre-Hellenes—Minoans and Mycenaeans—and a line of very dark-skinned blacks? It is also in this same period that we see Mycenaean pottery spread not only in Egypt but also in Nubia, at Aniba, at Aksha near the Second Cataract, and even further south at Sai. If this does not prove the Nilotic origin of the first blacks to figure in Western art, it would seem at least to create a strong presumption in that sense.[36]

17. Offering of gold. From Thebes, tomb of Sebekhotep. Dynasty XVIII, about 1400 B.C. Fragment of mural painting. 80 × 101.6 cm. London, British Museum.

18. Offerings of African products. From Thebes, tomb of Sebekhotep. Dynasty XVIII, about 1400 B.C. Fragment of mural painting. 78 × 66 cm. London, British Museum.

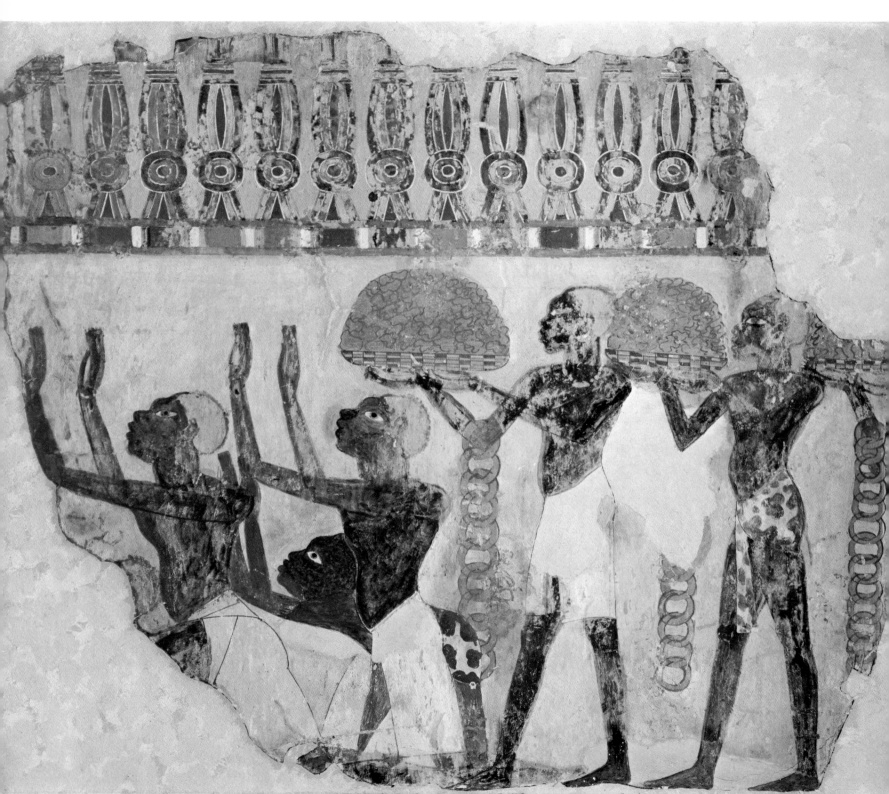

17

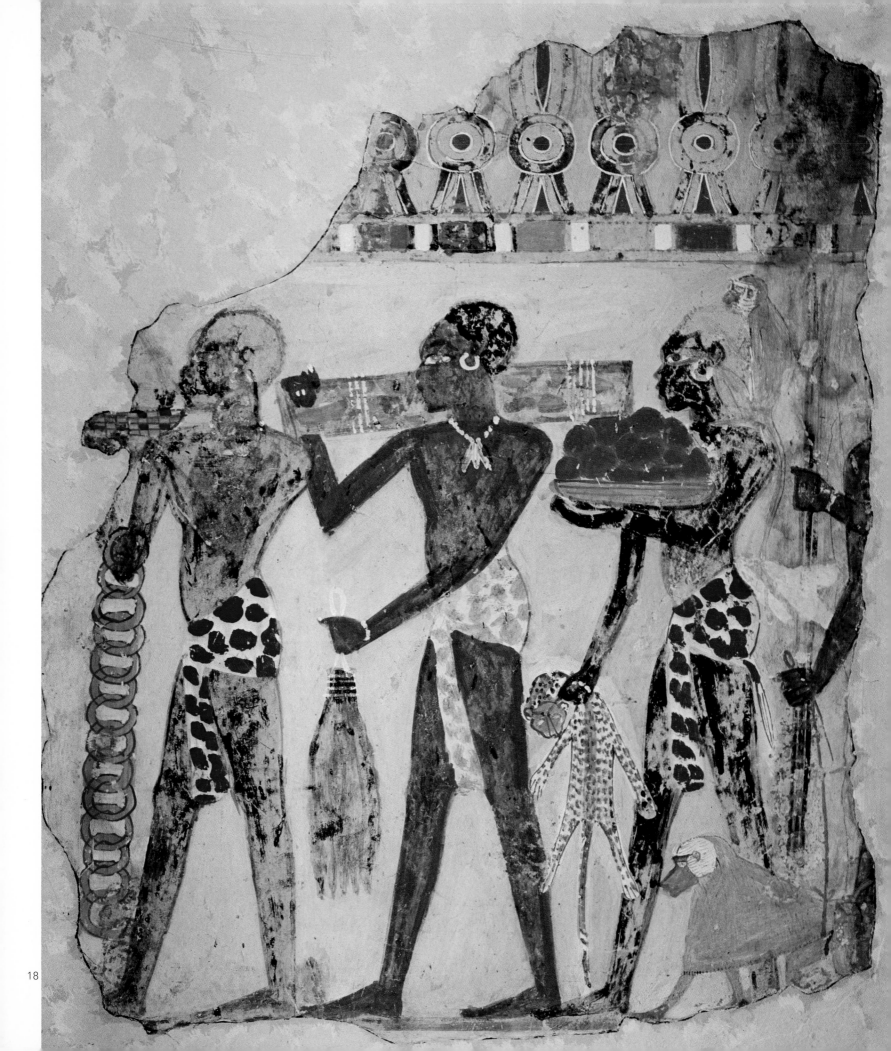

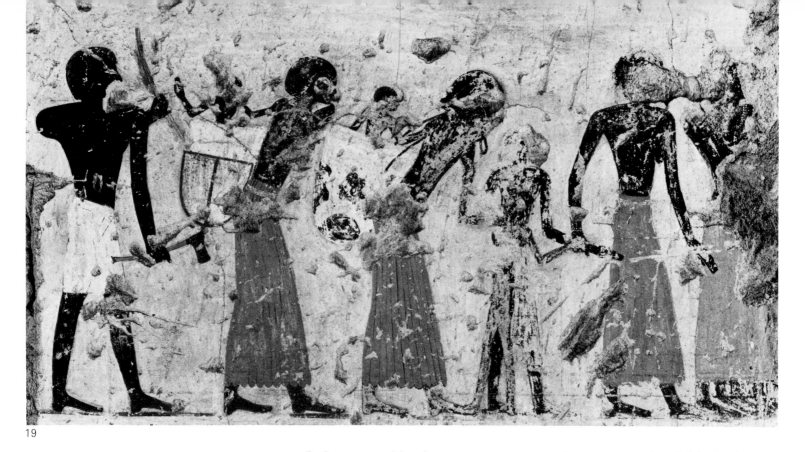

19

19. Tribute scene (detail): African women with children. Dynasty XVIII, about 1557-1504 B.C. Mural painting. Thebes, tomb of Inene.

20. Tribute scene (detail): group of black women with children. Dynasty XVIII, about 1425-1408 B.C. Mural painting. Thebes, tomb of Horemheb.

It is regrettable that we possess no other portrayals of blacks in the iconography of the very early years of the Eighteenth Dynasty, because, as we have just seen, it is in this period that the representations of types who are more or less marked by Negro features evolve toward those of conventional blacks. With the reign of Tuthmosis IV (1425-1408) the development is complete,[37] and we find ourselves in the presence of numbers of magnificent blacks whose nigritude is beyond question.

The African tribute-bearers seen in the tomb of Sebekhotep[38] present a remarkable contrast to the ones in the Rekhmire tomb, which is a scant generation earlier. The products carried by the natives are the same as they were under Tuthmosis III—gold, ebony, semi-precious stones, a leopard skin, a baboon, a monkey—but the human type is completely different. The skin pigmentation is an intense black, the short hair is kinky, the prognathism accentuated. The general appearance is quite different from that of the tributaries from the South in the Rekhmire tomb, and yet there are striking similarities. We see the same gems in both tombs, for instance the neck ornaments and particularly the semicircular earrings, and the same clothing—a very short loincloth, often of animal skin, hanging straight down between the legs. Anyone who has had an opportunity to observe the Nilotic blacks—Shilluks, Dinkas, and Nuers—cannot fail to be struck by the kinship of the tributaries in the tomb of Sebekhotep with the present inhabitants of the provinces of Bahr el Ghazal and Equatoria in the new Sudan Republic, who show the identical slenderness of body and length of the lower limbs.

The female figure in the tomb of Inene,[39] a little earlier than the one in the Rekhmire tomb, is less characteristic of the Upper Nile, but it introduces the typical image of the black woman into the Egyptian iconography of the black: she has pendulous breasts and tightly curled hair, and often carries a child on her back in a skin sack hanging by a strap that goes

figs. 17, 1

fig. 19

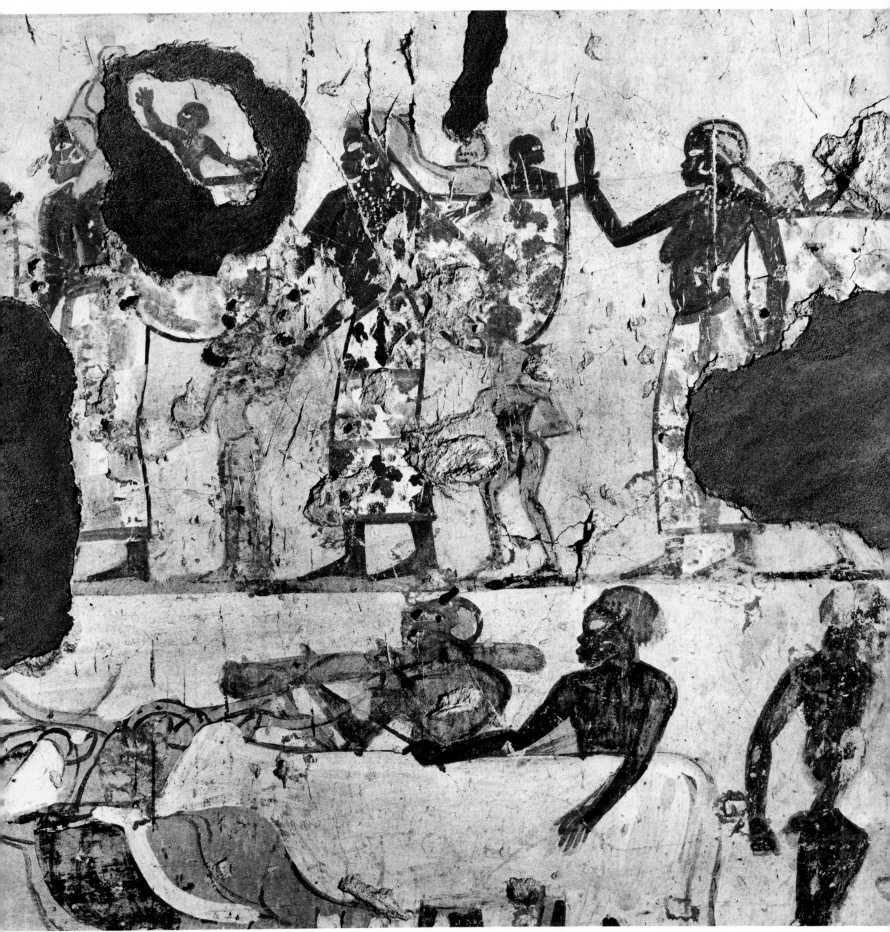

21

21. Stela of Amenhotep III. From Thebes. Dynasty XVIII, about 1408-1372 B.C. Limestone. 207 × 110 cm. Cairo, Egyptian Museum.

22. Detail of figure 21: black prisoners bound to the pharaoh's war chariot.

around her forehead. Like the men, the women have large earrings, but they wear a long waistcloth falling almost to the ankles instead of the men's short loincloth. As in the tomb of Sebekhotep, the black women portrayed fig. 20 in the contemporary tomb of Horemheb[40] are very different from the Africans represented in the tombs of Inene and Rekhmire some twenty-five years earlier.

So, in the neighborhood of 1400 B.C., the iconography of the black took shape. From then on, the Egyptian artist depicted the African as dark-skinned, with short hair whose kinky curls are frequently indicated by parallel bands. His nose is flattened, his lips thick, prognathism is often exaggerated. He wears an earring, sometimes a necklace, and a short loincloth. That is how he is portrayed twice over, chained to Amenhotep III's war chariot, on a stela in Cairo.[41] It is also typical that the black figs. 21, 22 usually appears as a prisoner of war. The conquest of Upper Nubia as far as the Fourth Cataract had not indeed put an end to hostilities between Egyptians and Africans from the South. There were still frequent military expeditions along the Upper Nile, either because the pharaoh considered it necessary to push back the native tribes who threatened the Egyptian installations, or, more probably, because he was sending raids deep into "black" territory in order to get hold of military recruits and servants.

The tomb of Huy provides an excellent example of what the iconography of the black had become in Egypt at the end of the Eighteenth Dynasty.[42] Huy was the "Royal Son of Kush"—or, to use a more modern title, the Governor General of the Sudan—during the short reign of Tutankhamun (1342-1333). He was buried in the Theban necropolis, not far from Medinet Habu on the hill of Qurnet Murai. A large number of the mural paintings in his tomb have to do with his activities as governor, and so are of the first importance for the study of the Egyptian domination along the Upper Nile during the second half of the New Kingdom.[43] Thus

56

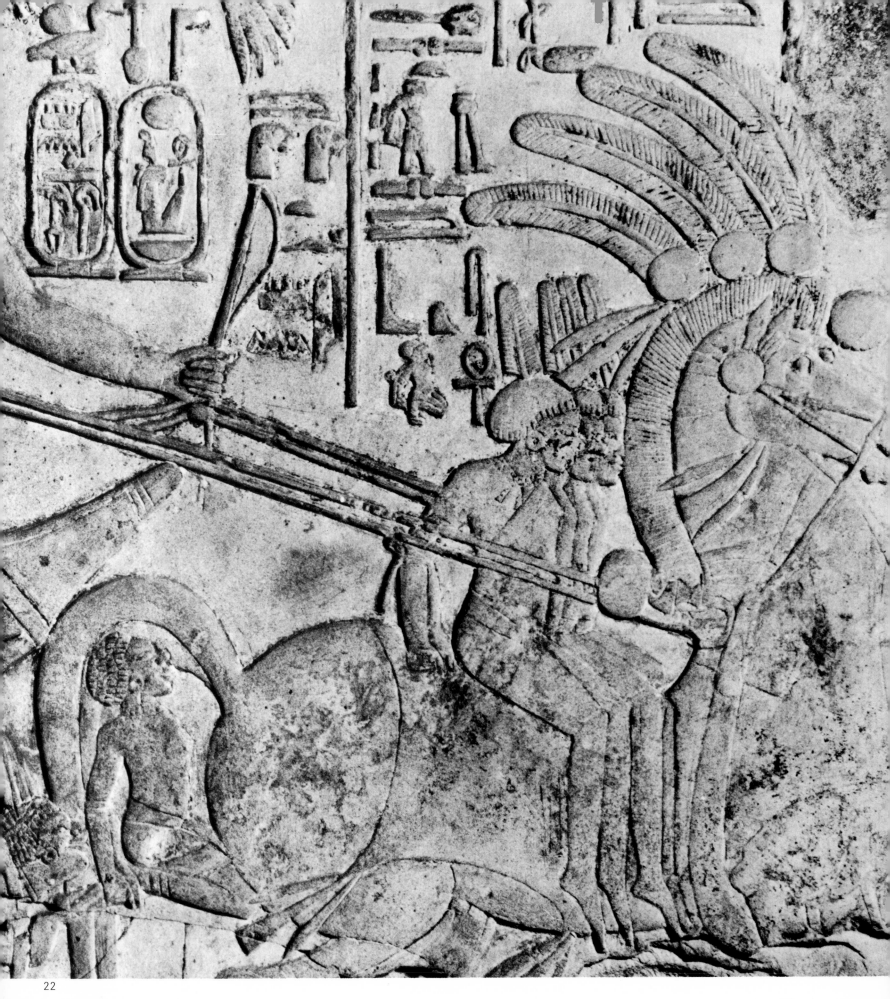

we witness his nomination as governor by Tutankhamun, his departure for the Upper Nile, his arrival at his African residence, and finally his reception, which apparently coincided with the preparation of the annual tribute he was to forward: the tribute is already stowed aboard the ships which will carry it to Egypt. Throughout these scenes, blacks appear frequently.　fig. 23

It is striking to observe that in these representations in the tomb of Huy the populations he governed are not ethnically homogeneous. Thus, for instance, when he goes ashore from the viceregal ship upon his arrival in Nubia, he is welcomed by dancing girls who are slim of body and wear their hair in slender braids, and who, despite the "African" earrings they wear, are Nubians. The original Africans, descendants of the people who inhabited the regions under the Old and Middle Kingdoms, had not entirely disappeared.

Alongside what might be called the ancient Nubian element the new African element is abundantly represented, notably in the scene of the delivery of the Tribute of the South to Tutankhamun. This scene has been reproduced many times, but unfortunately it has suffered extensive damage since its discovery early in the nineteenth century. In the first tier, we see the chieftains of the "Wawat," followed by servants and princesses, doing　fig. 24 obeisance to Tutankhamun,[44] to whom Huy is presenting them. The Wawat is the part of Nubia extending from the First to the Second Cataract. Its capital was Miam, the present Aniba; and it is interesting to note that the prince of Miam is represented as a black, with the charac-　fig. 25 teristic hair and earring. Yet the princesses who accompany him wear Egyptian clothes, and while their skin is very dark, the black characteristics are less marked. The last princess in the line is riding in a typically Egyptian chariot, but it is drawn by two oxen. The charioteer and the servant who tends the ox-team look like Nubians, since they have long hair and lighter complexions, and wear no earrings.

58

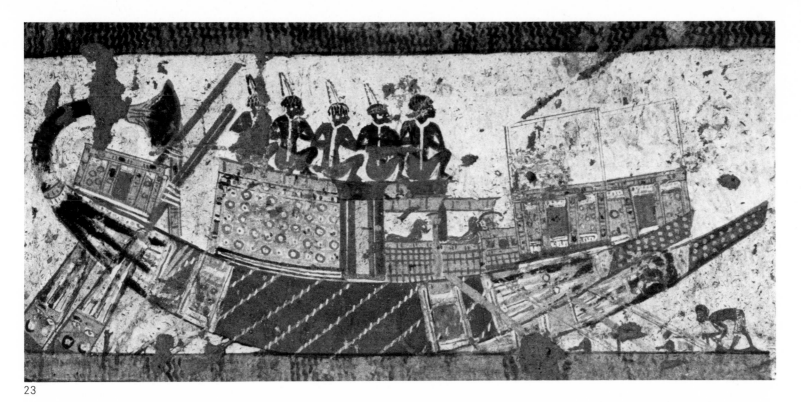

23

23. Bearing tribute from the South to Tutankh-
amun (detail): ship. Dynasty XVIII, about
1342-1333 B.C. Mural painting. Thebes, tomb of
Huy.

The servants carrying gold in bars and sacks, leopard skins, and a
giraffe's tail, are of a well-defined Negro type. They wear a sort of striped
skull-cap which has been compared to the wigs worn at present by the
Bantus of Zambesi. They also wear the earring, and their prognathism is
pronounced. It may be noted in passing that in the portrayal of the
preceding personages there is an alternation of intense black and a deep
reddish-brown in the color of the skin—no doubt an artistic convention.
Since, according to the rules of Egyptian design, the persons represented
were seen in profile and partially hid each other, the difference in color was
intended to bring out each individual silhouette, and therefore is not
significant. The fact is that all are blacks.

Following the princes and princesses behind the princely chariot, five
men and two women are represented. The men have their hands tied across fig. 26
the chest and wear a kind of carcanet or criminal's collar: they are
prisoners of war. The women hold two children by the hand and carry a
third child in a basket borne at shoulder level. All these individuals are of
the same type, very dark-skinned, wearing a round coiffure (or it may be a
wig) and the typical earring of the blacks. The prognathism of the men is
more pronounced than that of the women. The children are completely
naked, and their hair is done up in three tufts—the special hair-do of little
Negroes in Egyptian iconography.

The second and third tiers represent the Chieftains of the Land of cf. fig. 24
Kush, which, in the reign of Tutankhamun, extended from the Second to
the Fourth Cataract. The physical types portrayed—the chieftains as well
as the persons in their entourage—differ very little from the prisoners of
war in the first tier. They have the same shape of face, the same hair
arrangement, the same skin color, the earring. The only notable difference
is in the dress. While the black prisoners wear the short loincloth, the
Kushites, chieftains and servitors alike, are dressed like Egyptians.

24. Bearing tribute from the South to Tutankhamun. Detail: princes and princesses accompanied by servants. Below: Chieftains of the Land of Kush followed by tribute-bearers. Dynasty XVIII, about 1342-1333 B.C. Mural painting. Thebes, tomb of Huy.

25. Another detail: the prince of Miam and the Chieftains of the "Wawat."

26. Another detail: five black prisoners followed by two women with children.

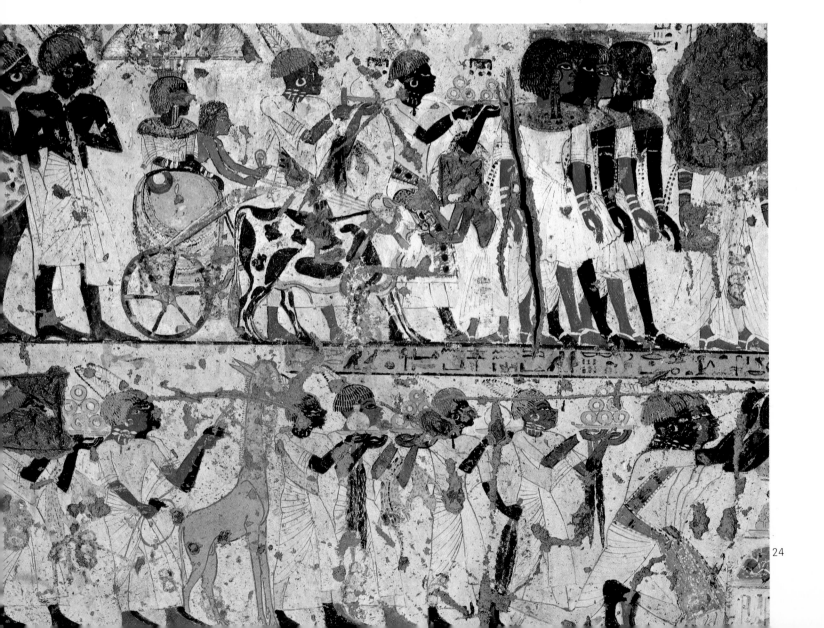

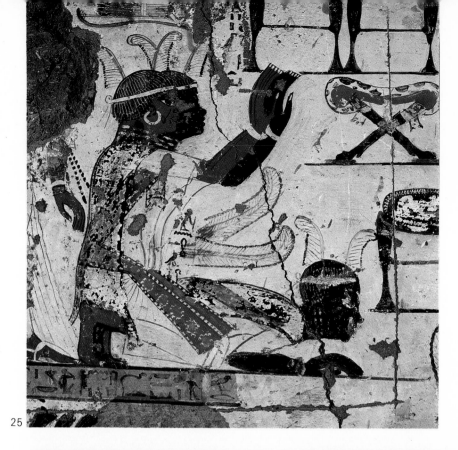

25

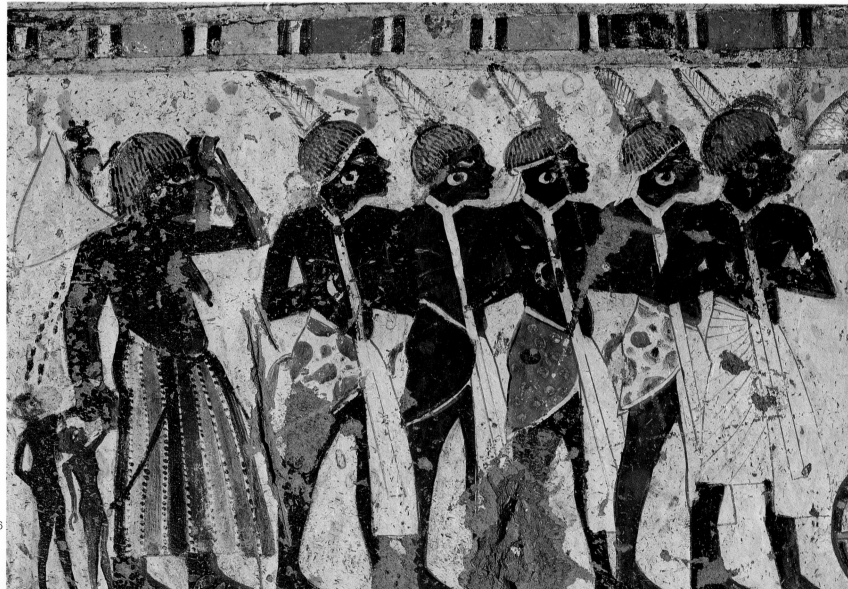

26

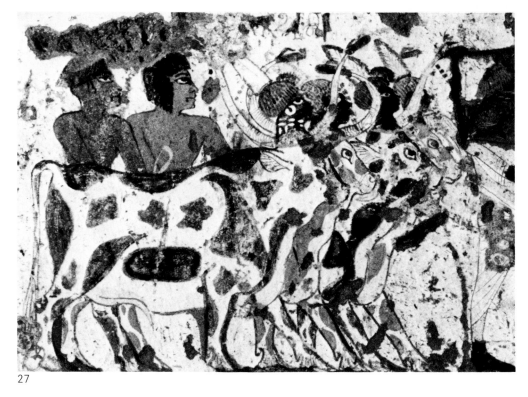

27. Bearing tribute from the South to Tutankh-amun (detail): herd of cattle. Dynasty XVIII, about 1342-1333 B.C. Mural painting. Thebes, tomb of Huy.

27

Examination of the products brought in by the two groups of tributaries shows that the Chieftains of Lower Nubia offered mostly manufactured articles—including bows, shields, pieces of furniture, chariots, decorative vases—things made out of raw materials which were plentiful in the South, such as gold, wood, ebony, and leather. Besides the articles, the tribute of the Wawat includes raw materials—gold in bars and sacks, semi-precious stones such as carnelian and jasper (in small quantities), pieces of unfinished ebony, elephant tusks, and two leopard skins.

The two tiers devoted to the Land of Kush show only raw materials. Here again we find gold in ingots and powdered (the latter in sacks), and semi-precious stones in larger quantity than in the tribute of Lower Nubia. Servingmen bring gold, giraffe tails, leopard skins, stones, and also live animals—a young giraffe and a herd of cattle whose horns are deliberately distorted. fig. 27

It has been suggested that the blacks of the tomb of Huy represent Negroes who came from the vast region extending from Darfur to Dar Fung with Kordofan in between (C. G. Seligman)[45]—in other words from the broad region of the subtropical steppes. To put it differently, whereas the blacks of the tomb of Sebekhotep, who are taller and slimmer, would be dolichocephalous Nilotics, ancestors of the Dinkas and Shilluks of today, the blacks of the tomb of Huy would be mesaticephalous, resembling the present inhabitants of the Nuba Mountains.[46] This brings out the importance, and also the fidelity, of the iconography of the black in pharaonic Egypt. Thanks to this art, in fact, we are able not only to add more than a thousand years to the history of the representation of the African black, but also to lay the foundations of the ancient history of the black people.

The paintings in the tomb of Huy enable us to discern, if not to resolve, the problems connected with the penetration of the subtropical blacks into the Nile Valley, on the one hand, and of the Egyptians into Africa south of

28

28. Egyptian military expedition returning to Egypt from the Upper Nile. Detail of low relief: rhinoceros. Dynasty XVIII, about 1504-1450 B.C. Armant, Temple of Monthu.

the Sahara, on the other. Judging by the tomb pictures, it can be surmised that the ancient Nubian population, first cousins to the pre-dynastic Egyptians, diminished considerably, even in Lower Nubia. A population with strong Negroid features replaced the earlier one. Meanwhile, the original Nubians were still present in Lower Nubia, and also, though in lesser numbers, in Upper Nubia. This would seem to be proved by the presence, in the second tier, of the two Africans of lighter complexion, one of whom has long hair, who tend the herd of bulls of the Chieftains of Kush. The new inhabitants, who were closer to the African type, became Egyptianized, as the dress of the tributaries in the second and third tiers shows. Yet the group of five prisoners and women and children in the first tier proves that free blacks still lived in the vicinity of the territories occupied by Egypt. The surprising thing is to see these people appear in the tribute of Lower Nubia and not in that of Kush, whose domain was farther to the south.

Are we to suppose that as early as 1360 B.C. the notorious route of the Darb el Arbaïn was used for what would have to be called the slave trade? We know that the great trails that start in Darfur and Kordofan and go toward the north, touching at the oasis of Selima, can turn off from there directly toward the Nile. This eastern branch of the Darb el Arbaïn, which was still used for the slave trade in the nineteenth century,[47] ends in the valley between Mirgissa and Buhen, hence in the heart of the Wawat country. The hypothesis is therefore heavy with implications, and we suggest it with considerable hesitancy. Yet it would best explain the presence of black Africans, prisoners of the Chieftains of Lower Nubia, in the tomb of Huy; and at the same time it would account for the resemblance of these blacks to the present inhabitants of Darfur and Kordofan.

The Theban paintings constitute an incomparable iconographic document, since they combine the color of flesh and clothing with flexibility of

29

29. Egyptian military expedition returning to Egypt from the Upper Nile. Detail of low relief: black dancers. Dynasty XVIII, about 1504-1450 B.C. Armant, Temple of Monthu.

30. Another detail of same relief: prisoners bearing products from the South.

31. Another detail of same relief: drummers.

line. Moreover we have just seen that since they group together a large number of individuals, the paintings make possible an historical approach to the problem of the coming of the black into the Western world. The paintings, however, are only one of the sources at our disposal: we shall now examine the bas-reliefs and the sculpture.

Some of the bas-reliefs are really nothing more than a different way of doing what the funerary paintings do: like these latter they are found in the tombs of high officials, where they fulfill the same role. I wish now to call attention to the bas-reliefs which are found in the temples as far back as the beginning of the Eighteenth Dynasty. One of the most important for the iconography of the black adorned the pylon of the Temple of Monthu at Armant (or Erment), in Upper Egypt south of Luxor. Here we see an Egyptian military expedition returning to Egypt from the Upper Nile,[48] fig. 30 and the pharaoh's army is bringing back numerous prisoners, both men and women.[49] The bad condition of this bas-relief is particularly regrettable because the figure of a rhinoceros could formerly be seen in it. This detail was unique in Egyptian iconography, and the presence of the beast proved fig. 28 that Egyptian penetration had reached the zone of the humid steppe.

Some forty blacks were represented in the scene. It is too bad that most of the heads have disappeared: those that remain seem to be of the same type as the blacks' heads in the tomb of Sebekhotep. The prisoners would therefore appear to belong to the Nilotic group, to judge by the photographs published here, which are much clearer than the very small ones in the original publication. The products carried are the usual raw materials—gold, ebony, giraffe tails, ostrich eggs. The live animals appear to belong to the Africa of the humid, or marshy, steppe: besides the rhinoceros there are buffalos. The scene seems to date from the reign of Tuthmosis III, although a later date is also possible.[50] There is a text in which Tuthmosis III mentions the capture of an animal which is probably

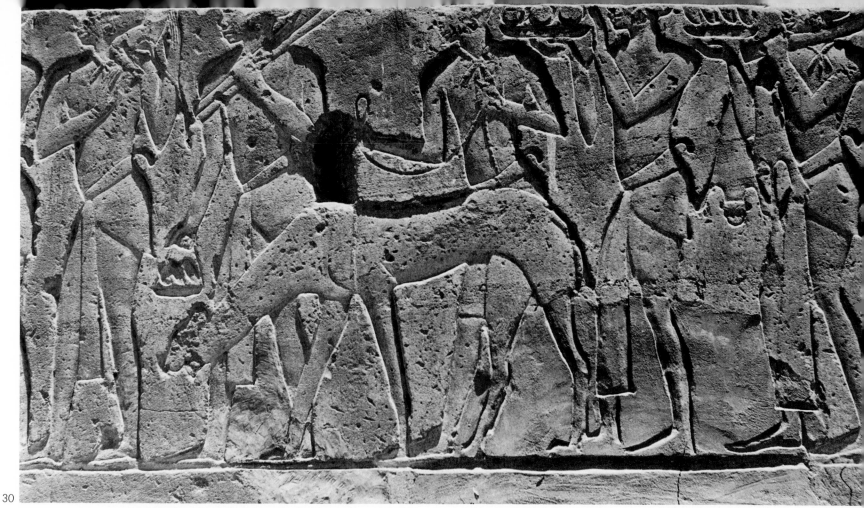

30

31

32. Procession of Amun (detail): black dancers and trumpet players. Dynasty XVIII, about 1342-1333 B.C. Low relief. Luxor, Temple.

33. Athletic contest presented before the court and foreign ambassadors. Detail of low relief: a black and an Egyptian wrestling. Dynasty XX, about 1198-1166 B.C. Medinet Habu, Great Temple.

34. Another detail of same relief: black man among the spectators.

33

32

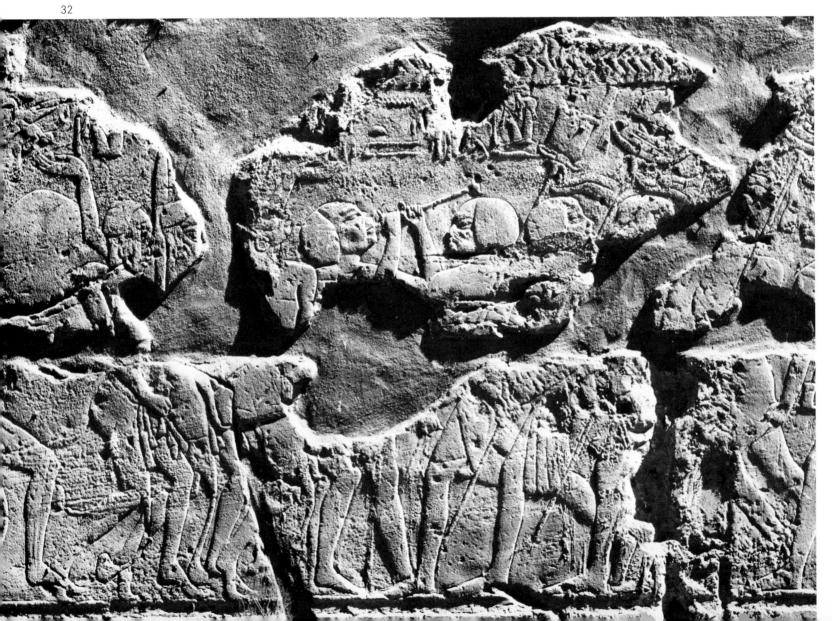

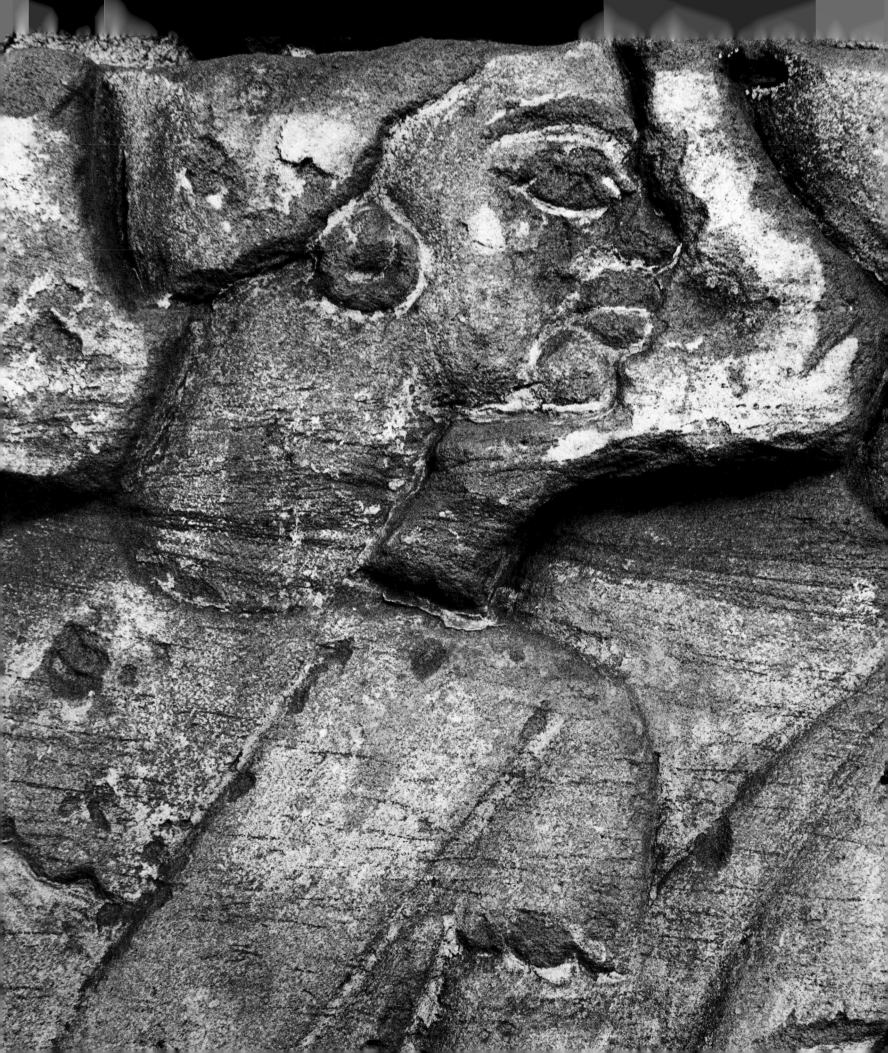

35. Fragment of column base: escutcheon of a conquered people from the South. Dynasty XVIII, about 1408-1372 B.C. Soleb, Temple of Amenhotep III.

a rhinoceros: the scene at Armant would therefore refer to that exploit. Among the blacks represented, a group of dancers is accompanied by two figs. 29, 3 drummers. The blacks were known in Egypt for their dancing, and it is interesting to find it portrayed here. We also find black dancers at the Luxor Temple, where Tutankhamun had them figure in the great procession of Amun[51] (to the left of the trumpet player). fig. 32

Representations of entire scenes devoted to Africans are relatively rare in the temples. Those at Armant and Luxor and the later ones at Medinet Habu which contain a notable scene with a black and an Egyptian wrestling,[52] and those at Beit el Wali (see *infra*), may be considered exceptional. figs. 33, 34 cf. fig. 60 On the other hand there are figurations of great importance for the iconography of the black in the "lists of foreign countries."

The Egyptians regarded the pharaoh as being by nature the lord and master of the whole universe. To symbolize this power, Egyptian art, from the beginning of the New Kingdom, decorated the temple walls with lists of the peoples conquered or subjugated by the Egyptian forces. These lists, which are often very long, are made up of a series of ovals (some notched, some not), each surmounted by the torso of a vanquished enemy with his arms tied behind his back and his head seen in profile. The name of the conquered country is inscribed within the oval. Thus we have both the name of the country and the physical appearance of its inhabitants. It is true that in many of these lists the Egyptian sculptors adopted a uniform type of figuration. All the northern countries are represented by a personage with a beard and an aquiline nose, be he Semitic, Asian, or Indo-European: the figure representing all the southern countries is that of a personage with a round headdress, a flat nose, and thick lips, whether he be Nilotic, Negro, or Nubian. Yet some of the lists obviously strive for more exact portraiture. Such are the fine figurations of blacks in the temple built by Amenhotep III at Soleb on the Upper Nile. This list is carved on the fig. 35

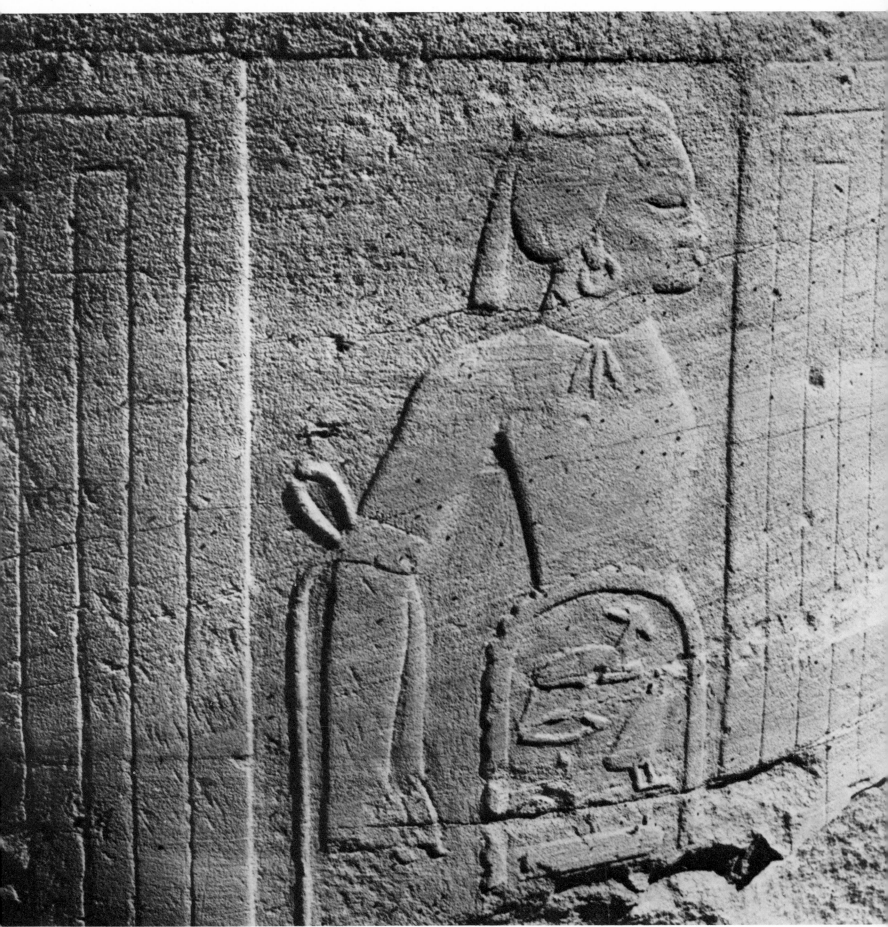

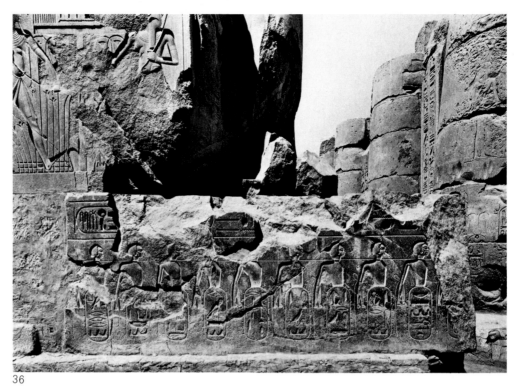

36

36. Base of a colossus of Ramesses II: list of the conquered Southern peoples. Dynasty XIX, about 1301-1235 B.C. Luxor, Temple.

37. Footstool: black and Asiatic captives in chains. From Thebes, tomb of Tutankhamun. Dynasty XVIII, about 1342-1333 B.C. Wood overlaid with gilt stucco and blue glass. Cairo, Egyptian Museum.

bases of the columns in Hypostyle Hall IV.[53] The columns in the northern half of the hall were decorated with escutcheons of the northern peoples, the columns on the left or south side with those of the southern peoples. These latter are surmounted by figures of blacks whose ethnic types seem to vary from one people to the other.

While similar lists relating to the Asian countries, seen in other temples both in Egypt and in the Sudan, have been studied frequently and well published, this has not been done for the black peoples. Yet we have here a mine of information, both onomastic and ethnological, which merits exploration.

The lists of the subjugated, or "spellbound," peoples do not all have the same value as the one at Soleb. The artists quickly fell into the habit of giving the same ethnic traits to all the southern peoples, as is evident in the list at Luxor on the plinth of a colossal statue of Ramesses II,[54] and in the one in the temple at Abydos,[55] which dates from the same period. In both instances the stonecutter repeated the same figure—round coiffure, earring, deep wrinkles in the face, thick lips—a type adequate, as he saw it, to represent the black. There is not much to be learned from such lists with regard to the iconography of the black, unless it is to determine how Egyptians of the end of the New Kingdom saw the Negro-type; but on the other hand the lists unquestionably give us valid information about ancient names in Africa.

The universal power of the pharaoh may also be symbolized by representing foreign peoples in chains under the sovereign's feet. Whether they serve as ornament on a royal throne or the base of a statue, the pharaoh's enemies are thus trampled underfoot for all eternity. To this type of representation belong the blacks in chains who appear on the furniture found in the tomb of Tutankhamun,[56] and on the sub-base of one of the colossi of Ramesses II at Abu Simbel[57] and of Ramesses III at Medinet

figs. 36, 39, 40 fig. 38

fig. 37 fig. 42

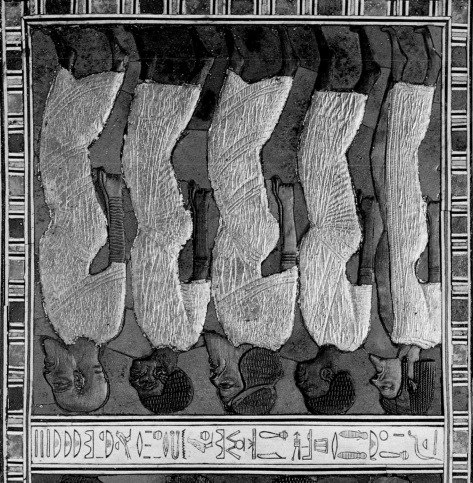
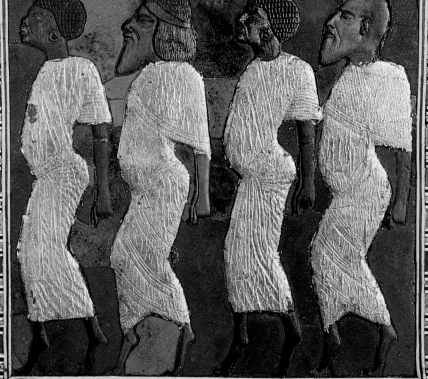

38. List of the conquered Southern peoples (detail): three escutcheons. Dynasty XIX, about 1301-1235 B.C. Low relief. Abydos, Temple of Ramesses II.

39, 40. Base of a colossus of Ramesses II: list of the conquered Southern peoples (details). Dynasty XIX, about 1301-1235 B.C. Luxor, Temple.

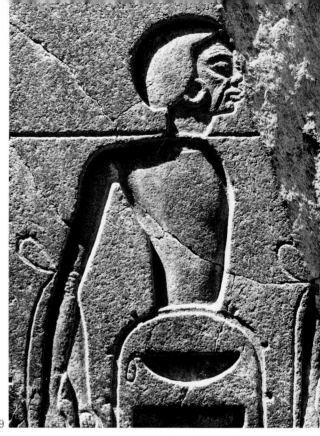

39

38

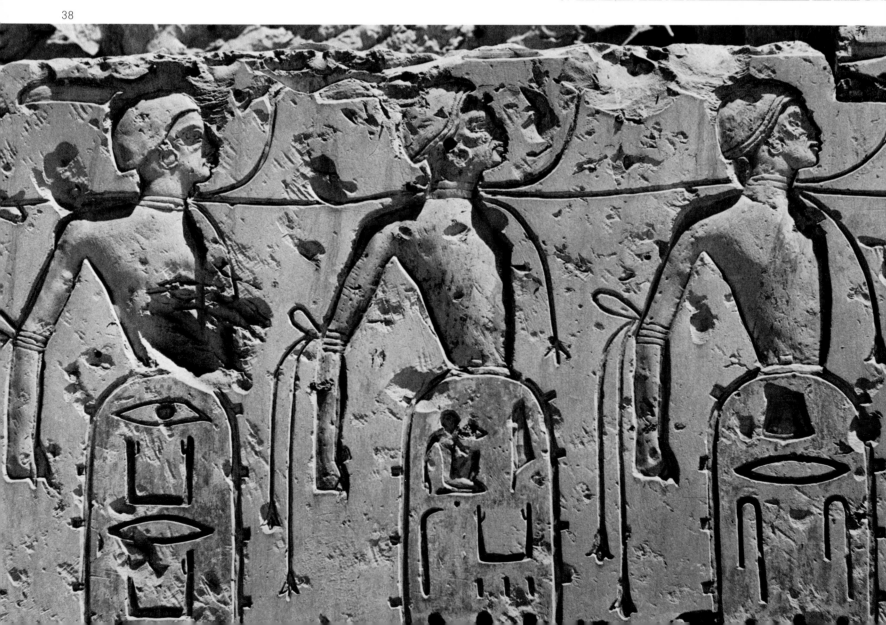

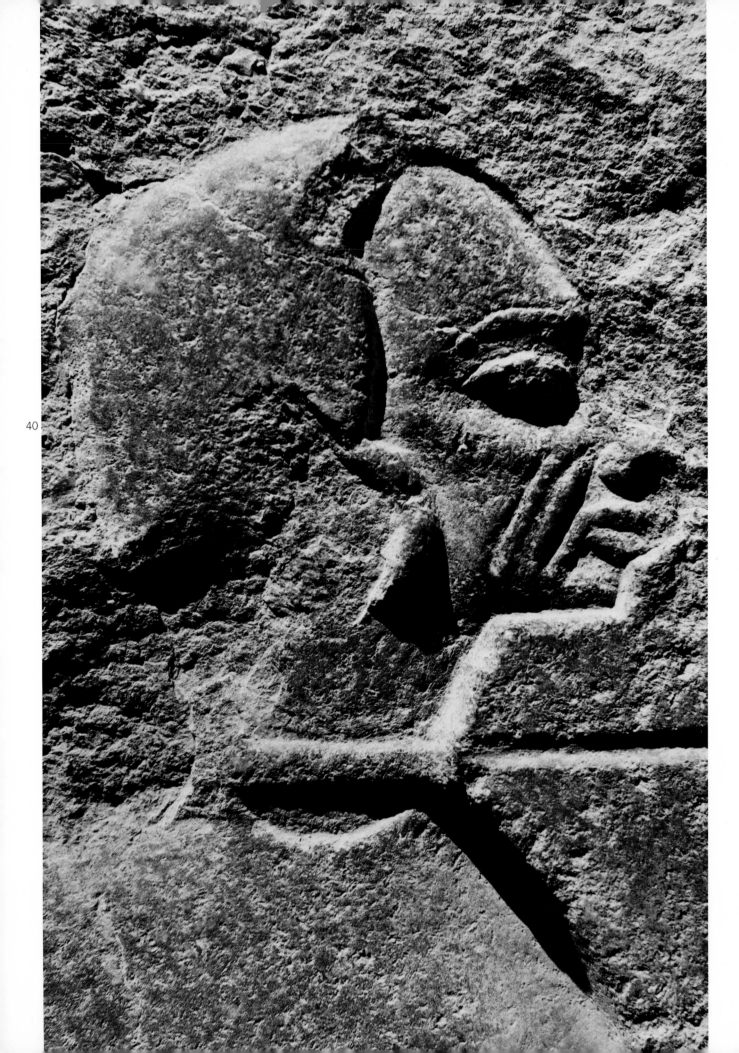

41

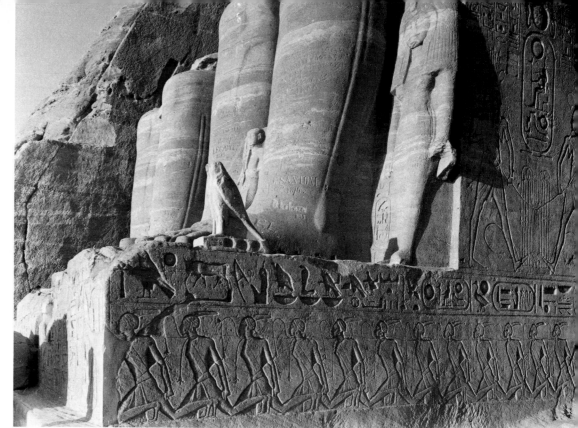

42

43

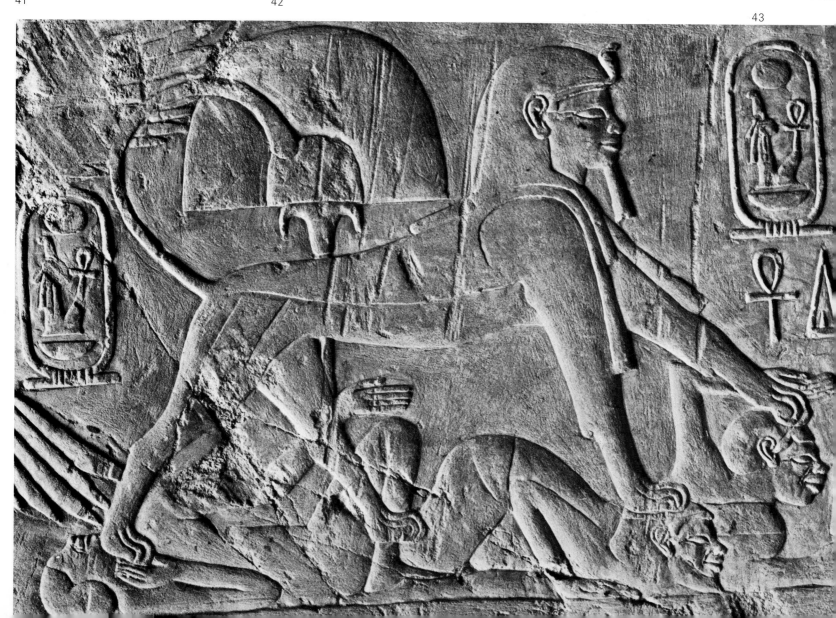

41. Kneeling black captive; detail of the socle of an Osiride pillar of Ramesses III. Dynasty XX, about 1198-1166 B.C. Medinet Habu, Great Temple.

42. Sub-base of a colossus of Ramesses II: row of kneeling prisoners. Dynasty XIX, about 1301-1235 B.C. Abu Simbel, Temple of Ra-Harakhte.

43. Amenhotep as a sphinx trampling his enemies; side panel of the pharaoh's throne. Dynasty XVIII, about 1408-1372 B.C. Thebes, tomb of Amenemhat-Sourer.

44. Architectural inlays: black prisoners. From Medinet Habu, Palace-Temple of Ramesses III. Dynasty XX, about 1198-1166 B.C. Polychrome faïence. H: approx. 25 cm. Cairo, Egyptian Museum.

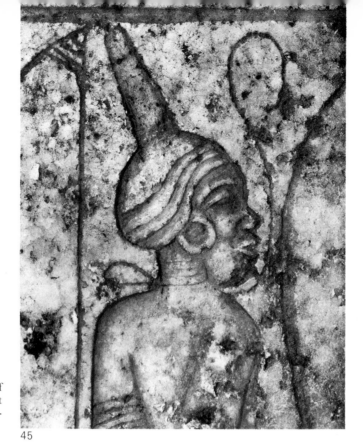

45

45. Head of a black prisoner; detail of relief carved on throne base. Dynasty XIX, about 1312-1298 B.C. Alabaster. Karnak, Great Temple of Amun.

46. Slaying of black and Asiatic prisoners by Ramesses III before Amun (detail). Dynasty XX, about 1198-1166 B.C. Low relief. Medinet Habu, Great Temple.

Habu.[58] It is unfortunate that in these figurations, as in those of the lists, fig. 41 the sculptors adopted a black "type" which they repeated over and over again—built-up wig, a feather in the hair, a big earring, thick lips, accentuated prognathism, in short the characteristic traits of the black. They did not strive for variety, nor, especially, for ethnic exactness, as their predecessors had done under Amenhotep III.

Apart from the "lists" of prisoners on pylons or bases of statues, the theme of the black conquered or in chains appears on numerous monuments. It will suffice here to mention the fine representation of Amenhotep III as a sphinx with his enemies, including two blacks;[59] the Negro fig. 43 with the very curious hair arrangement in the Hypostyle room at Karnak;[60] the innumerable figures of enemies on their knees, held firmly in the fig. 45 pharaoh's grasp before he has them put to death. There are always blacks among them, as at Medinet Habu.[61] They also appear, but more rarely, on fig. 46 the polychromed faïence plaques which once decorated the palace-temple of Ramesses III at Medinet Habu.[62] fig. 44

The last category of objects in the Egyptian iconography of the black is sculpture in the round. We have seen that in the Old Kingdom there were statues of prisoners in chains representing black people. The admirable head of a woman, dating from the same period, shows in another respect that the Egyptian artists could give a sensitive rendition of African beauty. cf. fig. 7 In the art of the New Kingdom, however, it is principally in what is called minor art that we find representations of Africans. The delicate statuette of a young girl just at the age of puberty, carrying an ointment vase, to be seen in the Gulbenkian Museum of Oriental Art, University of Durham, no doubt represents a Nubian.[63] She wears a necklace with a pendant in the figs. 47, 4 shape of the god Bes, god of joy and of the dance.[64] The narrow band around her hips indicates that she is a dancer or perhaps a servant: the figure immediately brings to mind the charming, boyish figure of the black

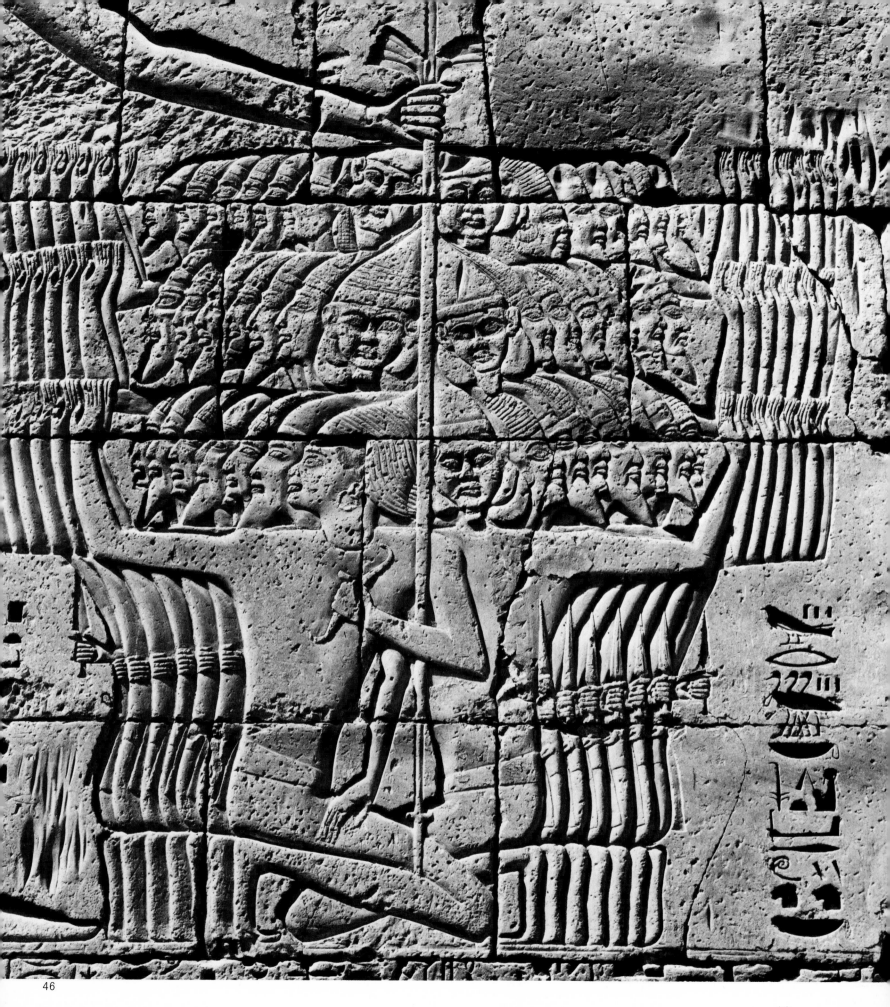

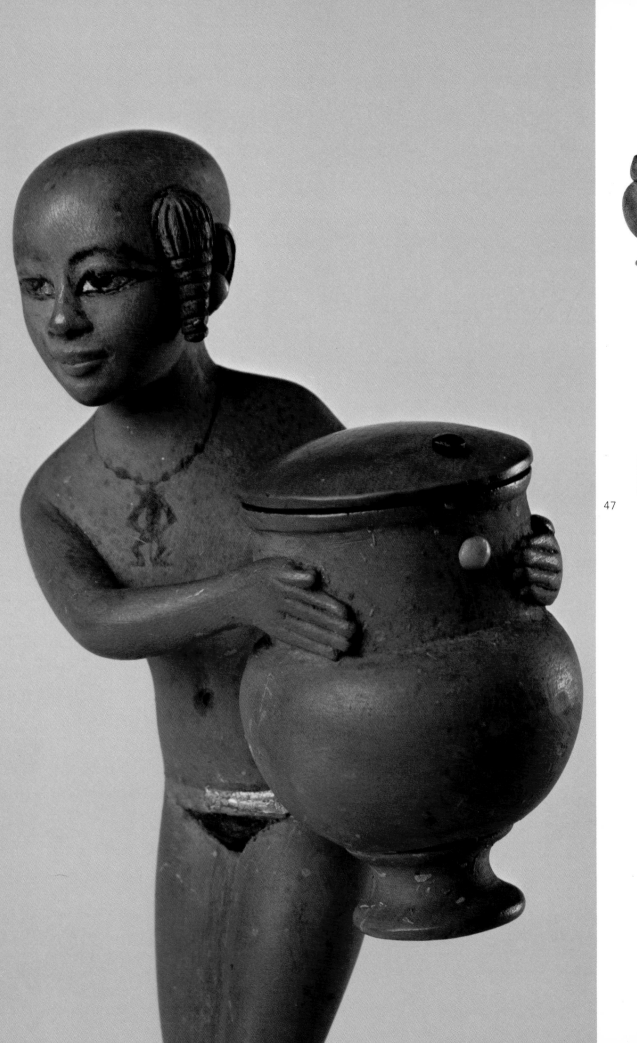

47 48

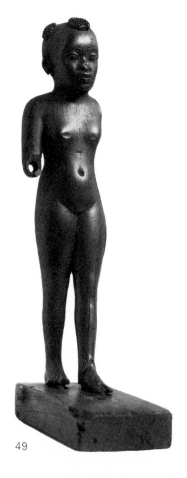

49

47, 48. Statuette of a young Nubian girl carrying an ointment jar. Late Dynasty XVIII, about 1350 B.C. Boxwood. H: 13 cm. Durham, University, Gulbenkian Museum of Oriental Art.

49, 50. Statuette of a young black girl presenting a stemmed bowl supported by a monkey, before and after restoration. Dynasty XVIII, about 1350 B.C. Ebony. H: 17.5 cm. London, University College.

51. Black dancer beside a woman playing a tabor. Early Dynasty XVIII, about 1570-1520 B.C. Detail of a mural painting. Thebes, tomb of Wah.

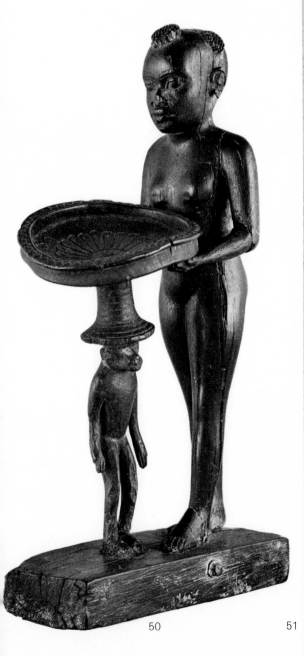

50

51

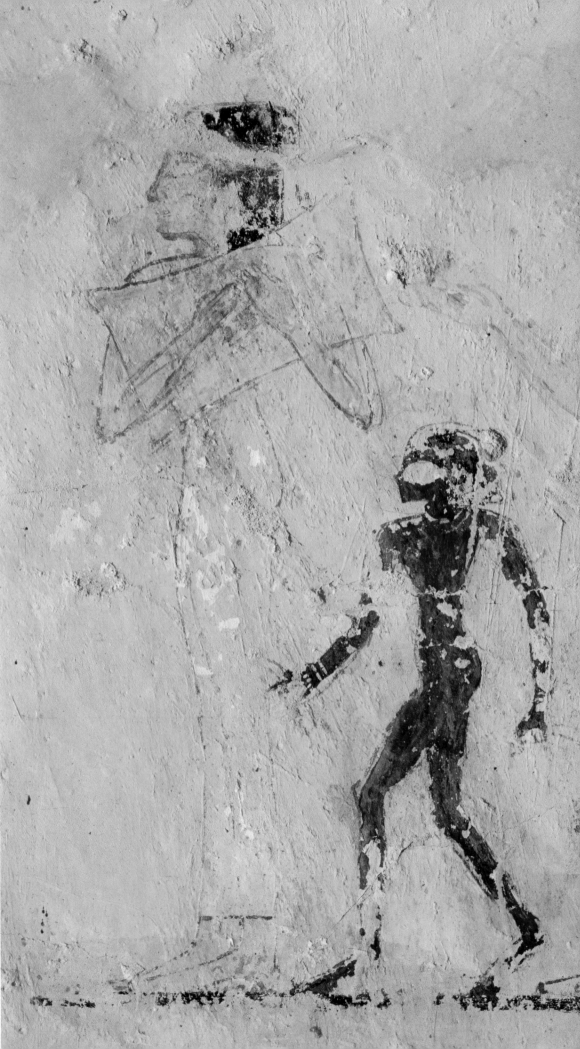

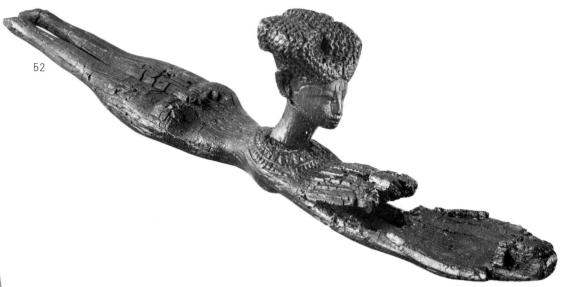

52

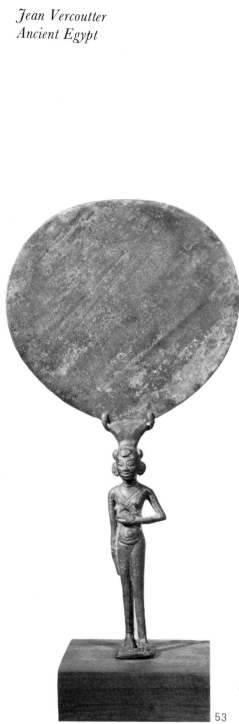

53

52. Ointment spoon in the form of a swimming black girl. From Abusir. Dynasty XVIII, between 1410 and 1372 B.C. Wood. L: 26.5 cm. Brooklyn, The Brooklyn Museum.

53. Mirror with handle carved in the form of a standing black girl. Dynasty XVIII, about 1560-1314 B.C. Bronze. Over-all H: 22.2 cm. Brooklyn, The Brooklyn Museum.

dancer in the tomb of Wah at Thebes, dating from the beginning of the Eighteenth Dynasty.[65] The curl at the left side of the face, which Egyptologists often call the "curl of youth," shows how Egyptianized she is. It is true that in the tomb of Huy the princesses of Lower Nubia wear the same curl. fig. 51 cf. fig. 24

A statuette of the same type and period, in the London University College, leaves no doubt about the race of the little girl represented.[66] She is carved out of ebony, and wears four tufts of hair like the ones we saw on the heads of black children in the Huy tomb. The footed cup carried by a monkey was found separately, but the fact that the monkey's feet fit into a hole in the base shows that the ensemble belonged to the statuette. The animal's presence emphasizes the African character of the whole; but a photograph taken by W.M.F. Petrie immediately after the acquisition of the statuette already gave evidence of this. The flat nose and thick lips were proof enough. We have here a representation in the round of one of the black dancers who were the delight of the Egyptians, as we know from a mural painting in the tomb of Horemheb, c. 1410 B.C.,[67] in which we see the same tufts of hair and flat nose as in the statuette, and in addition the large earring. A similar earring may have adorned the ear of the statuette, which is broken and incomplete. figs. 49, 50 cf. fig. 26 fig. 54

Young blacks seem to be associated with the idea of joy and relaxation. This is why they are represented holding ointment jars or perfume bottles, or figured on perfume spoons, like the young black girl with the crimped, carefully fashioned coiffure, in The Brooklyn Museum.[68] We might also call attention to a mirror dating from the Eighteenth Dynasty which is in the collection of the same museum:[69] the handle of the mirror is formed by the figure of a standing black girl. cf. fig. 47 fig. 52 fig. 53

There are numerous toilet articles which are decorated with African motifs, perhaps to commemorate graceful servingmaids skillfully entertaining their mistresses and attending to their dress and make-up; or these motifs may simply recall the fact that from the South came the incense and aromatic gums which were as indispensable for milady's toilette as they were for the cult of the gods.

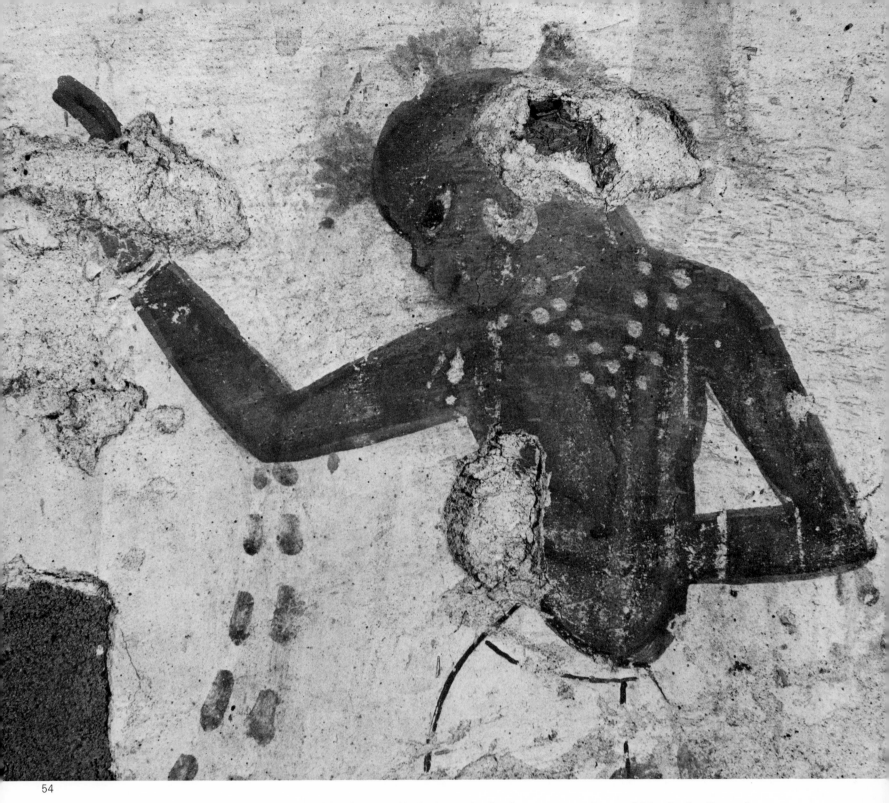

54. Young black dancer (detail). Dynasty XVIII, about 1425-1408 B.C. Mural painting. Thebes, tomb of Horemheb.

Having studied the principal representations of blacks in Egyptian art (though we are a long way from having seen or even mentioned all of them), we must now examine the place they occupy in the iconography of the black in general, and more especially the part they played in the development of this iconography in the Western world.

First of all, what do these figurations reveal about Egyptian attitudes toward the black world? It seems that these attitudes changed as the centuries went by.

From the beginnings until the twenty-first century B.C., there is no evidence that the black was looked down upon or excluded from polite

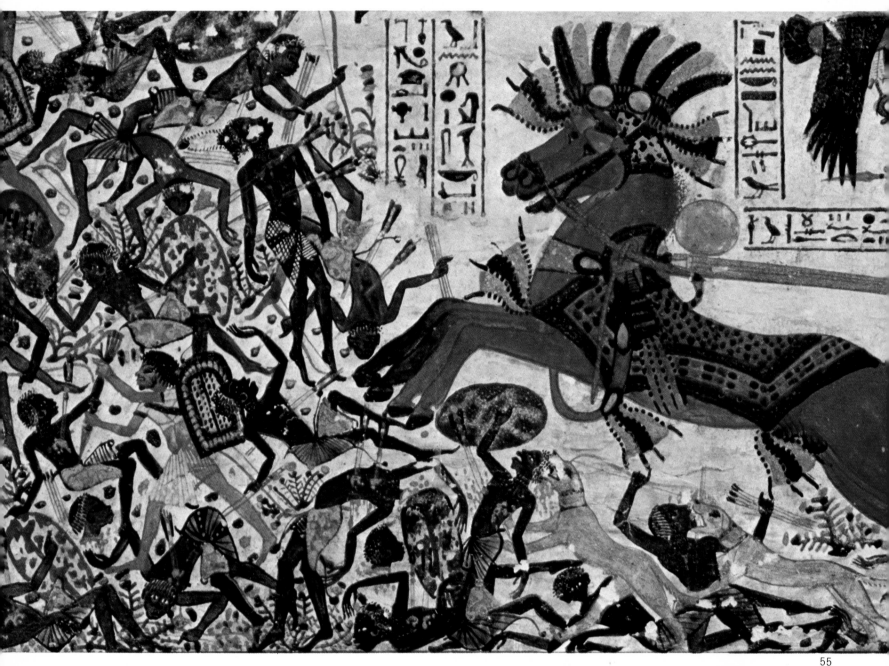

55

55. Tutankhamun's painted box (detail): pharaoh slaying blacks. From Thebes, tomb of Tutankhamun. Dynasty XVIII, about 1342-1333 B.C. Painted wood. H: 47 cm. Cairo, Egyptian Museum.

56. Tutankhamun's painted box: over-all view.

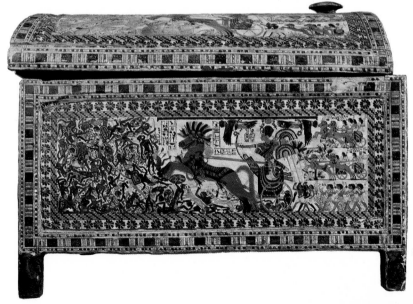

56

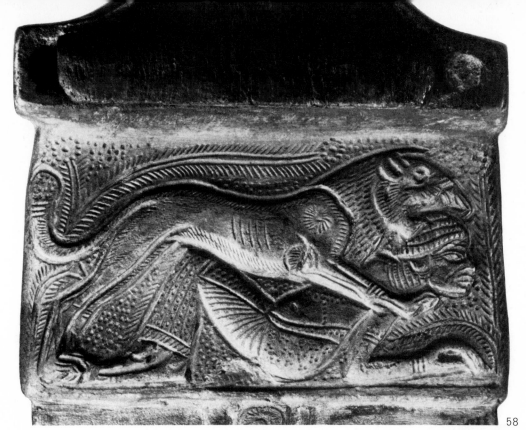

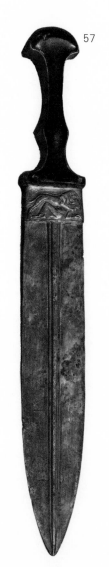

57. Dagger. From Semna. Dynasty XVIII. Bronze. L: 41.2 cm. Khartum, Sudan National Museum.

58. Detail of figure 57: black in the clutches of a lion.

society. The statues at Saqqara may indeed prove the pharaoh's desire to subjugate the black, but we must not forget that this attitude was universal, and that the representations of "spellbinding" also included Asians, Libyans, and even Egyptians! Inversely, the head of the black woman at Giza, like the figurations on the stelae of the First Intermediate Period, show that the Africans were accepted in Egypt, and even that mixed marriages occurred.

It is not until the Twelfth Dynasty that we see the Egyptians expressing hostile feelings toward Africans. On a celebrated stela[70] erected at the Second Cataract, the then frontier of Egypt facing the black kingdoms which were organizing to the south, Sesostris III, addressing the Egyptians, wrote:

The Nubian obeys the man who puts him down. When you oppose him he turns tail: when you give ground he becomes aggressive. They are not a people of might, they are poor and faint-hearted ... I captured their women, carried off their subjects, went forth to their wells, smote their flocks. I harvested their fields and set fire to them ...

On another stela in the same place, the same Sesostris III proclaims that he has established the frontier at Semna, at the Second Cataract, "in such a way as to keep any Nubian from crossing it on his way north either overland or by boat, or any herd of the Nubian."[71] This text has been called (inaccurately of course) the "first color bar" in universal history.

In fact, what we see here is a typical hostile reaction. The Africans, who had been peaceable even when exploited by pharaonic Egypt, had taken advantage of the disturbances in the Lower Nile Valley during the First Intermediate Period and had developed and organized, and they now represented a potential danger to Egypt. This explains why portrayals of

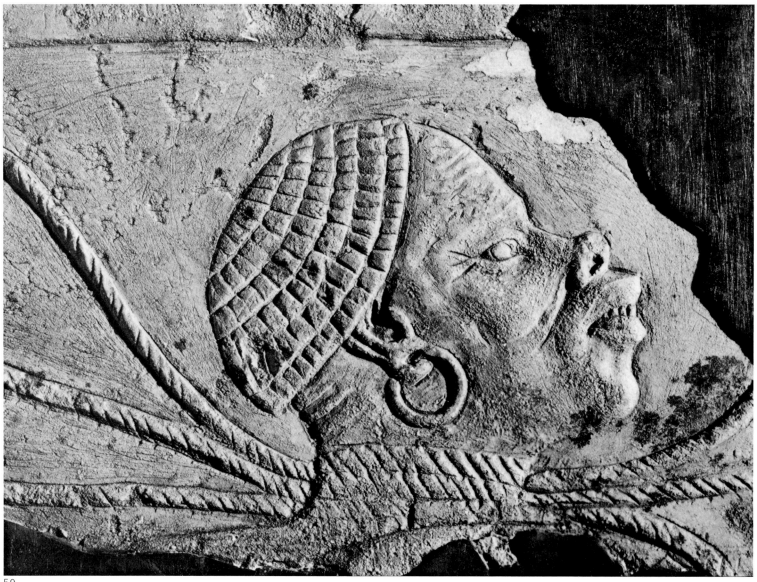

59

59. Head of prisoner bound about the neck; fragment of low relief (detail). Late Dynasty XVIII, about 1560-1314 B.C. Limestone. H: 12.5 cm. St. Louis, St. Louis Art Museum.

60. Blacks bearing tribute. Dynasty XIX, about 1301-1235 B.C. Low relief (detail). Beit el Wali, Temple of Ramesses II.

61. Counting of black captives; fragment of low relief (detail). From Memphis, tomb of Horemheb. Late Dynasty XVIII, prior to 1348 B.C. Limestone. Bologna, Museo Civico Archeologico.

62, 63. Details of figure 61.

warriors were from then on the most numerous in the iconography of the black in Egypt. Whether he was inducted (frequently by force, no doubt) into the Egyptian army, or whether he was fighting it, the black was, in the eyes of the Egyptians, above all a warrior or an enemy.

The seizure of all the territory between the First and Fourth Cataracts, beginning in the sixteenth century B.C., brought no change in this view. The black was thought of first and foremost as the inhabitant of "Kush the Contemptible" or "the Defeated," and he was despised both because he was feared and because he was exploited to the point of turning his land into a desert. Long after the conquest, Egyptian iconography continued to represent him as vanquished. It shows the blacks being massacred by Egyptian troops, as on the chest of Tutankhamun;[72] in the clutches of a lion, as in the scene adorning the dagger of an Egyptian in the African garrison at Semna;[73] driven into a pitiable herd under the soldiers' clubs, in the tomb of the general and later king Horemheb;[74] or forced to be the bearers of African products into Egypt, in the scenes in the temple at Beit el Wali in Lower Nubia.[75]

Two cruel images clearly express the Egyptian reaction to the black.

figs. 55, 5

figs. 57, 5
figs. 61-6

fig. 60

84

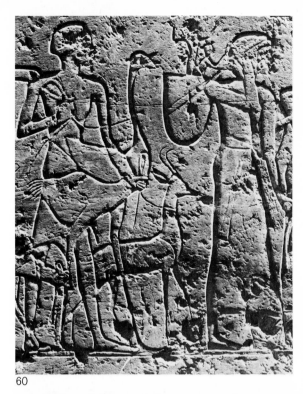

60

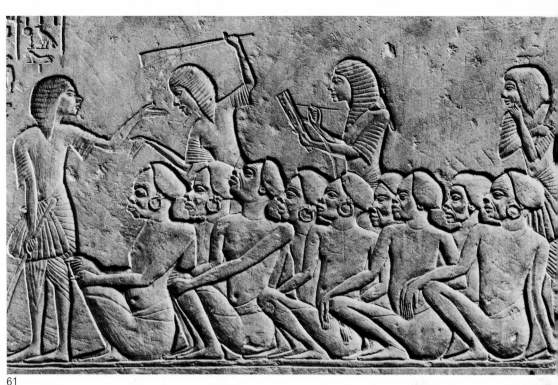

61

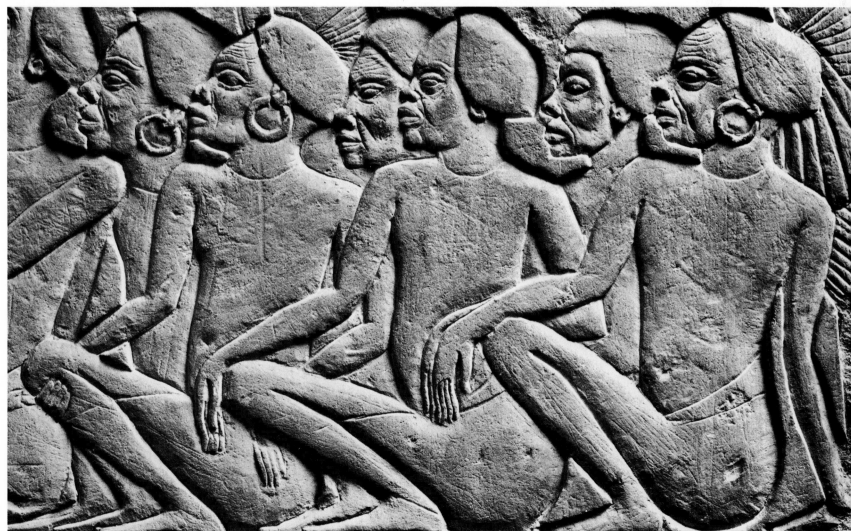

62

85

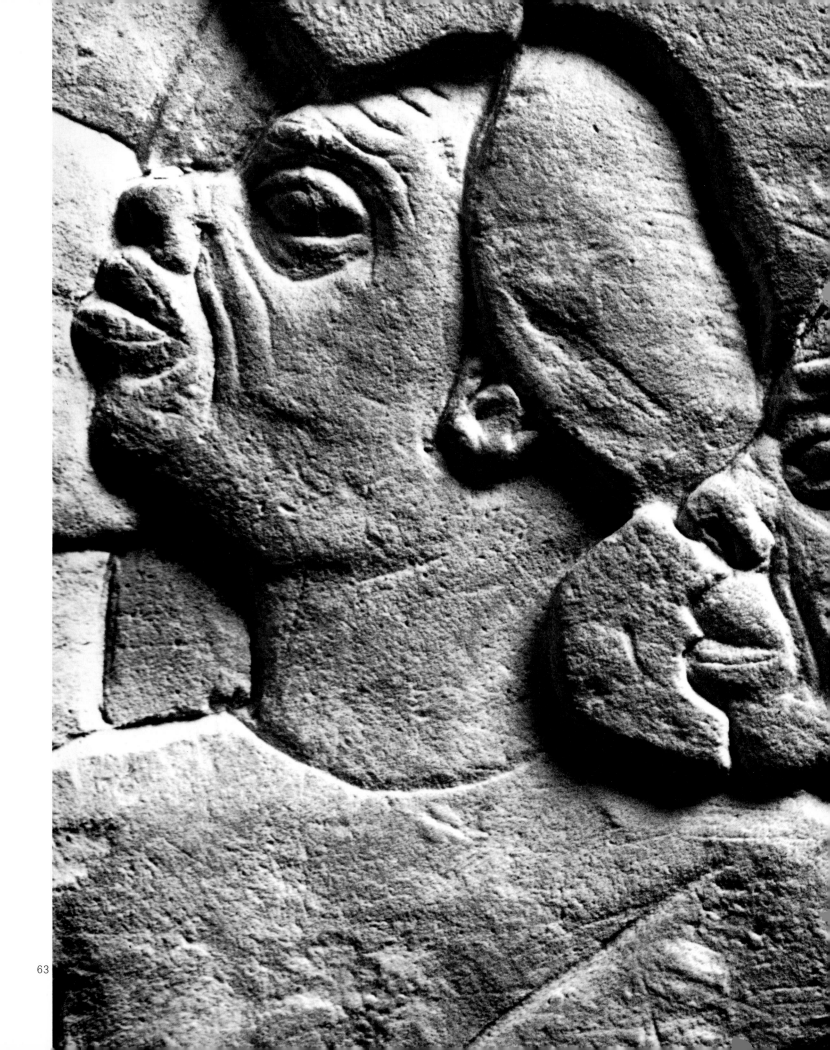

63

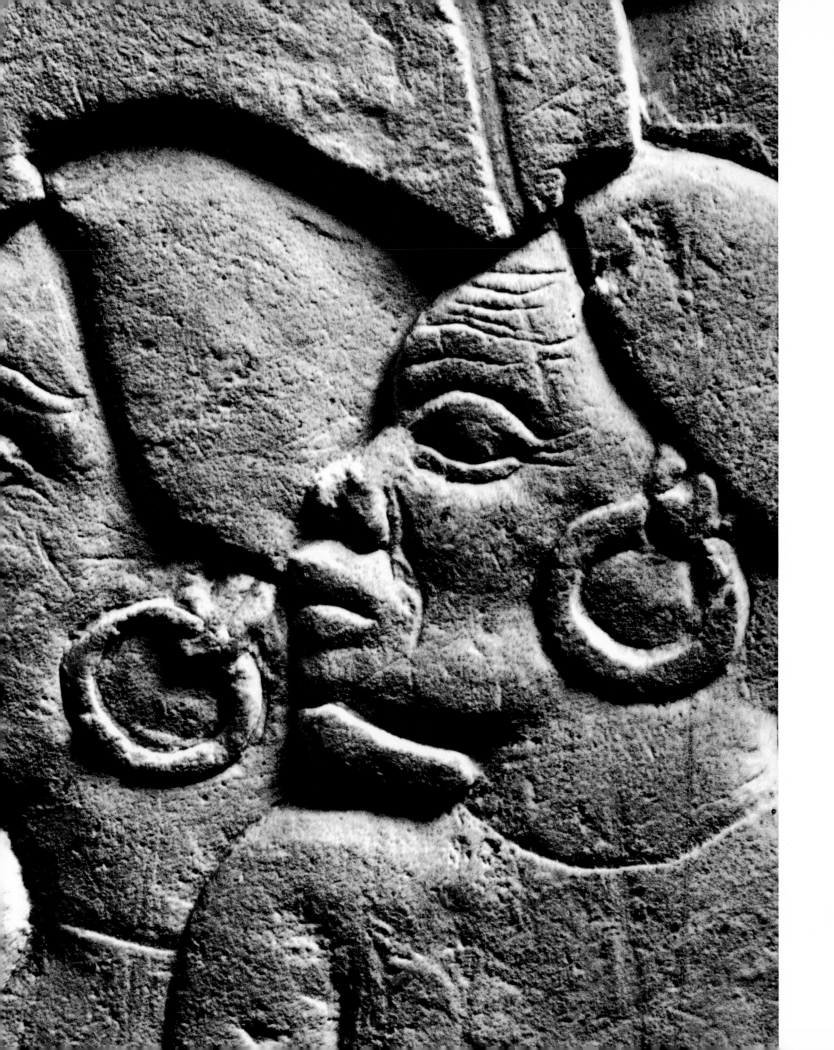

One is the caricatured head of a Negro bound about the neck, in the St. Louis Art Museum,[76] the other the figure of a kneeling prisoner, head down and arms tied behind his black, in The Brooklyn Museum.[77] It would seem that only young Africans were accepted in Egyptian society, where they entertained with their dancing or served faithfully as soldiers or domestic servants.

fig. 59
figs. 64, 6

The question has been raised whether the representations of the black in Egyptian art inspired the Greek artists. It is certain that as soon as they were installed at Naukratis, and perhaps even earlier, the Hellenes were in contact with blacks in the Nile Valley. It is equally certain that they had opportunities to see portrayals of blacks, if not in the Theban tombs, which probably were inaccessible to them, at least in the temples, for instance at Luxor and especially at Beit el Wali and Abu Simbel, where they left written evidence of their presence. Yet to me it seems difficult to establish any derivative relationship between Greek and Egyptian figurations of the black.

The greatest importance of the Egyptian iconography of the black is, in my opinion, its contribution to history. Thanks to the Egyptian portrayals we have, to my knowledge, the oldest testimony on the Africans. Also thanks to them we can, up to a certain point, draw a map of the distribution of the blacks in northeastern Africa, and then we perceive an extraordinary stability in that distribution. The representations in the tombs of Sebekhotep and of Huy remind one irresistibly of the present inhabitants of northeast Africa—the Nilotics of the Upper Nile, the blacks of Darfur and Kordofan.

Such results could not have been attained were it not for the remarkable ability of the Egyptian artists to seize characteristic detail and to render it with an accuracy that was often pitiless.

64, 65. Statuette of a kneeling captive. From Saqqara. Late Dynasty XVIII. Bronze. H: 14.3 cm. Brooklyn, The Brooklyn Museum.

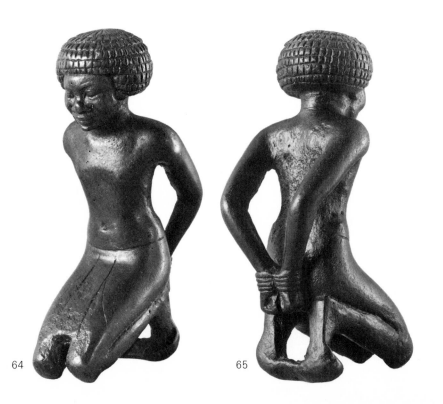

64

65

88

II

KUSHITES AND MEROÏTES: ICONOGRAPHY OF THE AFRICAN
RULERS IN THE ANCIENT UPPER NILE

JEAN LECLANT

A vigorous civilization developed in the Upper Nile Valley, south of Egypt,
at the end of the third millennium and through the first half of the second.
This was Kerma, and for us it is still very much of a mystery. Most likely it
is the principality to which the term *Kush*, first used to designate the
territories immediately south of the Second Cataract,[1] was finally applied.
After the "colonial" phase, which was contemporaneous with the heyday of
the Egyptian New Kingdom (1580-1085 B.C.), it was probably people from
the Kerma culture who founded the power that established itself in the
relatively rich agricultural basins of the great curve of the Nile, in the
present area of Dongola.[2]

In view of today's interest in the study of the first great African empires,
it is important to improve our knowledge of the populations which for more
than a thousand years (roughly from 800 B.C. to A.D. 300) constituted a
powerful force to the south of Egypt.[3] With successive capitals at Napata
(at the foot of the Gebel Barkal) and then at Meroë (on the edge of the
steppes of the Butana), a confederation of tribes[4] grouped under strong
leaders entered gradually into the stream of universal history.

Here we shall try to describe in some detail the features which Kushites,
Meroïtes, and Napateans present to posterity. The fact is that these peoples
of the Upper Nile,[5] themselves endowed with remarkable facial traits,
inherited the iconography of ancient Egypt. Having been subjects of the
pharaohs, they had themselves portrayed in the Egyptian style, without
omitting their own essential characteristics. So it is that in the gallery of
"portraits" of these Africans of bygone times, the glamor of art and
eventually the illusions of politics are blended with the appearances of
reality.

We know practically nothing about the earliest representatives of the
kingdom of Napata: what can we say about their faces and the way they
looked? The names of the ancestor princes who lie beneath their *tumuli* in

66

66. Fragment of a stela bearing the image of King Peye. From Gebel Barkal. Dynasty XXV, about 751-716 B.C. Red sandstone. 118 × 116 cm. Merowe, Merowe Museum.

67. Fragment of a stela with Kashta in profile. From Elephantine. Dynasty XXV, about 766-751 B.C. Sandstone. H: 20 cm. Cairo, Egyptian Museum.

the necropolis at El Kurru are unknown: Alara himself is as yet no more than a name.[6] We know a little more about his brother Kashta, who succeeded him. "Kashta" may have been a "program name," at least if the word is to be read as meaning "the Kushite." As to the vestiges of his features, they can be found on a corner of the modest fragment of a relief recovered at Elephantine:[7] "snub nose, receding chin, thick, prominent fig. 67 lips—in short a semi-Negroid type," as G. Maspero described him.[8] Is Kashta wearing the tight-fitting round cap which became the customary headgear of the Kushite kings?[9] The condition in which the eroded sandstone block has come down to us allows of no sure answer to this question.[10]

With the next king, the illustrious Piankhy (who will henceforth be called Peye)[11] we come into a better documented period: one of the inscriptions he ordered engraved—the stela of Victory—is among the longest and most detailed of ancient Egypt. True, the features of the great conqueror are now indistinct; the fact is that his rare surviving monuments have been defaced. On the great stela of Victory,[12] the standing figure of Peye can be seen in the lunette at the top, coming before Amun and Mut, but his face cannot be made out. On the other red sandstone stela, found by G. Reisner's American expedition in Temple B501 at Gebel Barkal,[13] fig. 66 the king's image has been restored, but the detail is not very clear. There is practically nothing more to see except the shawabtis of Tomb 17 at El Kurru, and these are meagre, indistinct documents for so glorious a personage.[14]

About 716 B.C., Shabaka, Peye's brother, mounted the throne, and brought the entire Nile Valley, all the way to the Delta, under the rule of the Kushite Empire. The compilers of the royal lists of Egypt consider him to be the founder of the Twenty-fifth Dynasty of pharaohs—the "Ethiopian" dynasty, as French historians call it. For our part we would be tempted

90

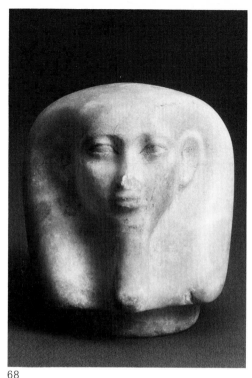

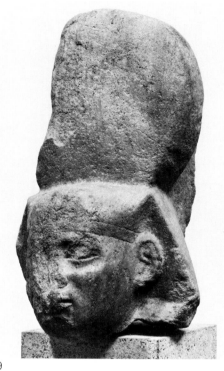

68

69

68. Lid of a Canopic jar: portrait of Shabaka. From El Kurru. Dynasty XXV, about 716-701 B.C. Alabaster. H: 17 cm. Khartum, Sudan National Museum.

69. Head of Shabaka. Dynasty XXV, about 716-701 B.C. Light brown quartzite. H: 46 cm. Munich, Staatliche Sammlung Ägyptischer Kunst.

70. Head of Shabaka. Dynasty XXV, about 716-701 B.C. Faïence. H: 3.3 cm. Paris, Musée du Louvre.

71. Head of Shabaka, fragment of a colossal statue. From depository at Karnak. Dynasty XXV, about 716-701 B.C. Pink granite. H: 97 cm. Cairo, Egyptian Museum.

to look for one of the most authentic portraits of this king in his own funerary material, recovered from his tomb at El Kurru, including a fine lot of shawabtis,[15] and particularly the alabaster cover of a Canopic jar.[16] fig. 68
Here we see a round face full in the cheek, lively eyes under heavy superciliary arches, a small mouth, thick-lipped, and a short chin.

Three fragments of statues, with the name "Neferkare-Shabaka" engraved on them, show traits fairly similar to the above. One of the heads, in the Louvre,[17] is very small in its dimensions; the material is faïence. The fig. 70
face is round with prominent cheekbones, framed in a large wig on the front of which two *uraei* stand out: the mouth is thick-lipped, the chin small.[18] Originally the head must have been surmounted by a disc. Such a disc appears on a head now in Munich:[19] this head, too, is very round, fig. 69
with a strong bone structure. The third head, belonging to a colossus at Karnak and preserved in Cairo,[20] is in a completely different style, marked fig. 71
by the traditions of the classical periods of Egyptian art. This shows how much school traditions can influence royal iconography, and warns us to be cautious. Yet we must keep in mind the identification recently proposed for a fine head in schist, lacking an epigraph, which is in The Brooklyn fig. 72
Museum:[21] it may be that this head should be added to the series.

A fine bronze statue of the kneeling king in Athens,[22] shows the same figs. 73, 74
facial traits, somewhat refined, perhaps, by the delicacy of the metalwork. As frequently occurs in portraits of the Kushite kings, Shabaka here wears three ram's heads, strung on a single cord, on his bare chest.[23] Other images, among the finest we have of Shabaka, are found on some of the blocks of figs. 75, 76
stone, originally from an earlier building, in the walls of Taharqa's Osireion on the Sacred Lake at Karnak.[24] Here again, in the Karnak sanctuary,[25] we are confronted with an "official" type of portrait, glorifying a victorious ruler who is placed on an equal footing with the gods of Egypt. The king, however, still wears the characteristic Ethiopian headgear,[26] a

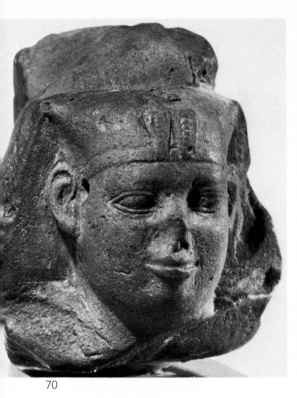

70

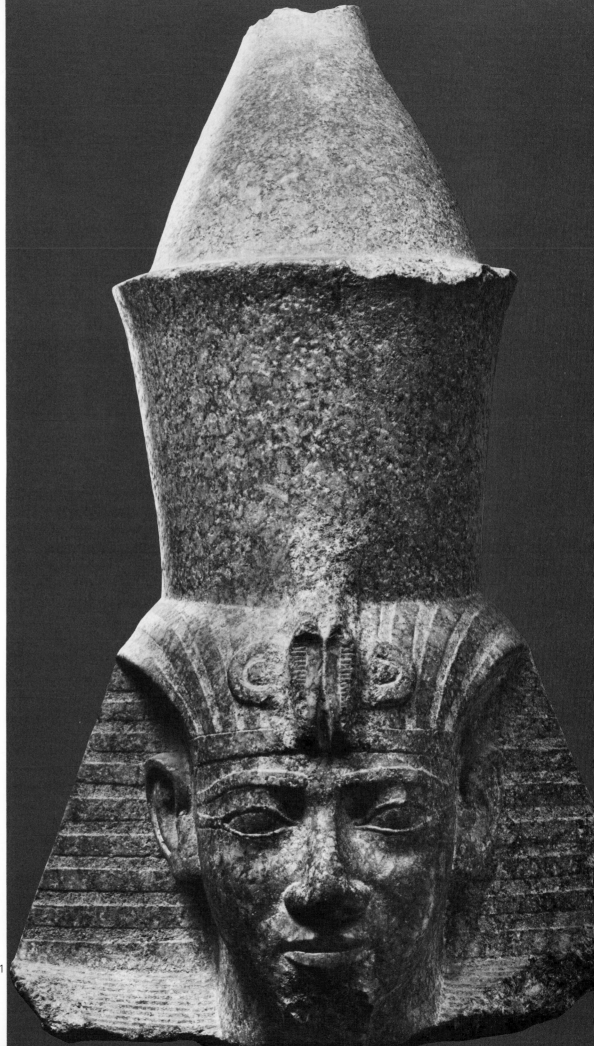

71

72. Head of Shabaka (?). Dynasty XXV, about 716-701 B.C. Green schist. H: 7 cm. Brooklyn, The Brooklyn Museum.

73,74. Statuette of Shabaka kneeling. Dynasty XXV, about 716-701 B.C. Bronze. H: 15.5 cm. Athens, National Museum.

75. Shabaka opposite a falcon-headed god, low relief on a reused block of stone. Dynasty XXV, about 716-701 B.C. Karnak, Osireion of Taharqa of the Lake.

76. Shabaka opposite a god, low relief on a reused block of stone. Dynasty XXV, about 716-701 B.C. Karnak, Osireion of Taharqa of the Lake.

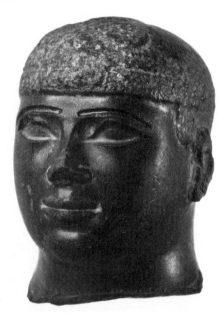

72

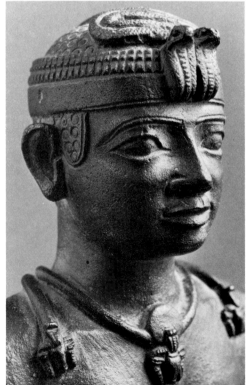

74

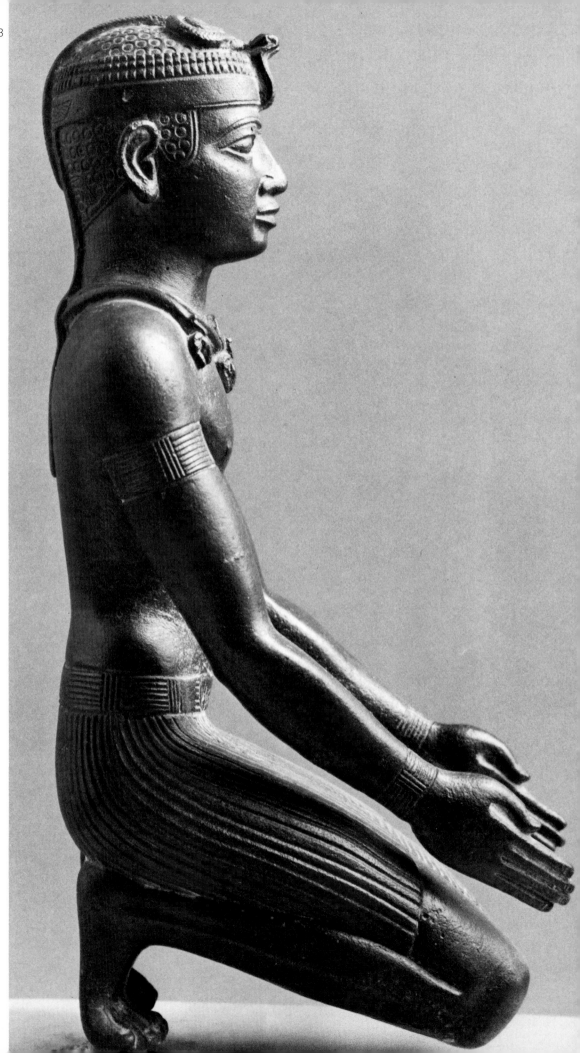

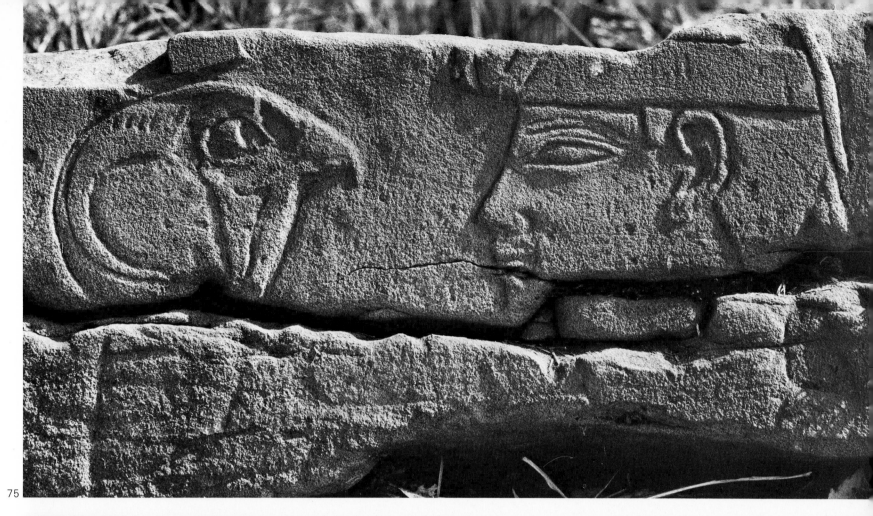

75

76

95

77. Statuette of Harmakhis. From depository at Karnak. Dynasty XXV, about 716-701 B.C. Red sandstone. H: 66 cm. Cairo, Egyptian Museum.

78. Shabataka before the god Amun (detail). Dynasty XXV, about 701-690 B.C. Low relief. Karnak, chapel of Osiris-Heqa-djet.

79. Colossal statue of Taharqa. From Gebel Barkal. Dynasty XXV, 690-664 B.C. Black granite. H: 382 cm. Khartum, Sudan National Museum.

80. Detail of figure 79: bows trampled beneath the pharaoh's feet.

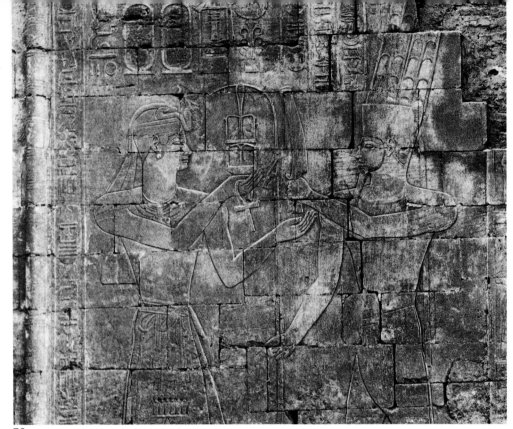

78

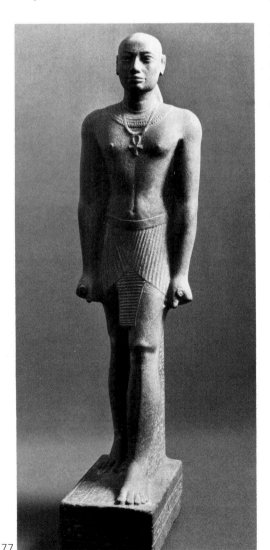

77

kind of hemispherical cap, no doubt made of skin rather than of cloth, tightly binding the nape of the neck, with a flap covering the temple. A thick bandeau encircles the bonnet, no doubt to hold it on: this must have been tied in a knot, the two ends falling behind the shoulders. On several documents in the Delta (private donation stelae to the temple of Horbeit)[27] the facial traits—strongly marked nose, fleshy mouth, and receding chin—look more African.

The statuette of a son of Shabaka, Harmakhis, high priest of Amun, found in the depository of the temple at Karnak,[28] brings us back to a fig. 77
clearly Egyptian style of imagery—a priest, grave of bearing, his scalp shaven, a wide necklace and a pendant cross of life standing out on his naked torso. But the *tanistry*, the custom by which succession to the Ethiopian crown was determined, prescribed that the heritage should pass to the oldest member of the next generation—that is, eventually, from uncle to nephew.[29] Hence Shabaka's successor was Shabataka, son of Peye. His image is seen in the chapel of Osiris-Heqa-djet[30] and on the south outer fig. 78
wall of the temple at Luxor. Conventional though they are, these representations indicate the king's Kushite features and the exotic details of his apparel (headdress[31] and jewels[32]). While we do not have many portraits of this king,[33] on the other hand we may have some of his remains: a few fragments of bone, notably of the skull, have been found in the descending shaft of the pillaged sepulcher at El Kurru (Ku. 18). No detailed study has yet been made of them.[34]

If, however, we are to form a good idea of the appearance of the "Ethiopian" king *par excellence*, we must turn to Taharqa, the great conqueror.[35] His long and glorious reign (690-664 B.C.) furnishes an ample series of representations of exceptionally high quality.[36] There is power and assurance in the king's stride as we see him in a colossal statue from the Gebel Barkal, which for a long time was located in the small local museum

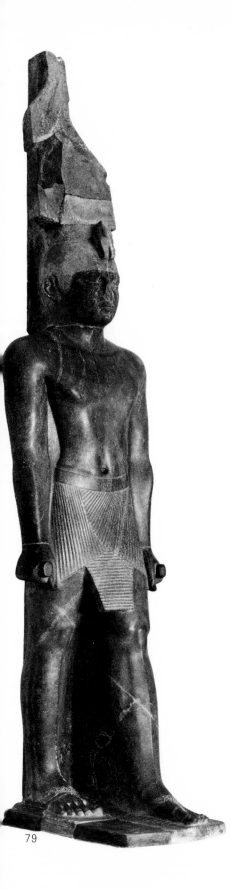

79

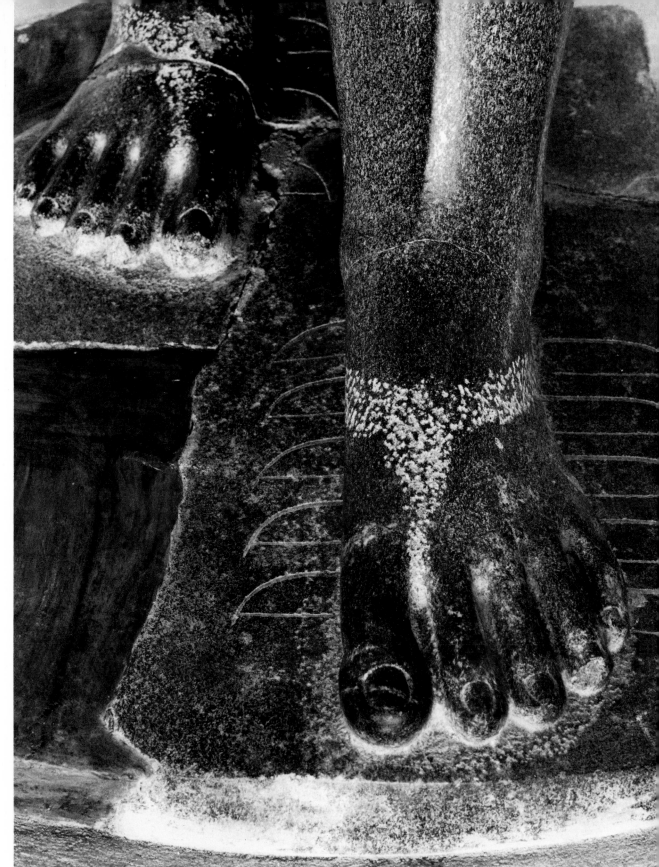

80

97

81. Head of Taharqa. Dynasty XXV, 690-664 B.C. Black granite. H: 35 cm. Cairo, Egyptian Museum.

at Merowe, deep in the Sudan, but is now one of the masterpieces on view in the new museum at Khartum.[37] The holes bored into some parts of the surface indicate that the splendid black granite[38] was embellished with gold ornaments—a headdress and bracelets. The head, very round, markedly brachycephalous, is tightly enclosed in the Ethiopian cap, which was protected by the customary double *uraeus* and surmounted by very tall feathers, now partly broken: the feathers were typical of the headdress of the god Onuris.[39] The circular face is heavy, the fleshy nose spreads over a wide, thick-lipped mouth, the short, strong chin emphasizes the extraordinary power of the face. The same characteristics are found in other works—much better known because more accessible—like the famous head in black granite,[40] which has the cartouche of Khu-Nefertum-Ra (Taharqa) on the dorsal shaft, and the head in Copenhagen,[41] which has no inscription. Must we leave out of this series the red granite head in Cairo,[42] also without inscription, and regard it rather as an image of Shabataka because of a line running from the side of the nose to the corner of the mouth? To us it seems that the iconography of the Ethiopian sovereigns is too complex and as yet not well enough known to consider this anything more than a hypothesis worthy of further study.[43]

figs. 79, 8

fig. 81

fig. 82

The king's features are perhaps heavier and marked with a certain provincialism, though very expressive in their roughness, in the statue in the British Museum,[44] which shows him as a sphinx, or in the magnificent series of criosphinx statues from Kawa,[45] in which he is seen facing forward, standing between the broad paws of a ram which protects him with its powerful muzzle. And we must keep in mind the peculiarities of metalwork in order to judge a remarkable group of small bronze figures of the king kneeling in the attitude of prayer or sacrifice.[46] These were ornaments for ships or for cultic statues, of which the finest, in the Musée du Louvre, shows Taharqa facing Hemen the falcon god.[47]

figs. 85, 8

fig. 87

figs. 83, 8

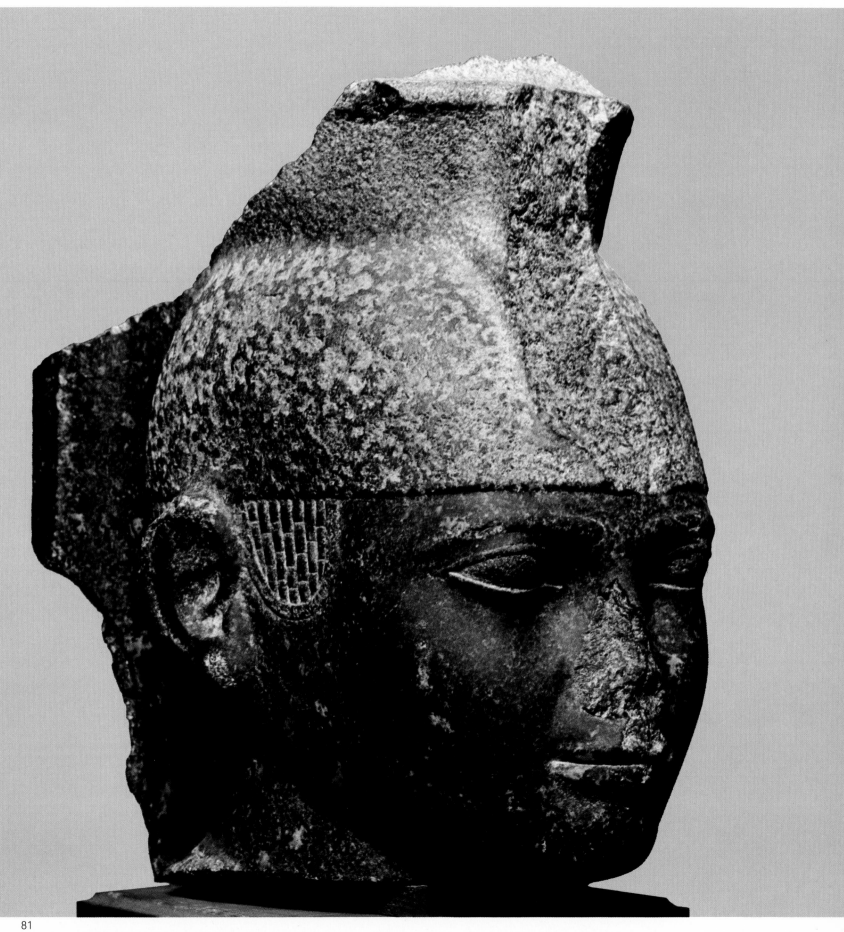

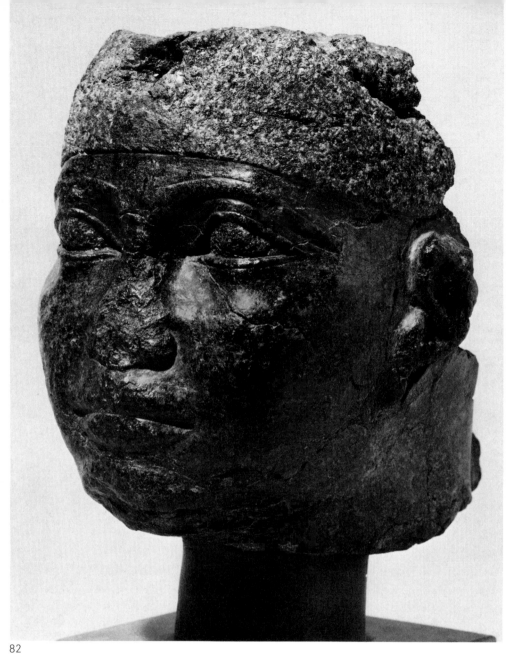

82

82. Head of Taharqa. Dynasty XXV, 690-664
B.C. Black basalt. H: 14 cm. Copenhagen, Ny
Carlsberg Glyptotek.

83, 84. Taharqa facing Hemen the falcon god.
Dynasty XXV, 690-664 B.C. Bronze, gold-plated
schist. H: 19.7 cm. Paris, Musée du Louvre.

83

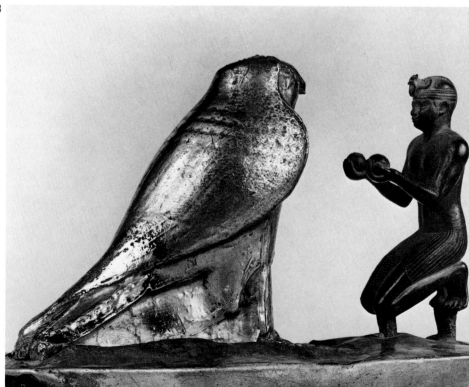

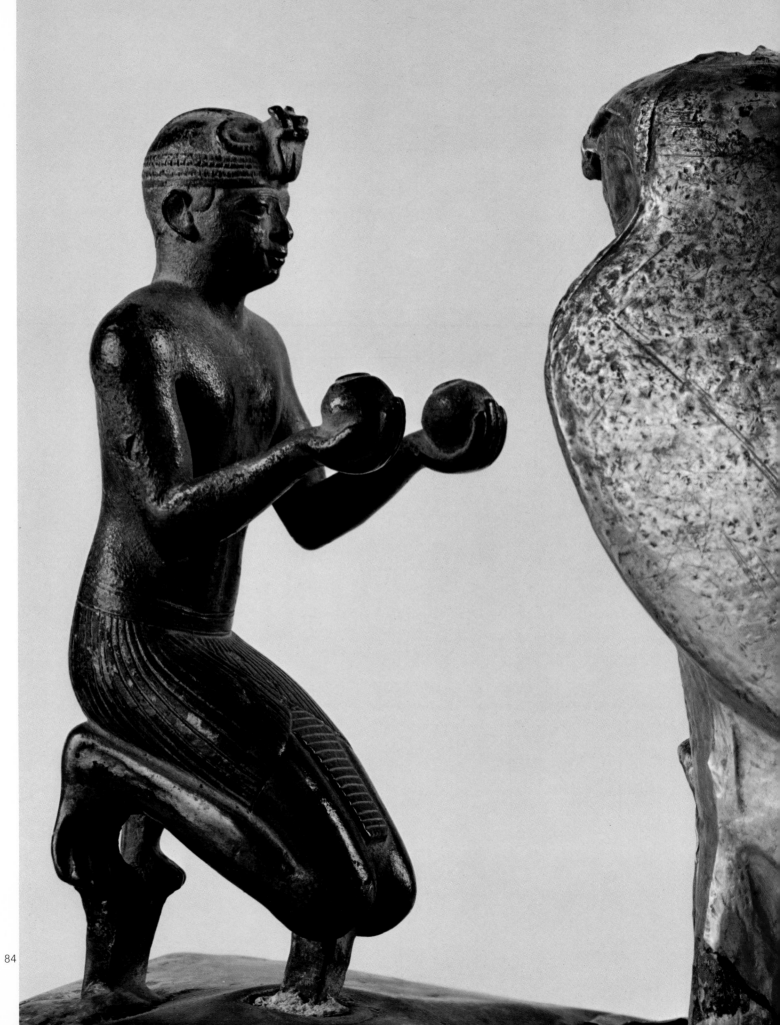

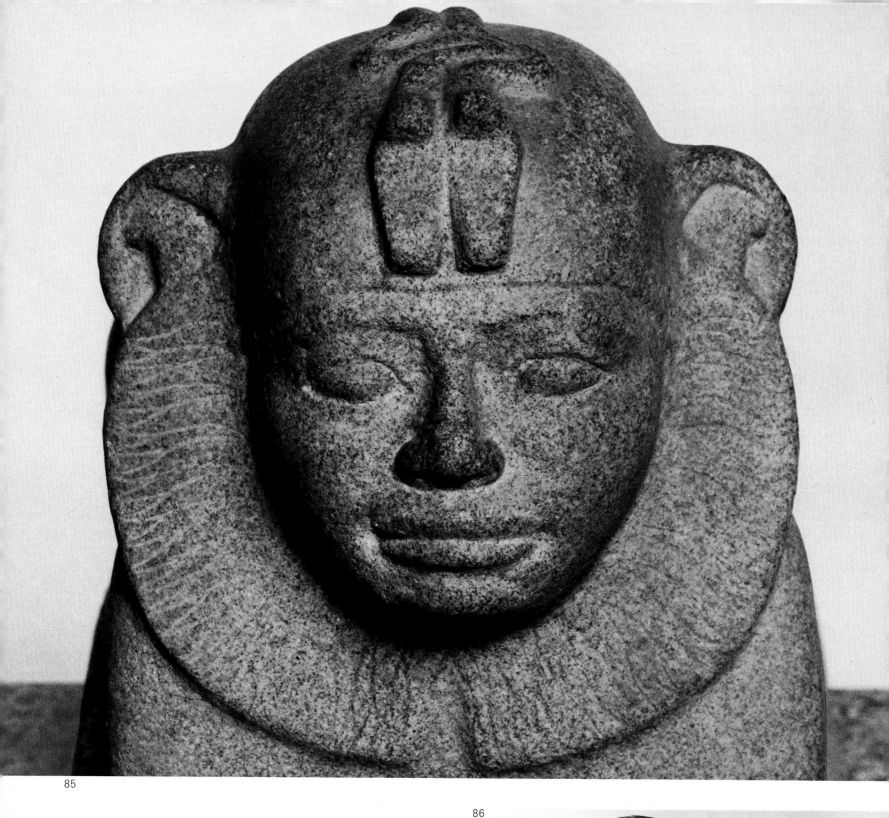

85

86

85, 86. Sphinx of Taharqa. From Kawa. Dynasty XXV, 690-664 B.C. Granite. L: 74.5 cm. London, British Museum.

87. Taharqa protected by a ram. From Kawa. Dynasty XXV, 690-664 B.C. Gray granite. H: 100 cm. Khartum, Sudan National Museum.

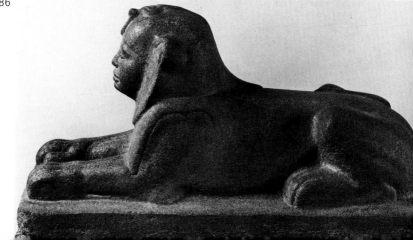

102

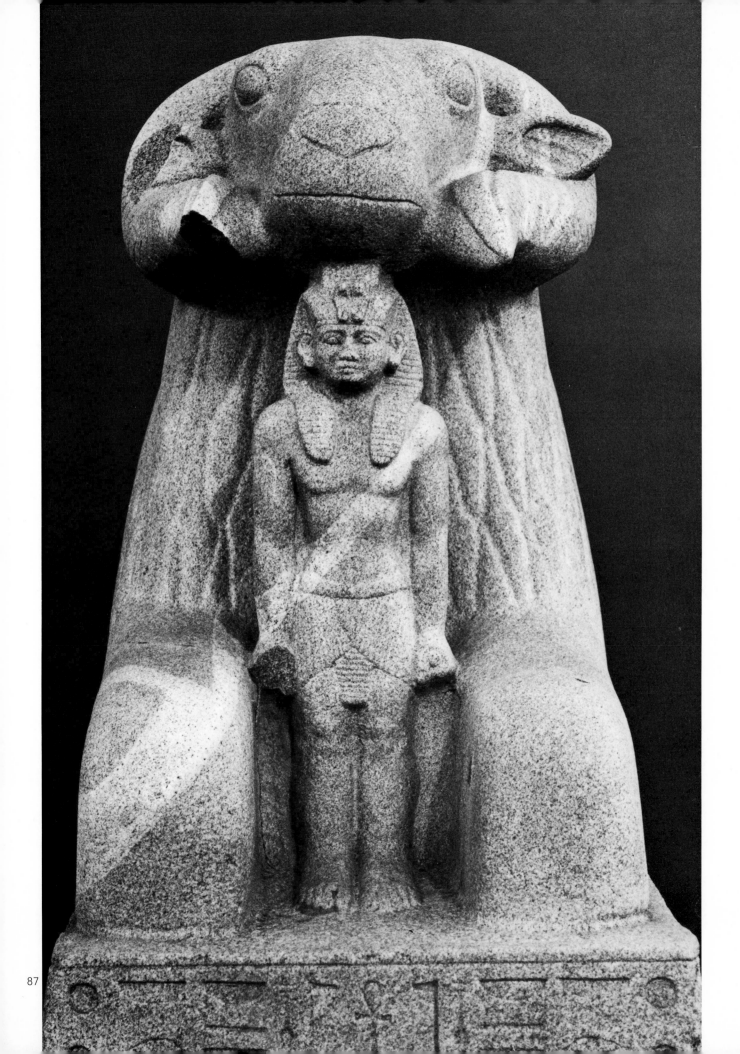

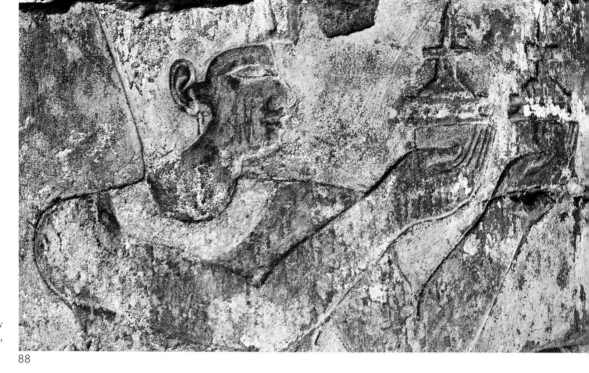

88

88. Taharqa making an offering of milk, low relief on a reused column drum. Dynasty XXV, 690-664 B.C. Karnak North.

89. Portrait of Taharqa, detail of low relief. Dynasty XXV, 690-664 B.C. Sandstone. Gebel Barkal, temple called Typhonium.

90. Portrait of Taharqa, fragment of low relief. Dynasty XXV, 690-664 B.C. Sandstone. 28 × 25.5 cm. Paris, Private Collection.

91. Portrait of Taharqa, low relief on a doorpost. Dynasty XXV, 690-664 B.C. Karnak, Edifice of Taharqa of the Lake.

92. Portrait of Taharqa, low relief on a doorpost. Dynasty XXV, 690-664 B.C. Sandstone. Sedeinga, west necropolis.

Portraits in relief present several iconographic types. In the Sudan the king appears as a typical Kushite with pronounced brachycephaly, a powerful neck, and sharply drawn features. This is how we see him on the walls of the temple called Typhonium at Gebel Barkal,[48] and again on the door of the temple at Semna West.[49] Resembling these portraits is the not very flattering one in crypt room E of the Edifice of Taharqa of the Lake,[50] which depicts him with a prominent nose, thick lips, and drooping eye.[51] But a real elegance distinguishes another series, so regular that despite vandalism and the damage wrought by time, the identification is beyond question. The slightly hooked nose, the sensual mouth, cheekbones salient but not exaggerated, wilful chin, all distinguish, among other portraits,[52] those in the colonnade which was rebuilt at Karnak North[53] and on the door of the Edifice of Taharqa of the Lake,[54] and appear again on the much eroded blocks of the door to Tomb W T1 at Sedeinga in the distant Sudan.[55] In fact this "portrait," perhaps even more than the vestiges of cartouches with the names of Khu-Nefertum-Ra (Taharqa), compelled us to conclude (bold as the hypothesis may be) that this was, if not the king's tomb, at the very least a burial place bearing his name and image in an exceptionally privileged way. Until now Pyramid No. 1 at Nuri has generally been thought to be Taharqa's tomb. A number of indices invite us to recognize this pyramid as a cenotaph which is fairly comparable to the Osireion at Abydos;[56] but the fact remains that an exceptional collection of shawabtis has been recovered there, and that the numerous faces found on them complete the rich gallery of portraits of Taharqa.[57]

fig. 89

fig. 90

fig. 88

fig. 91

fig. 92

figs. 93-95

97

In this specifically Egyptian type of funerary statuette the Kushite features of the king have not been omitted any more than they were for his predecessors. This characteristic example gives us a measure of the degree of syncretism that helped to shape the self-image of this double monarchy of Egypt and the Sudan.

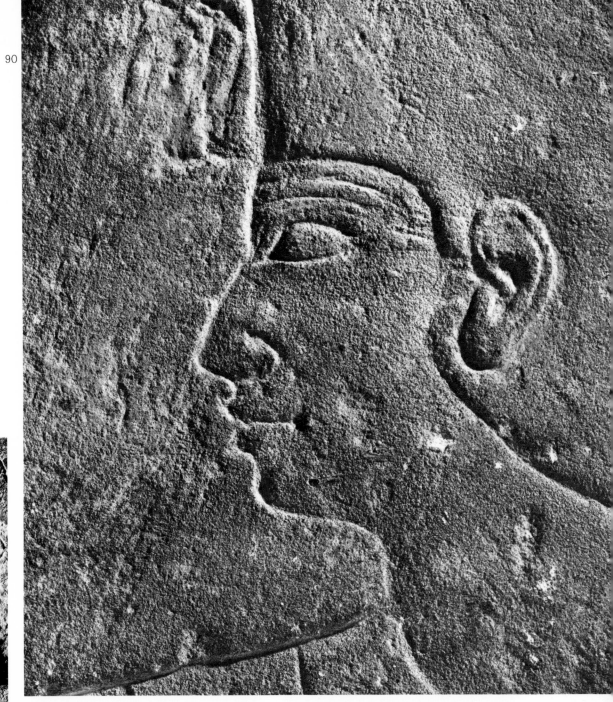

90

89

91

92

93. Shawabti of Taharqa. From Nuri. Dynasty XXV, 690-664 B.C. Alabaster. H: 33.3 cm. Khartum, Sudan National Museum.

94, 95. Shawabti of Taharqa. From Nuri. Dynasty XXV, 690-664 B.C. Ankerite. H: 33.1 cm. Boston, Museum of Fine Arts.

96. Carved ivory plaquette: royal lion-cub devouring a Kushite. From Nimrud. VIII century B.C. Ivory, gold, colored paste. H: 6 cm. London, British Museum.

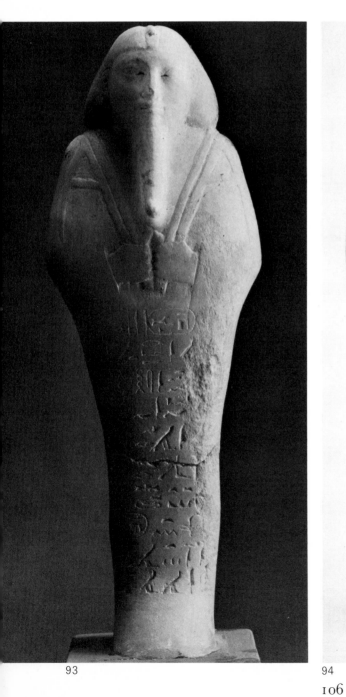

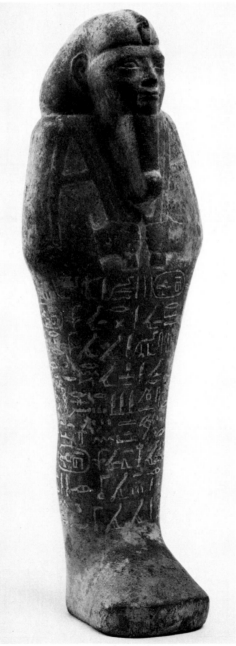

93

94

95

9

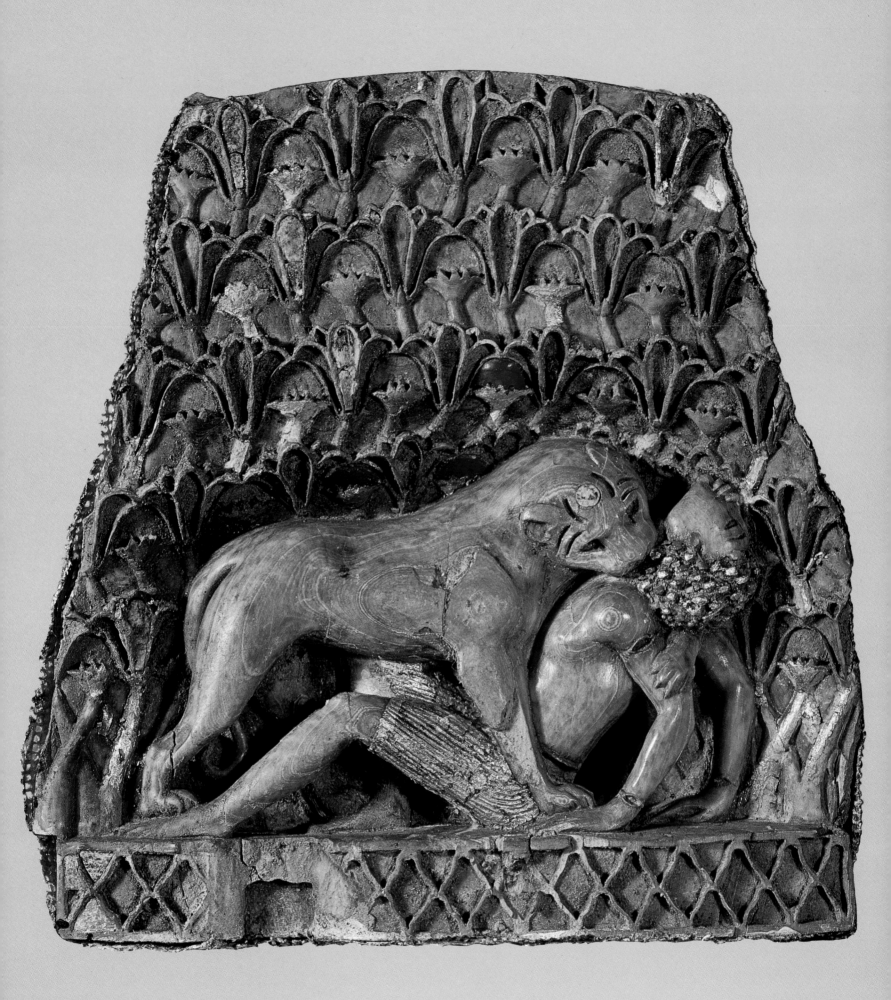

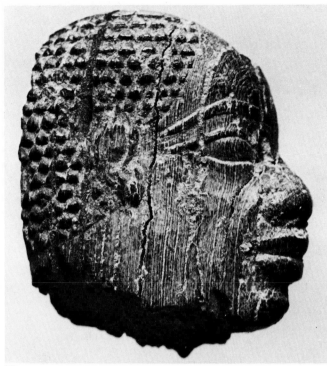
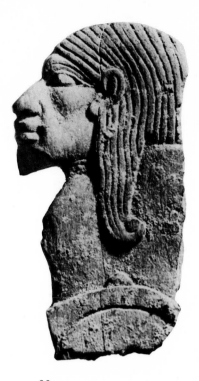

97. Shawabti of Taharqa. From Nuri. Dynasty XXV, 690-664 B.C. Black serpentine. H: 23 cm. Khartum, Sudan National Museum.

98, 99. Heads of a black and an Asiatic. From El Kurru, tomb of Shabataka. Dynasty XXV, about 701-690 B.C. Ivory inlays. H: 1.8 cm. Boston, Museum of Fine Arts.

98 99

We may now ask what the reaction to the Kushites was outside of the Nile Valley. The Bible reflects the fear which the Nubian warriors no doubt aroused (2 Kings 19:9; Isaiah 30:2-3, 37:9). Among the Assyrian ivories from Nimrud there is a magnificent piece fashioned according to a rather unusual technique which unites ivory, gold, colored paste, and stone; the inspiration of the design and style originated in the Nile Valley.[58] fig. 96 In this work, against an elegantly executed background of vegetation, the royal lion-cub gets ready to devour a Kushite with Negroid features and kinky hair: the victim is falling backwards and looks as if he is already dead. By way of mockery, and doubtless also to avenge himself on a dreaded enemy, the victorious Assarhaddon had himself portrayed on his great stelae at Sendjirli and Til Barsib in northern Syria, holding two prisoners on leashes strung through their lips as they hold out their hands in a gesture of supplication.[59] One of the two, whose features are strongly Negroid, has been thought to represent Ushanahuru, i.e., Nes(ou)-Onuris (Esanhure?), Taharqa's son: the inscription at Sendjirli records that he was carried off into captivity together with his father's harem.

On the attitude of the Kushites themselves toward the southern populations of their empire our information is slight and fragmentary. They put to their own uses the iconography of conquest typical of the Egyptian rulers. Thus Taharqa is depicted, on the back of the pylon of the Small Temple at Medinet Habu, in a conventional scene of triumph over Egypt's enemies.[60] On the socle of a statuette discovered inside the Temple of Mut,[61] Asiatics and Negroes are seen chained by the neck in the classical way. Their names in the escutcheons are simply a copy of those on a list of Horemheb: the list begins with Irem, then Gourses—the names of the Nubian peoples— "an obvious and naïve plagiarism," as A. Mariette judged it, with some severity and not much effort at understanding. In the preceding reign, on a delicately incised ivory, Shabataka had allowed himself the satisfaction of

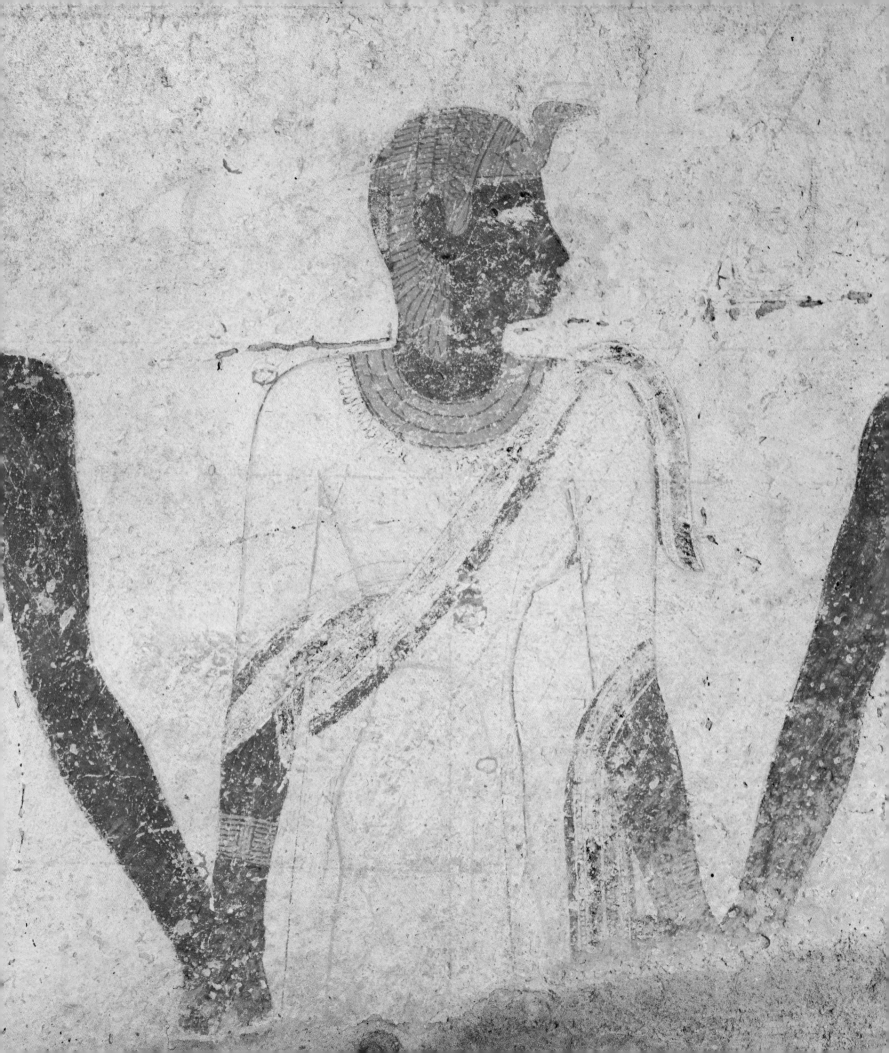

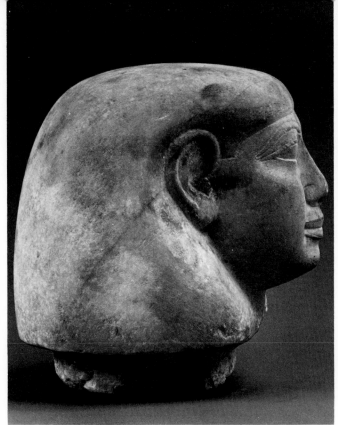

101

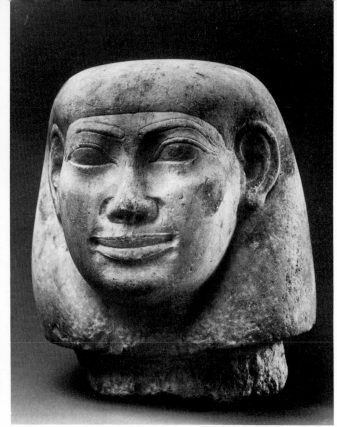

102

100. Queen Qalhata introduced by two divinities (detail). Dynasty XXV, VII century B.C. Mural painting. El Kurru, pyramid of Qalhata.

101, 102. Lid of a Canopic jar: portrait of Tanutamun. From El Kurru, tomb of Tanutamun. Dynasty XXV, 664-653 B.C. Alabaster. H: 17.7 cm. Boston, Museum of Fine Arts.

putting the characteristic image of a Negro in contrast to those of peoples of the North.[62] figs. 98, 99

We know almost nothing about the last king of the Twenty-fifth Dynasty: his name was Tanutamun, and he was the son of Shabataka and the nephew of Taharqa, his predecessor. Only by elimination might one attribute to this king a small sphinx head in black basalt in The Brooklyn Museum.[63] In fact, the king's features are found on shawabtis[64] and on a Canopic head in alabaster[65] which were found in his tomb (Ku. 16), and figs. 101, 102 on various reliefs. Up to this time these reliefs have had very poor publication; but we are happy to present here several details from the Theban chapel of Osiris-Ptah-Nebankh.[66] figs. 103-105

We have devoted a good deal of space to the iconography of kings, in which, as we have noted, a concern for individualized portraits is clearly discernible. To these royal effigies we should add a few rare portraits of queen-mothers[67] and "royal wives,"[68] and, more especially, the dazzling fig. 100 gallery of the female Divine Consorts, Amenirdas and Shepenwepet, virgins consecrated to the god.[69] Their charm, and the radiance of real power, explain why the memory was perpetuated down to the Greeks of the classical era, in two quite different images—in the *pallacae* (sacred prostitutes to whom Herodotus refers) and, more justly perhaps, in the Theonoë of Euripides' *Helen*.[70]

The most famous of the statues of Divine Consorts is the alabaster figure of Amenirdas I in Cairo.[71] The image of her adopted "daughter," Shepenwepet, is found on two sphinxes, each holding out a vase whose cover is decorated with the head of Amun's ram.[72] One of these is in Berlin,[73] the other in Cairo.[74] The features of the Divine Consorts are seen on fig. 112 the walls of several chapels. Amenirdas I is on the walls of the chapel of Osiris-Heqa-djet, in company with Sefkhet-'abu[75] or in front of Amun.[76] figs. 108, 106

In order to strike an average image of the Kushites,[77] we might perhaps fig. 109

103. Tanutamun greeted by Montu. Dynasty XXV, 664-653 B.C. Low relief. Karnak South, chapel of Osiris-Ptah-Nebankh.

104. Tanutamun presenting offerings to the god Osiris-Ptah (detail). Dynasty XXV, 664-653 B.C. Low relief. Karnak South, chapel of Osiris-Ptah-Nebankh.

105. Tanutamun before Osiris-Ptah (detail). Dynasty XXV, 664-653 B.C. Low relief. Karnak South, chapel of Osiris-Ptah-Nebankh.

106. Amenirdas I presenting bowls of wine to Amun (detail). Dynasty XXV, late VIII century B.C. Low relief. Karnak, chapel of Osiris-Heqa-djet.

107. Statue of Amenirdas I (detail). From Karnak North. Dynasty XXV, second half of VIII century B.C. Alabaster. Cairo, Egyptian Museum.

108. Amenirdas I facing Sefkhet-'abu (detail). Dynasty XXV, late VIII century B.C. Low relief. Karnak, chapel of Osiris-Heqa-djet.

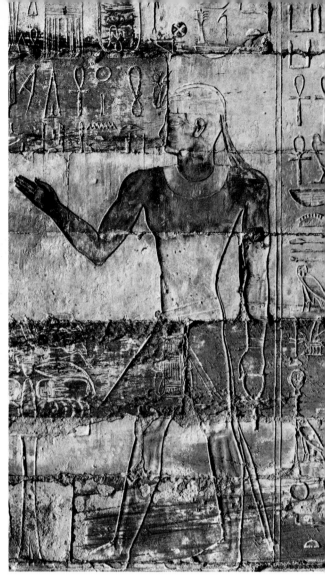

103, 104

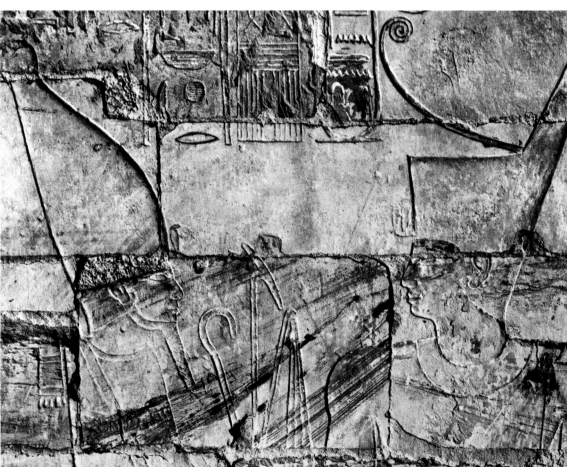

105

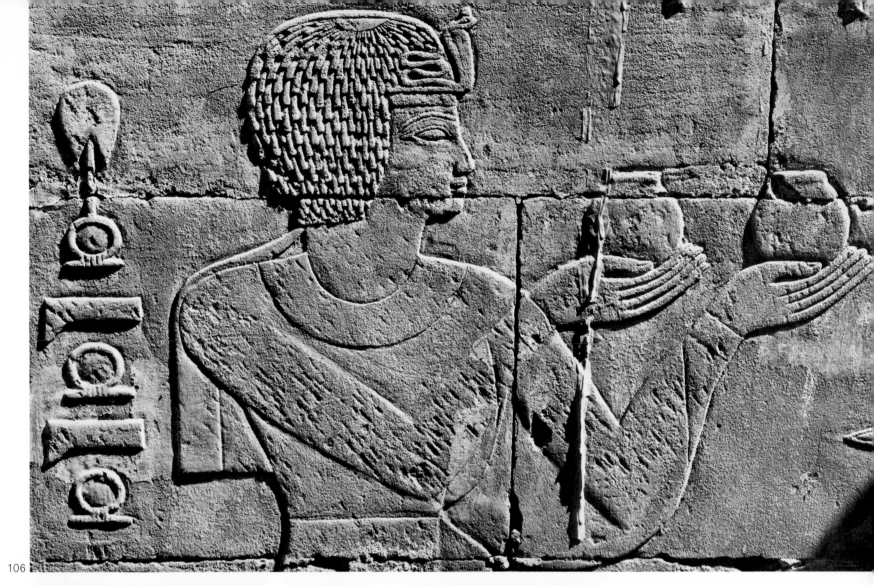

106

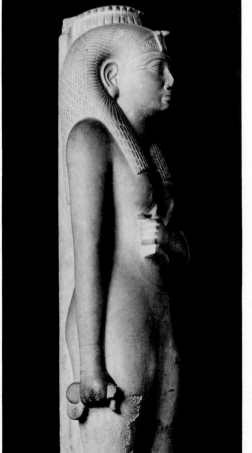

107

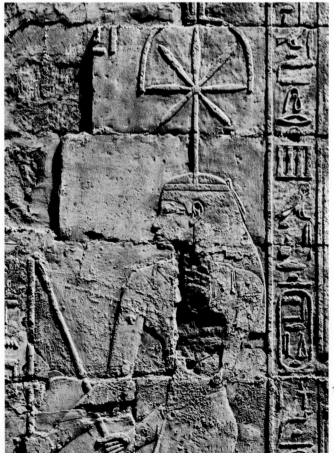

108

113

109. Statuette of a kneeling king. Dynasty XXV, early VII century B.C. Bronze. H: 9 cm. Copenhagen, Ny Carlsberg Glyptotek.

110. The god Ptah seen in profile, fragment of low relief (detail). Dynasty XXV. Sandstone. Paris, Private Collection.

111. Profile of the god Amun, low relief on a reused block of stone. Dynasty XXV, mid-VII century B.C. Sandstone. Karnak North.

112. Sphinx of Shepenwepet. From Karnak. Dynasty XXV, late VIII–early VII century B.C. Granite. H: 45 cm.; L: 82 cm. East Berlin, Staatliche Museen.

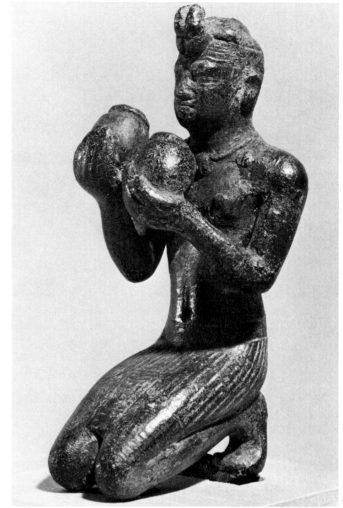

109

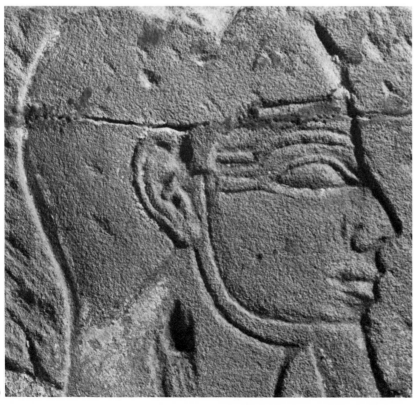

110

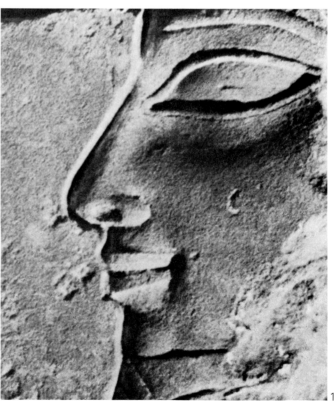

111

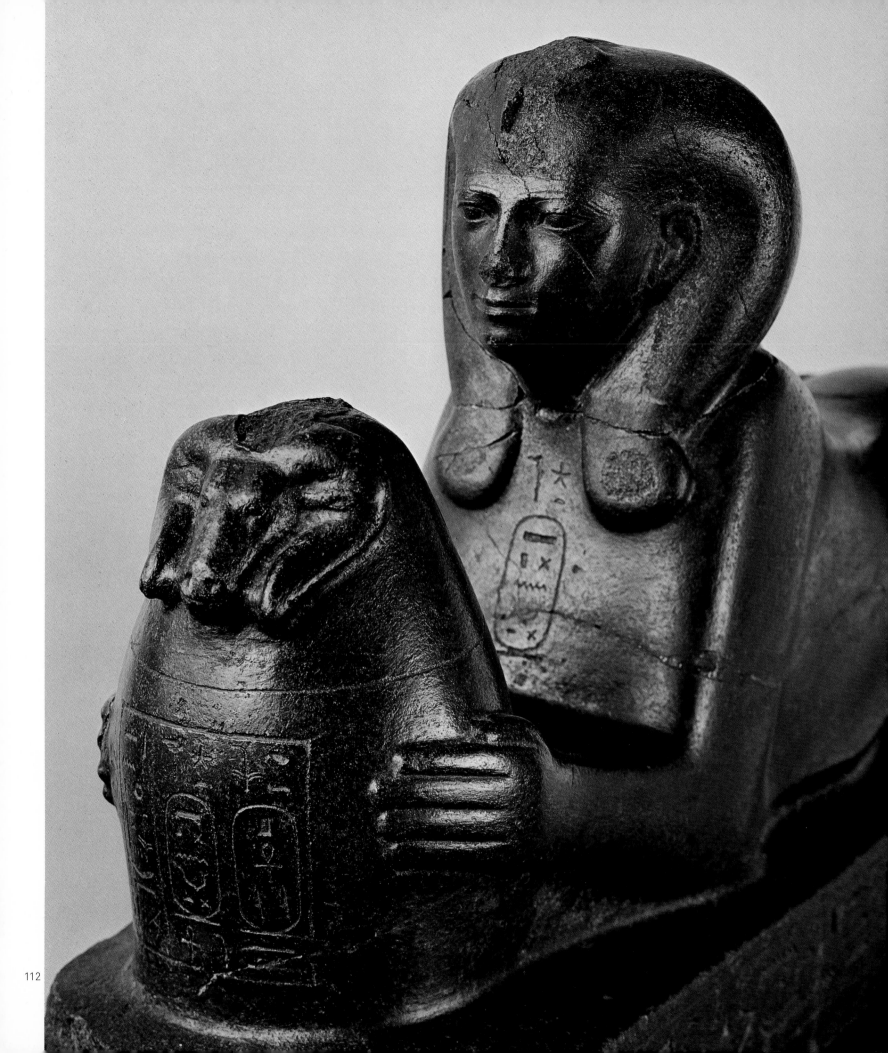

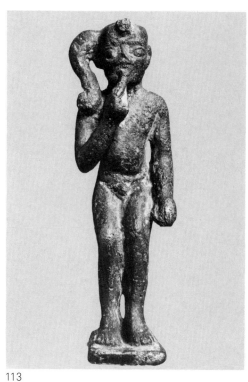

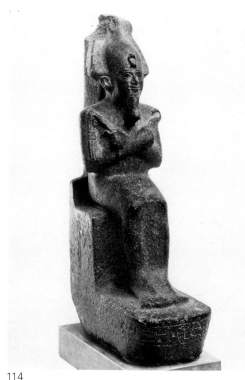

113

114

113. Pendant of Harpocrates. Dynasty XXV. Bronze. H: 8.4 cm. Nantes, Musée Thomas Dobrée.

114. Statuette of Osiris seated. From Medinet Habu. Dynasty XXV. Granite. H: 51 cm. Copenhagen, Ny Carlsberg Glyptotek.

115. Statue of Irigadiganen. From Karnak. Dynasty XXV. Gray-black granite. H: 45 cm. Cairo, Egyptian Museum.

have done better to turn to the very numerous representations of divinities. As in other periods of Egyptian history, they reflect the royal iconography; and a subtle analysis might discern in the image of certain of these gods the particular features of one or the other sovereign. But looking at the images of Amun[78] and Ptah,[79] of Harpocrates[80] and Osiris,[81] in the end we retain a generic picture of these Nubians, in whom there was often an admixture of Negro blood; they seem to have had the typical rather heavy nose, prominent cheekbones, fleshy lips, and powerful chin. *figs. 111, 110, 113, 114*

On the other hand, we would not have learned much from statues of non-royal personages, which are scarce in the Sudanese part of the Kushite Empire. In the Theban area, with the exception of a few rare examples that would be worth analyzing, they are, on the whole, subject to the influence of school traditions, imitating the styles of the great earlier periods.[82] Only Irigadiganen, all puffed up, dragging his weighty mass of fat, marches forward with heavy step.[83] Too obese to wear a man's loincloth without looking ridiculous, this "nobleman and prince, truly an intimate of the king who loves him," wears an unusual garment, a sort of smock with shoulder straps. *fig. 115*

One might have thought that when they were driven out of Egypt and went back to their motherland, the Kushites, having learned a great deal about technique, would have developed a more realistic and personal art of their own. Generally one emphasizes the formalism of the colossal statues of the sovereigns of the first Napata dynasty—Senkamanisken,[84] Anlamani,[85] and Aspelta[86] (between 650 and 560 B.C.). Yet such criticism may be too severe: for all that the ravages of time have done to them, they still express the power of the Kushite message. Attention might also be called to the reliefs of Aspelta in Temple T at Kawa.[87] *figs. 116, 119, 117 fig. 118*

We may note that the tradition of an "Egyptianized" art continued down through the centuries. Of course, in the view of the pure Egyptolo-

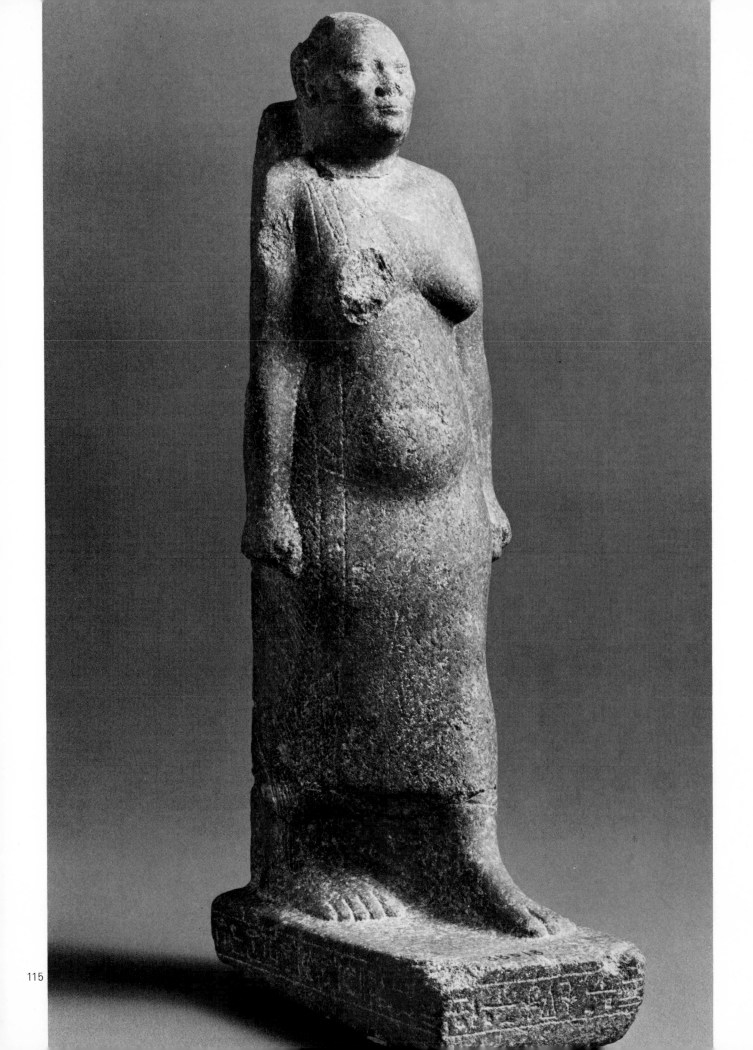

116. Statue of Senkamanisken. From Gebel Barkal. First Napata dynasty, second half VII century B.C. Black granite. H: 147 cm. Boston, Museum of Fine Arts.

117. Statue of Anlamani. From Gebel Barkal. First Napata dynasty, late VII century B.C. Red granite. H: 381 cm. Boston, Museum of Fine Arts.

118. Statue of Aspelta. From Gebel Barkal. First Napata dynasty, about 593-568 B.C. Granite. H: 332 cm. Boston, Museum of Fine Arts.

119. Detail of figure 116: head of Senkamanisken.

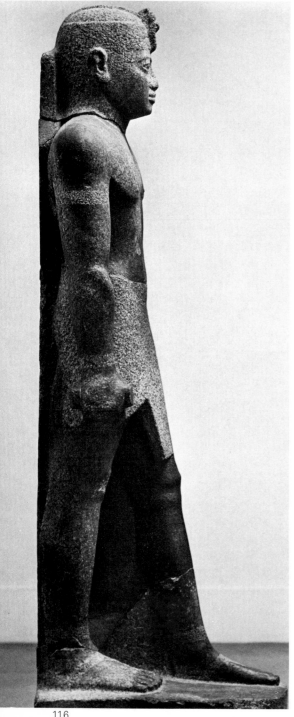

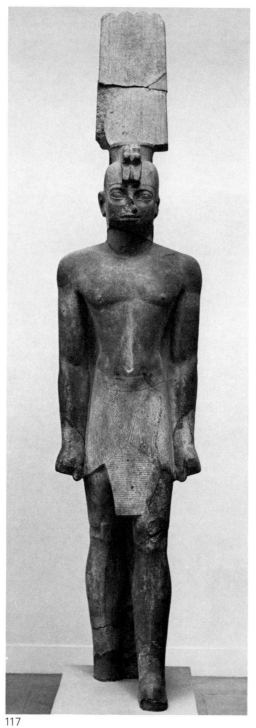

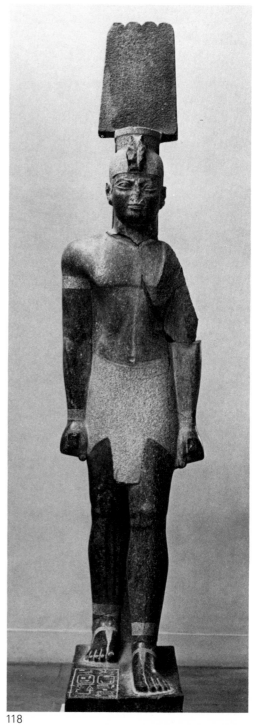

116

117

118

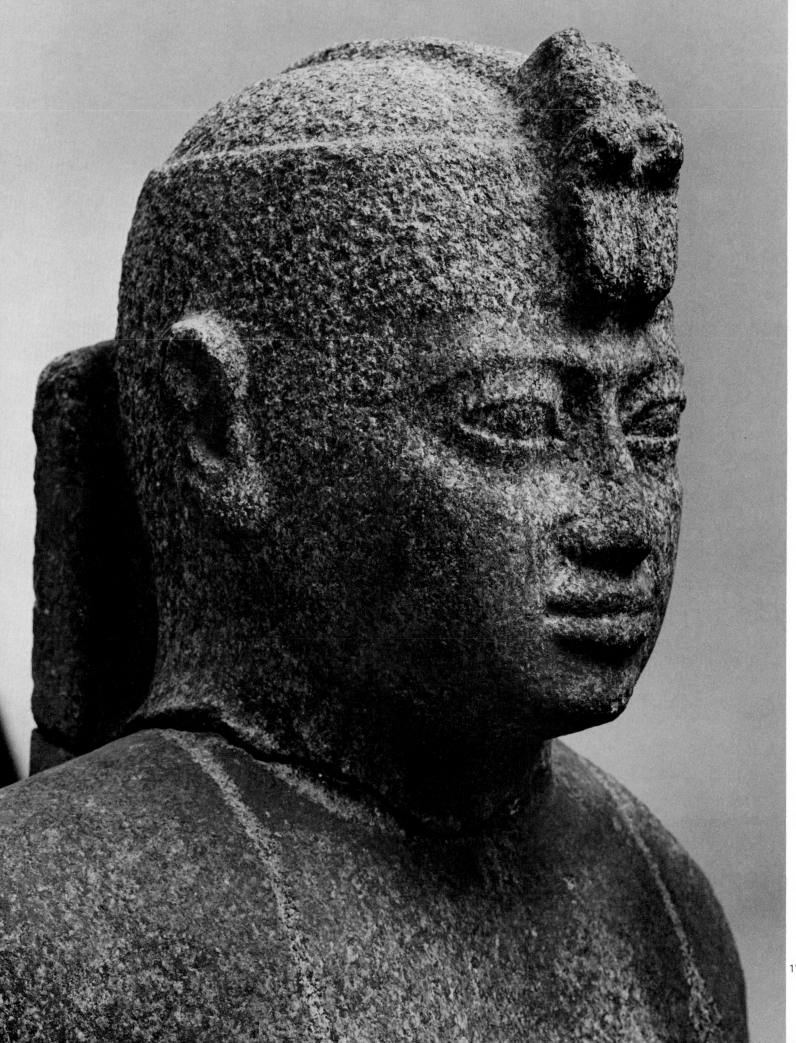

120

120. Sovereign adorned with jewels (detail). Mid-II century B.C. Low relief. North Begarawiyeh, pyramid chapel.

121. Meroïtic sovereign sitting enthroned. Mid-II century B.C. Low relief. North Begarawiyeh, pyramid chapel.

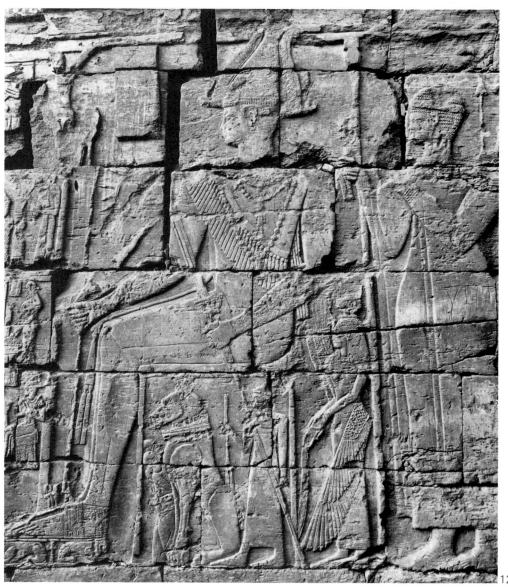

121

gist, it is "bastardized." But in Egypt itself, can the reliefs of the Ptolemies be compared with those of the golden age of the New Kingdom? Here we need to set up only a few direction signs, such as the decoration of the stela — fig. 123 of Nastasen (second half of the fourth century B.C.).[88] Following the fluctuations of politics or of cultural influences, which are not yet well known, Egyptian "renewals" are perceivable, for instance in the reign of Ergamenes (beginning of the third century B.C.),[89] or in those of Natakamani, and of Queen Amanitore (shortly before the Christian era).[90]

In any case the ethnologist's preference will be for more authentic documents. Before him lies the exploration of a vast documentation which so far has received only preliminary attention. He can go to the chapels of the vast necropolises of Meroë, in particular at North Begarawiyeh.[91] Although the chronology of the burial places is still subject to discussion, some few starting points, more or less certain, are available. If the identification of Tomb N 12 as that of Queen Shanakdakhete must be considered doubtful, it is safe to say that the tomb dates from about the middle of the second century B.C.;[92] the reliefs on the north[93] and south[94] walls allow us — figs. 120,1 to study the typical thick-set figure of the rulers of Meroë, clothed with

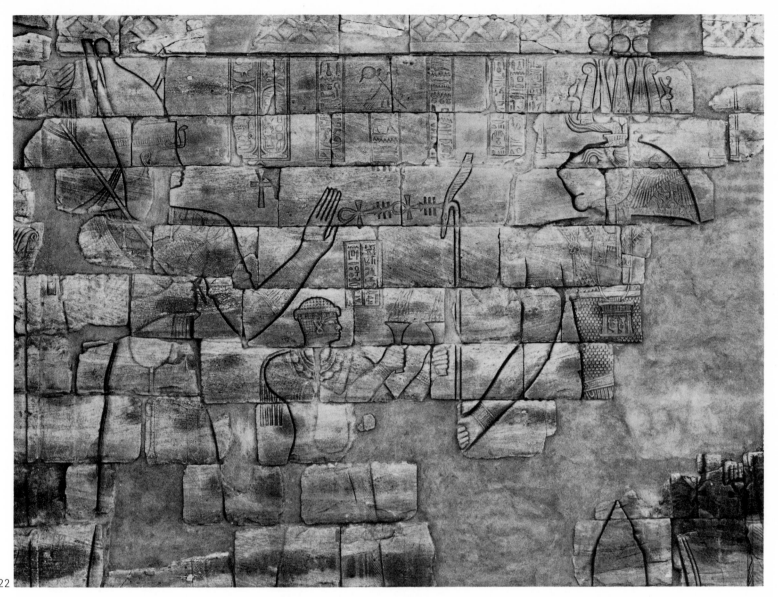

122

122. King Arnekhamani and his son Arka facing the god Apedemak. Late III century B.C. Low relief, sandstone. Musawwarat es-Sufra, Lion Temple.

rather showy elegance, loaded with large-beaded necklaces and pendants, adorned with complicated gorgets and wearing massive jewels in their ears. The facial traits are strongly marked, the peppercorn treatment of the hair is almost always in evidence.[95]

It is regrettable that better use has not been made of the human remains collected from the burial sites. According to the analysis of the bones from the tomb of King Amanitenmemide (about the middle of the first century A.D.), it seems that the skeleton of a relatively young man of the classic Mediterranean type was accompanied by those of two young Negroid women.[96] We may hope that the research carried on in recent years in the part of Nubia now flooded by the waters of the Sadd el Ali will give us more ample knowledge of the people living in that area in ancient times.[97]

The very distinctive features of the Meroïtes appear on the walls of their temples, which we are coming to know better thanks to recent explorations, among them the one conducted by F. Hintze. In the Lion Temple at Musawwarat es-Sufra[98] (end of the third century B.C.)[99] we see King Arnekhamani and his son Arka officiating. Looking at the young prince, fig. 122 one is reminded of the African portraits in classical Egyptian art: the

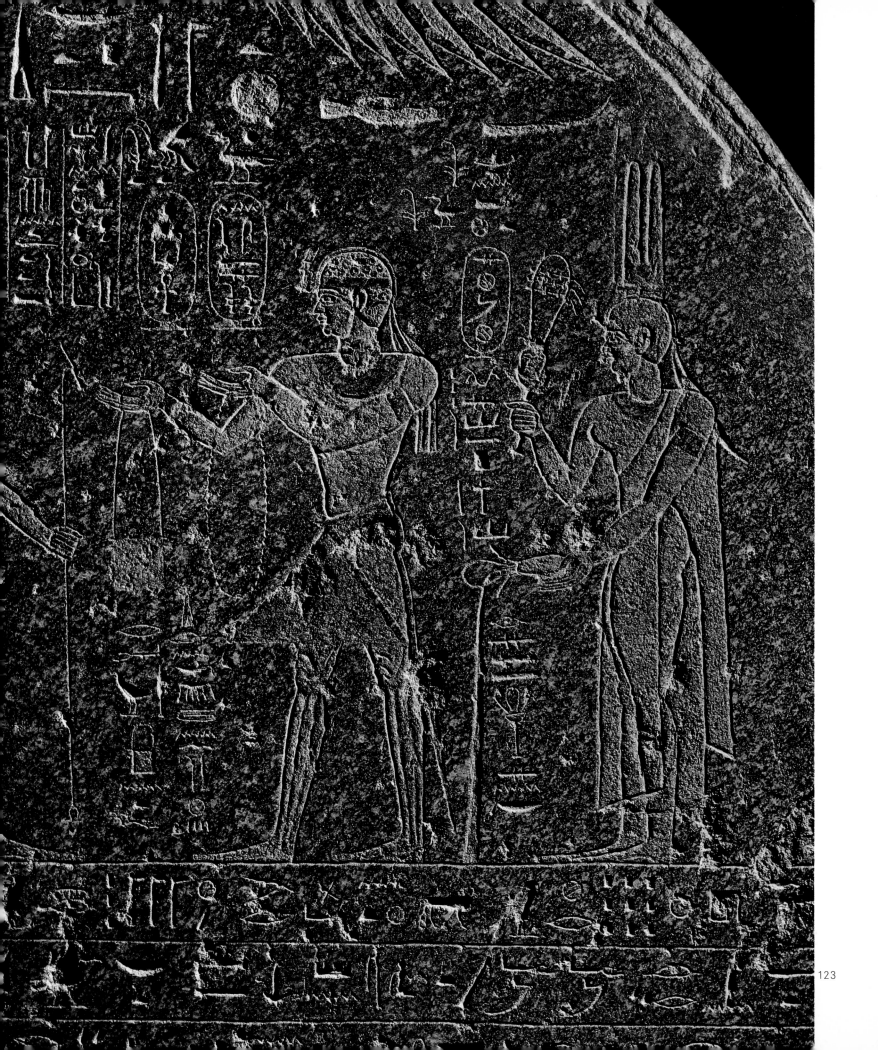

123. Stela of Nastasen (detail). Second half IV century B.C. Granite. East Berlin, Staatliche Museen.

124. Head of the god Sbomeker, detail of low relief. Late III century B.C. Sandstone. Musawwarat es-Sufra, Lion Temple.

125. Queen Amanitore and King Natakamani opposite the lion god, four-armed Apedemak. Late I century B.C.–early I century A.D. Low relief, sandstone. Naga, Lion Temple.

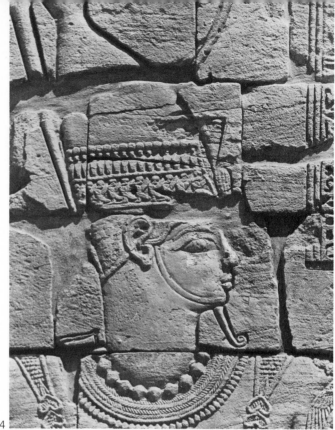

124

125

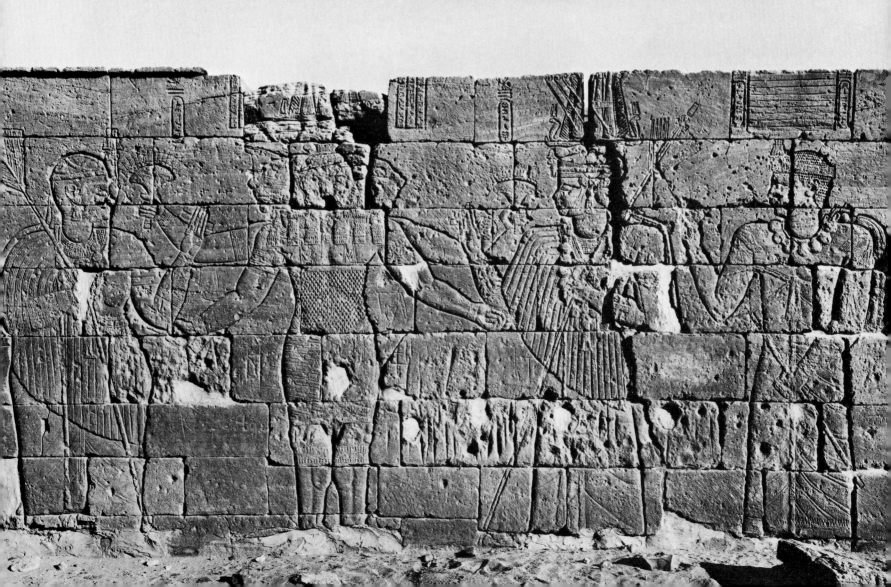

126. King Natakamani dominating his enemies. Late I century B.C.–early I century A.D. Low relief, sandstone. Naga, Lion Temple.

127. Cargill plaquette: Prince Arikankharer defeating his enemies. Early I century A.D. Sandstone. 20 × 25.4 cm. Worcester (Mass.), Worcester Art Museum.

128. "Negro goddess," detail of low relief. Late I century B.C.–early I century A.D. Sandstone. Naga, Lion Temple.

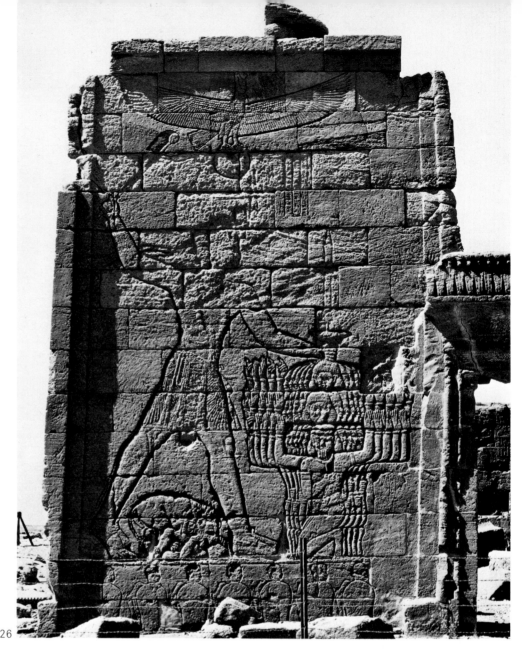

126

127

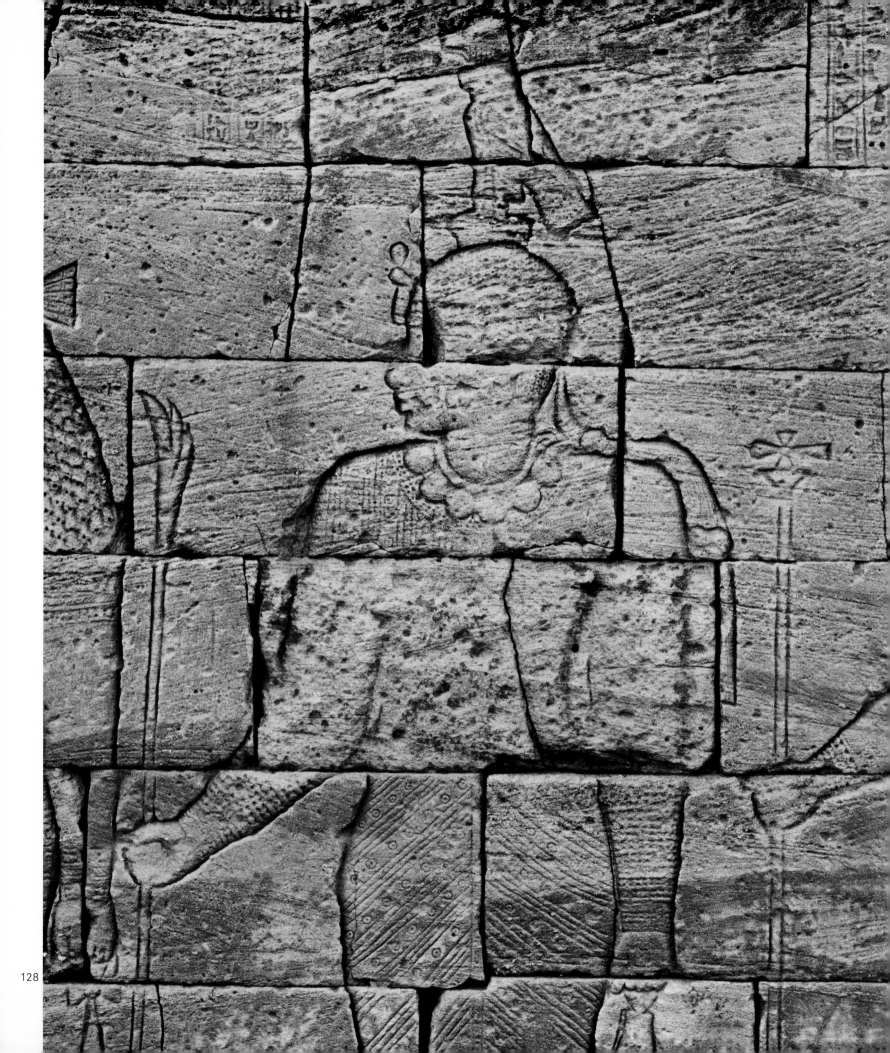

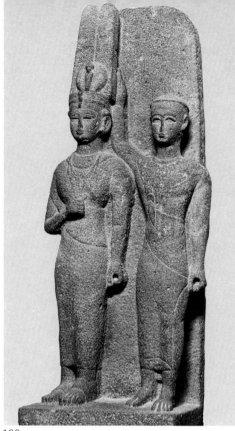

129

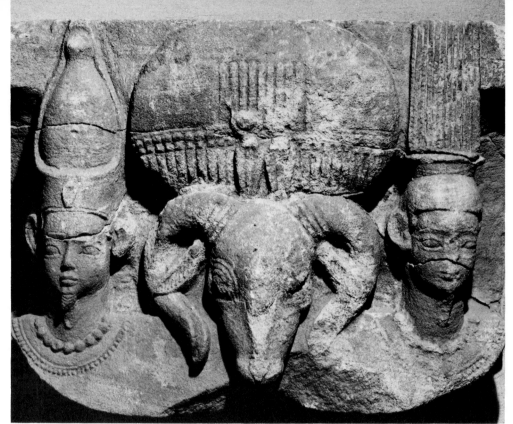

130

129. Group perhaps representing Queen Shanakdakhete and her son. II century B.C. High relief, basalt or gray granite. H: 161 cm. Cairo, Egyptian Museum.

130. Triad with the ram of Amun flanked by Sbomeker and Arsenuphis. From Musawwarat es-Sufra. III century B.C. High relief, sandstone. 51.5 × 72.5 cm. Khartum, Sudan National Museum.

131. Colossal statue. From Argo Island, Temple of Tabo. II century B.C. Gray granite. H: approx. 700 cm. Khartum, Sudan National Museum.

132. Pillar statue of a god. From Meroë, Temple of Isis. I century A.D. (?). Sandstone. H: 223 cm. Copenhagen, Ny Carlsberg Glyptotek.

impression is strengthened by the mass of kinky hair and the earring. But in general these powerful figures suggest Nubians and not Negroes. The images of the gods resemble those of the masters of the country.[100] The god Sbomeker,[101] who is invoked in a purely Egyptian hymn, is brachycephalous like the princes: his round face is set on a particularly powerful neck. The later portraits of rulers and gods in this same temple, dating from around the Christian era, are distinguished by their opulence and the diversity of the types, which may be drawn from various branches of the Kushite peoples. There, perhaps, is where we should look for one of the most characteristic images of the "queen-mother"[102]—the portrait of Amanitore advancing toward four-armed Apedemak.[103] This huge, steatopygous woman, stately of bearing, laden with the insignia of her power, faces the lion god, who holds out toward her face what may be a tuft of durra, and extends another hand to support her elbow. In the procession of divinities marches the one usually called the "Negro goddess."[104] The scenes of domination carved on the pylon of the temple at Naga[105] may be compared to the scene on the Cargill plaquette,[106] which shows Arikankharer, son of Natakamani, getting the upper hand of a clutch of enemies.

fig. 124

fig. 125

fig. 128
fig. 126
fig. 127

In like manner, in the course of centuries, sculpture in the round also derived from Egyptian models and reinterpreted certain of the pharaonic motifs. This is true of the group in Cairo, which may represent Queen Shanakdakhete and her son,[107] and also of the imposing statue of the ruler from the excavations at Meroë, now in the Ny Carlsberg Glyptotek in Copenhagen.[108] The colossi at Argo,[109] and some of the documents recently discovered by F. Hintze at Musawwarat es-Sufra, such as the triad of the ram of Amun flanked by Sbomeker and Arsenuphis,[110] should also be referred to. In these enigmatic faces, marked by the merest hint of a gentle smile, one might have been tempted to look for a trace of Indian influence.[111]

fig. 129

figs. 132, 1

fig. 130

131, 13

126

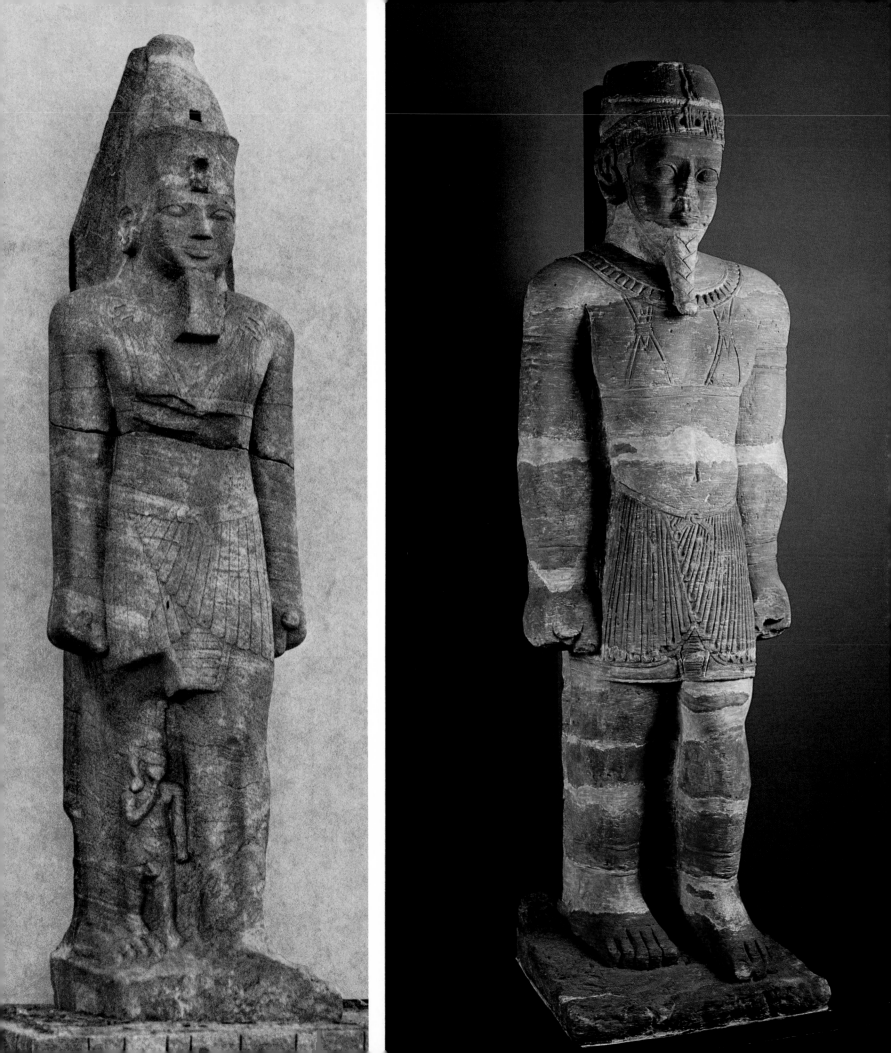

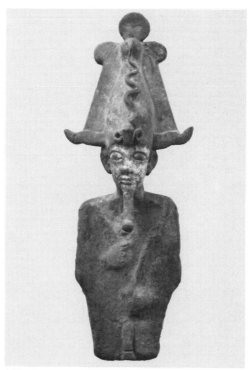

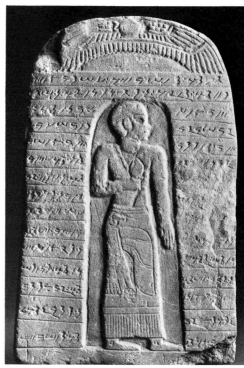

133. Statuette of Osiris. Bronze. Sedeinga, necropolis.

134. Funerary stela. From Dabarosa. Sandstone. 52 × 33 cm. Khartum, Sudan National Museum.

135. Statuette of a *ba*-bird. From Karanog, necropolis. Sandstone. H: 74.1 cm. Cairo, Egyptian Museum.

133

134

The techniques involved in the works we are studying here are always an important factor. Take, for instance, the bronze Osirises recently found by M. S. Giorgini's expedition in Cave W T9 in the Nubian necropolis at Sedeinga:[112] how much is taken from the model in the features of these strange, large-eyed faces, and how much is due to the gold plate covering the rough metal-castings, which are left just as they came from the mold?

fig. 133

Some funerary stelae, most of them crude but some more carefully wrought, show the naïve features of local notables.[113] But the richest assortment is that of the soul-bird (*ba*).[114] This curious combination of a human body with a human head, standing out in front of long bird wings,[115] seems to have been deposited in the statue chamber (*serdab*) of the pyramid which often stood over the Meroïtic grave.[116] What we see on some of these heads may be thought to be the "Ethiopian" cap with a strip in front of the ear: sometimes, instead of a simple, smooth bandeau, the headdress is adorned with a thin diadem in relief, decorated with chevrons, which might be the insigne of high rank.[117] In other instances, however, the head-covering is handled to look like short, curly hair.[118] The heads of *ba* in the lower-class necropolises are really curious. Violent in their expressiveness,[119] they sometimes present the facial "marks" which, still today, after thousands of years, characterize the peoples of Nubia.[120] From this point of view what could be more fascinating than the scarred head which rises on the front of a modest, crudely anthropomorphic sarcophagus found at Argin, not far downstream from the Second Cataract?[121]

fig. 134

fig. 135

fig. 136
fig. 138

fig. 137
fig. 139

fig. 140

In their simplicity, the last images we have referred to perhaps convey the real features and cultural marks of the ancient Upper Nile populations with the greatest degree of truth. Although they must have been not unlike the present inhabitants of the Northern Sudan, the Nubians in particular, most Meroïtes were, of course, not Negroes: their authentic portraits show them as very different from the peoples of deeper Africa. Probably they had

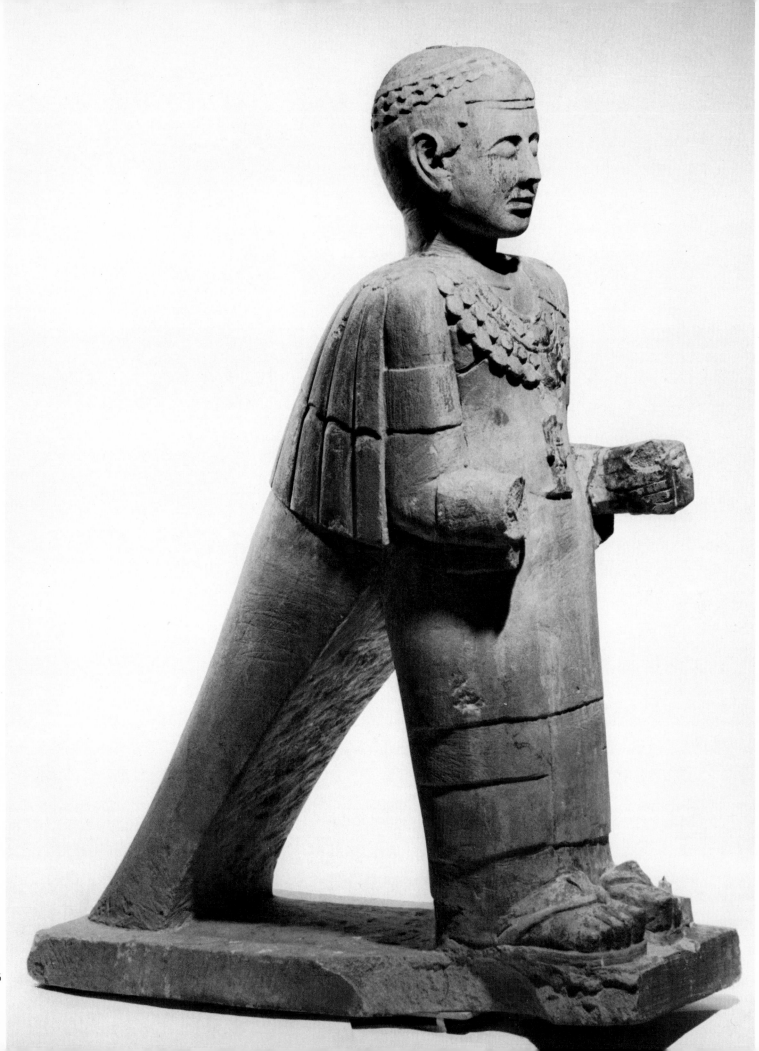

136. Head of a *ba*-bird (fragment). From Sedeinga, necropolis. Sandstone. Khartum, Sudan National Museum.

137. Head of a *ba*-bird. From Nag Gamus, necropolis. Sandstone. 9 × 16 cm. Madrid, Museo Arqueológico Nacional.

138. Head of a *ba*-bird. From Argin. Sandstone. H: 20 cm. Khartum, Sudan National Museum.

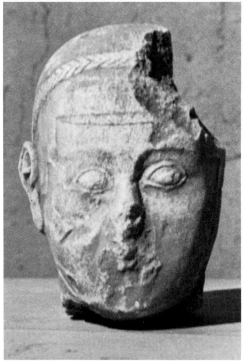

136

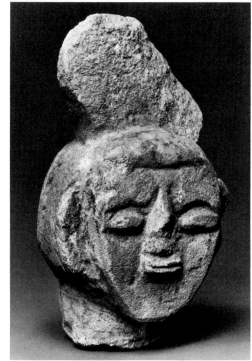

137

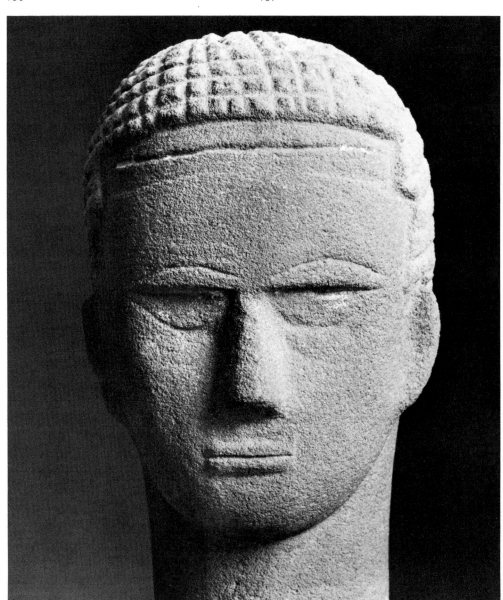

138

139. Head of a *ba*-bird (fragment). From Nag Gamus, necropolis. Sandstone. H: 7 cm. Madrid, Museo Arqueológico Nacional.

140. Anthropomorphic sarcophagus. From Argin. Terracotta. H: 22 cm.; L: 177 cm. Khartum, Sudan National Museum.

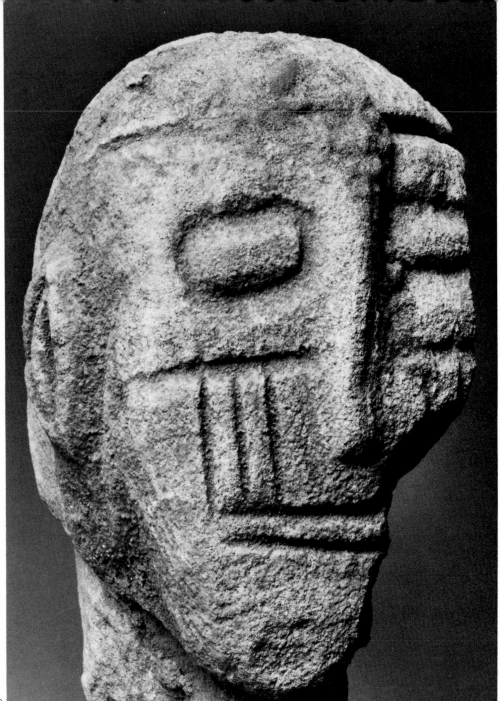

139

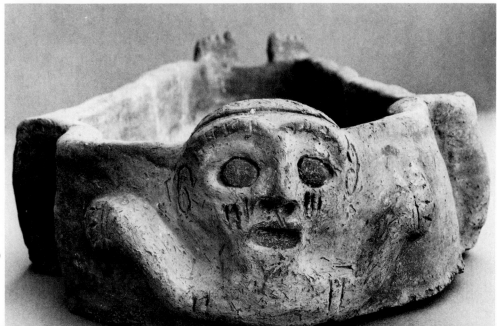

140

mingled with these peoples over the course of a long history during which the Kushite Empire brought together a number of quite diverse elements. In the desire to celebrate their power, they yielded to the temptation to borrow from Egypt its motif of domination. They often indulged the wish to establish a contrast between themselves and the kindred peoples whom they claimed to dominate. Nothing is more typical than the pendant in molded metal found in the necropolis at Sedeinga: it shows three prisoners with Negroid features, prostrate, with a vulture hovering over them and seizing them, thrusting his beak into the posterior of one, and grasping the other two in his claws.[122] In this curious way the symbolism came full fig. 141 circle, and the Meroïtes were finally represented conquering themselves and their African brothers.

141. Pendant: three African prisoners overpowered by a vulture. From Sedeinga, necropolis. Lead. Approx. 5.5 × 6 cm. Khartum, Sudan National Museum.

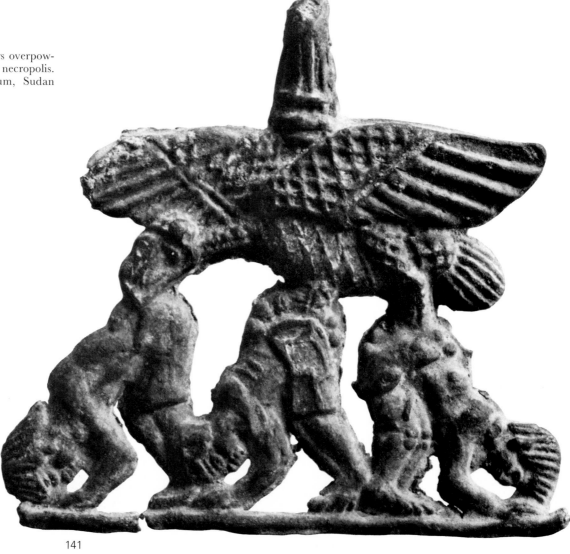

141

ICONOGRAPHICAL EVIDENCE ON THE BLACK POPULATIONS IN GRECO-ROMAN ANTIQUITY

FRANK M. SNOWDEN, JR.

INTRODUCTION

Representations of Negro peoples appear in every major period of classical art. Yet very few illustrations of blacks are included in handbooks and histories of Greek and Roman art; and when some are given, the choice always turns to the same small group of examples. Such a practice creates the impression that the Negro was not a familiar sight in the ancient world. There is abundant evidence, however, that he was far from being a prodigy as rare on earth as a black swan—Juvenal's *rara avis*.[1]

In general, two Negroid types have been the subjects of archeological studies: the so-called proper, true, or pure African Negro[2] who possesses Negroid characteristics in their most marked form, and another type frequently designated as Nilotic.[3] Specialists in the field of classical literature have given too much attention to the "pure" type, and not enough to the effects of racial crossings of blacks with whites,[4] a phenomenon amply attested by the ancient authors.[5] Archeologists likewise have failed to give due consideration to the types issuing from racial mixture.[6] As a consequence the picture of blacks in antiquity has been incomplete and evidence of importance to historians and anthropologists obscured. There are obvious difficulties involved in classifying mixed black-white types, and extreme caution is necessary in such a complex matter. What seem to be Negroid traits may at times be due merely to the range of physical characteristics in white races, or the result of the stylistic bent of an individual artist. While skeletal remains and anthropometric measurements would yield additional data, the information provided with respect to the kind of hair, form of lips, and breadth of nose in many representations of mixed types in Greek and Roman art is of considerable anthropological importance.[7]

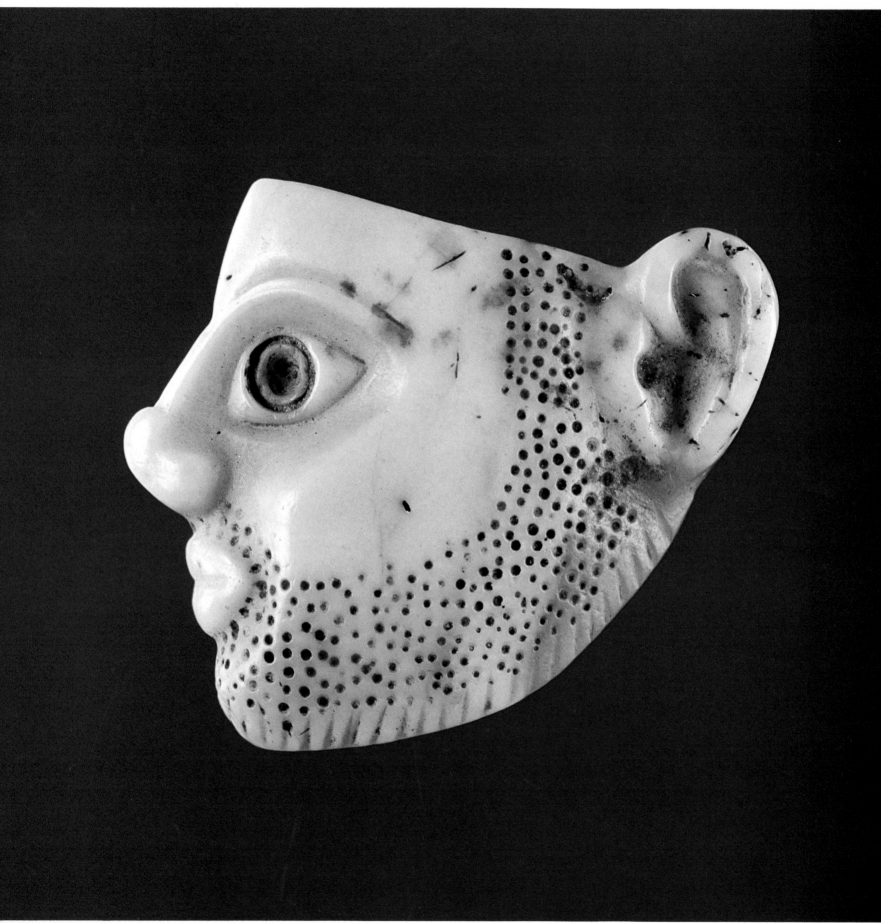

E.A. Hooton has pointed out that kinky or frizzly hair ordinarily appears in racial types in which there is at least a generous admixture of the Negro or Negrito.[8] J.H. Lewis has noted that no race other than the Negro or one intermixed therewith has woolly or kinky hair as a stable feature.[9] L. Bertholon and E. Chantre have analyzed results of black-white crossings in their detailed anthropological study of ancient and modern Tripolitania, Tunisia, and Algeria. They call attention to the degrees of Negro admixture as evidenced by the extent to which Negroid features appear in mixed North African peoples.[10] R. Bartoccini in his study of the somatic characteristics of ancient Libyans, illustrates his observations on racial crossings between Libyans and Negroes from the interior by pointing to the Negroid nose (broad) and hair (curly or woolly) of figures whom he regards as black-white crosses appearing in mosaics from Tripolitania.[11] O. Bates in his study of Eastern Libyans includes the criteria of platyrrhinism and thick lips.[12] Although much of the anthropological research on mixed black-white types in the ancient world has focused on Roman North Africa, the basic findings are relevant to race mixture elsewhere in the Greco-Roman world. Such conclusions demonstrate the importance assigned by anthropologists to the hair, lips, and nose as criteria for the classification of Negroid groupings. In my identifications, therefore, I have designated as mixed those individuals for whom such a classification seemed appropriate. I have also been guided by the opinions of scholars who have a wide knowledge of ancient art and who have developed a "sense" of non-Greek or non-Roman features.

The aim of this essay is to trace the history of interest in the Negro and mixed black-white types in art from the Minoan period to the third century A.D. and to relate the Negroes of the artists to the "Ethiopians" of the texts.[13] Our textual sources on Ethiopians in the ancient world are widely scattered and at times not very detailed. Such references may frequently take on new meaning when considered in conjunction with iconographical evidence. Observations on Ethiopians regarded by some scholars as figments of a fertile poetic imagination, or as untrustworthy reports of the uninformed, often turn out to be probable when illumined by archeology. Inadequate consideration has been given to the historical conditions of periods during which the Negro appeared in art, for example to his role as mercenary or as captive, whose presence in Greek and Roman lands stimulated interest in his race and in African myths. A comprehensive, illustrated survey of the major types of Negroes portrayed in Greek and Roman art, if it is presented within the framework of what is known of blacks in classical antiquity from other sources, may provide some useful guidelines for the evaluation of new discoveries.

When, and under what circumstances, were Negroes first depicted in European art? From what parts of Africa did they come, and how did the Greeks and Romans come in contact with them? To what extent does iconography confirm and complement what we learn from written sources about the physical characteristics of the "Ethiopians," about racial mixture, about the role of the Negro in Greco-Roman society? It is on points such as these that the archeological evidence provides an indispensable commentary.

142. Negroid profile carved in shell. From Ayious Onouphrios. Early second millennium B.C. L: 4.5 cm. Oxford, Ashmolean Museum.

135

143. *Jewel Fresco* (fragment): pendants in the form of heads of blacks wearing earrings. From Knossos. About 1600 B.C. Painted stucco. H: 8 cm. Herakleion, Archeological Museum.

144. Nubian archer (detail). From Assiut. Dynasty XI or XII, about 2000 B.C. Model in painted wood. Cairo, Egyptian Museum.

145. *The Captain of the Blacks.* Fresco fragment (reconstruction). From Knossos. About 1550-1500 B.C. 24 × 20 cm. Herakleion, Archeological Museum.

146. Detail of a procession: Negro clad in a loincloth. Fresco fragment (reconstruction). From Pylos, Palace of Nestor. Second half XIII century B.C. From M.L. Lang, *The Palace of Nestor at Pylos in Western Messenia*, vol. II, *The Frescoes* (Princeton University Press, 1969). Reprinted by permission of Princeton University Press and the University of Cincinnati.

147. Head of a young mixed type. Fresco fragment (detail). From Thera. About 1550-1500 B.C. H: approx. 10 cm. Athens, National Museum.

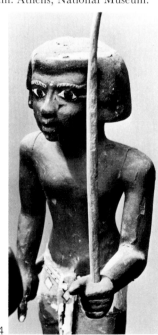
144

THE FORERUNNERS

During the Early Minoan period the population of southern Crete may have included a Negroid element. The presence of such an element from Libya in the Cretan population has been argued on the basis of an inlay of shell, now in the Ashmolean Museum.[14] The inlay may have come from an early circular tomb at Ayios Onouphrios. It depicts a bearded face, with thick lips and snub nose. Other objects might lead to the same observation for later periods. Among the faïences showing house fronts (Middle Minoan II)[15] there is one in which are seen the prow of a ship and swarthy, prognathous, clearly Negroid people, some steatopygic. It is uncertain, however, what role to assign to the non-Minoan figures in this scene, which, it has been suggested, may represent the siege of a seacoast town. Is the scene, as Sir Arthur Evans suggested, a pictorial record of a Minoan expedition in Africa? Pendants in the form of Negro heads appear on a fragment of a painted stucco relief dating from Middle Minoan III.[16] The hair is curly, the noses are snub, and large triple earrings hang from the ears. From Cyprus about 1750-1600 B.C. comes a Negro head of faïence found in a tomb at Lapithos.[17] It is difficult to determine with precision the significance of this early evidence of Negroes outside Africa. Scholars are in greater agreement with respect to their interpretations of the coal-black spearmen who appear in a fragment of a fresco, which Evans called *The Captain of the Blacks*, belonging to Late Minoan II.[18] The fresco depicts a Minoan captain, wearing a yellow kilt and a horned cap of skin, who leads, at the double, a file of black men similarly dressed. Evans regarded these troops as Negro auxiliaries, and saw this as an historical fact of the greatest significance; J.D.S. Pendlebury expressed the opinion that the fresco establishes the use of African mercenaries;[19] and A.R. Burn raised the question as to whether they were Nubians, "slave mamelukes bought from Pharaoh by a 'Minos' who can no longer trust his own subjects?"[20]

fig. 142

fig. 143

fig. 145

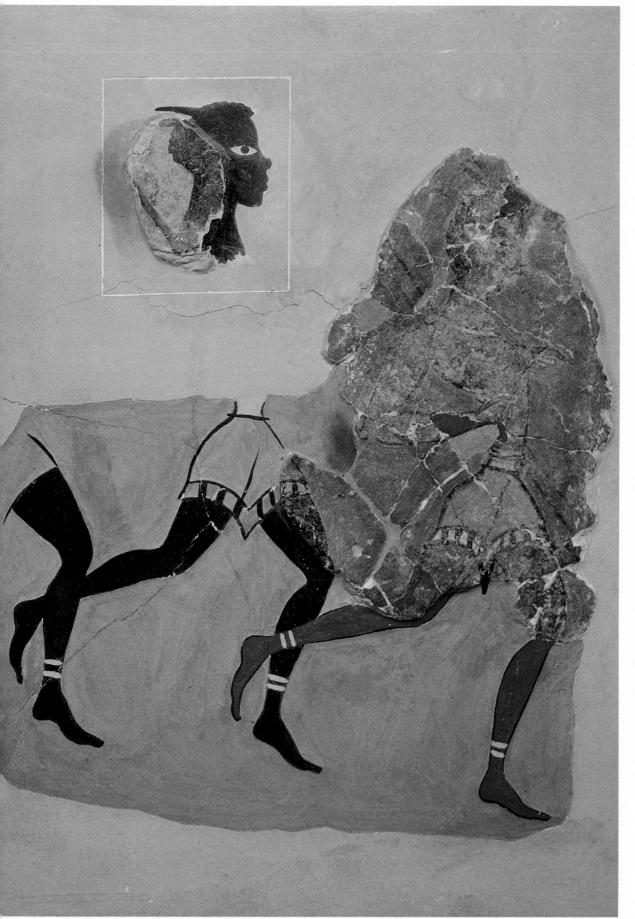

145

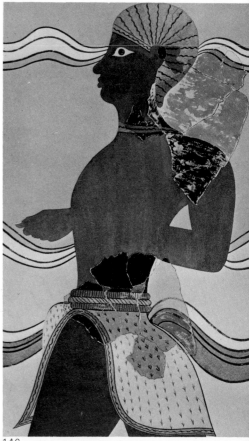

146

147

148. Casts of scarabs with heads of blacks. From Naukratis. VI century B.C. Diams: from 2.5 to 3.9 cm. Oxford, Ashmolean Museum.

149. Perfume vase juxtaposing a head of a bearded barbarian and a head of a Negro. From Cyprus. Late VII or early VI century B.C. Faïence. H: 4.9 cm. West Berlin, Staatliche Museen.

Significant additions to our knowledge of Negroes in pre-classical Greece have been made by recent archeological finds. A fragmentary fresco discovered in excavations at Thera in 1968, and dated between 1550 and 1500 B.C., gives us representation of an inhabitant of that island whose physical traits, S. Marinatos notes, "do not agree with what we know about the anthropological features of the 'Minoan' race."[21] The Theran is a young man whose black wavy hair, rather thick lips, and nose with reduced platyrrhiny are clearly shown. Although he acknowledges that these traits suggest a Negrito or a Nubian, Marinatos avoids a precise anthropological definition and concludes that the characteristics seem to indicate an "African." In my judgment, however, they justify classification as a mixed black-white type. In spite of suggestions of an African or Near East landscape in the fresco, the presence of a Minoan altar leads Marinatos to regard the scene as a local one, and the worshipper as either an islander or a prominent visitor of foreign origin, perhaps a prince. A pottery sherd found at Thera in 1970[22] is decorated with a profile head with curls on the forehead and thick lips: Marinatos rightly notes the resemblance between this figure and the young man in the fresco. fig. 147

Also to be noted from this early period are fragmentary frescoes depicting blacks, of the second half of the thirteenth century B.C., from the Palace of Nestor at Pylos.[23] In one fragment there is a procession in which four white men wear lion-skins while at least one black man wears a three-tiered Minoan kilt. M. Lang, who has described these frescoes, considers the kilt of the Negroes "most suggestive of a host of implications: sartorial and sociological as well as religious." The Negroes, in Lang's opinion, had come to the mainland under Minoan auspices. The scene can be explained in one of two ways: either the procession represented tribute-bearers including white subjects from the uncivilized interior and blacks from beyond the seas; or the scene was offertory and, as suggested by the presence of black foreigners and white natives, represented some kind of syncretism in the rite. The presence of blacks at Pylos, together with the fact that an ai-ti-jo-qo (Aithiops) is mentioned several times in the Pylos tablets,[24] points to a knowledge of blacks earlier than their more frequent appearance in Greek art from the late seventh century B.C. onwards. The Homeric testimony as to Ethiopians of the rising and setting sun and the black-skinned, woolly-haired Eurybates, herald of Odysseus,[25] also throws light on these earliest pictorial documents. A sound nucleus of fact, therefore, may form the basis of the combined literary and artistic evidence. fig. 146

An interpretation of Negroes in Crete and Pylos as soldiers would have some support in the example of Egypt, with its long tradition of Nubian mercenaries.[26] A striking illustration, belonging to a somewhat earlier period than that of the Minoan *Captain of the Blacks* fresco, is provided by the wooden models of forty black archers in Cairo, found in a tomb of a prince of Assiut.[27] Although the date is disputed, these wooden models at least show that the Egyptians employed mercenaries, and that there was a tradition of Ethiopian archers, known also to the Greeks as attested by their literature and art. Herodotus, who specifically calls attention to Ethiopian bows, recorded an exhibition of the skill of the king of the Ethiopian Macrobioi in handling the bow.[28] The Macrobioi, if H. Last's suggestion is correct,[29] originally meant "people of the long bow," a weapon which the fig. 144

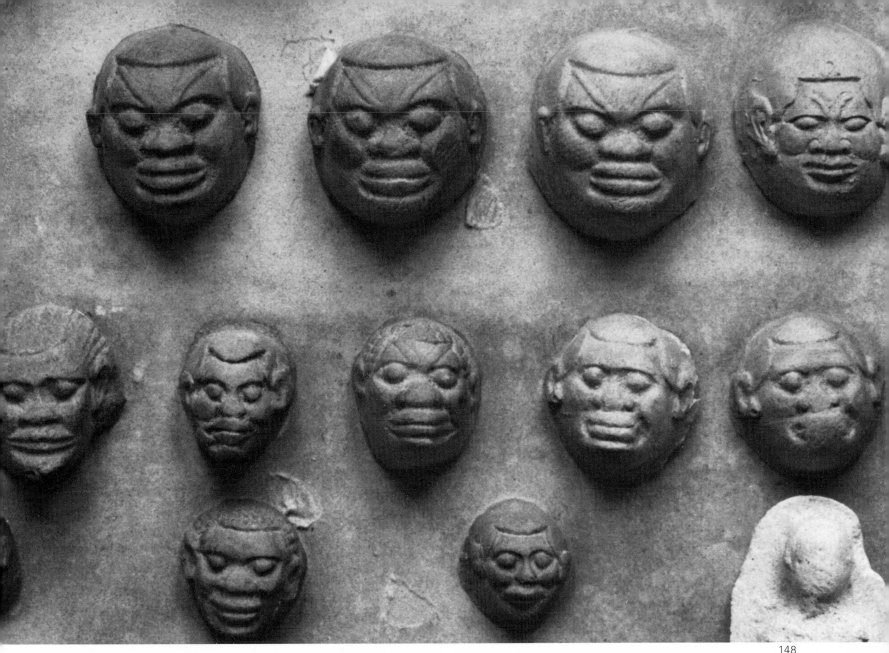

148

Egyptians regarded as characteristic of southern peoples. Apropos of an Ethiopian military tradition, mention should be made of the Twenty-fifth Dynasty, which eventually ruled an empire that extended from the shores of the Mediterranean to the far south. Herodotus' account of the invasion of Egypt by Sabacos (Shabaka) and a great Ethiopian army[30] implies awareness of a black military power to the south of Egypt. Such reports may have influenced the early artists in their depiction of black warriors.

SEVENTH AND SIXTH CENTURIES B.C.

It was in Egypt that Greeks of the seventh and sixth centuries B.C. met large numbers of Negroes for the first time. Ionian and Carian mercenaries served under Psamtik I (663-609 B.C.).[31] The names of some of the Greek mercenaries who participated in the punitive Nubian campaign of Psamtik II (594-588 B.C.), which may have reached the Fourth Cataract, have been recorded in inscriptions at Abu Simbel.[32] By the sixth century, Greeks, well established in Naukratis, had ample opportunity for contacts

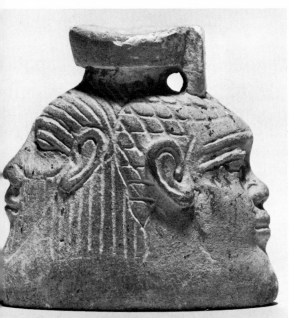

149

150, 151. Hydria. Side A: Heracles slaying Busiris' priests. Side B: soldiers coming to the aid of Busiris. From Caere. Second half VI century B.C. Terracotta. Vienna, Kunsthistorisches Museum.

152. Group of Nubian mercenaries, detail of a military parade. Dynasty XVIII, about 1425-1408 B.C. Mural painting. Thebes, tomb of Thanuny.

with Negroes. Scarab seals of the early sixth century from factories in that city provide striking examples of Negro types seen there.[33] The collections in the Ashmolean Museum contain twenty-one molds[34] with faces of fig. 148 Negroid type unearthed in the 1885-86 excavations at Naukratis, and an additional ten molds, probably from the same town. Worthy of notice are the frontal cicatrices in some of these figures, indicating the artists' observation of a cultural practice which appeared in the form of facial scarification of Meroïtic times.[35] One of the earliest vases with Janiform Negro-white heads, found in Cyprus, doubtless reflects knowledge of Negroes acquired in Naukratis and elsewhere in Egypt. The piece, a faïence perfume vase (late seventh-early sixth century B.C.),[36] juxtaposes a bearded white and a fig. 149 smooth-faced Negro with flat nose, thick lips, and woolly hair in the form of diamond-shaped blocks.

It is not unreasonable to propose, therefore, that Greek residence in Naukratis stimulated the interest of sixth-century Greek artists in the Negro and that the city and its environs were a center from which such interest radiated to various parts of the Greek world. Amasis of Athens, the potter, according to J. Boardman,[37] may have been a dusky-skinned metic, born in Egypt, who most likely spent his early years in Naukratis. That Rhoecus of Samos (the architect who worked with Theodorus in the first half of the sixth century) visited Naukratis is strongly suggested, H. Hoffmann has pointed out,[38] by an Archaic bowl bearing a dedication of Rhoecus to Aphrodite of Naukratis. If Amasis and Rhoecus lived for some time in Egypt, they must have passed on to their friends and fellow artists information about the physical characteristics of the people of the country as well as descriptions of visual portrayals of Negroes.

The artist who painted the lively Negroes on the Caeretan hydria figs. 150, (c. 530 B.C.) in Vienna,[39] as R. I. Hicks has noted,[40] may also have visited 151 Naukratis. Did the painter of the hydria have direct or indirect acquaintance with a scene such as that depicted on the tomb of Thanuny at Thebes (c. 1423-1410 B.C.)[41] showing the recruitment of five corpulent Nubian fig. 152 mercenaries? The soldiers coming to the assistance of King Busiris on the hydria are, like the earlier Nubians, five in number, clad only in loincloths, marching in a similar manner; the Greek Negroes carry clubs, the earlier soldiers, standards. The similarities between the two merit consideration in an assessment of Egyptian influence on Greek art. Since there are so few extant examples of Egyptian painting from the sixth century, a comparison of New Kingdom painting with scenes on later Greek vases is not without value for the light it may shed on what Greeks saw in Egypt in the sixth century. As J. Boardman has noted in this connection,[42] the conservatism in Egyptian art justifies a comparison of this type.

Only the Negro of the pronounced type was used as a model by Attic artists in the sixth century. From the outset the Negro's skin color, thick lips, broad nose, and especially his woolly hair fascinated the artists, who employed a variety of techniques to represent a type of hair so different from their own. There are several vases in the form of Negro heads from the late sixth century: a good example is a mug in Boston,[43] which is a fig. 154 careful rendering of the physical traits of a man whose wrinkles and crowfeet betray his age. An aryballos in Athens in the shape of a youthful

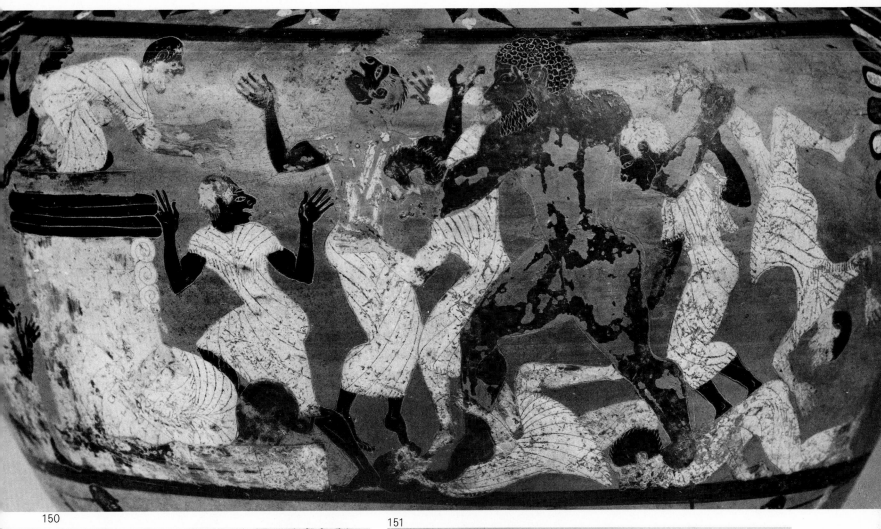

150

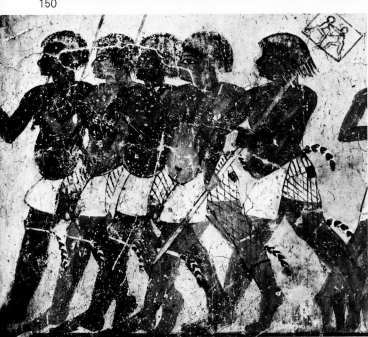

152

151

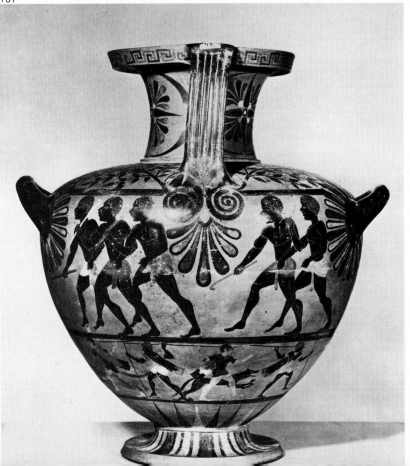

153. Aryballos in the form of a head of a Negro. From Eretria. Late VI century B.C. Terracotta. H: 12.8 cm. Athens, National Museum.

154. Attic kantharos in the form of a head of an elderly man. Second half VI century B.C. Terracotta. H: 17.7 cm. Boston, Museum of Fine Arts.

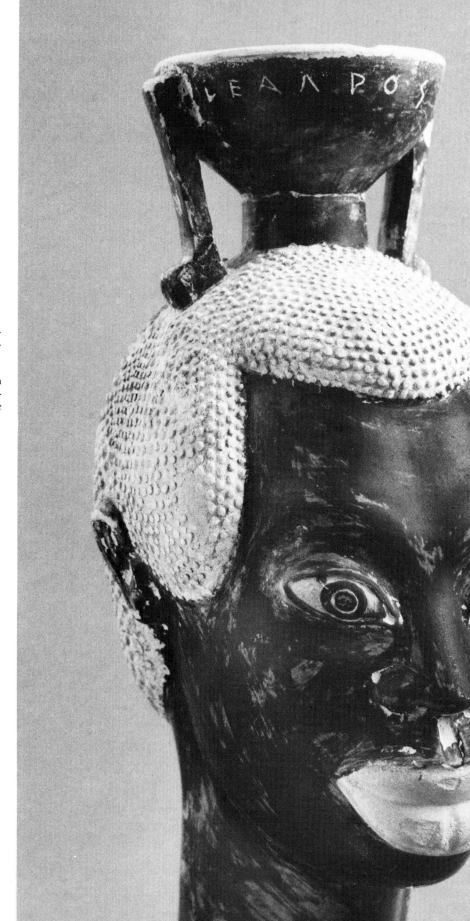

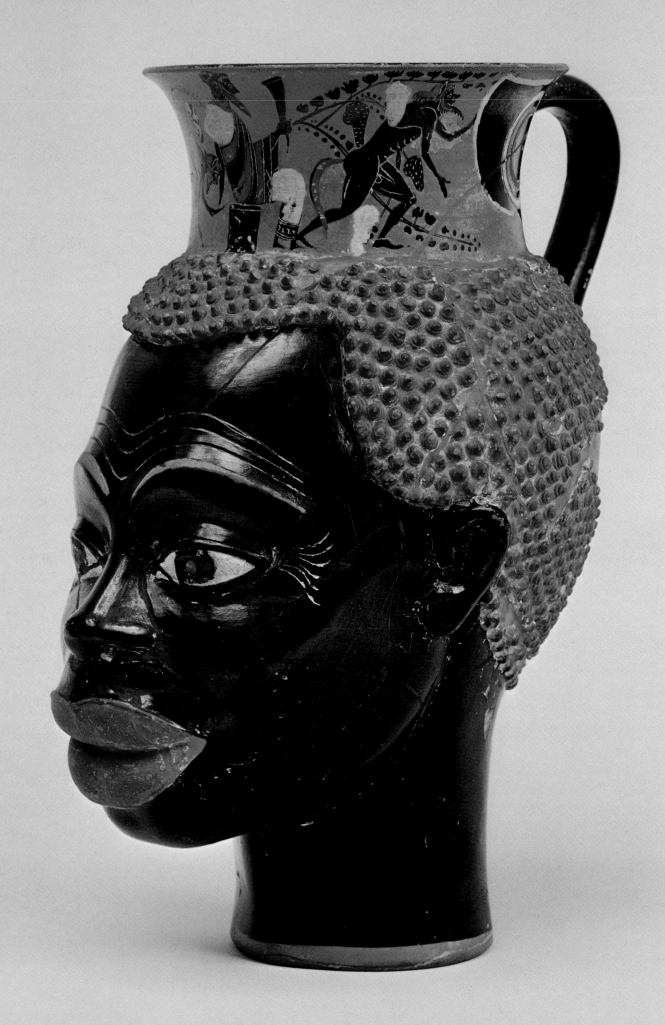

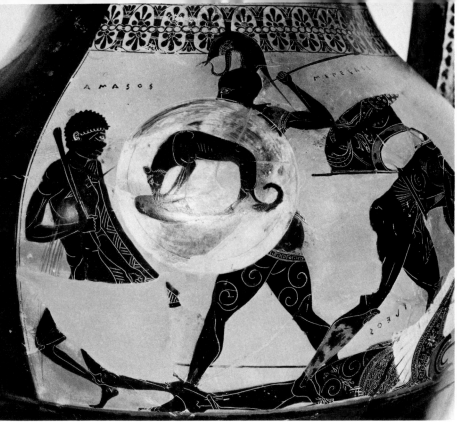

155

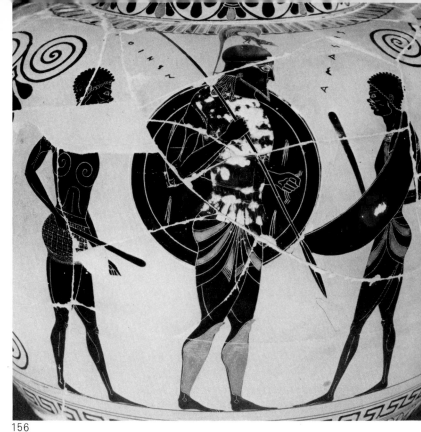

156

155. Exekias, amphora (detail): Memnon and an Ethiopian warrior. From Orvieto. About 550-525 B.C. Terracotta. Philadelphia, The University Museum.

156. Exekias, amphora (detail): Memnon and two Ethiopian warriors. About 550-525 B.C. Terracotta. London, British Museum.

157. Detail of figure 156: Ethiopian warrior.

158. Ethiopian warrior, interior of a cup. From Poggio Sommavilla. Late VI century B.C. Terracotta. Paris, Musée du Louvre.

Negro's head[44] is perhaps from the same workshop. Whether the model was young or old, there is a marked similarity in the type and technique of these early plastic vases. fig. 153

Stimulated by contacts with Egypt, sixth-century Greece turned to the mythological past of blacks. The legend of Memnon, seen with his Ethiopian soldiers on a series of black-figured amphorae dating from 550-525 B.C.,[45] proved particularly attractive. The designation of a black soldier as *Amasos* on one of these vases in Philadelphia and as *Amasis* on another in the British Museum has been interpreted as a reference by Exekias to his rival, Amasis.[46] A Negro between two Amazons is painted on a Brussels vase of the same type, attributed to the Swing Painter.[47] It should be noted that other Negroes on sixth-century vases who cannot be identified with certainty were also depicted as warriors. A nude Negro, with a chlamys over his right shoulder, appears on the interior of a red-figured kylix in the Louvre, dated about 520-500 B.C.[48] Holding his shield in the left hand and a lance in the right, he advances in a running position. A lekythos in Naples from Cumae in the Six's technique[49] also portrays a Negro warrior, wearing helmet, cuirass, and chiton, bending forward intently as he raises his round shield. Although it has been suggested that this figure and the Negro between two Amazons were both intended as representations of Memnon, the general opinion has been that the vases are too early for Memnon to be considered Negroid. Early literary accounts refer to Memnon as king of Ethiopians, but make no mention of his color. It would, however, be reasonable to suppose that some artists, curious about newly discovered Negroes and moved by stories of Negro soldiers in Mediterranean lands, conceived of Memnon as a Negro. At any rate, the prominence given to Negro warriors in these early vase-paintings is significant, for such portrayals must have been important in the development of the Greek image of Ethiopians. figs. 155-157 fig. 158

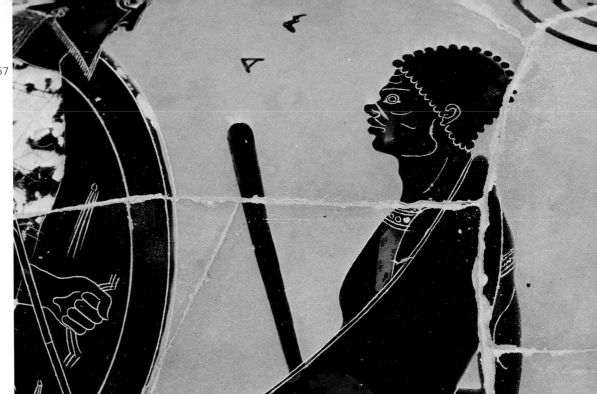

157

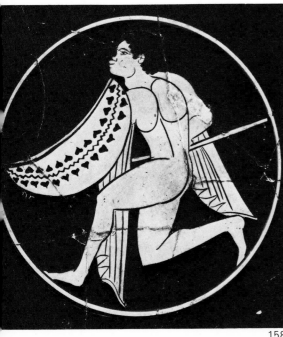

158

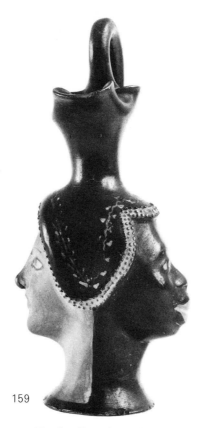

159

159. Oinochoe in the form of conjoined heads of a white woman and a Negro. From Vulci. V century B.C. Terracotta. H: 13.8 cm. Brussels, Musées Royaux d'Art et d'Histoire.

160. Kantharos in the form of conjoined heads of a white woman and a Negro. Late VI century B.C. Terracotta. H: 19.2 cm. Boston, Museum of Fine Arts.

Early Greek artists were struck by the obvious differences between the physical characteristics of whites and Negroes and dramatized the contrast by placing them in juxtaposition, as we have seen in the case of the faïence perfume vase.[50] Several other Negro-white Janiform head-vases of the late sixth and early fifth centuries may owe their origin to such a contrast. A Boston white-ground kantharos (before 510 B.C.) with black palmettes above which are checkers on a reserved ground,[51] and a Janiform oinochoe in Brussels from Vulci,[52] magnificently join together a Negro's and a white woman's head. Xenophanes exploited a similar contrast between the flat noses and black faces of the Ethiopians and the blue eyes and red hair of the Thracians.[53] In light of the later development of the "environmental" explanation of racial diversity and its corollary, the contrast between Scythians and Ethiopians, the approach of these artists is particularly noteworthy, for it may mark the beginning of a mode of thought quite influential in shaping Greek attitudes toward non-Greeks.[54] It is not impossible that the coroplasts who fashioned these conjoined black and white heads had in mind, as did the later "environmentalists," the effects of climate on the inhabitants of the extreme north and the south. If so, the works provide a significant commentary on the unbiased attitude of some of the first Greeks who actually encountered Negroes.

Although most blacks who appeared in early Greek art were probably of Egyptian origin directly or indirectly, other parts of Africa should not be overlooked. The North African terminals of caravan routes suggested to Evans[55] another possible route by which Negroes had reached Crete. Similarly, Carthage may have brought blacks to Sicily. Excavations in the island have yielded three terracotta heads, realistically portrayed, to be dated toward the end of the sixth or the beginning of the fifth century B.C. One of these, a mask found at Agrigento,[56] is one of the finest early portrayals of the pronounced Negro type to come down to us. The other

fig. 160
fig. 159

fig. 163

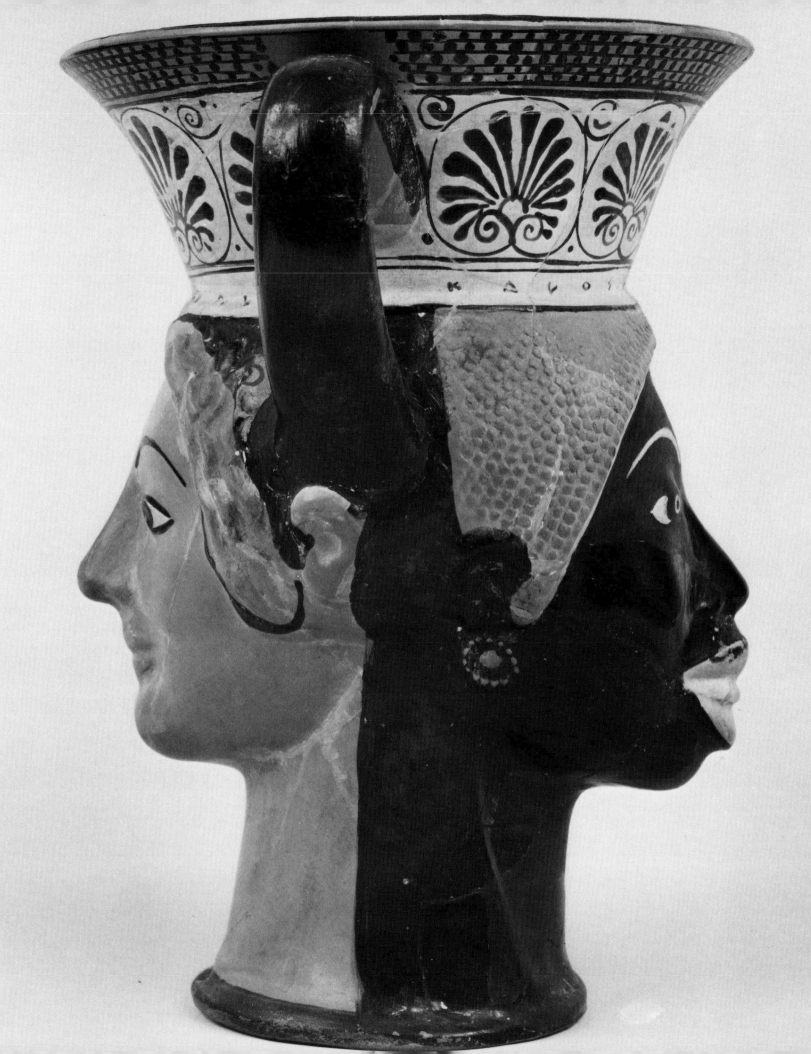

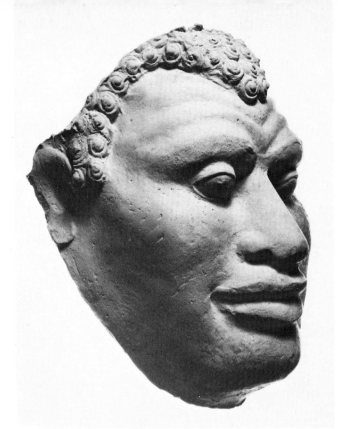

161

162

161, 162. Mask of a Negro: cast (modern) and mold. From Megara Hyblaea. Late VI or early V century B.C. Terracotta. H: 26 cm. Syracuse, Museo Archeologico Nazionale.

163. Mask of a Negro. From Agrigento. Late VI or early V century B.C. Terracotta. H: 10.5 cm. Agrigento, Museo Archeologico Nazionale.

two terracottas now at Syracuse were discovered in 1970—the portion of a small head at Naxos, and a slightly under life-size mold at Megara Hyblaea.[57] All three are careful studies of their models and show an intimate knowledge of the Negro's physical characteristics. Although the terracottas depict different subjects, there is a point of stylistic similarity— in each, the hair comes to a point on the forehead and forms a widow's peak. In one example, the artist used raised coils to represent the tightly coiled spirals of the Negro's hair, in another incised circles. From Centuripe comes additional evidence of the Negroid presence in the form of sixth-century bronze laver-handles decorated with Negroid heads, now in the Ashmolean Museum.[58] Sicily's proximity to North Africa, and the presence of Negroes among the Carthaginians who operated in the island, may explain the appearance of blacks in early Sicilian art. At any rate, if the report of Frontinus is trustworthy, Negroes were in Sicily in the early fifth century, for, according to the *Strategemata*, very black auxiliaries were among the Carthaginian prisoners captured by Gelon of Syracuse in 480 B.C.[59]

figs. 161-162

FIFTH CENTURY B.C.

How is the presence of the Ethiopian in fifth-century art and literature to be explained? Ethiopians, the most ulotrichous men on earth, according to Herodotus, fought with the Arabians under Arsames. Several notices in Aeschylus seem to point to blacks among Xerxes' warriors. Among the leaders of the Persian fleet included in Aeschylus' catalogue in the *Persians* was one, perhaps from Upper Egypt or even from Nubia, whose name, Arcteus, has been considered as the equivalent of the Ethiopian Taharqa.[60] Mention in the same play of thirty thousand "Black Horse" probably refers

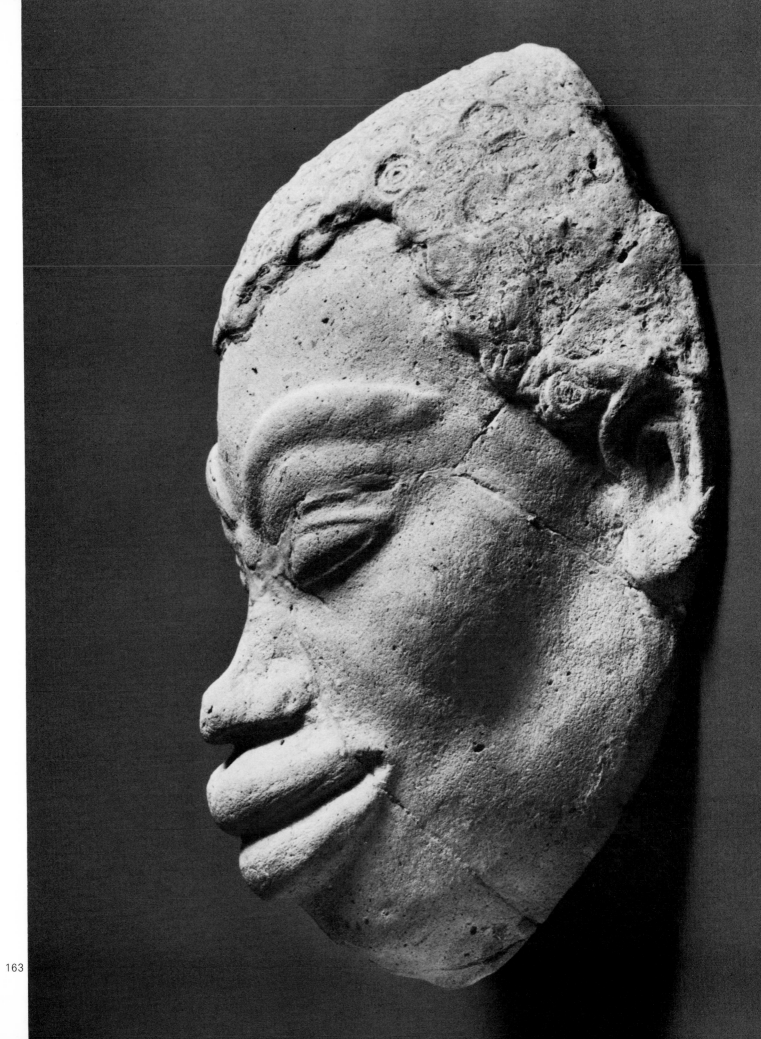

164

to men, and has been so interpreted.[61] These Aeschylean references, though probably not literally true, may reflect the first-hand knowledge of the tragic poet who fought at Marathon and perhaps at Salamis, and may be a confirmation of Herodotus' statement.

As Boardman has noted, the decoration of certain vases belonging to the period after Xerxes' invasion of Greece,[62] increasingly drew upon the epic theme of encounters between Greeks and Amazons, inspired in part by myths seemingly reflecting the sense of Greek supremacy over barbarians and Orientals. Ethiopians were included in this mythology. The *Aethiopis* of Arctinus recorded the defeat of the Amazonian Penthesilea and Memnon, king of the Ethiopians, at the hand of Achilles. Greek use of such myths involving the Negro, originally stimulated by contacts in Egypt, was furthered by the role of the Ethiopians in the Persian wars.

It is difficult not to associate a series of alabastra (some thirty in all) depicting Negro warriors[63]—in one instance a Negro and an Amazon on fig. 164
the same vase[64]—with the woolly-haired Ethiopians of Herodotus. The general consensus is that the group of alabastra is later than 500 B.C., dated more precisely by some between 480-460 B.C., and classified by Beazley as depending upon the Syriskos Painter. Even if this type of alabastron was in production before the Greek victories of Salamis and Plataea, the Negro-Amazon theme may have been originally suggested by reports of the Persian threat. Although Herodotus does not mention Ethiopians at Marathon and includes them specifically only in the army of Xerxes, it is possible that reports of Ethiopians in the Persian army reached Greece before 480 B.C. The painters of the Negro-Amazon alabastra, who received accounts of the mustering of Persian forces, could also have remembered the earlier Greco-Asian conflict in which Trojans, assisted by Amazons and Ethiopians, both celebrated for their skill in archery, were defeated by the Greeks. After Greeks in the Xerxes campaign had actually faced Ethiopians equipped with bows of not less than six feet,[65] contemporary events might have enhanced the value of the vases as mementos. The scenes on the alabastra would recall to the Greeks both an epic defeat of inhabitants of Asia, aided by Penthesilea and her Amazons and by Memnon and his Ethiopians, and a recent Greek victory over the Persians, though reinforced by foreign troops (Libyans and Ethiopians, the latter descendants of a people who had conquered and ruled Egypt). The miraculous Greek victories in which Aeschylus saw the workings of the justice of Zeus and a divine order had a precedent in the Greek mythological past.

The actual presence of Ethiopians on Greek soil after the Persian wars increased fifth-century interest in the Negro, which was furthered as stories came back from Egypt. It was in such a setting that we find for the first time rhyta with the lower part forming a plastic group of a Negro struggling with a crocodile.[66] With the crocodile coiled around his waist, the fig. 165
victim, writhing in pain, has only his left hand and arm free. The artist's modelling of the Negro's muscular structure and the expressive portrayal of pain in the victim's open mouth and eyes call to mind the spirit of the later Laocoön group. It is strange that one modern commentator regards the Laocoön as "morbidly tragic" but the Negro-crocodile representation as "comic in intent."[67] There is nothing comic about the way this Negro, like many an innocent, expresses his terror at the thought of impending death.[68]

164. Attic alabastron: Ethiopian warrior. Early V century B.C. Terracotta. H: 15.4 cm. Cambridge (Mass.), Fogg Art Museum, Harvard University.

165. Sotades, rhyton in the form of a Negro struggling with a crocodile. V century B.C. Terracotta. H: 24 cm. Boston, Museum of Fine Arts.

166. Pelike: Negro leading a camel. V century B.C. Terracotta. H: 36 cm. Leningrad, Hermitage Museum.

165

166

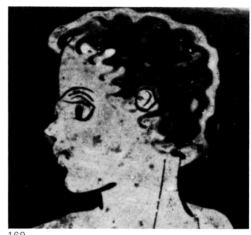

167

168

169

167. Pan Painter: one of Busiris' servants, detail of a pelike. V century B.C. Terracotta. Athens, National Museum.

168. Busiris (?), detail of a stamnos. From Vulci. V century B.C. Terracotta. Oxford, Ashmolean Museum.

169. Servant of Busiris, detail of a cup. From Vulci. Mid-V century B.C. Terracotta. West Berlin, Staatliche Museen.

170. Hydria (detail): Heracles and Busiris' servants. From Vulci. V century B.C. Terracotta. Munich, Staatliche Antikensammlungen.

171. Busiris in flight, interior of a cup. From Spina, necropolis. Early V century B.C. Terracotta. Ferrara, Museo Archeologico Nazionale.

172. Altamura Painter, stamnos: Heracles and Busiris. V century B.C. Terracotta. H: 37.5 cm. Bologna, Museo Civico Archeologico.

173. Ethiop Painter, pelike (detail): the prisoner Heracles followed by one of Busiris' servants. From Nola. Late V century B.C. Terracotta. Paris, Bibliothèque Nationale.

The inspiration for the ancient piece, the work of Sotades, is clear. In it the coroplast created a form that was to become popular in the next century. Stories of Egypt no doubt also provided the inspiration for the scene appearing on a Hermitage pelike showing a Negro leading a camel by a halter.[69] fig. 166

The fifth century saw no diminution of interest in myths associated with the Negro. The Busiris story was a favorite with vase painters. A variety of episodes depicts not only blacks of the "pure" type but also several intended as mixed black-white types. Negroes of the pronounced type are seen mostly in the vase paintings of the first part of the century. A Munich hydria[70] shows one Negro whom the liberated Heracles has grasped by the fig. 170 throat; another lying on the ground under the Greek's feet; and two others in flight. All four have shaven heads and wear earrings. On a pelike in Athens, the Pan Painter[71] dramatically contrasts, feature by feature, a fig. 167 bearded, black-haired, leptorrhine, uncircumcised Heracles and three bald, platyrrhine, circumcised Ethiopians. A Busiris, fleeing with his sacrificial instruments, adorns a Ferrara kylix from a tomb near Spina[72]—a Busiris fig. 171 whose broad nose and hair rendered by big dots (a method frequently chosen in the fifth century to represent the Negro's hair) indicate that the artist intended to represent the barbarian king as Negroid. A woolly-haired, flat-nosed, clearly Negroid figure whom Heracles seizes by the throat has been interpreted as Busiris in another version of this myth appearing on a red-figured stamnos in Oxford, dated about 470 B.C.[73] On fig. 168 another stamnos by the Altamura Painter, in Bologna,[74] Heracles raises his fig. 172 hand to strike a fallen Busiris, whose short, curly hair and slightly platyrrhine nose suggest that the painter conceived of both the king and his attendants as black-white crosses. On a red-figured kylix of about 450 B.C. in West Berlin,[75] the prisoner Heracles is led before an enthroned Busiris. fig. 169 Among the youths surrounding the king are two whose less pronounced

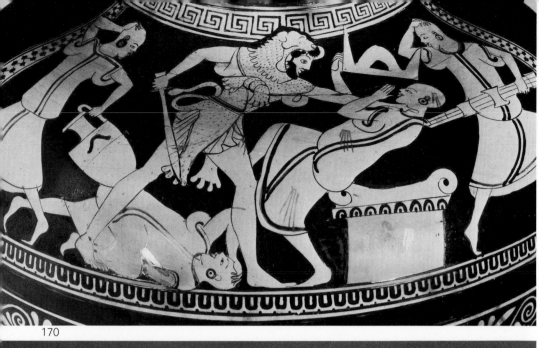

170

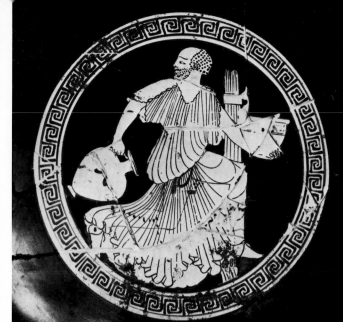

171

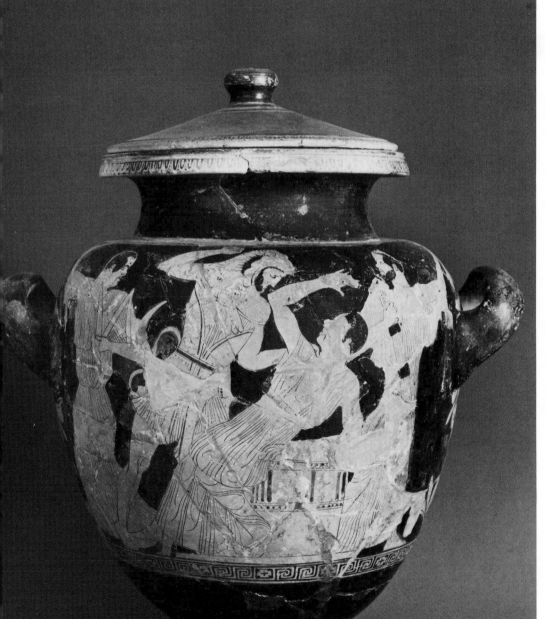

172

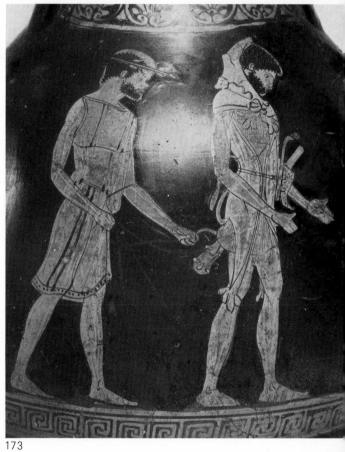

173

153

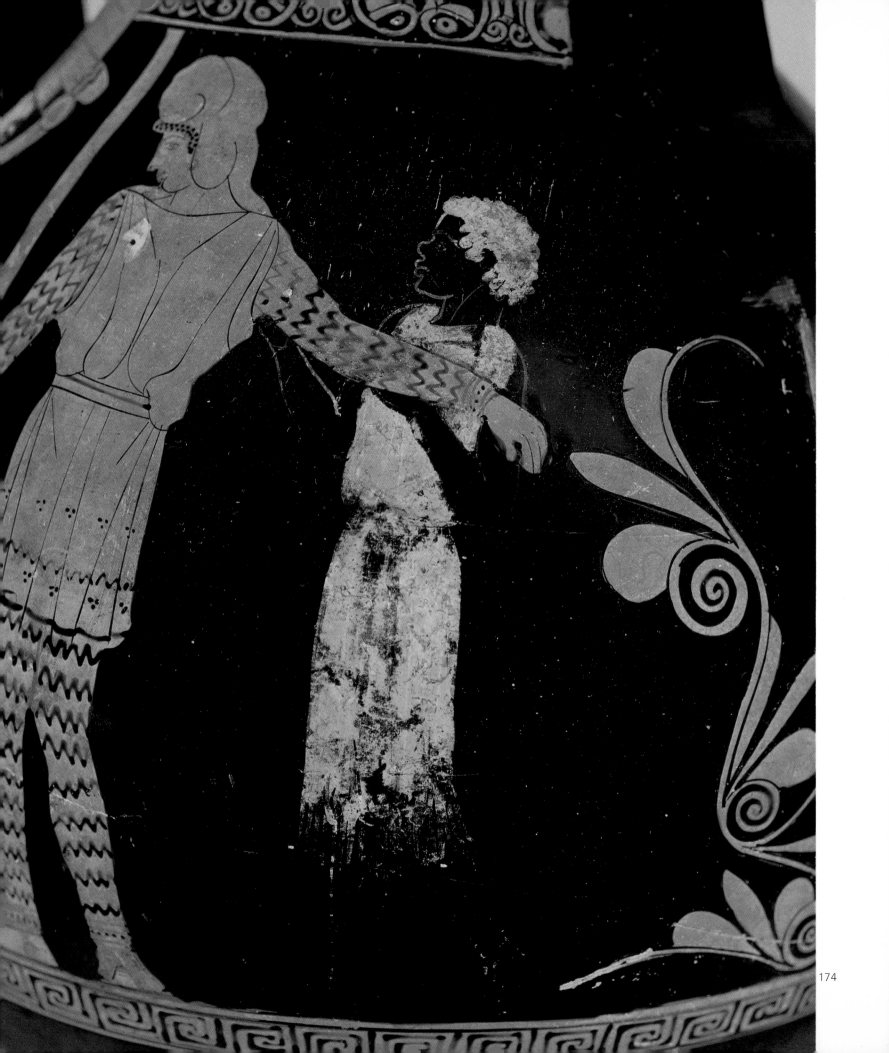

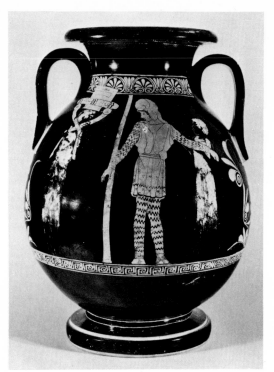

174. Workshop of the Niobid Painter: black servant supporting Andromeda, detail of a pelike. V century B.C. Terracotta. H: 44 cm. Boston, Museum of Fine Arts.

175. Workshop of the Niobid Painter, pelike: tying of Andromeda. Over-all view of the vase in figure 174.

175

Negroid features—nose, lips, and especially hair—indicate mixed types. On a pelike from Nola by the Ethiop Painter in the Bibliothèque Nationale,[76] Heracles, followed by a Negro, is shown proceeding in a very docile manner, uncharacteristic of his usual posture in such scenes. fig. 173

During the fifth century, playwrights exploited the dramatic value of *Aethiopica*. The theater may have provided the inspiration for vase painters who chose as subjects scenes from the Andromeda legend. A red-figured Boston pelike attributed to the workshop of the Niobid Painter[77] depicts a youthful black tying Andromeda to a stake, as her dejected father, Cepheus, supervises the sad proceedings. Both Cepheus and Andromeda are dressed in Persian garb, but the painter has sharply contrasted the broad, somewhat upturned nose and thick lips of the king with the nose and thin lips of his daughter. The vase painter, therefore, apparently conceived of Cepheus as a mixed black-white type and Andromeda as white. The three Negroes in the episode, drawn in white outline on a black background and with their mass of woolly hair also painted white, are rendered in an unusual but very effective manner. The *Andromeda* of Sophocles has been proposed as the source of inspiration for the scene on this pelike as well as for that on a somewhat later red-figured hydria in the British Museum,[78] which presents the preparations for the tying of Andromeda in the presence of Perseus, Cepheus, and eight mulatto attendants. The general setting of the *Andromeda* of Euripides, if M. Bieber is correct, can be somewhat reconstructed from the scenes on a calyx-krater from the end of the fifth century in East Berlin.[79] A member of the chorus wearing a tight jersey and a richly patterned chiton, and a mask with the features of a distinctly mixed, i.e., mulatto type, personifies Ethiopia, the scene of the action, while the other actors have Greek traits. The entire episode shows striking fidelity to an actual tragic performance, as if the artist had executed his design after witnessing the spectacle. In Greek art figs. 174, 175 figs. 176, 177

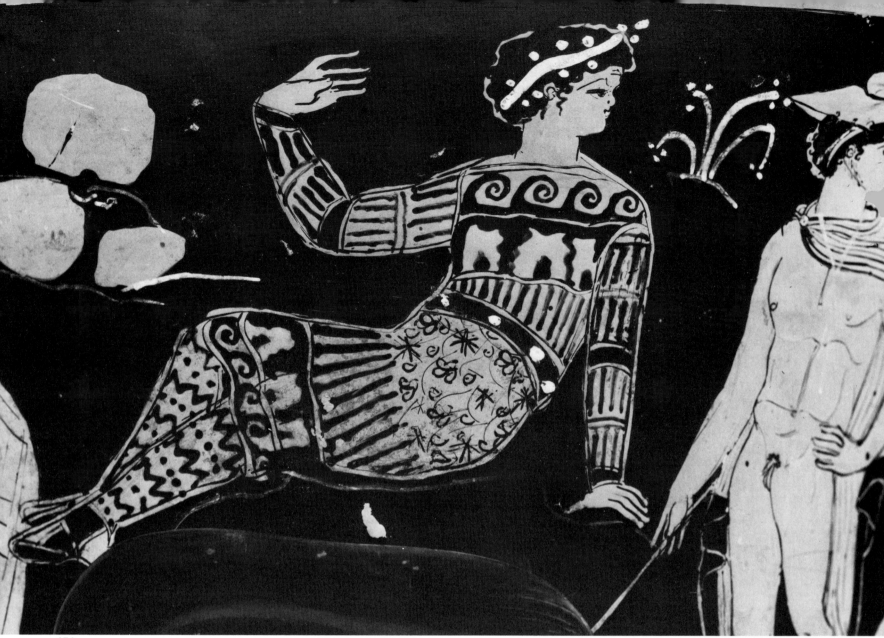

176

176. Personification of Ethiopia, detail of a
calyx-krater. From Capua. Late V century B.C.
Terracotta. H: 37.7 cm. East Berlin, Staatliche
Museen.

177. Calyx-krater: scene from the *Andromeda* of
Euripides (?). Over-all view of the vase in
figure 176.

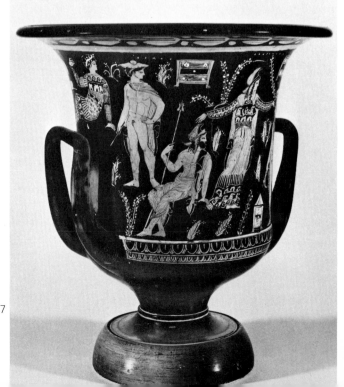

177

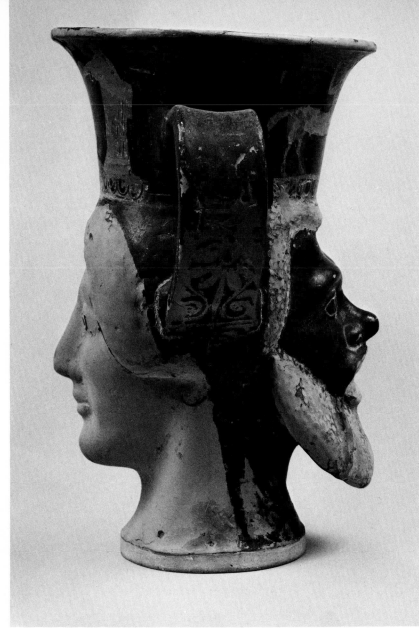

178

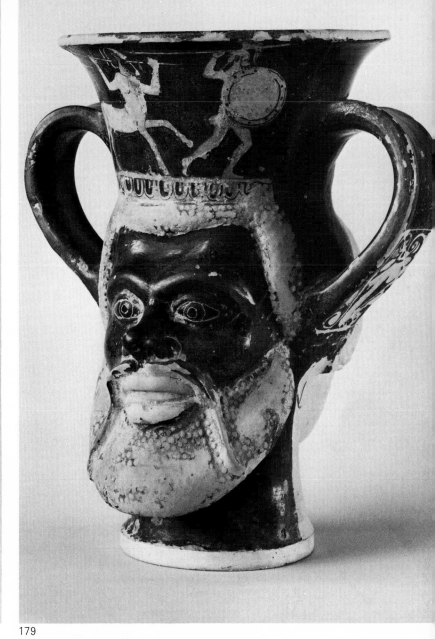

179

178, 179. Kantharos in the shape of conjoined heads of a white woman and a satyr. From Corchiano. V century B.C. Terracotta. H: 23.6 cm. San Simeon (Calif.), Hearst San Simeon State Historical Monument.

180. Plastic vase: Andromeda (?). Early IV century B.C. Terracotta. H: 21.2 cm. Oxford, Ashmolean Museum.

180

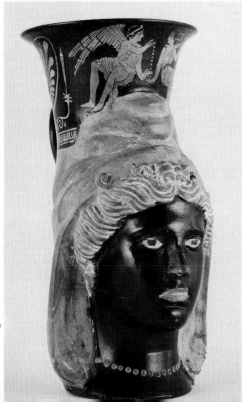

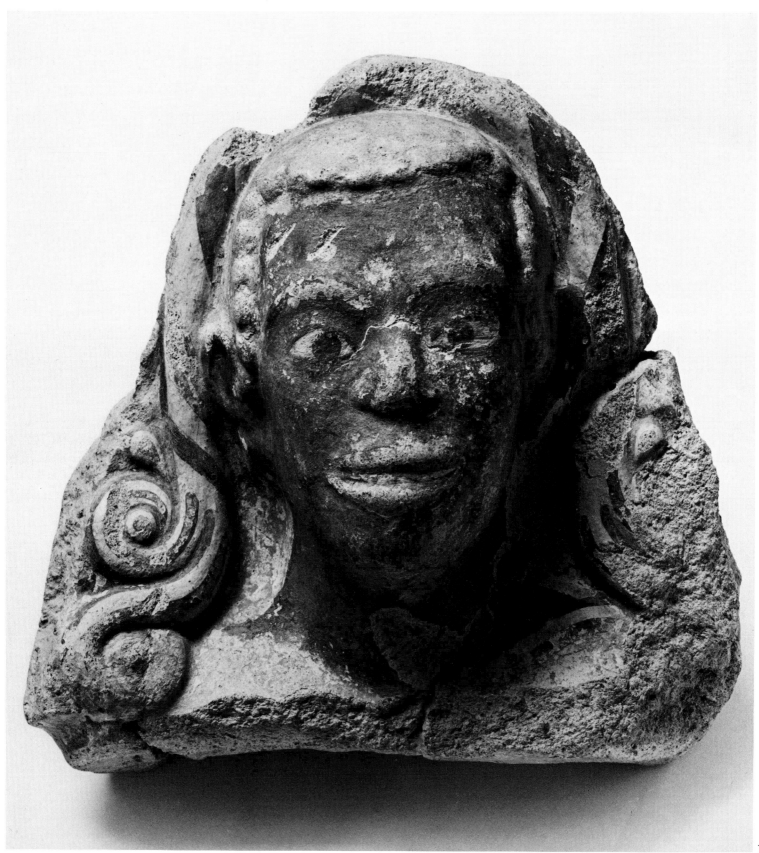

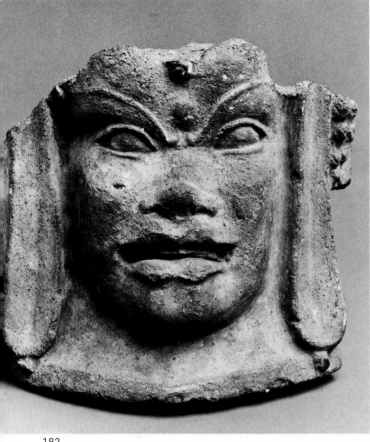

182

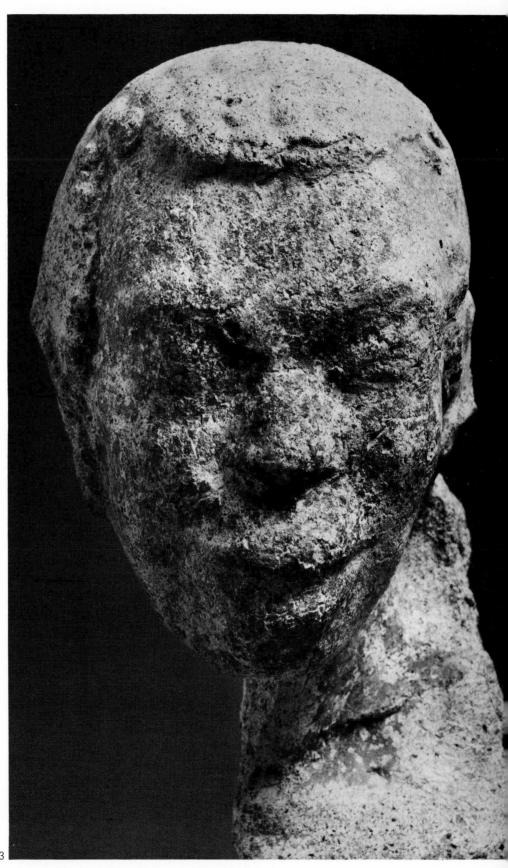

181. Antefix: mask of a Negro. From Cerveteri. First half V century B.C. Terracotta. H: 20 cm. Houston, D. and J. de Menil Collection.

182. Antefix: mask of a Negro. From Campania. Late VI century B.C. Terracotta. H: 14.6 cm. Hamburg, Museum für Kunst und Gewerbe.

183. Antefix: mask of a Negro. From Pyrgi. Early V century B.C. Terracotta. H: 20 cm. Rome, Museo Nazionale Etrusco di Villa Giulia.

183

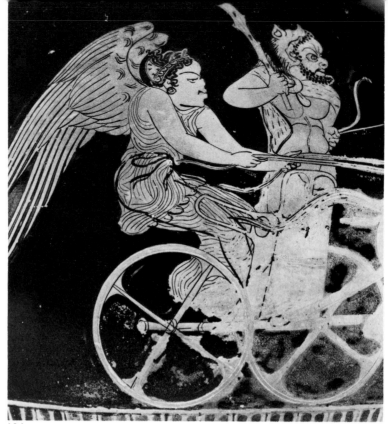

184. Negroid Victory driving Heracles' chariot, detail of an oinochoe. From Cyrenaica. Early IV century B.C. Terracotta. Paris, Musée du Louvre.

184

185. Negroid Circe offering a magic potion to Odysseus, detail of a skyphos. From Kabeirion. Late V or early IV century B.C. Terracotta. London, British Museum.

Andromeda was usually represented as white. In one instance, however, a Greek artist at the beginning of the fourth century may have conceived of her as a black-white cross. A vase in the form of a human head in the Ashmolean Museum[80] depicts a foreign woman whose flesh is black but other physical characteristics are perhaps Negroid only with respect to a slight thickness of the lips. The woman, J. D. Beazley has suggested,[81] may represent a dusky princess such as Andromeda, in which case the artist would have perhaps regarded her father as king of the Eastern Ethiopians, whom Herodotus had described as straight-haired. — fig. 180

The Busiris story, we know, was treated in comedies and satyr-plays. It is not unlikely that there were other Negro roles in satyric plays as well. Satyrs often resemble Negroes with respect to thickness of lips and platyrrhiny. A. D. Fraser[82] called attention to the interesting problem raised by what seems to be the assimilation of the type of the satyr and that of the Negro on fifth-century red-figured vases. Beazley noted that on a kantharos from Corchiano in San Simeon, California, in the shape of a woman's head and a satyr's head,[83] the flesh of the satyr is painted black, turning him into a kind of Negro. One of the earliest terracotta antefixes in the form of a Negro head was found in Campania and is to be dated to the end of the sixth century.[84] Negro heads are also among the antefixes which decorated the roofs of fifth-century temples at Cerveteri[85] and Pyrgi.[86] These may have been intended, like similar antefixes representing female and satyr heads, as guardians of the buildings they adorned.[87] — figs. 178, 179 — fig. 182 — figs. 181, 183

One explanation given of a scene on a fifth-century lekythos in Athens,[88] depicting a Negroid woman tied to a tree and tortured by five satyrs, is that it depicts an episode from a satyr-play. It has been suggested that either a satyr-play or a comedy was the inspiration for the scene of a Negroid Nike driving Heracles' chariot, as conceived by the painter of a fifth or early fourth-century oinochoe in the Louvre.[89] The heads of all the — fig. 184

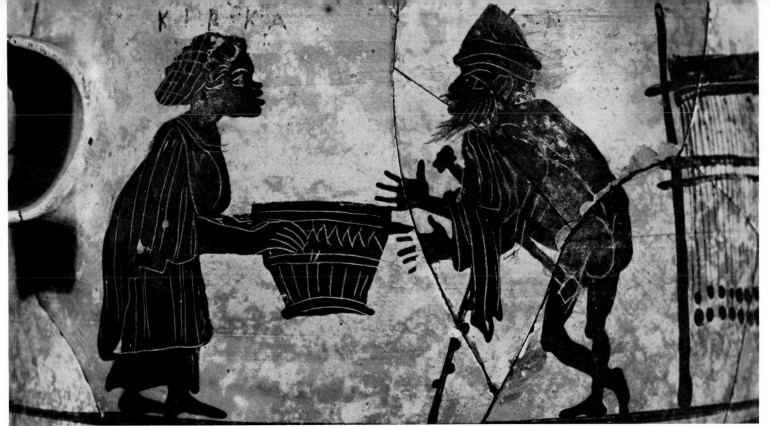

185

figures, in the opinion of Beazley,[90] reveal the influence of comic masks; why the artist decided to paint the Nike as pronouncedly Negro is not clear.

In light of the probable dramatic elements in the worship of the Kabeiroi,[91] the presence of Negroes in several so-called Kabeirion skyphoi from the late fifth or early fourth century should be noted. A decidedly Negroid Circe appears in two such vases. In one of them, in the British Museum,[92] Odysseus stands supported by a staff and bends over to receive the magic potion from Circe, who has changed one of her victims into a swine: in a third skyphos, in the Fogg Art Museum,[93] the artist may have intended Odysseus himself as Negroid. In another Kabeiric work a reclining Negroid male figure offers a wreath to one of three standing female figures, two of whom are Negroid and fully dressed, while the other, the only non-Negroid figure, is half-naked and holds a mirror before one of the other women.[94] The Negroid participants here have not been identified with certainty, but on other vases Mitos, Pratolaos, Aphrodite, and Hera have been regarded as possessing Negroid features.[95] Although scholars have seen an element of caricature and burlesque in such scenes, the reason for the presence of blacks and whites together in well-known legends remains as uncertain as much of the mysterious Kabeiric subject-matter.

The fact that Negroes appear on Greek coinage of important cities—in one instance on the reverse of an Athenian triobol, in East Berlin,[96] with a helmeted goddess on the obverse (c. 502 B.C.), and on the obverse of small silver coins from Delphi (c. 520-c. 421 B.C.)[97]—has given rise to a number of interpretations. In the absence of more abundant evidence it is difficult to establish certain identification in such matters. Of the several explanations advanced, however, the view that the Negro was Delphos, the eponym of Delphi, is to me the most convincing.[98] The father of Delphos was Apollo in one version, and Poseidon in another. All variants of the mother's name

fig. 185

figs. 186, 187
figs. 188-192

161

186 187 188 189 190

191

186, 187. Triobol. Obverse: helmeted goddess. Reverse: head of a Negro. From Athens. About 502 B.C. Silver. Diam: 1.2 cm. East Berlin, Staatliche Museen.

188, 189. Coins. Obverse: head of a Negro. From Delphi. V century B.C. Silver. Boston, Museum of Fine Arts.

190, 191, 192. Coins. Obverse: head of a Negro. From Delphi. V century B.C. Silver. Diams: from 0.8-0.9 cm. London, British Museum.

193. Kantharos: conjoined heads of Heracles and a Negro. V century B.C. Terracotta. H: 20 cm. Vatican, Museo Gregoriano Etrusco.

192

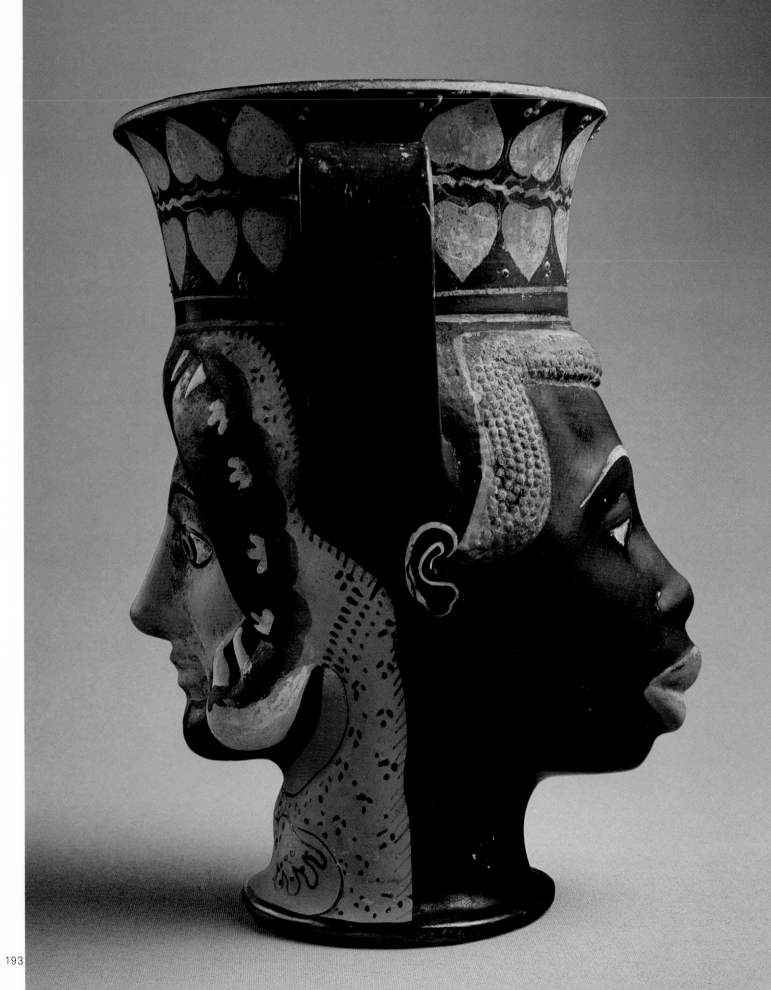

193

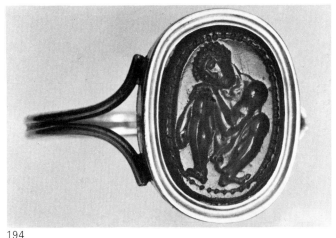

194

195

194. Cameo mounted in ring bezel: sleeping Negro, in a crouching position. Second half V century B.C. Carnelian. 1.2 × 0.9 cm. West Berlin, Staatliche Museen.

195. Statuette of a crouching Negro. From Rhodes. Early V century B.C. Terracotta. H: 7 cm. London, British Museum.

196, 197. Lekythos. Detail of side A: young Greek woman. Detail of side B: mulatto maid-servant. From Athens. Mid-V century B.C. Terracotta. East Berlin, Staatliche Museen.

198. Amphora: old man followed by a young servant. From Vulci. V century B.C. Terracotta. H: 49.2 cm. Copenhagen, Nationalmuseet.

except one—Thyia—are derivatives of words meaning black—Melantho, Melaena, Melanis, and Calaeno.[99] Such words, a study of color-terms as used in Greek literature reveals, were employed at times as equivalents of *Ethiopian*, particularly when supported by additional evidence.[100] The significance of this equivalence has been overlooked in discussions of Delphos' identity. Further, Delphos, according to one tradition, came to Phocis from Crete,[101] where blacks had been known as early as Minoan times. It is quite possible, therefore, that the Greeks, influenced by increased acquaintance with the African Negro in the late sixth and early fifth centuries, conceived of Delphos, whom they honored on their coinage, as a black. Recalling that his mother was named "Black" and that he had come from Crete, the Greeks of the fifth century perhaps concluded that "Mother Black" was a Negro and that Delphos resembled some of the familiar Negroid types from Naukratis or those seen on the streets of Athens.

One of the few references in Greek literature to Ethiopian slaves is found in Theophrastus, whose portrait of the "man of petty pride"[102] implies that black slaves were especially valued. Like the Ethiopian attendant in Theophrastus' characterization, Negroes appearing on several vases also seem to be personal servants or attendants. The figure of a crouching or sleeping Negro, often with a lantern beside him (a genre which became very popular in the Hellenistic and Roman periods), may portray personal attendants resting or sleeping while waiting to accompany their masters home from protracted banquets. Examples of this type of figure are mid-fifth century Rhodian terracotta statuettes of nude, squatting blacks, presumably derived from the style of a crude piece, apparently unfinished, dated to the beginning of the century.[103] Negroes appear also on gems. One such is a carnelian ringstone on which is the figure of a nude, sleeping boy with short, curly hair;[104] another, like the first, in the West Berlin museum, is a carnelian

fig. 195

fig. 194

196

197

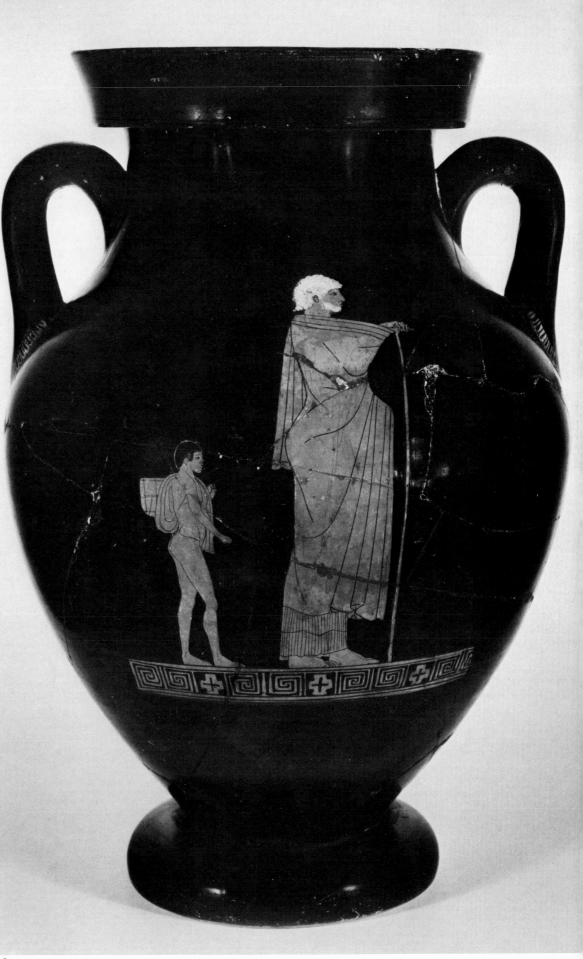

198

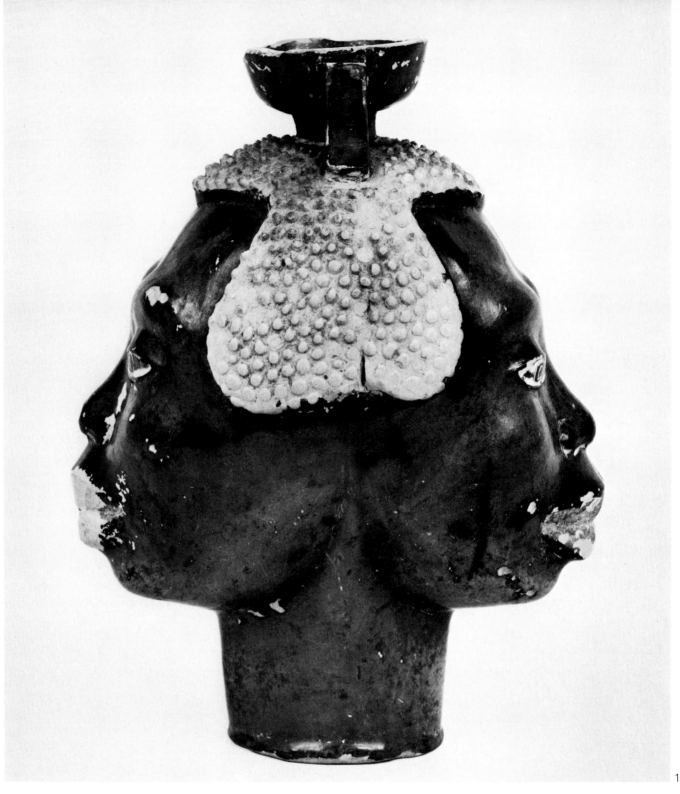

199. Aryballos juxtaposing two heads of Negroes. Early V century B.C. Terracotta. H: 12 cm. Boston, Museum of Fine Arts.

scaraboid [105] showing a crouching boy, with an aryballos hanging by a string from his right elbow. The mulatto diphrophoros whose non-Greek features are contrasted with those of a Greek woman depicted in a grave scene on a lekythos in East Berlin,[106] dating from about the middle of the century, was probably a trusted maidservant. Though apparently some scenes are drawn from the theater, to some extent they may also reflect daily activities and also suggest Negroes as personal attendants. Such a scene, for instance, appears on an amphora in Copenhagen [107] in which a little nude Negro carrying a folded cloak and a large basket walks behind a tall, bearded white man with white hair.

figs. 196, 197

fig. 198

The Ethiopian was a much more familiar sight in fifth-century Athens than previously, and Negroid physical traits continued to be the subject of detailed studies. Janiform vases in the shape of black and white heads continued to present a popular type of racial contrast, as on a Vatican kantharos[108] which juxtaposes Heracles and a Negro. It is in the fifth century that we see for the first time juxtaposed Negro heads like those from a single mold on a Boston ointment vase.[109] Even when working on a very small scale, artists were scrupulously faithful to the Negro's physical characteristics, as can be seen in the trumpeter on the shield of a warrior, painted on an amphora in Vienna[110] from Cerveteri. Masterly attention to racial features characterizes a Boston sard scarab from the end of the fifth century[111] which shows the portraitlike head of a Negro woman wearing an earring and a beaded necklace with a pendant. The head on this miniature intaglio, with its carefully delineated features, is one of the finest representations of the pronounced Negro type in Greek art, in the judgment of G. M. A. Richter.[112] Other splendid examples on a small scale are the British Museum gold pendant from Canusium in the form of a Negro head[113] and the black on a seal found recently near the sanctuary at Brauron.[114]

fig. 193

fig. 199

fig. 200
fig. 201

fig. 202

Artists in the sixth and early fifth centuries depicted Ethiopians of the pronounced Negroid type. Toward the middle of the fifth century, however, mixed black-white types, we have seen, began to appear[115]—at times Busiris, his attendants, participants in an Andromeda episode, in one instance Cepheus himself, a personification of Ethiopia in a scene from a tragedy, a dusky princess, and a mulatto woman attending her mistress. The reduced platyrrhiny, modified lip-thickness, and frizzly hair, on these later vases, rather than the tightly coiled spirals of "pure" Negroes, apparently reflected the artists' acquaintance with black-white crosses. How is the appearance of such racially mixed figures to be accounted for at that time? Negroes in the army of Xerxes in 480 B.C. who remained as captives were in all probability of the pronounced type so popular in early portrayals of blacks. Children by Greek women of these first black arrivals would be mixed, with reduced Negroid features. It was apparently such a mulatto type, often youthful, which the artists were depicting in the latter part of the fifth century.

In the next century Aristotle showed his awareness of crossings between Greek women and Ethiopians by his comments on the transmission of physical characteristics in the family of a woman from Elis and an Ethiopian.[116] The evidence of vase-painting, however, indicates that even before Aristotle's time the modified physical features of mixed black-white types had caught the eye of artists. It is reasonable, therefore, to assume that in the absence of any laws prohibiting unions of blacks and whites, many descendants of the fifth-century Ethiopians were assimilated into the predominately white population.[117]

FOURTH CENTURY B.C.

For Negroes in fourth-century art, one must turn especially to Sicily and Italy. In most general discussions of this period the Negro in Sicilian art has been overlooked, although several masks dating from about the middle of the fourth century point to the inclusion of Ethiopian roles in theater. A life-

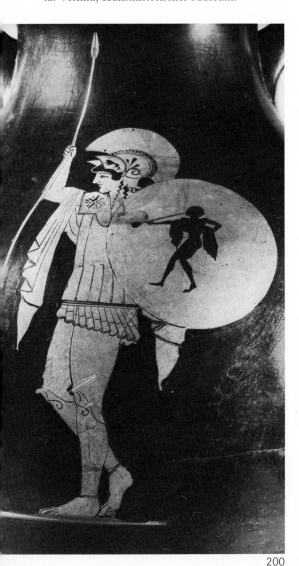

200. Hoplite holding a round shield decorated with a black trumpeter, detail of an amphora. From Cerveteri. Early V century B.C. Terracotta. Vienna, Kunsthistorisches Museum.

200

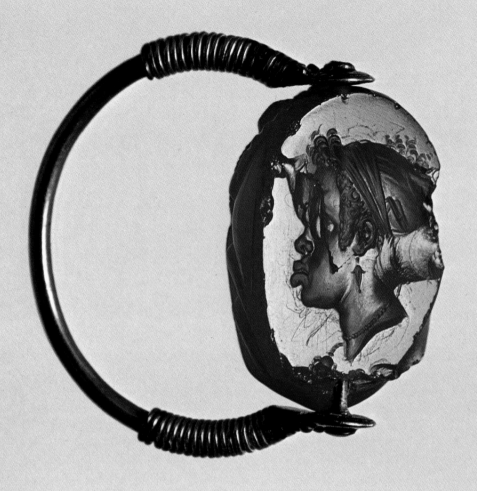

201

201. Intaglio mounted in a ring bezel: head of a
woman. Late V century B.C. Sard. H: 2.2 cm.
Boston, Museum of Fine Arts.

202. Pendant in the form of a Negro head.
From Canusium. V century B.C. Gold. London,
British Museum.

203. Mask of an old woman. From Lipari,
necropolis. Mid-IV century B.C. Terracotta. H:
7 cm. Lipari, Museo Archeologico Eoliano.

204. Mask of a Negro. Mid-IV century B.C.
Terracotta. H: 22.5 cm. London, British
Museum.

202

203

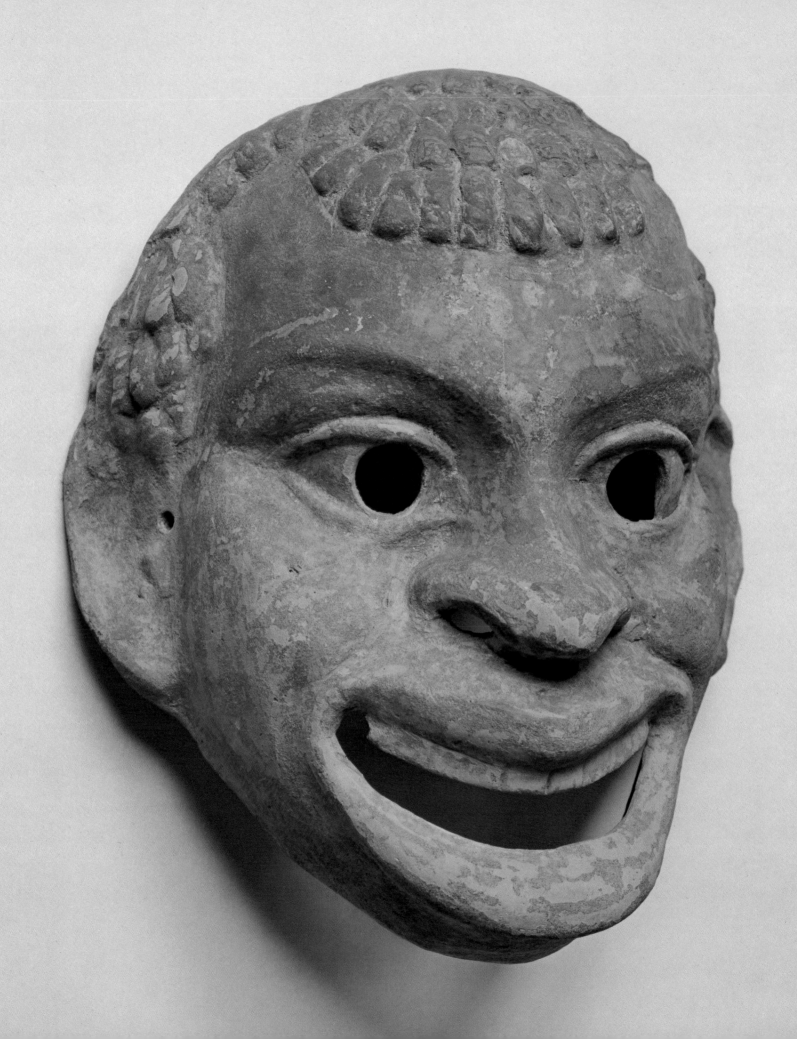

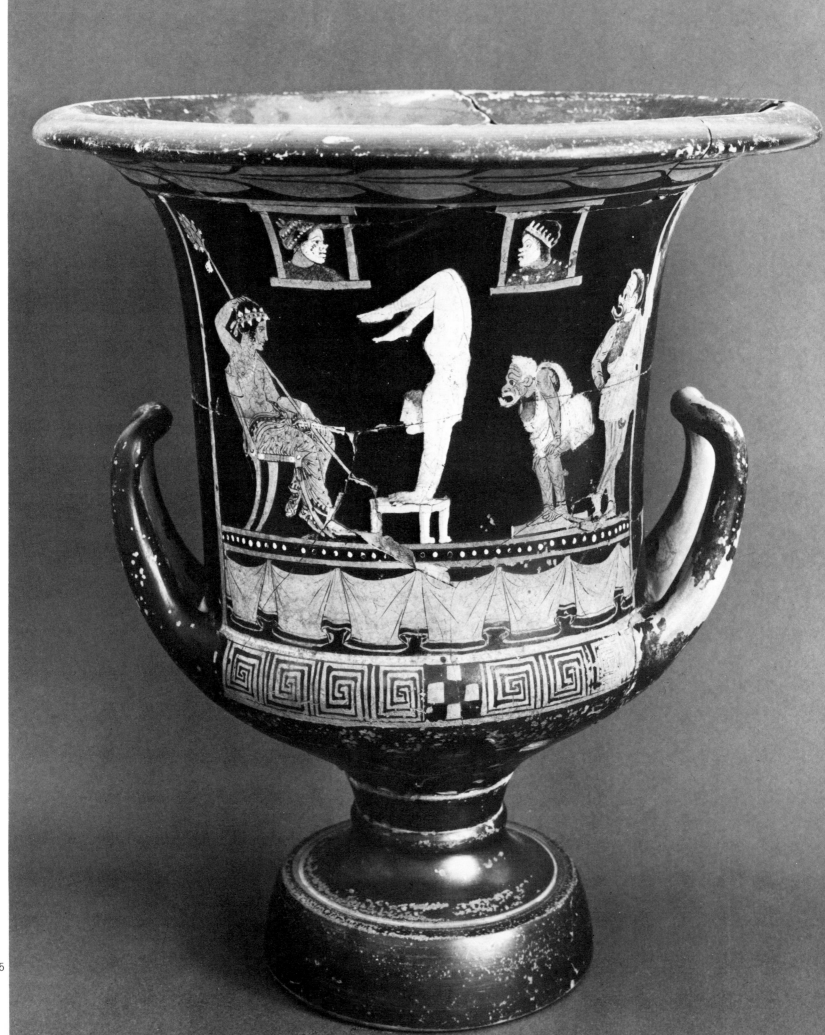

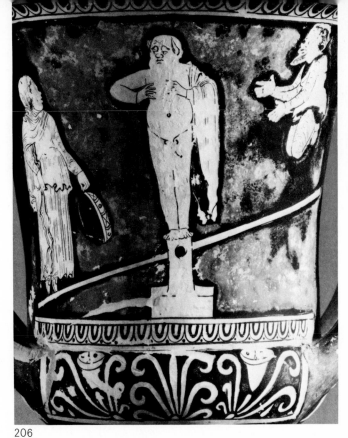
206

207

205. Assteas, calyx-krater: phlyax-farce observed by two women wearing Negroid masks. From Lipari, necropolis. IV century B.C. Terracotta. H: 40 cm. Lipari, Museo Archeologico Eoliano.

206. Calyx-krater (detail): female dancer and a caricatural figure seesawing on either side of a statue of Silenus. From Canicattini. IV century B.C. Terracotta. Syracuse, Museo Archeologico Nazionale.

207. Standing figure with Negroid features. From Carthage. IV century B.C. Terracotta. H: 20 cm. Tunis, Musée National du Bardo.

size terracotta mask of possible Sicilian provenance, now in the British Museum,[118] seems to be a faithful copy of a comic mask. The designer was thoroughly acquainted with the Negro type, as was the artist responsible for the mask of an aged Negro woman in the Museo Archeologico Eoliano.[119] This last was one of a set of terracotta tragic masks found in tombs at Lipari, which T. B. L. Webster in his reconstruction of the lost plays of Euripides has related to that playwright's *Alexandros*: the other masks representing Priam, Hecuba, Paris, Deiphobus, and Hector.[120] The Negro woman, Webster has suggested, may have been the nurse of Paris who brought about the identification of the long-lost prince on the occasion of his victory at the games instituted in his memory.

 A scene from a phlyax-farce painted on a calyx-krater, also in the Museo Archeologico Eoliano,[121] provides additional evidence of the association of Negroes with the theater. The vase, attributed to Assteas of Paestum, presents a female acrobat performing on a low stage before a seated Dionysus on the left and two phlyakes on the right. There are two windows above, from which two women wearing masks with distinctly Negroid features look down. In a scene on a red-figured calyx-krater of the period from Canicattini, now in Syracuse,[122] a female dancer, fully draped, stands on tiptoe. The treatment of the nose, the lips, and the tightly curled hair indicates that Negroid features were intended.

 Although it is hazardous to draw conclusions about racial characteristics from obviously exaggerated comic masks, the realism and anthropological fidelity of those cited above leave no doubt as to the artists' intent, which is as clear as in the case of numerous Kabeiric skyphoi from Boeotia, mentioned earlier.[123] In view of actual events—the destruction of Himera in 409 B.C. and the ensuing Carthaginian war with Dionysius I—one should not overlook the possibility that the presence of blacks who came to Sicily with the Carthaginians gave an added relevance to Negro roles in theater. Pertinent

fig. 204

fig. 203

fig. 205

fig. 206

208, 209. Etruscan oinochoe in the form of a Negro wearing a laurel wreath. Late V century B.C. Terracotta. H: 27 cm. Karlsruhe, Badisches Landesmuseum.

210. Rhyton: head of a man of mixed type. IV century B.C. Terracotta. H: 16.4 cm. Boston, Museum of Fine Arts.

211. Rhyton: head of a man of mixed type. IV century B.C. Terracotta. H: 14.5 cm. Rome, Museo Nazionale Etrusco di Villa Giulia.

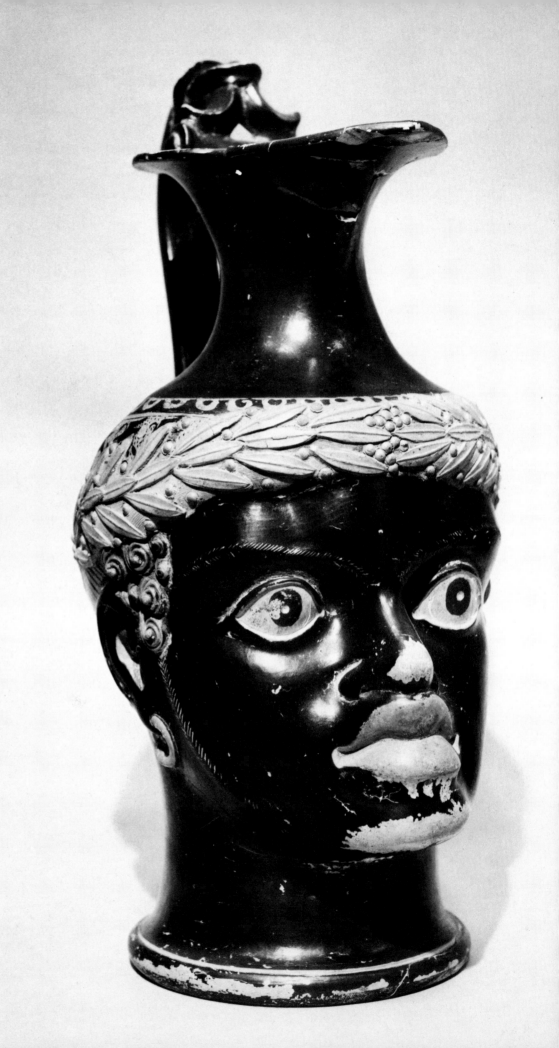

208-209

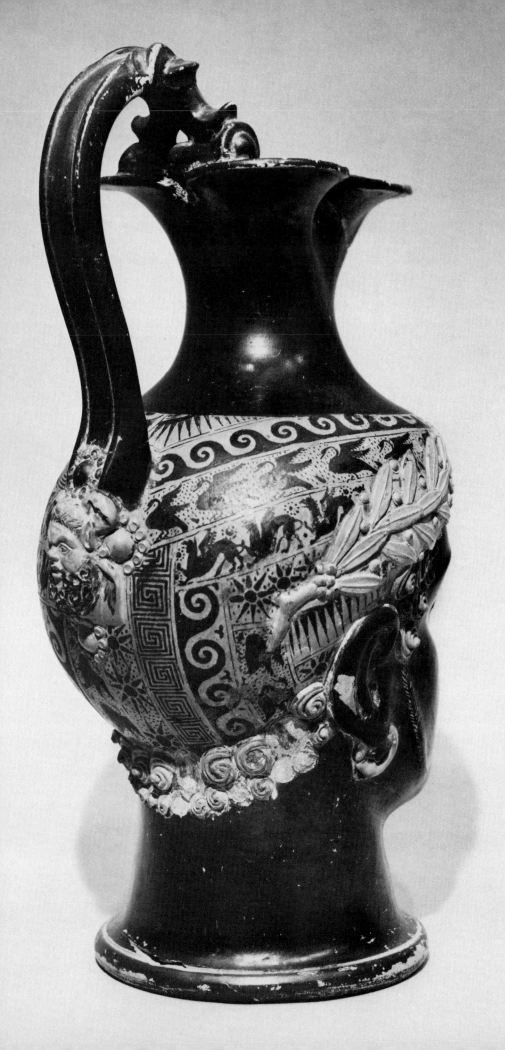

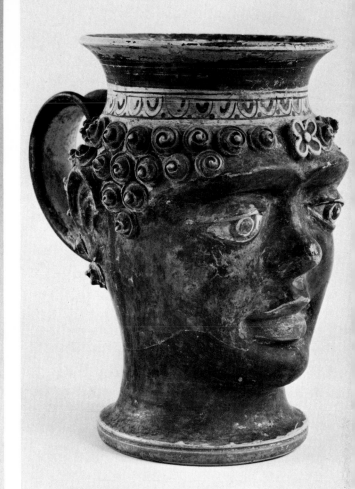

210 △ 211 ▽

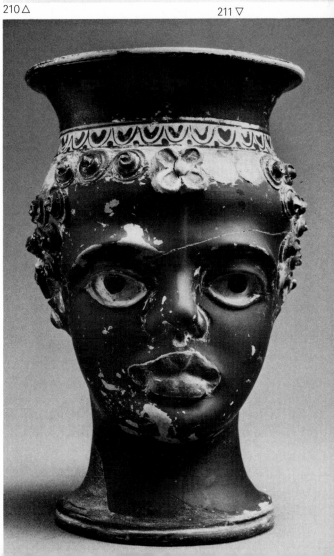

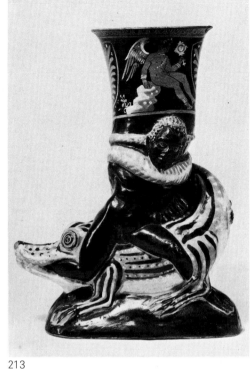

213

212. Head of a Negroid satyr, detail of a krater. From Bari. IV century B.C. Terracotta. Copenhagen, Nationalmuseet.

213. Rhyton: Negro youth struggling with a crocodile. From Apulia. IV century B.C. Terracotta. H: 21 cm. Leningrad, Hermitage Museum.

214. Rhyton: Negro youth struggling with a crocodile. From Apulia. IV century B.C. Terracotta. H: 22.2 cm. Cambridge, Fitzwilliam Museum.

212

to this point is the fact that among the fourth-century Sicilian Greek terracottas in the Musée National du Bardo described as "grotesques," there is one which warrants classification as Negroid on the basis of the broad nose and thick lips of the figurine.[124]

fig. 207

It was in Italy, especially in the south, that the Negro enjoyed popularity in the fourth century. Commentators on the art of this period have laid too much stress on what they consider the dullness and lifelessness of the Negro types represented. On the contrary, the potters and painters who accompanied Greek settlers were often no mean craftsmen and much of their work was of high quality. Negroes were apparently more available as models than has been generally realized. Further, the influence of Attic prototypes is obvious in fourth-century artists. The vase in the shape of a Negro head was widely adopted. Yet in a number of markedly similar Etruscan vases[125] prognathism and platyrrhiny are considerably less pronounced than in fifth-century heads. The most unusual example is an oinochoe (c. 420-410 B.C.)[126] which presents a youthful Negro wearing a laurel wreath and an earring in his right ear. The head is covered by an elaborately patterned, close-fitting cap, decorated with swans, griffons, stars, waves, and meanders, which covers the hair entirely except for rows of curls at the nape of the neck and before the ears. Although the thickness of the lips sometimes approaches that in earlier Negroid types, other examples[127] often show the hair in the form of raised spirals, perhaps to represent the less tightly-curled hair found in some black-white crosses. The modified and somewhat stylized features in these obviously popular Etruscan heads give the impression that the artists were using models which differed from other more Negroid people of whom the fourth century had knowledge. The Negroes molded in this kind of Etruscan vase resemble in general appearance many a descendant of black-white mixture in various parts of the world today. It is interesting to note that the type of vase which has back-to-back heads cast in the same mold (we have seen

figs. 208, 209

figs. 210, 211

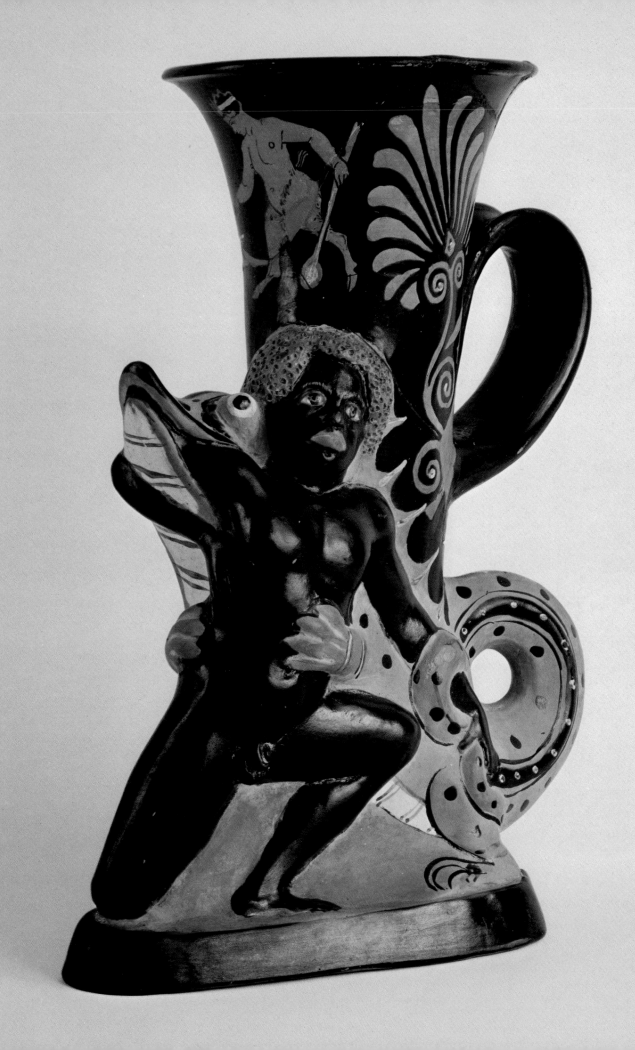

them with two Negro profiles) was also followed in an Etruscan vase [128] on which the crossbred features of the black made it possible to set him opposite a white satyr. Satyrs with strikingly Negroid traits are often found in southern Italy: an Apulian krater in Copenhagen is a good example. [129]

fig. 212

Another Attic creation was often imitated in Apulia—the vase of Sotades, the Negro boy-and-crocodile group. But the South Italian artists sometimes added ornamental flourishes absent in the Greek prototype; and while some examples are particularly lifeless, [130] the author of a Hermitage piece [131] may well have found his Negro model in his immediate surroundings. A lekythos in the Louvre, [132] from the same region, is decorated with the charming profile of a Negro whose hair, represented by tiny dots, recalls the manner of fifth-century vase-painters. Two plastic vases, one in Ruvo and the other in Naples, [133] in which reduced platyrrhiny and the type of hair are carefully observed, provide examples of mulattoes in fourth-century art.

fig. 214
fig. 213
fig. 215

figs. 216, 217

The popularity of the Negro theme in southern Italy is attested by many other examples. One of the most realistic portraits in classical art of women of the pronounced Negro type comes from Ruvo. The painter who depicted her on an askos, [134] nude in the midst of maenads and a satyr, was well acquainted with the racial characteristics of his agile dancer. Her type corresponds to that described with such accuracy in the *Moretum*: [135] "African in race, her whole figure proof of her country—her hair tightly curled, lips thick, color dark, chest broad, breasts pendulous, belly somewhat pinched, legs thin, and feet broad and ample." She is not an "old woman with grotesque features," as M. Bieber stated, [136] but what anthropologists call a "pure" Negro: both the artist of the askos and the author of the *Moretum* were good anthropologists.

figs. 219, 220

A scene on a Lucanian nestoris from the second quarter of the fourth century B.C. by the Brooklyn-Budapest Painter includes two youthful figures of the mixed black-white type. [137] In the center of the painting one of the youths, the only nude figure in the episode, with sword uplifted, is about to slay a terrified man, with curly beard and hair, dressed in full stage costume. The other Negroid figure, like one of the white figures clad only from the waist down, stands on the slayer's right, holding a knife in his right hand. The scene remains a puzzle since all interpretations leave some details or certain figures unexplained. At any rate, the central Negroid figure has been interpreted as Heracles slaying Busiris, Orestes murdering Aegisthus, and Lynceus, son of Aegyptus, killing Danaus. [138] In favor of associating the episode with the Danaid myth, however, is the fact that Aeschylus in the *Suppliants* describes the fifty sons of Aegyptus as black and emphasizes the "un-Greekness" and the "Africanness" of the Danaids. [139]

fig. 218

The fourth-century workshops anticipated the taste for the genre figures which became fashionable in the Hellenistic period. Two lekythoi, both in the British Museum, adapt the shape of the squatting Negro to the vase. One, with a wreath round his head, comes from Ruvo, [140] the other from southern Italy. [141] From the same area comes an askos in New York [142] which represents a boy seizing a goose. Boeotia was the source of another askos in Oxford [143] showing a boy bent over to the ground, and a third, in the British Museum, from Capua, [144] is a lifelike representation of a youth crouching as if asleep, with a cape knotted under his chin and carefully rendered facial scars. Such cicatrices, as we have seen in earlier examples from Naukratis, [145]

fig. 224
fig. 226

fig. 223

215. Lekythos: head of a Negro in profile. From South Italy. IV century B.C. Terracotta. Paris, Musée du Louvre.

216. Plastic vase: head of a man of mixed type. From Ruvo. Late IV century B.C. Terracotta. H: 25 cm. Ruvo, Museo Jatta.

217. Plastic vase: head of a man of mixed type. IV century B.C. Terracotta. H: 26.8 cm. Naples, Museo Archeologico Nazionale.

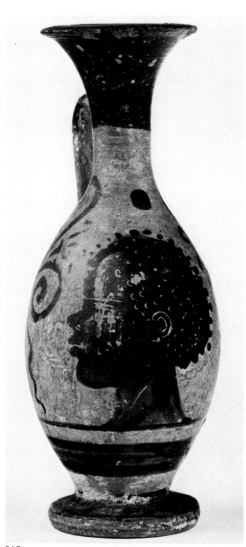

215

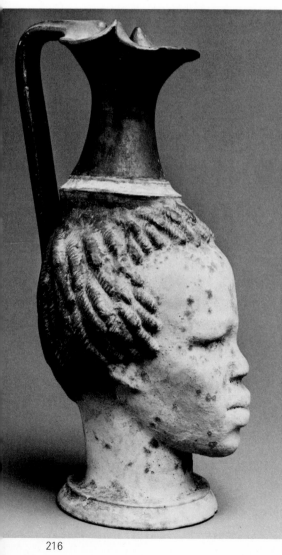

216

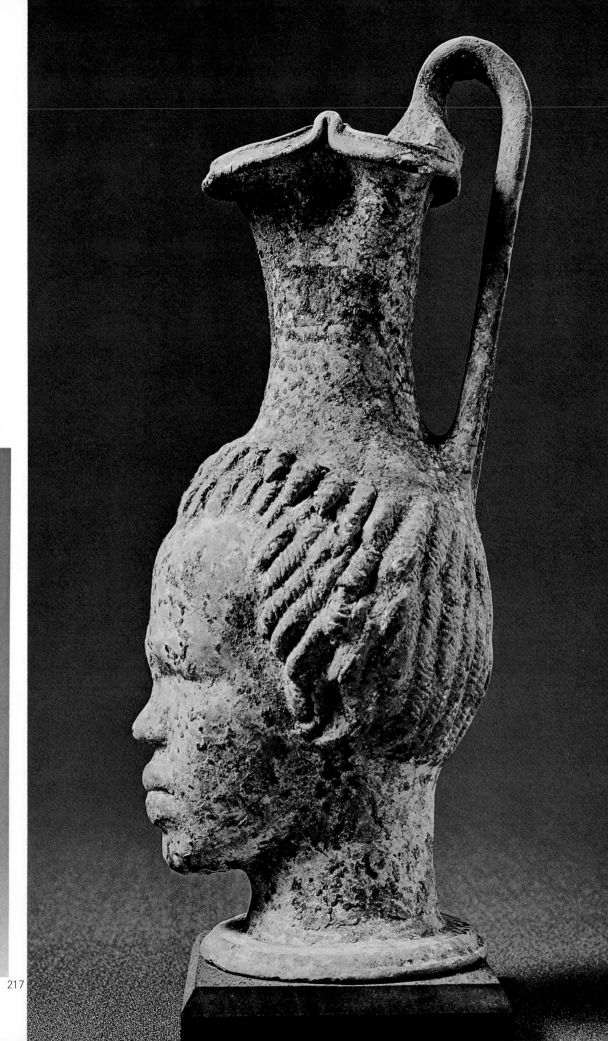

217

218. Brooklyn-Budapest Painter, krater: unidentified scene (Lynceus cutting the throat of Danaus?). From Taranto. Second quarter IV century B.C. Terracotta. H: 49 cm. Bonn, Akademisches Kunstmuseum der Universität.

219. Askos: black woman dancing between a maenad and a satyr. From Ruvo. IV century B.C. Terracotta. H: 23 cm. Ruvo, Museo Jatta.

220. Detail of figure 219: black dancer.

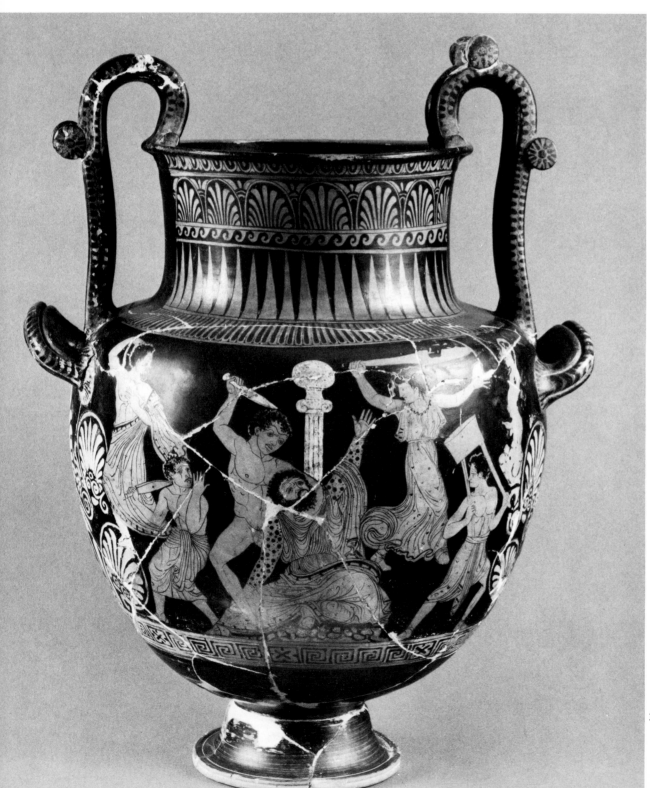

218

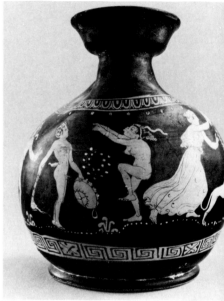

219

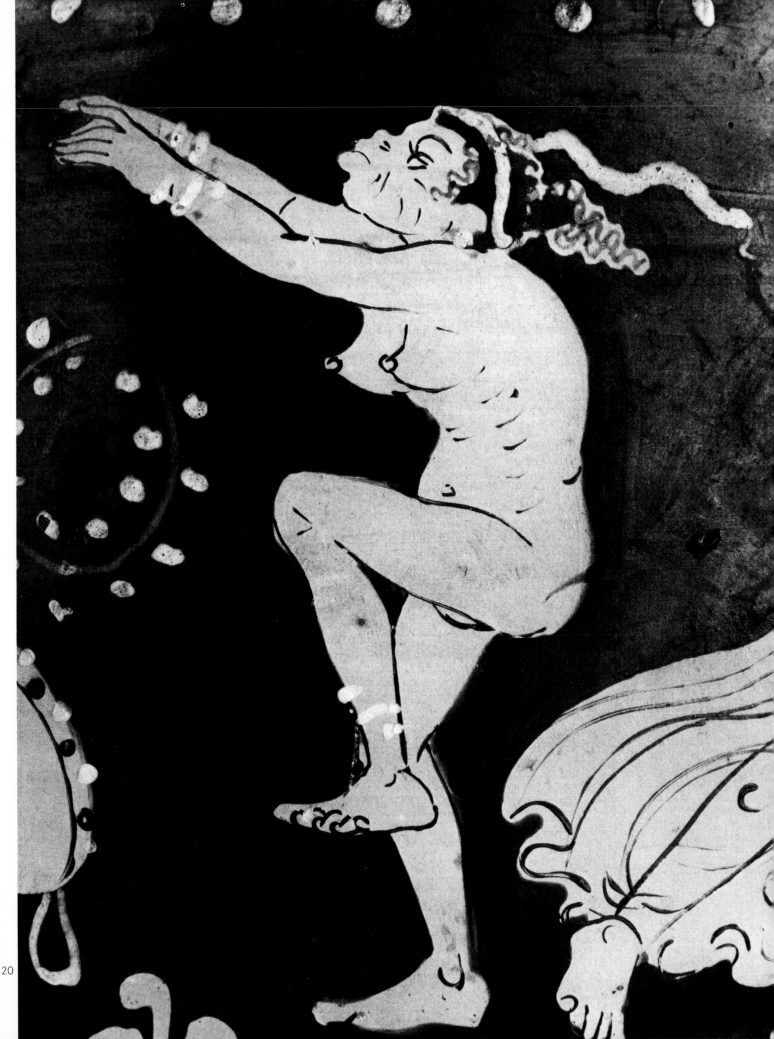

221, 222. Phiale decorated in relief with three
concentric rows of Negro heads and one row of
acorns. From Panagyurishte. Late IV century
B.C. Gold repoussé. Diam: 25 cm. Plovdiv,
National Archeological Museum.

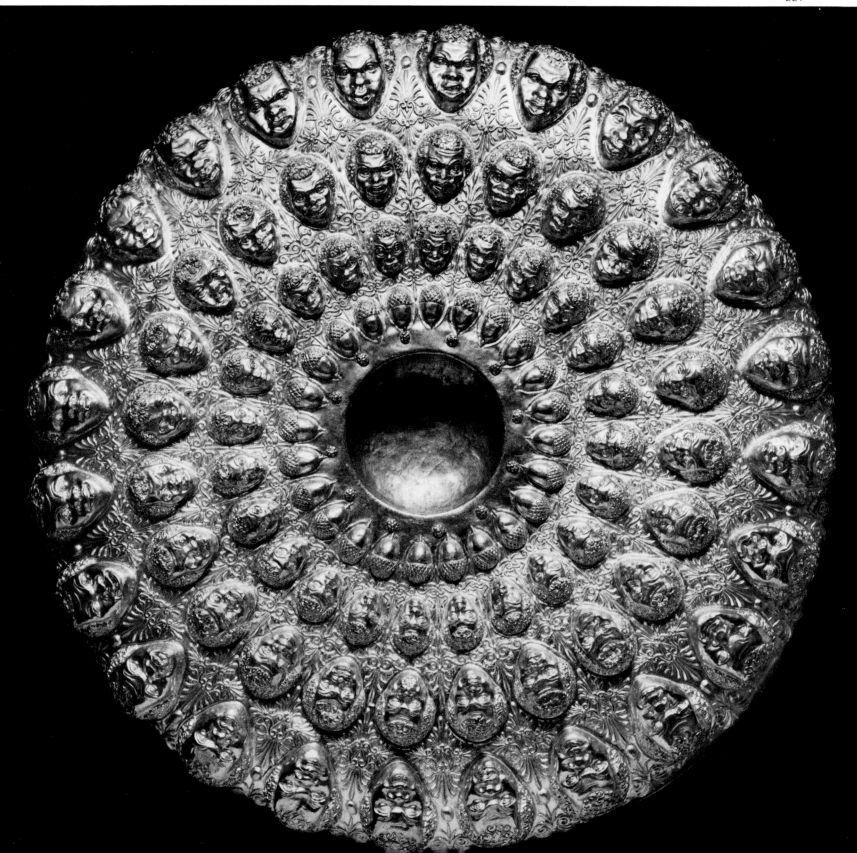

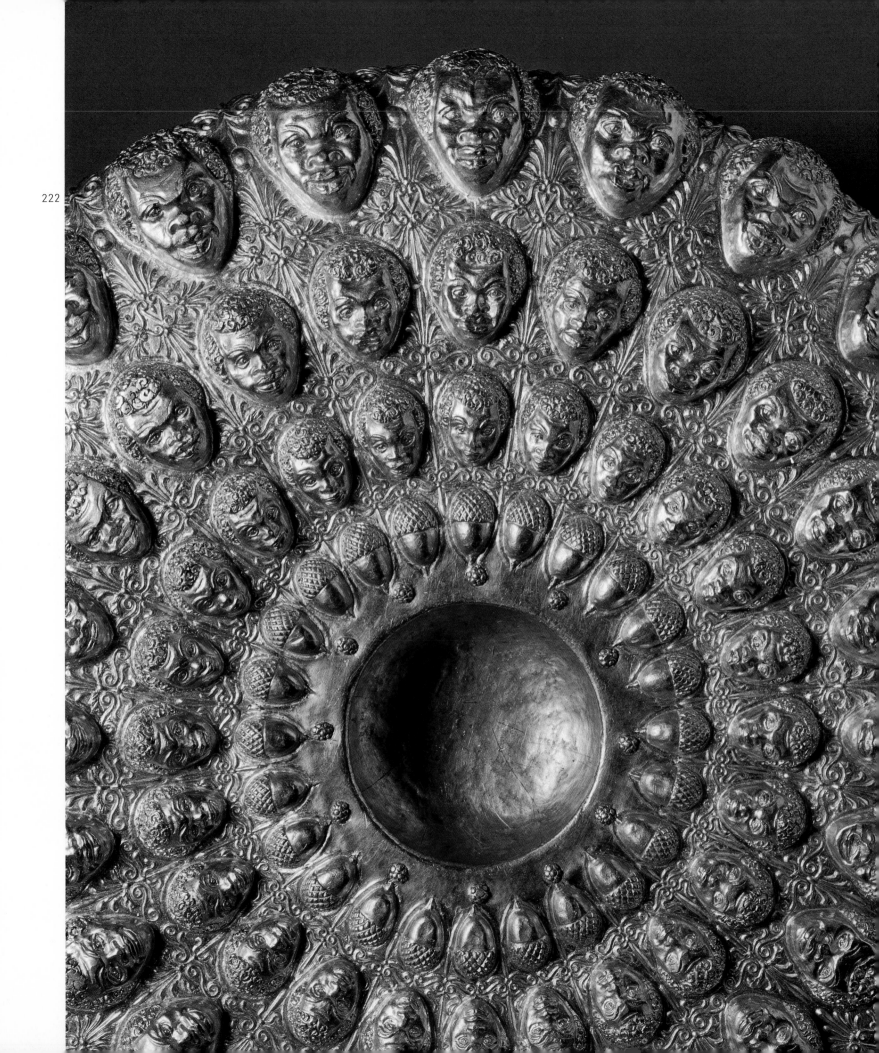

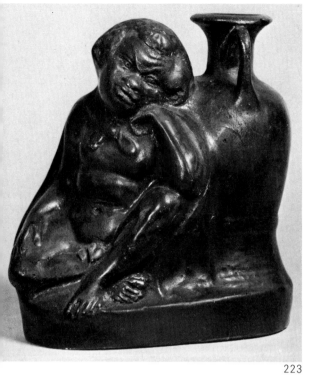
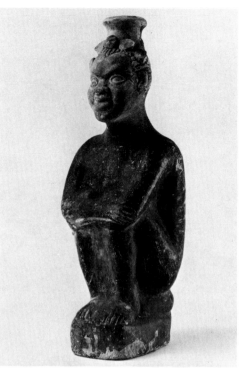
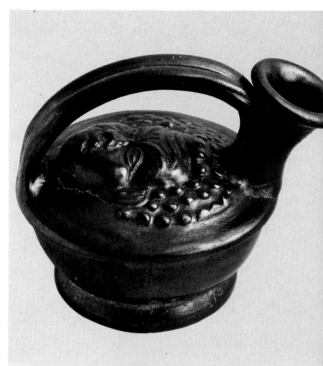

223 224 225

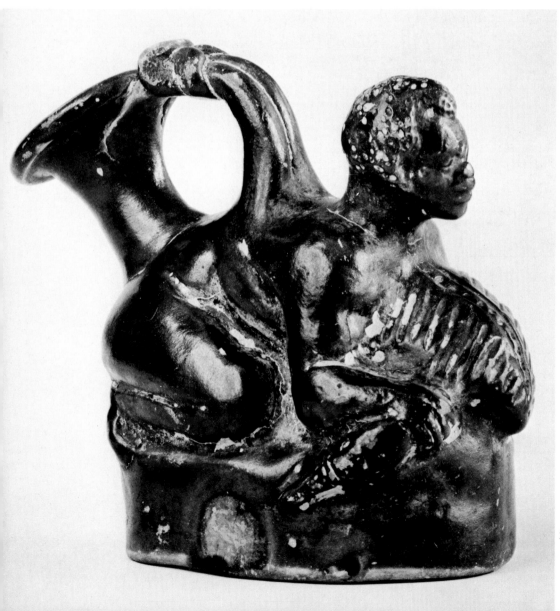

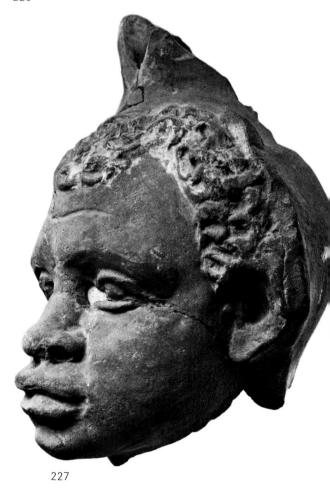

227

226

228

223. Askos in the form of a child crouching beside a vase. From Capua. IV century B.C. Terracotta. H: 8.9 cm. London, British Museum.

224. Lekythos in the form of a crouching child. From Ruvo. IV century B.C. Terracotta. H: 24 cm. London, British Museum.

225. Askos with a mask of a Negro in relief. From Cyprus. Late IV century B.C. Terracotta. H: 8 cm. Cambridge, Fitzwilliam Museum.

226. Askos in the form of a child seizing a goose. From South Italy. IV century B.C. Terracotta. H: 8.4 cm. New York, Metropolitan Museum of Art.

227. Fragment of a rhyton in the form of a Negro head. From Olynthus. IV century B.C. Terracotta. H: 14.2 cm. Cambridge (Mass.), Fogg Art Museum, Harvard University.

228. Boxing match, detail of a fresco. From Paestum. Second half IV century B.C. Paestum, Museo Archeologico Nazionale.

served as tribal marks or decorations among some Ethiopians. A recently discovered boxer, unquestionably black-skinned though lacking pronounced Negroid features, in a fresco on a tomb at Paestum of c. 340-320 B.C.,[146] and a fig. 228
terracotta statuette of a Negro dancer with a pointed cap in Taranto[147] whose verve and realistically portrayed physical features compare well with those of the Ruvo dancer, provide evidence both of the presence of blacks in southern Italy and of renewed artistic inspiration.

A terracotta phiale decorated with Negro heads and rows of acorns and bees has been found in a temple deposit at Locri in South Italy.[148] Negro heads also appear on a better-known gold phiale found at Panagyurishte in figs. 221,
southern Bulgaria.[149] This bowl of the late fourth century, which combines 222
three concentric circles of Negroes, twenty-four in each, with one row of palmettes and one of acorns, has been considered a replica of a well-known piece mentioned by Pausanias,[150] who tells us that a statue of Nemesis at Rhamnus held in its right hand a phiale on which Ethiopians were carved. Whether or not these two phialai were actually inspired by earlier pieces, the subjects in both cases are such lively creations that first-hand acquaintance with Negroes is not to be ruled out. The full-face mask of an Ethiopian, Attic in workmanship and equally realistic, appears on an askos in the Fitzwilliam fig. 225
Museum, discovered at Poli (Cyprus).[151] A rhyton in the Fogg Museum, from Olynthus,[152] provides a study, very effectively executed in red clay, of fig. 227
the pronounced Negroid type.

Two other pieces, found at Cyrene, have been interpreted as indicating black-white descent: the Zeus Ammon on a tetradrachm in East Berlin,[153] c. fig. 229
400 B.C., which C. T. Seltman regarded as Negroid on the basis of the hair and cast of countenance, and a sensitively modelled bronze head of about 350 B.C. in the British Museum,[154] probably that of a charioteer. The head, fig. 230
part of a statue found in the Temple of Apollo, is one of the earliest Greek portraits to be preserved. Apparently a North African native, the subject of

183

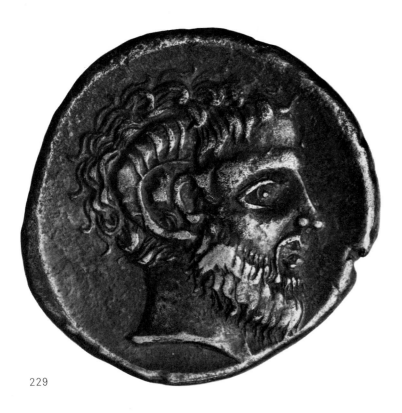

229

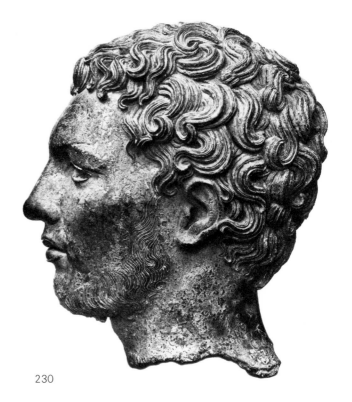

230

229. Tetradrachm. Obverse: Zeus Ammon. From Cyrene. About 400 B.C. Silver. Diam: 2.7 cm. East Berlin, Staatliche Museen.

230. Portrait of a North African of mixed type. From Cyrene, Temple of Apollo. Mid-IV century B.C. Bronze. H: 30 cm. London, British Museum.

231, 232. Young black groom steadying a horse, statue base (?). From Athens. Late IV or early III century B.C. Marble. 200 × 190 cm. Athens, National Museum.

233. Young mulatto groom, fragment of a funerary relief. Late IV century B.C. Marble. 88 × 57 cm. Copenhagen, Ny Carlsberg Glyptotek.

the bronze has been considered by some as a Berber, by others, particularly because of the rather full lips, as of mixed ancestry. In evaluating the opinions of those who have interpreted these two pieces as indicating black-white descent, one should keep in mind the anthropological criteria for mixed types, the provenance of the objects, and the not uncommon fusion, noted by anthropologists, of Negro and white stocks in North Africa from earliest times.[155]

The frequent inclusion of Negroes and mixed black-white types as grooms, charioteers, and jockeys in equestrian scenes should not be overlooked.[156] A fragment of a marble tomb-relief,[157] c. 320 B.C., in the Ny Carls- fig. 233 berg Glyptotek, depicts, standing beside a horse, a young man whom F. Poulsen, apparently puzzled by the treatment of the hair and lips, described as a "lad of distinctly plebeian type," whom he compared with what he called the "plebeian, realistically drawn slave girl" on the lekythos of about 450 B.C., mentioned above. In both cases, however, the features suggest mulattoes. The groom in another marble relief[158] found in Athens, now in figs. 231, the National Museum, is of the pronounced Negro type, with black pre- 232 served on his face and arms, and his tightly coiled hair represented with great skill. According to a suggestion of S. Karouzou,[159] the relief formed the base of a statue of an officer. It shows a restive horse, facing right, with its left foreleg raised, as the Negro groom, behind at the right in a second plane, leans backward and raises a whip in one hand, while with the other he holds a red object to the horse's mouth. The workmanship is excellent, the piece full of movement. Though noting that the style has certain characteristics in common with the last of the grave stelae, Karouzou points to early Hellenistic technique and suggests that the relief should be dated about 300 B.C. or immediately thereafter.

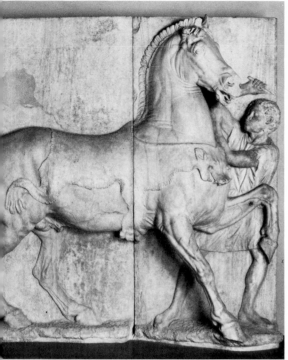

231

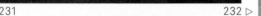

232 ▷

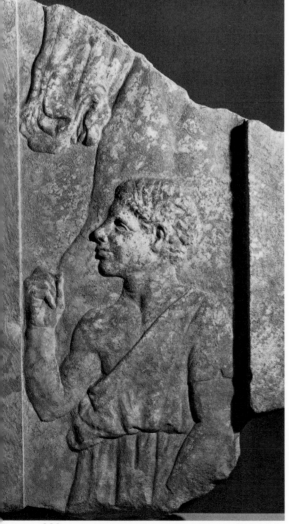

233

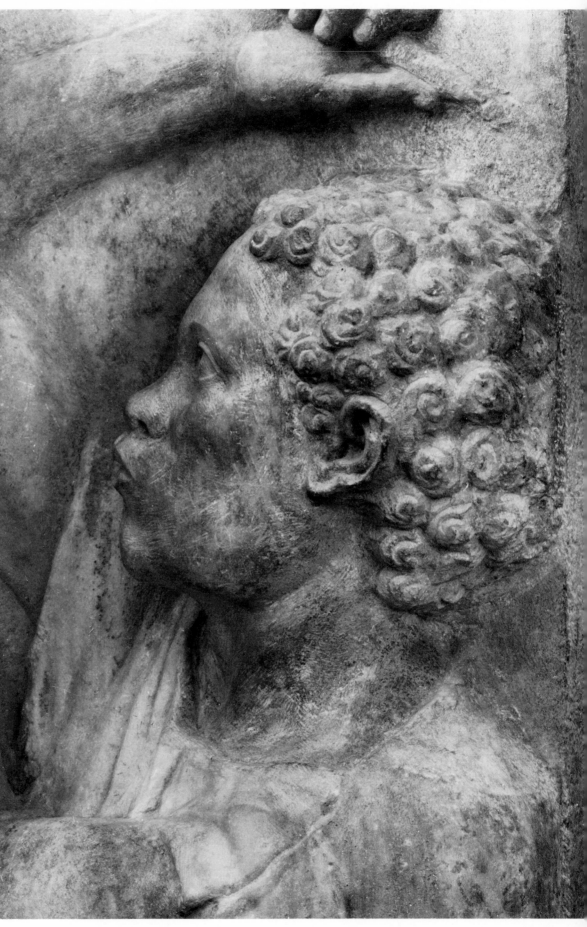

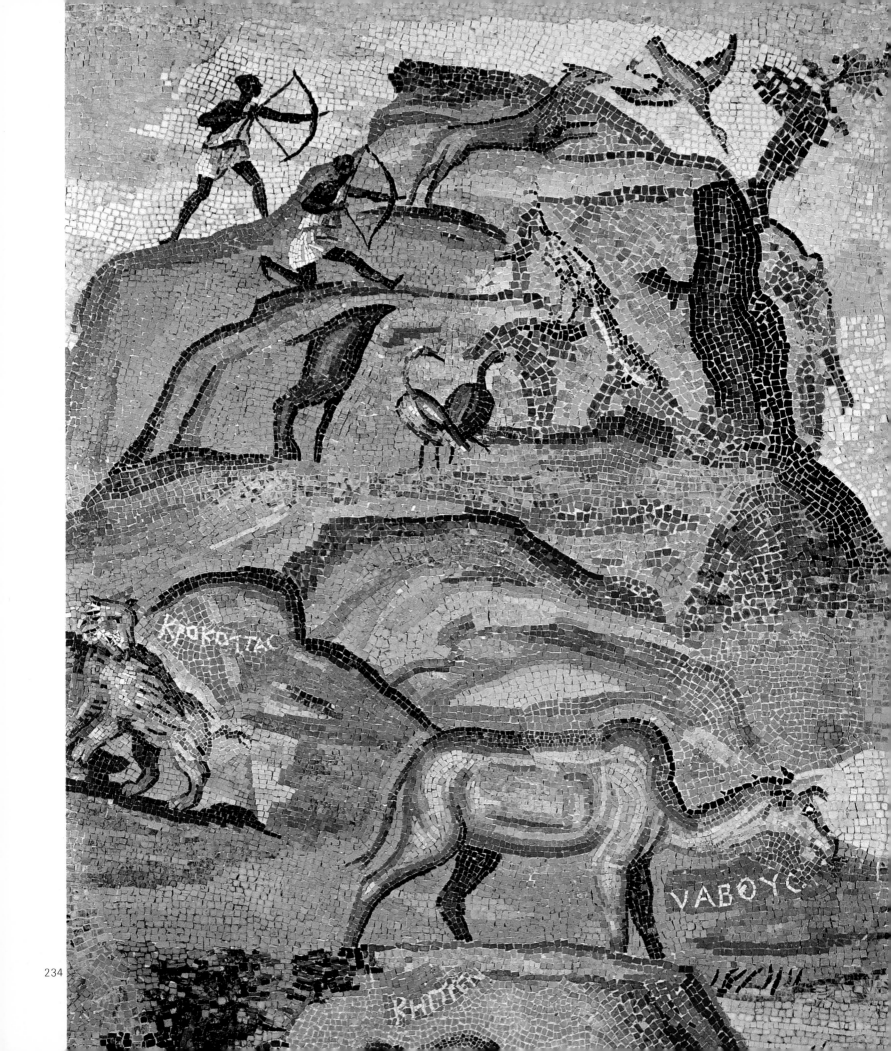

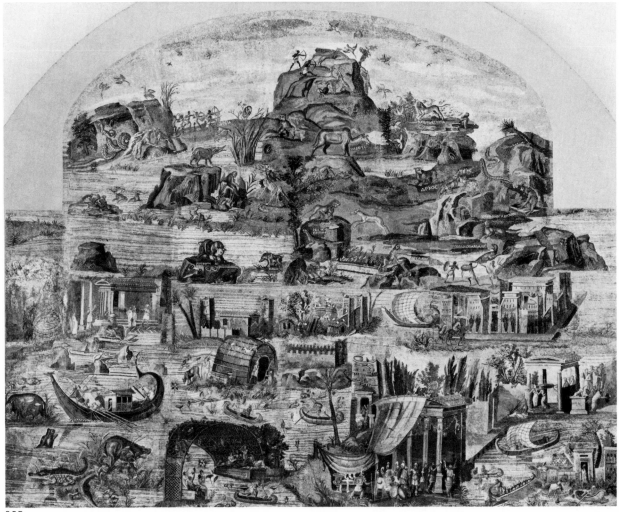

235

234. Landscape of the Upper Nile with two black hunters, detail of the Mosaic of the Nile in flood. From Praeneste, Temple of the Fortuna. I century B.C. Over-all dim. approx. 400 × 500 cm. Palestrina, Museo Archeologico Nazionale.

235. Mosaic of the Nile in flood: over-all view.

HELLENISTIC PERIOD

Beginning with their earliest encounters in Egypt and in Greece, the Negro, whether warrior, slave, or adventurer, fascinated Greek artists, as we have seen. The popularity of the Negro in Hellenistic studios, therefore, is what would be expected of artists drawn to realistic studies of non-Greeks and interested in the un-Greekness of foreign types. The wide variety of physical features in blacks, the "pure," the Nilotic, and various gradations of black-white mixture, provided a range of opportunities for the employment of artistic skill.

The Greeks were aware of the subtle changes from white to black in the pigmentation and physical features of peoples as one proceeded southward along the Nile. This awareness was evident in art long before Philostratus noted that inhabitants of the regions near the Egyptian-Ethiopian boundaries were not completely black but were half-breeds as to color, not so black as Ethiopians but blacker than Egyptians.[160] A depiction of Egyptian landscape and the Nile in flood—the Barberini mosaic at Palestrina[161]— probably inspired by a Hellenistic prototype, presented white figures in the foreground and, at the top, Ethiopian hunters whose black skin stands out effectively against their white garments.

As a result of their commercial policies and military activities, the Ptolemies extended their acquaintance with Ethiopia and Ethiopians living south

figs. 234, 235

187

of Egypt and in regions along the Red Sea. If Athenaeus is correct,[162] as early as the second Ptolemy large numbers of Ethiopians paraded in the great procession which took place in Alexandria during his reign. Like the earlier Greeks, the Ptolemies had encounters with Ethiopian warriors. Agatharchides[163] echoes these military experiences when he observes that Ethiopians would inspire fear in the Greeks, but not because of their blackness or the differences of their external features; such a fear ceases at childhood, for it is known that success in battle is determined not by external appearance or color but by courage and skill in the arts of war. Although the question of Ptolemaic military relations with the Ethiopians presents complicated problems, there is little doubt that these relations accounted for the presence of many Ethiopians in Egypt. The extensive gallery of Negro portraits, some realistic, others more freely handled, by Hellenistic craftsmen who worked in marble or more commonly in bronze or terracotta, would seem to indicate that blacks constituted a much larger element in the population of the Hellenistic world than has been generally realized. Moreover, a present-day visitor to Alexandria and other Egyptian cities gets the impression that many blacks seen there resemble those chosen by Hellenistic craftsmen as models.

Many studies of the Negro in Hellenistic art have concentrated on specialized aspects such as the squatting or crouched figure or on methods of treating the hair, but a comprehensive view of the representation of blacks in this period is lacking. Indeed, the failure to see the total picture has obscured the frequency with which the Negro was represented and the diversity of physical types with which the artists were acquainted. The expressive modelling, the anguish of features, the naturalistic portrayal of subjects in a variety of moods and movements, the engaging studies of children and single figures, the deeper understanding of the people—all these characteristics of Hellenistic art are found in the works which represent Negroes. The result is that several portraits of blacks carefully and sympathetically executed, are among the finest specimens of the period. It is also noteworthy that while artists often selected female models, especially for terracotta statuettes, when they were portraying blacks they preferred men and boys as subjects. This could have been due simply to the greater availability of male models. Then as in later times, fathers and sons may have left the Upper Nile Valley in search of work in areas where their varied skills made them employable.

The coroplast of a small terracotta head from the early ptolemaic period, now in the Ashmolean Museum,[164] was obviously intrigued by the particular physical traits of his subject: he emphasized the strongly everted lips, showed the hair by incising tiny circular dots in the clay, and added two frontal cicatrices, one of which is missing. A terracotta mask in Houston[165] represents a bearded, middle-aged Negro of a less pronounced type. In a strongly individualized bronze portrait of a Negro also in Houston[166] dating from the late third or the second century B.C., the craftsman has turned the head to one side, recalling, H. Hoffmann has suggested, the gesture of a Hellenistic ruler-portrait. Another interesting portrait of a Negro youth in bronze, in Providence, R.I.,[167] found in Egypt at Samannûd, dates from the second or the first century B.C.

fig. 236

fig. 238

fig. 237

fig. 239

Youths of the Nilotic type served as models for several fine small bronzes. Their similarity is marked in the general contour of features and the treatment of the hair, arranged in rows of corkscrew curls. One of these

236. Head of a Negro. Early III century B.C. Terracotta. H: 9.2 cm. Oxford, Ashmolean Museum.

237. Fragment of a balsamarium in the form of a Negro head. Late III or early II century B.C. Bronze. H: 7.7 cm. Houston, D. and J. de Menil Collection.

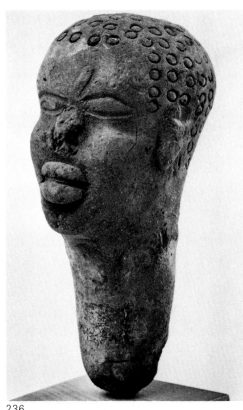

236

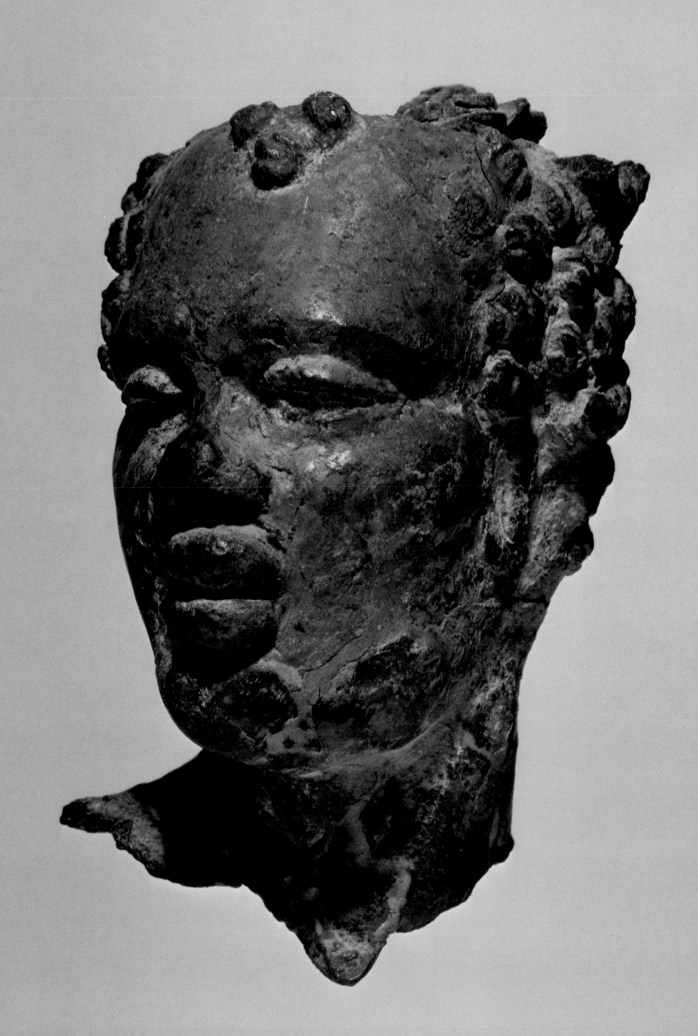

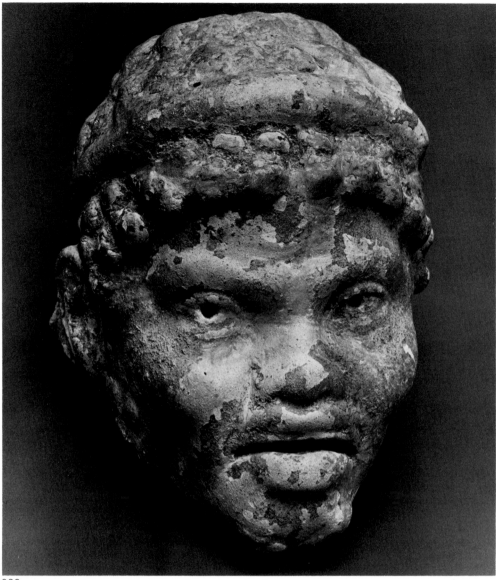

238

238. Mask of a Negro. III or II century B.C. Terracotta. H: 15.2 cm. Houston, D. and J. de Menil Collection.

239. Perfume vase: bust of a Negro youth. From Samannûd (Egypt). II or I century B.C. Bronze. H: 12.8 cm. Providence, Museum of Art, Rhode Island School of Design.

pieces, in the British Museum,[168] perhaps Alexandrian, which served as a perfume jar, has been described as the "most sensitive and sympathetic rendering of the subject known from antiquity."[169] Another, found in Tell Moqdam (Leontopolis),[170] is almost a double of the first. The third, in the Museo Archeologico in Florence,[171] of unknown but presumably Italian provenance, differs in that the features, though resembling those of the other two, are more delicate. Because of the excellent workmanship this head deserves to be better known. fig. 241

 fig. 242

From the same period also come two early examples, found in the Agora at Athens, of a type of lamp in the shape of finely modelled Negro heads—one perhaps the oldest example extant of its kind[172]—that was to be exceedingly popular in Roman times. In the other, made by hand rather than in a mold,[173] the artist has carefully modelled the head, hand-tooled the hair, and added a realistic touch by the inclusion of pierced holes for earrings or perhaps wick probes. fig. 240

The face was also the focus of the artist's attention in several small objects. Among these we note, in Houston, a gold head of a Negro which may

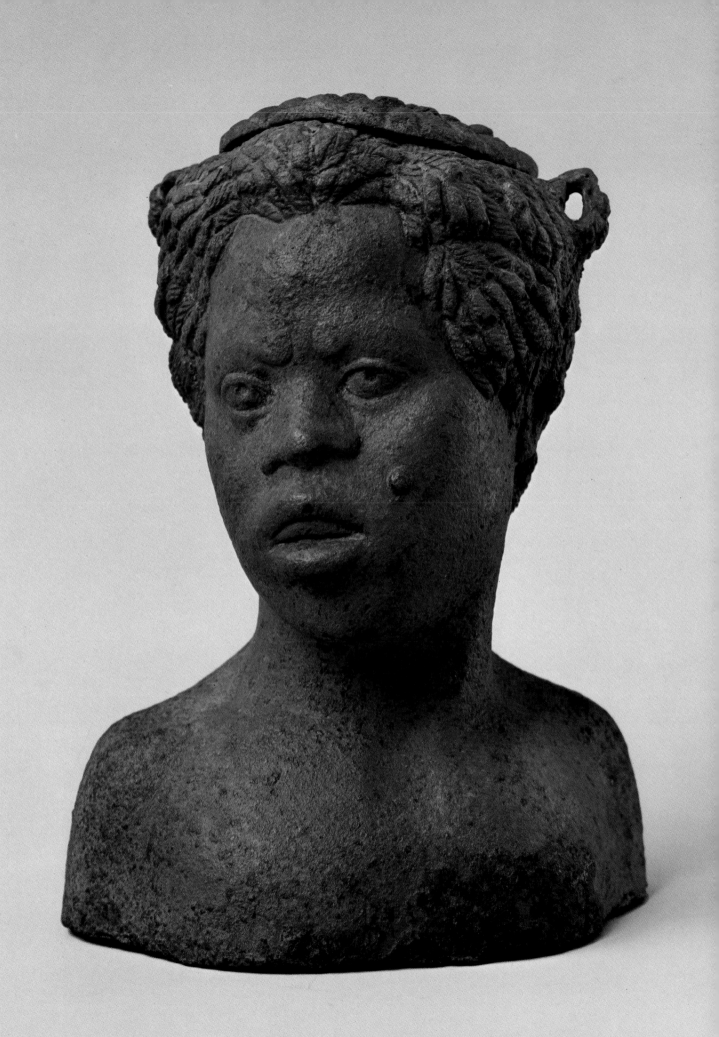

240. Lamp in the form of a Negro head. From Athens, Agora. II century B.C. Terracotta. L: 8.9 cm. Athens, Agora Museum.

241. Perfume vase: head of an adolescent of Nilotic type. About 100 B.C. Bronze. H: 10 cm. London, British Museum.

242. Balsamarium: head of an adolescent of Nilotic type. III or II century B.C. Bronze. H: 7.2 cm. Florence, Museo Archeologico.

240

241

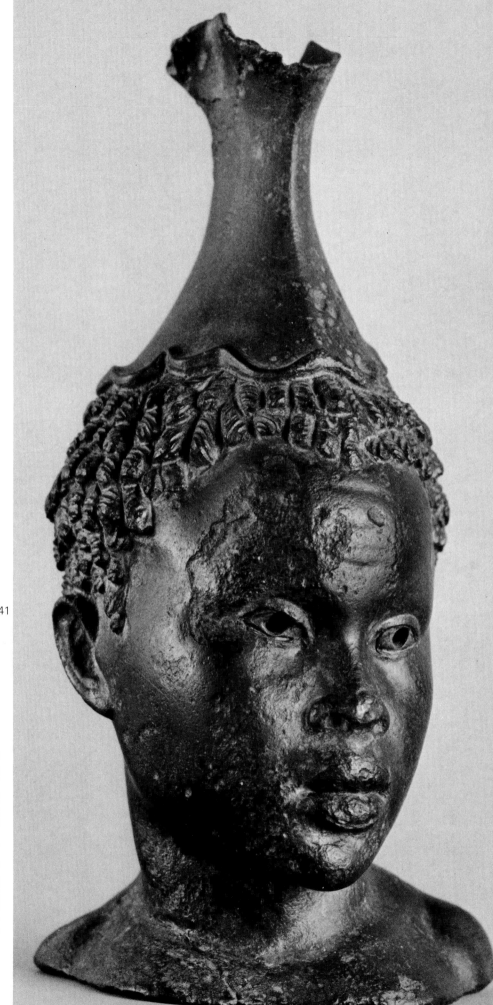

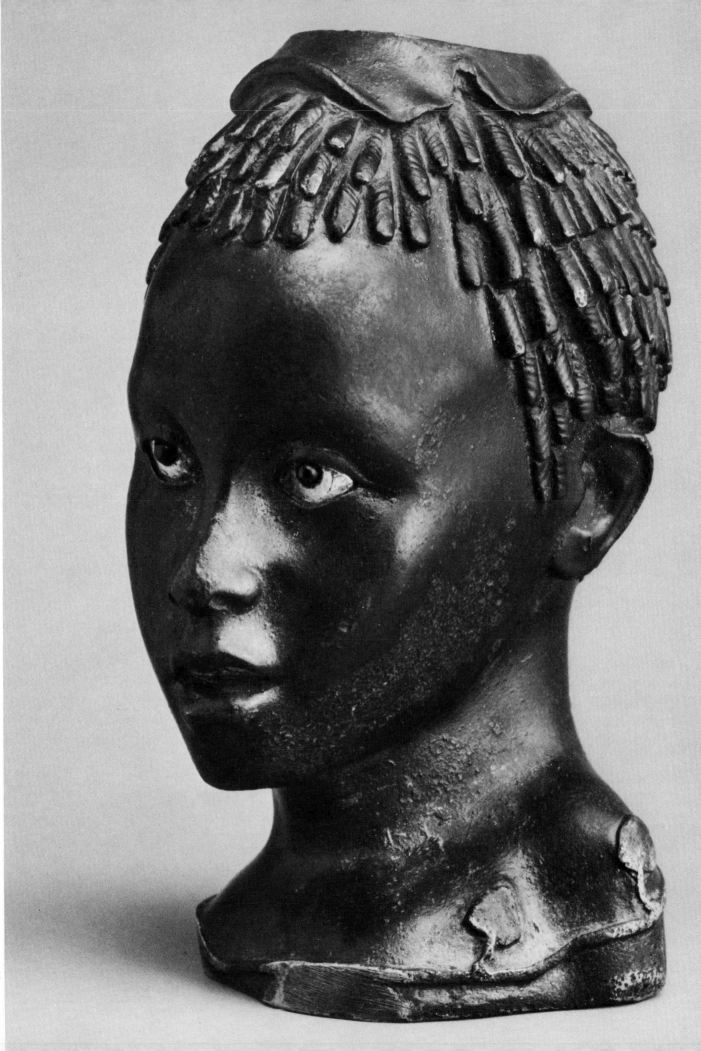

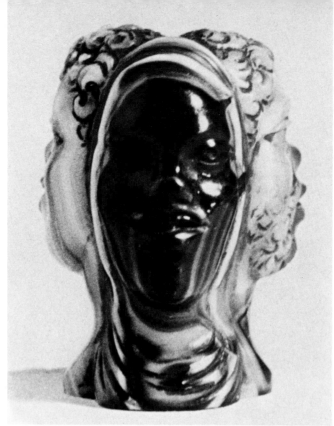

243

244

243. Handle or pommel in the form of three conjoined heads. From Egypt. Between 50 B.C. and A.D. 50. Agate. H: 3 cm. Whereabouts unknown.

244. Necklace with two heads of black women forming clasp. From Melos. III century B.C. Gold and garnet. L: 21.5 cm. London, British Museum.

245. Earrings in the form of Negro heads. Hellenistic Period. Amber and gold. H: 2.5 cm. Paris, Musée du Louvre.

246. Head of a Negro which may have adorned a pin. Hellenistic Period. Gold. H: 1.5 cm. Houston, D. and J. de Menil Collection.

have adorned a pin[174] and, in the British Museum, two garnet heads of Negro women,[175] set in gold, the hair skillfully rendered by twisted spirals of gold wire, at the end of a necklace. Another example is a pair of Louvre gold earrings which furnish the setting for two amber Negro heads with an elaborately spiraled coiffure.[176] fig. 246 fig. 244 fig. 245

Two other objects, from Egypt, should be mentioned because of their unusual interest. In one of these, formerly in the David M. Robinson Collection at the University of Mississippi, the artist, making skillful use of the light and dark shades of agate, has carved in the round three Negro heads, back to back,[177] one a woman in black with a white edge to her veil, the other two, in lighter stone, a bearded middle-aged man and a youth. C. T. Seltman suggested that perhaps an Alexandrian Greek was commissioned to create the piece, which represented a Meroïtic queen, her consort, and her son, and served as the knob of a small scepter or the handle to the lid of an agate casket or vase.[178] The other unusual object depicts two smiling Negro lovers in affectionate embrace, on a terracotta lagynion in East Berlin.[179] Their draped bodies curve to follow the line of the vase. fig. 243 figs. 247, 248

The handle of a bronze incense shovel in Brooklyn,[180] bearing an inscription to Serapis, is decorated with the head of a boy blowing over the surface of the pan. K. Herbert[181] supposes that this may be an adaptation of a well-known piece of the Hellenistic painter Antiphilus, *Boy Blowing a Fire*. figs. 249, 250

All these objects, showing as they do a deep interest in Negro heads, justify the inference that the artists, in order to catch many nuances of feature and feeling, approached their models with a wide variety of inspiration and technique. To this fact perhaps we owe a work such as the exceptionally fine dark gray head in The Brooklyn Museum. Slightly under life-size, the head is said to have been found in the Greek East, and has been dated from the second century B.C. by B. V. Bothmer, though D. Kiang is not certain and would hazard a guess that the object is Roman.[182] Bothmer has suggested figs. 251, 252

245-246

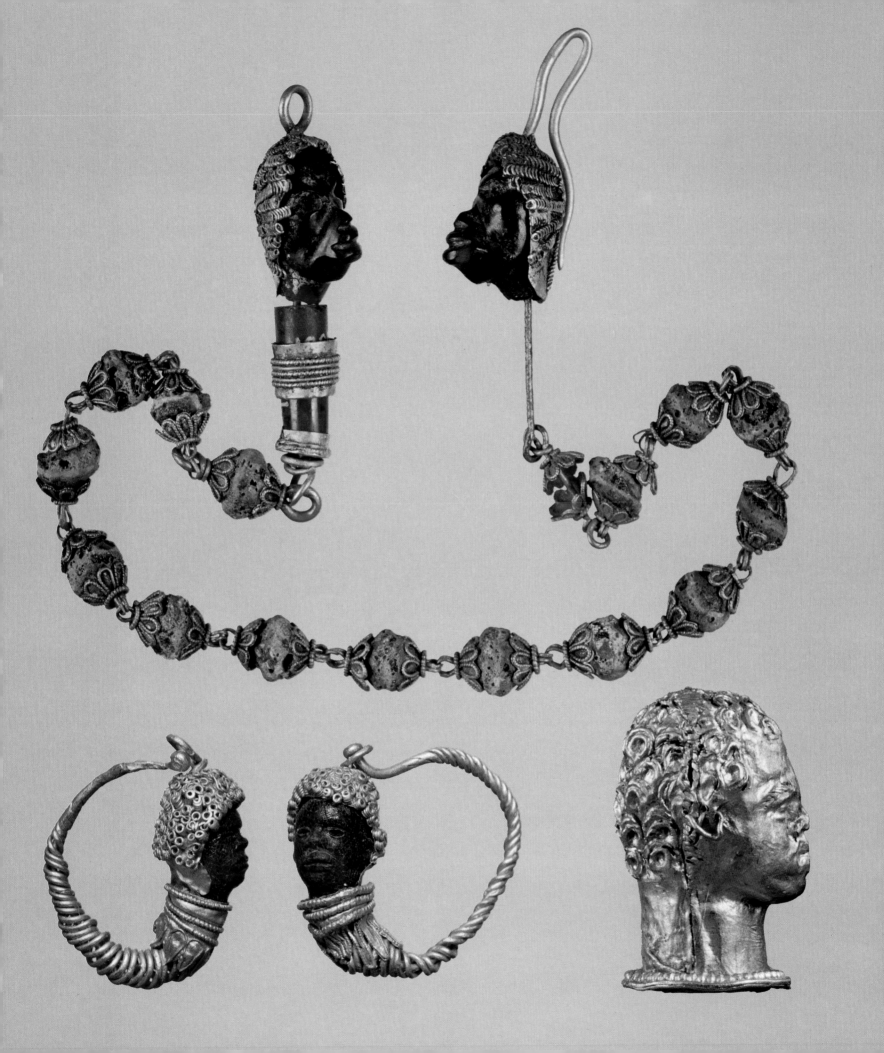

247, 248. Lagynion decorated with a couple embracing. From Cairo. Hellenistic Period. Terracotta. H: 16 cm. East Berlin, Staatliche Museen.

249, 250. Incense shovel with Negro head attached to handle. III century B.C. Bronze. Overall L: 47.8 cm.; H of head: 4 cm. Brooklyn, The Brooklyn Museum.

251. Head of a Negro youth. II century B.C. Gray marble. H: 28 cm. Brooklyn, The Brooklyn Museum.

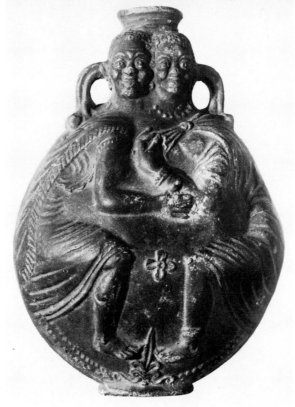
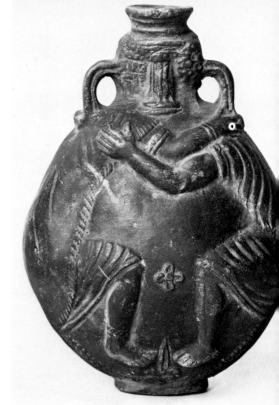

247

248

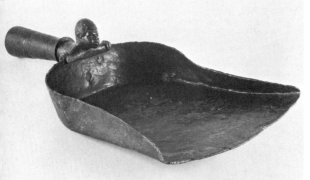

249

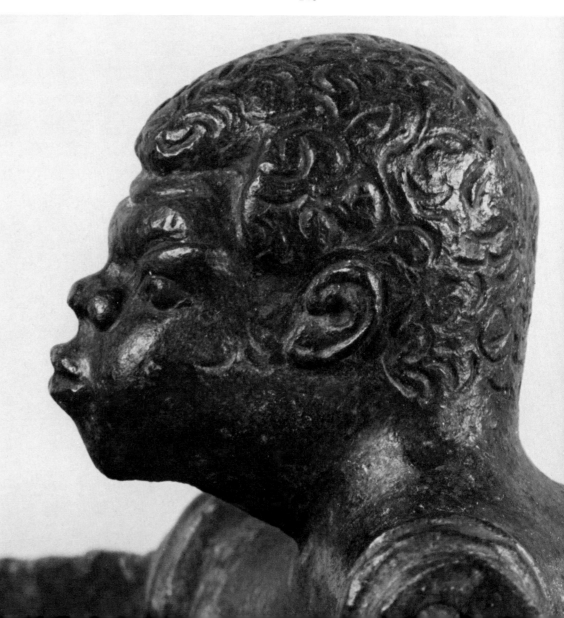

250

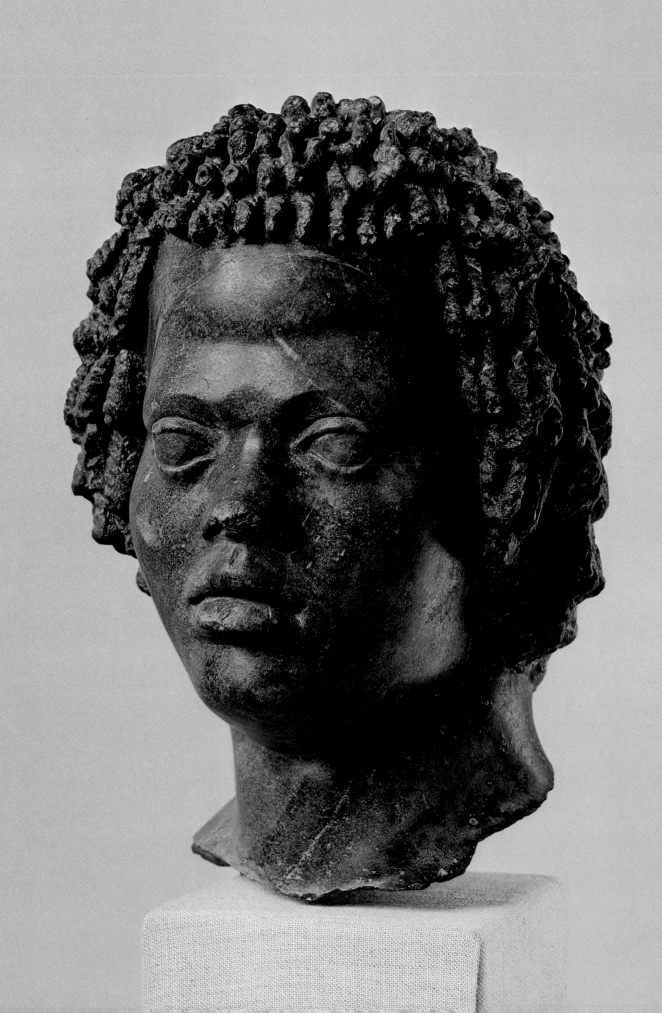

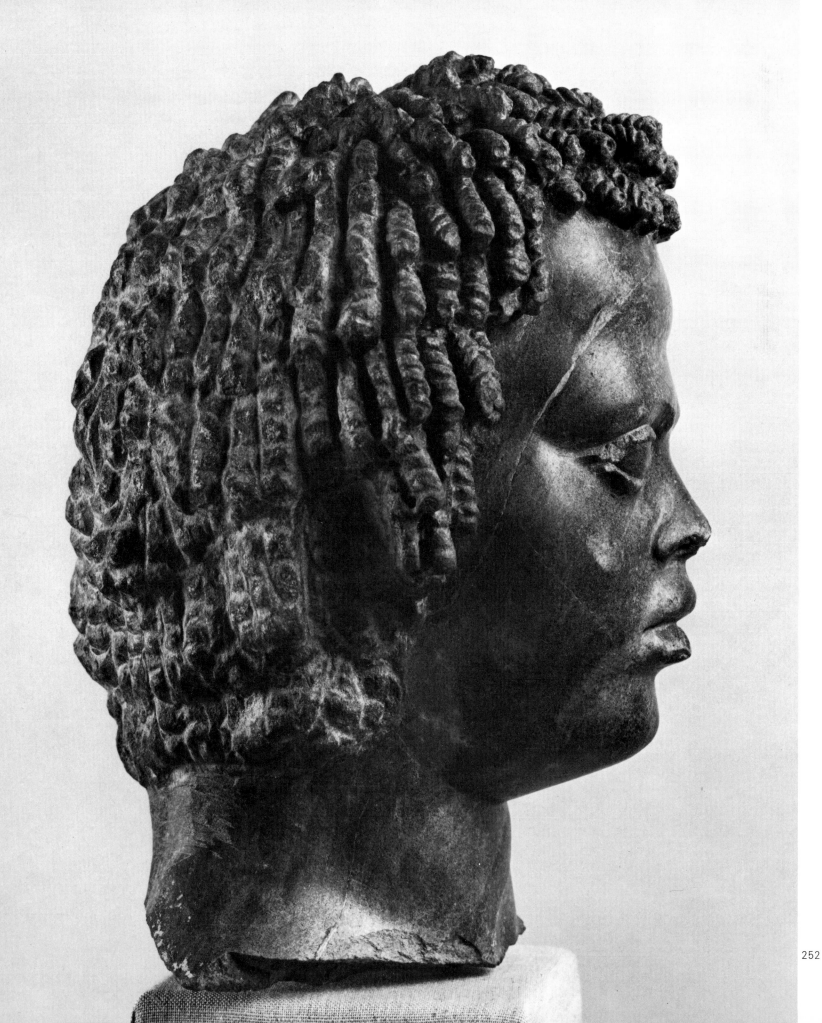

252. Head of a Negro youth, second view of figure 251.

that the model could have been a soldier or official in the administration of a Greek ruler, or perhaps a member of the household of a prominent Greek, while Kiang doubts that the head is a portrait and is inclined to regard it as a type rather than an individual. He could have been, of course, an Ethiopian nobleman who had come from Meroë to the Greek world for a number of reasons, personal or business, or merely to visit countries of which he had heard much.

Statuettes show the same variety as do the heads, and give evidence that the artists' keen observation expressed itself in the representation of a number of different poses. The majority of statuettes, whatever the medium may be, fall into the following categories: standing men or boys, some nude, others draped; squatting or crouched types; seated and kneeling figures; and dancers and others in action.

By far the best-known bronze statuette of a standing Negro from this period is the nude figure of a youthful musician from Chalon-sur-Saône;[183] his left arm probably held a musical instrument. The artist chose a graceful pose for his subject bending the body gently at the waist, and making effective use of the hands; and by careful attention to detail he created a sensitive face that ranks among the best in Hellenistic art. Another such work is the study in basalt of a young black in Athens[184] also apparently a musician; though the arms are broken off, they seem to have supported an instrument on the left shoulder. In both cases the artists were obviously attempting to capture the mood of the moment. The expressions of the youths suggest that their music recalled memories of their faraway homes. Even with a slight knowledge of an alien tongue, a newcomer could earn a livelihood as musician, singer, or dancer. In view of a common demand for exotic diversions, it is not unlikely that black entertainers were among those who ventured into Greek and Roman lands. Such itinerant black musicians are still popular in North Africa. Another example of the standing entertainer is a terracotta

figs. 253-255

figs. 256-258

253-255. Statuette of a young musician. From Chalon-sur-Saône. Hellenistic Period. Bronze. H: 20.2 cm. Paris, Bibliothèque Nationale.

253

254

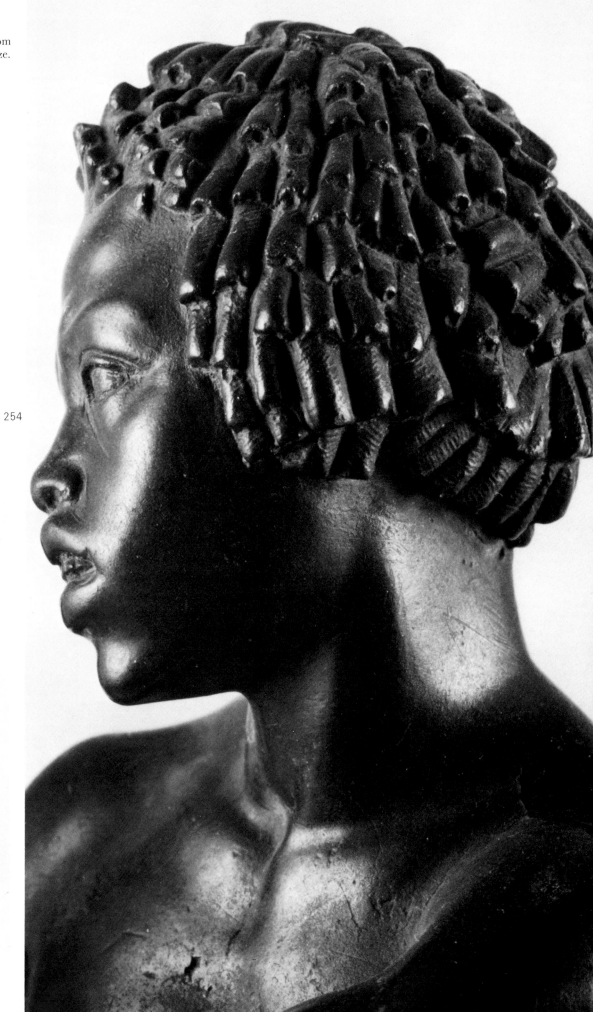

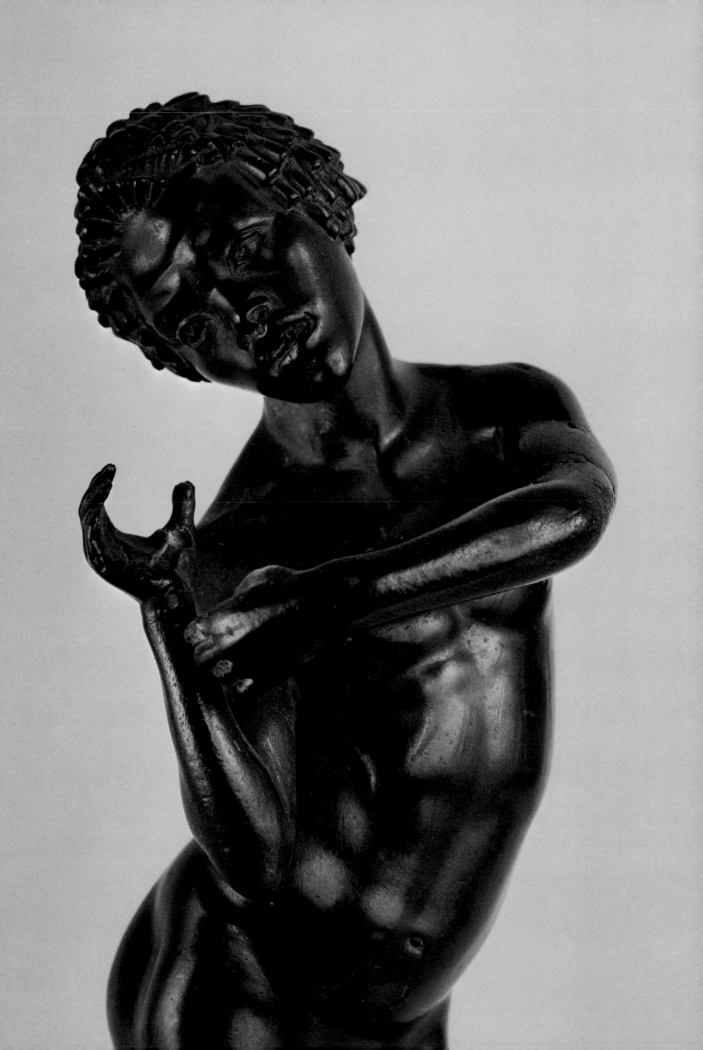

256-258. Statue of a young Negro, perhaps a musician. Hellenistic Period. Basalt. H: 40 cm. Athens, National Museum.

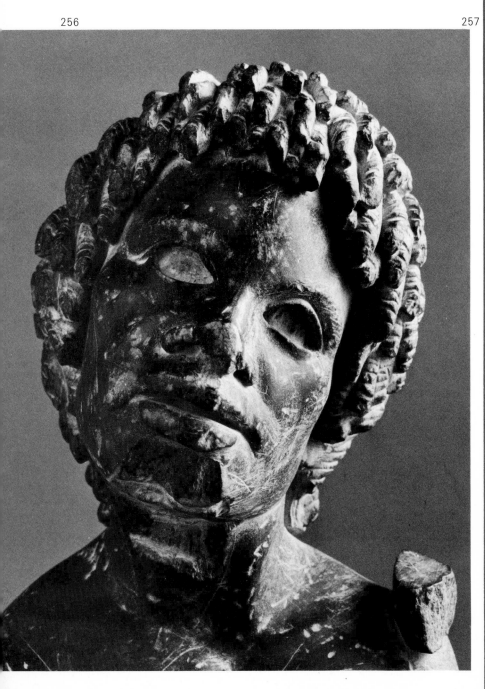

256

257

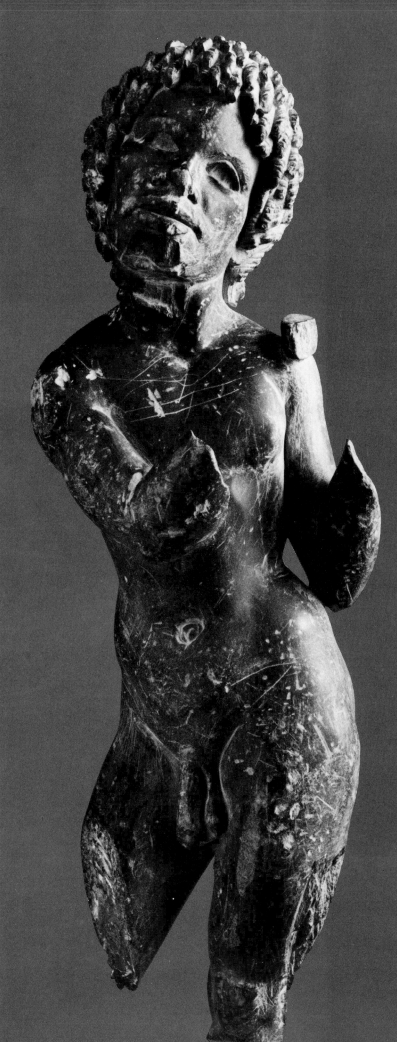

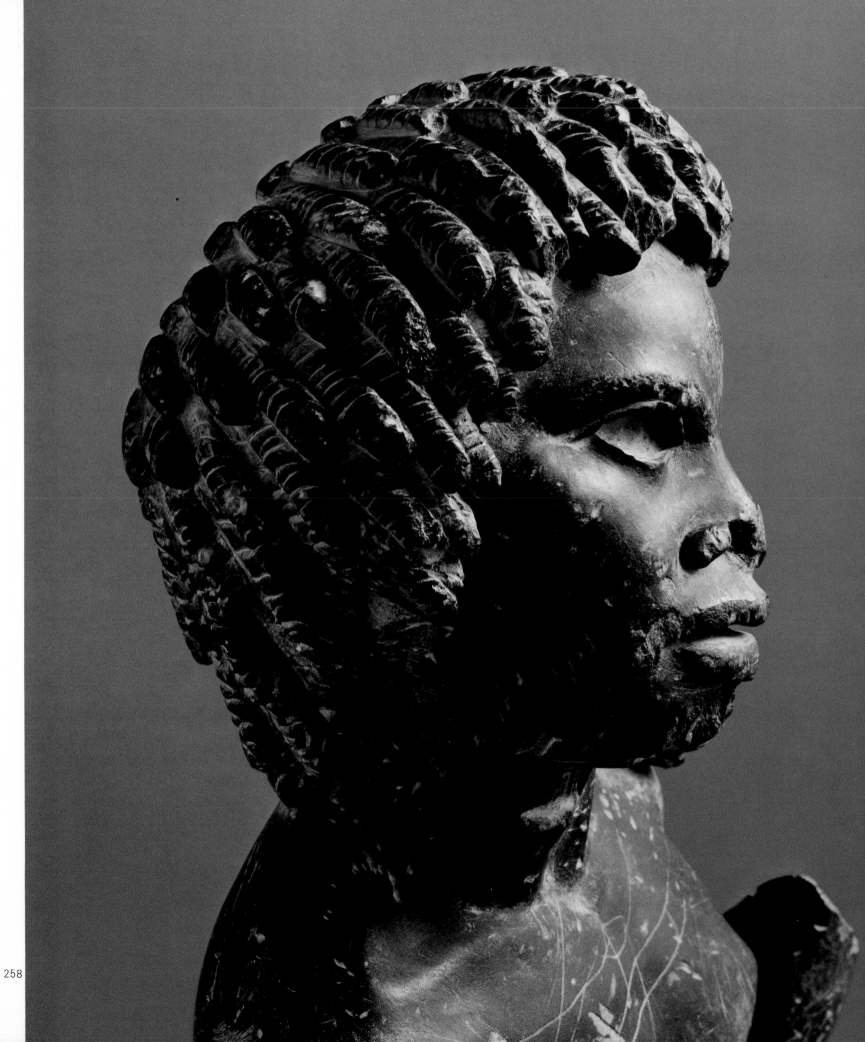

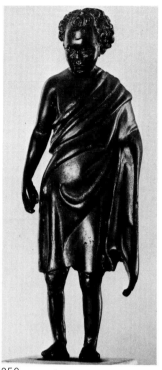

259

259. Statuette of a young orator. From Chalon-sur-Saône. Hellenistic Period. Bronze. H: 8 cm. Boston, Museum of Fine Arts.

260. Statuette of a young athlete. Hellenistic Period. Bronze. H: 18.3 cm. New York, Metropolitan Museum of Art.

261. Statuette of a captive or a slave. From Fayum. Hellenistic Period. Bronze. H: 13.2 cm. Paris, Musée du Louvre.

figure found in Tarentum, now in Trieste;[185] he is clothed only in a loincloth and holds what appears to be a castanet in his left hand.

Standing nude figures from the Hellenistic age include a Louvre bronze from the Fayum region,[186] representing a young slave or captive with his hands tied behind his back, smiling defiantly. Another, in Madrid, is a wreathed figure, with a tunic over the shoulder and forearm, holding a stick in the left hand and an indistinct object, possibly a torch, in the right.[187] Terracottas of this type may be illustrated by an excellent figure of an athlete,[188] and a pair of British Museum boxers[189] nude except for the midriff. One of the finest bronzes of the standing type is a statuette in the Metropolitan Museum[190] of a boy whose body is covered by a mantle twisted gracefully around his waist. The artist faithfully rendered the features of his model, and caught a vital and tense moment as the boy raises his left foot forward. Since the identification of the objects which he holds in his hands is not certain, he has been thought to represent either an athlete, a dancer, or a charioteer.

fig. 261

fig. 260

Turning now to the standing draped figures, we note two which deserve to be ranked among the best Hellenistic bronzes. One is a Boston statuette of a princely lad in the pose of an orator, probably the son of an Ethiopian nobleman sent to study with an Alexandrian master.[191] The other bronze, found at Bodrum,[192] is a statue of a boy with a slightly protruding stomach. This boy, who stands with arms outstretched and right hand almost completely closed, may also be an orator making an expressive gesture. In both instances the artists have captured the individuality of their models, whose less pronounced Negroid features suggest black-white mixture. Other examples of standing draped figures in bronze are the statuette of a Negro in the Bibliothèque Nationale[193] clad in a tunic, leaning forward as if pulling something, perhaps a cable; and another black in East Berlin[194] dressed in trousers, with his hands behind his back.

fig. 259
fig. 265

fig. 264

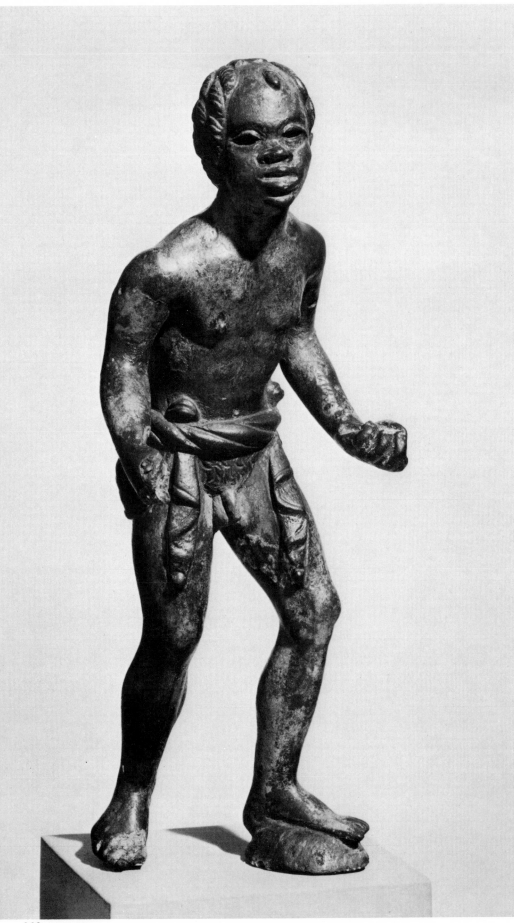

260

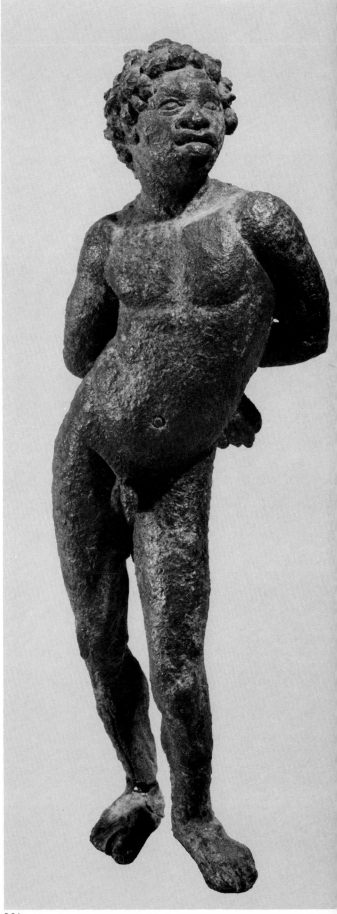

261

205

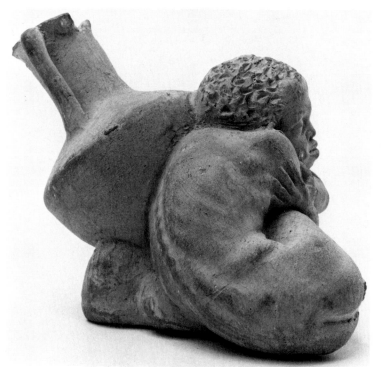

262

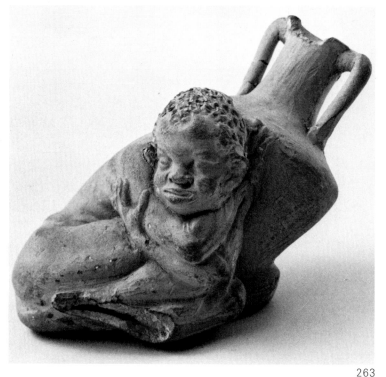

263

262, 263. Askos in the form of a youth sleeping beside an amphora. From Taranto. III century B.C. Terracotta. H: 6.3 cm. Oxford, Ashmolean Museum.

264. Statuette of a captive. From Egypt. Hellenistic Period. Bronze. H: 10.2 cm. East Berlin, Staatliche Museen.

265. Statue fragment: adolescent with Negroid features. From Bodrum. II or I century B.C. Bronze. H: 47 cm. Bodrum, Archeological Museum.

The squatting or crouching Negro, poverty-stricken and physically exhausted, was a favorite motif for Hellenistic artists, particularly in Egypt. It is not surprising that the compassion aroused by this spectacle caused them to produce several masterpieces, like the splendid Ashmolean terracotta figure of a boy asleep beside an amphora:[195] his backbone, ribs, and muscles, visible through the flesh, betray his half-starved condition. The entire conception, according to one critic, "for life-like realism and true pathos is probably without a rival amongst Greek terracottas."[196] A whole series of statuettes shows how exactly the craftsmen portrayed the way some Africans rest on their heels whether to work or to relax—a position which also impresses the traveller of today. A good example is a terracotta, in Alexandria, almost certainly a fragment of a lantern,[197] which represents a sleeping servingboy whose face is full of expression. Another is the bronze statuette from Alexandria in Athens[198] of an itinerant peddler, pitiably thin, asleep in front of his tiny tray of fruit, with his monkey on his right shoulder. Another position, that of a sleeping figure seated with his head resting on one raised knee, is caught in a small bronze, probably a Hellenistic original,[199] and in a ptolemaic statuette in limestone,[200] both in Copenhagen. A variant in black steatite in Boston[201] has the chin resting on both knees and the ankles linked together by bracelets. A quite different motif is seen in a British Museum terracotta which shows a black sitting on a rock and preparing to write on a scroll.[202] A statuette from Priene in West Berlin[203] is an imitation of the *Boy Pulling Out a Thorn (Spinario)*: a variation on a well-known theme, like the incense shovel, this terracotta gives us a sensitive study of a black boy. While terracotta was the most popular medium for this kind of statuette, other materials were also in use: this variety of types and styles is found in figurines of kneeling Negroes, one, in West Berlin, in black marble[204] and another, in Baltimore, in bronze.[205]

The movements of Negro entertainers, dancers, or juggglers provided

figs. 262, 263

fig. 267
fig. 268

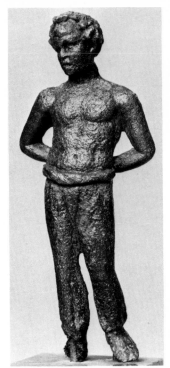

264

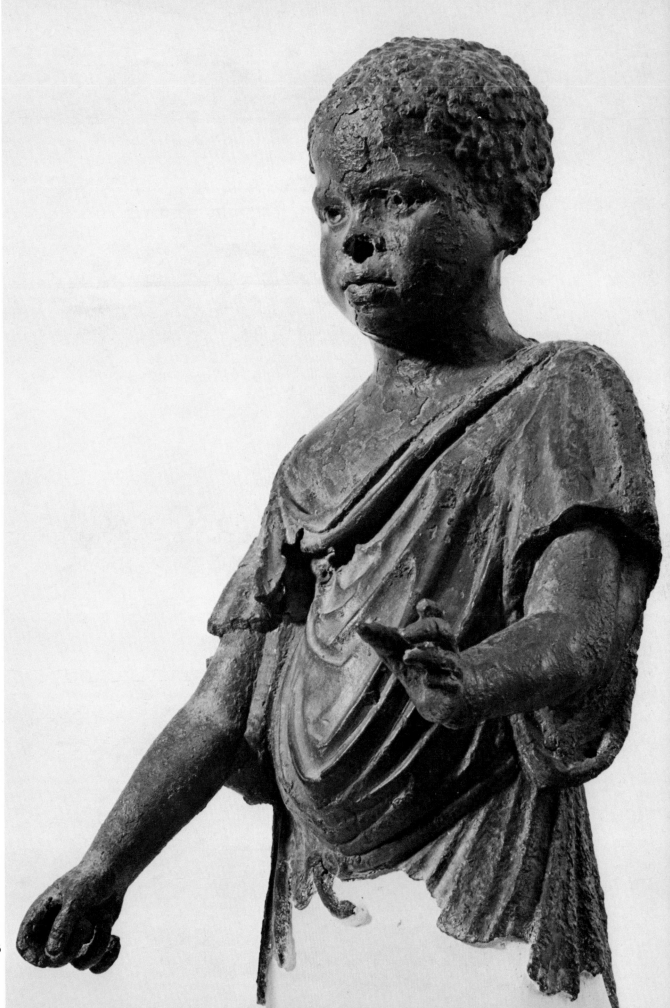

265

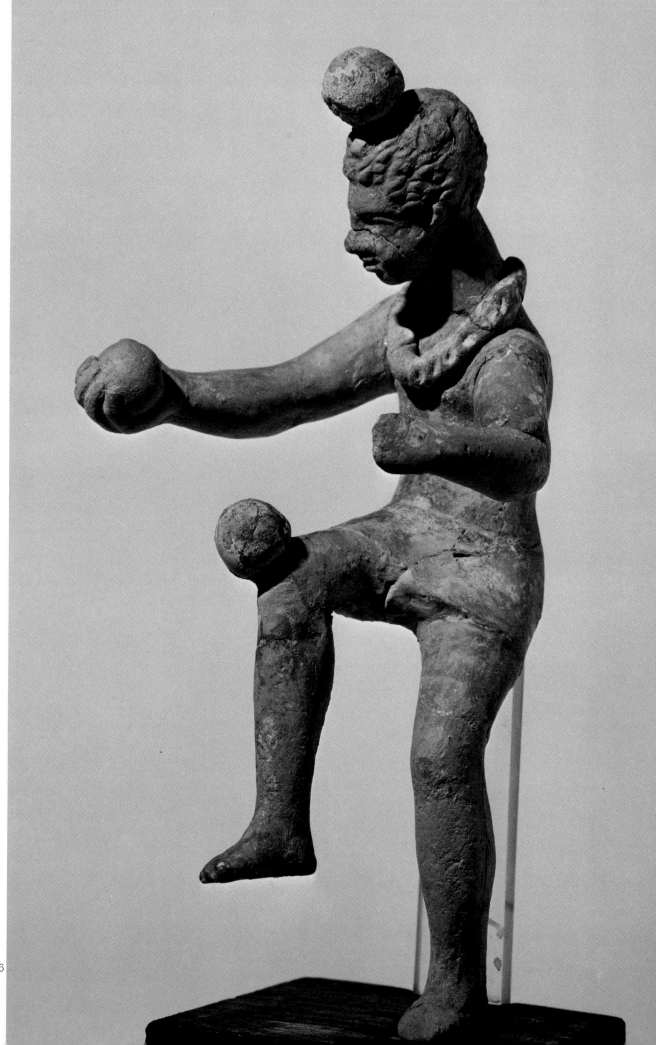

266. Statuette of a juggler. From Thebes. Hellenistic Period. Terracotta. H: 12.5 cm. East Berlin, Staatliche Museen.

267. Statuette of a Negro seated, writing on a scroll. From South Italy, Fasano. III century B.C. Terracotta. H: 20.4 cm. London, British Museum.

268. Statuette of a seated Ethiopian in imitation of the *Spinario*. From Priene. I century B.C. Terracotta. H: 17 cm. West Berlin, Staatliche Museen.

267

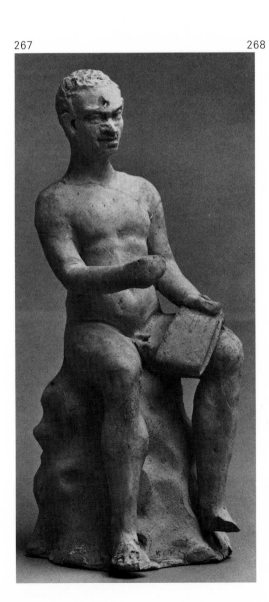

268

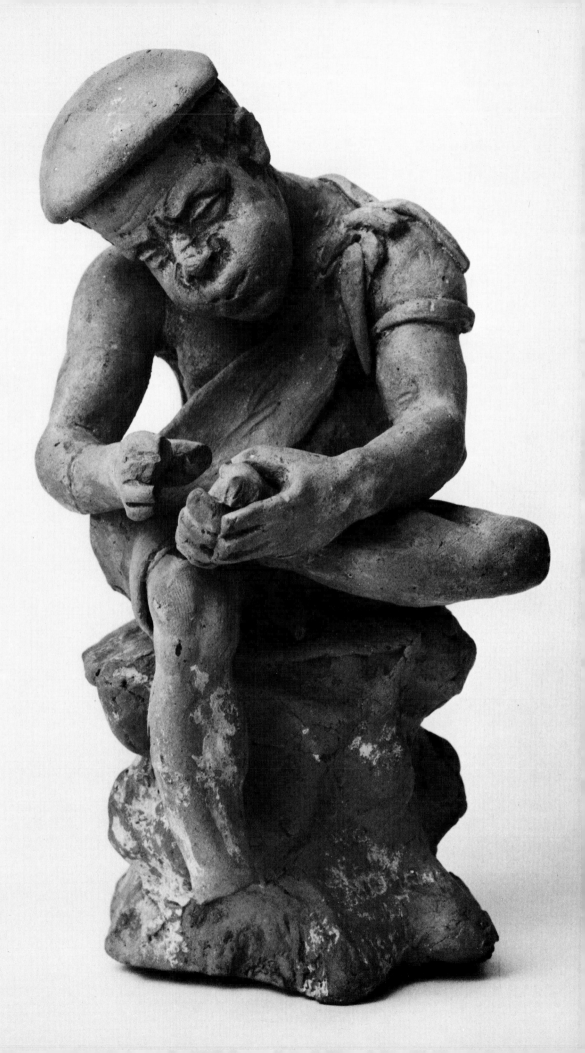

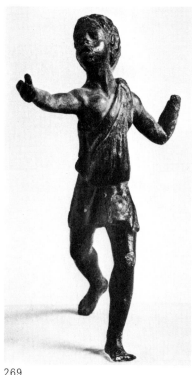

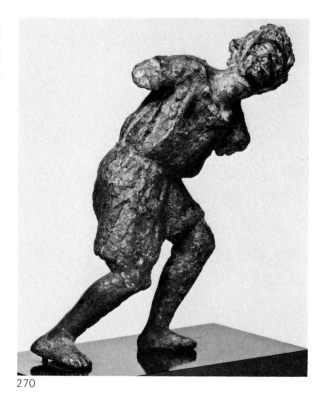

269

270

269. Statuette of a black dancer. From Herculaneum. Hellenistic Period. Bronze. H: 11.5 cm. Naples, Museo Archeologico Nazionale.

270. Statuette of a dancer (?). Hellenistic Period. Bronze. H: 10.1 cm. Baltimore, Walters Art Gallery.

271-274. Etruscan coins. Obverse: head of a black mahout. Reverse: elephant. III century B.C. Bronze. Diams: 1.8 and 1.9 cm. London, British Museum.

artists with an opportunity to create engaging studies of non-Greek types in action. Several bronzes have captured a kind of joyous agility. A dancer in Naples, balanced on the left foot, the right thrust backward, gracefully extends his arms outward;[206] in Baltimore, the figure, poised as a ballet dancer, with head slightly tilted back, gestures with his hands and executes a step skillfully.[207] Satyrlike leaps of Ethiopian war dancers were known to Heliodorus.[208] It was some such wild moment perhaps that attracted the creator of a bronze found at Carnuntum, which seems to represent the dancer at the instant when he has placed his full weight on his left foot, has thrust his right foot back, and has stretched his arms in order to maintain balance.[209] A pose that could be held only momentarily is the subject of another bronze in Baltimore.[210] A terracotta juggler from Thebes in East Berlin,[211] clad in a simple tunic, stands on one foot, the other leg bent, and is intent on juggling three balls. By far the best-known Hellenistic statue of a mixed black-white type in a momentary pose is that of the bronze jockey in Athens,[212] agile, tense, anxiously straining in an effort to ride his mount to victory.

fig. 269

fig. 270

fig. 266

fig. 275

Included in an elaborate animal frieze of the late third or early second century decorating the wall of a tomb at Marissa (Marêshah) in Palestine was an elephant, with a Negro attendant, labelled *Aethiopia*.[213] The frequent association of the elephant with Ethiopians[214] shows that the combination was regarded at times as a personification of Ethiopia.

The popularity of the Negro in Hellenistic art, the understanding of the life of this non-Greek people in alien lands, and the care and skill with which blacks are portrayed, reflect the cosmopolitanism of the age and prompt the inference that the sentiment of the kinship of all men as expressed by Menander and later adapted by Terence—"I am a man; I consider nothing human foreign to me"[215]—was not limited to philosopher or dramatist.

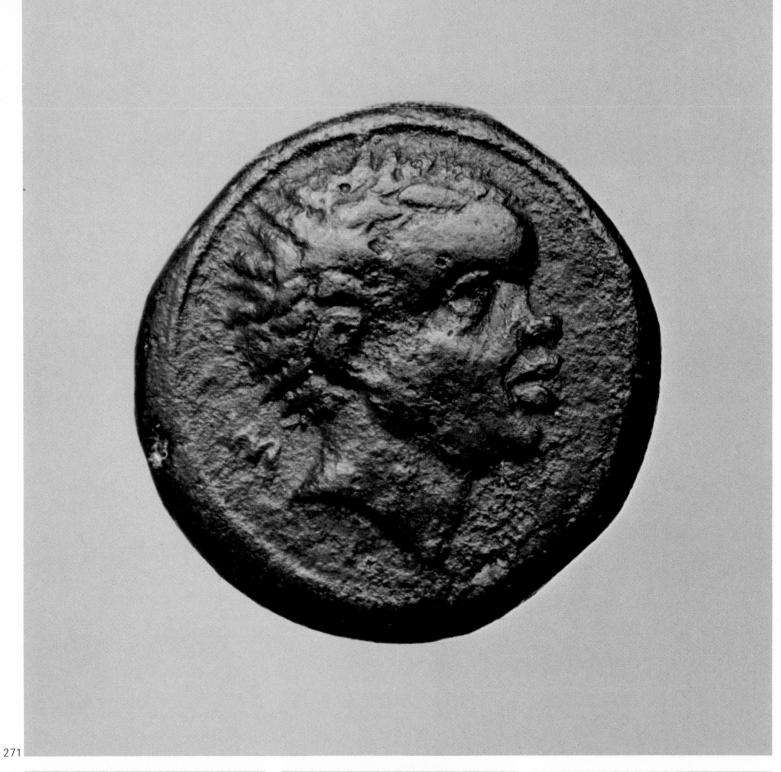

271

272

273-274

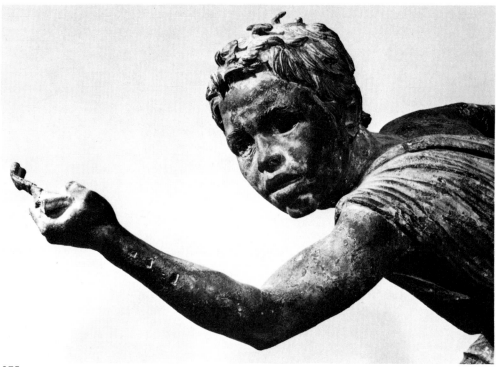

275. Statue of a jockey, detail of head. From Cape Artemisium. Late III century B.C. Bronze. H of figure: 84 cm. Athens, National Museum.

275

ROMAN PERIOD

Plautus was the first Roman author to make mention of blacks,[216] and in one instance he seems to imply the presence of Ethiopians on Italian soil, if the bucket-carriers at the circus, mentioned in the *Poenulus*, are to be identified as Ethiopians.[217] A roughly contemporary testimony on the type of black which Plautus may have had in mind is provided by the physical traits of a Negro appearing on the obverse (with an elephant on the reverse) of a third-century coinage.[218] Until recently these coins have usually been related to Hannibal's elephants and the impression made by the Carthaginian general's Negro mahouts upon the population of North Italy. Those who propose this theory argue that the coinage, perhaps issued in the neighborhood of Val di Chiana, was struck at a time when relations between Rome and her Etruscan allies in the area were strained.[219] E. S. G. Robinson specifically suggests Arretium as the provenance and 208-207 B.C. as the date of the issue.[220] F. Panvini Rosati, however, holds for an earlier date: in his view the coins were issued after the defeat of the Carthaginians at Panormus in 250 B.C., when L. Caecilius Metellus captured a large number of war-elephants.[221] After the Roman victory, Panvini Rosati notes, captured elephants were reported to have been paraded throughout Italy.[222]

figs. 271-274

Whether we accept the earlier or later dating, the Negro, as Robinson has pointed out, is surely the animal's driver, which leads to the probability that the Romans had encountered Negro mahouts among Carthaginian forces, perhaps in both the First and Second Punic wars. For it should not be forgotten that black auxiliaries, if we can trust Frontinus, served in the Carthaginian army as early as the fifth century B.C.[223] The Negro's experience in handling elephants is also attested by a later Pompeian terracotta in Naples, of a Negro riding a tower-bearing elephant,[224] and by several references in the literature of the empire.[225] In view of the probable import of the Plautine

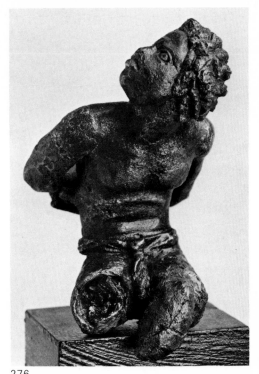

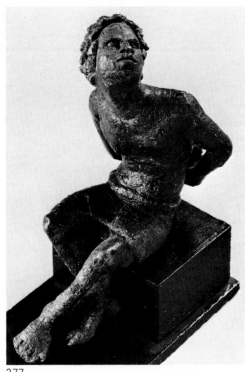

276

277

276, 277. Two statuettes of captives. Late I century B.C. Bronze. H: 11 and 13.3 cm. East Berlin, Staatliche Museen.

reference and of the realism of the images on the bronze coinage, the later inclusion of Ethiopians and Nubae in the list of Hannibal's troops as given by Silius Italicus[226] should not be lightly dismissed.

Allusions to blacks, scarce in Republican literature, became more numerous in the Augustan era. Increased acquaintance with the Negroid type, due to Roman activity in Africa, is also reflected in the art of the period. Like the Greeks, the Romans, from the time of Augustus until late in the empire, came to know very well the Ethiopians in Egypt and those from the south: both military encounters and diplomatic relations contributed to this knowledge. C. Petronius, prefect of Egypt, was required to engage in two campaigns between 24 B.C. and 22 B.C.[227] and to sponsor diplomatic conferences with Ethiopian ambassadors before a settlement was reached. In the course of these operations Petronius captured some generals of the Ethiopian queen, whom he sent to Alexandria: on one occasion he sent one thousand prisoners to Augustus.[228] Two Negroes in bronze, in East Berlin,[229] with their hands tied behind their backs, have been considered a record of prisoners taken in one of the Petronius campaigns. There can be little doubt that the many terracotta figurines of Negro warriors found in Egypt were recollections of the black soldiers whom the Romans of the early empire encountered. Strabo[230] informs us that the Ethiopian equipment consisted of oblong shields made of oxhide, axes, pikes, and swords. Several of these statuettes show some of the axes to be double-edged,[231] some shields oval and others rectangular.[232]

figs. 276, 277

fig. 278
fig. 279

Encounters with Ethiopians south of Egypt during the reign of Nero received notice by Roman authors. Records of diplomatic exchanges between Romans and their Ethiopian opponents have been preserved. A life-size marble bust in the Museo Torlonia in Rome,[233] of perhaps Flavian date, with a draped cloth over the left shoulder, may represent one of the Negroes who participated in such diplomatic relations. Other evidence of such

fig. 280

213

278. Statuette of a warrior carrying a double-edged ax. From Fayum. II or III century A.D. Terracotta. H: 21.5 cm. Houston, Menil Foundation Collection.

279. Statuette of a warrior carrying an ax and a shield. From Egypt. Roman Period. Terracotta. H: 19 cm. Amsterdam, Allard Pierson Museum.

280. Bust of an Ethiopian. I century A.D. Gray-black marble. Diam of medallion: 140 cm. Rome, Museo Torlonia.

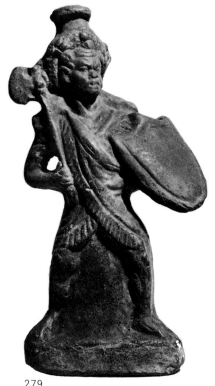

279

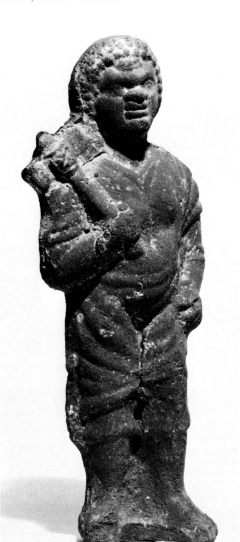

278

contact in Egypt is provided by the yellow limestone head of a Negro in Copenhagen,[234] found in Meroë, which has been considered a gift of a Roman official to a Meroïtic king or the work of an itinerant Roman sculptor in Nubia about 100 A.D.

It was not only in Egypt and the regions to the south that the Romans came in contact with Ethiopians. As a result of their activity in various parts of North Africa, the Romans developed an intimate acquaintance with blacks living in the cities along or near the North African coast. While North Africa is treated in detail elsewhere in this volume, it is relevant to my essay, however, to mention that blacks from North Africa found their way to other regions of the empire, where art and literature also helped to make them better known. Among the troops of Septimius Severus in Britain, for example, the *Historia Augusta* notes the presence of an Ethiopian soldier;[235] a *numerus Maurorum* was stationed at a third-century garrison at Aballava (Burgh-by-Sands).[236] The emperor, therefore, may well have recruited other Ethiopians among his auxiliaries.[237] The presence of seemingly Negroid soldiers, with conical caps, on the Arch of Septimius Severus in the Roman Forum,[238] is probably not fortuitous. Also worthy of note in this regard is a scene on a Palazzo Rondinini sarcophagus of the early third century A.D. in which two figures, one a helmeted Negro, stand to the right of a Roman general, whose features resemble those of Septimius Severus.[239] The officer fig. 281 grasps the hilt of his sword with one hand and extends his other hand toward suppliant barbarian warriors as a female prisoner is brought forward against her will. Though the reason for the presence of the Negro is not certain, the suggestion that he was a bodyguard[240] is plausible in view of the African connections of Septimius Severus and the mention of an Ethiopian in the troops of the emperor in Britain.

It was no doubt the presence of blacks in the population of North Africa, as attested by both art and literature, that called them to the attention of

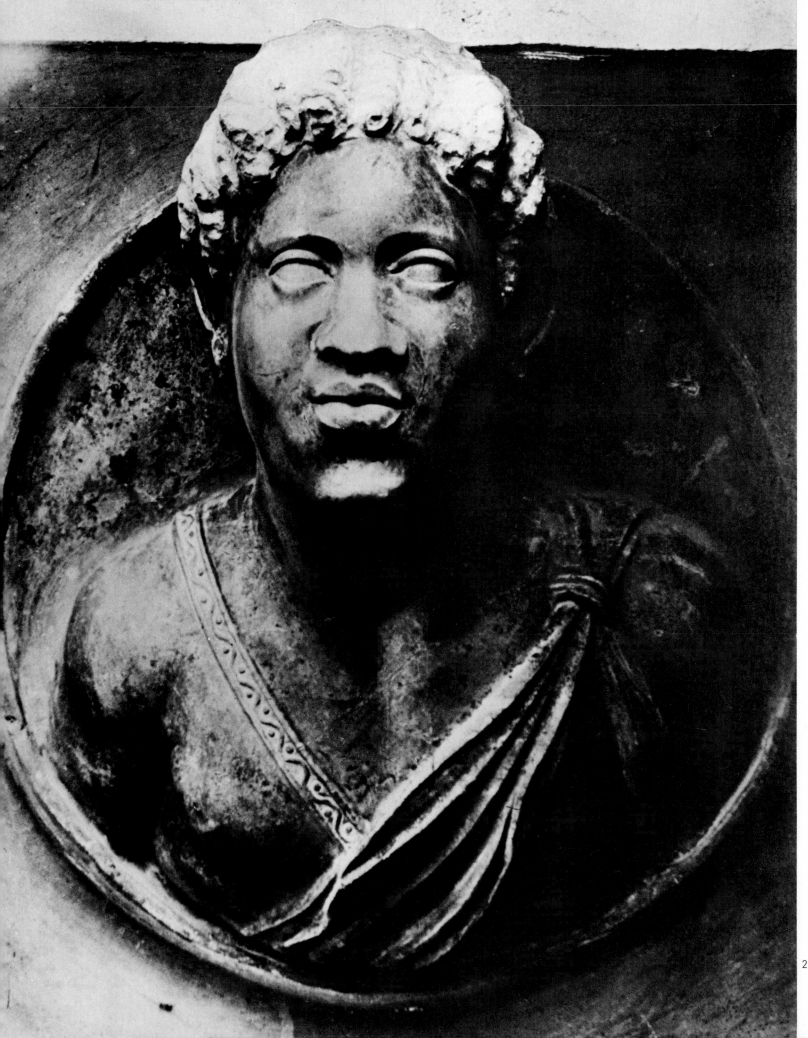

280

St. Augustine. It is reasonable to suggest that Augustine's awareness of Ethiopians and his use of Ethiopians in his imagery reflected his experience with blacks whom he knew and saw as he travelled about North Africa. With the words "*Aethiopia credet Deo*" Augustine included Ethiopians in his vision of Christian brotherhood.[241] His commentaries on verses from Psalms[242] and his observations in the *City of God*[243] made unequivocal pronouncements on the black man's inclusion in the Church. Correspondence from the end of the fifth century A.D. between a deacon, Ferrandus of Carthage, and St. Fulgentius, Bishop of Ruspe, in the North African province of Byzacena (southern Tunisia) concerning a Negro slave[244] is an interesting practical application of the principle enunciated by St. Augustine, that the Church, as the glory of God demanded, was to embrace the Ethiopian who lived at the end of the world.

The technique of certain mosaics of the Imperial Villa at Piazza Armerina, it has been noted,[245] is comparable in some respects to that of mosaics of 300 A.D. in Tunisia and Algeria. Many of the episodes, especially the hunting scenes, were of North African inspiration and may well have been the work of craftsmen who came from North Africa. In the *Little Hunt*, in which hunters are being served by slaves, a Negro boy on his hands and knees blows on the smoldering embers of a fire.[246] A detail of the *Great Hunt*[247] depicts a cart drawn by two zebus and loaded with animals in cages, while an Ethiopian with thick, curly hair, of a mixed black-white type common in North African mosaics, leans backwards to urge on his team. fig. 283

Allegorical personifications of "Africa," even though in some instances possibly inspired by Hellenistic concepts, may reflect an increased knowledge of African physical types. We have seen that as early as the fifth century B.C. the painter of a calyx-krater chose a mulatto woman to personify Ethiopia.[248] In a fresco at Pompeii[249] representing the apotheosis of Alexandria, the city is symbolized by a woman enthroned in the center, Asia and a dark- fig. 282

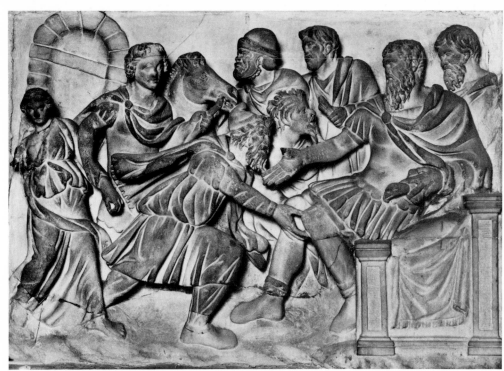

281. Sarcophagus fragment: barbarians before a Roman general surrounded by soldiers. First half III century A.D. Marble. 57 × 82 cm. Rome, Palazzo Rondinini.

281

skinned Africa on either side. Sidonius Apollinaris[250] speaks of Africa weeping, with her black *(nigras)* cheeks torn. The author of the Pompeian fresco used the color of the skin as the distinguishing characteristic, and we find the same usage in the later mosaic, representing a woman flanked by a tiger and a small elephant, on the pavement of the south apse of the *Great Hunt* gallery at Piazza Armerina.[251] This scene has been interpreted as personifying Africa or Egypt. In other instances, however, artists of the Roman period were not satisfied to suggest "Africa" merely by pigmentation, which varied from region to region. "Africa," as seen by one sculptor, was a mulatto woman with flat nose, thick lips (neither feature very pronounced), and long flowing hair.[252] The sculptor of a marble statuette from Lower Egypt, of the first century A.D. or a little earlier, created a graceful figure whose hair, covered with the skin of an elephant's head, hangs down in an undulating mass. A transparent drapery, bound at the waist, drops loosely down to her sandals and reveals her delicately youthful figure. Beside her lies a lion, like a watchdog, with half-open mouth. At her side is an object, the purpose of which is not clear, but which may have supported the right hand holding a cornucopia. Here "Africa" is neither a Negro of the pronounced type nor a Berber, but a black-white mixture whose exotic features were of much interest to the careful observer.

fig. 286

F. Cumont has published a marble head dating from the first century A.D., its place of origin perhaps in Ostia. He considers the piece to be a fragment from a statuette of the goddess Libya.[253] "It probably stood in an oratory," he writes. "If it really was found in Ostia, some merchant from Cyrene, established in that port, probably worshipped this divinity of his country with the hope that she would prosper his undertakings." The traits are idealized, but the head may be recognized as that of a mulatto or a quadroon; among other characteristics, the rather broad nostrils and thick lips led Cumont to regard it as Negroid. Following his example, and in view of

fig. 285

217

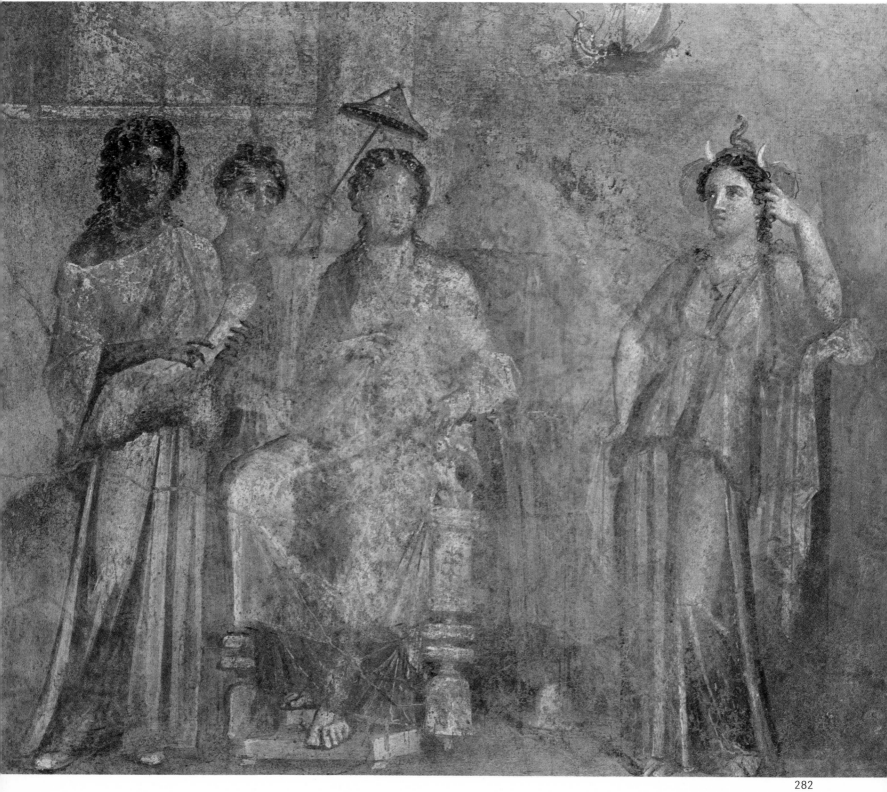

282. Apotheosis of Alexandria enthroned between Asia and Africa. From Pompeii, House of Meleager. I century A.D. Mural painting. 98 × 141 cm. Naples, Museo Archeologico Nazionale.

283. *Great Hunt Mosaic.* Detail: Ethiopian leading a team of oxen. IV century A.D. Piazza Armerina, Imperial Villa.

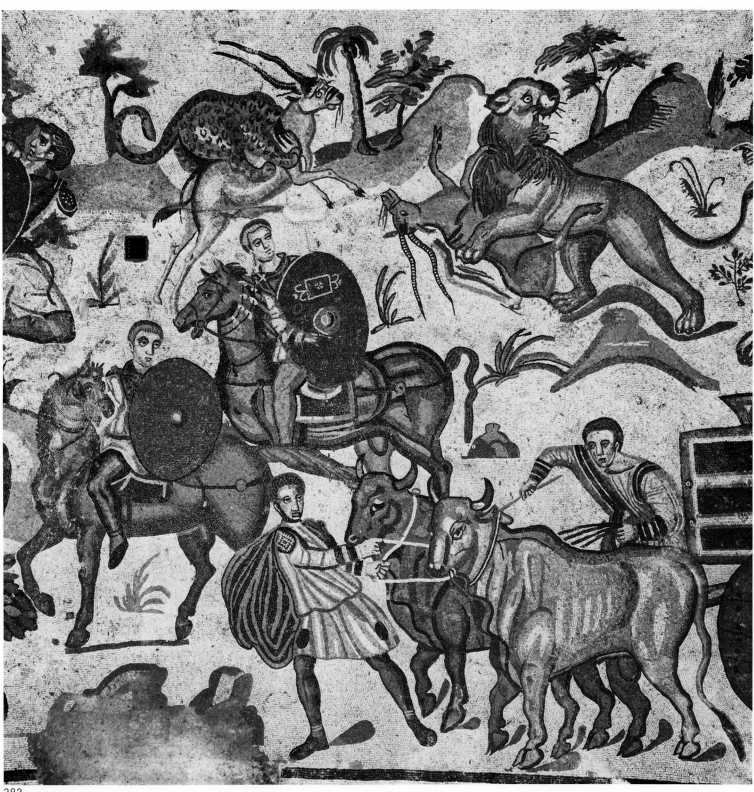

283

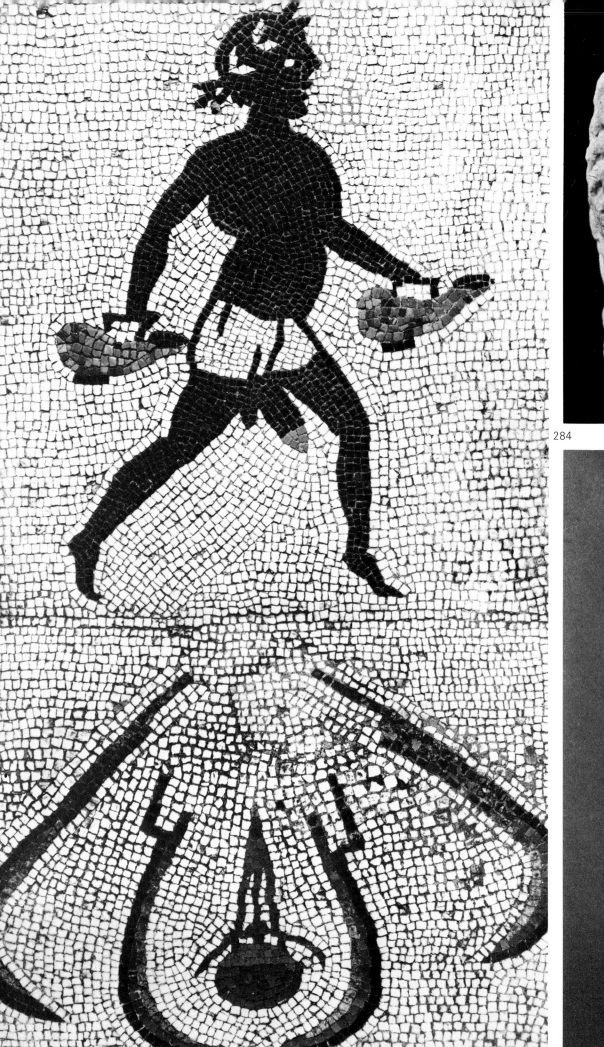

284 285 △ 286 ▽

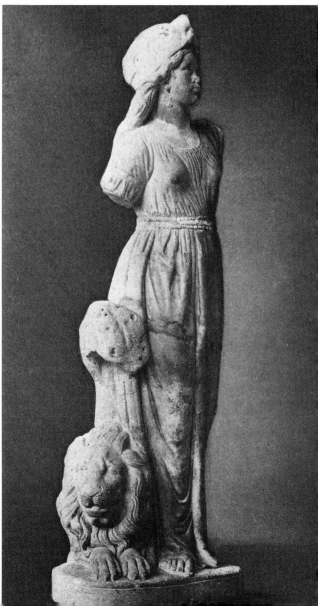

287

284. Mosaic: black bath-attendant. I century A.D. 100 × 60 cm. Pompeii, House of the Menander.

285. Head of a woman representing Libya. From vicinity of Rome. I century A.D. Marble. H: 14.5 cm. Private Collection.

286. Statuette: allegory of Africa. From Lower Egypt. I century A.D. Marble. H: 72 cm. Whereabouts unknown.

287. Vase in the form of a Negro head. From Pompeii. I century A.D. Enamelled red glass. H: 10.5 cm. Naples, Museo Archeologico Nazionale.

288. Isiac ceremonial with several black officiating priests. From Herculaneum. I century A.D. Mural painting. 81 × 82 cm. Naples, Museo Archeologico Nazionale.

289. Isiac ceremonial: sacred dance performed by a black. From Herculaneum. I century A.D. Mural painting. 87 × 83 cm. Naples, Museo Archeologico Nazionale.

the concordant testimony of texts, archeology, and anthropology, it is reasonable to grant North Africa its place when mixed types in Roman art are under study.

The presence of the Negro in Campania during the early empire is attested by various sources, including two literary references. According to Dio Cassius,[254] when Nero was entertaining Tiridates at Puteoli, on one day "no one but Ethiopians—men, women, and children—appeared in the theater." A concentration of Ethiopians in the Campanian area would be expected, since Puteoli was a thriving harbor and docked a steady succession of ships from Alexandria. Nero's Ethiopian ventures have been referred to previously. Petronius, who knew Campania well, introduces at Trimalchio's banquet two long-haired *(capillati)* Ethiopians, who were just like the men who scatter sand in the amphitheater:[255] in mentioning Ethiopians in the amphitheater Petronius seems to be referring to a not uncommon sight. A record of the presence of black girls is preserved in Pompeian graffiti.[256]

Archeological discoveries in Campania have impressively complemented and corroborated the written records. Among the casts of bodies of people who perished during the eruption of Vesuvius in 79 A.D. was one which has been regarded as Negroid especially on the basis of the lips and nose.[257] A macrophallic Negro is seen in a mosaic at the entrance to the caldarium of the House of the Menander:[258] he wears a wreath of leaves, and carries an askos in each hand. His appearance is important especially because it shows one of the ways blacks were employed—namely as bath-attendants—attested elsewhere in art and literature. The mosaic may also be additional proof of the presence of blacks in Campania, as well as a vase in the shape of a Negro's head, found at Pompeii.[259]

fig. 284

fig. 287

Among the participants in Isiac ceremonials painted on a pair of frescoes from Herculaneum, in the Naples museum, are several dark-skinned figures, some obviously intended as Negroes, others as white. In a discussion of one of

221

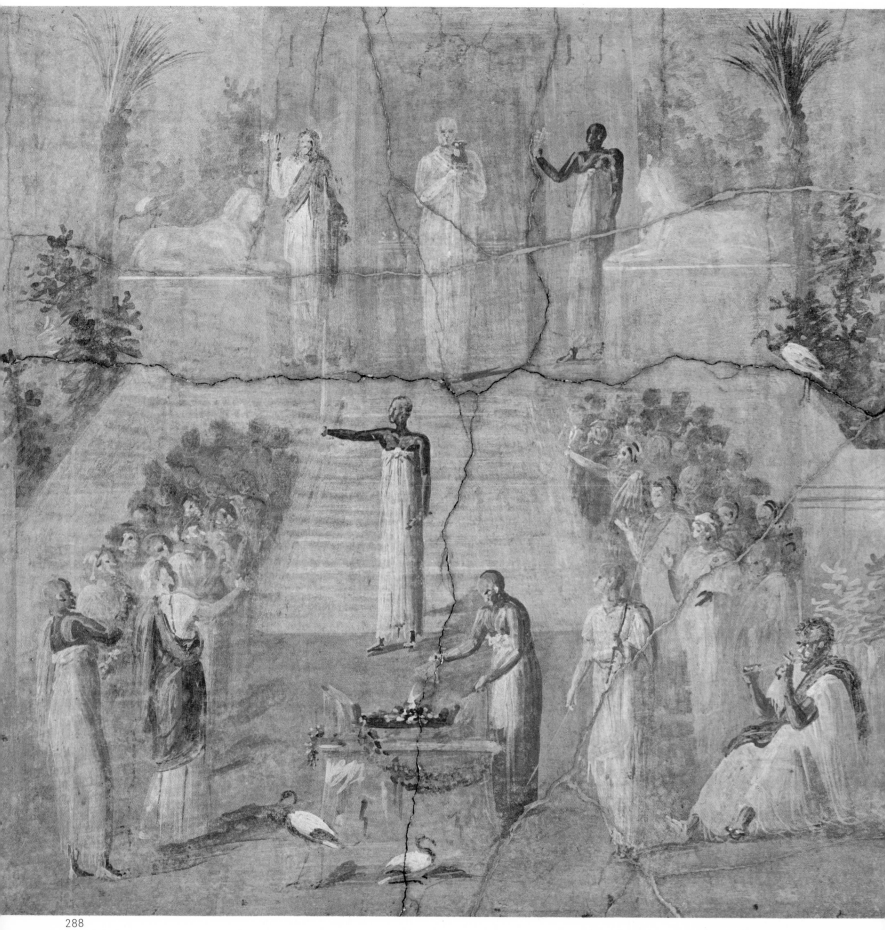

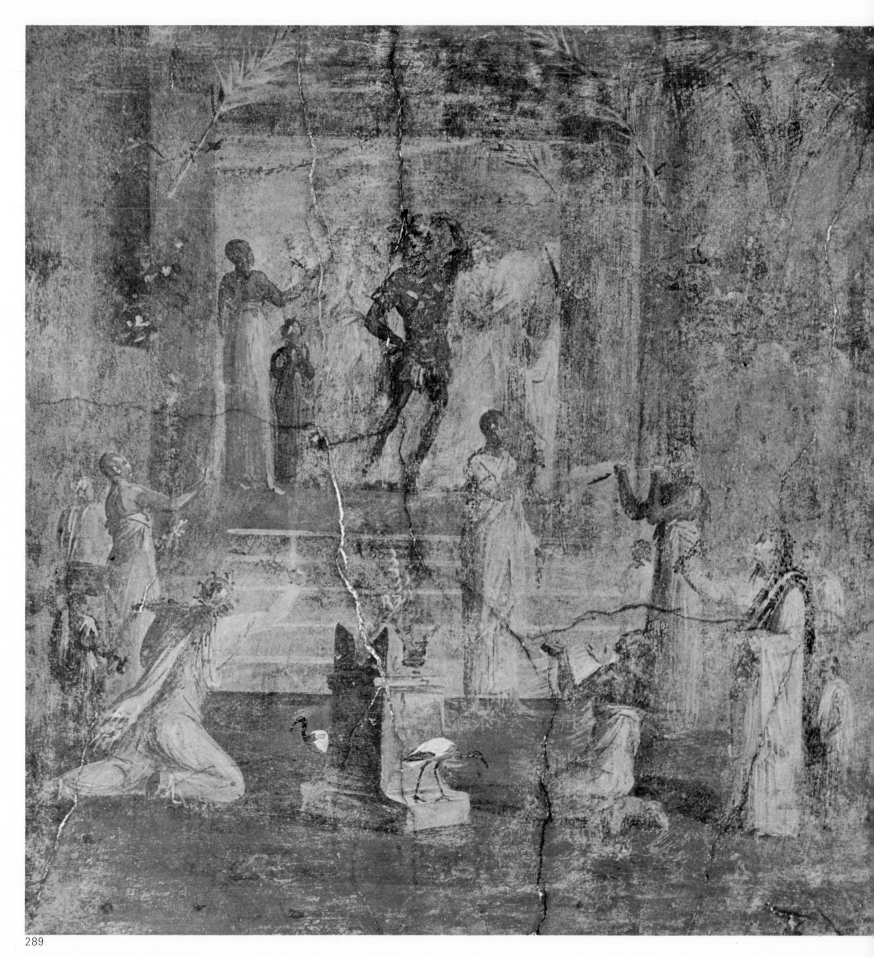

290. Statue of a youth standing with arms extended forward. From Tarragona. I century A.D. Bronze. H: 82 cm. Tarragona, Museo Arqueológico Provincial.

291, 292. Statue of a singer or actor. From vicinity of Naples. II century A.D. White marble. H: 167 cm. Naples, Museo Archeologico Nazionale.

these paintings G. Ch.-Picard [260] expresses the opinion that the artist may well have depicted a scene which he had observed at first hand. The author specifically calls attention to three black figures whom he designates as Negroes: one of two officiants flanking the high priest as he leaves the sanctuary; a figure standing at the bottom of the temple steps, gesturing imperiously at a group of worshippers; and a person seated in front, playing a flute. In order to heighten the dramatic effect, the painter used these Negro devotees to advantage: they are contrasted with the other participants, and enliven the scene with the brilliance of their long white tunics, which emphasize the ebony hue of their heads and shoulders. Of the several blacks in the companion Isiac fresco, [261] one central figure, executing perhaps an authentic African dance, is performing what is apparently an important part of the ritual, as the eyes of most of the worshippers are focused upon him. Participation in Isiac worship would be expected in light of other evidence that Ethiopians, when they came to Greece and Italy, retained their enthusiasm for Isis, who was so popular with them in Africa. [262]

fig. 288

fig. 289

Found also at Herculaneum was a marble relief, now in Naples, of a charioteer [263] leaning eagerly forward as he holds the reins. A Negro, whose life-size statue in white marble was found near Naples, [264] has been considered a singer or actor of the second century A.D. Perhaps his reputation equalled that of Glycon, a tragic actor in the time of Nero, a tall, dark man with a hanging lower lip, manumitted by the emperor, who bought out the interest of one of his owners for three hundred thousand sesterces. [265] Both the literary and archeological evidence, therefore, is sufficient to show that blacks resided in Campania and that artists used some of them as models.

figs. 291, 292

Works found from England to Meroë and from Spain to Asia indicate that Negroes were a common sight in more than one province. The artists of the first centuries after Christ shared the interest of earlier eras in blacks. Even if many of the art objects came from studios in Egypt or Italy, the very popularity of certain types implies a widespread demand. [266] Further, the physical features give us some idea of the racial types known to the populations of the empire and of what the word *Ethiopian* meant when it was used in a text of the period.

Hellenistic inspiration is obvious in many Roman works, as, for example, in several studies of standing nude boys in bronze. In one of these from the late Republican or early Imperial period, [267] found at Perugia, in the British Museum, the artist has studiously rendered the boy's features and slender body; left hand upward and right hand on his hip, the boy presents a striking pose. A standing boy with a noticeably protruding stomach is also the subject of another bronze at Tarragona. [268] In this instance the nude youth has his hands in front of him, palms up. In still other studies the artists have varied the upright posture with equal effect: these differ in the slight bending at the waist and the changed position of the hands. The graceful posture of a bronze found in Reims [269] is reminiscent of the youthful Chalon-sur-Saône musician. [270] The features being highly individualized and the hair differently treated, each of these four heads represents a distinct type of Negro.

figs. 290, 303

figs. 295, 296

Standing draped boys were also cast by artists in the Roman period. Hellenistic influence is apparent both in the general conception of the figures and in the handling of the drapery of two bronze statuettes, one found at Augusta Raurica near Basel, [271] and the other at Avignon. [272] In fact, a glance

figs. 293, 294

290

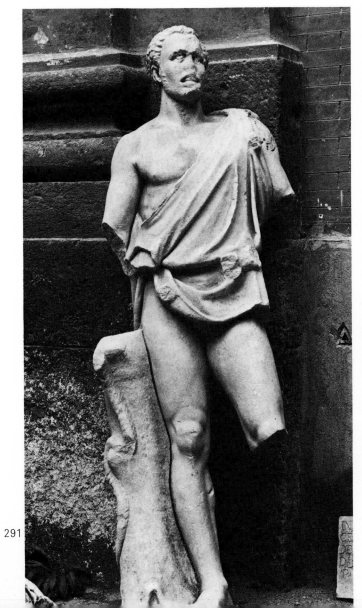

291

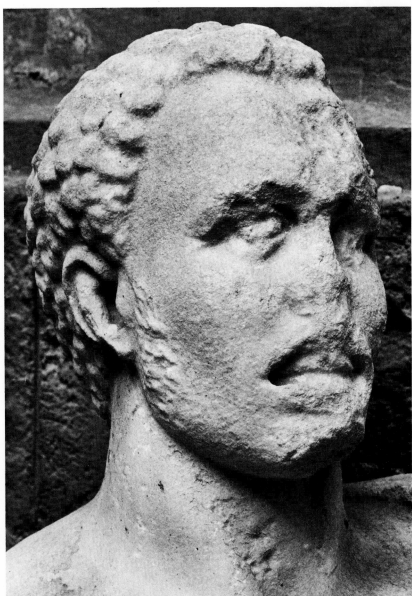

292

293. Statuette of a draped Ethiopian. From Augusta Raurica. Roman Period. Bronze. H: 6.8 cm. Augst, Römermuseum.

294. Statuette of a draped Ethiopian. From Avignon. Roman Period. Bronze. H: 6.1 cm. Saint-Germain-en-Laye, Musée des Antiquités Nationales.

295, 296. Statuette of a nude, black youth. From Reims. Roman Period. Bronze. H without base: 16 cm. Saint-Germain-en-Laye, Musée des Antiquités Nationales.

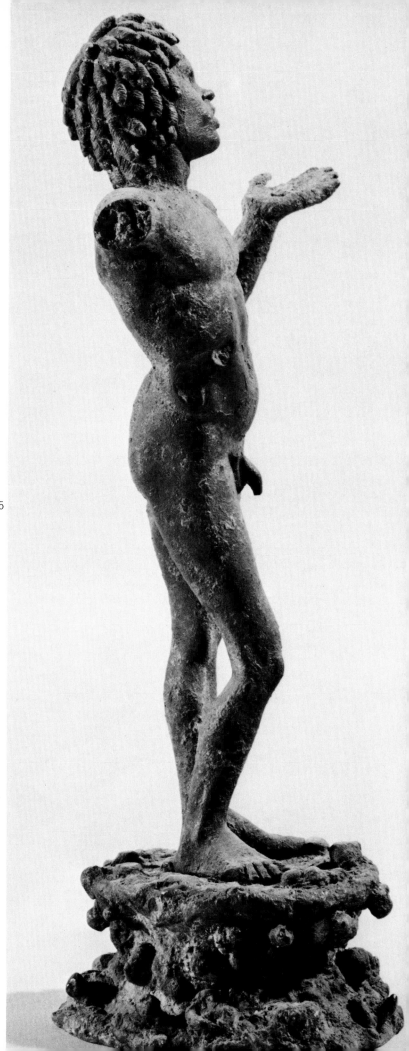

293
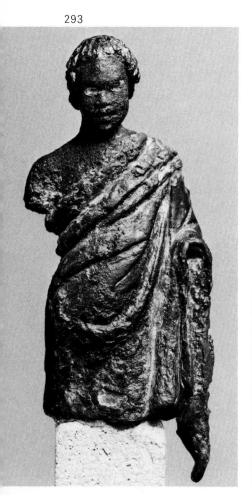

294
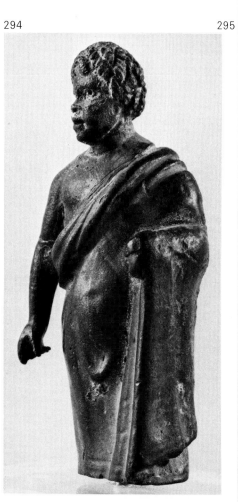

295

226

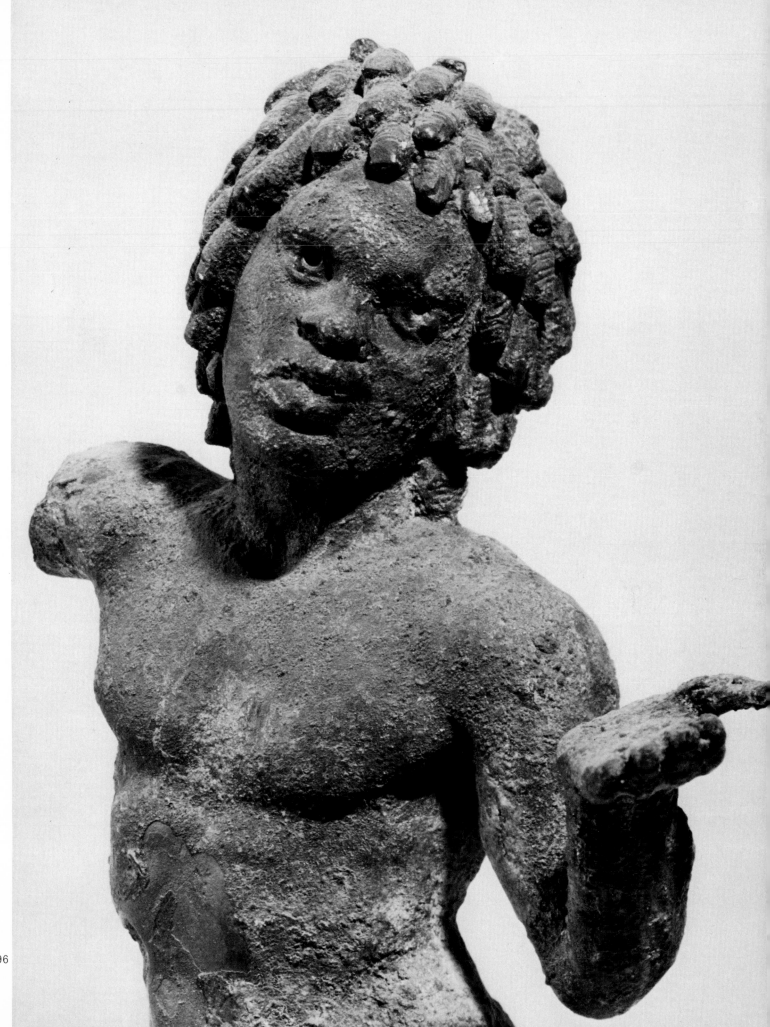

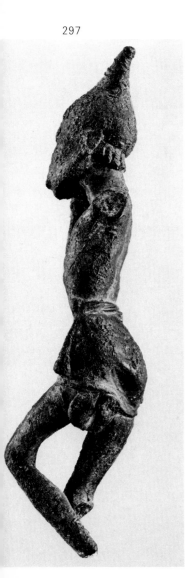

297

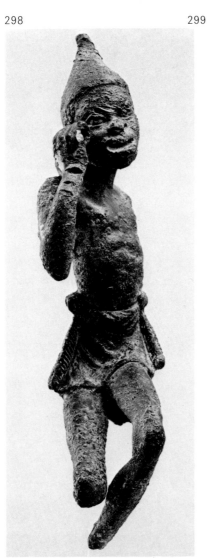

298

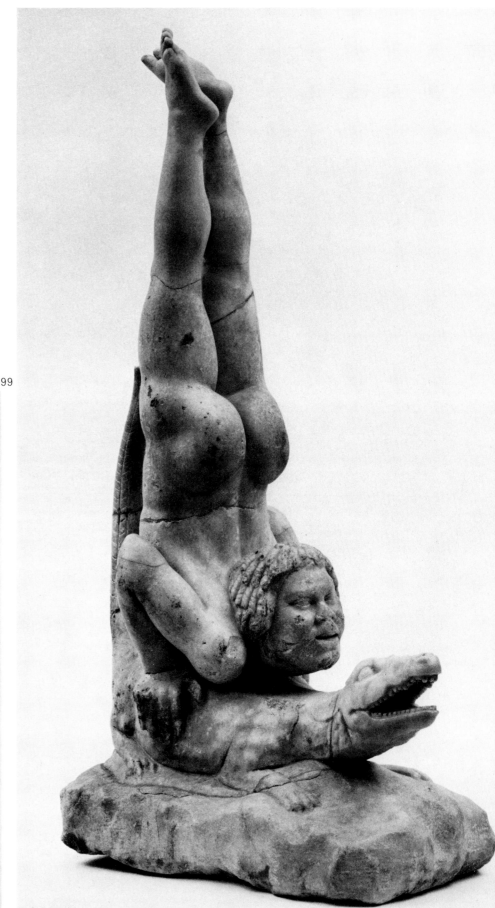

299

228

297, 298. Statuette of a phlyax-actor. I century B.C. or I century A.D. Bronze. H: 17 cm. Houston, D. and J. de Menil Collection.

299. Statue of an acrobat balancing on a crocodile. Roman Period. Marble. H: 75 cm. London, British Museum.

300. Statuette of a tightrope walker clad in a short tunic. From Saint-Ay. Roman Period. Bronze. H: 16 cm. Orléans, Musée Historique et Archéologique de l'Orléanais.

301. Statuette (partially melted) of a Negro. Roman Period. Lead. H: 6 cm. Wall, Letocetum Museum.

302. Rattle: child asleep in a squatting position. From Corinth. I century A.D. Terracotta. H: 8.7 cm. Corinth, Archeological Museum.

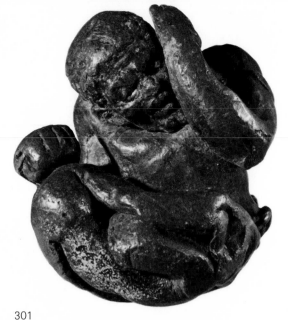

301

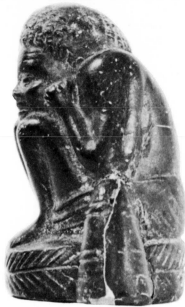

302

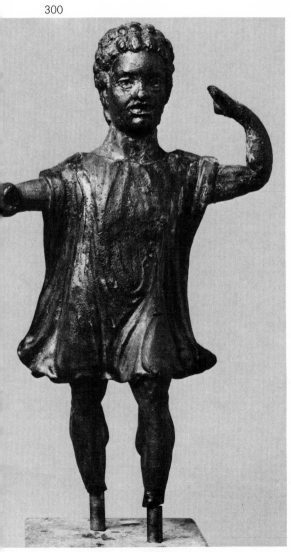

300

at these bronzes calls to mind the earlier Hellenistic statues of youthful orators.[273] Both Roman bronzes have protruding stomachs, but not so pronounced as the Bodrum boy; like the Hellenistic pieces, both are mixed black-white types.

Roman games or animal exhibitions[274] may have inspired marble statues of Negro acrobats, such as one poised on a crocodile, in the British Museum.[275] A bronze phlyax-actor in Houston[276] whose intense trancelike expression and contorted posture have suggested that he is performing a native war dance, recalls the fury of the Hellenistic bronze from Carnuntum. An animated study of an acrobat is the subject of another statuette, found at Saint-Ay (Loiret).[277] The mixed Negroid ancestry is apparent in the treatment of hair, nose, and lips, and the artist has rendered effectively the graceful folds of a short tunic which covers the youthful figure. Figurines in lead, late derivatives of this type of small statuary, have been found in several areas of Europe, and in England at Bath (Somerset)[278] and Wall (Stratfordshire).[279]

Although Roman artists often followed the traditions of their predecessors, they adapted the figure of the Negro to a greater variety of utilitarian objects. Our sources give no explanation for the frequent appearance of blacks on such objects, but the terracotta rattle in the form of a squatting Negro boy, found in the first-century A.D. grave of a child at Corinth, may provide a clue. The rattle, the hollow inside containing two clay pellets, was buried with the Corinthian boy: signed by Philokleides, it was apparently the work of an artist well known for his toys.[280] As children outgrew their toys they dedicated them to gods—for instance the lively boxwood rattle which Leonidas of Tarentum memorialized in a dedication from a Philocles to Hermes.[281] The rattle may have been merely a favorite toy, or, since it was shaped in the form of a widely used motif—the squatting Negro—it may possibly connote a popular belief in the apotropaic charm of the black. A

fig. 299

figs. 297, 298

fig. 300

fig. 301

fig. 302

229

303. Statue of a youth standing with arms extended forward (detail). From Tarragona. I century A.D. Bronze. Tarragona, Museo Arqueológico Provincial.

304. Perfume vase: head of a Negro. Roman Period. Bronze. H: 15.8 cm. Paris, Bibliothèque Nationale.

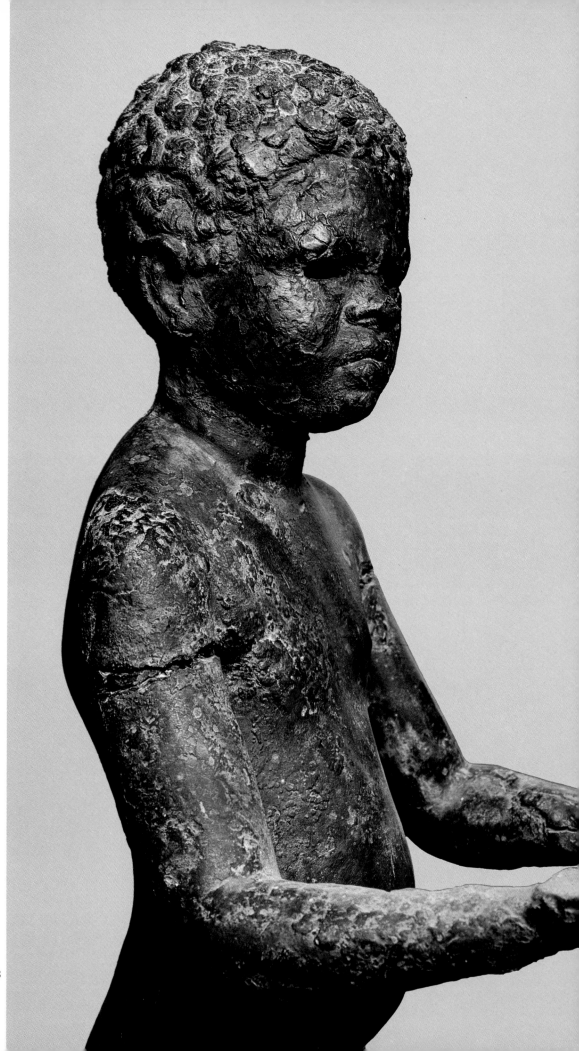

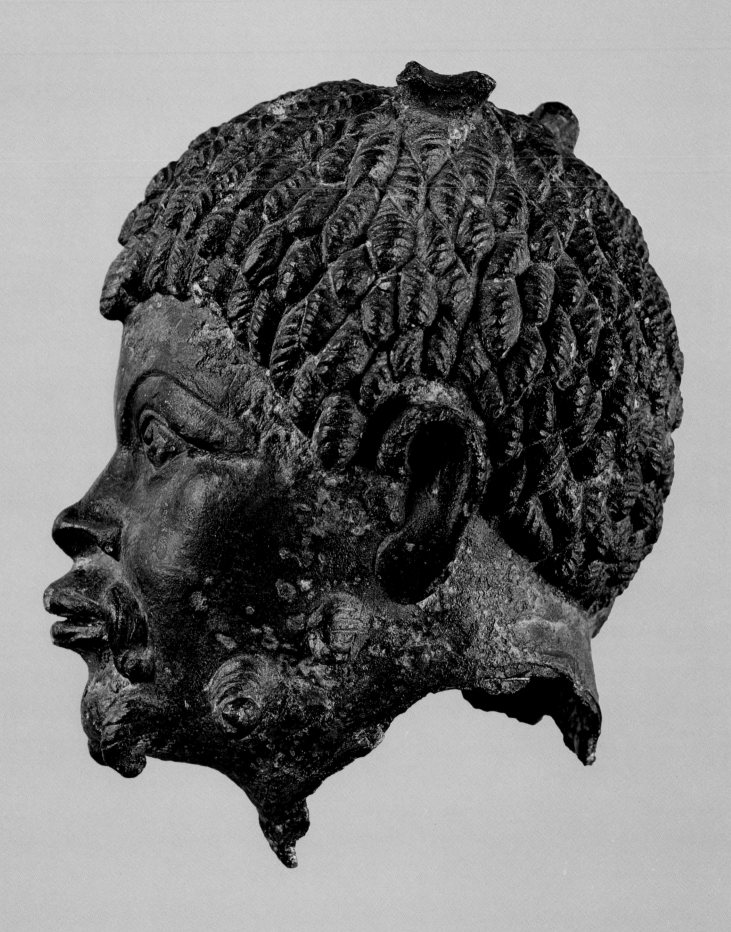

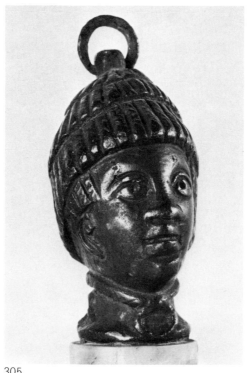

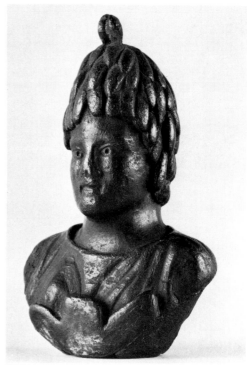

305

306

305. Counterweight: head of a Negro. Roman Period. Bronze. H: 6.2 cm. Paris, Bibliothèque Nationale.

306. Counterweight: bust of a woman. Roman Period. Bronze. H: 10 cm. Paris, Bibliothèque Nationale.

307. Fragment of a scraper decorated with bust of a diver. Roman Period. Bronze. L: 9.1 cm. Paris, Bibliothèque Nationale.

308. Bust of a child. Roman Period. Bronze. H: 4.5 cm. Paris, Bibliothèque Nationale.

309. Inkwell in the form of a crouching Negro. Roman Period. Bronze. H: 6.9 cm. Paris, Bibliothèque Nationale.

310, 311. Two nails with Negro heads. Roman Period. Bronze. H: 3.4 and 2.5 cm. Paris, Bibliothèque Nationale.

312. Lamp in the form of a Negro head. Roman Period. Bronze. L: 8.5 cm. Paris, Bibliothèque Nationale.

313. Vase in the form of a Negro head. Roman Period. Bronze. H: 9 cm. Paris, Musée du Petit Palais.

314. Furniture attachment: head of a Negro. II century A.D. Bronze. H: 9.6 cm. Cambridge, Fitzwilliam Museum.

315. Bowl decorated with three heads in relief. From Avenches. I or II century A.D. Bronze. H: 5.6 cm. Geneva, Musée d'Art et d'Histoire.

316. Boundary marker with Negro head. Roman Period. Bronze. H of head: 2.5 cm. Oxford, Ashmolean Museum.

similar explanation may be valid for the frequent use of Negroes in the household objects described below.[282]

The rich Cabinet des Médailles collection of Negro bronzes in the Bibliothèque Nationale includes numerous examples which illustrate the variety of ethnic types represented by the artists of the period, and the diversity of the utensils then in use. The collection includes two bronzes obviously modelled after persons of mixed black-white ancestry—a bust of a child with a strap hanging from the right shoulder crosswise over his chest,[283] and that of a Negro woman whose chest is covered with a tunic, a suspension ring at the top suggesting that the piece was used as a counterweight.[284] Other objects in the collection provide a sampling of the pronounced types: a full-length figure, crouching, forming an inkwell;[285] a bust of a diver, arms extended in front of him to form a scraper;[286] heads in the round—one, a vase, a careful study of a lively face, with a painstaking rendering of the unusual beard,[287] another, a counterweight, with a *bulla* around the neck,[288] and a third, a very expressive one forming a lamp;[289] heads in relief, in the center of a circular pendant bordered with silver,[290] or on the tops of wrought nails.[291] Other examples are located in several museums, for instance a lovely vase in the Petit Palais;[292] a counterweight found at Leicester, England;[293] a furniture attachment;[294] a boundary marker;[295] and a bronze bowl found in Switzerland at Avenches, the outside of which is decorated with three heads in high relief.[296]

A similar wide variety of Negro types appears in terracottas. From Egypt come several statuettes of warriors,[297] among them a fully equipped gladiator with breastplate, sword, and rectangular shield in Alexandria.[298] A Negroid figure in Hildesheim recalls the familiar motif of the calf-bearer.[299] Lamps and heads from statuettes showing blacks with three vertical incisions on the cheeks attest that cicatrices of this type were not uncommon among Negroes in Egypt during the Roman period.[300] Other

fig. 308

fig. 306
fig. 309

fig. 307

fig. 304

figs. 305,
312

figs. 310,
311

fig. 313

fig. 314

fig. 316

fig. 315

fig. 317

fig. 318

figs. 319,
320

307 308 309 310-311

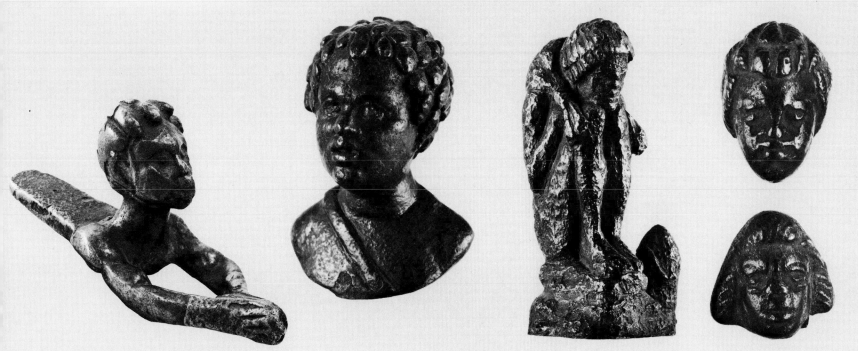

312-313 314-315 316

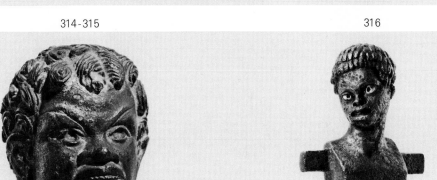

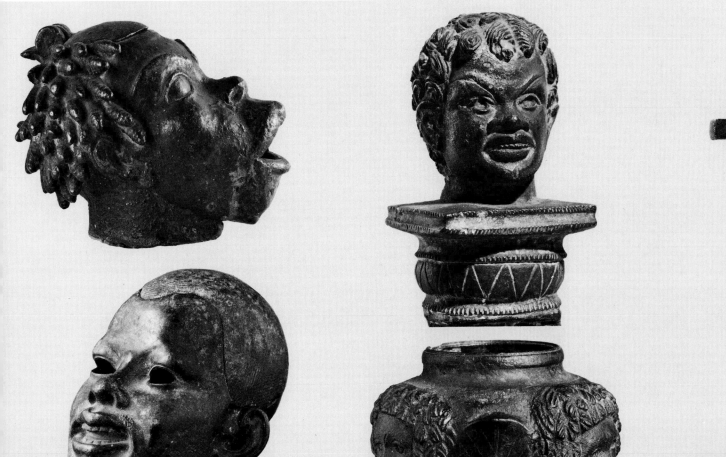

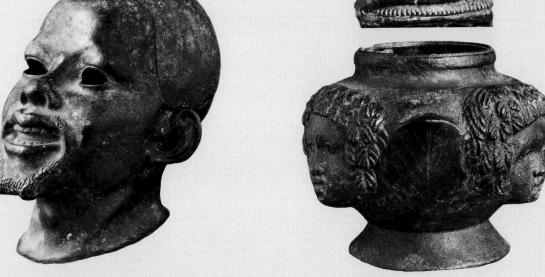

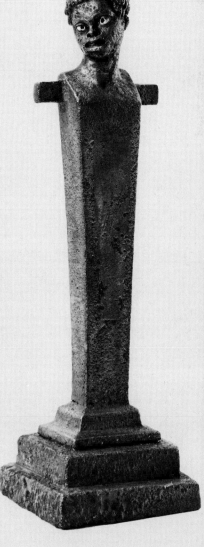

317. Statuette of a gladiator. From Egypt. Roman Period. Terracotta. H: 21 cm. Alexandria, Greco-Roman Museum.

318. Statuette of a Negro carrying a ram. From Egypt. Roman Period. Terracotta. H: 20.5 cm. Hildesheim, Roemer-Pelizaeus-Museum.

319. Lamp in the form of a Negro head with facial cicatrices. From Egypt. I century A.D. Terracotta. L: 8 cm. Bonn, Akademisches Kunstmuseum der Universität.

320. Lamp in the form of a Negro head with facial cicatrices. From Egypt. Roman Period. Terracotta. Cairo, Egyptian Museum.

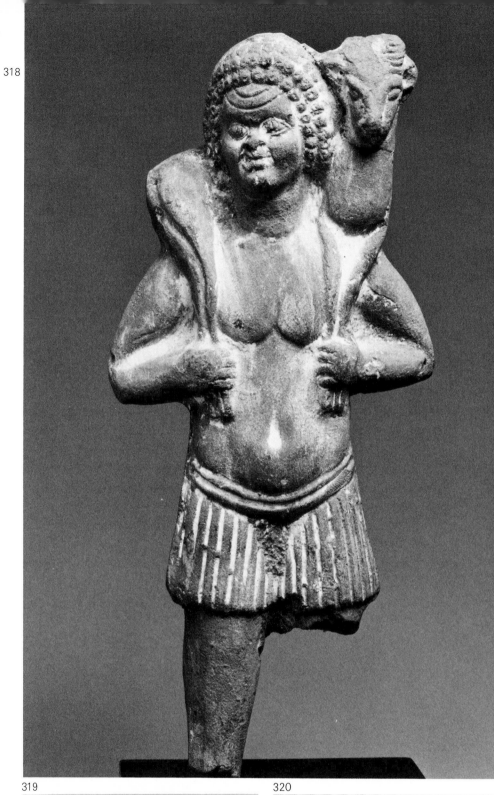

318

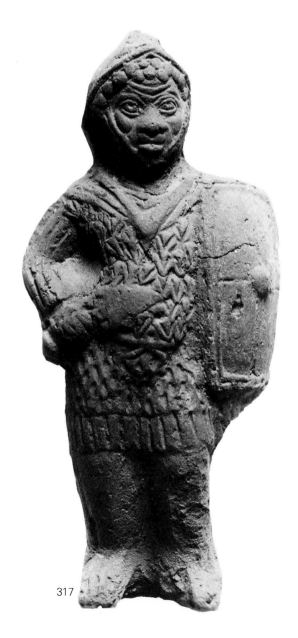

317

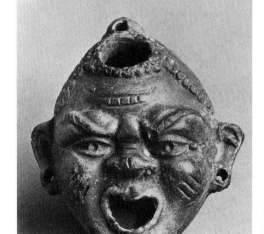

319

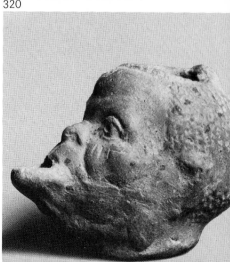

320

321. Head of a youth. From Athens, Agora. First half III century A.D. Terracotta. H: 5 cm. Athens, Agora Museum.

322. Head of a man. From Athens, Agora. Mid-III century A.D. Marble. H: 31.5 cm. Athens, Agora Museum.

323. Head of a laughing Negro. From Cologne. III century A.D. Terracotta. H: 9.3 cm. Cologne, Römisch-Germanisches Museum.

324. Lamp in the form of a Negro youth seated. From Athens, Agora. First half III century A.D. Terracotta. H: 11.8 cm. Athens, Agora Museum.

325. Pepper pot in the form of an old man napping. From Chaourse-Montcornet. Roman Period. Silver. H: 9 cm. London, British Museum.

326. Intaglio: Negro head. II or I century B.C. Glass paste. 0.8 × 1.1 cm. Geneva, Musée d'Art et d'Histoire.

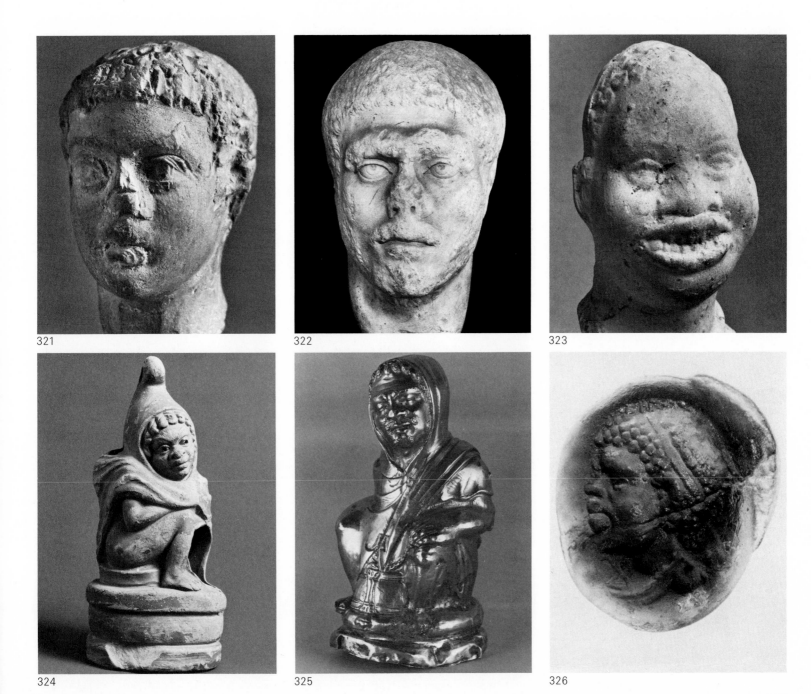

321

322

323

324

325

326

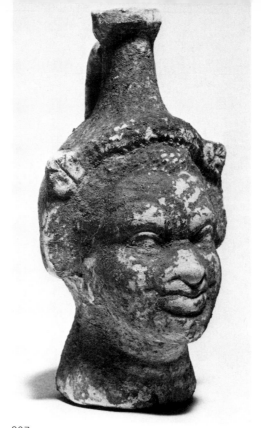

327. Plastic vase: Negro head. II or III century
A.D. Terracotta. H: 15.2 cm. Houston, D. and J.
de Menil Collection.

328. Plastic vase: Negro head. II or III century
A.D. Terracotta. H: 30 cm. Houston, D. and J.
de Menil Collection.

327

terracotta heads are notable for their individuality. For instance, a youthful
head from the first half of the third century,[301] the mixed-type features of fig. 321
which strongly resemble those of a marble sculpture dated 250-260 A.D.[302] fig. 322
(both pieces found in the Agora in Athens), and a sketchily modelled head
with pronounced Negroid traits[303] found at Cologne and dating from the fig. 323
first half of the third century: this last is made still more expressive by the
wide smile which reveals the teeth. Other heads, no less interesting than the
foregoing, were made for practical uses, like the unusually large head-vase
in Houston, said to be from Asia Minor and dating from the second or
third century:[304] beneath the lustrous green glaze the ceramicist skillfully fig. 328
rendered the amused expression of his subject. There are also vases more
ordinary in workmanship.[305] Articles for common use sometimes turned out fig. 327
to be small works of art. A plastic terracotta lamp from the Athens
Agora,[306] dating from the first half of the third century, takes the shape of a fig. 324
squatting boy wearing a *cucullus*. Its attractive style compares favorably
with that of a precious British Museum silver pepper pot found in the
Chaource Treasure;[307] the form is similar, but the figure here is that of a fig. 325
sleeping old man. The Negro head may also be reserved for purely or-
namental uses; we find it in glass-paste jewelry on the bezel of a ring[308] and fig. 326
on earrings.[309]

The frequency with which black-white mixed types appear in the art of
the early Imperial period can be judged to a certain extent through many
examples so far provided. The question of racial mixture between blacks
and whites in the Greco-Roman world, however, is of sufficient interest to
warrant my noting that the scientific curiosity of Aristotle about the
transmission of inherited characteristics was shared by Pliny the Elder and
Plutarch.[310] Black or dark women received tributes from Roman as well as
from Greek poets. Interracial unions were frequent enough in the empire
for satirists to find the birth of a Negroid child a source of amusement for

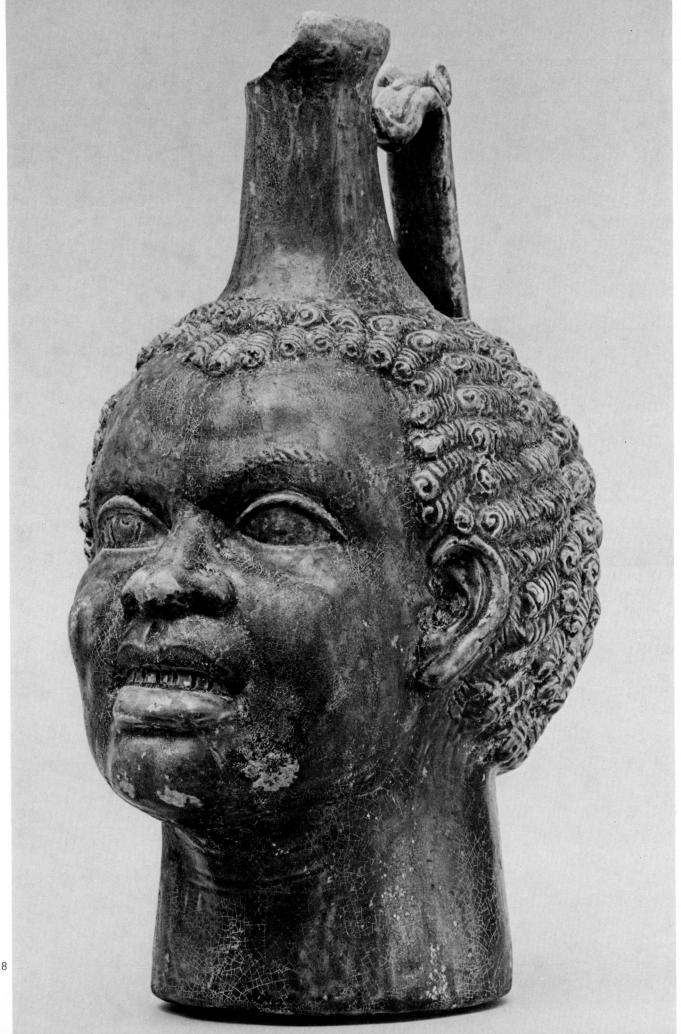

328

329. Head of an African (?) priest. I century B.C. Limestone. H: 34 cm. Syracuse, Museo Archeologico Nazionale.

330. Head of an Isiac priest. From Athens. Late I century B.C. or early I century A.D. Marble. H: 30 cm. Copenhagen, Ny Carlsberg Glyptotek.

the Roman public when it pointed to adultery. The bearing of unexpected mulatto children gave rise to a theory of "maternal impression," mentioned by Quintilian and Heliodorus. But, as among the Greeks, nowhere in these observations are found theories of "racial purity" or strictures on "miscegenation."[311]

In order to bring out still more clearly the various gradations of black-white crossings and to call attention to additional examples of racial intermixture attested in the literature of the early empire, we present a number of portraits produced over the period from the first century B.C. through the second century A.D. Bronzes and terracottas often represented Negroes low on the social scale, but some statues in stone were undoubtedly portraits of blacks of other classes, including men and women who perhaps attained wealth and rank. In the Museo Archeologico Nazionale, Syracuse, is a limestone head of a bald man with thick lips and a broad nose, whom N. Bonacasa calls an Egyptian or Libyan, perhaps a priest.[312] Except for this head, the others are in marble: the Copenhagen head of a priest of Isis found in Athens,[313] and that of an African in Amsterdam who has also been considered a Libyan.[314] There are portraits of a woman in Athens,[315] of a little girl in Boston,[316] of adolescents in the Vatican and in East Berlin[317]— all anonymous, like the innumerable pieces in the museums of classical antiquity entitled *Bust of a Man* or *Head of a Woman*. There is one exception to this anonymity. We have already seen the studious figure of a young boy who probably went to Alexandria for his education. From the second century we have the East Berlin portrait of Memnon,[318] the Negro whose devotion to study so impressed Herodes Atticus, the celebrated sophist and patron of the arts, that he adopted him as his son. If we knew more about the lives of the nameless blacks whose lifelike portraits have come down to us, it is highly probable that their biographies would read exactly as those of many other persons of foreign extraction who achieved distinction in Greece and Italy.

fig. 329
fig. 330
figs. 331, 332
fig. 333
figs. 334, 335

figs. 336-338

What we see in the ancient graphic and plastic arts and crafts bears out what we gather from the writings of antiquity which have come down to us. Distinctions were made between slave and free, between Greeks and barbarians. The Greeks and Romans, however, attached no special stigma to color and developed no special theory of darker peoples *qua* darker peoples. Like other foreigners, blacks could overcome the "barbarian obstacle" if they were inclined to do so. Though a man came from faraway Scythia or distant Ethiopia, though a man was as physically different from the Greek or Roman as the blackest Ethiopian or the blondest Scythian, such distinctions were unimportant to those Greeks and Romans who commented on the diversity of mankind. It is intrinsic merit, says Menander, that counts. Similarly the early Church embraced both Scythian and Ethiopian. It was the *Ethiopian*, the blackest and remotest of men, who was selected as an important symbol of early Christianity's mission. By *Ethiopians*, declared Augustine, all nations were signified.

The Greco-Roman artistic picture, as we have seen, is consistent with the brief statement, given above, of certain views expressed in classical and early Christian literature.[319] The frequency with which the Negro was portrayed, especially when taken in relation to classical literature, justifies

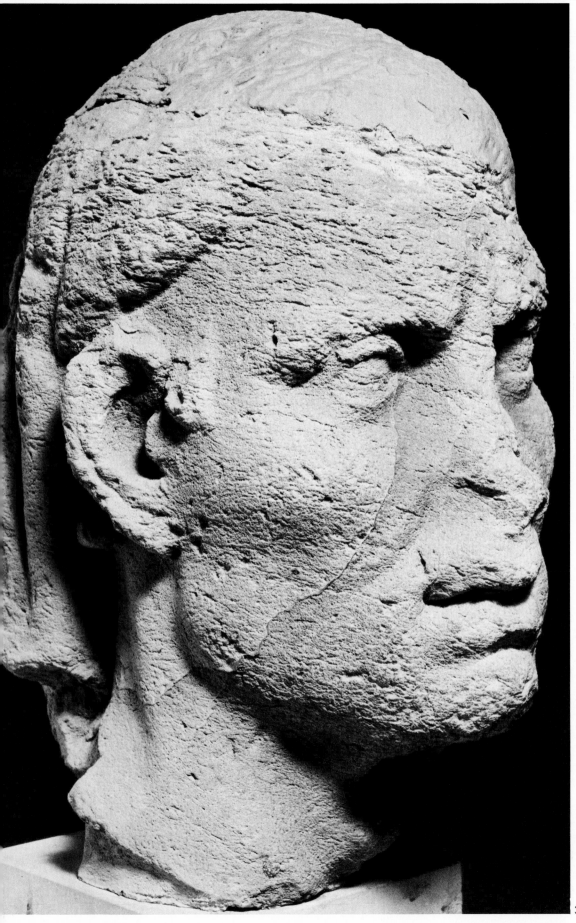

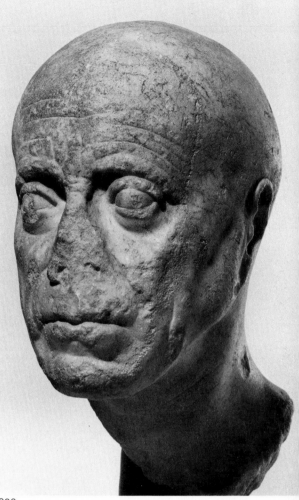

330

329

239

331, 332. Head of an African. From Egypt. Between 50 B.C. and A.D. 50. Marble. H: 22 cm. Amsterdam, Allard Pierson Museum.

333. Head of a woman. From Athens, Agora. Early II century A.D. Marble. H: 11.6 cm. Athens, Agora Museum.

334. Head of a young girl. From Corinth. II century A.D. Marble. H: 22.5 cm. Boston, Museum of Fine Arts.

335. Head of a black youth. I century A.D. Marble. H: 25 cm. Vatican, Museo Gregoriano Profano.

331

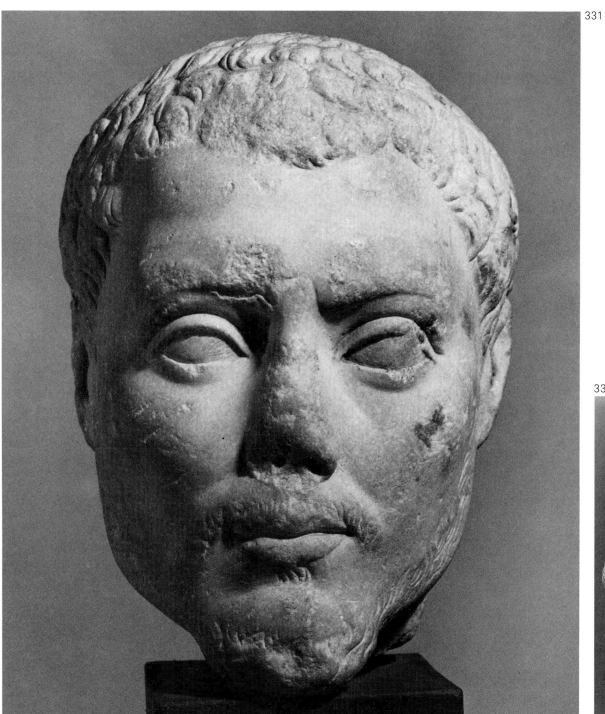

332

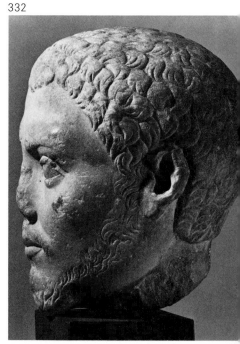

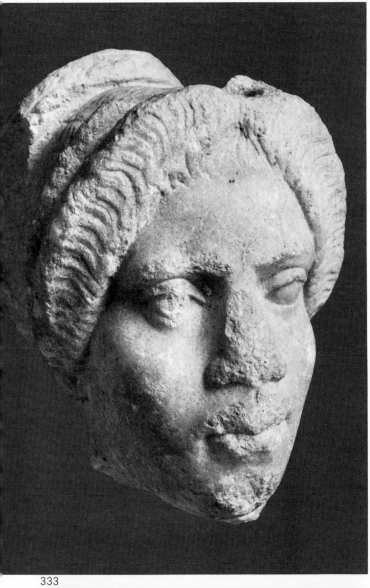

333

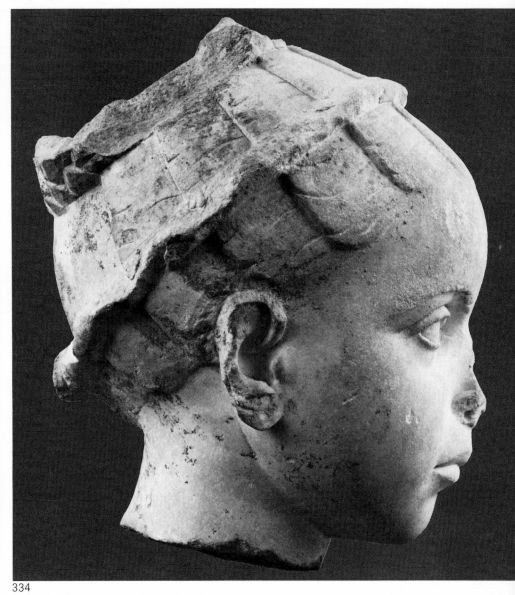

334

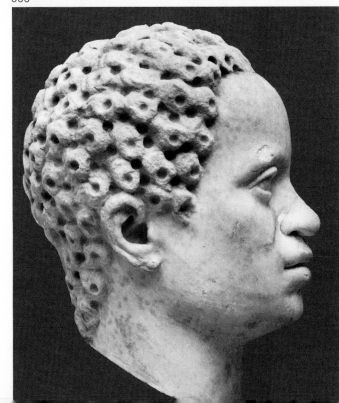

335

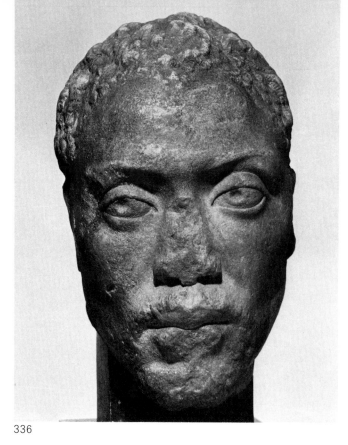

336-338. Portrait of Memnon, disciple of Herodes Atticus. From Thyreatis. II century A.D. Marble. H: 27.3 cm. East Berlin, Staatliche Museen.

336

a reassessment of the numbers of Negroes in the population of the ancient world. The literary evidence also suggests that the Negroes of the artists and craftsmen were inspired by an acquaintance with blacks in their midst more often than has been realized. A wide range of types, with varying degrees of Caucasoid admixture, is observable from the middle of the fifth century B.C. onward. Most Ethiopians may have looked alike to Philostratus,[320] but not to all Greek and Roman artists. Similarly, Negroes may look alike to those critics who have regarded most Negroes in Greek and Roman art as repetitions of a few "typical" blacks, but such an opinion overlooks the many individualized Negroes we have seen. Even in the Roman period, artists working in Hellenistic traditions were not always blind to the interesting anthropological characteristics of Negroes whom they encountered. Motifs were at times repeated but the freshness and vitality of the Negroes portrayed often suggest that the models were contemporaries of the artists.[321]

Finally, what about the attitudes of the artists themselves toward the Negroes who served as their models? Although some scholars have allowed the classical works to speak for themselves, others have not, but instead have made observations such as the following: the ugliness of the Negro seems to have appealed alike to sculptor, engraver, and painter;[322] as a rule the Negro is most absurdly drawn in Greek vases;[323] Memnon is represented as white because of the Greek aversion to Negroid features;[324] the Negroes on the Panagyurishte phiale are "almost caricatures";[325] the Negro Spinario is an outright instance of the comic;[326] and the dance-movement executed by a Negro is "a pose no white person would think of assuming."[327]

An examination of the ancient record, we have seen, does not provide support for the opinions just cited. Aesthetic considerations often provided an overriding motivation for the selection of the Negro: H. Metzger's

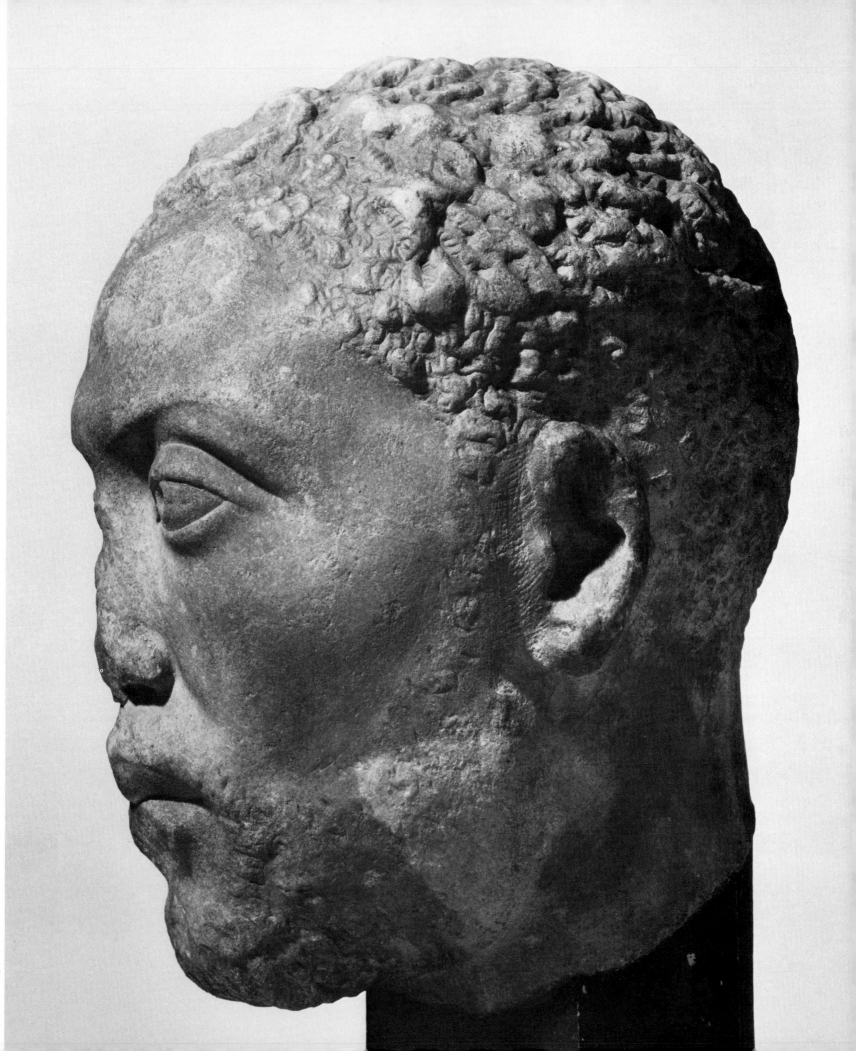

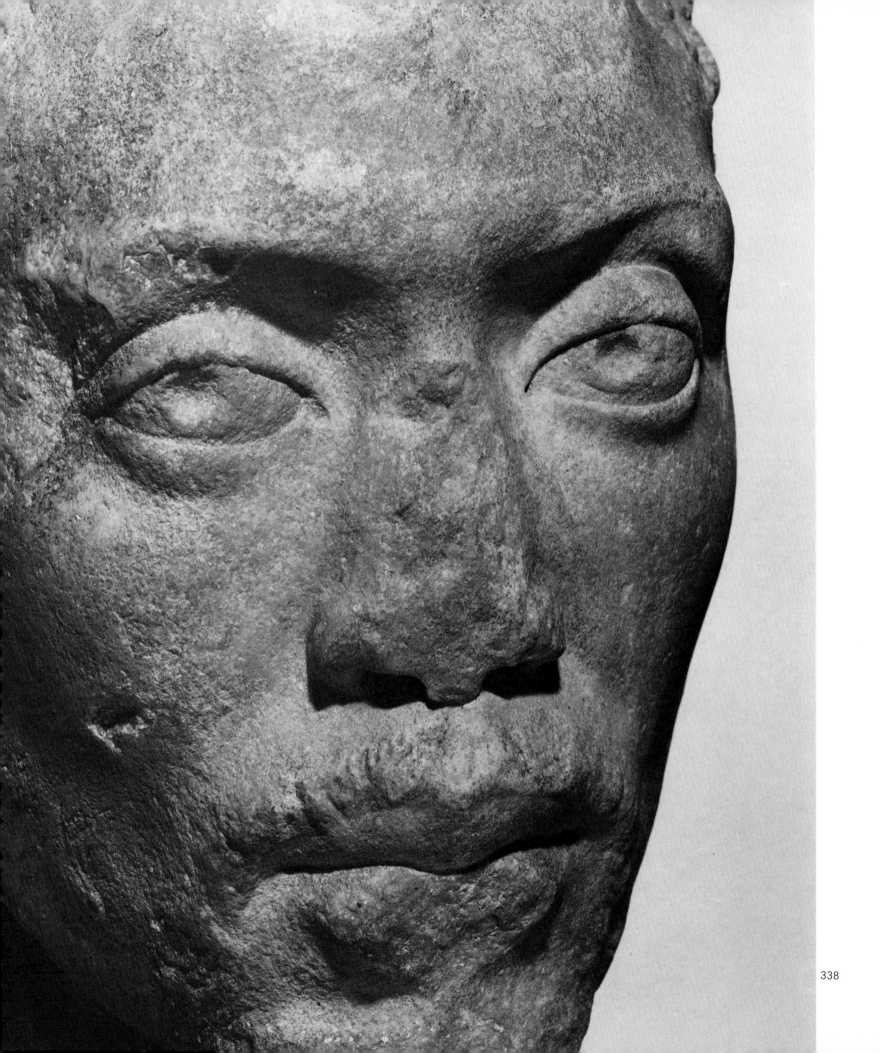

338

aesthetic emphasis deserves, in my judgment, a wider application, and should not be limited to the Greek vases he had in mind when he wrote: "... il est un point qui ne saurait être contesté: l'attirance qu'a exercée l'homme noir sur les artistes du monde grec."[328] In some cases a belief in the supposed apotropaic charm of Negroes may have been a factor but some modern art critics have seen apotropaic, "grotesque," or caricature where none existed. There is no reason, however, to conclude that those classical artists who depicted blacks in comic or satirical scenes were motivated by color prejudice. Whites of many races appeared in comic or satirical scenes. Why should Negroes have been excluded? If Negroes had been depicted *only* as caricatures or "grotesques," or if satirical scenes were the rule and not the exception, there might be some justification for the pejorative interpretations of the Negro in classical art as cited above, which are apparently influenced by the animosities and color antipathy of some modern societies. But this was not the case. As in classical literature, there is in ancient art no evidence which demonstrates that there was a stereotyped concept of the Negro as ugly, apotropaic, or comic. On the contrary, the varied and often sympathetic treatment he received, over many centuries and in a wide variety of media and art forms, suggests strongly not only that classical artists chose the Negro as a subject for many of the same reasons as they represented individuals of various other races, but also that they were often motivated in this choice by aesthetic considerations. The approach of Greek and Roman artists in their renderings of the black was evidently in the spirit of those classical authors whose comments on the Ethiopian, at home or abroad, attached no great importance to the color of a man's skin.

IV

THE ICONOGRAPHY OF THE BLACK
IN ANCIENT NORTH AFRICA

JEHAN DESANGES

It is quite clear that the classical world came to know the blacks by way of
the Nile Valley: the evidence set forth in the preceding chapters is abun-
dant proof of this. We cannot, however, reject a priori, from the mere fact
of its geographical location, the possibility that Punic (later Roman) Africa
may have had direct knowledge of the black world, knowledge which in the
course of time could have spread throughout the Roman Empire. For this
reason it seems appropriate to devote a special study to the representations
of the black in the art of ancient North Africa, after evaluating as far as
possible the likelihood of contact between the Libyco-Punic (and later the
Libyco-Roman) world and the world of the blacks.

It is difficult to draw an exact line between the areas settled by white
and Negroid populations in ancient North Africa. According to the prehis-
torians,[1] a certain number of North Africans of the Neolithic period show
Negroid characteristics. It is possible, but not certain, that the deterioration
of the climate of the Sahara, about 3000 B.C.,[2] caused an increase in the
number of blacks settling along the edge of the desert.[3] The remains of a
child discovered in 1959 by F. Mori in the deposit under a rock shelter at
Acacus (Fezzan)—carbon-14 dating of the bones indicates a date of
3446 ± 180 B.C.—show definite Negroid characteristics.[4] P. Cintas[5] has
established the presence of numerous Negroids in burial places going back
to the beginning of the Punic period. Frontinus[6] mentions auxiliaries in the
Punic army in Sicily who were completely black *(qui nigerrimi erant)* in the
fifth century B.C. At the end of the fourth century, according to Diodorus,[7]
a lieutenant of Agathocles subjugated a tribe quite like the Ethiopians in
skin color (the Asphodelodes) in the course of a campaign in Upper Libya,[8]
i.e., probably in northern Tunisia.

There is considerable evidence of the presence of blacks or Negroids[9]
along the southern fringe of North Africa in the Roman period. Ptolemy's

246

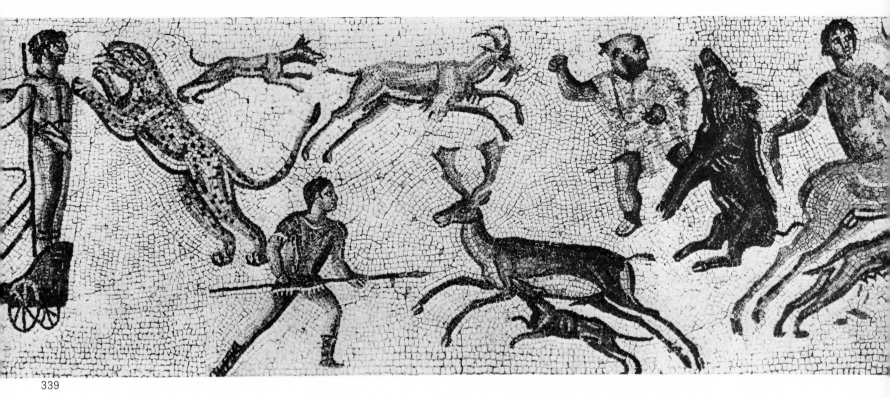

339

fig. 339

339. Mosaic of the Gladiators (detail): torture of Garamantes attacked by wild beasts. From Zliten. Late I century A.D. Tripoli, Archaeological Museum.

Nygbenitae Ethiopians[10] are very probably the Nybgenii who in Trajan's time[11] were settled in the extreme southern part of Tunisia, no doubt having wandered as nomads into the Cydamus region (Ghadames).[12] Ptolemy calls some of the natives of the same area *Erebidae*,[13] i.e., sons of Erebus or children of darkness. The Garamantes themselves were somewhat black (ἠρέμα μέλανες), according to the Alexandrian geographer,[14] though not completely so: thus they resembled the inhabitants of the Triakontaschoinos above Syene (Assuan) and differed from the Meroïtes.

This valuable information is confirmed by the anthropological studies conducted by S. Sergi in the Garamantic burial places in the Fezzan.[15] The prisoners (very likely Garamantes) in the mosaic at Zliten[16] are particularly dark[17] and show Negroid features, although they are not Negroes. Moreover, if we take Ptolemy's word for it,[18] Garamantes and Ethiopians had the same king and were neighbors. The existence of very ancient settlements of blacks in the Fezzan was still held by the Arab geographers of the Middle Age.[19] In our day black or Negroid elements perhaps ethnically related to the races of the Upper Nile, and probably present in the area since ancient times, are found in the oases of southern Tunisia: they have been the object of an anthropological study[20] which should be extended to all the oases along the northern edge of the Sahara.

There is also evidence of the presence of "Burnt Faces" in the southern part of what is now Algeria. As early as the last year of Jugurtha's war, Bocchus I was recruiting among his Ethiopian "neighbors" who were settled east of the Moroccan Atlas.[21] According to Ammianus Marcellinus,[22] Count Theodosius, in 374 A.D., had an encounter with Ethiopians far south of Auzia (Aumale), beyond a mountainous region; and the poet Claudian[23] praised Theodosius for his excursions in the deserts of Ethiopia. The engagement may have taken place in the neighborhood of Laghouat, the other side of the Oulad Naïl Mountains, although the excavations at

Castellum Dimmidi (Mesaeed) have not turned up any traces of Negroid inhabitants.[24] We know that according to Pliny the Elder the Nigris formed the southern boundary of Gaetulia:[25] beyond that was Ethiopia. Furthermore, it is generally agreed that the Nigris is to be identified as the Wadi Djedi.[26] The presence of a group farther east, between the Wadi Djedi and the Chott Djerid, is recorded in an inscription at Palermo,[27] which calls them *"Nigrenses Majores"*; they are also on record as having a bishop in 411.[28] It is quite possible that their ethnic name perpetuates the memory of a black population living in antiquity in the Negrine oasis, which includes two groups of ruins (Nigris Gemella?).[29] We know that in Roman times one of these agglomerations, now Besseriani, was called Ad Majores. Early in the fifth century of our era, Paulus Orosius[30] locates some Ethiopians south of Numidia and the Uzare Mountains,[31] and also in the sandy region situated south of Caesarean Mauretania and Mount Astrix.[32] These late testimonies make it clear that the introduction of the camel into the Sahara did not hurt the Ethiopians as much as E. F. Gautier thought it did.[33] Moreover, a mosaic at Thuburbo Maius,[34] dating from the end of the fourth century, proves that there were black camel-drivers.

fig. 340

Lastly, southern Morocco was also partially populated in antiquity by dark-skinned peoples. According to the *Periplus* of Scylax,[35] the coast of the continent facing the island of Cerne was inhabited by Ethiopians who were winemakers—which, by the way, shows that this island was not in a tropical or desert zone, as R. Mauny has correctly noted.[36] In the classical period, Nigritae and Pharusii,[37] who lived on either side of the Moroccan High Atlas, sometimes coming down into the basin of the Umm er Rbia[38] or making their way by the route of the *chotts* to Cirta (Constantine),[39] were bowman peoples closely related to the Ethiopians. It may be that their chariots enabled them to penetrate into the Sahara.[40] As for the Perorsi of the Sous,[41] they were simply considered to be Ethiopians, as were the Daratitae[42] around the mouth of the Draa. Lastly, Ptolemy[43] mentions "white Ethiopians" *(Leucoaethiopes)* farther north in the region of Cape Rhir, just as he locates "black Gaetuli" *(Melanogaetuli)* west of the Garamantes.[44] This could refer to an intermediate population, a cross of half-Gaetuli and half-Ethiopian.[45] In a more general way, the darker-skinned peoples to the south of Cape Rhir were called Western Ethiopians *(Aethiopes Hesperii)* by the Greco-Romans.[46]

Thus we come to the conclusion that the southern areas of Morocco and Algeria, the oases of southern Tunisia, the Fezzan, and perhaps even the oasis of Ammon (Sîwa) were, in antiquity, peopled to a considerable extent by Negroids. Yet this evidence does not lead inevitably to the conclusion that an ethnic relationship exists between the Ethiopians of the old authors and the present populations along the Senegal and Niger rivers. It is much more likely that we are dealing with an original ethnic agglomeration[47] which later on was reduced and altered, in part by Libyco-Berbers reinforced by tribes driven back from the north under Roman pressure, and in part by Negroes from western Africa, imported later by Arab slave merchants.

Granted, then, that in antiquity Ethiopians were established along the whole southern fringe of Africa Minor, we must address ourselves to a second problem—that of the trans-Saharan traffic in ancient times. This

340. Mosaic of the Black Camel-riders. From Thuburbo Maius. IV century A.D. 84 × 98 cm. Tunis, Musée National du Bardo.

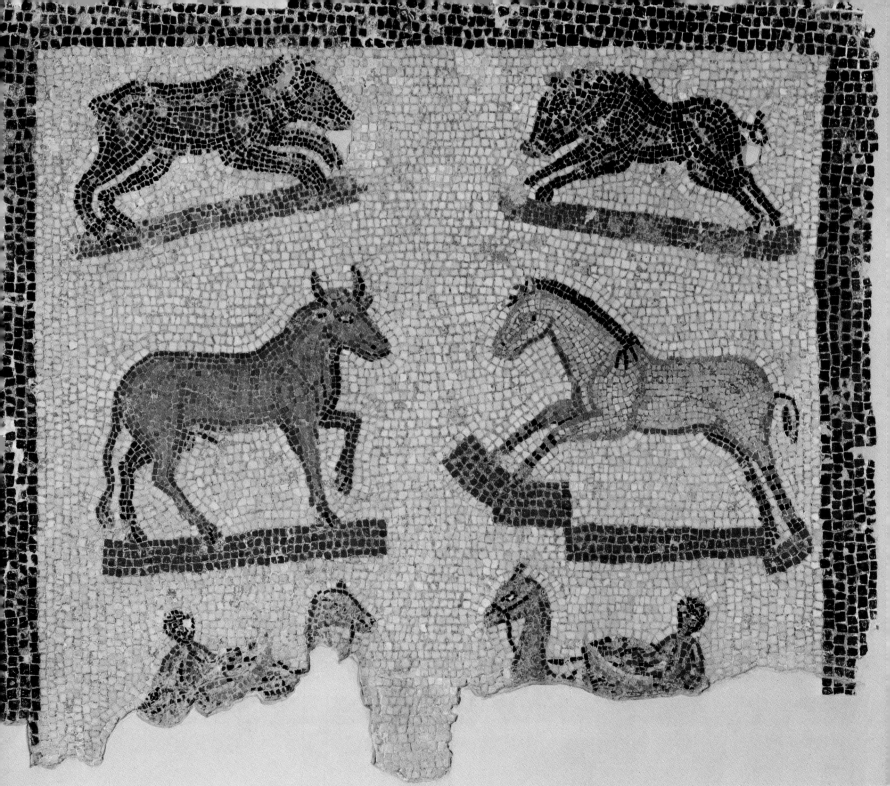

340

traffic would logically have put the Punic, and later the Greco-Roman world in contact with the blacks who came from tropical Africa by the trails of the Sahara or by way of the Atlantic Ocean.

There is no thought, of course, of denying the existence of the "chariot roads" in the Punic and Roman periods, their existence having been brilliantly demonstrated by such specialists as H. Lhote[48] and R. Mauny.[49] Yet there is reason to admit the possibility of travel in stages, no one vehicle necessarily going the whole way across the Sahara.[50] One way or the other, even supposing that the crossing of the Sahara was divided up between several intermediary peoples, blacks from the Senegal and Niger areas could, from stage to stage, have reached Roman Africa. Still it does not seem to us that trans-Saharan communications in antiquity can have been a very large operation, perhaps for the reason that the camel did not come into common use in the Sahara, and particularly in the western Sahara, until rather late.[51] In view of this relatively negative finding support has been sought, in part, in the argument *a silentio*, a dubious argument in itself but one that gains strength when it is based upon the examination of many groups of documents. We must remember that Roman Africa has yielded over fifty thousand inscriptions, and that there are abundant literary, historical, and geographical sources through which it can be studied.

Very few trans-Saharan expeditions by the overland route were recorded in antiquity, and the interpretation of the documents is difficult. It has been conjectured[52] that the young Nasamones who set out from Augila (Aoudjila) and went "toward the Zephyr," i.e., westward (their journey is narrated by Herodotus),[53] in fact reached the Bahr el Ghazal, a tributary of the Chad: in antiquity references to the winds and the indications of direction in general give rise to some strange confusions.[54] Mago of Carthage, who thrice crossed the land "without water,"[55] may simply have traveled the paths of thirst[56] to the Ammon oasis.[57] In the Roman period, the only known expeditions that may have reached the approaches of Nigerian Africa are those of Septimius Flaccus and especially of Julius Maternus, which in our opinion[58] must be dated in the reign of Domitian, or more exactly between 85 and 90 A.D.

The maritime route seems to have been used even less. After Polybius' voyage along the coast of southern Morocco,[59] there is no record of any expedition with Senegal as its destination. Moreover the extraordinary extension given by Ptolemy[60] in the middle of the second century A.D. to the coast of Morocco (he has it stretching as far as the Draa) is sufficient evidence that the geographer had much less information about the shores beyond the Draa than about those of the Red Sea and the Indian Ocean. Again, as R. Mauny has shown,[61] the pattern of winds and currents made it impossible for the ships of antiquity to navigate back from Senegal to Morocco. We do indeed have narratives of *peripli* made in the tropical seas in ancient times, notably those of Euthymenes of Marseille[62] and of the Carthaginian Hanno;[63] but the tradition which has reached us contains details so strange that we may doubt that these voyages ever took place at all. At any rate, ancient geographical knowledge of western Africa stopped along the boundary between Morocco and the Sahara and at the Canary Islands. The southernmost archeological vestiges of antiquity have been unearthed in the island of Mogador.[64]

341

342

341. Amulet in the form of a head of a black. Black glass paste. H: 1.6 cm. Constantine, Musée Gustave Mercier.

342. Scarab with head of a black. From Carthage. Jasper. H: 2.7 cm. Tunis, Musée National du Bardo.

343. Mask of a man. From Carthage. VII or VI century B.C. Terracotta. H: 19 cm. Tunis, Musée National du Bardo.

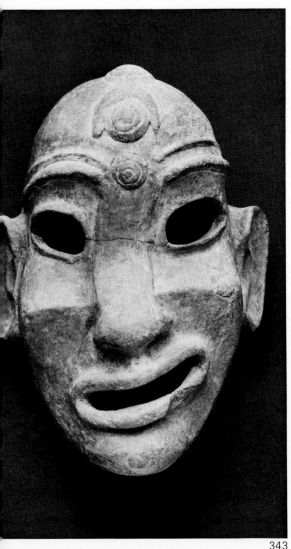
343

There is nevertheless some disposition to assert the existence of a considerable volume of traffic across the Sahara in the Punic and Roman periods, because it is generally held that the ancient world tapped African sources of gold by other routes than that of the Nile Valley. Carthage, notably, is supposed to have owed its wealth to its commercial relations with the Bambuk in the basin of the Senegal.[65] In fact the only text that can be adduced to prove that Carthage imported gold from the Atlantic side of Africa is the well-known passage of Herodotus[66] that describes silent trade or dumb barter, practiced in an African area situated beyond the Pillars of Hercules. This was a way of doing business that dispensed with face-to-face encounter. The sellers laid out their goods on the beach, retired to their ships, and lit a smoking fire as a signal. The prospective buyers then came and inspected the merchandise, deposited an amount of gold which they considered a fair price, and withdrew, leaving both goods and gold in place. The merchants returned, and if the amount of gold satisfied them they took it and sailed away; if not, the procedure was repeated until all parties were satisfied. Thus they avoided a potentially dangerous direct contact and got around problems of language. E. F. Gautier sees here a similarity with a passage of Yacout[67] that describes the same sort of trade in Senegal. But we must point out that this kind of commerce was a common thing on the outskirts of the ancient world.[68] Moreover the identification of the region in which the trade described by Herodotus was carried on with the Bambuk, appealing as it may be at first sight, is in fact a risky one: the ancients sought gold in many places where it is not mined in our day. Carthage's gold may have come from southern Morocco, since there are deposits of the metal in the mountains of that area.[69] Gold also came from Spain[70] and perhaps from Gaul.[71] Let us keep in mind that the gold coming from Africa may simply have been exchanged, in very early times, on the island of Mogador,[72] where evidences of the Phoenician

presence in the seventh and sixth centuries B.C. have been brought to light. The possibility of the importation of gold from Senegal into southern Morocco by the land route (the western chariot road),[73] rather than by the sea route, which in reality was not usable, cannot be rejected out of hand; but it should be pointed out that neither the *Periplus* of Hanno nor that of Scylax had a word to say about such traffic[74] and it oversimplifies the case to say that the traffic was kept secret.[75] In order to support the hypothesis of a gold trade using the western chariot road, R. Mauny[76] has resorted to a linguistic argument: the word for *gold* in the Sous *(urerh, ureg)*, in the Mzab *(urar)*, among the Tuareg *(urer, uror, ura)*, the Sonrhay *(ura)*, and in western Senegal *(urus)*, derive, in his opinion, from the Punic *haras*. This etymology strikes us as not in the least convincing. We prefer to find the origin of these words in the Latin *auraria*, which designates the gold mine,[77] the tax in gold, and all sorts of gold objects (cf. the Romanian *aurarie*). The word *auraria* may very well have spread slowly from Roman Africa through the desert to the Niger.

As regards the Roman period, not only is there no proof of a gold trade in Atlantic Africa, but there are strong indications that neither Morocco, nor, *a fortiori*, Senegal, provided gold to Rome. In order to refute the artificial constructs of certain Alexandrian savants who had Menelaus travelling among the Ethiopians along the ocean coast beyond the Pillars of Hercules, Strabo,[78] in the period of Augustus, stresses the absence of gold, silver, and electrum among these peoples, whereas the palace of Menelaus overflowed with these treasures. According to Strabo, the Western Ethiopians possessed nothing but ivory. About 110 A.D., the hostility of Bogos (i.e., Bocchus), king of Maurusia, toward Eudoxus of Cyzicus,[79] inspired by his fear that through this explorer foreigners would discover the route to his kingdom, proves that the Romans, unlike the Carthaginians and despite Polybius' expedition[80] some forty years earlier, did not establish relations with Maurusia. Later on, the annexation of the kingdom of Mauretania by Claudius in 41 A.D. does not seem to have brought about any increase in Rome's gold resources[81] comparable to the gains which followed the annexation of Gaul by Caesar[82] or that of Dacia by Trajan.[83] The island of Mogador, moreover, seems to have been almost completely abandoned under the early empire between the reign of Claudius and the era of the Severi,[84] and no gold articles have been found there. H.G. Pflaum[85] has made the point that the Mauretanias were of little profit to the Romans, which explains why the area was entrusted to a procuratorian administration—a "low-budget" operation. Due to the lack of local resources, the Romans never created a second African legion in Mauretania, and this doubtless explains several phenomena such as the frequent occurrence of revolts in the area even during the golden age of the Antonines, the failure to Romanize the Taza Gap, and the raids into Baetica. How can such parsimony, with its obvious disadvantages, be accounted for if we suppose that there was an appreciable flow of African gold through the Mauretanias to Rome? And the same may be said regarding the other precious products of tropical Africa, including slaves.[86]

Are we then to assume that gold from western Africa came to the Punics by way of the Tassili-n-Ajjer, with the Garamantes, who then were caravaneers without camels, serving as a relay?[87] Here again we have no

344. Nilotic mosaic (detail): Pygmy armed with a stick. From el Alia. Late I or early II century A.D. Sousse, Musée Archéologique.

345. Fragment of a Nilotic mosaic: Pygmies and a hippopotamus. From Sousse. First half III century A.D. 145 × 215 cm. Sousse, Musée Archéologique.

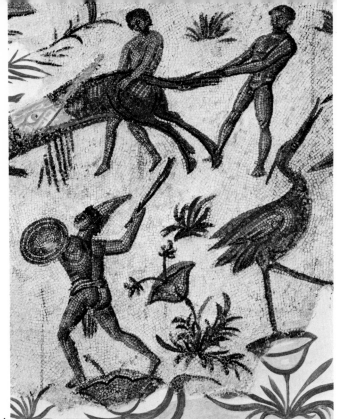

344

345

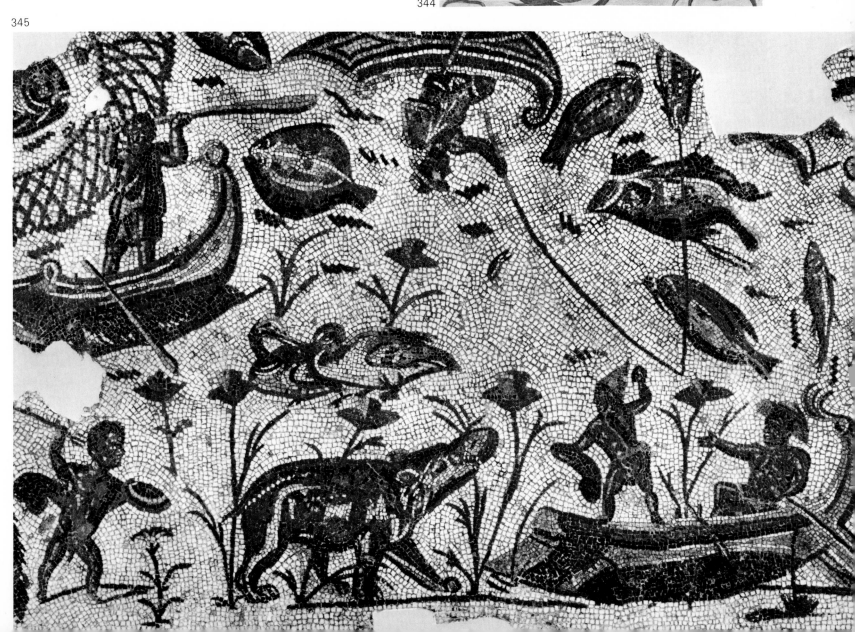

definite proof to support the statements frequently made by modern historians. It is often alleged that the customs at Lepcis brought in a talent a day[88] to the Punic treasury before Masinissa took over the territory and the revenues, and it is widely thought that the talent was of gold. The fact is that Polybius speaks of payment by Carthage to Masinissa of five hundred talents,[89] probably representing taxes for a year and a half, but he does not say what kind of talents they were. Livy likewise fails to specify the nature of the daily talent collected at Lepcis. But we know that when the Greeks simply used the term *talent*, they meant the talent of silver. Appian,[90] moreover, expressly refers to an indemnification in talents of silver connected with the dispute over the Emporia. Thus we arrive at a 90 percent reduction of the daily return from the taxes collected from the territory of which Lepcis was the chief town, and which extended from the altars of the Philaeni, at the innermost curve of the Gulf of Sirte, as far west as Tacape (Gabès). This is still a considerable sum,[91] amounting to some forty-eight pounds of silver: even at that the tax imposed was high. But we must keep in mind the agricultural riches of the Emporia, the soil of which Polybius describes as excellent,[92] and also the fact that the southern area of Tunisia and the Djeffara then were the home of flocks of ostriches,[93] the feathers being a marketable item, of elephants hunted for their ivory,[94] of lions and panthers[95] whose skins were prized. In short, granted the probability that there was traffic by caravan between the Emporia and the African interior, with the Garamantes acting as intermediaries, there is no proof that this traffic was on a large scale,[96] nor especially that it involved gold. In the better-known Roman period the Garamantes are mentioned with reference not to gold but to precious stones.[97] It is our opinion[98] that the expedition of Julius Maternus had as its purpose the capture of rhinoceroses for Domitian's festivals, and there is no indication that it was motivated by the thirst for gold. Furthermore the pre-Islamic tombs of the Sahara contain few gold articles.[99] Need we add that outside of the celebrated passage of Herodotus[100] which describes the Garamantes in hot pursuit of the Troglodyte Ethiopians, there is no reason to imagine a massive traffic in blacks through the Tassili-n-Ajjer? While the Ethiopians were at times discontented subjects of the king of the Garamantes, it does not seem that he handed them over in droves to the Mediterranean powers. In any case the highly doubtful hypothesis of a black slave trade in antiquity cannot be supported by an erroneous hypothesis of a trans-Saharan traffic in gold.

We might also mention that in E. Demougeot's opinion[101] the abundance of Cyrenean coinage after 450 B.C. indicates the existence of a traffic in African gold much farther to the east. In fact it is only after the arrival of Alexander in Egypt, in 331 B.C., that there is evidence of a sudden increase in gold coins of Cyrene.[102] Why then should we not explain this phenomenon by the generosity of Alexander, whose bags were full of Persian gold—especially since Cyrene had earned the Macedonians' gratitude by selling huge quantities of wheat on the Greek market at the time of the famine of 330-326 B.C.?[103] After 310-308[104] the weight of the gold coins of Cyrene diminished, perhaps on account of the disastrous expedition of Ophellas into Carthaginian territory. If there had been a traffic in gold across the Sahara, terminating in Cyrene, the city should have been able to overcome its financial difficulties.

346. Mosaic: Allegory of the Life-giving Nile (detail): black musicians in front of a nilometer. From Lepcis Magna, House of the Nile. II century A.D. Tripoli, Archaeological Museum.

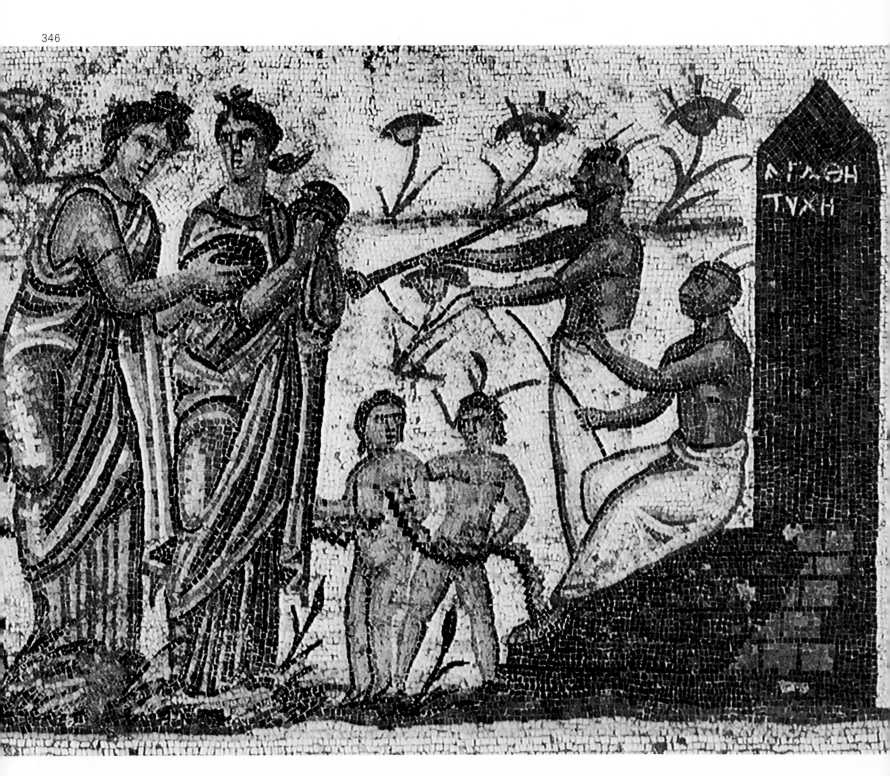

346

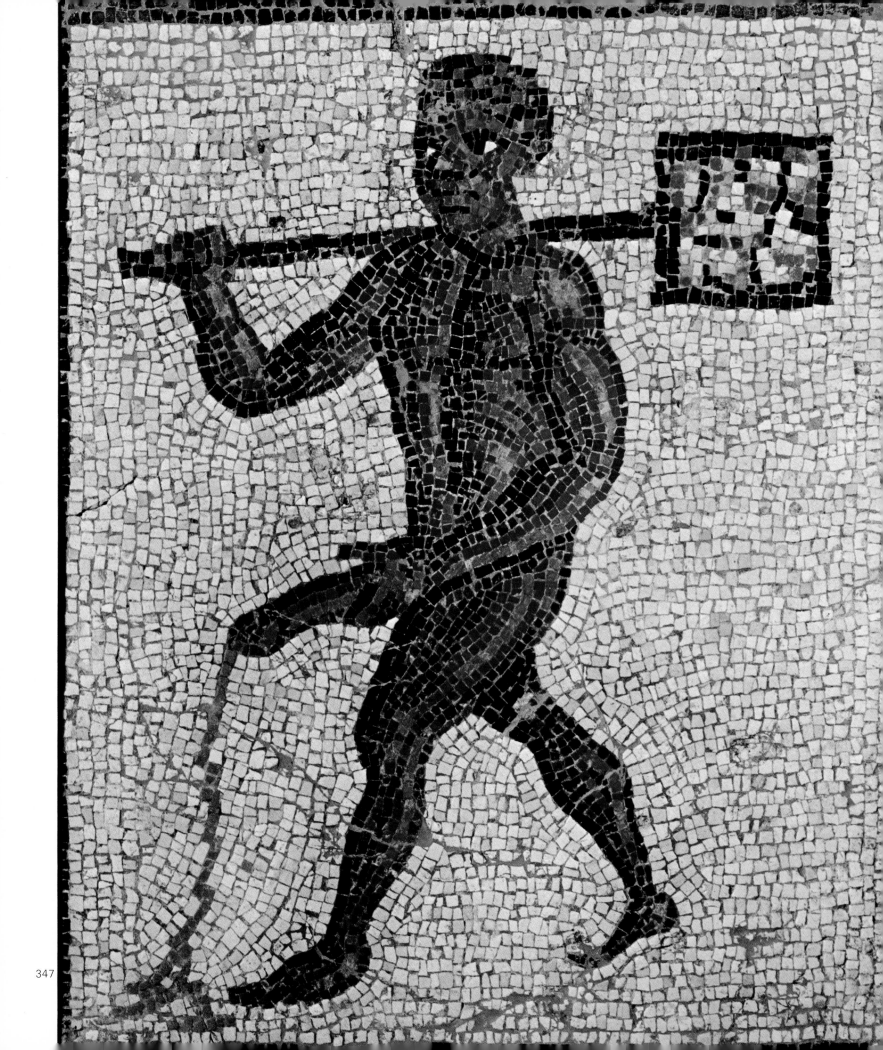

347

348

347. Mosaic: black bath-attendant. From Timgad, northwestern baths. 82 × 70 cm. Timgad, Musée Archéologique.

348. Mosaic of the Gladiators (detail): ostrich hunt. From Zliten. Late I century A.D. Tripoli, Archaeological Museum.

A conclusion seems to us inevitable, although it may not satisfy the romantic imagination of many Africanists: since the evidence of commercial relations with tropical Africa over trans-Saharan routes is so rare, both for the Punic and for the Roman periods, these relations cannot be considered an historic fact of any great importance.[105] Trade via ocean routes is, in our opinion, open to question. One way or the other, there is no indication that commerce across the Sahara included an appreciable traffic in slaves coming from the Sudan. Furthermore, it may be that slaves were not very numerous in many parts of ancient North Africa. A recent study by J. Marion[106] on the population of Volubilis shows that slaves and freedmen made up less than 10 percent, which was much lower than the percentage in Italy and particularly in Rome. But a study made in 1936 on the nomenclature of slaves[107] shows that even in Rome as many slaves were called *Meroës* as were called *Gaetulicus* and *Maurus* together, and most of these latter would not have been blacks. The Romans must have taken the black slave for a Nilotic, even if the *Meroës* may not all have come from the Upper Nile.

In Africa itself the black slaves were often classed with the pre-Saharan populations, as witness a metrical inscription at Hadrumetum.[108] Psychoanalysts might be interested in studying this inscription, of which we give a rough translation:[109]

> The shit of the Garamantes has spread across our sky,
> And the black slave rejoices in his pitch-black body.
> If the voice coming out of his mouth did not sound human,
> The look of him would scare men like a horrid ghost.
> May dread Tartarus, O Hadrumetum, snatch away
> your monster for himself:
> Such is the guard the house of Pluto should have.[110]

257

Another example: Claudian[111] tells us that at the end of the fourth century Gildo forced the women of Carthage into unions which produced "children of a color to frighten the cradle itself." The fathers are called Ethiopians, but are also designated as Nasamones,[112] although the latter were a Libyan people living along the frontier between Cyrenaica and Tripolis.

Once it is granted that the blacks in ancient North Africa were not generally Sudanese but "indigenous," is it permissible to recognize them in the local iconography?

Sad to say, the answer is in most cases negative, and in others doubtful. P. Cintas to the contrary,[113] it is very hard to agree that the Punic amulets figuring Negro heads[114] actually portray local ethnic types. Extreme prudence is also in order with regard to the Negroid masks at Carthage, which are the subject of a masterly commentary by C. Picard.[115] It is probable that the two series of documents belong to a Phenico-Egyptian tradition.

figs. 341, 342

fig. 343

As for the Roman period, one must ruthlessly eliminate the Pygmies and other Negroes of the Nilotic mosaics, so numerous in Roman Africa, as L. Foucher has shown.[116] In this field, wherein a highly artificial taste for the exotic finds expression, the artistic themes convey no sense whatever of the realities of daily life in the Africa of the Romans. A. Mahjoubi,[117] in his recent publication of a new hunt mosaic at Carthage, displays a laudable prudence when he refuses to draw historical conclusions from the representation of elephants in Africa at the time of the Tetrarchy. The theme of the struggle between the elephant and the python portrayed in this mosaic is known in Africa at least as early as the period of Augustus,[118] and in the last analysis admits of an Egyptian origin which takes us back to the predynastic era![119] As for the young elephant which is being dragged aboard a ship by a mounted hunter, it is more likely that he is on the shore of the Red Sea than on the Mediterranean.[120] So also for the Pygmies in so many other mosaics, confronting exotic beasts in the usual grotesque postures,[121] most often in a river landscape which is more or less that of the Upper Nile: they tell us nothing about the presence of blacks in North Africa. It also happens at times, as at Lepcis Magna in the Villa of the Nile, that blacks other than the conventional Pygmies—in this instance musicians[122]—present characteristics that should interest a Nubia specialist: they too are outside the limits of our inquiry. Likewise, one would like to have more assurance that the ostrich hunters at Zliten[123] are not Strouthophagi from the Red Sea,[124] but Ethiopian tribes from the confines of Tunisia and the Fezzan.[125]

figs. 344, 345

fig. 346

fig. 348

We might also eliminate from our area of concern the perfume vases shaped like a Negro bust and usually called *balsamaria*. Of course they have been found here and there in North Africa,[126] but also in many other regions of the Roman world.[127] They seem to have come from Alexandria, originally at least.[128] We should be equally careful with regard to lamps in the shape of Negro heads, a motif which could have been popular in widely separated areas.[129]

fig. 351

figs. 352-354

Finally, we must not rely on representations of mythological themes to illustrate the problem of the presence of Negroid elements in North Africa. Let us consider for instance the magnificent solar mosaic at Constantine, recently published by A. Berthier, the learned curator of the museum.[130]

figs. 356, 357

349. Fragment of a mosaic: chariot race in a circus and black grooms (detail). From Gafsa. VI or VII century A.D. Tunis, Musée National du Bardo.

350. Mosaic of Silenus (detail): young black behind a dromedary. From El Djem, House of Silenus. Late II or early III century A.D. El Djem, Musée Archéologique.

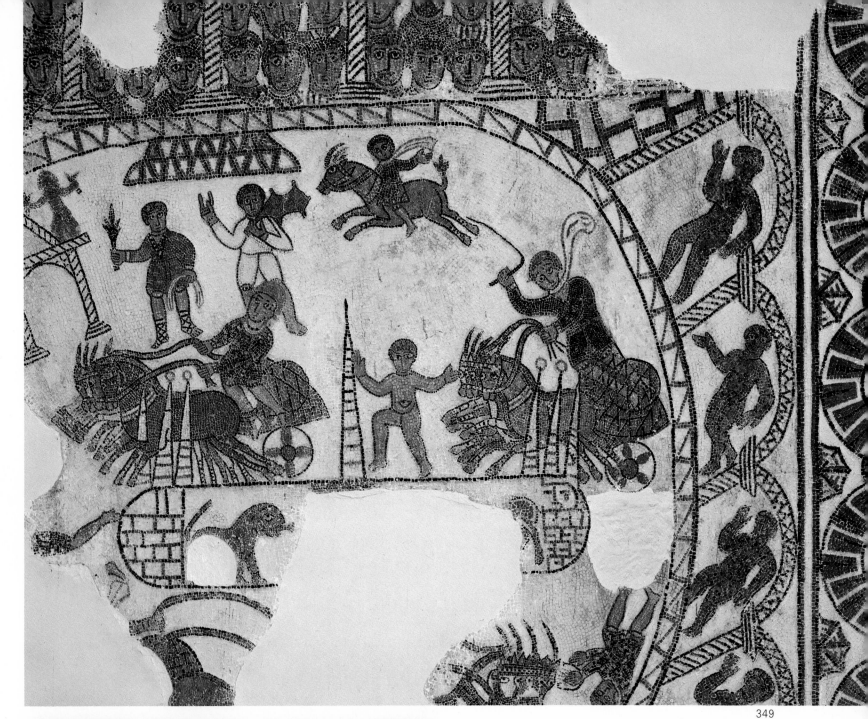

349

350

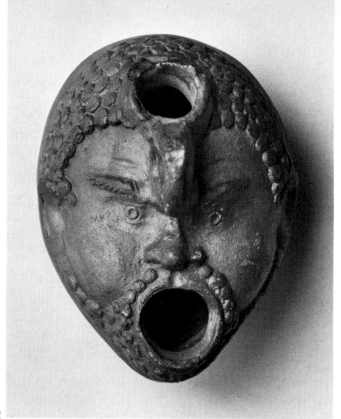

352

351. Fragment of a balsamarium. From Constantine. Bronze. H: 6.5 cm. Constantine, Musée Gustave Mercier.

352. Lamp in the form of a head of a black. Terracotta. H: 9 cm. Timgad, Musée Archéologique.

353. Lamp. From Tiddis. Terracotta. L: 12 cm. Constantine, Musée Gustave Mercier.

354. Lamp. Terracotta. L: 12 cm. Tunis, Musée National du Bardo.

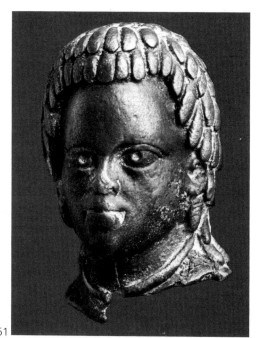

351

The panel in which black swimmers are coming to the surface of the water suggests the dawn: an eagle is on the wing at the zenith; in the last panel a diving bull symbolizes the sunset. It is very probable that the black swimmers send us back to Memnon, the legendary son of Aurora, who reigned over the Ethiopians. With these givens, even if the Constantine mosaicist may possibly have had some direct acquaintance with blacks, we are pretty far away from the realities of life in Africa.

The state of the case is therefore, on the whole, very disappointing. What representations of the black shall we retain as evidence of contacts which are not traceable to the Nile Valley, the original source of artistic and decorative themes which are repeated almost everywhere? The number of documents surviving after this process of elimination is surprisingly limited, and we fear that scholarship may still relegate some of them to series that lie outside our frame of reference. We may mention the slave of the baths of Timgad, whose natural endowments are superb;[131] the herm of the thermae of Antoninus,[132] who, according to G. and C. Ch.-Picard, "has the wide nose of the present-day Sudanese rather than the much thinner nose of the Hamitic race"; the black sorcerer of Carthage;[133] perhaps the black grooms in a mosaic at Gafsa,[134] although we are not really certain that they are blacks; more surely the camel drivers of Thuburbo Maius;[135] the young black at Thysdrus (El Djem) behind a dromedary;[136] the black fowler at the foot of a tree, setting out his snares in the branches,[137] in a domain of the region of Uthina (Oudna); and the cook in the large hunt mosaic at Hippone.[138] Finally one would like to utilize a fresco detached from a funerary cippus in the Thina necropolis south of Sfax, representing a little Negro carrying a jug on his shoulder, but the fresco has disappeared.[139] The mosaic of the wrestlers, now in the Sfax museum, also comes from Thina. One of the four wrestlers, the second from the left in the bottom row, is clearly dark-skinned, but his features are not particularly

fig. 347

figs. 358, 359

fig. 360

fig. 349

fig. 340

fig. 350

fig. 355

fig. 361

fig. 362

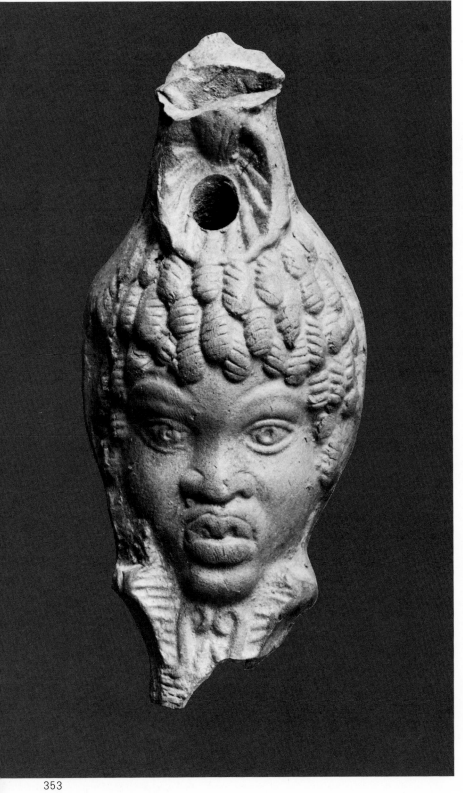

353

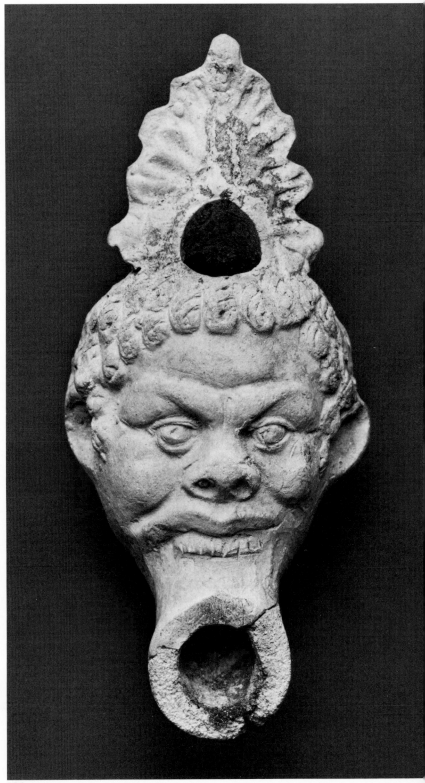

354

261

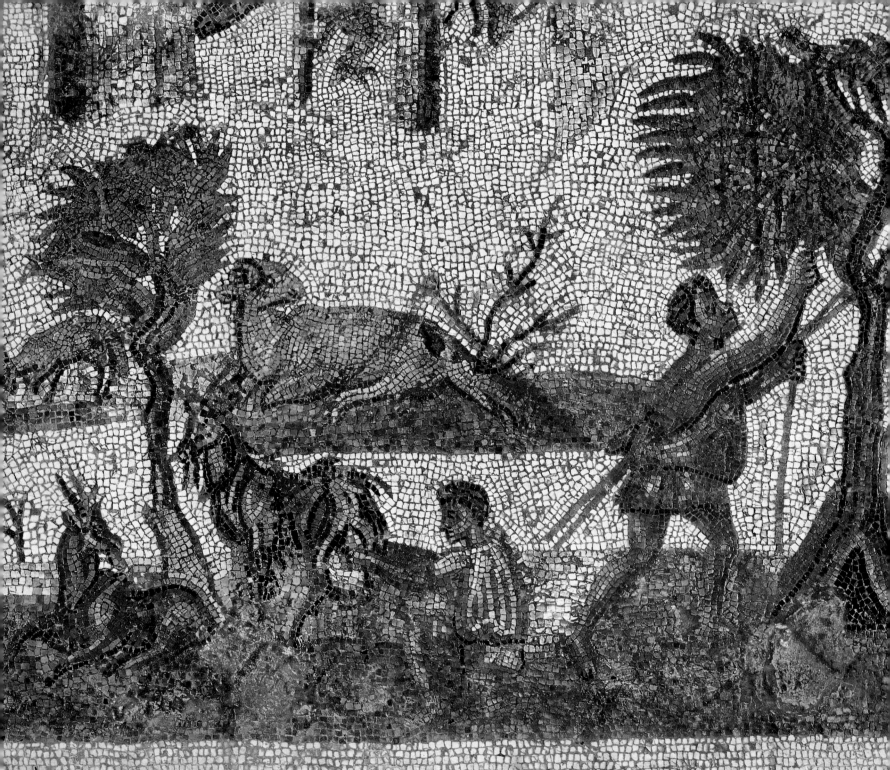

355. Mosaic: rural scene (detail): fowling. From Uthina, House of the Laberii. III century A.D. Tunis, Musée National du Bardo.

356. Solar mosaic. From Sidi M'Cid. II or III century A.D. Approx. 750 × 510 cm. Constantine, Musée Gustave Mercier.

357. Detail of figure 356: black swimmers symbolizing the Dawn.

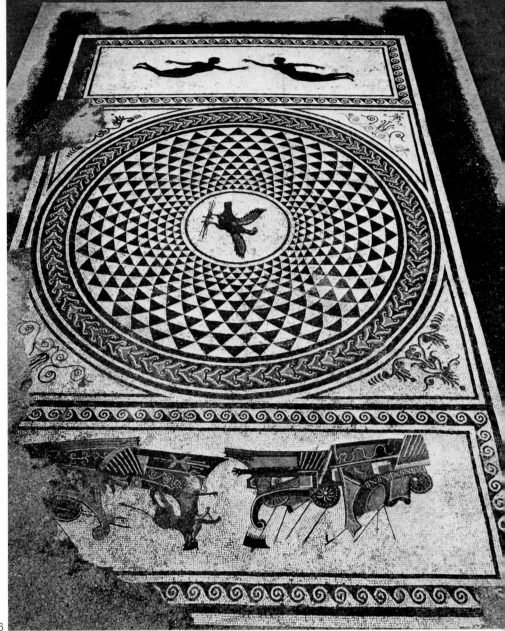

356

357

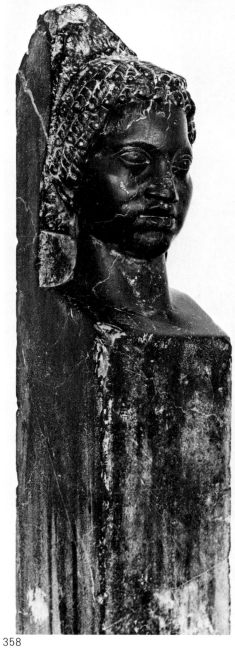

358

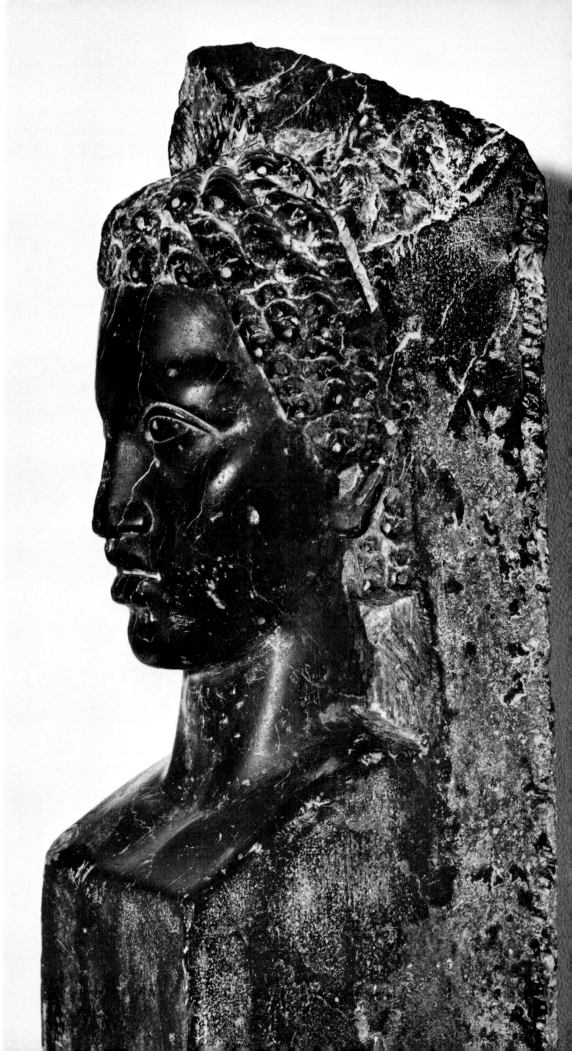

359

358, 359. Herm ending in an African head. From Carthage, Baths of Antoninus Pius. Mid-II century A.D. Black limestone. Over-all H: 80 cm. Carthage, Antiquarium.

360. Black sorcerer, detail of the Mosaic of the Seasons. From Carthage, House of the Seasons. IV century A.D. Carthage, Musée de Carthage.

361. Black cook, detail of the Hunt Mosaic. From Hippo Regius. IV century A.D. Annaba, Musée.

360

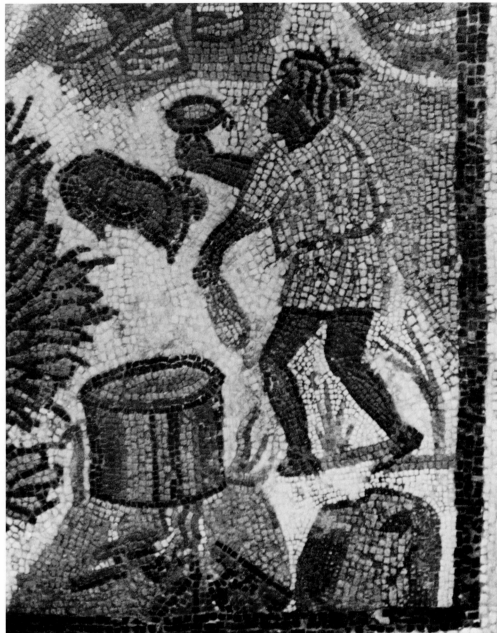

361

Negroid.[140] In short, the number of really significant documents barely reaches ten. It must always be remembered that blacks were rather frequently employed in the baths[141] and as grooms[142] throughout the Roman world, and that this could have promoted a conventional usage of these themes. On the other hand there is reason to doubt that the little Negro at Sousse,[143] dating from the Antonine period, has any relation with campaigns in the Sahara, as L. Foucher thinks.[144] The way his young nigritude is set against the dove he holds in his left hand signals an Alexandrian affectation. One may also question the reality of the Negroid traits which some have thought they discerned in certain personifications of Africa.[145] But at least it may be permissible to detect these Negroid features in one or the other portrait of Juba II[146] or in the faces of some few "Garamantes" in the Zliten mosaic.[147]

fig. 365

figs. 363, 364

fig. 366

265

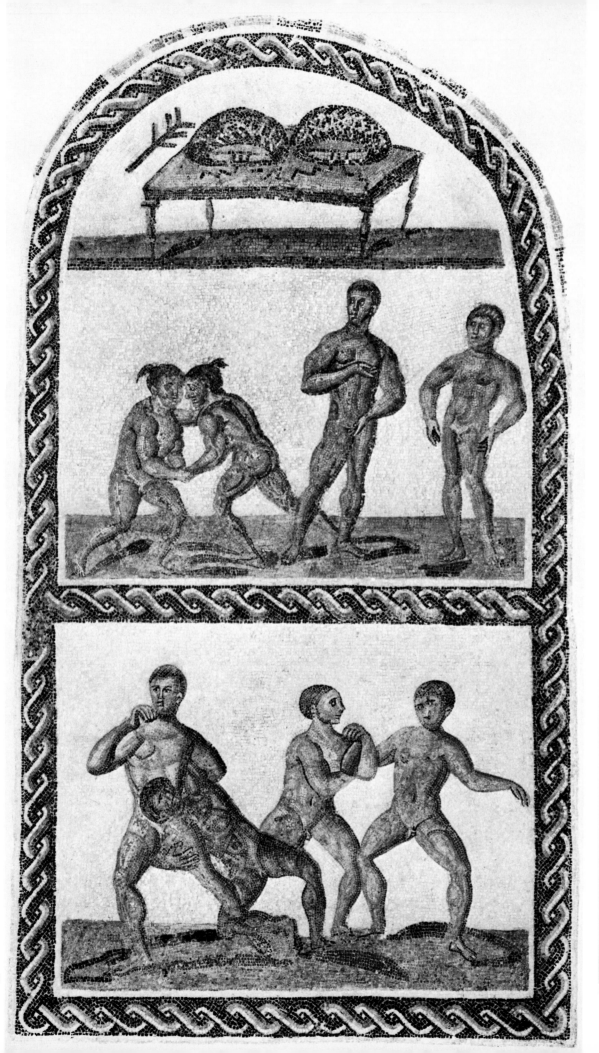

362

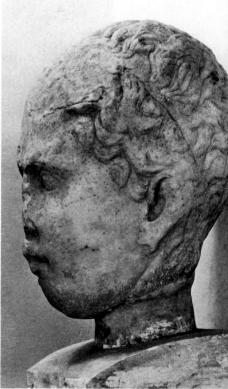

363

362. Mosaic of the Wrestlers. From Thina. III century A.D. 240 × 136 cm. Sfax, Musée Archéologique.

363, 364. Portrait of Juba II, king of Mauretania. From Cherchell. Late I century B.C. or early I century A.D. Marble. H: 28 cm. Cherchell, Musée Archéologique.

365. Statuette of a black youth holding a bird in his left hand. From Sousse. II century A.D. Black marble. H: 52.5 cm. Sousse, Musée Archéologique.

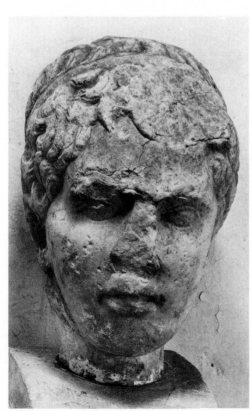

364

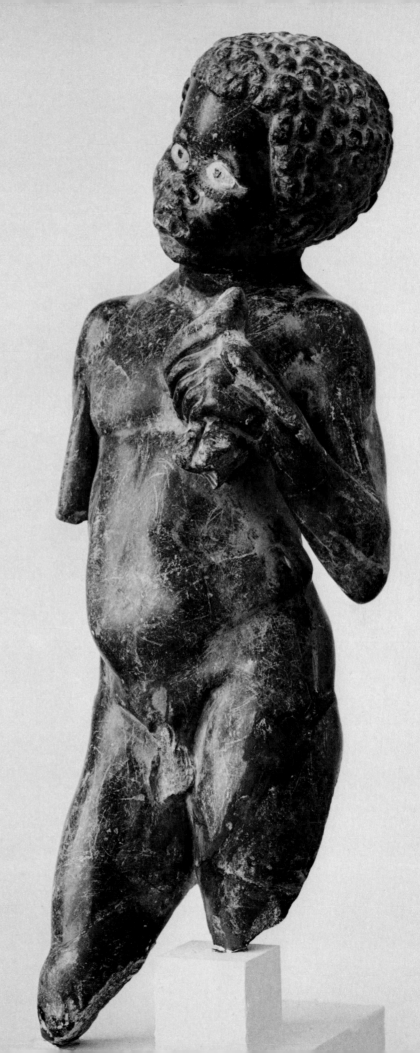

365

It is time to come to a firm conclusion. The presence of blacks in ancient Africa is irrefutably proven by literary and epigraphic evidence. Their number was certainly not largely increased by an influx across the Sahara, because no important commercial traffic justified such an influx. There was no considerable movement of blacks from North Africa into the Roman world, and the evidence of their presence there is reduced to a small number of indisputable iconographic records. To the ancient world the black was essentially a Nilotic; but the Maur and the Garamante[148] were often looked upon and thought of as being half black.

366. Mosaic of the Gladiators (detail): Garamante coming between a bear and a bull. From Zliten. I century A.D. Tripoli, Archaeological Museum.

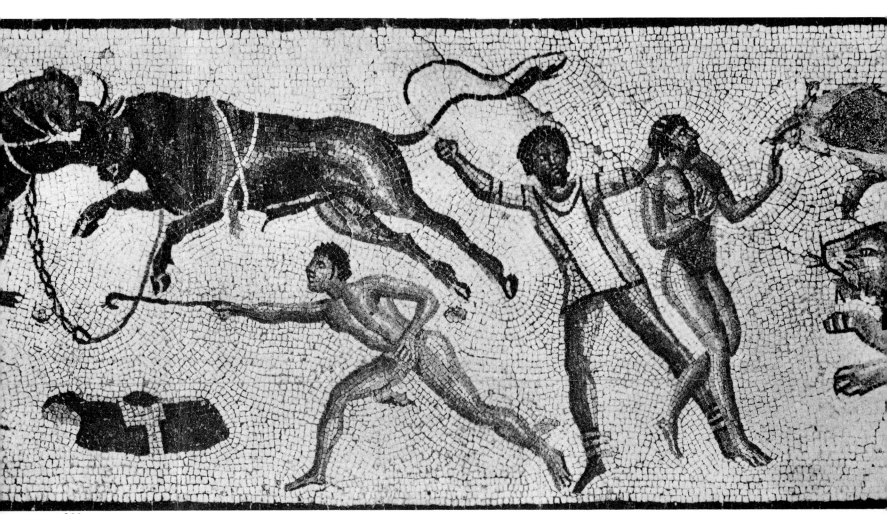

366

V

EGYPT, LAND OF AFRICA, IN THE GRECO-ROMAN WORLD

JEAN LECLANT

The Saïtic, or Twenty-sixth, Dynasty (664-525 B.C.) marked the opening of the Nile Valley to the Mediterranean world and to Greek influence; but as compared with what is conventionally called "classical civilization," Egypt presented a strikingly different culture, and continued to do so down to the end of antiquity.[1] As the Greeks and the Romans saw it, this strange land, which passed for one of the most characteristic of the African continent, appeared to be Africa's outlet to the Mediterranean, rather than Carthage with its Phoenician origins, or North Africa, whose peoples had no such strongly distinctive culture. In the classical tradition, it is true, another country—"Ethiopia," land of the sun and the gods, which the Egyptians themselves already considered a land of myths[2]—could also symbolize black Africa. In Homer, the gods go off to banquet among the blameless Ethiopians;[3] Herodotus upholds the glory of Ethiopia, following a tradition[4] renewed by the prestige of the glorious pharaohs of the Twenty-fifth Dynasty[5] and the charm of the Divine Consorts of Thebes;[6] in the late Roman period, the enchantments of this land blessed by the gods are woven into several ancient romances, the best known of which is the *Aethiopica* of Heliodorus.[7] The fact is that the "Ethiopia" of the ancients is to be identified with the Land of Kush, the renowned kingdom of Napata and later of Meroë, which stretched far to the south beyond the frontier of Egypt, and which lived on until the fourth century of our era. Compared with this "Ethiopia," which was somewhat legendary because of its remoteness and the rarity of its distant relations with the Mediterranean Basin, Egypt, better known, in direct contact with the classical world yet so different from it, could be regarded as the door to Africa[8] and the black continent.[9]

Egypt exported typically African products to the countries around the Mediterranean. In the Hellenistic period[10] ivory, gold, ostrich plumes and eggs, and some slaves from black Africa probably were shipped through the

kingdom of Meroë.[11] From East Africa came ivory, myrrh, incense, and cinnamon, which Egypt sent on around the Mediterranean, either raw or as manufactured articles as in the case of ivory.[12] From East Africa the Ptolemies obtained the elephants used by their armies. This was made possible by the establishment of hunting stations on the Red Sea and the Somalian coasts, but it appears that the beasts were reserved for use by the Egyptians.[13]

In the Roman period a small part of the trade between Africa and the Mediterranean seems to have been carried on by Saharan tribes, who may have brought black slaves, a little ivory, some precious woods, ostrich plumes, skins, and wild animals for the circus games into the provinces of Africa, Numidia, and Mauretania.[14] The greater part of African imports passed, however, through Egypt,[15] the way stations being Meroë and sometimes, possibly, the kingdom of Axum: included were ebony, ivory, gold, black slaves, precious stones, wild beasts, and animal skins.[16] From the beginning of the empire and even earlier, Egypt had become in a way the major transit point for the South and the Orient; besides the African products, a good part of the imports from Arabia, India, and China passed through Alexandria.[17] We also note that Egypt was the only country manufacturing papyrus (a Nilotic rather than African product, it is true), which the ancient world used in huge quantities.[18]

Where did black slaves come from in the ancient world? This is a problem that deserves more attention. Although our information on the point is inadequate, it seems that during the Hellenistic era Carthage provided these slaves to a greater extent than Egypt. In ptolemaic Egypt slaves were a less important economic factor than in other countries of the Hellenistic world,[19] and the Ptolemies had taken measures against the exporting of Egyptian slaves.[20] But beginning with the first century of the Christian era it was from Egypt, more probably than from the Roman province of Africa and the Mauretanias, that black slaves were brought into the Roman Empire.[21]

The theme of the black in Greco-Roman literature and art has been ably studied by G. H. Beardsley,[22] whose work was resumed and completed by F.M. Snowden.[23] Throughout the material gathered by these authors a constant association between the black and Egypt is manifest. For the Greeks and the Romans the essential problem was how to differentiate the Egyptians from themselves. They no doubt found it difficult to "place" an Egyptian who would present a physical type distinct enough from their own to be immediately recognized *as* Egyptian. Compared with themselves as Mediterraneans, the image of a kind of Levantine would not have sufficed to characterize the people of the Nile Valley. The strangeness of the ancient pharaonic civilization, the uniqueness of its nature and climate, the river whose flooding never ceased to inspire commentaries,[24] simply had to engender a human being fundamentally different in appearance from the Greek or the Roman. So it was that the Negro quite naturally became a kind of heraldic symbol of Egypt.

Exekias, a Greek painter who specialized in the decoration of vases in the third quarter of the sixth century B.C., gave the names *Amasis* and *Amasos* to two blacks whom he pictured on one of his receptacles.[25] This

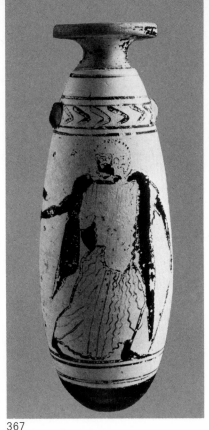

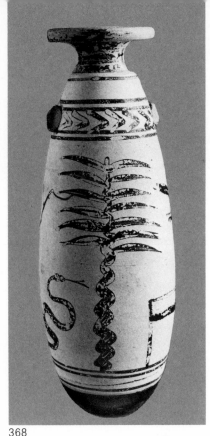

367

368

367, 368. Alabastron with a draped warrior on one side and a palm tree and serpent on the other. V century B.C. Terracotta. H: 15 cm. Athens, National Museum.

again shows the association between the black and Egypt, *Amasis* being the Greek form of the name of an Egyptian pharaoh of the Twenty-sixth Dynasty. It may also be that an Egyptian, black or mixed type, is to be seen in the work of another vase-painter working in Athens at about the same time, for again the name *Amasis* occurs.[26]

The legend of the Greek hero Heracles killing King Busiris, who had sought to sacrifice him, in Egypt, gave inspiration to Greek vase-painters. They showed the hero seizing Busiris or his slaves depicted as blacks.[27] We may discern here a reminiscence of the theme of the pharaoh slaughtering his enemies, one of the most frequent themes in pharaonic iconography.

According to Beardsley, plastic ointment jars and pitchers in the shape of Negro heads[28] appeared at Naukratis, the celebrated trading center in Lower Egypt, and were copied in the Greek world beginning in the sixth century B.C. They probably inspired the well-known series of Greek Jani-form vases[29] which have the head of a black on one side and that of a white on the other.[30]

The interest of Greek potters in "African" themes and in the evocation of the world beyond, which was associated with Egypt, is also seen in the series of alabastra dating from the period of the wars of the Medes and the Persians (490-480 B.C.).[31] Obviously these were to be used in connection with the cult of the dead. On their white ground are simplified drawings— Ethiopian warriors, palm trees, the phoenix, and Amazons, these latter occasionally connected with Libya[32] which recalls the Homeric legend.

Among the masterpieces of Sotades the potter (fifth century B.C.) was a plastic vase, the admirable fragments of which, coming from Egypt and more precisely from Memphis, and now preserved in the Musée du Louvre, have been studied in a remarkable essay by Mme Lilly Kahil.[33] The vase itself presents a Persian leading a camel and accompanied by his black servingman.[34] The painting on the rhyton shows a war scene, which may

figs. 367, 368

fig. 369

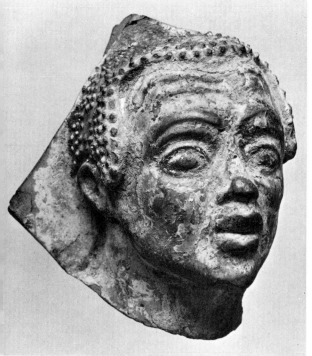

369

369. Fragment from rhyton by the potter Sotades: head of a black servant. From Memphis. V century B.C. Terracotta. 5.4 × 4.1 cm. Paris, Musée du Louvre.

370. Another fragment of the same rhyton: head of a Persian in high relief and battle scene including a crouching Negroid figure. H: approx. 16 cm.

371. Rhyton in the form of a black struggling with a crocodile. From Ruvo. Late V century B.C. Terracotta. H: 25.5 cm. Ruvo, Museo Jatta.

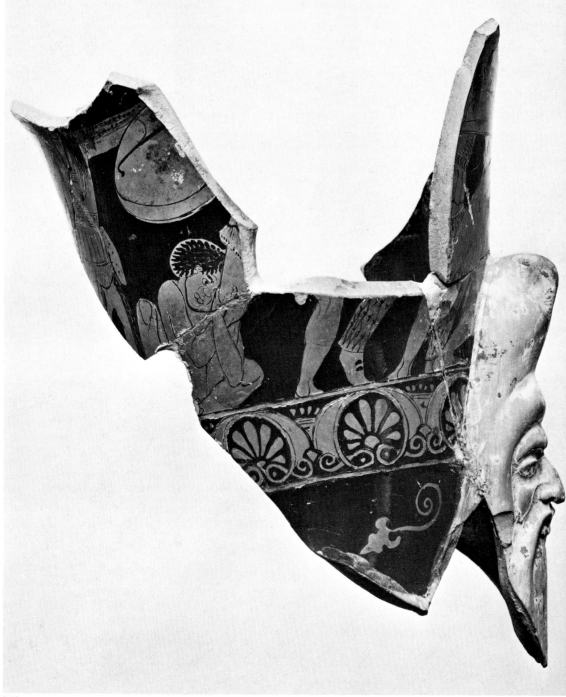

370

represent one of the historic battles in which Persians and Greeks met in the Delta toward the middle of the fifth century. On one of the fragments a Negroid man[35] crouches before a Greek, clinging to his leg and imploring his help. His features are typically African, and he is an "Egyptian" ally of the Greeks, as the learned Hellenist indicates.[36] fig. 370

The theme of the crocodile seizing a black, well known in Greek art, is also a reference to Egypt. A series of plastic vases by Sotades, of which several have been found at Thasos,[37] shows such an animal swallowing a black youth. The beguiling inscription engraved on the base of one of these rhytons, "the amorous crocodile," seems to have been added by a mer-

272

chant of Thasos or by the owner of the vase. The same theme appears a
century later on plastic vases in Apulia.[38] Naturally we shall find it in the fig. 371
numerous Nilotic scenes represented in Roman art.

We may add that in Roman art figurations of blacks occur much more
frequently.[39] They are usually taken to be products of "Alexandrian art" or
of "Alexandrian inspiration." Such representations are found in bust-
balsamaria (perfume jars dating mostly from the second and third centu- fig. 372
ries),[40] balances in the shape of Negro busts, plastic vases in terracotta,
lamps, and statuettes of wrestlers and jugglers.[41] In most cases we do not
yet know much about where these "Negro objects" were manufactured.
The so-called "Alexandrian art" is not at all well known. The term is a
loose one, its limits poorly defined, and it is generally abused—a convenient
catch-all for "the picturesque exotic, the spicy anecdote, and caricatured
realism."[42] All representations of blacks cannot be of Alexandrian manu-
facture. Yet even when these reservations are made, it is still true that the
"Negro objects," so common in Roman art, unquestionably were inspired
by the popular art of Greco-Roman Egypt, in which these various icono-
graphic types are found.[43] Another reference to Egypt is seen in a statue, dug
up at Aphrodisias in Caria,[44] of a black carrying a receptacle, leaning
against the dorsal pillar typical of pharaonic statues.[45]

No less African than the Negro type is the theme of the Pygmy, which
occurs frequently in the Nilotic scenes so prized in the Roman Empire. Of
course this theme was not unknown in the Greek period. The motif of the
battle between Pygmies and cranes,[46] also found in literature, figures on a
Kabeiric vase from Thebes in Boeotia,[47] and on the renowned François
vase dating from the sixth century B.C.[48] Later it was used on coins of the
Roman Republic minted about 70 B.C.[49] The theme has its parallel in
Egypt, where a knife-handle shows an ithyphallic Pygmy fighting a crane.[50]

It was, however, in the Roman period that the Pygmy theme had its
greatest vogue. Most often it is found in grotesque representations attrib-
uted, like the "Negro objects," to "Alexandrian art."[51] Here again objec-
tions have been raised to a too facile attribution to Egypt.[52] But even if all
these grotesque dwarfs (not all of them Negroes, besides) are not of Egyp-
tian manufacture, there is good reason to suppose that their origin is to be
sought in the Nile Valley, where numerous examples have been found.[53] fig. 373
The grotesque as a genre goes back to pharaonic Egypt,[54] where Pygmies,
imported from black Africa since the days of the Old Kingdom,[55] were
highly valued, particularly for their talents as dancers.[56]

In Roman art the Pygmy, grotesque or not, generally appears in Nilotic
scenes, which became very fashionable.[57] The most famous is the Nilotic fig. 378
mosaic at Praeneste, Italy, executed in the first century B.C. It presents the
whole of Egypt, from Nubia to Alexandria, at the time the Nile is in
flood.[58] Egypt, land of Africa, is symbolized at the top of the picture by fig. 374
Nubian huntsmen and animals, some of the latter fabulous; the action
takes place in a setting of rocks and plants. Unfortunately this part of the
mosaic has been much restored. A series of terracotta plaques made at
Rome or in Latium[59] in the first century A.D. shows Nilotic scenes with fig. 376
Pygmies who cruise about in boats amidst water-birds, crocodiles, and
hippopotamuses. The presence of a village with its straw huts accentuates
the African character of the whole scene.

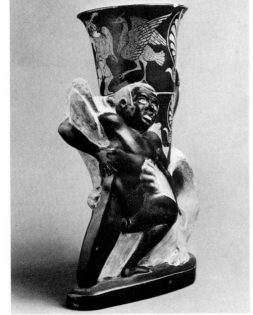

371

273

372. Balsamarium in the form of a bust of a black. From Ostia. II century A.D. Bronze. H: 15 cm. Vatican, Museo Gregoriano Profano.

373. Statuette of a draped Pygmy standing beside a vase. From Fayum. II-III century A.D. Terracotta. H: 13.8 cm. Houston, Menil Foundation Collection.

374. Mosaic of the Nile in flood (detail): Nubian hunters pursuing a monkey. From Praeneste, Temple of the Fortuna. I century B.C. Palestrina, Museo Archeologico Nazionale.

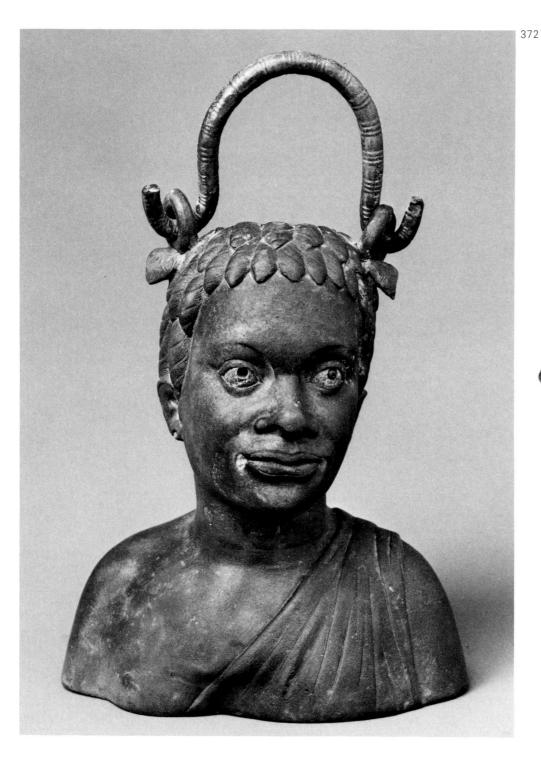

372

373

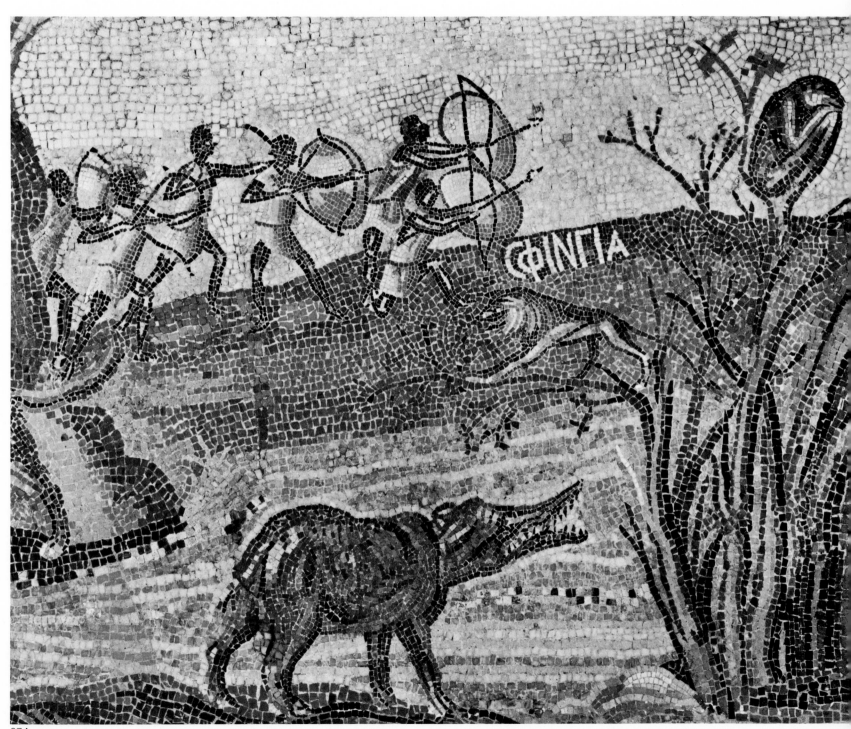

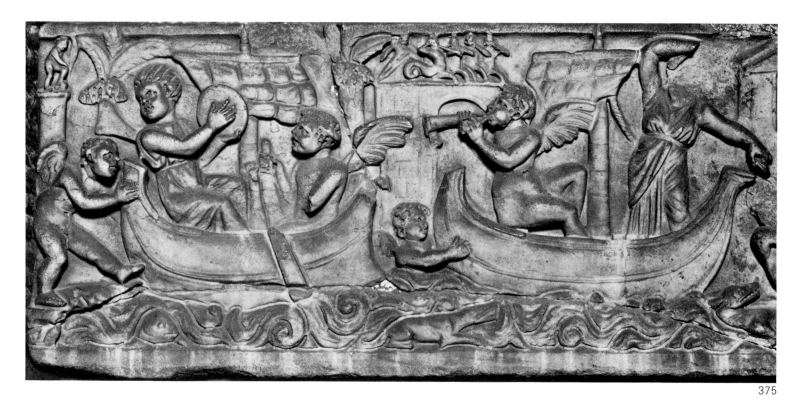

375. Sarcophagus decorated with a Nilotic scene (detail). From Rome. Mid-III century A.D. Marble. Rome, Museo Nazionale Romano.

376. Terracotta plaque: Nilotic landscape with Pygmies in a boat. From Latium. I century A.D. 50.5×48 cm. Rome, Museo Nazionale Romano.

377. Pygmies fighting crocodiles and a hippopotamus. From Pompeii, Casa del Gallo. I century A.D. Detail of a mural painting. Naples, Museo Archeologico Nazionale.

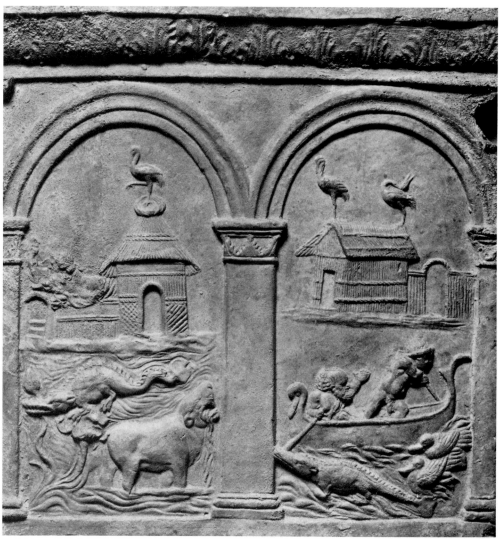

376

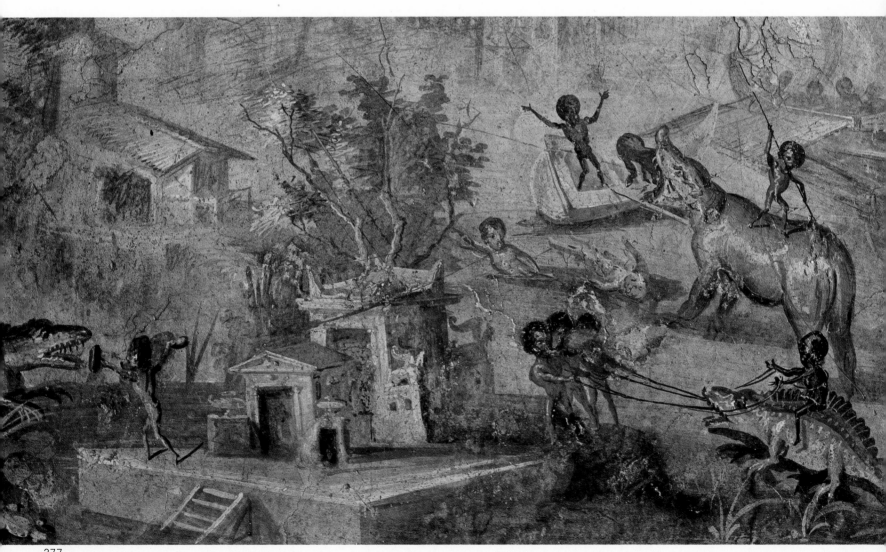

377

378. Nilotic scene (detail): Pygmies protecting themselves from a crocodile. I century A.D. Mural painting. Pompeii, Casa dei Pigmei.

379. Statuette of Harpocrates on horseback. From Fayum. II-III century A.D. Terracotta. H: 16.2 cm. Paris, Musée du Louvre.

The Nilotic images can indeed be regarded as genre scenes, rich in a humor that can turn to cruel satire when the Pygmy is made the butt of ridicule. Yet one may wonder whether a certain symbolism is not sometimes hidden beneath such a simplistic approach. With regard to a Nilotic relief with Pygmies at Székesfehérvar in Hungary, which may belong to a funerary monument from the second century A.D., it has been noted[60] that the scenes are not merely decorative, but symbolize Egypt as the realm of the gods and the dead. The relations between funerary symbolism and scenes of the Nile might also be indicated by a marble sarcophagus from the Via Ostiensis, now in Rome, on which is seen a river, with barques and fig. 375 crocodiles cleaving its waters, in the midst of a landscape of palms and buildings.[61] Egypt as a land of Africa, like the "Ethiopia" of the ancients, can therefore appear as a mythical country, evocative of the Beyond.

The Nilotic scenes, moreover, are not without religious significance, and the problem of exoticism in Egyptian cults in the Greco-Roman period must be considered with this in mind. Certain Nilotic images are integrated into a clearly Isiac context.[62] For instance, in a mosaic at Mérida, in Spain, Isis, holding a sistrum, is shown in a Nile landscape which includes a crocodile devouring a man, probably a Pygmy.[63]

The theme of the Pygmy hunting or attacking[64] the crocodile or the fig. 377 hippopotamus[65] might be a recall of Horus triumphing over his enemies represented as Nilotic beasts;[66] one such example can be studied on the inner face of the west wall of the enclosure of the Horus temple at Edfu.[67]

Other documents associate the Pygmies with Horus-Harpocrates. Certain terracottas of Greco-Roman Egypt show the Pygmy as a grotesque fig. 379 Harpocrates, with two lotus-buds sometimes crossed above the *pshent*, the double crown of the Egyptian pharaohs.[68] Similar images have been unearthed at Delos, but these grotesque dwarfs may not all be Negroid.[69]

The god Bes—apotropaic dwarf, protector of women in labor, divinity of music and the dance, defender against the Evil Eye and harmful spirits—is the most African of the Egyptian gods.[70] It has even been suggested fig. 380 that he is an altered image of the ancient African initiator, perhaps a survival of primitive totemism. His connection with the lion has been pointed out, the lion being very typical of the African domain and bound up with the oldest traditions of prehistory.[71] He does not properly belong to the Isiac pantheon worshipped in the Greco-Roman world. Yet his image spread almost everywhere around the Mediterranean Basin as a sort of emblem of exotic magic. He was identified with the Phoenician Patechus and the Greek Kabeiri, and to some extent with Silenus and even with Heracles, as his various iconographic types show. Statuettes and amulets representing him have been excavated from a number of Greek and Roman sites. Among the most typical we may mention a sistrum with a composite handle (supposed to have come from the Iseum in the Campus Martius), on which the dancing figures of Bes and Isis are shown back to figs. 381, back in symmetrical poses.[72] There is also a sculpture in red porphyry 382 found at Porto, the port of Ostia, consisting of a figure of Bes surmounted by a bust of Hathor.[73]

Images of blacks, and statuettes of ithyphallic Negroes in particular, were often symbols of fertility and fecundity in the Greco-Roman world. Some of these have been found in shrines of Demeter, a deity who can

378

379

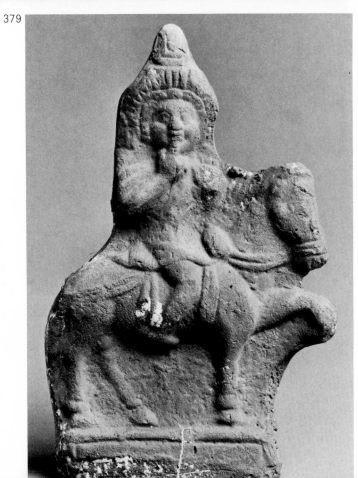

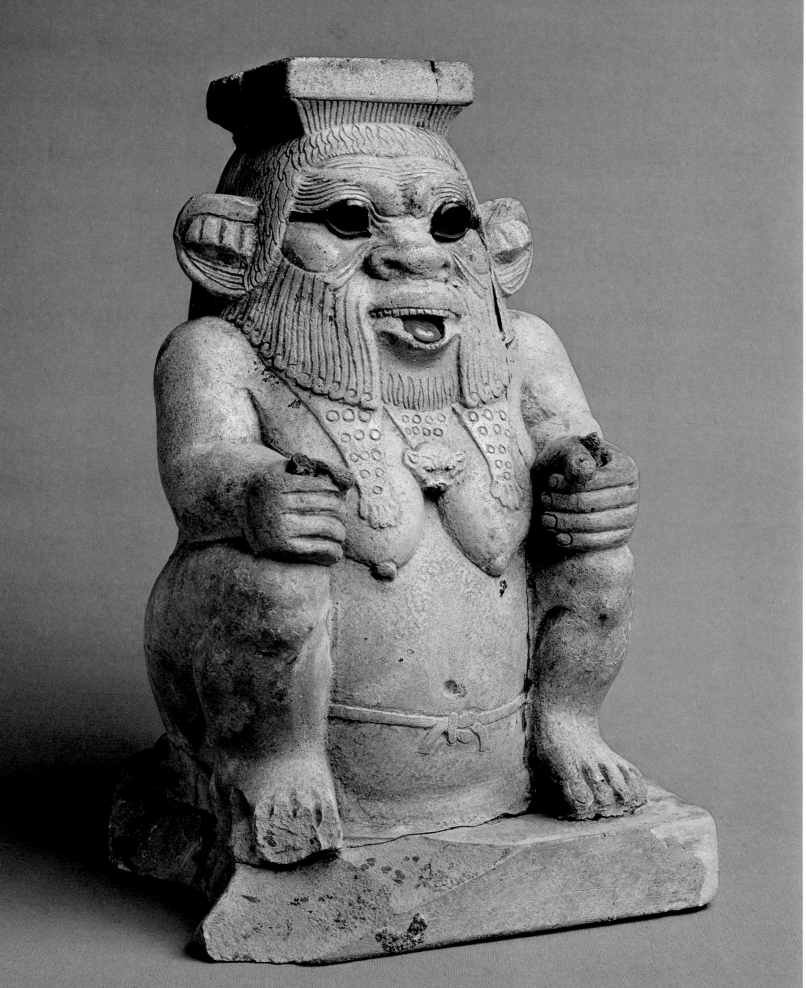

380. "Grand Bès" seated. Saïtic Period. Faïence.
H: 17.7 cm. Paris, Musée du Louvre.

381, 382. Handle of a sistrum with a Bes and an
Isis dancing back to back. From Rome, Temple
of Isis. Roman Period. Bronze. Paris, Musée du
Louvre.

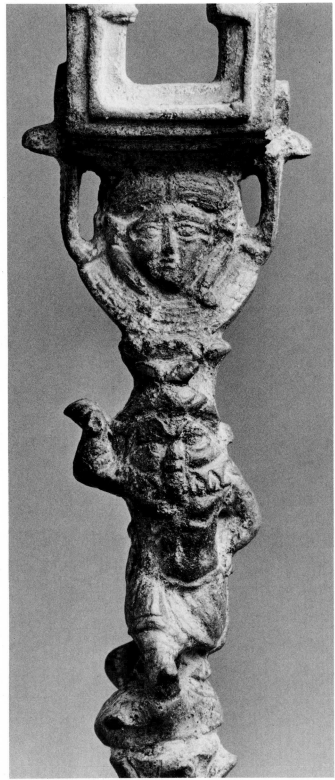

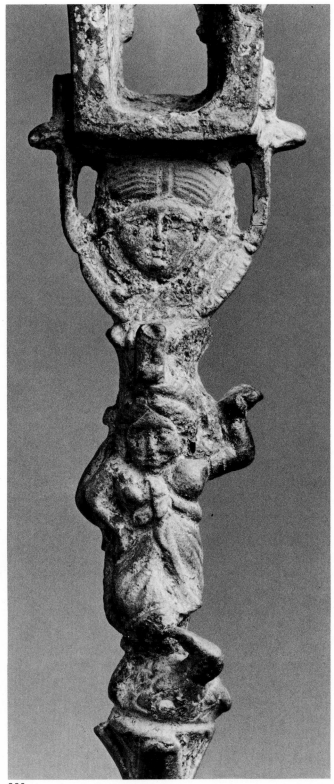

381

382

383. Funerary relief: sacred dance performed during an Isiac ceremony. From Ariccia. Early II century A.D. Marble. 50 × 110 cm. Rome, Museo Nazionale Romano.

384. Detail of figure 383: musicians and dancers.

sometimes be identified with Isis.[74] Figurations of ithyphallic blacks and dwarfs, which are numerous in Greco-Roman art, may also be nothing more than charms against the Evil Eye.[75]

There is evidence of the presence of blacks in Greece.[76] Orientals and Egyptians seem to have been in Italy in relatively large numbers.[77] Egypt provided a sizable contingent of slaves destined for Rome, and there were blacks among them.[78] The role played by these Negroes in the cult of Isis has been brought out by F. M. Snowden.[79] When the cult of the Isiac gods spread through the Greek world, it was often established by authentic Egyptian priests, as was the case at Delos, for instance. Their part in the installation and propagation of the cult guaranteed the genuineness of the Egyptian rites. The use of black personnel in the Isiac temples in Italy during the Roman period probably sprang from this same concern for authenticity,[80] but even more, it seems, from a heightened taste for the exotic.[81] Blacks as priests, musicians, and dancers lent an African flavor to the ceremonies, just as the ancient statues and sculptures brought from Egypt to decorate the temples of Isis gave them an Egyptian cast, which was meant to plunge the initiated in a very special atmosphere, thus captivating both their senses and their minds.

A well-known marble relief, once part of a sarcophagus on the Via Appia near Ariccia,[82] not far from Rome, shows a ceremony in progress in the courtyard of an Isiac temple with a portico filled with statues. Isis(?) is in the center of the portico; on either side of her is a Bes flanked by two cynocephali (African baboons); farther to the right Apis stands on a raised base; the two deities in shelters may be Isis and Serapis; a palm tree and a row of ibises add a Nilotic, African note to the whole scene. In the courtyard, before a frenzied audience gesticulating on a podium at the right, sacred dances are performed to the sound of castanets and double flutes (?), by figures of whom some have fairly pronounced Negroid characteristics.[83]

figs. 383, 384

A painting at Herculaneum presents another scene in which a black clad in a loincloth executes a sacred dance in a temple of Isis;[84] the dancer's leafy headdress recalls the feathered headpiece of the god Bes. Now Bes, as we have noted, was the Egyptian god of music and the dance, and from the time of the Old Kingdom, Negroes and Pygmies brought into Egypt from black Africa were prized for their skill as dancers. Their dances, mere entertainments at first, seem to have taken on a magical and funerary significance.[85] Dances by blacks could therefore be performed as part of Isiac feasts like that of the November Isia, in which the death and resurrection of Osiris were acted out.

To the left of the dancer in the Herculaneum painting, a priest with swarthy skin, shaking a sistrum, could also be a black. A black priest wielding the sistrum of Isis appears in another painting at Herculaneum[86] that seems to depict the start of a procession, perhaps for the feast of the Navigium Isidis in March.[87]

Like the Ariccia relief, these two paintings contain sacred ibises strutting about in the courtyard of the sanctuary. Were these African birds, sacred to Thoth, the Egyptian god of wisdom and the sciences, raised in the Isiac temples in the Occident, to which they lent a further exotic touch?[88]

The Ariccia relief has shown us Africans playing music in connection with ceremonies in Isiac temples in the West. In the Herculaneum painting

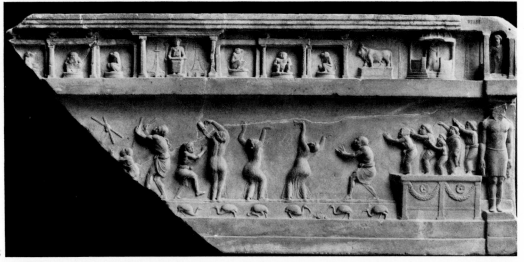

383

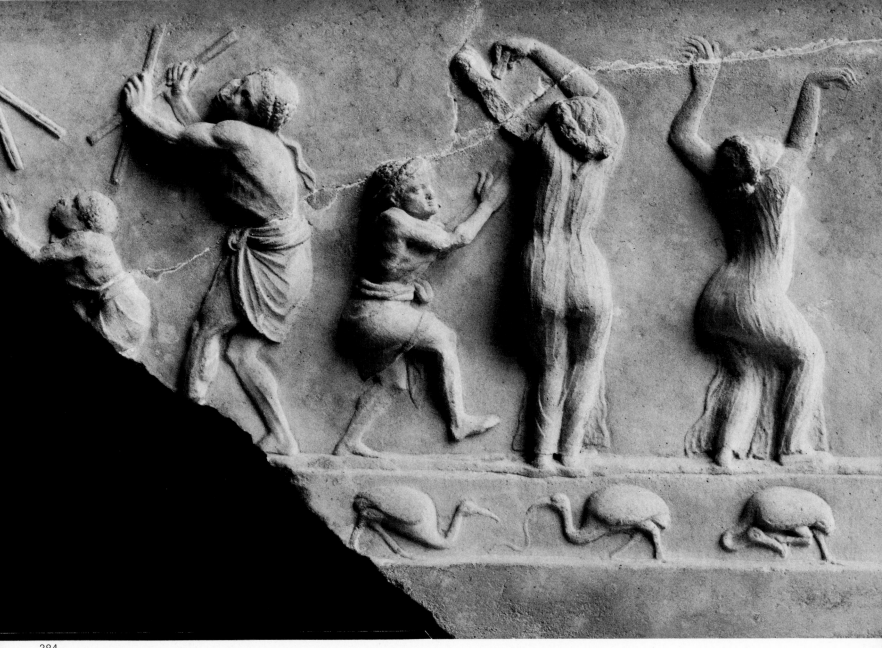

384

283

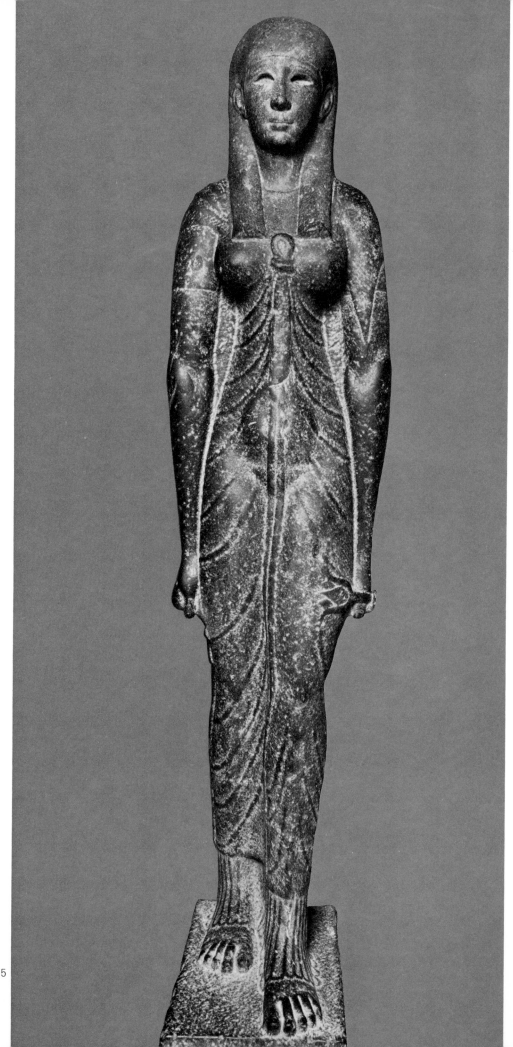

that portrays the preparations for a procession, there might be some question about the racial origin of a dark-skinned priest playing a tuba (or a flute?), at the extreme right of the picture.[89] On the other hand the tuba-player seen in a mosaic at Lepcis Magna, Tripolitania, is certainly a black: with a compatriot who beats time with a baton, he accompanies the cortège of the Nile-god. The mosaic is in the pavement of a villa built in the second century A.D.[90]

One may also admit the presence of blacks in the sacred Isiac dramas. According to Suetonius,[91] for the night after Caligula was murdered a spectacle was being prepared in which "scenes from the underworld" were to be played by Egyptians and "Ethiopians." Given Caligula's Egyptomania, these scenes may have been related to the Isiac mysteries.[92] Such presentations are attested by Apuleius (*Metamorphoses* 11.23) in the Isiac initiation of his hero Lucius.

Pharaonic civilization and the cult of Isis had prolongations well beyond the fall of paganism; reminiscences of ancient Egypt are numerous.[93] The origin of the medieval Black Virgins[94] is still a matter of much controversy.[95] Some have seen in them a survival of the figures of Isis giving the breast to Horus or holding him on her knees. In any case it seems probable that the iconographic type of the Madonna and Child derives from that of Isis holding Horus.[96] Furthermore there are several known Roman statues of Isis in black stone. An Isis-Fortuna in Hadrian's villa at Tivoli is in black basalt,[97] as is another statue of the goddess, coming from the same place.[98] Are we to see, in the Black Virgins of the Middle Age in Western Europe, where Eastern influences were so numerous, a last echo of ancient Egypt, regarded as the land of Africa *par excellence*? In any case, and in a much more general way, medieval tradition was to perpetuate a deep sense of the mythical Africa which, as we have seen, was fundamentally related to the themes of the afterlife.

fig. 385

385. Statue of Isis. From Tivoli, Hadrian's villa. I century A.D. Black basalt. H: 143 cm. Vatican, Museo Gregoriano Egizio.

ABBREVIATIONS

AAA	*Athens Annals of Archaeology*
ABSA	*The Annual of the British School at Athens*
AdE	*Annales d'Ethiopie*
AJA	*American Journal of Archaeology*
AmAn	*American Anthropologist*
Annales E.S.C.	*Annales. Economies, Sociétés, Civilisations*
AntCl	*L'Antiquité Classique*
ASAE	*Annales du Service des Antiquités de l'Egypte*
AthMitt	*Mitteilungen des Deutschen Archäologischen Instituts. Athenische Abteilung*
BAM	*Bulletin d'Archéologie marocaine*
BCH	*Bulletin de correspondance hellénique*
BIFAN	*Bulletin de l'Institut français d'Afrique noire*
BIFAO	*Bulletin de l'Institut français d'archéologie orientale*
BMA	*The Brooklyn Museum Annual*
BMFA	*Bulletin of the Museum of Fine Arts, Boston*
BMMA	*Bulletin of the Metropolitan Museum of Art, New York*
BMQ	*The British Museum Quarterly*
BSAA	*Bulletin de la Société Archéologique d'Alexandrie*
BSFE	*Bulletin de la Société française d'Egyptologie*
CdE	*Chronique d'Egypte*
CRAIBL	*Comptes rendus de l'Académie des Inscriptions et Belles-Lettres*
CVA	*Corpus Vasorum Antiquorum*
JAfrH	*The Journal of African History*
JARCE	*Journal of the American Research Center in Egypt*
JEA	*Journal of Egyptian Archaeology*
JHS	*The Journal of Hellenic Studies*
Libyca: Arch. Epigr.	*Libyca: Archéologie, Epigraphie*
MDIK	*Mitteilungen des Deutschen Archäologischen Instituts, Abteilung Kairo*
MIO	*Mitteilungen des Instituts für Orientforschung*
MJB	*Münchner Jahrbuch der bildenden Kunst*
MNL	*Meroitic Newsletter*
MonPiot	*Monuments et Mémoires publiés par l'Académie des Inscriptions et Belles-Lettres, Fondation Eugène Piot*
NC	*The Numismatic Chronicle*
RA	*Revue Archéologique*

RAE	*Revue Archéologique de l'Est et du Centre-Est*
RAfr	*Revue Africaine*
RdE	*Revue d'Egyptologie*
REA	*Revue des Etudes anciennes*
REG	*Revue des Etudes grecques*
REL	*Revue des Etudes latines*
RGM	*Revue de Géographie du Maroc*
RivIstArch	*Rivista del R. Istituto d'Archeologia e Storia dell'Arte*
RT	*Recueil de Travaux relatifs à la philologie et à l'archéologie égyptiennes et assyriennes*
TAPA	*Transactions of the American Philological Association*
ZÄS	*Zeitschrift für ägyptische Sprache und Altertumskunde*

I

JEAN VERCOUTTER

THE ICONOGRAPHY OF
THE BLACK IN ANCIENT
EGYPT:
FROM THE BEGINNINGS
TO THE TWENTY-FIFTH
DYNASTY

1 H. JUNKER, "The first appearance of the Negroes in History," *JEA* 7 (1921): 121-32.

2 G. A. REISNER, *The Archaeological Survey of Nubia: Report for 1907-1908* (Cairo, 1910), vol. I, pp. 332-38.

3 A colloquium organized by UNESCO convened in Cairo from 28 January-3 February 1974 to discuss the theme: Populations of Ancient Egypt. The meeting brought together a score of internationally recognized experts.
The colloquium agreed on the idea that the use of the terms "*Hamite*" or "*Chamite*," even with quotation marks, should be viewed with reservations, that they have no racial or anthropological content. Most of the participants, including some of the specialists in linguistics, rallied to this opinion. The group expressed the hope that these terms would gradually fall into disuse.

4 E. H. NAVILLE, *The Temple of Deir el Bahari*, The Egypt Exploration Society Memoirs, vol. XVI (London, 1894-1908), pt. 3, pl. 76.

5 G. POSENER, *ZÄS* 83 (1958): 38-43.

6 B. PORTER and R. MOSS, *Topographical Bibliography of Ancient Egyptian Hieroglyphic Texts, Reliefs, and Paintings*, vol. V, *Upper Egypt: Sites...* (Oxford, 1937), p. 237 (hereafter cited as *TB*); more recently, D. M. DIXON, "Land of Yam," *JEA* 44 (1958): 40-55.

7 Cf. W. R. DAWSON, "Pygmies and Dwarfs in Ancient Egypt," *JEA* 24 (1938): 185 ff. The translation *Pygmy* is accepted by R. O. FAULKNER, *A Concise Dictionary of Middle Egyptian* (Oxford, 1962), p. 314, and *The Ancient Egyptian Pyramid Texts*, trans. R. O. FAULKNER (Oxford, 1969), p. 191; also by S. SAUNERON and G. POSENER, *Dictionnaire de la civilisation égyptienne* (Paris, 1959), p. 235.

8 FAULKNER, *Ancient Egyptian Pyramid Texts*, p. 191; K. SETHE, *Die altägyptischen Pyramidentexte* (Leipzig, 1910), vol. II, par. 1189a, p. 163.

9 London, British Museum, 37201.

10 Three of the figures and the base of the toy are in the Egyptian Museum, Cairo. One of the statuettes is in New York, Metropolitan Museum of Art, 34.1.130. W. C. HAYES, *The Scepter of Egypt: A Background for the Study of the Egyptian Antiquities in the Metropolitan Museum of Art*, pt. I, *From the Earliest Times to the End of the Middle Kingdom* (New York, 1953), pp. 222-23, fig. 139.

11 Cairo, Egyptian Museum, JE 51729 and JE 51730.

12 Saqqara, Temple of the pyramid of Pepy I, PP 60 and PP 22. Cf. J. P. LAUER and J. LECLANT, "Découverte de statues de prisonniers au temple de la Pyramide de Pépi I^er," *RdE* 21 (1969): 55-62, and pls. VIII-X.

13 DIXON, *JEA* 44 (1958): 40-55.

14 Boston, Museum of Fine Arts, 14.719. Cf. G. A. REISNER, *A History of the Giza Necropolis* (Cambridge, Mass., 1942), vol. I, pls. 52-56.

15 J. VANDIER, *Manuel d'archéologie égyptienne*, tome III, *Les grandes époques. La statuaire* (Paris, 1958), p. 47.

16 K. SETHE, *Die Ächtung feindlicher Fürsten, Völker und Dinge auf altägyptischen Tongefässscherben des mittleren Reiches* (Berlin, 1926); G. POSENER, *Princes et Pays d'Asie et de Nubie* (Brussels, 1940).

17 Boston, Museum of Fine Arts, 20.1121.

18 New York, Metropolitan Museum of Art, 26.3.232. Cf. HAYES, *The Scepter of Egypt*, pt. I, p. 220, fig. 136.

19 L. BORCHARDT, *Statuen und Statuetten von Königen und Privatleuten, Musée du Caire Catalogue Général des Antiquités Egyptiennes* (Berlin, 1911), vol. I, pls. 55-56 and pp. 164-65 (hereafter cited as *CGC*).

20 Cairo, Egyptian Museum, JE 30969 (= CG 257); from the tomb of Prince Mesehty, Assiut.

21 J. VANDIER, *Mo'alla. La Tombe d'Ankhtifi et la tombe de Sebekhotep*, Bibliothèque d'Etude de l'Institut Français d'Archéologie Orientale, vol. XVIII (Cairo, 1950), pp. 126-29 and pl. XXVI.

22 G. JÉQUIER, *Douze ans de fouilles dans la nécropole memphite, 1924-1936*, Mémoires de l'Université de Neuchâtel, vol. 15 (Neuchâtel, 1940), pp. 136-37.

23 Leiden, Rijksmuseum van Oudheden, F.1947/9.1.

24 H. E. WINLOCK, *Excavations at Deir El Bahari, 1911-1931* (New York, 1942).

25 H. G. FISCHER, "The Nubian Mercenaries of Gebelein during the First Intermediate Period," *Kush* 9 (1961): 44-80.

26 T. SÄVE-SÖDERBERGH, "The Nubian Kingdom of the Second Intermediate Period," *Kush* 4 (1956): 54-64.

27 SÄVE-SÖDERBERGH, *Kush* 4 (1956): 58; A. H. GARDINER, *Egypt of the Pharaohs* (Oxford, 1962), p. 168.

28 D. LORTON, "The So-called 'Vile' Enemies of the King of Egypt (in the Middle Kingdom and Dyn. XVIII)," *JARCE* 10 (1973): 65-66.

29 T. SÄVE-SÖDERBERGH, *Ägypten und Nubien: Ein Beitrag zur Geschichte altägyptischer Aussenpolitik* (Lund, 1941), pp. 152, 155-62.

30 G. A. REISNER, "The Viceroys of Ethiopia," *JEA* 6 (1920): 28-55, 73, and 88; H. GAUTHIER, "Les 'Fils Royaux de Kouch' et le personnel administratif de l'Ethiopie," *RT* 39 (1921): 179-238.

31 Cairo, Egyptian Museum, JE $\frac{8|6}{24|4}$.

32 W. Y. ADAMS, "Post-Pharaonic Nubia in the Light of Archaeology. I," *JEA* 50 (1964): 103-109.

33 N. DE G. DAVIES, *The Tomb of Rekh-mi-Rē at Thebes*, Publications of the Metropolitan Museum of Art Egyptian Expedition, vol. II (New York, 1943), pls. XVIII-XXII.

34 Thebes, necropolis of Sheikh Abdel Qurna, tomb of Rekhmire (no. 100): hall, painting on north wall.

35 DAVIES, *Tomb of Rekh-mi-Rē*, vol. I (1943), pp. 29-30.

36 On this subject, see the study by F. M. Snowden, Jr. in this book.

37 See, for instance, H. CARTER and D. E. NEWBERRY, *The Tomb of Thoutmôsis IV*, *CGC* (Westminster, 1904), p. 33, figs. 15-20.

38 London, British Museum, 921 and 922; from Thebes, tomb of Sebekhotep (no. 63). Cf. PORTER and MOSS, and E. BURNEY, *TB*, vol. I, *The Theban Necropolis*, pt. I, *Private Tombs*, 2nd ed., rev. and aug. (Oxford, 1960), tomb 63, pp. 126-27.

39 Thebes, necropolis of Sheikh Abdel Qurna, tomb of Inene (no. 81): pillared court, painting on north wall, west of the passage.

40 Thebes, necropolis of Sheikh Abdel Qurna, tomb of Horemheb (no. 78): hall, east wing, painting on north wall. PORTER and MOSS, *TB*, vol. III, *Memphis* (1931), pp. 195-97; I. E. S. EDWARDS, "A Fragment of Relief from the Memphite Tomb of Haremhab," *JEA* 26 (1940): 1-2; J. D. COONEY, "A Relief from the Tomb of Haremhab," *JEA* 30 (1944): 2-4; A. GARDINER, "The Memphite Tomb of the General Haremhab," *JEA* 39 (1953): 3-12.

41 Cairo, Egyptian Museum, JE 31409 (= CG 34026); from Thebes. Cf. P. LACAU, *Stèles du Nouvel Empire*, *CGC* (Cairo, 1909), vol. I, Stela 34026, pp. 59-62, pls. XX-XXI.

42 N. M. DE G. DAVIES and A. H. GARDINER, *The Tomb of Huy, Viceroy of Nubia in the Reign of Tut'ankhamūn*, Theban Tombs Series, 4th memoir (London, 1926).

43 Thebes, necropolis of Qurnet Murai, tomb of Huy (no. 40): hall, painting on north wall, west of the passage.

44 DAVIES and GARDINER, *Tomb of Huy*, pls. XXIII, XXVII, XXVIII.

45 DAVIES and GARDINER, *Tomb of Huy*, p. 25 and n. 1.

46 DAVIES and GARDINER, *Tomb of Huy*, p. 24.

47 J.L. BURCKHARDT, *Travels in Nubia*, 2nd ed. (London, 1822), pp. 151, 153, 441, 444-45.

48 Armant, Temple of Monthu: pylon, east pier.

49 R. MOND and O.H. MYERS, *Temples of Armant* (London, 1940), vol. II, pls. I and IX, pp. 23-24.

50 MOND and MYERS, *Temples of Armant*, vol. I (1940), p. 25.

51 Luxor, Temple: relief on east wall of Processional Colonnade. Cf. PORTER and Moss, and BURNEY, *TB*, vol. II, *Theban Temples*, 2nd ed. (1972), p. 315, (84).

52 Medinet Habu, Great Temple: first court, relief on south wall.

53 PORTER and Moss, *TB*, vol. VII, *Nubia, The Deserts, and Outside Egypt* (1951), pp. 171-72, (23). A complete edition of the captives is now in preparation by the Schiff Giorgini Mission.

54 Luxor, Temple: court of Ramesses II, socle of colossus of Ramesses II, west of entrance passage to the Great Colonnade. Cf. PORTER and Moss, *TB*, vol. II, *Theban Temples*, 2nd ed., p. 313, (70).

55 Abydos, Temple of Ramesses II: south wall of portico. Cf. PORTER and Moss, *TB*, vol. VI, *Upper Egypt: Chief Temples...* (1939), pp. 33-34, Second Pylon (1)-(2); p. 35, Portico (16).

56 See for example the footrest in Cairo, Egyptian Museum, JE 62045; C. DESROCHES-NOBLECOURT, *Vie et mort d'un pharaon*, photographs by F.L. Kenett (Paris, 1963), pl. XI (facing p. 50) and pl. XIX (facing p. 90); cf. also N.M. DE G. DAVIES, *Tutankhamun's Painted Box* (Oxford, 1962), pl. II *(The Slaughter of the Nubians)*, and pp. 17-18; see also pl. V *(The Heraldic Design)*, and p. 21.

57 Abu Simbel, Temple of Ra-Harakhte: base of second statue in front of wall south of entrance. PORTER and Moss, *TB*, vol. VII, *Nubia*, p. 100, (25).

58 Medinet Habu, Great Temple: first court, north portico, seventh statue from east.

59 Thebes, necropolis of El Khokha, tomb of Amenemhat-Sourer (no. 48): portico, relief on west wall, north of the passage.

60 Karnak, Great Temple of Amun: Hypostyle Hall, socle of throne in front of south pier of second pylon.

61 Medinet Habu, Great Temple: first pylon, east wall of south pier.

62 Cairo, Egyptian Museum, JE 36457 and JE 36457 H.

63 Durham, University of Durham, Gulbenkian Museum of Oriental Art, Inv. North. 752.

64 H. BONNET, *Reallexikon der ägyptischen Religionsgeschichte* (Berlin, 1952), pp. 101-109.

65 Thebes, necropolis of Sheikh Abdel Qurna, tomb of Wah (no. 22): painting on south wall of hall, east of the passage.

66 London, University College, Department of Egyptology, U.C. 14210.

67 Cf. *supra*, n. 40.

68 Brooklyn, The Brooklyn Museum, 37.620 E; from Abusir (Saqqara).

69 Brooklyn, The Brooklyn Museum, 60.27.1; probably from Tell el Amarna.

70 SÄVE-SÖDERBERGH, *Ägypten und Nubien*, p. 77; GARDINER, *Egypt of the Pharaohs*, p. 37.

71 SÄVE-SÖDERBERGH, *Ägypten und Nubien*, p. 76; POSENER, *ZÄS* 83 (1958): 41.

72 Cairo, Egyptian Museum, JE 61467; from Thebes, tomb of Tutankhamun. Cf. DAVIES, *Tutankhamun's Painted Box*, pl. II.

73 Khartum, Sudan National Museum, 2468.

74 Bologna, Museo Civico Archeologico, KS 1887; relief from the tomb of Horemheb at Memphis.

75 Beit el Wali, Temple of Ramesses II: outer court, relief on south wall. Cf. PORTER and Moss, *TB*, vol. VII, *Nubia*, p. 23, (6)-(7), p. 25, (25).

76 St. Louis, St. Louis Art Museum, 18: 1940; provenance unknown.

77 Brooklyn, The Brooklyn Museum, 37.267 E; from Saqqara.

II

JEAN LECLANT

KUSHITES AND MEROÏTES:
ICONOGRAPHY OF THE
AFRICAN
RULERS IN THE
ANCIENT UPPER NILE

1 G. POSENER, "Pour une localisation du pays Koush au Moyen Empire," *Kush* 6(1958): 39-65.

2 For the development of this region and its place in the broad history of the Nile Valley and Northeast Africa, cf. H. DESCHAMPS, ed., *Histoire générale de l'Afrique noire* (Paris, 1970), pp. 132-48.

3 For recent details, with bibliographical references, see J. LECLANT, "Les études méroïtiques, état des questions," *BSFE* 50 (December 1967): 6-15, pls. I-III; and idem, "L'archéologie méroïtique, Recherches en Nubie et au Soudan, Résultats et perspectives," Actes du Premier Colloque International d'Archéologie Africaine, Fort Lamy, 1966, *Etudes et Documents tchadiens*, Mémoires I (1969), pp. 245-62.

4 On the "federative" character of the empire of Napata, cf. the second stela of Peye (Merowe, Merowe Museum, Inv. Khartum 1851), lines 17-18: "Amun of Napata has made me ruler of every tribe. The one to whom I say, 'You are king,' he will be king: the one to whom I say, 'Do not be king,' he will not be king."

5 We use the expression *Upper Nile* by contrast to the Lower Nile Valley, which corresponds to Egypt. In fact, the central part of the Napatean and Meroïtic Empire lay mainly along the Middle Nile, between the Sixth and Second Cataracts.

6 It may be, however, that two skulls (19-3-392 and 19-3-673) discovered at El Kurru by the American excavation team should be regarded as belonging to Alara and his twin sister: cf. D. DUNHAM, *The Royal Cemeteries of Kush*, vol. I, *El Kurru* (Cambridge, Mass., 1950), p. 118 (hereafter cited as *RCK*), and the review of *RCK* by M. F.L. MACADAM in *Antiquity* 109 (March 1954).

7 Cairo, Egyptian Museum, JE 41013. G. MASPERO, "Notes de voyage," *ASAE* 10 (1909): 9-10 (no illustration); J. LECLANT, "Kashta, Pharaon, en Egypte," *ZÄS* 90 (1963): 74-78 and fig. 1.

8 MASPERO, *ASAE* 10 (1909): 10.

9 For the Ethiopian cap, cf. *infra*, pp. 92, 96 and n. 26.

10 Neither can Kashta's image on a *menat* counterweight be of any help on this point: cf. LECLANT, *ZÄS* 90 (1963): 79.

11 A. HEYLER and J. LECLANT, "Review of F. Hintze, *Die Inschriften des Löwentempels von Musawwarat es Sufra*," *Orientalistische Literaturzeitung* 61 (1966): col. 552; R.A. PARKER, "King *Py*, a Historical Problem," *ZÄS* 93 (1966): III ff.; J.J. JANSSEN, "Smaller Dâkhla Stela (Ashmolean Museum no. 1894. 1076)," *JEA* 54 (1968): 172; and especially K. H. PRIESE, "Nichtägyptische Namen und Wörter in den ägyptischen Inschriften der Könige von Kusch I," *MIO* 14 (1968): 166-75.

12 Triumphal stela of Peye: Cairo, Egyptian Museum, JE 48862. The bibliography is abundant, but we do not have at our disposal a good photograph of this very important document.

13 Merowe, Merowe Museum, Inv. Khartum 1851 (cf. *supra*, n. 4). G. A. REISNER, "Inscribed Monuments from Gebel Barkal," *ZÄS* 66 (1931): 91 and pl. V.

14 Shawabti of Peye, Ku. 17, 19-4-140. Cf. DUNHAM, *RCK*, vol. I, *El Kurru*, p. 66 and pl. XLIV A. Some shawabtis have also been found in the tomb of Shabaka (ibid., p. 57). On the shawabtis of various Kushite rulers, cf. D. DUNHAM, "Royal Shawabti Figures from Napata," *BMFA* 49 (1951): 40-48, 10 figs.

15 Shawabti of Shabaka, Ku. 15, 19-4-140. Cf. DUNHAM, *RCK*, vol. I, *El Kurru*, p. 57 and pl. XLIV B and C, and *RCK*, vol. II, *Nuri* (Boston, 1955), p. 256 and fig. 200.

16 Khartum, Sudan National Museum, 1894; from El Kurru (Ku. 15, 19-2-677). Cf. DUNHAM, *RCK*, vol. I, *El Kurru*, p. 56 and pl. XXXVII C and H.

17 Paris, Musée du Louvre, AF 6639. Cf. J. YOYOTTE, "Plaidoyer pour l'authenticité du scarabée historique de Shabako," *Biblica* 37 (1956): 468, pl. III; E. R. RUSSMANN, "Two Royal Heads of the Late Period in Brooklyn," *BMA* 10 (1968-69): 93, figs. 4-6.

18 The "Ethiopian" sovereigns as kings of Egypt and the Sudan almost always wear the double *uraeus*: cf. J. LECLANT, "Une statuette d'Amon-Rê-Montou au nom de la divine adoratrice Chepenoupet," *Mélanges Maspero*, vol. I, *Orient ancien*, 4th fasc. (1961), p. 79; idem, *Recherches sur les monuments thébains de la XXVᵉ dynastie dite éthiopienne* (Cairo, 1965), pp. 325-26. There are some exceptions, however (ibid., p. 325, n. 2; idem, "La nécropole de l'Ouest à Sedeinga en Nubie soudanaise," *CRAIBL* [1970]: 250).

19 Munich, Staatliche Sammlung Ägyptischer Kunst, ÄS 4859; the provenance of this head is uncertain. Cf. H. W. MÜLLER, "Kopf einer Statue des ägyptischen Sonnengottes aus dem alten Reich," *Pantheon* 18 (May 1960): 109-13; idem, *Werke Altä-*

gyptischer und Koptischer Kunst, Die Sammlung Wilhelm Esch, Duisburg (Munich, 1961); *Die Ägyptische Sammlung des Bayerischen Staates*, Exhibition catalogue, Staatliche graphische Sammlung (Munich, 1966), no. 24; *Staatliche Sammlung Ägyptischer Kunst* (Munich, 1972), pp. 33-34, no. 20 a.

20 Cairo, Egyptian Museum, JE 36677 (=CG 42010); from depository at Karnak. Cf. G. LEGRAIN, *Statues et Statuettes de Rois et de Particuliers, Musée du Caire Catalogue Général des Antiquités Egyptiennes* (Cairo, 1906), vol. I, p. 8 and pl. V (hereafter cited as *CGC*); R. ENGLEBACH, "A Head of King Shabaka," *ASAE* 29 (1929): 15-18; K. BOSSE, *Die menschliche Figur in der Rundplastik der ägyptischen Spätzeit von der XXI. bis zur XXX. Dynastie* (Glückstadt, 1936), p. 79, no. 224; J. YOYOTTE, "Le martelage des noms royaux éthiopiens par Psammétique II," *RdE* 8 (1951): 220, no. 28 and 230, no. 1; LECLANT, *Recherches*, p. 119.

21 Brooklyn, The Brooklyn Museum, 60.74. Cf. RUSSMANN, *BMA* 10 (1968-69): 97-101, figs. 10-12.

22 Athens, National Museum, 632. Cf. P. KABBADIAS, ed., *Musée National* (Athens, 1894), p. 35, no. 168; RUSSMANN, *BMA* 10 (1968-69): 93 and figs. 7-9.

23 On the ram's head (the ram was the animal sacred to the god Amun, object of the Ethiopians' principal cult) and its frequent use as ornament, cf. G. MÖLLER, *Die Metallkunst der alten Ägypter* (Berlin, 1925), p. 45, nn. 162-63, pp. 53-54 and nn. 231-32; LECLANT, *Recherches*, pp. 326-29; RUSSMANN, *BMA* 10 (1968-69): 91, n. 11.

24 J. LECLANT, "Quelques données nouvelles sur l'Edifice dit de Taharqa près du Lac Sacré à Karnak," *BIFAO* 49 (1950): 190-92, pls. II-IV; idem, *Recherches*, pp. 77-78 and pls. XLI B and XLV.

25 On the official representation of Shabaka at Karnak and Luxor, cf. LECLANT, *Recherches*, pp. 337-39 and illustrations.

26 For the Ethiopian cap, cf. LECLANT, *Recherches*, pp. 323-24.

27 For the donation stela in New York, Metropolitan Museum of Art, 55.144.6, cf. A. DANINOS, *Collection d'antiquités égyptiennes de Tigrane Pacha d'Abro* (Paris, 1911), no. 75, p. 10, and pl. 32; N. E. SCOTT, "Recent Additions to the Egyptian Collection," *BMMA* 15 (November 1956): 85-86, no. 14; J. YOYOTTE, "Les principautés du Delta au temps de l'anarchie libyenne," *Mélanges Maspero*, vol. I, *Orient ancien*, p. 172, n. 4. For the donation stela, Paris, Musée du Louvre, E 10571, cf. YOYOTTE, ibid., p. 126, n. 21; cf. pp. 140 and 172.

28 Cairo, Egyptian Museum, JE 38580 (=CG 42204). Cf. LEGRAIN, *Statues, CGC* (1914), vol. III, pp. 12-13 and pl. XI; H. KEES, *Die Hohenpriester des Amun von Karnak* (Leiden, 1964), pp. 163 ff.; LECLANT, *Recherches*, pp. 123-24.

29 P. VIOLLET, "Mémoire sur la Tanistry," *Mémoires de l'Institut de France. Académie des Inscriptions et Belles-Lettres*, 32, no. 2 (1891): 275-317, quoted by J. DESANGES, "Vues grecques sur quelques aspects de la monarchie méroïtique," *BIFAO* 66 (1968): 102.

30 Karnak, chapel of Osiris-Heqa-djet: eastern side of the facade. For the Theban reliefs of Shabataka, cf. LECLANT, *Recherches*, pp. 342-43 and illustration; for the chapel of Osiris-Heqa-djet, cf. ibid., pp. 47-54 and pls. XXII-XXIII, XXVI.

31 Cf. *supra*, n. 25.

32 Cf. *supra*, n. 23.

33 Reference might also be made to the king's shawabtis in his tomb, Ku. 18, 19-4-141 b: cf. DUNHAM, *RCK*, vol. I, *El Kurru*, p. 69 and pl. XLV A and B. But the remains of the Canopic jar cover in the shape of a human head (19-2-239, 240) seem in such bad condition that they cannot be used (ibid., p. 68).

34 For the remains of Shabataka, cf. DUNHAM, *RCK*, vol. I, *El Kurru*, pp. 118-19 (19-2-228).

35 On the tradition of Taharqa the Conqueror, cf. G. GOOSSENS, "Taharqa le Conquérant," *CdE*, 22, 44 (1947): 239-44; J. JANSSEN, "Que sait-on actuellement du Pharaon Taharqa?," *Biblica* 34 (1953): 34; LECLANT, *Recherches*, pp. 116 and 350-51; idem, "Les relations entre l'Egypte et la Phénicie," in *The Role of the Phoenicians in the Interaction of Mediterranean Civilizations*, ed. W.A. WARD, Papers Presented to the Archaeological Symposium at the American University of Beirut; March 1967 (Beirut, 1968), pp. 15-16.

36 On the complex iconography of Taharqa, cf. J. LECLANT, "Sur un contrepoids de menat au nom de Taharqa. Allaitement et 'apparition' royale," *Mélanges Mariette* (Paris, 1961), pp. 258-59; RUSSMANN, *BMA* 10 (1968-69): 95-96.

37 Khartum, Sudan National Museum, 1841; from Gebel Barkal (B904). Cf. G.A. REISNER, "The Barkal Temples in 1916 (continued from Vol. V, p. 112)," *JEA* 6 (1920): pl. XXXIII 1; F. ADDISON, *A Short Guide to the Museum of Antiquities*, 2nd ed. rev. and enl. (Khartum, 1934), pp. 10-11; W.S. SMITH, *The Art and Architecture of Ancient Egypt* (Baltimore, 1965), pl. 177. Note that the left foot, in front, is resting on five bows, the right foot (rear) on three bows: since the "Nine Bows" were the traditional symbol of the people trampled underfoot by the pharaoh, must we surmise that the bow representing the African enemy was left out?

38 Was this stone chosen deliberately? We doubt it, because there are statues of Ethiopian kings carved out of other materials of different colors. Regarding the head in Cairo, Egyptian Museum, CG 560, M.A. MURRAY (*The Splendour that was Egypt* [London, 1949], p. 262) remarked: "... it is in black granite, an appropriate colour in which to represent a negro." The fact is that Taharqa was not a Negro but a Kushite. In any case, we cannot accept the reconstruction of the "Negroid" Taharqa proposed by W. BRUNTON, *Great Ones of Ancient Egypt* (London, 1929), pl. facing p. 160; cf. p. 33.

39 J. LECLANT and J. YOYOTTE, "Notes d'histoire et de civilisation éthiopiennes," *BIFAO* 51 (1952): 29, n. 3.

40 Cairo, Egyptian Museum, CG 560; bought at Luxor. Cf. L. BORCHARDT, *Statuen und Statuetten von Königen und Privatleuten, CGC*, (Berlin, 1925), vol. II, p. 108, pl. 94; LECLANT, *Recherches*, pp. 183-84.

41 Copenhagen, Ny Carlsberg Glyptotek, AEIN 1538. Cf. BOSSE, *Die menschliche Figur*, p. 77, no. 212; O. KOEFOED-PETERSEN, *Catalogue des statues et statuettes égyptiennes* (Copenhagen, 1950), p. 53, no. 87, pl. 99.

42 Cairo, Egyptian Museum, CG 1291. LECLANT, *Recherches*, p. 183, n. 2; RUSSMANN, *BMA* 10 (1968-69): 95, cf. pp. 89 and 104.

43 It may be that we should attribute to Taharqa (or else to Tanutamun) a statue which was left in a quarry at Tombos; cf. B. PORTER and R. MOSS, *Topographical Bibliography of Ancient Egyptian Hieroglyphic Texts, Reliefs, and Paintings*, vol. VII, *Nubia, the Deserts, and Outside Egypt* (Oxford, 1951), p. 174 (hereafter cited as *TB*); D. DUNHAM, "Four Kushite colossi in the Sudan," *JEA* 33 (1947): 63-65. Among the statues of anonymous Ethiopians which have not yet been closely studied, we may include the head in Florence, Museo Archeologico, 7656 (W. VON BISSING, *Denkmäler ägyptischer Skulptur* [Munich, 1914], p. 64, n. 8) and the Turin sphinx, Museo Egizio, 1413 (A. FABRETTI, F. ROSSI, and R.V. LANZONE, *Regio Museo di Torino* [Turin, 1882], vol. I, p. 111, no. 1413); W. GOLÉNISCHEFF, "Amenemhā III et les Sphinx de 'Sân,'" *RT* 15 (1893): 136 and pl. V. Among the examples not yet studied, attribution of which to the Twenty-fifth Dynasty has been suggested but is still subject to discussion, we shall mention here only the head in New York, Metropolitan Museum of Art, 66.99.64 (H.G. FISCHER, "Gallatin Egyptian Collection," *BMMA* 25 [March 1967]: 258).

44 London, British Museum, 1770. PORTER and MOSS, *TB*, vol. VII, *Nubia*, p. 190; S.R.K. GLANVILLE, "A Statue of Tirhaqah (Taharqa) and other Nubian Antiquities," *BMQ*, 7, no. 2 (1932): 45-46, pl. XIX b; cf. the Kawa sphinx, no. 0732 (M.F.L. MACADAM, *The Temples of Kawa* [London, 1955], vol. II, p. 139, pl. LXXIV).

45 These criosphinxes are divided among several collections: Khartum, Sudan National Museum, 24002; London, British Museum, 1779; Oxford, Ashmolean Museum, 1931.553: PORTER and Moss, *TB*, vol. VII, *Nubia*, p. 185; S.R.K. GLANVILLE, "41. Granite Ram from the Sudan," *BMQ*, 8, no. 1 (July 1933-34): 43, pl. XI; MACADAM, *Temples of Kawa*, vol. II, pp. 138-39 and pls. XLIV g, XLVII b, L a-c.

46 Taharqa's name appears on the front of the belt on the small bronze in the Ny Carlsberg collection in Copenhagen, AEIN 1595, formerly in the MacGregor Collection: cf. H. SCHÄFER, *ZÄS* 33 (1895): 114, pl. VI; BOSSE, *Die menschliche Figur*, p. 56, no. 147, pl. VIII a; KOEFOED-PETERSEN, *Catalogue des statues*, p. 54, no. 89, pl. 101.

For another bronze bearing the name of Taharqa, cf. the group in Paris, Musée du Louvre, E 25276, mentioned below in n. 47.

As already stated (cf. *supra*, n. 22), Shabaka's name appears on a bronze in the National Museum, Athens.

We have an important series of small but anonymous royal "Ethiopian" bronzes, the characteristics of which merit detailed study: E.L.B. TERRACE, "Three Egyptian Bronzes," *BMFA* 57 (1959): 48-53, can be consulted with regard to two bronzes in Boston, Museum of Fine Arts, 21.3096 and 72.4333. We may note some few other examples:

The excavations at Kawa. MACADAM, *Temples of Kawa*, vol. II, pp. 143-44, pl. LXXIX. Cf. Brussels, Musées Royaux d'Art et d'Histoire, E 6942 and Copenhagen, Ny Carlsberg Glyptotek, AEIN 1696.

Leningrad, Hermitage Museum, 731. BOSSE, *Die menschliche Figur*, no. 135A, pl. VII c and d; idem, "Zwei Kunstwerke aus der Ägyptischen Sammlung der Ermitage," *ZÄS* 72 (1936): 131-35; LECLANT, *Mélanges Mariette*, p. 258, n. 6; V. PAVLOV and M. MATIE, *Pamiâtniki iskusstva drevnego Egipta v muzeiakh Sovetskovo soiuza* (Moscow, 1958), figs. 82-83; RUSSMANN, *BMA* 10 (1968-69): 89, n. 6 and idem, "Further Aspects of Kushite Art in Brooklyn," *BMA* 11 (1969-70): 155-56, n. 48 (the king is standing).

Copenhagen, Ny Carlsberg Glyptotek, AEIN 605. KOEFOED-PETERSEN, *Catalogue des statues*, p. 54, no. 91, pl. 101. Cf. *infra*, n. 77 and fig. 109.

Copenhagen, Nationalmuseet, 397.

Cairo, Egyptian Museum, CG 823. BORCHARDT, *Statuen und Statuetten, CGC*, vol. III (1930), p. 113, pl. 152.

Khartum, Sudan National Museum, 5459. J. LECLANT, "Deux acquisitions récentes du Musée de Khartoum," *Kush* 1 (1953): 52, pl. XV.

Paris, Bibliothèque Nationale, Cabinet des Médailles ("Inventaire méthodique de la collection d'antiquités égyptiennes conservée au Cabinet des Antiques et Médailles," G. LEGRAIN, comp. [1894-96], p. 127).

Brooklyn, The Brooklyn Museum, 69.73.

We should also note some small figures of Harpocrates wearing the double *uraeus*:

Hildesheim, Roemer-Pelizaeus-Museum, 348. G. ROEDER, *Ägyptische Bronzewerke* (Glückstadt, 1937), p. 19, par. 81, pl. 9 g, h; B. HORNEMANN, *Types of Ancient Egyptian*

Statuary (Copenhagen, 1957), vol. III, no. 781.

Nantes, Musée Thomas Dobrée (deposit of the Louvre, 1404-13). For a similar type in carnelian, see the amulet discovered at Matara, Ethiopia; Addis Ababa, Addis Ababa Museum, JE 2832 (J. LECLANT, "Notes sur l'amulette en cornaline," *AdE* 6 [1965]: 86-87, pl. LXVII 1).

47 Paris, Musée du Louvre, E 25276. Cf. J. VANDIER, "Hemen et Taharqa," *RdE* 10 (1955): 73-79 and pl. 5; J. LECLANT, "L'archéologie de la vallée du Nil," in G. CH.-PICARD, *L'archéologie, découverte des civilisations disparues* (Paris, 1969), p. 195. Note also the small bronze sphinx in the Louvre, E 3916, an ornament from a sacred barge (VANDIER, *RdE* 10 [1955]: 78 and fig. 4).

48 Gebel Barkal, Temple B 300; Room 3, north of the passage which leads to the sanctuary. PORTER and MOSS, *TB*, vol. VII, *Nubia*, pp. 208-211.

49 PORTER and MOSS, *TB*, vol. VII, *Nubia*, p. 149.

50 LECLANT, *BIFAO* 49 (1950): pl. III D; idem, *Recherches*, pp. 67, 350, n. 1 and pl. XLVI A.

51 Probably this frankly unflattering type of iconography was developed to emphasize the Kushite origin of the king. A comparable image is seen on a relief figuring Harprê (but very likely representing the king himself), on the back of the facade of the secondary building dedicated by Taharqa east of the Temple of Amun-Ra-Montu at Karnak North (LECLANT, *Mélanges Mariette*, p. 259 and fig. 2; idem, *Recherches*, pp. 88-89 and pl. LV). The same sort of image is found again on small objects such as *menats*: a counterweight in the Metropolitan Museum of Art, 41.160.104 (LECLANT, *Mélanges Mariette*, p. 258, pl. I A and B); a fragment of a *menat* in Cairo, Egyptian Museum, CG 12913 (G.A. REISNER, *Amulets, CGC*, vol. II [Cairo, 1958], p. 50, pls. XII and XXVI; LECLANT, *Mélanges Mariette*, p. 277, n. 2 and fig. 6). In a similar style, in some instances, the Divine Consorts look rather out of sorts.

52 For instance, the fragment of a relief in a private collection, Paris; cf. fig. 90.

53 Fragment of the drum of a column coming from the colonnade reused at Karnak North, block A 234. C. ROBICHON, P. BARGUET, and J. LECLANT, *Karnak-Nord IV (1949-1951)*, Fouilles de l'Institut Français du Caire, vol. XXV (Cairo, 1954), pt. I, p. 104 and pt. II, pls. LXXXIX and XC.

54 Karnak, doorpost from the Edifice of Taharqa of the Lake. LECLANT, *BIFAO* 49 (1950): 181-82, pl. IV; idem, *Dans les pas des Pharaons* (Paris, 1958), pp. 26 and 122, pl. 41; idem, *Recherches*, p. 75 and pl. XL.

55 Sedeinga (Sudanese Nubia), west necropolis, doorpost of Tomb W T 1. M. SCHIFF GIORGINI, "Première Campagne de Fouilles à Sedeinga, 1963-64," *Kush* 13 (1965): 118-23, figs. 4 and 5; LECLANT, *CRAIBL* (1970): 249-52, figs. 2 and 3.

56 Nuri Tomb No. 1 presents more than one unusual feature. Its pyramid comprises two buildings, one enclosed within the other. Water bathes the lower part of the infrastructure, which has lateral niches and a corridor running around the central area, the latter being isolated like an island. Finally the American expedition's publication states: "Burial. No trace" (DUNHAM, *RCK*, vol. II, *Nuri*, p. 9). A sketchy note published by G.A. REISNER, "Known and Unknown Kings of Ethiopia," *BMFA* 16 (1918): 72, mentions "a few fragments of bones," but these are not mentioned in Reisner's other report published that year: "Preliminary Report of the Harvard-Boston Excavations at Nûri: The Kings of Ethiopia after Tirhaqa," in *Harvard African Studies*, vol. II, *Varia Africana II*, ed. O. BATES (Cambridge, Mass., 1918), pp. 45-46. All the funerary material seems to have been systematically removed out of Tomb W T 1 at Sedeinga, nothing was left there except strips of gold leaf in unexpectedly large quantities. The skeleton had been methodically broken into very small splinters; it is the skeleton of a male about fifty years old.

57 DUNHAM, *RCK*, vol. I, *El Kurru*, p. 10, fig. 197, pl. CXL; idem, *BMFA* 49 (1951): 47; VANDIER, *RdE* 10 (1955): 77, n. 1. Here we present photographs of three of these shawabtis: Khartum, Sudan National Museum, 1389; Boston, Museum of Fine Arts, 21.11748; and Khartum, Sudan National Museum, 1421.

58 London, British Museum, 127412; from Nimrud. Cf. R. D. BARNETT, *A Catalogue of the Nimrud Ivories with other examples of Ancient Near Eastern Ivories in the British Museum* (London, 1957), no. o.1 (127412); A. PARROT, *Assur* (Paris, 1961), p. 152, figs. 186, 187 and p. 372.

59 D. M. DIXON, "The Origin of the Kingdom of Kush (Napata-Meroë)," *JEA* 50 (1964): 130-31; LECLANT in *Role of Phoenicians*, p. 16, pls. IX b and X b. For the stelae at Til Barsib, cf. F. THUREAU-DANGIN, *Til Barsib* (Paris, 1936), pp. 151-56, pls. XII-XIII; PARROT, *Assur*, pp. 35, 76, 77, fig. 86, p. 368. For Sendjirli, cf. D. D. LUCKENBILL, *Ancient Records of Assyria and Babylonia* (Chicago, 1927), vol. II, pp. 224-27, pars. 573-81; PARROT, *Assur*, p. 34, fig. 39 C, pp. 35 and 366.

60 LECLANT, *Recherches*, pp. 149-51, 351.

61 For the socle of the statuette from the Temple of Mut, Cairo, Egyptian Museum, CG 770 (=JE 2096). Cf. A. MARIETTE, *Karnak: Etude topographique et archéologique* (Leipzig, 1875), p. 67; LECLANT, *Recherches*, pp. 116, 351; for the model of Horemheb, cf. R. HARI, *Horemheb et la reine Moutnedjemet* (Geneva, 1965), pp. 257-62.

62 Boston, Museum of Fine Arts, 21.308; ivory from the tomb of Shabataka, Ku. 18, 19-3-1581 a. Cf. DUNHAM, *RCK*, vol. I, *El Kurru*, p. 69 and pl. XXXIV E.

63 Brooklyn, The Brooklyn Museum, 05.316. Cf. RUSSMANN, *BMA* 10 (1968-69): 101-104, figs. 15-16.

64 Shawabti of Tanutamun, Ku. 16, 19-4-142. Cf. DUNHAM, *RCK*, vol. I, *El Kurru*, p. 61, pl. XLV C and D; several shawabtis have also been found in Shabaka's tomb (ibid., p. 57). For Dunham's study, cf. *supra*, n. 14.

65 Boston, Museum of Fine Arts, 21.2801; from the tomb of Tanutamun at El Kurru, Ku. 16, 19-3-573. Cf. DUNHAM, *RCK*, vol. I, *El Kurru*, p. 61 and pl. XXXVII E, 2 and F.

66 Karnak South, chapel of Osiris-Ptah-Nebankh: Room I, west wall; Room II, north and south walls. On the Theban reliefs of Tanutamun, cf. LECLANT, *Recherches*, pp. 351-52; for the reliefs in the chapel of Osiris-Ptah-Nebankh (ibid., pp. 110-13), the only available reference used to be A. MARIETTE, *Monuments divers recueillis en Egypte et en Nubie*, text by G. MASPERO (Paris, 1889), pls. 79-87.

67 In Egypt itself the Kushite kings seem to have regarded the queen-mother as of little importance, although Taharqa repeatedly mentions his mother, Queen Abar, on the stelae of the Year VI. This was not true in the Sudan. Queen Qalhata, mother of Tanutamun (?), was entombed in the Egyptian manner at El Kurru (Ku. 5). Cf. PORTER and MOSS, *TB*, vol. VII, *Nubia*, p. 196, with important mural paintings.

68 For the queens of the Ethiopian dynasty we may point out in particular the upper part of the statue of a "royal wife" in the Nicholson Museum of Antiquities, University of Sydney (Australia), Inv. R 41, whose face is wholly restored, and whose name, unfortunately, has disappeared. Cf. PORTER and MOSS, and E. BURNEY, *TB*, vol. I, *The Theban Necropolis*, pt. 2, *Royal Tombs and Smaller Cemeteries*, 2nd ed., rev. and aug. (Oxford, 1964), p. 794; W. M. F. PETRIE, *A History of Egypt (from the XIXth to the XXth Dynasties)* (London, 1905), vol. III, p. 304, fig. 130; G. ROEDER, "Statuen ägyptischer Königinnen," *Mitteilungen der vorderasiatischen Gesellschaft* 37 (1932): 5-10, 2 figs. Some have thought this princess could be identified as Shepenwepet or Amenirdas II, but the few traces of titles remaining on the rear pillar exclude this possibility.

69 Until a complete inventory, now being put together, is available, reference may be made to LECLANT, *Recherches*, pp. 353-86; cf. also idem, "Tefnout et les Divines Adoratrices'" *MDIK* 15 (1957): 166-71, pls. XXI-XXIII. On Amenirdas I, daughter of Kashta, cf. the notice in the *Lexikon der Ägyptologie* (Wiesbaden, 1975), vol. I, cols. 196-99; on Amenirdas II, daughter of Taharqa, cf. ibid., cols. 199-201.

70 On the Ethiopian image, and particularly on the tradition of the Divine Consorts in

the works of the authors of classical antiquity, cf. Leclant, *Recherches*, pp. 384, 403.

71 Cairo, Egyptian Museum, CG 565; from Karnak North, south chapel of the Monthu enclosure. Borchardt, *Statuen und Statuetten, CGC*, vol. II, pp. 114-15 and pl. 96; Leclant, *Recherches*, pp. 96-98 and pl. LXI. A replica in bronze, found in the same place and formerly in the Allemant Collection, is in Antwerp (C. de Wit, *Vleeshuis Catalogus*, vol. VIII, *Egypte* [Antwerp, 1959], p. 40, no. 152; inv. 79.1.125).

72 On the sacred vase of Amun presented particularly in cortèges, cf. E. Schott, "Die heilige Vase des Amon," *ZÄS* 98 (1970): 34-50, 6 figs.

73 East Berlin, Staatliche Museen, Ägyptisches Museum, 7972; sphinx found in the sector of the Sacred Lake at Karnak. Cf. *Ausführliches Verzeichnis der Ägyptischen Altertümer und Gipsabgüsse* (Berlin, 1899), p. 246 and fig. 51; Leclant, *Recherches*, p. 130.

74 Cairo, Egyptian Museum, JE 36954 (= CG 42201); from depository at Karnak, no. 156. Legrain, *Statues, CGC*, vol. III, pp. 9-10 and pl. IX; Leclant, *Recherches*, pp. 120-21.

75 Chapel of Osiris-Heqa-djet: Room I, north wall, western part. Leclant, *Recherches*, p. 53, no. 33.

76 Chapel of Osiris-Heqa-djet: Room I, north wall, eastern part. Leclant, *Recherches*, p. 52, no. 22, and pl. XXVIII A.

77 Bronze statuette in Copenhagen, Ny Carlsberg Glyptotek, AEIN 605. Cf. *supra*, n. 46.

78 Profile of the god Amun on the reused block A 204, Karnak North, which came from the left facade of the Edifice of the Divine Consorts. Cf. Robichon et al., *Karnak-Nord IV*, pt. I, pp. 110-12; pt. II, pls. XCVI-XCVII.

79 Paris, Private Collection, fragment of a relief; provenance unknown. The "*piquetage en pluie*" (pockmarking hammered into the stone) is not original, nor is it intended as decoration.

80 Nantes, Musée Thomas Dobrée (deposit of the Louvre, 1404-13); bronze pendant of Harpocrates in a sitting posture. For the theme of the child with a double *uraeus*, cf. *supra*, n. 46.

81 Copenhagen, Ny Carlsberg Glyptotek, AEIN 72 (formerly Sabatier Collection); granite statuette of Osiris seated, probably from Medinet Habu. The statuette bears the cartouche of Amenirdas, daughter of Kashta; Leclant, *Recherches*, p. 165, D, 10.

82 The iconography brought together in J. Leclant, *Montouemhat, quatrième prophète d'Amon, Prince de la Ville* (Cairo, 1961), may be considered from this point of view.

83 Cairo, Egyptian Museum, JE 38018. Cf. L.P. Kirwan, "A Sudanese of the Saite Period," *Mélanges Maspero*, vol. I, *Orient ancien*, 1st fasc. (1934), pp. 373-77 and 1 pl.; Drioton-Vigneau, *Encyclopédie photographique de l'Art, Le Musée du Caire* (Paris, 1949), p. 30 and pl. 173; Leclant, *Recherches*, p. 123; S. Donadoni, *Cairo, Museo Egizio* (Milan, 1969), pp. 150-51. The transcription in Egyptian hieroglyphs which gives us "Irigadiganen" seems to correspond to a Meroïtic schema such as *arik-tk-ñ*: cf. Priese, *MIO* 14 (1968): 188, n. 123.

84 Three statues of Senkamanisken were found in a depository of statuary at Gebel Barkal: one of them is in Boston, Museum of Fine Arts, 23.731, another in Khartum, Sudan National Museum, 1842: cf. Porter and Moss, *TB*, vol. VII, *Nubia*, p. 221. A headless statue can be seen in the Virginia Museum of Fine Arts in Richmond, Va.

85 In the same depository at Gebel Barkal two statues of Anlamani were found: one is in Boston, Museum of Fine Arts, 23.732, the other in Khartum, Sudan National Museum, 1845; cf. Porter and Moss, *TB*, vol. VII, *Nubia*, p. 221.

86 From the same place comes the statue of Aspelta, now in Boston, Museum of Fine Arts, 23.730: cf. Reisner, *JEA* 6(1920): pl. XXXIII 3; D. Dunham, *The Egyptian Department and its Excavations* (Boston, 1958), fig. 74; W. S. Smith, *Ancient Egypt as represented in the Museum of Fine Arts*, 4th ed. fully rev. (Boston, 1960), p. 167. The face of the small sphinx found at Defeia (seven miles northeast of Khartum) is now too indistinct to give a good idea of the sovereign's features (J. Vercoutter, "Le Sphinx d'Aspelta de Defeia," *Mélanges Mariette*, pp. 97-104 and 1 pl.). On the other hand, his features are discernible on the king's shawabtis (Dunham, *RCK*, vol. II, *Nuri*, p. 81, fig. 197, pl. CXL; cf. also London, British Museum, 55511 and Brussels, Musées Royaux d'Art et d'Histoire, E 6107, M. Werbrouck, "Salle de Nubie," *Bulletin des Musées Royaux d'Art et d'Histoire* 24 [1952]: 8); on the reliefs in Temple T at Kawa (Macadam, *Temples of Kawa*, vol. II, pls. XVIII, LI a, and LVII); and on the lunette of the "stela of enthronement" (Mariette, *Monuments divers*, pl. 9).

87 Macadam, *Temples of Kawa*, vol. II, pl. XVIII b.

88 East Berlin, Staatliche Museen, Ägyptisches Museum, 2268. Cf. H. Schäfer, *Die äthiopische Königsinschrift des Berliner Museums* (Leipzig, 1901), 4 pls.; Porter and Moss, *TB*, vol. VII, *Nubia*, p. 193; *Nubien und Sudan im Altertum: Sonderausstellung* (Berlin, 1963), pp. 23-27, fig. 3. Nastasen, who came about twenty-sixth in the series of Kushite kings (c. 325-315 B.C.), seems to have been the last to have shawabtis placed in his tomb (Dunham, *RCK*, vol. I, *El Kurru*, p. 118).

89 The identification of Ergamanes has been the subject of recent discussions: cf. F. Hintze, *Die Inschriften des Löwentempels von Musawwarat es Sufra*, Abh. d. Deutsch. Akad. d. Wiss. zu Berlin, Kl. f. Sprachen, Literatur und Kunst (Berlin, 1962), pp. 13-19; M. F. L. Macadam, "Queen Nawidemak," *Allen Memorial Art Museum Bulletin* 23 (1966): 53-54, n. 29; B. G. Haycock, "Towards a Date for King Ergamenes," *Kush* 13 (1965): 264-66; S. Wenig, "Bemerkungen zur Chronologie des Reiches von Meroe," *MIO* 13 (1967): 44; cf. also *infra*, n. 98.

90 See a list of monuments of Natakamani and Amanitore in Dunham, *RCK*, vol. IV, *Royal Tombs at Meroë and Barkal* (Boston, 1957), pp. 7 and 10; P. L. Shinnie, *Meroe: A Civilization of the Sudan*, Ancient Peoples and Places, vol. 55 (New York and London, 1967), Index, pp. 225 and 228. On the role of Amanitore, cf. Wenig, *MIO* 13 (1967): 36-41.

91 S. E. Chapman (and D. Dunham), *RCK*, vol. III, *Decorated Chapels of the Meroitic Pyramids at Meroë and Barkal* (Boston, 1952).

92 F. Hintze, *Studien zur meroitischen Chronologie und zu den Opfertafeln aus den Pyramiden von Meroe* (Berlin, 1959), pp. 36-39.

93 Relief on the north wall of the chapel of Pyramid Beg N 12. Porter and Moss, *TB*, vol. VII, *Nubia*, p. 249; Chapman and Dunham, *RCK*, vol. III, *Decorated Chapels*, pls. 10 A and 26 A; F. and U. Hintze, *Alte Kulturen im Sudan* (Leipzig, 1967), pl. 79 (English ed.: *Civilizations of the Old Sudan* [New York, 1968]).

94 Relief on the south wall of the chapel of Pyramid Beg N 12. Porter and Moss, *TB*, vol. VII, *Nubia*, p. 249; G. A. Reisner, "The Meroitic Kingdom of Ethiopia: A Chronological Outline," *JEA* 9 (1923): pl. V; Chapman and Dunham, *RCK*, vol. III, *Decorated Chapels*, pl. 10 B.

95 Compare the hair treatment of the Nubians figured on the reliefs of the tributaries of Persepolis: cf. E. Schmidt, *Persepolis* (Chicago, 1953), vol. I, pl. 19; E. Walser, "Die Völkerschaften auf den Reliefs von Persepolis," *Teheraner Forschungen* 2 (1966): pls. 30 and 31. See the comparisons made by J. Leroy, "Les 'Ethiopiens' de Persépolis," *AdE* 5 (1963): 293-95, pls. CLXII-CLXIII, and more recently by I. Hofmann, *Studien zum meroitischen Königtum* (Brussels, 1971), p. 72.

96 Dunham, *RCK*, vol. IV, *Royal Tombs at Meroë and Barkal*, pp. 143-45.

97 Several works, which represent a solid beginning in the long-neglected field of physical anthropology, may be consulted: M.-Cl. Chamla, *Aksha*, vol. III, *La population du cimetière méroïtique* (Paris, 1967); O. Vagn Nielsen, *The Scandanavian Joint Expedition to Sudanese Nubia*, vol. IX, *Human Remains* (Stockholm, 1970); T. Dzierzyk-rai-Rogalski, "Les recherches anthropologiques polonaises en Egypte et au Soudan dans les années 1958-1966," *Actes du VIIe Congrès International des Sciences Préhistoriques et Protohistoriques, Prague, 21-27 Août 1966*

(Prague, 1970), vol. 2, pp. 1275-76; E. STROUHAL, "Anthropological Analysis of Skeletal Remains from Rock Tombs at Naga el-Farik in Egyptian Nubia," *Anthropologie*, 10, 2-3 (1972): 97-121.

98 For the Lion Temple at Musawwarat es-Sufra, consult F. Hintze's large work, which is in preparation; cf. also HINTZE, *Die Inschriften des Löwentempels von Musawwarat es Sufra*; F. and U. HINTZE, *Alte Kulturen im Sudan*, pls. 97-108 and 128. According to the learned observations of the excavator, the introduction of epithets within Arnekhamani's cartouche would suggest that this king reigned about the year 220 B.C. Previously, in his *Studien zur meroitischen Chronologie*, pp. 23-24, Hintze had placed Arnekhamani about 315 B.C.; cf. also *supra*, n. 89.

99 Musawwarat es-Sufra, Lion Temple: north outer wall; King Arnekhamani and his son Arka facing the lion-god Apedemak. F. HINTZE, *Musawwarat es Sufra*, band I, pt. 2, *Der Löwentempel. Tafelband* (Berlin, 1971), pl. 16 b.

100 Musawwarat es-Sufra, Lion Temple: south outer wall; King Arnekhamani and his son Arka facing the cortège of the gods led by the god Apedemak. HINTZE, *Musawwarat es Sufra*, band I, pt. 2, *Der Löwentempel*, pl. 16 a.

101 Musawwarat es-Sufra, Lion Temple: the god Sbomeker, fig. 124.

102 On the Candaces, "queen-mothers" *par excellence*, cf. B. G. HAYCOCK, "The Kingship of Kush in the Sudan," *Comparative Studies in Society and History* 7 (1965): 461-80; I. S. KATZNELSON, "Candace and the Survivals of the Maternality in Kush," *Palestinski Sbornik*, 15, 78 (1966): 35-40 (in Russian); WENIG, *MIO* 13 (1967): 36-41; DESANGES, *BIFAO* 66 (1968): 89-104; idem, "Un point de repère chronologique dans la période tardive du royaume de Méroé," *MNL* 7 (July 1971): 2-5.

103 Naga, Lion Temple: western outer wall. F. LL. GRIFFITH, *Meroitic Inscriptions* (London, 1911), vol. I, pl. XX; SHINNIE, *Meroe*, pls. 10-11.

104 Naga, Lion Temple: northern outer wall. PORTER and MOSS, *TB*, vol. VII, *Nubia*, p. 269, (21)-(22); GRIFFITH, *Meroitic Inscriptions*, vol. I, p. 60, no. 14 and pl. XVIII.

105 GRIFFITH, *Meroitic Inscriptions*, vol. I, pl. XVII; SHINNIE, *Meroe*, pl. 8.

106 Worcester, Mass., Worcester Art Museum, 1922.145. Published by F.LL. GRIFFITH, "Meroitic Studies III," *JEA* 4 (1917): 21-24, pl. 5; bibliography given in J. LECLANT and A. HEYLER, "Préliminaires à un Répertoire d'Epigraphie Méroïtique," *MNL* 1 (October 1968): 15, s.n., REM 1005.

107 Cairo, Egyptian Museum, CG 684. Cf. BORCHARDT, *Statuen und Statuetten, CGC*,

vol. III, pp. 28-29; J. PIRENNE, *Histoire de la civilisation de l'Egypte ancienne* (Paris and Neuchâtel, 1963), vol. III, pl. 109 and p. 443; S. WENIG, "Die Meroitische Statuengruppe CG 684 im ägyptischen Museum zu Kairo," *MNL* 3 (October 1969): 13-17 and fig.

108 Copenhagen, Ny Carlsberg Glyptotek, AEIN 1082; pillar statue found at Meroë in 1911 during the excavations carried out by the University of Liverpool. Cf. KOEFOED-PETERSEN, *Catalogue des statues*, no. 138, p. 76, and pl. 147; A. MALRAUX, *Le Musée imaginaire de la sculpture mondiale* (Paris, 1952), pl. 107; SHINNIE, *Meroe*, cover and pl. 24. This statue, long considered to be the image of a sovereign, has recently been interpreted as that of a god: cf. S. WENIG, "Meroitische Kunst," *Journées Internationales d'Etudes Méroïtiques*, Paris, 10-13 July 1973, to be published in *Meroitica*.

109 Colossi lying in front of the Temple of Tabo on the island of Argo; recently transported to Khartum, Sudan National Museum, 23983. Cf. PORTER and MOSS, *TB*, vol. VII, *Nubia*, p. 180; SHINNIE, *Meroe*, pl. 23.

110 Khartum, Sudan National Museum, 24003; relief discovered in the Great Enclosure of Musawwarat es-Sufra. F. and U. HINTZE, *Alte Kulturen im Sudan*, pls. 100-101.

111 Consult A. J. ARKELL, "Meroë and India," in *Aspects of Archaeology in Britain and Beyond: Essays presented to O.G.S. Crawford*, ed. W. F. GRIMES (London, 1951), pp. 32-38; J. LECLANT, "Fouilles et travaux en Egypte et au Soudan, 1962-1963," *Orientalia* 33 (1964): 386-87; I. HOFMANN, "Der sogennante Omphalos von Napata," *JEA* 56 (1970): 187-92, pls. LXVI-LXVII; idem, *Wege und Möglichkeiten eines indischen Einflusses auf die meroitische Kultur* (St. Augustin bei Bonn, 1975). But differing opinions have recently come from several quarters.

112 J. LECLANT, "Fouilles et travaux en Egypte et au Soudan, 1967-1968," *Orientalia* 38 (1969): 289, figs. 54 and 58; idem, *CRAIBL* (1970): 267 and fig. 12.

113 Khartum, Sudan National Museum, 5587; unpublished stela found at Dabarosa. Cf. PORTER and MOSS, *TB*, vol. VII, *Nubia*, p. 218; P. L. SHINNIE, *Report on the Antiquities Service and Museums 1948*, Sudan Government (Khartum, n.d.), p. 7; F. HINTZE, "Notes: 'Drei Meroitische Graffiti aus Unternubien,'" *Kush* 9 (1961): 283; idem, "Die Struktur der 'Deskriptionssätze' in den meroitischen Totentexten," *MIO* 9 (1963): 13, 14, 23. Mention may also be made here of a stela found in Cemetery 214 near Abu Simbel: cf. W. B. EMERY and L. P. KIRWAN, *The Excavations and Survey between Wadi es-Sebua and Adindan, 1929-1931* (Cairo, 1935), pls. 27 and 29; REM 1024 (with bibliography) in J. LECLANT and A. HEYLER, "Préliminaires à un Répertoire d'Épigraphie Méroïtique," *MNL* 2 (April 1969): 14.

114 C. L. WOOLLEY and D. RANDALL-MacIver, *Karanòg: The Romano-Nubian Cemetery*, Eckley B. Coxe, Jr. Expedition to Nubia, vol. IV (Philadelphia, 1910), pls. 1-10; W. K. SIMPSON, "The Pennsylvania-Yale Expedition to Egypt. Preliminary Report for 1963: Toshka and Arminna (Nubia)," *JARCE* 3 (1964): pl. X, fig. 4.

115 Cairo, Egyptian Museum, JE 40232; from necropolis at Karanog, tomb 187. Cf. WOOLLEY and RANDALL-MacIver, *Karanòg*, vol. III (1910), p. 47 and vol. IV, pls. 1 and 2, upper.

116 LECLANT, *CRAIBL* (1970): 254-59, fig. 4.

117 Khartum, Sudan National Museum; from necropolis at Sedeinga. Cf. LECLANT, *CRAIBL* (1970): 259 and fig. 8; idem, "Fouilles et travaux en Egypte et au Soudan, 1969-1970," *Orientalia* 40 (1971): fig. 52.

118 Khartum, Sudan National Museum, 13365; from Argin. Cf. M. A. GARCIA GUINEA and J. TEIXIDOR, *La necrópolis meroítica de Nelluah (Argín Sur, Sudán)*, Memorias de la Misión Arqueológica Española en Nubia (Egipto y Sudán), vol. VI (Madrid, 1965), p. 102 and pl. XXXIX.

119 See, for example, the head found in the necropolis at Nag Gamus, tomb 95; cf. M. ALMAGRO, *La necrópolis meroítica de Nag Gamus (Nubia Egipcia)*, Memorias de la Misión Arqueológica Española en Nubia (Egipto y Sudán), vol. VIII (Madrid, 1965), pp. 163-64, fig. 189, and pl. VIII 2; attached to and of one piece with the head is a disc, originally painted red.

120 For the three vertical scars (the *selukh*) still characteristic of the populations of the northern Sudan, consult the references brought together by I. HOFMANN, *Die Kulturen des Niltals von Aswân bis Sennar* (Hamburg, 1967), p. 399, pl. VII 1 and 2, pl. VIII 6; see also WOOLLEY and RANDALL-MacIver, *Karanòg*, vol. III, p. 57 and vol. IV, pl. 62; L. KEIMER, "Une petite tête romaine en terre cuite représentant une Soudanaise à cicatrices faciales," *BSAA* 40 (1953): 32-34 (small Alexandrian head in terracotta); ALMAGRO, *La necrópolis meroítica*, p. 176, fig. 205.1, pl. VIII-1 (head of a *ba* statue); SHINNIE, *Meroe*, pl. 46 (Faras vase in Oxford, Ashmolean Museum, 1912-324).

121 Khartum, Sudan National Museum, 10045. SADIK NUR, "Two Meroitic Pottery Coffins from Argin in Halfa District," *Kush* 4 (1956): pl. XIII.

122 Khartum, Sudan National Museum, 20391; from necropolis of the western tombs at Sedeinga. LECLANT, *CRAIBL* (1970): 267-68; idem, *Orientalia* 40 (1971): fig. 50.

III

FRANK M. SNOWDEN, JR.

ICONOGRAPHICAL
EVIDENCE ON THE BLACK
POPULATIONS
IN GRECO-ROMAN
ANTIQUITY

I am deeply indebted to Herbert Hoffmann and David Gordon Mitten for their valuable criticisms of this essay. They are of course in no way responsible for, nor do they necessarily share the opinions expressed.

1 Juvenal 6.165.

2 M. J. Herskovits in *Encyclopaedia Britannica* (Chicago, London, New York, 1960), vol. XVI, s.v. "Negro," p. 193. Some of the physical features of this type are: dark or black color expressed in a variety of ways, tightly curled hair, platyrrhine nose, and thick, often everted lips.

3 In the Nilotic type, the nose is less platyrrhine, the lips less thick, and the hair less tightly curled than in the "true" Negro. Herskovits, *Encyclopaedia Britannica*, s.v. "Negro," p. 193, notes that the degree to which reduced Negroid traits in the Nilotic type are a result of Caucasoid admixture is debatable and considers it preferable to regard this as another highly specialized Negroid type. For a recent discussion of the physical characteristics of Negroes, see Chap. 18 ("The Negrids [Negroes]") in *Race* by J.R. Baker (New York, 1974), pp. 325-42.

4 M. J. Herskovits, *The American Negro: A Study in Racial Crossing* (1928; Bloomington, Indiana, 1964), pp. 19-20, in a chapter entitled "The Physical Type He Is Forming," comments as follows on the wide range of physical traits in the "highly mixed" American Negro: "They range from the man of dark-brown skin and African appearance to the man who is almost white, and from the broad-nosed, thick-lipped black man to the Caucasoid-looking, thin-lipped, narrow-nosed 'technical' Negro. Then there is hair form, varying from the tightly curled to that of Indian-like straightness."

5 On the physical characteristics of Ethiopians as described in classical authors, see my *Blacks in Antiquity: Ethiopians in the Greco-Roman Experience* (Cambridge, Mass., 1970), pp. 1-11.

6 The failure of archeologists to consider ancient testimonies on race mixture involving blacks and to employ the criteria used by modern anthropologists in classifying mixed black-white types has often left serious lacunae in their descriptions of Negro types. Some scholars have "explained away" frizzly hair in obviously Negroid individuals as "stylization." B. V. Bothmer, *Egyptian Sculpture of the Late Period: 700 B.C. to A.D. 100* (Brooklyn, N.Y., 1960), pp. 170-71, provides such an explanation in his interpretation of a basalt head of a man, perhaps from the Fayum, whose clearly thick lips, together with frizzly hair, strongly suggest Negroid admixture. In the course of this essay, we shall encounter other instances of this failure to recognize the Negroid type (see *infra*, nn. 157, 238, 298).

7 For apparent Negroid traits in skeletal samples from Greece at various periods from Early Neolithic to the nineteenth century, see J.L. Angel's statement in his review of *Blacks in Antiquity*, *AmAn* 74(1972): 159.

8 E. A. Hooton, *Up from the Ape*, rev. ed. (New York, 1946), p. 483.

9 J. H. Lewis, *The Biology of the Negro* (Chicago, 1942), p. 61.

10 L. Bertholon and E. Chantre, *Recherches anthropologiques dans la Berbérie orientale (Tripolitaine, Tunisie, Algérie)* (Lyon, 1913), vol. I.

11 R. Bartoccini, "Quali erano i caraterri somatici degli antichi Libi?," *Aegyptus* 3(1922): 165-66. Cf. C. M. Daniels, *The Garamantes of Southern Libya* (Stoughton, Wisc. and North Harrow, Eng., 1970), p. 27.

12 O. Bates, *The Eastern Libyans* (London, 1914), pp. 43-45.

13 Such a perspective was the goal in *Blacks in Antiquity*, a comprehensive history of blacks in the Greco-Roman world, which may be consulted with some profit for additional information. The present essay develops and treats the subject of the Negro in Greek and Roman art in greater detail than was possible in the earlier study (© Copyright 1970 by the President and Fellows of Harvard College). I am grateful to the President and Fellows of Harvard College and to The Belknap Press of Harvard University Press for permission to make use of material and to develop ideas which appear in *Blacks in Antiquity*.

14 Oxford, Ashmolean Museum, 1938.537. A. Evans, *The Palace of Minos at Knossos* (London, 1928), vol. II, pt. I, pp. 45-46, and fig. 21a; S. Hood, *The Minoans: Crete in the Bronze Age* (London, 1971), p. 225 and pl. 66.

15 Evans, *Palace of Minos* (1921), vol. I, pp. 310-11, figs. 228-30.

16 Herakleion, Archeological Museum. S. Alexiou, *Guide du Musée Archéologique d'Heraclion* (Athens, 1969), p. 113 (Room XV, Case 173). Evans, *Palace of Minos*, vol. I, p. 312 and fig. 231, p. 526 and fig. 383.

17 P. Åström, *The Middle Cyrriote Bronze Age* (Lund, 1957), p. 158, fig. 18.

18 Herakleion, Archeological Museum. Alexiou, *Guide*, p. 115 (Room XVI). Evans, *Palace of Minos*, vol. II, pt. II, pp. 755-57, pl. XIII.

19 J.D.S. Pendlebury, *The Archaeology of Crete: An Introduction*, reprint ed. (1939; New York, 1965), pp. 200-201, 222.

20 A.R. Burn, *The Pelican History of Greece* (Baltimore, 1966), p. 44.

21 The fresco is now in the National Museum, Athens; S. Marinatos, "An African in Thera (?)," *AAA*, 2, fasc. 3(1969): 374-75 and color pl. 1. S. Marinatos, *A Brief Guide to the Temporary Exhibition of the Antiquities of Thera* (Athens, 1971), pp. 22-23, comments on the possible Egyptian origin of the Theran and points out that his large circular earring is similar to those worn by Nubians and in general by various southern peoples depicted in Egyptian art. He states that until more evidence comes to light it is not possible to determine whether the Theran represents a foreign element or whether he belongs to the permanent population. R. Morse, "The Frescoes of Thera: Spectacular Finds in Ancient Aegean Rubble," *Smithsonian* 2(1972): 20, in commenting on this fresco and the museum's designation of the figure as an "African?" states that no one is quite sure why an "African" should have been in Thera. The evidence presented in this essay, however, throws some light on the question. The nose and lips of the Negroid figure depicted in the fresco should be compared with the features on the inlay of shell from Knossos (see *supra*, n. 14).

22 S. Marinatos, "Thera, Excavations 1970," *AAA* 4 (1971): 73-74 and fig. 25. In a description of frescoes found recently at Thera, *Excavations at Thera VI (1972 Season)* (Athens, 1974), Marinatos calls attention (pp. 53-54 and pl. 107) to the presence in a maritime scene in the so-called *Miniature Fresco* of crew members with "upturned" noses, and notes that "this must have been (and perhaps is still) the special feature of a negroid Libyan stock," and suggests (p. 55) that such evidence of African types points to: a) intimate connections between Thera and Libya; b) an important role of Libyan dignitaries among Therans; and c) the probable mixing of Aegean and Libyan blood.

23 Chora, Archaeological Museum. M.L. Lang, *The Palace of Nestor at Pylos in Western Messenia*, vol. II, *The Frescoes* (Princeton, N.J., 1969), pp. 61-62, 94 and pls. 44, 129, 129 D.

24 M. Ventris and J. Chadwick, *Documents in Mycenaean Greek* (Cambridge, 1956), pp. 243-44, 248, 250-52; L.A. Stella, *La civiltà micenea nei documenti contemporanei* (Rome, 1965), p. 210; C.J. Ruijgh, *Etudes sur la grammaire et le vocabulaire du grec mycénien* (Amsterdam, 1967), pp. 316-17.

25 HOMER *Iliad* 1.423-24, 23.205-207; idem, *Odyssey* 1.22-24, 4.84, 5.282, 287, and for Eurybates, 19.246-47; PAUSANIAS 10.25.4, 8; *Blacks in Antiquity*, pp. 19, 102, 270-71.

26 *Blacks in Antiquity*, pp. 286-87.

27 Cairo, Egyptian Museum, CG 257. L. BOR-CHARDT, *Statuen und Statuetten von Königen und Privatleuten, Musée du Caire Catalogue Général des Antiquités Egyptiennes* (Berlin, 1911), vol. I, pp. 164-65 and pl. 55; G. MASPERO, *Guide du visiteur au Musée du Caire*, 4th ed. (Cairo, 1915), pp. 336-37 and no. 3346; J. H. BREASTED, JR., *Egyptian Servant Statues*, Bollingen Series, 13 (Washington, D.C., 1948), p. 102; *The Egyptian Museum, Cairo: A Brief Description of the Principal Monuments* (Cairo, 1964), p. 61, no. 3346. Dates from as early as the Ninth or Tenth to the Twelfth Dynasty have been suggested for these models.

28 HERODOTUS 3.21-22; cf. 7.69.

29 H. LAST, "Αἰθίοπες Μακρόβιοι," *Classical Quarterly* 17(1923): 35-36. The *Periplus* of SCYLAX 112 (*Geographici graeci minores*, ed. C. MÜLLER [Paris, 1855], vol. I, p. 94 [hereafter cited as *GGM*]), in commenting on the Ethiopians who bartered with the Phoenicians at Cerne notes that Ethiopians were archers.

30 HERODOTUS 2.137, 139.

31 HERODOTUS 2.152, 154.

32 M. N. TOD, ed., *A Selection of Greek Historical Inscriptions*, 2nd ed. (Oxford, 1946), no. 4; A. BERNARD and O. MASSON, "Les inscriptions grecques d'Abou-Simbel," *REG* 70(1957): 1-42; S. SAUNERON and J. YOYOTTE, "La campagne nubienne de Psammétique II et sa signification historique," *BIFAO* 50(1952): 157-207.

33 J. BOARDMAN, *The Greeks Overseas* (Baltimore, 1964), p. 144 and pl. 12 C.

34 Oxford, Ashmolean Museum, 1888-216.

35 Cf. *supra*, J. LECLANT, "Kushites and Meroïtes," fig. 140. P. L. SHINNIE, *Meroe: A Civilization of the Sudan*, Ancient Peoples and Places, vol. 55 (New York and London, 1967), p. 155 and fig. 54. PETRONIUS *Satyricon* 102 had knowledge of Ethiopians with frontal cicatrices. Classical authors also noted the practice of tattooing among some Ethiopians: *Periplus* of SCYLAX 112, *GGM*, vol. I, p. 94; PLINY *Naturalis Historia* 33.111-12; SEXTUS EMPIRICUS *Hypotyposes* 1.148.

36 West Berlin, Staatliche Museen, Antikenabteilung, V.I. 3250. E. BUSCHOR, "Das Krokodil des Sotades," *MJB* 11(1919): 34 and fig. 49. For a similar single head of a Negro from Naukratis, see a faïence vase, Boston, Museum of Fine Arts, 03.835.

37 J. BOARDMAN, "The Amasis Painter," *JHS* 78(1958): 1-3 and idem, *The Greeks Overseas*, p. 169.

38 H. HOFFMANN, "Foreign Influence and Native Invention in Archaic Greek Altars," *AJA* 57(1953): 193; BOARDMAN, *The Greeks Overseas*, p. 149.

39 Vienna, Kunsthistorisches Museum, IV. 3576. A. FURTWÄNGLER and K. REICHHOLD, *Griechische Vasenmalerei*, Series I (Munich, 1904), pp. 255-60 and pl. 51; M. ROBERTSON, *Greek Painting* (Geneva, 1959), pp. 75-76.

40 R. I. HICKS, "Egyptian Elements in Greek Mythology," *TAPA* 93 (1962): 106.

41 Thebes, tomb of Thanuny (no. 74): west wall of room, south of the passage. A. MEKHITARIAN, *Egyptian Painting*, trans. S. Gilbert (New York, 1954), pp. 95-97 and color pl. on p. 97.

42 BOARDMAN, *The Greeks Overseas*, pp. 166-68.

43 Boston, Museum of Fine Arts, 00.332. For discussions of these and similar vases, see J. D. BEAZLEY, "Charinos (Attic Vases in the Form of Human Heads)," *JHS* 49 (1929): 41-78; F. CROISSANT, "Collection Paul Canellopoulos (IV): Vases plastiques attiques en forme de têtes humaines," *BCH* 97 (1973): 205-225.

44 Athens, National Museum, 2385; from Eretria. BEAZLEY, *JHS* 49 (1929): 77, no. 8.

45 Philadelphia, The University Museum, MS 3442. J. D. BEAZLEY, *Attic Black-figure Vase-painters* (Oxford, 1956), p. 145, no. 14 (hereafter cited as *ABV*) and idem, *The Development of Attic Black-figure* (Berkeley, Calif., 1951), pp. 68-69 and pl. 30.
 London, British Museum, 1849.5-18.10. BEAZLEY, *ABV*, p. 144, no. 8 and p. 686; H. B. WALTERS, *Catalogue of the Greek and Etruscan Vases in the British Museum*, vol. II, *Black-Figured Vases* (London, 1893), p. 83, no. B 209; *Blacks in Antiquity*, p. 48, fig. 19.
 New York, Metropolitan Museum of Art, 98.8.13. *Blacks in Antiquity*, p. 48, fig. 18.

46 For Amasis, see *Blacks in Antiquity*, pp. 16-17. Cf. n. 37, *supra*.

47 Brussels, Musées Royaux d'Art et d'Histoire, A 130 (=BEAZLEY, *ABV*, p. 308, no. 82). Cf. D. VON BOTHMER, *Amazons in Greek Art* (Oxford, 1957), p. 93, no. 23. F. MAYENCE in *CVA*, Belgium, fasc. 1, Brussels, fasc. 1, group III He, pl. 7, 1a, follows C. Lenormant and J. De Witte in regarding the Negro as Memnon, whereas Beazley and Bothmer identify him as an attendant of Memnon; *Blacks in Antiquity*, p. 45, fig. 15.

48 Paris, Musée du Louvre, MNB 406; from Poggio Sommavilla, c. 520-500 B.C. E. POTTIER, *Catalogue des vases antiques de terre cuite*, III, *L'Ecole attique*, 2nd ed. (Paris, 1929), p. 925, no. G 93 (=J. D. BEAZLEY, *Attic Red-figure Vase-painters*, 2nd ed. [Oxford, 1963], vol. I, p. 225, no. 4 [hereafter cited as *ARV²*]).

49 Naples, Museo Archeologico Nazionale, 86339. H. HEYDEMANN, *Die Vasensammlungen des Museo Nazionale zu Neapel* (Berlin, 1872), p. 864, no. 172; *Monumenti Antichi* (Milan, 1913), vol. 22, pt. 1, 507; *Blacks in Antiquity*, p. 50, fig. 21.

50 N. 36, *supra*.

51 Boston, Museum of Fine Arts, 98.926. For this and the following vase, see BEAZLEY, *JHS* 49 (1929): 47 and 61.

52 Brussels, Musées Royaux d'Art et d'Histoire, R 434.

53 Frg. 16 in H. DIELS, *Die Fragmente der Vorsokratiker*, 10th ed. (Berlin, 1961), vol. I.

54 See *Blacks in Antiquity*, pp. 169-77 and 196-205 for the origin and development of the Scythian-Ethiopian contrast. Earlier studies of these Janiform vases failed to relate these black-white heads to the anthropological contrast of northerners and southerners which appears frequently in Greek literature from Xenophanes onward, and so have overlooked an obvious explanation of the contrasting of whites and blacks in art, which began as Greek acquaintance with African Negroes increased.

55 EVANS, *The Palace of Minos*, vol. II, pt. II, pp. 755-56.

56 Agrigento, Museo Archeologico Nazionale, S 83. P. GRIFFO and G. ZIRRETTA, *Il Museo Civico di Agrigento: un secolo dopo la sua fondazione* (Palermo, 1964), p. 61; R. A. HIGGINS, *Catalogue of the Terracottas in the Department of Greek and Roman Antiquities, British Museum* (London, 1954), vol. I, *Text, Greek: 730-330 B.C.*, p. 323, no. 1195.

57 Syracuse, Museo Archeologico Nazionale. I am indebted to Mr. Malcolm Bell III of the University of Virginia for calling my attention to these two unpublished Sicilian terracottas, now located in Syracuse, and to Prof. Georges Vallet and Dr. Paola Pelagatti for their courtesy in providing me with photographs.

58 Oxford, Ashmolean Museum, 1890.222. *Ashmolean Museum Summary Guide: Department of Antiquities*, 4th ed. (Oxford, 1931), p. 91; *Blacks in Antiquity*, p. 40, fig. 8.

59 FRONTINUS *Strategemata* 1.11.18; S. GSELL, *Histoire ancienne de l'Afrique du Nord*, vol. I, *Les conditions du développement historique*, 3rd ed. (Paris, 1921), p. 303, n. 6; E. W. BOVILL, *The Golden Trade of the Moors*, 2nd ed., rev. and with additional material by R. HALLETT (London, 1968), pp. 21-22; cf. B. PACE, *Arte e civiltà della Sicilia antica* (Milan, 1935), vol. I, p. 255, on the possibility of there being Negroes in Sicily in the Greek period.

60 AESCHYLUS *Persae* 311-12; H. R. HALL, *The Cambridge Ancient History*, vol. III, *The Assyrian Empire* (Cambridge, 1925), p. 315.

61 AESCHYLUS *Persae* 315; H. D. BROADHEAD, *The Persae of Aeschylus* (Cambridge, 1960), p. 110; cf. editions: P. MAZON (Paris, 1920), p. 73; P. GROENEBOOM (Göttingen, 1960), vol. I, pp. 79-80; L. ROUSSEL (Montpellier, 1960), p. 127.

62 J. BOARDMAN, *Greek Art* (New York, 1964), p. 186.

63 BEAZLEY, *ARV²*, vol. I, pp. 267-69. For an example of this type, see Cambridge, Mass., Fogg Art Museum, Harvard University,

1960.327; for a variant in the form of a reclining Ethiopian warrior painted on the rear of a plastic kantharos, see Boston, Museum of Fine Arts, 98.928 (= BEAZLEY, *ARV*², vol. I, p. 265, no. 78, p. 267 and vol. II [1963], p. 1534).

64 West Berlin, Staatliche Museen, Antikenabteilung, 3382. U. GEHRIG, A. GREIFENHAGEN, N. KUNISCH, *Führer durch die Antikenabteilung* (Berlin, 1968), p. 124; BEAZLEY, *ARV*², vol. I, p. 269; *Blacks in Antiquity*, p. 46, fig. 16. For a recent discussion of Libyan Amazons, see J.O. DE G. HANSON, "The Myth of the Libyan Amazons," *Museum Africum: West African Journal of Classical and Related Studies* 3 (1974): 38-43.

65 HERODOTUS 7.69.

66 A good example is a rhyton by Sotades: Boston, Museum of Fine Arts, 98.881; H. HOFFMANN, *Attic Red-Figured Rhyta* (Mainz, 1962), pp. 22-23.

67 G. H. BEARDSLEY, *The Negro in Greek and Roman Civilization: A Study of the Ethiopian Type* (Baltimore, 1929; New York, 1967), p. 38. For the view that the Negro-crocodile group was regarded at least in Thasos, if not elsewhere, as being essentially in the spirit of parody, see F. SALVIAT, "Le crocodile amoureux," *BCH* 91 (1967): 96-101.

68 J. Abudu, a modern Nigerian artist, has carved in black wood a man surprised by a crocodile as he draws water from a river—a water pot has fallen from his head; the victim cries for help: illustration for A. O. OSULA, "Nigerian Art," *Nigeria* 39 (1952): 48. Neither artist, Greek or Nigerian, in my judgment, saw anything comic in the incident. The painter of a Pompeian fresco of a Republican or early Augustan date, in depicting a defecating nude Negro, threatened by a crocodile with his menacing open jaws, is also stressing the element of fear in the surprised Negro, as A. MAIURI states in "Una nuova pittura nilotica a Pompei," *Atti della Accademia Nazionale dei Lincei*, 8, 8th ser. (1956): 73-74. J.-P. CÈBE, *La caricature et la parodie dans le monde romain antique, des origines à Juvénal* (Paris, 1966), p. 354, includes the fresco in his study.

69 Leningrad, Hermitage Museum, B 1570. K. SCHAUENBURG, "Die Cameliden im Altertum," *Bonner Jahrbücher* 155-56 (1955-56): pl. 3, 1. For another example of a Negro in a camel scene, see the fragments belonging to a plastic vase by Sotades, found at Memphis (Paris, Musée du Louvre, CA 3825) and L. KAHIL, "Un nouveau vase plastique du potier Sotadès, au Musée du Louvre," *RA*, fasc. 2 (1972): 273-74, 277-78, and figs. 4 and 11.

70 Munich, Staatliche Antikensammlungen, 2428. *CVA*, Germany, band 20, Munich, band 5, pl. 227, no. 4 and pl. 228, no. 4; BEAZLEY, *ARV*², vol. I, p. 297. For a recent study of Busiris in Greek literature and art, see S. E. KALZA, Ὁ Βούσιρις ἐν τῇ Ἑλληνικῇ Γραμματείᾳ καὶ Τεχνῇ (Athens, 1970).

71 Athens, National Museum, 9683. A. DUMONT and J. CHAPLAIN, *Les Céramiques de la Grèce propre* (Paris, 1888), vol. I, pl. XVIII and BEAZLEY, *ARV*², vol. I, p. 554, no. 82.

72 Ferrara, Museo Archeologico Nazionale, 609; from necropolis of Valle Trebba, Tomb 499. S. AURIGEMMA and N. ALFIERI, *Il Museo Nazionale Archeologico di Spina in Ferrara*, 2nd ed. (Rome, 1961), pp. 19-20 (= BEAZLEY, *ARV*², vol. I, p. 415, no. 2 and vol. II, p. 1652); see B.M. FELLETTI MAJ, "Due nuove ceramiche col mito di Heracles e Busiris," *RivIstArch*, 6, fasc. 3 (1938): 216 for the view that the painters of the Busiris vases confused the physical features of Egyptians and Negroes. Worthy of note in this connection is the observation of H. R. HALL in *Cambridge Ancient History*, vol. VI, *Macedon* (1927), pp. 159-60, who suggests that the Ethiopian and Negro elements in the Egyptian race were probably more apparent in antiquity than today, after many of both races from the armies of the Ethiopian kings had settled in Egypt in the eighth century.

73 Oxford, Ashmolean Museum, G 270. *CVA*, Great Britain, fasc. 3, Oxford, fasc. 1, pp. 22-23, pl. XXVI, nos. 1-4 and pl. XXXI, no. 5.

74 Bologna, Museo Civico Archeologico, 174. *CVA*, Italy, fasc. 27, Bologna, Museo Civico, fasc. 4, p. 19 and pl. 71, no. 5; pl. 93, no. 1; pl. 94, nos. 6-7; BEAZLEY, *ARV*², vol. I, p. 593, attributes the vase to the Altamura Painter.

75 West Berlin, Staatliche Museen, Antikenabteilung, F 2534. *CVA*, Germany, band 21, Berlin, band 2, pl. 100: 1, 2, 4; BEAZLEY, *ARV*², vol. II, p. 826.

76 Paris, Bibliothèque Nationale. A. DE RIDDER, *Catalogue des vases peints de la Bibliothèque nationale* (Paris, 1902), p. 288, no. 393; BEAZLEY, *ARV*², vol. I, p. 665; E. PARIBENI, *Enciclopedia dell'arte antica, classica e orientale* (Rome, 1960), vol. III, p. 466, s.v. "Etiope" (hereafter cited as *EAA*).

77 Boston, Museum of Fine Arts, 63.2663. H. HOFFMANN, "Attic Red-figured Pelike from the Workshop of the Niobid Painter, ca. 460 B.C.," *BMFA* 16 (1963): 108; A. D. TRENDALL and T.B.L. WEBSTER, *Illustrations of Greek Drama* (London, 1971), pp. 63-65 and fig. III, 2, 2 (Boston).

78 London, British Museum, 1843.11-3.24. C.H. SMITH, *Catalogue of the Greek and Etruscan Vases in the British Museum* (London, 1896), vol. III, no. E 169; BEAZLEY, *ARV*², vol. II, pp. 1062 and 1681; TRENDALL and WEBSTER, *Illustrations of Greek Drama*, pp. 63-65 and fig. III, 2, 3 (London); *Blacks in Antiquity*, p. 54, fig. 26.

79 East Berlin, Staatliche Museen, Antikensammlung, 3237. M. BIEBER, *The History of the Greek and Roman Theater*, 2nd ed., rev. and enl. (Princeton, N.J., 1961), pp. 31-32, figs. 110-11a; BEAZLEY, *ARV*², vol. II, pp. 1336, 1690; T.B.L. WEBSTER, *The Tragedies of Euripides* (London, 1967), p. 304; cf.

K.M. PHILLIPS, JR., "Perseus and Andromeda," *AJA* 72 (1968): 7 and fig. 17; TRENDALL and WEBSTER, *Illustrations of Greek Drama*, p. 78.

80 Oxford, Ashmolean Museum, G 227.

81 BEAZLEY, *JHS* 49 (1929): 74; *CVA*, Great Britain, fasc. 3, Oxford, fasc. 1, p. 10 and pl. IV, nos. 7-8, where Beazley comments on the lips which seemed to him to be somewhat rubbed down and perhaps were originally thicker; BEAZLEY, *ARV*², vol. II, p. 1550, no. 2. For further observations pertinent to the black-white Cepheus and Andromeda, see discussion in text, pp. 155, 160.

82 A. D. FRASER, "The Panoply of the Ethiopian Warrior," *AJA* 34 (1935): 40.

83 San Simeon, Calif., Hearst San Simeon State Historical Monument, 5715. BEAZLEY, *ARV*², vol. II, p. 1537. J. DESANGES, "L'Antiquité gréco-romaine et l'homme noir," *REL* 48 (1970): 92, notes that POMPONIUS MELA (1.48) and PLINY THE ELDER (5.7.44 and 46), though following Hellenistic sources, listed Satyrs among the inhabitants of inner Africa.

84 Hamburg, Museum für Kunst und Gewerbe, 1917.1002. E. VON MERCKLIN, "Antiken im Hamburgischen Museum für Kunst und Gewerbe," *Archäologischer Anzeiger* (1928): cols. 394-95, no. 87 R; figs. 107, 108.

85 Houston, D. and J. de Menil Collection, CA 7009. H. HOFFMANN. *Ten Centuries That Shaped the West: Greek and Roman Art in Texas Collections*, Exhibition catalogue, Institute for the Arts, Rice University, Houston, Texas, 15 October 1970-3 January 1971 (Houston, 1970), pp. 299-300, no. 146, and pl. See also Paris, Musée du Louvre, Cp. 4797; cf. A. ANDRÉN, *Architectural Terracottas from Etrusco-Italic Temples: Text* (Lund and Leipzig, 1940), p. 51, Group III:10 and *Plates* (1939), Group III:10, pl. 18:58; idem, *EAA* (1958), vol. I, s.v. "Antefissa," pp. 405-406.

86 Rome, Museo Nazionale Etrusco di Villa Giulia, no inv. no. ANDRÉN, *EAA*, vol. I, pp. 405-406. HOFFMANN, *Ten Centuries*, p. 300. To Hoffmann's bibliography, add for Pyrgi, G. COLONNA, "The Sanctuary at Pyrgi in Etruria," *Archaeology* 19 (1966): 13.

87 ANDRÉN, *EAA*, vol. I, p. 405. G. H. CHASE, *Greek, Etruscan, and Roman Art, The Collections of the Museum of Fine Art, Boston, 1963*, rev. and with additions by C. C. VERMEULE, (Boston, 1963), p. 193.

88 Athens, National Museum, 1129 (= BEAZLEY, *ABV*, p. 709, addendum to p. 586). Cf. *Blacks in Antiquity*, p. 230, fig. 89.

89 Paris, Musée du Louvre, N 3408.

90 BEAZLEY, *ARV*², vol. II, p. 1335, no. 34; TRENDALL and WEBSTER, *Illustrations of Greek Drama*, p. 117 and fig. IV,2 (Paris).

91 Cf. PAUSANIAS 9.25.5.

92 London, British Museum, 1893.3-3.1. H. B. WALTERS, "Odysseus and Kirke on a Boeotian Vase," *JHS* 13 (1892-93): 77-87 and pl. IV. On Negroid features depicted on Kabeirion vases, see *Blacks in Antiquity*, pp. 161 and 182, and R. LULLIES, "Griechische Kunstwerke Sammlung Ludwig, Aachen," *Aachener Kunstblätter* 37 (1968): 132-33 and pl. 54. For the other Negroid Circe, see a Kabeirion skyphos in Oxford, Ashmolean Museum, G 249; WALTERS, *JHS* 13 (1892-93): 81 and pl. IV; *Blacks in Antiquity*, p. 64, fig. 36.

93 Cambridge, Mass., Fogg Art Museum, Harvard University, 1925.30.127. *CVA*, U.S.A., fasc. 1, Hoppin and Gallatin Collections: Hoppin Collection, pl. 5, no. 1 and p. 5.

94 P. LEVI, "A Kabirion Vase," *JHS* 84 (1964): 155-56 and pls. V-VI.

95 G. BECATTI, *EAA* (1963), vol. V, s.v. "Negro," p. 398 and idem, *EAA* (1965), vol. VI, s.v. "Pigmei," p. 168; Mitos, Krateia, and Pratolaos on Kabeirion skyphos, Athens, National Museum, AP 10426; *Blacks in Antiquity*, p. 236, fig. 96; Aphrodite and Hera on skyphos, Boston, Museum of Fine Arts, 99.533; *Blacks in Antiquity*, p. 237, fig. 97.

96 East Berlin, Staatliche Museen, Münzkabinett, Prokesch-Osten Collection (acquired 1875). C. T. SELTMAN, *Athens: Its History and Coinage before the Persian Invasion* (Cambridge, 1924), pp. 97, 200, and pl. XXII.

97 London, British Museum, E.H.P.375.N.5 (= B.M.C. Delphi 7), E.H.P.375.N.6 (= B.M.C. Delphi 8), E.H.P.375.N.7 (= B.M.C. Delphi 9). B. V. HEAD, *Catalogue of Greek Coins (Central Greece)*, ed. R.S. POOLE (London, 1884), p. 25, nos. 7-9, pl. IV 6-8; idem, *Historia Numorum: A Manual of Greek Numismatics* (1911; London, 1963), pp. 340-41; SELTMAN, *Athens*, p. 97, fig. 61. Boston, Museum of Fine Arts, 04.803 and 04.804. A. B. BRETT, *Catalogue of Greek Coins: Museum of Fine Arts, Boston* (Boston, 1955), p. 132, nos. 974-75, pl. 52, who dates the Boston Delphic coins 490-479 B.C.

98 E. SIMON's recent interpretation of these coins ("Aphrodite Pandemos auf attischen Münzen," *Schweizerische numismatische Rundschau* 49 [1970]: 15-18), like most earlier discussions, has dismissed too lightly the significance of the name of Delphos' mother and has given insufficient attention to Greek acquaintance with African Negroes in the late sixth and fifth centuries B.C. The heads depicted on these coins are obviously of the pronounced Negroid type, as their tightly curled hair, thick lips, and platyrrhine noses clearly indicate. Both Simon's suggestion that the Negroes are "Sileni of Aphrodite" and her emphasis on associating them with Eastern myths overlook the accurate anthropological knowledge that Greeks had acquired of African Negroes in the sixth and fifth centuries. Whatever the identity of

the Negroes represented, they certainly were not eastern Ethiopians. (Ethiopians of Asia, whoever they were, even by HERODOTUS' criteria [7.70], were straight-haired while those of Africa were the most woolly-haired of all men.) The Negroes on the coins, it should be emphasized, have tightly coiled, not straight hair. In addition, Simon states that the figure on the coinage could not be a Negro because no Greek heroes or heroines are depicted with Negro features. See discussions of Busiris (nn. 72-74, *supra*), Cepheus (n. 77, *supra*), Andromeda (nn. 77-78, *supra*); Circe, Aphrodite, Hera, and others in Kabeirion vases (nn. 92-95, *supra*), and Nike (n. 89, *supra*); and Zeus-Ammon (n. 153, *infra*).

99 *Scholia in Aeschyli Eumenides* 2 (W. DINDORF, ed., 1851), p. 129. OVID *Metamorphoses* 6.120; *Scholia in Euripidis Orestem* 1094 (E. SCHWARTZ, ed., 1887), p. 204; PAUSANIAS 10.6.3-4.

100 See *Blacks in Antiquity*, pp. 4-5 and 268-69.

101 *Servii... in Vergilii Carmina Commentarii*, ed. G. THILO and H. HAGEN (Leipzig, 1902), vol. III, fasc. 2, p. 431.

102 THEOPHRASTUS *Characteres* 21.4.

103 London, British Museum, 1948. 11-1.1. HIGGINS, *Catalogue of Terracottas*, vol. I, *Text*, p. 73, no. 158; C. BLINKENBERG, *Lindos: fouilles de l'Acropole*, vol. I, *Les petits objets* (Berlin, 1931), *Text*, no. 2384 and vol. I, *Plates*, pl. 112, no. 2384.
For further examples, see BLINKENBERG, *Lindos*, vol. I, *Text*, nos. 2381-82 and vol. I, *Plates*, pl. 112, nos. 2381-82; HIGGINS, *Catalogue of Terracottas*, vol. I, *Text*, pp. 94-95, nos. 261-66 and p. 95, nos. 268-69 and vol. I, *Plates*, pls. 45-46; idem, *Greek Terracottas* (London, 1967), pp. 61, 63, and pl. 25 C; cf. J. SIEVEKING, *Die Terrakotten der Sammlung Loeb* (Munich, 1916), vol. I, p. 20 and pl. 28, no. 2, perhaps a Negro.

104 West Berlin, Staatliche Museen, Antikenabteilung, FG 347. G. M. A. RICHTER, *The Engraved Gems of the Greeks Etruscans and Romans*, pt. I, *Engraved Gems of the Greeks and Etruscans* (London, 1968), p. 87, no. 267.

105 West Berlin, Staatliche Museen, Antikenabteilung, FG 176. RICHTER, *Engraved Gems*, pt. I, p. 49, no. 86.

106 East Berlin, Staatliche Museen, Antikensammlung, 3291 (= BEAZLEY, *ARV²*, vol. II, p. 1227, no. 9). Cf. *Blacks in Antiquity*, p. 53, fig. 25.

107 Copenhagen, Nationalmuseet, Chr. VIII 320. *CVA*, Denmark, fasc. 3, Copenhagen, fasc. 3, p. 105 and pls. 130, 1 a, 1 c (= BEAZLEY, *ARV²*, vol. I, p. 256, no. 1).

108 Vatican, Museo Gregoriano Etrusco, 16539. BEAZLEY, *JHS* 49 (1929): 60, the Vatican Group.

109 Boston, Museum of Fine Arts, 98.888 (= BEAZLEY, *ARV²*, vol. II, p. 1530, no. 3). Cf. *EAA*, vol. I, s.v. "Barbari," p. 973 and fig. 1225.

110 Vienna, Kunsthistorisches Museum, IV 3724 (= BEAZLEY, *ARV²*, vol. I, p. 280, no. 9).

111 Boston, Museum of Fine Arts, 23.581.

112 RICHTER, *Engraved Gems*, pt. I, p. 97, no. 323; J. BOARDMAN, *Greek Gems and Finger Rings: Early Bronze Age to Late Classical* (London, 1970), p. 201 and pl. 530.

113 London, British Museum, 1872.6-4.659. F. H. MARSHALL, *Catalogue of the Jewellery, Greek, Etruscan, and Roman, in the Department of Antiquities, British Museum* (London, 1911), p. 258, no. 2272, and pl. XLV.

114 M. S. F. HOOD, "Archaeology in Greece, 1961-62," *Archaeological Reports for 1961-62, Supplement to JHS* 82 (1962): 6 and fig. 4.

115 *Supra*, n. 98.

116 ARISTOTLE *De generatione animalium* 1.18.722a; cf. also idem *Historia animalium* 7.6.586a. For contacts of Elis with Egypt during the reign of Psamtik II (598-588 B.C.), see W. DECKER, "La délégation des Eléens en Egypte sous la 26e dynastie (Hér. II 160-Diod. I 95)," *CdE* 49 (1974): 31-42.

117 C. B. DAY, *A Study of Some Negro-white Families in the United States* (Cambridge, Mass., 1932): the photograph of a quadroon (pl. 6) is an illustration of the disappearance of Negroid physical traits as a result of racial mixture. An individual in the Greco-Roman world possessing such "white" characteristics would not have been considered "Ethiopian" or "Negroid"; there was no counterpart of "sociological" or "technical" Negroes in classical antiquity. Even in America, where the colonial fathers passed many acts designed to discourage miscegenation, it is estimated that at the end of the colonial period there were more than sixty thousand mulattoes in the English colonies: J. H. JOHNSTON, *Race Relations in Virginia and Miscegenation in the South 1776-1860* (Amherst, Mass., 1970), p. 190.

118 London, British Museum, 1926.3-24.96. H. B. WALTERS, *Catalogue of the Terracottas in the Department of Greek and Roman Antiquities, British Museum* (London, 1903), p. 365, no. D 361; HIGGINS, *Catalogue of Terracottas*, vol. I, *Text*, p. 323, no. 1195 and vol. I, *Plates*, pl. 163.

119 Lipari, Museo Archeologico Eoliano, 3040. L. BERNABÓ-BREA and M. CAVALIER, *Il Castello di Lipari e il Museo archeologico eoliano* (Palermo, 1958), pp. 78-79; L. BERNABÓ-BREA, *Musei e monumenti in Sicilia* (Novara, 1958), p. 84.

120 WEBSTER, *The Tragedies of Euripides*, p. 172. WEBSTER (*Monuments Illustrating Tragedy and Satyr Play*, University of London Institute of Classical Studies, Bulletin Supplement, no. 20, 2nd ed. [London, 1967], p. 71) had suggested Astyanax as the identification for the mask which he here identifies as Paris because he considers the youth represented too old to be Astyanax but well suited for Paris in the *Alexandros*.

121 Lipari, Museo Archeologico Eoliano, 927. L. Bernabó-Brea, *Museen und Kunstdenkmäler in Sizilien* (Munich, 1959), p. 78 and P. E. Arias, *A History of 1000 Years of Greek Vase Painting*, trans. and rev. B. Shefton (New York, 1962), pp. 390-91 and fig. 240; see A. D. Trendall, *EAA*, vol. III, s.v. "Fliacici, Vasi," pp. 708-709; Trendall and Webster, *Illustrations of Greek Drama*, p. 128 and fig. IV,11 (Lipari).

122 Syracuse, Museo Archeologico Nazionale, 47039. *CVA*, Italy, fasc. 17, Syracuse, fasc. 1, IV E, pl. 4, 1; A. D. Trendall, *The Red-Figured Vases of Lucania, Campania, and Sicily* (Oxford, 1967), vol. I, *Text*, p. 592, no. 46.

123 *Supra*, nn. 92-95.

124 Tunis, Musée National du Bardo, I 152. M. Yacoub, *Le Musée du Bardo* (Tunis, 1969), p. 15 (Room IV, Case 8).

125 J. D. Beazley, *Etruscan Vase-Painting*, Oxford Monographs on Classical Archaeology, no. 1 (Oxford, 1947), pp. 187-88, 305; *Blacks in Antiquity*, p. 27 and figs. 29-32.

126 Karlsruhe, Badisches Landesmuseum, 73/129. R. Perry and H. A. Cahn, *Art of Ancient Italy, Etruscans, Greeks and Romans*, Exhibition catalogue, André Emmerich Gallery (New York, 1970), pp. 30-31, no. 43, photographs and bibliography cited there.

127 Boston, Museum of Fine Arts, 07.863 and Rome, Museo Nazionale Etrusco di Villa Giulia, 16338.

128 New York, Metropolitan Museum of Art, 06.1021.204. Beazley, *Etruscan Vase-Painting*, pp. 188, 305; *Blacks in Antiquity*, p. 233, fig. 93.

129 Copenhagen, Nationalmuseet, Chr. VIII 88. *CVA*, Denmark, fasc. 6, Copenhagen, fasc. 6, pp. 197-98 and pl. 254: 2a.

130 Cambridge, Fitzwilliam Museum, GR. 58.1865. Paris, Bibliothèque Nationale: de Ridder, *Catalogue des vases peints*, p. 673, no. 1252 (Janzé 157) and pl. XVIII; East Berlin, Staatliche Museen, Antikensammlung, F 3408. For a discussion of the Negro and crocodile groups, see Buschor, *MJB* 11 (1919), esp. pp. 1-8 and figs. 1-12.

131 Leningrad, Hermitage Museum, B 960.

132 Paris, Musée du Louvre, N 2566. *Blacks in Antiquity*, p. 63, fig. 35.

133 Ruvo, Museo Jatta, 1113. H. Sichtermann, *Griechische Vasen in Unteritalien aus der Sammlung Jatta in Ruvo* (Tübingen, 1966), p. 63, no. 127, pls. 166-67; and Naples, Museo Archeologico Nazionale, C.S.-968; A. Levi, *Le terrecotte figurate del Museo Nazionale di Napoli* (Florence, 1926), p. 177, no. 786.

134 Ruvo, Museo Jatta, 1402. Sichtermann, *Griechische Vasen*, p. 56, no. 90 and pl. 146; *Blacks in Antiquity*, p. 34, fig. 2 and p. 234, fig. 94; Trendall and Webster, *Illustrations of Greek Drama*, pp. 128-29 and fig. V, 12 (Ruvo).

135 *Moretum*, 31-35.

136 Bieber, *History of the Greek and Roman Theater*, p. 296.

137 Bonn, Akademisches Kunstmuseum der Universität Bonn, 2667.

138 Trendall and Webster, *Illustrations of Greek Drama*, p. 114 and fig. III, 6, 3; and T. B. L. Webster, "Fourth Century Tragedy and the Poetics," *Hermes* 82 (1954): 304. Webster states that the scene may be connected with an episode in the *Lynceus* of Theodectes, i.e., Lynceus slays an aged Danaus as Hypermestra and a boy carry off pieces of Danaus' throne, and suggests that the foreign appearance of Lynceus is a result of his relation to Aegyptus. For a Negro of a physical type somewhat similar to the central Negroid figure in this vase, see one of the fragments belonging to a plastic vase by Sotades (Paris, Musée du Louvre, CA 3825) depicting a nude Negro in a scene involving Persians and Greeks, Kahil, *RA*, fasc. 2 (1972): 280-82 and fig. 13; see *infra*, J. Leclant, "Egypt, Land of Africa," figs. 369 and 370.

139 *Blacks in Antiquity*, p. 157, and B. M. Felletti Maj and H. R. Hall, *supra*, n. 72. It should also be pointed out that some vase-painters represented Busiris as Negroid (see pp. xxx), and that Cepheus in one instance was depicted as a mixed black-white type (see pp. 152-155).

140 London, British Museum, 1873.8-20.287. Walters, *Catalogue of Vases*, vol. IV, *Vases of the Latest Period* (1896), p. 264, no. G 167.

141 London, British Museum, 1873.8-20.288. Walters, *Catalogue of Vases*, vol. IV, p. 264, no. G 168.

142 New York, Metropolitan Museum of Art, 41.162.45. G. M. A. Richter, *Handbook of the Greek Collection*, The Metropolitan Museum of Art (Cambridge, Mass., 1953), p. 132, pl. 112 e. *Blacks in Antiquity*, p. 65, fig. 38.

143 Oxford, Ashmolean Museum, 1922.205. *Ashmolean Museum Summary Guide*, p. 87; *Blacks in Antiquity*, p. 64, fig. 37.

144 London, British Museum, 1873.8-20.285. Walters, *Catalogue of Vases*, vol. IV, p. 262, no. G 154.

145 *Supra*, n. 35.

146 Paestum, Museo Archeologico Nazionale, 21522; from Paestum, Andriuolo tomb 48. M. Napoli, *Il Museo di Paestum* (Naples, 1969), pp. 89-90. See "Treasure at Paestum," *Time* (26 January 1970): 46; F. Villard, "Les nouvelles tombes peintes de Paestum," *Archeologia* 35 (July-August 1970): 34-43.

147 Taranto, Museo Nazionale, I.G. 4077. C. Drago, *Il Museo Nazionale di Taranto* (Rome, 1956), pp. 25 and 65; G. M. A. Hanfmann, *Classical Sculpture* (Greenwich, Conn., 1967), p. 332 and pl. 252; *Blacks in Antiquity*, p. 239, fig. 100.

148 Reggio Calabria, Museo Nazionale, 6416. G. Jacopi, "Lorrikà," *Presenza* 1 (1947): 239 and figs. 1-2.

149 Plovdiv, National Archeological Museum, 3204. N. M. Kontoleon, "The Gold Treasure of Panagurischte," *Balkan Studies* 3 (1962): 185-200 and bibliography cited there; D. von Bothmer, "A Gold Libation Bowl," *BMMA* 21 (1962-63): 154-66; *Blacks in Antiquity*, pp. 125, 148-49, and fig. 39, pp. 66-67.

150 Pausanias 1.32.2-3.

151 Cambridge, Fitzwilliam Museum, GR.102. 1890. *CVA*, Great Britain, fasc. 6, Cambridge, fasc. 1, p. 39 and pl. XLI, no. 12.

152 Cambridge, Mass., Fogg Art Museum, Harvard University, 1960.404.

153 East Berlin, Staatliche Museen, Münzkabinett, 996/1872. C. T. Seltman, *Greek Coins: A History of Metallic Currency and Coinage Down to the Fall of the Hellenistic Kingdoms*, 2nd ed. (London, 1955), p. 183 and pl. XLII 6; E. S. G. Robinson, *Catalogue of the Greek Coins of Cyrenaica*, reprint ed. (1927; Bologna, 1965), p. xxxiii, rejects a Negroid classification for the Zeus on the coinage of Cyrenaica and considers the hair Libyan.

154 London, British Museum, 1861.11-27.13. H. B. Walters, *Catalogue of the Bronzes, Greek, Roman, and Etruscan, in the Department of Greek and Roman Antiquities, British Museum* (London, 1899), pp. 34-35, no. 268, notes that the head was found together with fragments of bronze horses. Beardsley, *The Negro*, p. 75, considers the lips suggestive of a Negro strain and Becatti, *EAA*, vol. V, s.v. "Negro," p. 399, comments on the exotic appearance resulting from the thickness of the lips and the short beard. A. W. Lawrence, *Later Greek Sculpture and its Influence on East and West*, reprint ed. (1927; New York, 1969), p. 18, considers the head a realistic portrait of an African of Berber stock; and D. Haynes, *Fifty Masterpieces of Classical Art in the British Museum* (London, 1970), no. 37, suggests that the head is that of a Berber, presumably one of the Hellenized natives of Cyrene.

155 For fusion of Negro and Libyan stocks, see Bates, *The Eastern Libyans*, pp. 39, 43-44, 69; and for anthropological criteria used in classifying black-white types, *supra*, nn. 4, 8, 12.

156 For a Negro groom on the interior of an Attic red-figured cup attributed to Onesimos by Beazley, see O. W. Muscarella, ed., *Ancient Art: The Norbert Schimmel Collection* (Mainz, 1974), no. 60, and N. Himmelmann, *Archäologisches zum Problem der griechischen Sklaverei*, Akademie der Wissenschaften und der Literatur in Mainz, Abhandlungen der Geistes- und Sozialwissenschaftlichen Klasse, Jahrgang 1971, no. 13 (Mainz, 1971), p. 19(629) and figs. 16-18. See also *Anthologia Latina*, ed. A. Riese and F. Bücheler (Leipzig, 1894), vol. I, no. 293, p. 251 for a poem which eulogizes an undefeated black charioteer. For other Negro grooms or "horsemen," see a mosaic from Carthage, J. W. Salomonson, *La mosaïque aux chevaux de l'antiquarium de Carthage*,

Etudes d'archéologie et d'histoire ancienne publiées par l'Institut historique néerlandais de Rome, vol. I (The Hague, 1965), Tableau 4 (fig. 8, pl. LVIII 2), described on pp. 95-96, and another from Gafsa, Ya-coub, *Le Musée du Bardo*, p. 52.

157 Copenhagen, Ny Carlsberg Glyptotek, IN 2807. P. Reutersward, *Studien zur Polychromie der Plastik (Griechenland und Rom)* (Stockholm, 1960), pp. 62-63 and pl. VII; F. Poulsen, *Catalogue of Ancient Sculpture in the Ny Carlsberg Glyptotek* (Copenhagen, 1951), p. 166, no. 229 b. See also Boardman, *Greek Gems*, p. 294 and pl. 61, for a fourth century, green jasper scaraboid in London with a Negro (?) stable boy.

158 Athens, National Museum, 4464.

159 S. Karouzou, *National Archaeological Museum: Collection of Sculpture: A Catalogue* (Athens, 1968), p. 127 and pl. 49. Karouzou, though suggesting the date as approximately 300 B.C., states that the chronology is debatable. G. M. A. Richter, *A Handbook of Greek Art*, 2nd ed. (London, 1960), p. 166, suggests the second half of the third century. Cf. idem, *The Sculpture and Sculptors of the Greeks*, 4th ed., newly rev. (New Haven, Conn. and London, 1970), p. 76 and fig. 377.

160 Philostratus *Vita Apollonii* 6.2.

161 Palestrina, Museo Archeologico Nazionale. G. E. Rizzo, *La pittura ellenistico-romana* (Milan, 1929), p. 81, pls. 188-89; G. Gullini, *I Mosaici di Palestrina*, Supplement to *Archeologia Classica* (Rome, 1956), p. 43 and pls. XX, XXIII, and XXV; P. Romanelli, *Palestrina* (Naples, 1967), pp. 67-69, pl. XXXI, and figs. 68 and 93.

162 Athenaeus *Deipnosophistae* 5.201a. In the opinion of P. M. Fraser, *Ptolemaic Alexandria* (Oxford, 1972), vol. I, *Text*, p. 74, blacks were as familiar a part of the Alexandrian scene in antiquity as they are today and economic factors which in modern times have attracted Sudanese to Cairo and Alexandria may also have been responsible for northward migrations of Negroes.

163 Agatharchides *De Mari Erythraeo* 16, *GGM*, vol. I, p. 118. Fraser, *Ptolemaic Alexandria*, vol. I, pp. 541-42 and vol. II (1972), *Notes*, pp. 775-77, considers the observations on the courage and military skill of the Ethiopians part of a warning of a regent to an unidentified youthful Ptolemy, perhaps Epiphanes (205-180 B.C.) on the undesirability of launching an expedition against the Ethiopians.

164 Oxford, Ashmolean Museum, G 97.

165 Houston, D. and J. de Menil Collection, CA 6911; said to be from Sicily, third to second century B.C. Hoffmann, *Ten Centuries*, pp. 286-88, no. 140.

166 Houston, D. and J. de Menil Collection, CA 6387. Hoffmann, *Ten Centuries*, pp. 173-75, fig. 81a-e.

167 Providence, Museum of Art, Rhode Island School of Design, 11.035. D. M. Brinkerhoff, "Greek and Etruscan Art in the Museum of Rhode Island School of Design," *Archaeology* 11 (1958): 154 (photograph) and 155.

168 London, British Museum, 1955.10-8.1. D. E. L. Haynes, "Bronze Bust of a Young Negress," *BMQ* 21(1957): 19-20, pl. IV; *Blacks in Antiquity*, p. 86, fig. 61.

169 *The Illustrated London News* (22 October 1955): 681.

170 P. Perdrizet, *Bronzes grecs d'Egypte de la collection Fouquet* (Paris, 1911), p. 57, and pl. XXV, no. 94.

171 Florence, Museo Archeologico, 2288. H. Read, *A Coat of Many Colours: Occasional Essays* (London, 1945), frontispiece and p. 2.

172 Athens, Agora Museum, L 4614. R. H. Howland, *The Athenian Agora, Results of Excavations Conducted by the American School of Classical Studies*, vol. IV, *Greek Lamps and Their Survivals* (Princeton, N.J., 1958), p. 157, no. 615.

173 Athens, Agora Museum, L 2207. Howland, *Athenian Agora*, vol. IV, *Greek Lamps*, no. 616 and pl. 48.

174 Houston, D. and J. de Menil Collection, CA 74-02.

175 London, British Museum, TB 97. Marshall, *Catalogue of Jewellery*, p. 216, no. 1962, and pl. XXXVI.

176 Paris, Musée du Louvre, Bj. 181 and Bj. 182. A. de Ridder, *Catalogue sommaire des bijoux antiques* (Paris, 1924), p. 17, nos. 181-82 (C 85), pl. VIII.

177 I have been informed that this agate piece was stolen from the University of Mississippi Museum several years ago and has not been recovered.

178 C. T. Seltman, "Two Heads of Negresses," *AJA* 24(1920): 18-22 and fig. 4; Beardsley, *The Negro*, p. 109 and fig. 21. Seltman is inclined to date the piece between 50 B.C. and A.D.50.

179 East Berlin, Staatliche Museen, Ägyptisches Museum, 20797. P. Jacobsthal, "Rhodische Bronzekannen aus Hallstattgräbern," *Jahrbuch des Deutschen Archäologischen Instituts* 44(1929): 201, fig. 4.

180 Brooklyn, The Brooklyn Museum, 67.70.

181 K. Herbert, *Greek and Latin Inscriptions in The Brooklyn Museum* (Brooklyn, 1972), pp. 14-16 and pl. V, where the bronze shovel is discussed. The painting of Antiphilus is mentioned by Pliny *Naturalis Historia* 35.40.138.

182 Brooklyn, The Brooklyn Museum, 70.59. For accounts of this recent acquisition, see "A Black Man in Brooklyn," *The Connoisseur* 176 (1971): 131; B. V. Bothmer, "A Young Nubian Immortalized: Brooklyn's New Acquisition," *Apollo*, 93, no. 108 n.s. (February 1971): 126-27; and D. Kiang, "The Brooklyn Museum's New Head of a Black," *Archaeology* 25 (1972): 4-7.

183 Paris, Bibliothèque Nationale. E. Babelon and J. A. Blanchet, *Catalogue des bronzes antiques de la Bibliothèque nationale* (Paris, 1895), no. 1009; M. Bieber, *The Sculpture of the Hellenistic Age*, rev. ed. (New York, 1961), p. 96; C. M. Havelock, *Hellenistic Art: The Art of the Classical World from the Death of Alexander the Great to the Battle of Actium* (London, 1971), no. 99 and p. 127; G. Becatti, *The Art of Ancient Greece and Rome from the Rise of Greece to the Fall of Rome* (New York, 1967), p. 274, considers the Hellenistic statuettes of Negro boys, whether strolling peddlers or street singers, as lyrical, realistic, and psychological interpretations of life in Alexandria and cites the Chalon-sur-Saône statuette (fig. 257 on p. 252) as an excellent example; W. Fuchs in J. Boardman, J. Dörig, W. Fuchs, and M. Hirmer, *The Art and Architecture of Greece* (London, 1967), p. 514 and pl. 302, who does not follow the usual interpretation of the boy as a musician but describes him as a young porter and suggests that he may have originally carried an elephant's tusk over his right shoulder. J. D. Cooney, "A Miscellany of Ancient Bronzes," *The Bulletin of the Cleveland Museum of Art*, 58, no. 7 (1971): 210-14, notes that the Bibliothèque Nationale Negro and the bronze of a standing Negro beggar in the Cleveland Museum of Art (63.507) are so similar in composition as to suggest that they are from the same Alexandrian workshop and "represent the cream of Alexandrian production in this medium."

184 Athens, National Museum, 22. S. Reinach, *Répertoire de la statuaire grecque et romaine* (Paris, 1898), vol. II, pt. 2, p. 561, no. 6.

185 Trieste, Museo Civico di Storia e d'Arte, 4865 (T.205). F. Winter, *Die Typen der figürlichen Terrakotten*, vol. II, *Jüngere Typen* (Berlin and Stuttgart, 1903), p. 449, no. 6. For itinerant musicians in North Africa, see L. C. Briggs, *The Living Races of the Sahara*, Papers of the Peabody Museum of Archaeology and Ethnology, Harvard University, vol. XXVIII, no. 2 (Cambridge, Mass., 1958), pp. 73, 75.

186 Paris, Musée du Louvre, MNC 1645. A. de Ridder, *Les Bronzes antiques du Musée du Louvre* (Paris, 1913), vol. I, p. 57, no. 361, and pl. 30. For slave or captive, see M. I. Rostovtzeff, *The Social and Economic History of the Hellenistic World* (Oxford, 1941), vol. II, p. 900 and pl. CI.

187 Madrid, Museo Arqueológico Nacional, 2991. R. Thouvenot, *Catalogue des figurines et objets de bronze du Musée Archéologique de Madrid*, vol. I, *Bronzes grecs et romains* (Bordeaux and Paris, 1927), p. 55, no. 261, pl. XIII.

188 Sieveking, *Die Terrakotten* (1916), vol. II, pl. 84.

189 London, British Museum, 1852.4-1.1 and 1852.4-1.2. Walters, *Catalogue of Terracot-*

tas, p. 311, no. D 85 and p. 310, no. D 84; *Blacks in Antiquity*, p. 77, fig. 49.

190 New York, Metropolitan Museum of Art, 18.145.10. RICHTER, *Handbook of the Greek Collection*, p. 125, pl. 104 f.

191 Boston, Museum of Fine Arts, 59.11. C. C. VERMEULE, "Greek, Etruscan and Roman Bronzes Acquired by the Museum of Fine Arts, Boston," *Classical Journal* 55 (1960): 199-200 and fig. 7; M. COMSTOCK and C.C. VERMEULE, *Greek, Etruscan, and Roman Bronzes in the Museum of Fine Arts, Boston* (Boston, 1971), no. 82, pp. 78-79.

192 Bodrum, Archeological Museum, 756. *Art Treasures of Turkey*, ed. T. C. WITHERSPOON (Washington, D.C., 1966), p. 93 and no. 145. C. M. HAVELOCK in *Hellenistic Art*, no. 133 and p. 141, in commenting on the boy's curved fingers raises the question as to whether the boy was holding an object in each hand; as one possibility he suggests that he was making an offering of some type; and expresses doubt that the boy was holding reins and was a groom, as has been suggested.

193 Paris, Bibliothèque Nationale. BABELON and BLANCHET, *Catalogue des bronzes*, pp. 440-41 and no. 1010; *Blacks in Antiquity*, p. 245, fig. 109.

194 East Berlin, Staatliche Museen, Antikensammlung, 7456. K. A. NEUGEBAUER, *Die griechischen Bronzen der klassischen Zeit und des Hellenismus* (Berlin, 1951), pp. 88-90 and pl. 40, no. 72; the figure is described as a young Celt. The physical characteristics, in my judgment, are clearly Negroid.

195 Oxford, Ashmolean Museum, 1884.583. *Ashmolean Museum Summary Guide*, p. 90.

196 A. J. EVANS, "Recent Discoveries of Tarentine Terra-Cottas," *JHS* 7 (1886): 37-38, pl. LXIV.

197 Alexandria, Greco-Roman Museum, 24127. A. ADRIANI, *Annuaire du Musée Gréco-romain (1935-39)* (Alexandria, 1940), p. 104 and pl. E. For observations on crouching Negro boys, see T. HADZISTELIOU-PRICE, "The Type of the Crouching Child and the 'Temple Boys,'" *ABSA* 64 (1969): 103, 109-110.

198 Athens, National Museum, Δ 452. T. SCHREIBER, "Alexandrinische Sculpturen in Athen," *AthMitt* 10 (1885): 383-84 and pl. XI 2; REINACH, *Répertoire de la statuaire*, vol. II, pt. 2, p. 562, no. 4. For another treatment of a poor Negro, see the bronze statuette of a Negro beggar in the Cleveland Museum of Art, discussed by J. D. COONEY, *supra*, n. 183.

199 Copenhagen, Ny Carlsberg Glyptotek, IN 2755. POULSEN, *Catalogue of Ancient Sculpture*, p. 609, no. 16; *Blacks in Antiquity*, p. 77, fig. 48.

200 Copenhagen, Ny Carlsberg Glyptotek, AEIN 1957. O. KOEFOED-PETERSEN, *Egyptian Sculpture in the Ny Carlsberg Glyptothek*, 2nd ed. (Copenhagen, 1962), p. 36 and pl. 52; *Blacks in Antiquity*, p. 76, fig. 47.

201 Boston, Museum of Fine Arts, 01.8210. *Blacks in Antiquity*, p. 72, fig. 42.

202 London, British Museum, WT 312. WALTERS, *Catalogue of Terracottas*, p. 311, no. D 86.

203 West Berlin, Staatliche Museen, Antikenabteilung, TC 8626. GEHRIG, et al., *Führer durch die Antikenabteilung*, p. 230. R. A. HIGGINS, *Greek Terracottas*, p. 120 and pl. 58A, regards the piece as a "creation of unusual charm" and "transformed by the coroplast into a human document, a sympathetic study of a racial type." C. M. HAVELOCK, in *Hellenistic Art*, no. 136 and p. 143, however, considers it a "marvelous parody of the dignified original," and an example of Hellenistic humor.

204 West Berlin, Staatliche Museen, Antikenabteilung, 493. REINACH, *Répertoire de la statuaire*, vol. II, pt. 2, p. 563, no. 8.

205 Baltimore, Walters Art Gallery, 54.2428. *The Walters Art Gallery, The Twenty-fifth Annual Report of the Trustees to the Mayor and City Council of Baltimore for the Year 1957* (Baltimore, 1957), pp. 38-40.

206 Naples, Museo Nazionale, 5486. REINACH, *Répertoire de la statuaire*, vol. II, pt. 2, p. 563, no. 4.

207 Baltimore, Walters Art Gallery, 54.702. D. K. HILL, *Catalogue of Classical Bronze Sculpture in the Walters Art Gallery* (Baltimore, 1949), p. 71, no. 149, and pl. 5; *Blacks in Antiquity*, p. 241, fig. 103.

208 HELIODORUS *Aethiopica* 9.19.

209 Bad Deutsch-Altenburg, Museum Carnuntinum, 11949. R. FLEISCHER, *Die römischen Bronzen aus Österreich* (Mainz, 1967), pp. 152-53, pl. 108, no. 205; *Blacks in Antiquity*, p. 240, fig. 102.

210 Baltimore, Walters Art Gallery, 54.2372. D. K. HILL, "A Bronze Statuette of a Negro," *AJA* 57 (1953): 265-67 and pl. 75.

211 East Berlin, Staatliche Museen, Antikensammlung, TC 8327. A. KÖSTER, *Die griechischen Terrakotten* (Berlin, 1926), pp. 89-90 and pl. 101; H. A. HARRIS, *Sport in Greece and Rome*, ed. H. H. SCULLARD, Aspects of Greek and Roman Life Series (London, 1972), no. 49 and p. 107. For a recently discovered figurine of a pronounced Negro, perhaps a juggler, see P. BRUNEAU, "Tombes d'Argos," *BCH* 94 (1970): 473-74 and fig. 95.

212 Athens, National Museum, 15177. HANFMANN, *Classical Sculpture*, p. 329 and pls. 232-33. RICHTER, *A Handbook of Greek Art*, p. 166; HAVELOCK, *Hellenistic Art*, no. 132 and p. 141.

213 J. P. PETERS and H. THIERSCH, *Painted Tombs in the Necropolis of Marissa [Marêshah]*, ed. S. A. COOK (London, 1905), p. 26; E. R. GOODENOUGH, *Jewish Symbols in the Greco-Roman Period*, vol. I, *The Archaeological Evidence from Palestine*, Bollingen Series, 37 (New York, 1953), p. 68.

214 See *infra*, nn. 218-25.

215 TERENCE *Heautontimorumenos* 77; see A. LESKY, *A History of Greek Literature*, trans. J. Willis and C. Detter (New York, 1966), pp. 661-62. It is interesting to note that the *Heautontimorumenos* of the dark-skinned Terence was based on a play by Menander, who emphasized that merit transcends racial barriers and that it makes no difference whether one is Scythian or Ethiopian.

216 PLAUTUS *Poenulus* 1289-91. Plautus also seems to be referring to a black nurse in *Poenulus* 1112-13.

217 PLAUTUS, *Collected Works*, trans. P. Nixon, Loeb Classical Library, vol. IV (London and New York, 1932), p. 131; G. E. DUCKWORTH, *The Complete Roman Drama* (New York, 1942), vol. I, p. 777; *Oxford Latin Dictionary*, fasc. I (Oxford, 1968), s.v. "Aegyptini," p. 63.

218 London, British Museum, R.P.K.1.P.218 (=B.M.C. Etrurian Uncertain 17), S.N.G. (Lloyd) 31. R.S. POOLE, *A Catalogue of the Greek Coins in the British Museum: Italy* (London, 1873), p. 15, nos. 17-21.

219 H. H. SCULLARD, "Hannibal's Elephants," *NC*, 8, 6th ser.(1948): 163; W. GOWERS and H. H. SCULLARD, "Hannibal's Elephants Again," *NC*, 10, 6th ser.(1950): 279-80.

220 E. S. G. ROBINSON, "Carthaginian and Other South Italian Coinages of the Second Punic War," *NC*, 4, 7th ser. (1964): 47.

221 F. PANVINI ROSATI, "La monetazione annibalica," in *Studi Annibalici, Atti del Convegno svoltosi a Cortona, Tuoro sul Trasimeno, Perugia, ottobre 1961*, 5, n.s. (1961-64) (Cortona, 1964): 178-80; cf. J. DESANGES, "Les chasseurs d'éléphants d'Abou-Simbel," *Actes du quatre-vingt-douzième Congrès national des Sociétés Savantes*, Section d'Archéologie, Strasbourg et Colmar 1967 (Paris, 1970), p. 36, n. 28.

222 OROSIUS 4.9.14.

223 FRONTINUS *Strategemata* 1.11.18.

224 Naples, Museo Archeologico Nazionale, 124845. A. RUESCH, *Guida illustrata del Museo Nazionale di Napoli* (Naples, 1908), p. 145 and fig. 44; LEVI, *Le terrecotte figurate*, pp. 196-97, no. 848 and pl. XIII 1; BEAZLEY, *Etruscan Vase-Painting*, p. 212; *Blacks in Antiquity*, pp. 224-25, fig. 82.

225 SENECA *Epistulae* 85.41; MARTIAL 1.104-9-10, 6.77.8; ACHILLES TATIUS 4.4.6.

226 SILIUS ITALICUS *Punica* 3.265-69.

227 For the dates, see S. JAMESON, "Chronology of the Campaigns of Aelius Gallus and C. Petronius," *The Journal of Roman Studies* 58 (1968): 82.

228 STRABO 17.1.54.

229 East Berlin, Staatliche Museen, Antikensammlung, Br. 10485, Br. 10486. K.A. NEUGEBAUER, "Aus der Werkstatt eines griechischen Toreuten in Aegypten," *Schumacher-Festschrift* (Mainz, 1930), p. 236, pl. 23.

230 STRABO 17.1.54.

231 Houston, Menil Foundation Collection, 72-62 DJ(4). P. PERDRIZET, *Les terres cuites grecques d'Egypte de la collection Fouquet* (Nancy, Paris, Strasbourg, 1921), vol. I, p. 131, no. 357; vol. II, pl. CI. There are two similar figurines in the Greco-Roman Museum in Alexandria. The first one (19505) from Hadra holds a double-axe and an oval shield; E. BRECCIA, *Terrecotte figurate greche e greco-egizie del Museo di Alessandria*, Société royale d'archéologie d'Alexandrie, Monuments de l'Egypte gréco-romaine, tome 2 (Bergamo, 1930), fasc. 1, p. 63, no. 340 and pl. XXVIII, no. 4. The second statuette (23099) has the same type of axe and wears a cloth draped over his shoulders; BRECCIA, *Terrecotte figurate* (1934), fasc. 2, p. 50, no. 317 and pl. LXXI, no. 363.

232 Amsterdam, Allard Pierson Museum, 7316. *Allard Pierson Museum Algemeene Gids* (Amsterdam, 1937), p. 50, no. 465, and pl. XXV; ROSTOVTZEFF, *Social and Economic History of the Hellenistic World*, vol. II, p. 900 and pl. CI, fig. 2.

233 Rome, Museo Torlonia, 209. S.A. MORCELLI, C. FEA, and P.E. VISCONTI, *La Villa Visconti (ora Torlonia) descritta* (Imola, 1870), p. 38, no. 209. I have examined the Roman bronze bust of a goateed figure described as representing a Negro prince, Leiden, Rijksmuseum van Oudheden, F 1952/2.2; *Fasti Archeologici*, 8, no. 206 (1953): 19, but the physical features do not seem to me to warrant a classification as Negroid except for a slight thickness in the lips.

234 Copenhagen, Ny Carlsberg Glyptotek, AEIN 1336. KOEFOED-PETERSEN, *Egyptian Sculpture*, p. 38 and pl. 53; *Blacks in Antiquity*, p. 92, fig. 69.

235 SCRIPTORES HISTORIAE AUGUSTAE *Septimius Severus* 22.4-5.

236 R. G. COLLINGWOOD and R. P. WRIGHT, *The Roman Inscriptions of Britain* (Oxford, 1965), vol. I, p. 626, no. 2042; A. BIRLEY, *Septimius Severus: The African Emperor* (London, 1971), pp. 265-66.

237 L. A. THOMPSON, "Africans in Roman Britain," *Museum Africum: West African Journal of Classical and Related Studies* 1 (1972): 36.

238 R. BRILLIANT, *The Arch of Septimius Severus in the Roman Forum*, Memoirs of the American Academy in Rome, vol. 29 (Rome, 1967), pls. 78 c, d; 80 a, 81. The author describes the soldiers as having "full fleshy profiles, large curving noses with well defined nostrils, full lips..." (p. 247), but he does not mention that the features may be Negroid; *Blacks in Antiquity*, p. 142 and fig. 86, p. 228.

239 Rome, Palazzo Rondinini. L. SALERNO, *Palazzo Rondinini* (Rome, 1965), p. 259, no. 85, and fig. 139.

240 F. MATZ and F. VON DUHN, *Antike Bildwerke in Rom* (1881; Rome, 1968), p. 440, no. 3332.

241 AUGUSTINE *Enarrationes in Psalmos* 67.41 (*Corpus Christianorum, Series Latina* 39.898 [hereafter cited as *CCL*]).

242 AUGUSTINE *Enarrationes in Psalmos* 73.16 (*CCL* 39.980).

243 AUGUSTINE *De civitate Dei* 16.8.

244 FULGENTIUS *Epistulae* 11-12 (*Patrologiae Cursus Completus, Series Latina* 65.378-92).

245 P. L. MACKENDRICK, *The Mute Stones Speak: The Story of Archaeology in Italy* (New York, 1960), p. 332; M. GUIDO, *Sicily: An Archaeological Guide* (London, 1967), p. 137.

246 Piazza Armerina, Imperial Villa: room north of the peristyle. B. PACE, *I mosaici di Piazza Armerina* (Rome, 1955), pl. XVIII; G. V. GENTILI, *Mosaics of Piazza Armerina: The Hunting Scenes*, trans. B. Wales (Milan, 1964), p. 5; idem, *La Villa Erculia di Piazza Armerina: I mosaici figurati* (Rome, 1959), p. 21, pl. XXI.

247 Piazza Armerina, Imperial Villa: Great Corridor. GENTILI, *Mosaics of Piazza Armerina*, pl. VIII.

248 N. 79, *supra*.

249 Naples, Museo Archeologico Nazionale, 8898; from the Casa di Meleagro. G.E. RIZZO, *La pittura ellenistico-romana*, p. 47 and pl. LXXXIII; A. DE FRANCISCIS, *Il Museo nazionale di Napoli* (Naples, 1936), pl. XLVIII; L. ROCCHETTI, *EAA*, vol. I, s.v. "Alessandria," pp. 217-18 and fig. 318, and s.v. "Africa," p. 108, who considers the figure an important representation of Africa.

250 SIDONIUS APOLLINARIS *Carmina* 5.53-54.

251 GUIDO, *Sicily*, p. 139; G. V. GENTILI, *EAA*, vol. VI, s.v. "Piazza Armerina," p. 151.

252 M. COLLIGNON, "L'Afrique personnifiée: Statuette provenant d'Egypte acquise par Jean Maspero," *MonPiot* 22 (1916): 163-73 and pl. XVI.

253 Paris, Private Collection. F. CUMONT, "Tête de marbre figurant la Libye," *MonPiot* 32(1932): 41-50 and pl. IV.

254 DIO CASSIUS *Epitome* 62.63.3; cf. M. GRANT, *Gladiators* (London, 1967), p. 34. V. TRAN TAM TINH, *Le culte des divinités orientales en Campanie* (Leiden, 1972), p. 25, cites the Dio Cassius reference in support of his opinion that there was a large Isiac community at Puteoli.

255 PETRONIUS *Satyricon* 34.

256 *Corpus Inscriptionum Latinarum* IV 1520, 6892.

257 R.S. LULL, *Organic Evolution* (New York, 1917), p. 413. In a letter to me on this point, Dr. Lull wrote: "It was the mold of the features, the nose and lips especially, which the plaster cast brought out in which the negroid and white contrast was brought out." In correspondence with me on the same point, Prof. M.I. Rostovtzeff wrote: "The observation of Professor Lull is not new. It refers to one of the casts of men and animals who perished in Pompeii during the catastrophe.... One of these is regarded as being a cast of a body of a slave and several people suggested that the cast of the face of this body shows negroid features."

258 Pompeii, House of the Menander: entrance to caldarium. A. MAIURI, *La Casa del Menandro e il suo tesoro di argenteria* (Rome, 1933), vol. I, pp. 146-47 and fig. 68. *Rhetorica ad Herennium* 4.50.63 and *Blacks in Antiquity*, pp. 272-73.

259 Naples, Museo Archeologico Nazionale, 129404.

260 Naples, Museo Archeologico Nazionale, 8924. G. CH.-PICARD, *Roman Painting*, Pallas Library of Art Series, vol. 4 (London, 1970), p. 101.

261 Naples, Museo Archeologico Nazionale, 8919. *Blacks in Antiquity*, pp. 189-90; R.E. WITT, *Isis in the Graeco-Roman World* (London, 1971), pp. 23, 71, 72, pls. 23 and 26. For another black occupying a central position in a painting of about the same period, see the fresco of the Domus Aurea of Nero depicting a procession of robed women moving to the right. A black, with a headdress somewhat similar to that of the black in the Herculaneum fresco, and, also like the Herculaneum black, nude except for a type of shirt around his waist, leads an animal (sheep?) in the same direction as the women, five of whom are on his right and four on his left. Cf. M. BORDA, *La pittura romana* (Milan, 1958), pp. 70-72 and R. BIANCHI BANDINELLI, *Roma: L'arte romana nel centro del potere* (Milan, 1969), pp. 134, 404, and pl. 141.

262 See *Blacks in Antiquity*, pp. 189-92.

263 Naples, Museo Archeologico Nazionale, 6692. S. REINACH, *Répertoire de reliefs grecs et romains* (Paris, 1912), vol. III, p. 94, no. 1; *Blacks in Antiquity*, p. 78, fig. 50.

264 Naples, Museo Archeologico Nazionale. D. FACCENNA, "Rappresentazione di negro nel Museo Nazionale di Napoli," *Archeologia Classica* 1(1949): 188-95 and pls. LIV-LV.

265 *Scholia ad Persium* 5.9 (E. KURZ, ed., 1899).

266 For the role of commercial ties between Egypt and Europe and the influence of Isiac cults in the circulation of Negroid types, even in Britain, in the early centuries of the empire, see M. MALAISE, "A propos d'un buste-balsamaire en bronze du musée de Tongres. Sur les traces d'influences alexandrines à Atuatuca," *Latomus* 29(1970): 142-56 and pls. I-III; and L. RICHARD, "Aegyptiaca d'Armorique," ibid. 31(1972): 88-104 and pl. III.

267 London, British Museum, 1908.5-15.1. H.B. WALTERS, *Select Bronzes, Greek, Roman, and Etruscan, in the Department of Antiquities, British Museum* (London, 1915), pl. LXVIII; *Blacks in Antiquity*, p. 90, fig. 66.

268 Tarragona, Museo Arqueológico Provincial, 527. F. POULSEN, *Sculptures antiques de musées de province espagnols* (Copenhagen, 1933), p. 58, pl. LVIII, figs. 90-92.

269 Saint-Germain-en-Laye, Musée des Antiquités Nationales, 818. S. REINACH, *Description raisonnée du Musée de Saint-Germain-en-Laye: Bronzes figurés de la Gaule romaine* (Paris [1884]), p. 211, no. 198(818).

270 See *supra*, n. 183.

271 Augst, Römermuseum, 61.6532. For a study of this and the next statuette, see R. STEIGER, "Drei römische Bronzen aus Augst," *Gestalt und Geschichte: Festschrift Karl Schefold*, Antike Kunst, no. 4 (Bern, 1967), pp. 192-95 and pl. 62-63.

272 Saint-Germain-en-Laye, Musée des Antiquités Nationales, 32.542. REINACH, *Bronzes figurés*, p. 213, no. 199; H. ROLLAND, *Bronzes antiques de Haute-Provence*, XVIIIᵉ supplément à "Gallia" (Paris, 1965), pp. 103-104, no. 191, and fig. 191.

273 See *supra*, nn. 191-92.

274 Five crocodiles were exhibited in Rome by Marcus Scaurus in 58 B.C. (PLINY *Naturalis Historia* 8.40.96) and thirty-six crocodiles were killed in a pool in the Circus Maximus at games in 2 B.C. (DIO CASSIUS *Epitome* 55.10.8).

275 London, British Museum, 1768. A. H. SMITH, *A Catalogue of Sculpture in the Department of Greek and Roman Antiquities, British Museum* (London, 1904), vol. III, pp. 114-15, no. 1768. Rome, Museo Nazionale Romano, 40809; S. AURIGEMMA, *Le Terme di Diocleziano e il Museo Nazionale Romano* (Rome, 1946), p. 72, no. 184; W. HELBIG and H. SPEIER, *Führer durch die öffentlichen Sammlungen klassischer Altertümer in Rom*, 4th ed. (Tübingen, 1969), vol. III, p. 202, no. 2288.

276 Houston, D. and J. de Menil Collection, X608; HOFFMANN, *Ten Centuries*, pp. 170-72, no. 80.

277 Orléans, Musée Historique et Archéologique de l'Orléanais, 8632. F. BRAEMER, *L'Art dans l'Occident romain: trésors d'argenterie, sculptures de bronze et de pierre*, Exhibition catalogue, Paris, Palais du Louvre, July-October 1963 (Paris, 1963), p. 92, no. 401.

278 J. M. C. TOYNBEE, *Art in Britain under the Romans* (Oxford, 1964), p. 356 and pl. LXXXI b.

279 Wall, Letocetum Museum. TOYNBEE, *Art in Britain*, pl. LXXXI c. The partly crumpled and molten state of this statuette is apparently due to exposure to heat in ancient times.

280 Corinth, Archeological Museum, T2001, TC209. T. L. SHEAR, "Excavations in the North Cemetery at Corinth in 1930," *AJA* 34(1930): 429 and fig. 19.

281 *Anthologia Palatina* 6.309.

282 On the "apotropaic" charm of the Negro, see *Blacks in Antiquity*, pp. 272-73; D. G. MITTEN and S. F. DOERINGER, *Master Bronzes from the Classical World* (Cambridge, Mass., 1968), p. 119. For items of figured bronze furniture in the Roman period, see idem, *Master Bronzes*, pp. 229-31. See HADZISTELIOU-PRICE, *ABSA* 64(1969): 110, for the suggestion that figurines of crouching Negro boys in graves may have been substitutes for children's servants or companions.

283 Paris, Bibliothèque Nationale. BABELON and BLANCHET, *Catalogue des bronzes*, p. 442, no. 1016.

284 Paris, Bibliothèque Nationale. BABELON and BLANCHET, *Catalogue des bronzes*, pp. 445-46, no. 1025.

285 Paris, Bibliothèque Nationale. BABELON and BLANCHET, *Catalogue des bronzes*, p. 441, no. 1013.

286 Paris, Bibliothèque Nationale. BABELON and BLANCHET, *Catalogue des bronzes*, p. 443, no. 1017.

287 Paris, Bibliothèque Nationale. BABELON and BLANCHET, *Catalogue des bronzes*, p. 443, no. 1018.

288 Paris, Bibliothèque Nationale. BABELON and BLANCHET, *Catalogue des bronzes*, p. 445, no. 1021.

289 Paris, Bibliothèque Nationale. BABELON and BLANCHET, *Catalogue des bronzes*, p. 444, no. 1019.

290 Paris, Bibliothèque Nationale. BABELON and BLANCHET, *Catalogue des bronzes*, p. 445, no. 1022.

291 Paris, Bibliothèque Nationale. BABELON and BLANCHET, *Catalogue des bronzes*, p. 445, nos. 1023 and 1024.

292 Paris, Musée du Petit Palais, Dutuit 83. H. LAPAUZE, C. GRONKOWSKI, and A. FAUCHIER-MAGNAN, *Catalogue sommaire des collections Dutuit*, new ed. (Paris, 1925), no. 83; [W. FROEHNER], *Collection Auguste Dutuit* (Paris, 1897), p. 34, no. 60, pl. LVI.

293 Leicester, Museum and Art Gallery, 112.1858. TOYNBEE, *Art in Britain*, pp. 119-20 and pl. XXXII e.

294 Cambridge, Fitzwilliam Museum, GR.25. 1904.

295 Oxford, Ashmolean Museum, Fortnum B 50.

296 Geneva, Musée d'Art et d'Histoire, C 237. BRAEMER, *L'Art dans l'Occident romain*, p. 120, no. 541.

297 *Supra*, nn. 231-32.

298 Alexandria, Greco-Roman Museum, 23241. BRECCIA, *Terrecotte figurate*, fasc. 2, p. 50, no. 318, and pl. LXXI, no. 362. We must also note a North African terracotta figurine (third century A.D.) of a gladiator:

J. DENEAUVE, "Terres cuites de l'Afrique romaine," *Mélanges de Carthage* (Paris, 1964-65), vol. X, p. 132. The author's description—"L'épatement du nez, le dessin de la bouche aux lèvres épaisses ... coiffure ... formée de cheveux crépus ..."—gives no indication of Negroid features. In this case (cf. nn. 8, 159, *supra*) the probability of Negroid-white extraction should not be excluded.

299 Hildesheim, Roemer-Pelizaeus-Museum, 2248. A. IPPEL and G. ROEDER, *Die Denkmäler des Pelizaeus-Museums zu Hildesheim* (Berlin, 1921), p. 166; for a similar terracotta (third century A.D., from Egypt) of a Negro carrying a calf, see V. VERHOOGEN, *Terres cuites grecques aux Musées Royaux d'Art et d'Histoire (Guide sommaire)* (Brussels, 1956), p. 38 and fig. 35.

300 Terracotta lamp, c. first century A.D., Bonn, Akademisches Kunstmuseum der Universität Bonn, Vas. 1424. Roman terracotta lamp, Cairo, Egyptian Museum, 42110, with cicatrices on left cheek only. Cf. *Blacks in Antiquity*, pp. 22-23 and p. 35, fig. 3; L. KEIMER, "Une petite tête romaine en terre cuite représentant une Soudanaise à cicatrices faciales," *BSAA* 40 (1953): 32-34 and fig. 2. See *supra*, n. 35.

301 Athens, Agora Museum, T873. C. GRANDJOUAN, *Athenian Agora*, vol. VI, *Terracottas and Plastic Lamps of the Roman Period* (1961), p. 55, no. 404.

302 Athens, Agora Museum, S435. E. B. HARRISON, *Athenian Agora*, vol. I, *Portrait Sculpture* (1953), pp. 59-60, pl. 29, no. 45.

303 Cologne, Römisch-Germanisches Museum, 25,396.

304 Houston, D. and J. de Menil Collection, CA 6920. HOFFMANN, *Ten Centuries*, p. 448, no. 205, photographs on pp. 449 and 450.

305 Houston, D. and J. de Menil Collection, CA 6714. HOFFMANN, *Ten Centuries*, p. 446, no. 204, and photograph on p. 447.

306 Athens, Agora Museum, L3457. GRANDJOUAN, *Athenian Agora*, vol. VI, *Terracottas*, p. 80, no. 1062, and pl. 30.

307 London, British Museum, 1889.10-19.16. H. B. WALTERS, *Catalogue of the Silver Plate (Greek, Etruscan, and Roman) in the British Museum* (London, 1921), pp. 38-39, no. 145, and pl. XXIII. For another pepper pot in the form of a Negroid boy holding a puppy, see B. FILOW, "Le trésor romain de Nicolaévo," *Bulletin de la Société Archéologique bulgare* 4(1914): 46 and pl. 1; D. E. STRONG, *Greek and Roman Gold and Silver Plate* (Ithaca, N.Y., 1966), p. 178. For a silver pitcher with the handle in the form of a Negro's head, found in the house of Meleager at Pompeii, see MAIURI, *La Casa del Menandro*, vol. I, pp. 359-60 and vol. II, pl. LIII.

308 Geneva, Musée d'Art et d'Histoire, MF 2858.

309 Houston, D. and J. de Menil Collection, CA 6716. For Roman glass cups molded in the form of Negro heads, see *supra*, n. 259

and New York, Metropolitan Museum of Art, 81.10.226.

310 PLINY *Naturalis Historia* 7.12.51 and PLUTARCH *De sera numinis vindicta* 21(563).

311 See *Blacks in Antiquity*, pp. 178-79, 192-95.

312 Syracuse, Museo Archeologico Nazionale, 747 (first century B.C.); N. BONACASA, *Ritratti greci e romani della Sicilia* (Palermo, 1964), pp. 25-26, no. 27, pl. XII, 1-2.

313 Copenhagen, Ny Carlsberg Glyptotek, IN 2032. F. POULSEN, "Tête de prêtre d'Isis trouvée à Athènes," *Mélanges Holleaux* (Paris, 1913), p. 221 and pl. VI, and CH. PICARD, *La sculpture antique de Phidias à l'ère byzantine* (Paris, 1926), p. 306; POULSEN, *Catalogue of Ancient Sculpture*, p. 326, no. 458a.

314 Amsterdam, Allard Pierson Museum, 7872. *Algemeene Gids*, p. 60, no. 539; F.W. VON BISSING, "Mitteilungen aus meiner Sammlung. III. Kopf eines Libyers," *AthMitt* 34(1909): 29-32 and pl. I.

315 Athens, Agora Museum, S1268. HARRISON, *Athenian Agora*, vol. I, *Portrait Sculpture*, pp. 31-32, no. 20, pl. 15.

316 Boston, Museum of Fine Arts, 96.698. L.D. CASKEY, *Catalogue of Greek and Roman Sculpture*, Museum of Fine Arts, Boston (Cambridge, Mass., 1925), pp. 215-16, no. 127.

317 Vatican, Museo Gregoriano Profano, 10155. O. BENNDORF and R. SCHÖNE, *Die antiken Bildwerke des Lateranensischen Museums* (Leipzig, 1867), p. 37, no. 56. East Berlin, Staatliche Museen, Antikensammlung, SK 1579; *Stephanos: Theodor Wiegand* (Berlin, 1924), p. 16 and pl. XIII.

318 East Berlin, Staatliche Museen, Antikensammlung, SK 1503. G. SENA CHIESA, *EAA* (1961), vol. IV, s.v. "Memnone—2°," p. 1001; R. BIANCHI BANDINELLI, *Rome: The Late Empire*, trans. P. Green (London, 1971), p. 297 and pl. 273.

319 See *Blacks in Antiquity*, chaps. VIII and IX.

320 PHILOSTRATUS *Imagines* 1.29.

321 E. MVENG, a professor at the Federal University of Cameroon, who has a first-hand knowledge of African blacks, makes the following observations on the blacks of Greek and Roman art in *Les Sources grecques de l'histoire négro-africaine* (Paris, 1972), p. 70: "L'examen des types représentés nous offre un vaste tableau des principaux types négro-africains connus de nos jours, dans l'Afrique du Centre, de l'Est comme de l'Ouest Le Nègre que l'on rencontre à Athènes du VIIIᵉ au Iᵉʳ siècle avant l'ère chrétienne n'est pas réductible ... à un groupe ethnique. Il représente authentiquement le monde négro-africain, dans son unité et dans sa diversité." In commenting on the features of several Negro children (p. 71), Mveng writes: "On est frappé du réalisme de ces portraits qui, incontestablement, ont été pris sur le vif."

322 SELTMAN, *AJA* 24(1920): 14.

323 W. N. BATES, "Scenes from the Aethiopis on a Black-figured Amphora from Orvieto," *Transactions of the Department of Archaeology*, University of Pennsylvania, Free Museum of Science and Art (Philadelphia, 1904), pts. I and II, p. 50.

324 ROBERTSON, *Greek Painting*, p. 67.

325 D. VON BOTHMER, *BMMA* 21 (1962-63): 161.

326 BEARDSLEY, *The Negro*, p. 81.

327 HILL, *AJA* 57(1953): 266.

328 H. METZGER's review of *Blacks in Antiquity*, *REA* 73(1971): 498. See BEAZLEY, *JHS* 49(1929): 39 for another observation on the aesthetic appeal of the Negro: "The black man gets in not because he has strong prophylactic properties, nor is more addicted to wine, or perfume, than the white man, but because it seemed a crime not to make negroes when you had that magnificent black glaze."

307

IV

JEHAN DESANGES

THE ICONOGRAPHY OF
THE BLACK IN
ANCIENT NORTH AFRICA

1 L. BALOUT, *Les hommes préhistoriques du Maghreb et du Sahara* (Algiers, 1955), no. 54, p. 121 (La Meskiana); no. 84, p. 173 (Redeyef); no. 86, p. 179 (Asselar); cf. idem, *Préhistoire de l'Afrique du Nord: essai de chronologie* (Paris, 1955), p. 480 (some reservations about the size of the Negroid population); L.C. BRIGGS, "The Stone-age Races of Northwest Africa," *Bulletin of the American School of Prehistoric Research* 18 (1955): 81.

2 Concerning this approximate date, cf. A.J. ARKELL, *Shaheinab: An Account of the Excavation of a Neolithic Occupation Site* (London, 1953), pp. 106-107, and J. LECLANT's observations in his review of A. J. Arkell's *History of the Sudan*, *Kush* 5 (1957): 95 (in 3490 B.C. ± 380 or 3110 B.C. ± 450, drier climate than that of Early Khartum); H. J. HUGOT, *Recherches préhistoriques dans l'Ahaggar nord-occidental 1950-1957* (Paris, 1963), p. 164 (in 3450 B.C. ± 150, more humid climate than at present in the Ahaggar). The guano in the shelter at Taessa (Hoggar), which shows that the land dried up in 2730 B.C. ±300, still contains pollens of cypress, Aleppo pine, maple, etc.: cf. A. PONS and P. QUÉZEL, "Première étude palynologique de quelques paléosols sahariens," *Travaux de l'Institut de recherches sahariennes* 16 (1957): 34-35; G. DELIBRIAS, H. HUGOT, and P. QUÉZEL, "Trois datations de sédiments sahariens récents par le radio-carbone," *Libyca: Anthropologie, Préhistoire, Ethnographie* 5 (1957): 267-70. Finally reference should be made to the map of rainfall in the Sahara for the period from 5000 to 3000 B.C., established by K.W. BUTZER in *Histoire de l'utilisation des terres des régions arides*, ed. L. DUDLEY STAMP (Paris, 1961), p. 45.

3 A recent study by M.-CL. CHAMLA, "Les populations anciennes du Sahara et des régions limitrophes," *Mémoires du Centre de Recherches Anthropologiques, Préhistoriques et Ethnographiques* (Paris, 1968), vol. IX, seems, however, to prove that in the proto-historic era non-Negroids constituted more than 40 percent of the population of the Sahara, the blacks not more than 25

percent. On the difficulty of defining the criteria of nigritude in the examination of bone remains, cf. M. CHABEUF, "A propos de l'Homme de Grimaldi: Mélanodermes, Nègres et Négroïdes," in G. CAMPS and G. OLIVIER, ed., *L'Homme de Cro-Magnon: Anthropologie et Archéologie* (Paris, 1970), pp. 93-98.

4 F. SATTIN and G. GUSMANO, "La cosidetta 'mummia' infantile dell'Acacus," *Supplements to Libya Antiqua* 1 (1964): 8.

5 P. CINTAS, "Fouilles puniques à Tipasa," *RAfr* 92 (1948): 307-308; cf. earlier, S. GSELL, *Histoire ancienne de l'Afrique du Nord*, vol. IV, *La civilisation carthaginoise* (Paris, 1920), pp. 173-74 (hereafter cited as *HAAN*).

6 FRONTINUS *Strategemata* 1.11.18 (G. GUNDERMANN, ed., 1888), p. 34: c. 480 B.C.

7 DIODORUS SICULUS 20. 57: in the same passage he mentions Tokai (Thugga?) and Meskhela (Masculula?).

8 On the meaning of this expression, cf. J. DESANGES, "Rex Muxitanorum Hiarbas (Justin, XVIII, 6, 1)," *Philologus* 111 (1967): 307, n. 7.

9 The ancients used the term *Ethiopians*, meaning "burnt faces." The term is vague, but in any case implies a pigmentation darker than that of the Gaetuli.

10 PTOLEMY 4.7.10 (C. MÜLLER, ed., 1901), p. 785.

11 *Corpus Inscriptionum Latinarum*, VIII, 22786 c, 22787, 22788 (hereafter cited as *CIL*), in the Telmine region east of Djerid; R. CAGNAT, "Les Nugbenoi de Ptolémée," *CRAIBL* (1909): 568-79. Metatheses are frequent in Ptolemy.

12 PTOLEMY 4. 3. 6, p. 642, mentioned near the Tidamensii, which must be corrected to Kidamensii or inhabitants of Cydamus (Ghadames).

13 PTOLEMY 4. 3. 6, p. 642. Another such indication of the relation established between the blacks and Hell is in the metrical inscription at Hadrumetum, translated on p. 257.

14 PTOLEMY 1. 9. 7, p. 25. According to the same author (1. 8. 5, p. 21), the Garamantes are "already rather Ethiopian." On the Garamantes, cf. J. DESANGES, *Catalogue des tribus africaines de l'Antiquité classique à l'ouest du Nil* (Dakar, 1962), pp. 93-96; R. C. C. LAW, "The Garamantes and Trans-Saharan Enterprise in Classical Times," *JAfrH* 8 (1967): 181-200; C.M. DANIELS, *The Garamantes of Southern Libya* (Stoughton, Wisc. and North Harrow, Eng.,1970).

15 S. SERGI in *Scavi Sahariani, Monumenti antichi* (Rome, 1951), vol. XLI, cols. 443-504. There is something arbitrary about the author's refusal to identify the anthropological groups III and IV, which are more or less Negroid, with the ancient Garamantes, who would be represented only by groups I and II, which are Mediterranean.

16 Tripoli, Archaeological Museum; from Zliten, House of Dar Buc Ammera. Cf. in the collection *L'Italia in Africa, Le scoperte archeologiche 1911-1943*: S. AURIGEMMA, *Tripolitania*, vol. I, *I Monumenti d'Arte decorativa*, pt. 1, *I Mosaici* (Rome, 1960), pls. 137 and 151-56.

17 G. CH.-PICARD, *La civilisation de l'Afrique romaine* (Paris, 1958), p. 266, says of the Garamantes that they are "recognizable by their bronzed skin." However, G. VILLE, "Essai de datation de la mosaïque des gladiateurs de Zliten," in *La mosaïque gréco-romaine*, Colloques internationaux du Centre National de la Recherche Scientifique, Paris, 29 August-3 September 1963 (Paris, 1965), p. 147, n. 1, raises the question whether the saffron yellow of the Garamantes' skin may not be some sort of paint that was smeared on condemned prisoners.

18 PTOLEMY 1. 8. 5, p. 21.

19 EL-BEKRI, *Description de l'Afrique septentrionale*, trans. M.G. de Slane, rev. ed. (Paris, 1913), p. 27: the land of the blacks begins at Zuila; p. 49: it begins at the sands which lie south of Ifrikiya; IBN KHALDŪN, *Histoire des Berbères et des dynasties musulmanes de l'Afrique septentrionale*, trans. M.G. de Slane (Algiers, 1852), vol. I, p. 190. Again, in 1610 the Dey Othman sent an expedition to the "country of the Negroes," in the city called Aghademes, less than forty days from Tunis (probably Ghadames, some 680 miles from Tunis): cf. J. PIGNON, *Un document inédit sur la Tunisie au XVIIᵉ siècle* (Paris and Tunis, [1962]), pp. 31-35. At present, the land of the blacks begins only four hundred miles south of the Gulf of Sirte: cf. R. MAUNY, *Tableau géographique de l'Ouest africain au Moyen Age, d'après les sources écrites, la tradition et l'archéologie* (Dakar, 1961), p. 444.

20 R. COLLIGNON, "Etude sur l'ethnographie générale de la Tunisie," *Bulletin de géographie historique et descriptive* 1 (1886): 309-15. GSELL, *HAAN*, vol. I, *Les conditions du développement historique* (1913), p. 294, describes the type as follows:
Height above average; skull very long and narrow, the top sloping toward the back; sloping forehead; prominent superciliary ridges; strong cheekbones; a long, pear-shaped face; deeply notched nose, short and turned up but not flattened; wide mouth with strong lips; receding chin; wide, square shoulders; the trunk like an inverted cone, very narrow above the pelvic cavity. The skin is very dark, a reddish brown; the eyes deep black; the hair only slightly kinky and jet black.

21 APPIAN *Numidica* 5.1 (L. MENDELSSOHN, ed., 1879), p. 325.

22 AMMIANUS MARCELLINUS 29. 5. 34. On this campaign cf. S. GSELL, "Observations géographiques sur la révolte de Firmus," *Recueil des notices et mémoires de la Société archéologique du Département de Constantine* 36 (1903): 21-46, esp. 38-40.

23 CLAUDIAN *Fourth Consulate of Honorius* vv. 34-35: he adds that Theodosius surrounded the Atlas: *cinxitque nouis Atlanta maniplis*.

24 G. Ch.-Picard, *Castellum Dimmidi* (Algiers and Paris, 1947), pp. 22-31: but in our opinion this author's proposed identification (p. 28) of the ancient Nigris with a river in the tropical zone, perhaps the present Niger, is not acceptable.

25 Pliny *Naturalis Historia* 5. 30; comments by J. Desanges, "Les territoires gétules de Juba II," *REA* 66(1964): 44-45.

26 L. Vivien de Saint-Martin, *Le Nord de l'Afrique dans l'Antiquité grecque et romaine* (Paris, 1863), pp. 473ff.: Gsell, *HAAN*, vol. I, *Les conditions du développement historique*, pp. 297 ff.; J. Carcopino, *Le Maroc antique* (Paris, 1943), p. 21.

27 *CIL*, X, 8045, 12.

28 J. Mesnage, *L'Afrique chrétienne: évêchés et ruines antiques d'après les manuscrits de Mgr. Toulotte, et les découvertes archéologiques les plus récentes* (Paris, 1912), p. 261.

29 This is a possible interpretation of an ethnic name mentioned in Pliny *Naturalis Historia* 5. 37: Miglis R¹E²; Milgis F²; Niglis D; nis glis r.

30 Orosius *Adversus Paganos* 1. 2. 45, in *Geographi latini minores*, ed. A. Riese (Heilbronn, 1878), p. 67 (hereafter cited as *G.l.m.*).

31 Cf. also *Historia Brittonum* in *Monumenta Germaniae Historica*, 1, *Auctores Antiquissimi*, ed. Th. Mommsen (Berlin, 1898), XIII, *Chronica minora*, III, p. 157 (Azariae), and El-Bekri, *Description de l'Afrique septentrionale*, p. 297 (Azouer). Maybe what we have here is Ptolemy's Mount Buzara (4. 2. 4, p. 602, and 4. 3. 6, p. 634), which lies both in Mauretania and Numidia. In any case Ptolemy (4. 6. 5, p. 743) mentions the Ethiopian "Girrei" south of the Gir River (Wadi Djedi, Wadi Rhia?): cf. also, Claudian *Idylls* 4, vv. 20-21: *domitorque ferarum Girrhaeus*.

32 Orosius *Adversus Paganos* 1. 2. 46, in *G.l.m.*, p. 68. This refers to the Gangines Ethiopians, who are probably identical with the Aganginae Ethiopians in Ptolemy 4. 6. 6, p. 748.

33 E. F. Gautier, *Le passé de l'Afrique du Nord: les siècles obscurs* (Paris, 1937), pp. 224-25.

34 Tunis, Musée National du Bardo, 2996; from Thuburbo Maius, House of the Camel-riding Blacks. See L. Poinssot in *Bulletin archéologique du Comité des travaux historiques et archéologiques* (1938-39-40): 394; G. Ch.-Picard, *Le monde de Carthage* (Paris, 1956), pl. 41.

35 Scylax *Periplus* 112 in *Geographici graeci minores*, ed. C. Müller (Paris, 1855), vol. I, p. 94.

36 R. Mauny, "Autour d'un texte bien controversé: le 'périple' de Polybe (146 avant J.-C.)," *Hespéris* 36 (1949): 56-58.

37 Desanges, *Catalogue des tribus*, pp. 226-27 and 230-32. A certain Pherusa, "an African woman with woolly hair and dark flesh," is mentioned at Pompeii: cf. R. Etienne, *La vie quotidienne à Pompéi* (Paris, 1966), p. 141. Her name is perhaps related to that of the Pharusii or Pharusi.

38 Ptolemy 4. 6. 6, p. 747, calls the Pharusii "people who live along the river Anatis." The Anatis is either the Umm er Rbia or the Tensift. According to Strabo 17. 3. 3, the Pharusii and Nigritae had, in ancient times, advanced to the vicinity of Lixos (Larache).

39 Strabo 17. 3. 7.

40 Since the Pharusii and Nigritae were bowmen, it does not seem possible to identify them with the javelin-armed horsemen of the rock carvings of the western Sahara: cf. R. Mauny, "Une route préhistorique à travers le Sahara occidental," *BIFAN* 9(1947): 341-57.

41 Desanges, *Catalogue des tribus*, pp. 233-34.

42 Desanges, *Catalogue des tribus*, pp. 213-14.

43 Ptolemy 4. 6. 6, p. 745.

44 Ptolemy 4. 6. 5, p. 743: apparently north of the Girrei Ethiopians, who lived along the Wadi Rirh.

45 But cf. the reservations made by Gsell, *HAAN*, vol. V, *Les royaumes indigènes: organisation sociale, politique et économique* (1927), p. 9, n. 7.

46 Desanges, *Catalogue des tribus*, pp. 246-48. According to Athenaeus, *Deipnosophistae* 2.62e, the Western Ethiopians inhabited a mountainous region near the ocean and not far from the territory of the Gaetuli. This would put them in the Moroccan High Atlas or in the Anti-Atlas.

47 Cf. *supra*, n. 20. At least on this point we agree with H. Lhote, "Problèmes sahariens," *BAM* 7(1967): 81. In our opinion "Ethiopian" means dark-skinned, not necessarily Negro. Conclusions which are similar but which insist on the ethnic diversity of the Ethiopians of the Sahara since ancient times will be found in two recent studies: H. von Fleischhacker, "Zur Rassen- und Bevölkerungsgeschichte Nordafrikas unter besonderer Berücksichtigung der Äthiopiden, der Libyer und der Garamanten," *Paideuma* 15(1969): 12-53; and especially G. Camps, "Recherches sur les origines des cultivateurs noirs du Sahara," *Revue de l'Occident musulman et de la Méditerranée* 7(1970): 35-45. At the end of his study Camps proposes, as the origin of the word *hartani* (plur. *haratin*), which now designates the dark-skinned people of the western Sahara, the Latin *hortus* (garden: cf. *hortulanus* "gardener").

48 H. Lhote, "Route antique du Sahara central," *Encyclopédie mensuelle d'Outre-Mer*, I, fasc. 15 (November 1951): 300-305; idem, "Chars rupestres du Sahara," *CRAIBL* (April-June 1963): 225-38.

49 Cf. *supra*, n. 40.

50 Law, *JAfrH* 8(1967): 184.

51 On this problem, cf. E. Demougeot, "Le chameau et l'Afrique du Nord romaine," *Annales E. S. C.*, 15, no. 2(1960): 209-47, a treatment which is completed by J. Kolendo, "Epigraphie et archéologie, le *praepositus camellorum* dans une inscription d'Ostie," *Klio* 51(1969): 287-98.

52 R. Carpenter, "A Trans-Saharan Caravan Route in Herodotus," *AJA* 60(1956): 231-42.

53 Herodotus 2. 32-33.

54 Cf. K. Nielsen, "Remarques sur les noms grecs et latins des vents et des régions du Ciel," *Classica et Mediaevalia* 7(1945): 1-113; R. Böker in A.F. von Pauly and G. Wissowa, *Real-Encyclopädie der klassischen Altertumswissenschaft* (Stuttgart, 1958), VIII A, 2, s.v. "Winde" (D. Windnamen, E. Windrosen), cols. 2288-2381. Ptolemy 1. 8. 6, p. 22, says that the Saharans confuse the direction of the Notos (south wind) with that of the Lips (southwest wind). Diodorus 17. 50 and Quintus Curtius *Historiae Alexandri Magni* 4. 7. 18-19 are off by 90 degrees in placing the Nasamones of the Gulf of Sirte north of the oasis of Ammon (Siwa), whereas they should be located to the west. Moreover, Quintus Curtius, in the same passage, puts the Simi (flat-nosed) Ethiopians west of the oasis, whereas they are really toward the south or even the southeast.

55 Athenaeus *Deipnosophistae* 2. 22. 44e. The land "without water" has neither river nor spring, but may receive some rainfall: cf. Herodotus 4. 173.

56 J. Leclant, "'Per Africae sitientia.' Témoignages des sources classiques sur les pistes menant à l'oasis d'Ammon," *BIFAO* 49 (1950): 208.

57 At any rate, this, according to Apollonius Dyscolus *Scriptores rerum mirabilium* 25 (who quotes Aristotle), is the oasis reached by Andron or Archonides of Argos: Athenaeus *Deipnosophistae* 2. 22. 44e, compares this exploit to Mago's. The land of the Psylli, south of the Gulf of Sirte, is already called "land without water" by Herodotus 4. 173. According to Dalion, quoted by Pliny *Naturalis Historia* 6. 194, the Vacathi (i.e., Ptolemy's *Bakatae* 4. 5. 12, p. 692, these being eastern neighbors of the Nasamones) depended entirely on rainwater.

58 J. Desanges, "Note sur la datation de l'expédition de Julius Maternus au pays d'Agisymba," *Latomus* 23(1964): 713-25.

59 Pliny *Naturalis Historia* 5. 9-10; P. Pédech, "Un texte discuté de Pline. Le voyage de Polybe en Afrique (H.N. V. 9-10)," *REL* 33(1955): 318-32.

60 R. Mauny, "L'Ouest africain chez Ptolémée," in *Conferência internacional dos Africanistas ocidentais. Second Conference. Bissau, 1947* (Lisbon, 1950), pp. 239-93.

61 R. Mauny, *Les navigations médiévales sur les côtes sahariennes antérieures à la découverte portugaise (1434)* (Lisbon, 1960), pp. 10-19.

62 Cf. also G. Chovin, "Les rapports entre la Gaule et le Maroc antique," *Hespéris* 44(1957): 250-52; Yu. B. Tsirkin, "The First Greek Voyages in the Atlantic

Ocean," *Vestnik Drevnej Istorii* 98(1966): 123-28 (in Russian).

63 The bibliography of the numerous studies dedicated to the *Periplus* of Hanno can be found in A. DILLER, *The Tradition of the Minor Greek Geographers*, Philological Monographs published by the American Philological Association, no. 14(Lancaster, Pa., 1952), pp. 48-99 and 179. The most important article in twenty years on this subject is G. GERMAIN, "Qu'est-ce que le 'Périple' d'Hannon, document, amplification littéraire ou faux intégral?," *Hespéris* 44(1957): 205-48. Many modern scholars, however, see Hanno getting as far as the Cameroon coast. For one reference, see CARCOPINO, *Le Maroc antique*, pp. 73-163.

64 A. JODIN, *Mogador: comptoir phénicien du Maroc atlantique* (Tangier, 1966); idem, *Les établissements du roi Juba II aux îles Purpuraires (Mogador)*, Fouilles du Service des Antiquités du Maroc (Tangier, 1967). Note, however, a rock carving at the Wadi Draa showing an ancient (or rather medieval?) ship: cf. R. MAUNY, *Gravures, peintures et inscriptions rupestres de l'Ouest africain*, Initiations africaines, vol. 11 (Dakar, 1954), fig. 7, no. 14.

65 GAUTIER, *Le passé de l'Afrique du Nord*, p. 49; CARCOPINO, *Le Maroc antique*, p. 107; G. K. JENKINS and R. B. LEWIS, *Carthaginian gold and electrum coins* (London, 1963), pp. 25-26. In fact, PLINY *Naturalis Historia* 33.51, emphatically asserts that after Zama, Rome exacted from Carthage no tribute in gold, but only a tribute in silver.

66 HERODOTUS 4. 196.

67 Y. KAMAL, *Monumenta cartographica Africae et Aegypti* (Cairo and Leiden, 1935), vol. III, fasc. 5, pp. 953 and 960; but an account of this commerce was given two centuries earlier by MAÇOUDI, *Les prairies d'or*, trans. C. Barbier de Meynard (Paris, 1865), vol. IV, pp. 92-93.

68 Cf. A. HERMANN, "'Stummer Handel' im alten Ägypten," in E. GRÄF, ed., *Festschrift Werner Caskel* (Leiden, 1968), pp. 185-88; S. LIEBERMAN, "Contact between Rome and China" (University of Michigan, 1953), pp. 179-81.

69 A. BERNARD, *L'Afrique septentrionale et occidentale*, Géographie Universelle, tome XI, ed. P. VIDAL DE LA BLACHE and L. GALLOIS (Paris, 1937), pt. 1, p. 167: "Cobalt ... ore was mined in which gold seems to be in sufficient quantity to be worth exploiting; at Bou Azzer, in the Anti-Atlas, the gold content in Pre-Cambrian quartz veins seems to reach and exceed 500 grams to the ton." Cf. also GSELL, *HAAN*, vol. I, *Les conditions du développement historique*, p. 515, n. 3. AL-YAʿKŪBĪ, *Les Pays*, trans. G. Wiet (Cairo, 1937), p. 225, points out the existence of surface gold in the lands of the Banū Darʿa, on the Saharan frontier of Morocco. The presence of alluvial gold in the Tazeroualt and in the region of Tafraout (Anti-Atlas) has recently been noted by B. ROSENBERGER, "Les vieilles exploitations

minières et les centres métallurgiques du Maroc," *RGM*, 18, pt. 2(1970): 83-84. Moreover there was an ancient gold-mining operation at Timesgadiouine: idem, *RGM*, 17, pt. 1(1970): 82; and in a region much farther to the east, at Bou Maadene in the Sargho, some 60 km. (37.2 miles) west of Sigilmassa: idem, *RGM*, 17, pt. 1(1970): 86.

70 STRABO 3. 2. 8-9 (Turdetania); PLINY *Naturalis Historia* 33. 67 and 78 (northern and western Spain).

71 L. RICHARD, "Note sur l'or alluvionnaire de la Gaule," *RAE* 18(1967): 289-93.

72 A. JODIN, "L'archéologie phénicienne au Maroc. Ses problèmes et ses résultats," *Hespéris-Tamuda* 7(1966): 15.

73 R. MAUNY, "Essai sur l'histoire des métaux en Afrique occidentale," *BIFAN*, 14, no. 2 (1952): 552; idem, *Tableau géographique de l'Ouest africain*, p. 399.

74 Following CARCOPINO, *Le Maroc antique*, pp. 117-19, it has become customary to refer to PALAIPHATOS 31 (N. Festa, ed., 1902), p. 46. But the text which has come down to us under the name of Palaiphatos is a late, composite collection. Moreover, all the author says is that the inhabitants of Cerne are "loaded with gold." The Greek adjective used by Palaiphatos—*chrysoi*—can merely indicate wealth, with no implication of a traffic in gold.

75 There is a judicious critique of the notion of this "Punic secret" in M. TARRADELL, *Marruecos púnico* (Tetuan, 1960), pp. 263-64.

76 MAUNY, *BIFAN*, 14, no. 2 (1952): 554.

77 TACITUS *Annales* 6. 19; W. VON WARTBURG, *Französisches etymologisches Wörterbuch* (Tübingen, 1948), vol. I, p. 182.

78 STRABO 1. 2. 32. In the same passage, the only possible argument Strabo can see in favor of the thesis which attributed wealth to the Ethiopians living beyond the Pillars of Hercules (an argument he considered refutable) was their proximity to Arabia and India.

79 STRABO 2. 3. 4.

80 PLINY *Naturalis Historia* 5. 9-10.

81 When, shortly after the annexation of the kingdom of Mauretania, Claudius celebrated his triumph over Britain (43 A.D.), the finest gold crowns he received were given by Citerior Spain and Gallia Comata. PLINY THE ELDER *Naturalis Historia* 33. 54, makes no mention of the Mauretanias in connection with this event.

82 SUETONIUS *Caesar* 54. 2.

83 Cf. also J. GUEY, "De 'L'or des Daces' (1924) au livre de St. Bolin (1958)," *Mélanges Carcopino* (Paris, 1966), pp. 445-75.

84 JODIN, *Les établissements du roi Juba II*, p. 24. It is true that SENECA, during Nero's principate, insists on the importance of the maritime traffic along the Atlantic coast (*Natu-*

rales quaestiones 4a. 2. 24, repeated by AELIUS ARISTIDES *Orationes* 36. 91). In Marcus Aurelius' time, however, PAUSANIAS (1. 33. 6), declares that navigators never approach the Atlas.

85 H. G. PFLAUM, "Principes de l'administration romaine impériale," *Bulletin de la Faculté des Lettres de Strasbourg* 37 (1958-59): 181.

86 Note that slaves are counted among Mauretania's chief resources by the *Expositio totius mundi et gentium*, Sources chrétiennes, no. 124, ed. J. Rougé (Paris, 1966), par. 60, p. 200 (middle of the fourth century A.D.).

87 G. and C. CH.-PICARD, *La vie quotidienne à Carthage au temps d'Hannibal, IIIe siècle avant Jésus-Christ* (Paris, 1958), p. 225.

88 LIVY 34. 62.

89 POLYBIUS 31. 21. 8.

90 APPIAN *Libyca* 72. If Appian is talking about the talent of Carthage, it weighed 22.140 kg. (48.7 lbs.).

91 Note that PLUTARCH *Life of Crassus* 1, does not think that Crassus' fortune of 300 talents in his early days amounted to much. This was about the equivalent of the annual taxes from Lepcis a century earlier—and even more if Crassus' talents were Attic (26.160 kg.: 57.55 lbs.), and those of Lepcis, Punic (22.140 kg.: 48.7 lbs.). At the end of his life, Crassus was worth 7000 talents. According to Cicero (quoted by STRABO 17. 1. 13), Ptolemy Auletes, Cleopatra's father, drew 12,500 talents a year from Egypt: the Egyptian talent weighed 27.288 kg. (60 lbs.).

92 POLYBIUS 3. 23. 2. On the fertility of the coastal region near Tacape (Gabès), cf. PLINY *Naturalis Historia* 16. 115 and 18. 188-89.

93 H. CAMPS-FABRER, *La disparition de l'autruche en Afrique du Nord* (Algiers, 1963), pp. 26 and 33. The ostrich disappeared from these regions in the second half of the nineteenth century.

94 PLINY *Naturalis Historia* 5.26 and 8. 32. The elephant disappeared from North Africa about the end of the first century A.D., perhaps under the Flavian emperors, except on the border of Roman Morocco, where the animal seems to have survived longer.

95 On the lion, cf. GSELL, *HAAN*, vol. I, *Les conditions du développement historique*, pp. 111-12; the panther and the leopard were often called simply *africanae*, idem, *HAAN*, vol. I, pp. 112-13. In the Roman era the wild beasts were sought for the circus games. In the third century A.D. the killing of a leopard was worth 500 denarii in Tunisia: cf. A. BESCHAOUCH, "La mosaïque de chasse à l'amphithéâtre découverte à Smirat en Tunisie," *CRAIBL* (1966): 136.

96 This is also the opinion of E. W. BOVILL, *The Golden Trade of the Moors*, 2nd ed., rev. and with additional material by R. HALLETT (London, 1968), pp. 22-23, and of

Mauny, *Tableau géographique*, p. 398. It is likely that we will get fuller information from the digs underway at Bou Ngem under the direction of R. Rebuffat: cf. R. Rebuffat, J. Deneauve, G. Hallier, "Bu Njem 1967," *Libya Antiqua* 3-4(1966-67): esp. 94-95.

97 Pliny *Naturalis Historia* 5. 34, points out that the only trade between the Ethiopian Troglodytes and the coast dealt in the carbunculus, of which one variety was called *Garamantic* (Pliny *Naturalis Historia* 37. 92) or *Carthaginian* (Strabo 17. 3. 11 and 19); cf. also Vibius Sequester in *G. l. m.*, p. 147. There was also a traffic in similar stones between Carthage and the mountains of the Nasamones (cf. Pliny *Naturalis Historia* 36. 104), which shows on Peutinger's Table, segm. VIII, 2-3: this was an east-west trade. On the difficulty of identifying these stones, cf. T. Monod and M. Dalloni, *Mission scientifique du Fezzân, 1944-1945*, vol. VI, *Géologie et Préhistoire* (Algiers, 1948), pp. 151-54.

98 Cf. our article cited *supra*, n. 58.

99 Gsell, *HAAN*, vol. VI, *Les royaumes indigènes: vie matérielle, intellectuelle et morale* (1927), p. 36; Mauny, *BIFAN*, 14, no. 2(1952): 552-53.

100 Herodotus 4. 183.

101 Demougeot, *Annales E.S.C.*, 15, no. 2 (1960): 215, n. 5.

102 L. Naville, *Les monnaies d'or de la Cyrénaïque (450 à 250 av. J.-C.). Contribution à l'étude des monnaies grecques antiques* (Geneva, 1951), p. 20.

103 G. Oliverio, "Iscrizioni di Cirene, III: La stele dei cereali," *Rivista di Filologia e di Istruzione Classica* 6 (1928): 232-35.

104 Naville, *Les monnaies d'or*, p. 61.

105 It is noteworthy that ancient coins are rarely found in Africa south of the Roman frontier: cf. R. Mauny, "Monnaies anciennes trouvées en Afrique au sud du *limes* de l'empire romain," *Libyca: Arch. Epigr.* 4(1956): 249-61.

106 J. Marion, "La population de Volubilis à l'époque romaine," *BAM* 4 (1960): 133-87, esp. 181-82.

107 J. Baumgart, "Die römischen Sklavennamen" (University of Breslau, 1936), p. 64.

108 *Anthologia Latina*, ed. A. Riese and F. Bücheler (Leipzig, 1894), vol. I, no. 183, pp. 155-56.

109 On the connection sometimes made between the black and excrement, cf. J.-P. Cèbe, *La caricature et la parodie dans le monde romain antique, des origines à Juvénal* (Paris, 1966), p. 349 and n. 7; p. 353 and n. 11 (Pygmies); p. 354 and nn. 5 and 6 (full-size Negroes).

110 *Faex Garamantarum nostrum processit ad axem*
 Et piceo gaudet corpore verna niger.
 Quem nisi vox hominem labris emissa sonaret,
 Terreret visu horrida larva viros.
 Dira, Hadrumeta, tuum rapiant sibi Tartara
 monstrum:
 Custodem hunc Ditis debet habere domus.

111 Claudian *De bello Gildonico* vv. 192-93.

112 The Nasamones have at times been considered as being related to the Ethiopians; cf. Desanges, *Catalogue des tribus*, p. 154, n. 6.

113 P. Cintas, *RAfr* 92(1948): 308. Besides the Tipasa amulet with the Negro head, we must mention the one from Carthage; cf. J. Vercoutter, *Les objets égyptiens et égyptisants du mobilier funéraire carthaginois* (Paris, 1945), p. 279, no. 908 and pl. XXIV, 908, full face and profile, as well as an unpublished amulet in Constantine, Musée Gustave Mercier, reproduced here, kindly brought to our attention by Mme M. Roche.

114 Vercoutter, *Les objets égyptiens*, pp. 279, 282, and 284, against Gsell, *HAAN*, vol. IV, *La civilisation carthaginoise*, pp. 97-98. The same can be said of the scarabs imported at an early period from Egypt (cf. Vercoutter, *Les objets égyptiens*, p. 93), some of which represent Negro heads; for two examples, now in Tunis, Musée National du Bardo, cf. esp., idem, *Les objets égyptiens*, p. 195, no. 451, and pl. XIII; p. 198, no. 461, and pl. XIII (reproduced in this volume, fig. 342).

115 Tunis, Musée National du Bardo, 1558 Pd.; from Carthage, Dermech, tomb 10 (6). C. Picard, "Sacra Punica. Etude sur les masques et rasoirs de Carthage," *Karthago* 13(1965-66): 11-12 and 40-55.

116 Sousse, Musée Archéologique, 10438; from el Alia. L. Foucher, "Les mosaïques nilotiques africaines," in *La mosaïque gréco-romaine*, pp. 137-45.

117 A. Mahjoubi, "Découverte d'une nouvelle mosaïque de chasse à Carthage," *CRAIBL* (1967): 264-77, esp. 270.

118 L. Müller, *Numismatique de l'ancienne Afrique*, vol. II, *Les monnaies de la Syrtique, de la Byzacène et de la Zeugitane* (Copenhagen, 1861), no. 37, p. 61; cf. B. E. Thomasson, *Die Statthalter der römischen Provinzen Nordafrikas von Augustus bis Diocletianus* (Lund, 1960), vol. II, p. 16. Perhaps the crushed serpent symbolizes Syrtic Gaetulia (where reptiles abounded) and, in general, those who rebelled against Roman or Mauretanian order. In fact Ptolemy of Mauretania used the symbol again; cf. J. Mazard, *Corpus nummorum Numidiae Mauretaniaeque* (Paris, 1955), nos. 403-405, p. 129.

119 L. Keimer, "Histoires de serpents dans l'Egypte ancienne et moderne," *Mémoires présentés à l'Institut d'Egypte* (Cairo, 1948), vol. L, pp. 26-37, with references to Egyptian representations and the testimonies of ancient authors (Diodorus, Pliny the Elder, Aelianus, etc.).

120 For the shipping of elephants on the Red Sea, cf. W. Krebs, "Einige Transportprobleme der antiken Schiffahrt," *Altertum* 11 (1965): 96-101. A hippopotamus is likewise driven toward a ship in a Nilotic mosaic in Sousse, Musée Archéologique, 10457; from Hadrumetum (Sousse), triclinium of a villa (fig. 345). Cf. L. Foucher, *Guide du Musée de Sousse* (Tunis, 1967), p. 29 and fig. 34.

121 Tripoli, Archaeological Museum; from Wadi ez Zgaia, baths. Cf. Cèbe, *La caricature*, pp. 345-54; Foucher in *La mosaïque gréco-romaine*, p. 138, speaks of "images at times ferocious in their humor."

122 Tripoli, Archaeological Museum; from Lepcis Magna, House of the Nile. Cf. Aurigemma, *I Mosaici*, pl. 86.

123 Tripoli, Archaeological Museum; from Zliten, House of Dar Buc Ammera. Cf. Aurigemma, *I Mosaici*, pl. 158, ostrich hunters.

124 Diodorus 3. 28 and Photius, *cod.* 250, 57, after Agatharchides; Strabo 16. 4. 11, after Artemidorus; Ptolemy 4. 7. 10, p. 782.

125 Cf. *supra*, n. 93. The ancient authors make note of hunter tribes in this region—the Girrhaei and the Oreipaei; cf. Desanges, *Catalogue des tribus*, pp. 216 and 229. The Garamantes themselves, according to Lucian *Dipsades* 2 and 6, hunted the ostrich and (ibid. 7) put ostrich eggs to a number of different uses. Recent digs at Bou Ngem, 100 km. (62 miles) as the crow flies from the shore of the Gulf of Sirte, have brought about the discovery of numbers of ostrich eggs: cf. "Séance du 24 janvier 1970," *Bulletin de la Société d'Archéologie classique* 4 (1969-70): 12 (comment by R. Rebuffat).

126 L. Pressouyre, "A propos d'un 'balsamaire' trouvé à Lamaurelle (L.-et-G.)," *RA*, tome 2(1962): 165-81. To the African balsamaria mentioned *passim*, we might perhaps add a small Negro head in bronze in Constantine, Musée Gustave Mercier, no. F445 of the 1904 catalogue, on exhibition in the Salle de la Victoire: I owe this addition to the kindness of the museum's curator, A. Berthier.

127 Lastly, M. Malaise, "A propos d'un buste-balsamaire en bronze du musée de Tongres. Sur les traces d'influences alexandrines à Atuatuca," *Latomus* 29(1970): 142-56.

128 Pressouyre, *RA*, tome 2(1962): 178. On the Alexandrian origin of these objects, see for the present, serious reservations raised by S. Boucher, "Problèmes d'influence alexandrine sur les bronzes de l'époque romaine," *Latomus* 32(1973): 799-811.

129 For instance, an unpublished lamp from Tiddis in the shape of a Negro head, Case 58 B in Constantine, Musée Gustave Mercier, no. 91 Bus., of which we give a photograph, fig. 353, with the permission of A. Berthier, who was kind enough to call our attention to this lovely object. We may add that he is preparing a comprehensive publication of the Tiddis lamps. He also gives us notice of another lamp (no. 170 in the museum reserves): part of it is broken off, but it certainly represents a Negro. Finally we should mention one lamp in the

Musée Archéologique, Timgad (cf. A. Ballu and R. Cagnat, *Musée de Timgad*, Musées et collections archéologiques de l'Algérie et de la Tunisie [Paris, 1903], p. 28 and pl. XI, no. 3), and another in Tunis, Musée National du Bardo, Room X.

130 Constantine, Musée Gustave Mercier; from Sidi M'Cid. Cf. A. Berthier, "Une mosaïque solaire trouvée à Constantine," *Mélanges Carcopino*, pp. 113-24. P. Bruneau, "Perspectives sur la mosaïque gréco-romaine," *REG* 79(1966): 713-14 and n. 3, and G. Ch.-Picard, "Les thermes du thiase marin à Acholla," *Antiquités Africaines* 2(1968): 149, n. 2, have questioned A. Berthier's solar interpretation. It is certain that mosaics at Pompeii and Ostia and in Este, Museo Nazionale Atestino, show black swimmers which resemble those in the Constantine mosaic but have no solar implication: cf. particularly M.E. Blake, "The Pavements of the Roman Buildings of the Republic and Early Empire," *Memoirs of the American Academy in Rome* 8(1930): 80 and pl. 48, fig. 3 (Este), p. 123 (Pompeii); G. Becatti, *Scavi di Ostia*, vol. IV, *Mosaici e pavimenti marmorei* (Rome, 1961), p. 43, no. 64, and pl. CVII. But the setting of the Constantine swimmers in the over-all composition is very different. An Etruscan engraved mirror found at Todi and dating from the fourth century B.C. shows the head of an Ethiopian in proximity to the Quadriga of Helios (Rome, Museo Nazionale Etrusco di Villa Giulia, 2745 [Room 34, Case 2]; M. Moretti, *Il Museo Nazionale di Villa Giulia* [Rome, 1967], pp. 325-26, fig. 214, p. 327). Whatever side one may take in this controversy, the fact remains that the black swimmer is a conventional theme imported into North Africa.

131 Timgad, Musée Archéologique; from Timgad, northwestern baths (at entrance to room, between two tepidaria). Cf. F. G. de Pachtère, *Inventaire des mosaïques de la Gaule et de l'Afrique*, vol. III, *Afrique proconsulaire, Numidie, Maurétanie (Algérie)* (Paris, 1911), no. 86, p. 22. The realism of the rendering prompts Gsell, *HAAN*, vol. I, p. 302, n. 2, to think that the artist was working from living models. But the black with an oversize phallus was a traditional theme; cf. Cèbe, *La caricature*, p. 351 and n. 9 (Pygmies); p. 354 (full-grown Negroes).

132 Carthage, Antiquarium, 319; from Carthage, Baths of Antoninus Pius. Cf. G. Ch.-Picard, *Le monde de Carthage*, pl. 3; G. and C. Ch.-Picard, *La vie quotidienne à Carthage*, p. 218.

133 Carthage, Musée de Carthage; from Carthage, House of the Seasons (triclinium). Cf. G. Ch.-Picard, *La Carthage de saint Augustin* (Paris, 1965), pp. 73-77.

134 Tunis, Musée National du Bardo, A19; from Gafsa. Cf. P. Gauckler, *Inventaire des mosaïques de la Gaule et de l'Afrique*, vol. II, *Afrique proconsulaire (Tunisie)* (1910), no. 321, pp. 108-109.

135 Cf. *supra*, n. 34.

136 El Djem, Musée Archéologique, House of Silenus, Room 7. Cf. L. Foucher, *Découvertes archéologiques à Thysdrus en 1960*, Institut d'Archéologie, Tunis. Notes et Documents, n.s., vol. IV (Tunis, 1961), p. 28, middle of the third century A.D. It is true, as Foucher remarks (p. 30), that the camel belongs to the Dionysiac imagery: in any case this is an African dromedary and not an Asian camel.

137 Tunis, Musée National du Bardo, A105; from Uthina (Oudna), House of the Laberii. Cf. P. Gauckler, "Le domaine des Laberii à Uthina," *MonPiot* 3(1896): 200 ff., pl. 22; P. Romanelli, "Riflessi di vita locale nei mosaici africani," *La mosaïque gréco-romaine*, p. 282 and n. 14*bis* (this author compares the scene with a passage of Apuleius *Metamorphoses* 11. 8).

138 Annaba, Musée; from Hippo Regius (Hippone). F. G. de Pachtère, "Les nouvelles fouilles d'Hippone," *Mélanges d'Archéologie et d'Histoire de l'Ecole française de Rome* 31 (1911): 334-35 and pls. XIX-XX, lower right corner.

139 R. Massigli, *Musée de Sfax* (Paris, 1912), p. 14. The fresco, no longer complete at that time, originally included a two-wheel vehicle of the *araba* type, drawn by mules, which seems to give it documentary value. Our colleague and friend, Prof. S. Lancel, could find no trace of it in the Musée Archéologique of Sfax. On the other hand, following a stay in Tunisia, he called to our attention several of the documents we have cited here, and we thank him cordially.

140 M. Yacoub, *Guide du Musée de Sfax* (Tunis, 1966), pl. XV, fig. 1, and p. 45.

141 The custom came from the Greeks; cf. G. H. Beardsley, *The Negro in Greek and Roman Civilization: A Study of the Ethiopian Type* (Baltimore, 1929; New York, 1967), p. 117.

142 Cf. particularly Athens, National Museum, 4464: a black holding a horse by the bridle (c. 300 B.C.).

143 Sousse, Musée Archéologique. Cf. Beardsley, *The Negro*, no. 284, p. 131.

144 L. Foucher, *Hadrumetum* (Tunis, 1964), p. 171.

145 Constantine, Musée Gustave Mercier; from Thibilis (Announa). Beardsley, *The Negro*, nos. 280, 281, and 282, p. 130. In fact, the literary testimony of Sidonius Apollinaris *Carmina* 5. 53-54, attributing black cheeks to Africa, is more convincing than the examples drawn by Beardsley from statuary and numismatics. The nigritude of the Africa of Berrouaghia and of that of Announa (after cleaning) seems entirely doubtful; cf. V. Waille, "Note sur l'éléphant, symbole de l'Afrique à propos d'un bronze récemment découvert à Berrouaghia (Algérie)," *RA*, 17, 3rd ser. (1891): 380-84; A. Berthier, "Une statuette de la déesse Afrique," *Hommages à Albert Grenier*, Collection Latomus, vol. LVIII, 1 (Brussels, 1962),

pp. 286-87 and figs. 1 and 2. Granted that the Africa represented on coins (cf. Müller, *Numismatique de l'ancienne Afrique*, vol. III, *Les monnaies de la Numidie et de la Maurétanie* [1862], p. 43, no. 58; p. 100, no. 15; p. 107, no. 1) has her hair done "in parallel, tiered corkscrews"—a style traditional in Libyco-Berber North Africa—she still does not look Negroid.

146 Cherchell, Musée Archéologique, 21. Cf. E. Boucher-Colozier, "Quelques marbres de Cherchel au Musée du Louvre," *Libyca: Arch. Epigr.* 1(1953): 26 and fig. 2.

147 Cf. especially the Garamante in pl. 156, Aurigemma, *I Mosaici*, coming in between a bear and a bull.

148 *Mauros* in Greek came to mean "Ethiopian" or even "black": cf. W. den Boer, "The native Country of Lusius Quietus," *Mnemosyne*, 1, 4th ser. (1948): 331-32; idem, "Lusius Quietus, an Ethiopian," *Mnemosyne* 3 (1950): 263-65 (but in our opinion Lusius Quietus the Moor was an Ethiopian from Cerne, i.e., probably from Mogador); compare also F.M. Snowden, Jr., *Blacks in Antiquity: Ethiopians in the Greco-Roman Experience* (Cambridge, Mass., 1970), pp. 11-12 (an excellent monograph which came out after the present essay was already in the hands of the editors). With regard to the habit of considering the Garamante as more or less the same as the Ethiopian, it is particularly significant that Luxorius, an African poet at the court of the Vandal kings in the early sixth century, in one of his poems (M. Rosenblum, *Luxorius: A Latin Poet among the Vandals*, Records of Civilization Sources and Studies, no. LXII [New York and London, 1961], Poem 43, p. 136) contrasts the pretty girl from Pontus, symbolizing the Nordic and fitting the feminine ideal of the Vandals, with an ugly (*foeda*) Garamante, the southern type farthest from the Nordic. It seems that this was the poet's way of continuing the old tradition of the Greek Janiform vases, and renewing the contrast established by the earliest Greek ethnography between Thracians and Scythians on one side and Ethiopians on the other.

V

JEAN LECLANT

EGYPT, LAND OF AFRICA,
IN THE
GRECO-ROMAN WORLD

1 See the papers presented at the seventh Congrès international de Papyrologie, Geneva, 1952, on the theme "L'originalité de l'Egypte dans le monde gréco-romain" (proceedings published in *Museum Helveticum* 10[1953]), particularly the incisive treatment by C. Préaux, "Les raisons de l'originalité de l'Egypte," pp. 203-21 of that journal.

2 L. Kákosy, "Nubien als mythisches Land im Altertum," *Annales Universitatis Scientiarum Budapestinensis de Rolando Eötvös nominatae, Sectio Historica* 8(1966): 3-10.

3 Homer *Iliad* 1. 423-24; idem, *Odyssey* 1. 22-25.

4 T. Säve-Söderbergh, "Zu den äthiopischen Episoden bei Herodot," *Eranos [Eranos Rudbergianus]* 44(1946): 68-80; D. Herminghausen, "Herodots Angaben über Aethiopien" (University of Hamburg, 1964).

5 Shabaka is a model of the king-legist (Herodotus 2. 137, 139; Diodorus 1. 65); Taharqa is seen as a great conqueror (Megasthenes, fragment 20; Strabo 1. 3. 21 and 15. 1-6; cf. G. Goossens, "Taharqa le Conquérant," *CdE*, 22, 44[1947]: 239-44; J. Janssen, "Que sait-on actuellement du Pharaon Taharqa?," *Biblica* 34[1953]: 34).

6 J. Leclant, *Recherches sur les monuments thébains de la XXVᵉ dynastie dite éthiopienne* (Cairo, 1965), pp. 384 and 403.

7 E. Feuillâtre, *Etudes sur les Ethiopiques d'Héliodore*, Publications de la Faculté des Lettres et Sciences Humaines de Poitiers, 11 (Paris, 1966); see J. Leclant's review, *REG* 81(1968): 629-32.

8 C. Préaux, "Les Grecs à la découverte de l'Afrique par l'Egypte," *CdE*, 32, 64(1957): 284-312.

9 In recent years a number of essays have treated the civilization of ancient Egypt with regard to its African implications. Some have gone to the extreme of defining it as a "Negro culture." For corrections and precisions on these delicate problems of in-

terpretation, cf. J. Leclant, "Afrika," in *Lexikon der Ägyptologie* (Wiesbaden, 1975), vol. I, cols. 85-94, with bibliography; R. Herzog, "Aegypten und das negride Afrika," *Paideuma* 19-20 (1973-74): 200-212.

10 C. Préaux, "Sur les communications de l'Ethiopie avec l'Egypte hellénistique," *CdE*, 27, 53(1952): 257-81.

11 M. I. Rostovtzeff, *The Social and Economic History of the Hellenistic World* (Oxford, 1941), vol. I, p. 383.

12 Ibid., p. 386.

13 W. Krebs, "Die Kriegselefanten der Ptolemäer und Äthiopier," *Wissenschaftliche Zeitschrift der Universität Rostock* 17(1968): 427-47; J. Desanges, "Les chasseurs d'éléphants d'Abou-Simbel," *Actes du quatre-vingt-douzième Congrès national des Sociétés Savantes*, Section d'Archéologie, Strasbourg et Colmar, *1967* (Paris, 1970), pp. 31-50.

14 M. I. Rostovtzeff, *The Social and Economic History of the Roman Empire*, 2nd ed., rev. by P. M. Fraser (Oxford, 1957), vol. I, pp. 66, 154, 335.

15 Ibid., pp. 154, 307, 338; J. Schwartz, "L'Empire romain, l'Egypte et le commerce oriental," *Annales E.S.C.*, 15, fasc. 1(1960): 18-44.

16 In the other direction, imports went from the Mediterranean toward the Sudan; cf. T. Kraus, "Rom und Meroe," *MDIK* 25(1969): 53-54. For glasswares, cf. U. Monneret de Villard, *La Nubia Romana* (Rome, 1941), pp. 37-39; and especially the material brought together, on the occasion of the discovery of the Sedeinga glass, in an article by J. Leclant, "Glass from the Meroitic Necropolis of Sedeinga (Sudanese Nubia)," *Journal of Glass Studies* 15(1973): 52-68.

17 The caravan cities and the Phoenician coast at the termini of the trade routes from Asia must also be kept in mind.

18 C. Préaux, *L'Economie royale des Lagides* (Brussels, 1939), pp. 187-96.

19 Ibid., pp. 303, 317. It is difficult to estimate the number or proportion of "Ethiopians" in the population of ptolemaic Egypt. To judge by names alone, the proportion would seem to have been surprisingly small: cf. F. Heichelheim, *Die auswärtige Bevölkerung im Ptolemäerreich*, Supplement to *Klio*, no. 18 (Leipzig, 1925), pp. 66-67, 85, 87, 98, 99, 108. S. Davis, *Race-Relations in Ancient Egypt*, 2nd ed. (London, 1953), does not even touch upon the problem. J. Desanges has called my attention to the epitaph of a black slave in the Berlin museum, inv. 13471, published and annotated by E. Bernand, *Inscriptions métriques de l'Egypte gréco-romaine*, Annales littéraires de l'Université de Besançon, tome 98 (Besançon and Paris, 1969), inscription no. 26, pp. 143-47. The epitaph certainly seems to have been "composed by a local poet of Greek culture."

20 Rostovtzeff, *History of Hellenistic World*, vol. I, p. 321; vol. II, pp. 1262-63.

21 M. Bang, "Die Herkunft der römischen Sklaven," *Mitteilungen des Kaiserlich-deutschen Archäologischen Instituts, Römische Abteilung* 25(1910): 248. See also *infra*, for the blacks in Italy.

22 G. H. Beardsley, *The Negro in Greek and Roman Civilization: A Study of the Ethiopian Type* (Baltimore, 1929; New York, 1967).

23 F. M. Snowden, "The Negro in Classical Italy," *American Journal of Philology* 68(1947): 266-92; idem, "The Negro in Ancient Greece," *AmAn* 50(1948): 31-44; idem, "Some Greek and Roman Observations on the Ethiopians," *Traditio* 16(1960): 19-38. Lastly see F. M. Snowden's synthesis, *Blacks in Antiquity: Ethiopians in the Greco-Roman Experience* (Cambridge, Mass., 1970).

24 D. Bonneau, *La crue du Nil, divinité égyptienne, à travers mille ans d'histoire (332 av.-641 ap. J.-C.)*, Etudes et Commentaires, 52 (Paris, 1964).

25 Snowden, *Blacks in Antiquity*, pp. 16-17.

26 J. Boardman, *The Greeks Overseas* (Baltimore, 1964), pp. 167, 169, and fig. 48.

27 Among the finest examples is the pelike by the Pan Painter, Athens, National Museum, 9683 (J. D. Beazley, *Attic Red-figure Vase-painters*, 2nd ed. [Oxford, 1963], vol. I, p. 554 [hereafter cited as *ARV²*]). On this subject, see R. I. Hicks, "Egyptian Elements in Greek Mythology," *TAPA* 93(1962): 102-107; B. M. Felletti Maj, "Due nuove ceramiche col mito di Heracles e Busiris," *RivIstArch*, 6, fasc. 3(1938): 207.

28 On the plastic vases in the shape of Negroes and the other representations of blacks in the Greek world, besides the bibliography given above, cf. U. Hausmann, "Hellenistische Neger," *AthMitt* 77(1962): 255-81, pls. 74-80.

29 C. T. Seltman, "Two Heads of Negresses," *AJA* 24(1920): 14 ff.

30 In the texts the traditional contrast is between the Ethiopian and the Scythian, the latter now and then alternating with the Thracian; cf. Snowden, *Blacks in Antiquity*, pp. 171-77 and 196-98.

31 Athens, National Museum, 13887; alabastron with a draped warrior on one side and a palm tree and serpent on the other; Beazley, *ARV²*, vol. I, pp. 267-70.

32 J. Thimme, "Griechische Salbgefässe mit libyschen Motiven," *Jahrbuch der Staatlichen Kunstsammlungen in Baden Würtemberg* 7(1970): 7-30, especially p. 12.

33 Paris, Musée du Louvre, CA 3825. L. Kahil, "Un nouveau vase plastique du potier Sotadès, au Musée du Louvre," *RA*, fasc. 2(1972): 271-84; J. D. Beazley, *Paralipomena: Additions to Attic Black-figure Vase-painters and to Attic Red-figure Vase-painters*, 2nd ed. (Oxford, 1971), p. 416.

34 Kahil, *RA*, fasc. 2(1972): figs. 4 and 11. This "little Negro" (pp. 276, 278) cannot be a Libyan (p. 280). We must not forget that the Persian Empire, which had had to

annex a small part of Lower Nubia, regularly counted the Land of "Kush" among its tributaries; cf. J. LEROY, "Les 'Éthiopiens' de Persépolis," *AdE* 5(1963): 293-95; see also the "country of the Nehesy" on the base of the statue of Darius recently discovered at Suse; J. YOYOTTE, "Les inscriptions hiéroglyphiques. Darius et l'Egypte," *Journal Asiatique* 260(1972): 256 and 259.

35 KAHIL, *RA*, fasc. 2(1972): fig. 13.

36 Ibid., p. 282.

37 E. BUSCHOR, "Das Krokodil des Sotades," *MJB* 11(1919): 1-43; F. SALVIAT, "Le crocodile amoureux," *BCH* 91(1967): 96-101, figs. 1 and 2.

38 Ruvo, Museo Jatta, 1408: rhyton.

39 A fine gallery of portraits of Negroes and mixed types is given in SNOWDEN's *Blacks in Antiquity*; cf. also R. WINKES' remarks, "Physiognomonia: Probleme der Charakterinterpretation Römischer Porträts," in *Aufstieg und Niedergang der römischen Welt*, vol. I, *Von den Anfängen Roms bis zum Ausgang der Republik*, Band 4, ed. H. TEMPORINI (Berlin and New York, 1973), pp. 908-909.

40 Vatican, Museo Gregoriano Profano, 16953: bronze balsamarium found in Ostia. On balsamaria, cf. L. PRESSOUYRE, "A propos d'un 'balsamaire' trouvé à Lamaurelle (L.-et-G.)," *RA*, tome 2(1962): 165-81; K. MAJEWSKI, "Brązowe balsamaria antropomorficzne w cesarstwie rzymskim," *Archeologia* [Warsaw] 14(1963): 95-126 (with summary in Russian and French: "Balsamaires anthropomorphes en bronze dans l'Empire romain"); P. LEBEL, "Une vue d'ensemble sur les balsamaires romains en forme de buste humain," *RAE* 16(1965): 309-11; M. MALAISE, "A propos d'un buste-balsamaire en bronze du Musée de Tongres. Sur les traces d'influences alexandrines à Atuatuca," *Latomus* 29(1970): 142-56. Lastly, see the reservations expressed by S. BOUCHER, "Problèmes de l'influence alexandrine sur les bronzes d'époque romaine," *Latomus* 32(1973): 799-811 and pls. XXII-XXVI.

41 A. RADNÓTI, "Rómaikori néger szobrocska Köszegen," *Dunántúli Szemle* 7(1940): 84-92; J. LECLANT, "Statuette de Nègre en Hongrie," *RA* 34(1949): 99-100. For a statuette of a Negro acrobat in Rome, Museo Nazionale Romano, 40809, see also S. AURIGEMMA, *Le Terme di Diocleziano e il Museo Nazionale romano*, 3rd ed. (Rome, 1954), p. 114, no. 306.

42 J. MARCADÉ, *Au Musée de Délos. Etude sur la sculpture hellénistique en ronde bosse découverte dans l'île* (Paris, 1969), p. 407.

43 P. PERDRIZET, *Les terres cuites grecques d'Egypte de la collection Fouquet* (Nancy, Paris, Strasbourg, 1921), vol. I, pp. 139-40, nos. 369-70, vol. II, pl. XCVII; E. BRECCIA, *Terrecotte figurate greche e greco-egizie del Museo di Alessandria*, Société royale d'archéologie d'Alexandrie, Monuments de l'Egypte gréco-romaine, tome 2 (Bergamo, 1930),

fasc. 1, p. 73, no. 470, pl. XXXI 8 and pl. LVI 2; idem, *Terrecotte figurate* (1934), fasc. 2, p. 47, no. 293, pl. LXXIV 379; I. NOSHY, *The arts in Ptolemaic Egypt* (London, 1937), p. 98, with bibliography; P. GRAINDOR, *Terres cuites de l'Egypte gréco-romaine* (Antwerp, The Hague, 1939), p. 142, no. 61, and pl. XXII.

44 This according to K. T. ERIM, "De Aphrodisiade," *AJA* 71(1967): 236-39, pl. 70, who also mentions the discovery of the statue of a black in a sunken ship near Bodrum.

45 Even in texts of the late period, the term *Egyptian* may designate a black person. This is true, as J. Desanges has been kind enough to point out to me, in the case of the charioteer who always wins, and of the hunter Olympius, both sung by Luxorius; cf. M. ROSENBLUM, *Luxorius: A Latin Poet among the Vandals*, Records of Civilization Sources and Studies, no. LXII (New York and London, 1961), Poem 7, p. 114 and Poem 67, p. 150.

46 On the antiquity of the theme of the battle between the Pygmies and the cranes, cf. M.H. SWINDLER, "A Terracotta Altar in Corinth," *AJA* 36(1962): 512-20.

47 Boston, Museum of Fine Arts, 99.534. SNOWDEN, *Blacks in Antiquity*, p. 37, fig. 6.

48 Florence, Museo Archeologico, 4209: Attic crater found in Chiusi.

49 H. A. GRUEBER, *Coins of the Roman Republic in the British Museum* (London, 1910), vol. I, no. 3468.

50 P. PERDRIZET, *Bronzes grecs d'Egypte de la collection Fouquet* (Paris, 1911), p. 55, no. 88, and pl. XXIII.

51 J.-J. HATT, "Observations sur quelques statuettes gallo-romaines en bronze du Musée de Strasbourg," *RAE* 14(1961): 116-29, figs. 42-43, with CH. PICARD's comments, pp. 147-52; J. LECLANT, "Du Nil au Rhin. De l'Antique Egypte au cœur de l'Europe," in *Mélanges offerts à Polys Modinos* (Paris, 1968), pp. 76, 77, 82. For Germania, cf. G. GRIMM, *Die Zeugnisse ägyptischer Religion und Kunstelemente im römischen Deutschland*, Etudes préliminaires aux religions orientales dans l'Empire romain, tome 12 (Leiden, 1969), pp. 47-48.

52 W. BINSFELD, "Grylloi: Ein Beitrag zur Geschichte der antiken Karikatur" (University of Cologne, 1956), pp. 34-35, 39-40. For reservations of a technical nature, cf. J. CONDAMIN and S. BOUCHER, "Recherches techniques sur les bronzes de Gaule romaine, IV," *Gallia* 31(1973): 157-83.

53 Houston, Menil Foundation Collection, 72-62 DJ(3). PERDRIZET, *Les terres cuites grecques d'Egypte*, vol. I, p. 164, no. 476; vol. II, pl. CV (below on the right): statuette of a draped Pygmy, standing beside a vase. See also PERDRIZET, *Bronzes grecs d'Egypte*, pp. 53 ff.

54 A. BADAWY, "Le grotesque: invention égyptienne," *Gazette des Beaux-Arts* 66(1965):

189-98; J.-P. CÈBE, *La caricature et la parodie dans le monde romain antique, des origines à Juvénal* (Paris, 1966), pp. 354 ff.

55 Harkhuf, nomarch of Elephantine, had carved in his tomb the letter he received from the young Pepy II, the last king of the Sixth Dynasty, thanking him for the dwarf that Harkhuf brought him after one of his expeditions in the South. On this, cf. W. R. DAWSON, "Pygmies and Dwarfs in Ancient Egypt," *JEA* 24(1938): 185-89.

56 Cf. *infra*.

57 Pompeii, Casa dei Pigmei, mural painting; from oecus. For the Pygmies in Roman painting, see the inventory drawn up by K. SCHEFOLD in *Vergessenes Pompeji* (Bern, 1962), Appendix III, pp. 197-202. On Nilotic scenes, see, e.g., C.M. DAWSON, *Romano-Campanian Mythological Landscape Painting*, Yale Classical Studies, vol. 9 (New Haven, 1944); K. SCHEFOLD, *Pompejanische Malerei, Sinn und Ideengeschichte* (Basel, 1952), pp. 58-81; L. FOUCHER, "Les mosaïques nilotiques africaines," in *La mosaïque gréco-romaine*, Colloques internationaux du Centre National de la Recherche Scientifique, Paris, 29 August-3 September 1963 (Paris, 1965), pp. 137-43; BONNEAU, *La crue du Nil*, pp. 89 ff.

58 Palestrina, Museo Archeologico Nazionale. G. GULLINI, *I mosaici di Palestrina*, Supplement to *Archeologia Classica* (Rome, 1956); BONNEAU, *La crue du Nil*, pp. 90-94, pl. III.

59 Rome, Museo Nazionale Romano, 62662. A relief from the same mold is in Leiden, Rijksmuseum van Oudheden, K 1956/8.2. J.H.C. KERN, "A Roman 'Campana' Relief with Nile Landscape (Pygmy Village)," *Oudheidkundige Mededelingen uit het Rijksmuseum van oudheden te Leiden*, 39, n.s. (1958): 11-17, pl. III, and figs. 3-5.

60 A. DOBROVITS, "A Székesfehérvári Múzeum 'Nilusi Jelenet' dombormüve," *Szépmüvészet* (1942): 11-14. J. LECLANT, "Un relief pannonien d'inspiration égyptisante," *RA* 36 (1950): 147-49.

61 Rome, Museo Nazionale Romano, 113065.

62 The Nilotic landscapes with Pygmies hunting a hippopotamus, among the paintings in the Aula Isiaca on the Palatine in Rome, should probably not be included in this series; cf. G.E. RIZZO, *Le pitture dell'Aula di Caligola (Palatino)*, Monumenti della Pittura antica scoperti in Italia, III, fasc. 2 (Rome, 1936), p. 26, figs. 25 and 28. The present tendency is to date this monument not from Caligula but from Augustus, so it is doubtful that these paintings belong to an Isiac context.

63 A. GARCIA Y BELLIDO, *Les religions orientales dans l'Espagne romaine*, Etudes préliminaires aux religions orientales dans l'Empire romain, tome 5 (Leiden, 1967), p. 123, no. 57, pl. XIV.

64 Naples, Museo Archeologico Nazionale, 113195: fresco from Pompeii, garden of the

Casa del Gallo; Cèbe, *La caricature*, p. 349 and n. 4, pl. VII. In this fresco, the scene is placed near an Egyptian temple, a fact which establishes the connection between the Pygmies and Egypt; cf. B. Maiuri, *Museo Nazionale di Napoli*, Musei e monumenti (Novara, 1958), p. 115.

65 We note the antiquity of the theme in the Nile Valley, and call attention to a Nubian rock carving at Tomâs, in which a hippopotamus is shown swallowing a small man. J. Leclant, "Fouilles et travaux en Egypte et au Soudan, 1960-1961, I. Fouilles en Egypte," *Orientalia* 31(1962): pl. XXXIV, fig. 10.

66 M. Gavelle, "Sur un vase sigillé à décor égyptisant trouvé dans les fouilles de Saint-Bertrand-de-Comminges," *Mélanges d'Archéologie et d'Histoire offerts à André Piganiol* (Paris, 1966), vol. I, p. 498, n. 1, regarding a lamp at Lectoure (Gers).

67 A. M. Blackman and H. W. Fairman, "The Myth of Horus at Edfu—II: The Triumph of Horus over his Enemies, A Sacred Drama," *JEA* 28(1942): 32-38; idem, "The Myth of Horus at Edfu—II (Continued)," *JEA* 29(1943): 2-36; idem, "The Myth of Horus at Edfu—II (Concluded)," *JEA* 30(1944): 5-22, 79-80.

68 Paris, Musée du Louvre, S1640; from Fayum. Perdrizet, *Bronzes grecs d'Egypte*, nos. 86-87, 90-92, pl. XXIII, and no. 360, pl. XXIX; idem, *Les terres cuites grecques d'Egypte*, pp. xxvii-xxviii and 35; Graindor, *Terres cuites de l'Egypte*, p. 47 and nos. 20, 22, 58; W. Deonna, "De télesphore au 'moine bourru'; dieux, génies et démons encapuchonnés," *Latomus* 21(1955): 95-96.

69 A. Laumonier, *Exploration archéologique de Délos faite par l'Ecole française d'Athènes. Les figurines de terre cuite* (Paris, 1956), tome I, nos. 1198-99, 1211-12.

70 A very characteristic example is the "Grand Bès," from the Saïtic period, in Paris, Musée du Louvre, E10929. He is seated and wears a leopard skin.

71 F. Ballod, *Prolegomena zur Geschichte der zwerghaften Götter in Ägypten* (Moscow, 1913); F. Jesi, "Bès initiateur, Eléments d'institutions préhistoriques dans le culte et dans la magie de l'ancienne Egypte," *Aegyptus* 38 (1958): 171-83; idem, "Bes e Sileno," *Aegyptus* 42 (1962): 257-75.

72 Paris, Musée du Louvre, 8076. M. Malaise, *Inventaire préliminaire des documents égyptiens découverts en Italie*, Etudes préliminaires aux religions orientales dans l'Empire romain, tome 21 (Leiden, 1972), p. 200, no. 372 b; H. Wild, *Les danses sacrées de l'Egypte ancienne*, Sources Orientales, 6 (Paris, 1963), p. 82, n. 178.

73 S. Curto, "I monumenti egizi nelle Ville Torlonia a Roma," *Oriens Antiquus*, 6, fasc. 1 (1967): 54, pl. XXI, fig. 2. Let us mention also a statuette of Bes, which served as a fountain, a Roman work of the

end of the second or beginning of the third century, in Cambridge, Fitzwilliam Museum, GR.1.1818.

74 Snowden, *AmAn* 50(1948): 40, n. 94.

75 G. Siebert, "Lampes corinthiennes et imitations au Musée National d'Athènes," *BCH* 90(1966): no. 17, pp. 503-506, fig. 23, for a Sparta lamp from the third century A.D., decorated with two ithyphallic dwarf dancers of whom one wears an animal mask over his head, and an Antioch mosaic showing a dwarf pointing his phallus at the Evil Eye, which is already being attacked by monstrous animals.

76 See F. M. Snowden's publications, cited *supra*, n. 23.

77 M. Malaise, *Les conditions de pénétration et de diffusion des cultes égyptiens en Italie*, Etudes préliminaires aux religions orientales dans l'Empire romain, tome 22 (Leiden, 1972), pp. 71-75, 321-30.

78 Ibid., pp. 322, 328; the Roman inscriptions in Italy introduce several personages named *Meroe*, who were probably of African origin; cf. ibid., p. 328, n. 5.

79 F. M. Snowden, "Ethiopians and the Isiac Worship," *AntCl*, 25, fasc. 1 (1956): 112-16.

80 A head of a priest of Isis, dating from the first century A.D. and found at Athens, identifiable by the shaven scalp and a ritual mark, would seem to be that of a mulatto; cf. F. Poulsen, "Tête de prêtre d'Isis trouvée à Athènes," *Mélanges Holleaux* (Paris, 1913), pp. 217-23, pl. VI; Snowden, *AntCl*, 25, fasc. 1 (1956): 114.

81 In vv. 532-42 of the sixth *Satire*, in which he pours ridicule on exotic cults and particularly those of Egypt, Juvenal may have had in mind the increasing exoticism of the Isiac cult when he derides the devotee who, if Io or Isis so ordered, would go all the way to Meroë to fetch water from the Nile with which to sprinkle the temple of Isis.

82 Rome, Museo Nazionale Romano, 77255. R. Paribeni, "Ariccia-rilievo con scene egizie," *Notizie degli Scavi di Antichità* (1919): 106-112; Snowden, *AntCl*, 25, fasc. 1 (1956): 115; idem, *Blacks in Antiquity*, fig. 5, a and b; Malaise, *Inventaire des documents égyptiens*, pp. 58-59 and pl. 2.

83 R. Mauny, in his review of *Blacks in Antiquity* (*Gnomon* 43[1971]: 831), would term the Ariccia dancers "steatomerous" rather than "steatopygous."

84 Naples, Museo Archeologico Nazionale, 8919. V. Tran Tam Tinh, *Essai sur le culte d'Isis à Pompéi* (Paris, 1964), pp. 27-28 and pl. XXIV; idem, *Le culte des divinités orientales à Herculanum*, Etudes préliminaires aux religions orientales dans l'Empire romain, tome 17 (Leiden, 1971), no. 59, pp. 39-42, fig. 41; Malaise, *Inventaire des documents égyptiens*, pp. 252-53 and pl. 36.

85 Wild, *Les danses sacrées de l'Egypte*, pp. 78-85.

86 Naples, Museo Archeologico Nazionale, 8924. For these two frescoes from Hercu-

laneum, refer to figs. 288 and 289 in F. M. Snowden's essay in this volume.

87 Tran Tam Tinh, *Essai sur le culte d'Isis*, p. 27, pl. XXIII; idem, *Le culte des divinités orientales à Herculanum*, no. 58, pp. 28-38, 83-84, fig. 40; Malaise, *Inventaire des documents égyptiens*, pp. 251-52, pl. 35.

88 V. Tran Tam Tinh, however (*Le culte des divinités orientales à Herculanum*, pp. 45-46), thinks that the ibises could not have survived in this climate of the Campania. In his opinion the figures of birds seen in these documents represent statues. In support of his thesis he cites two life-size statues of ibises, in marble and bronze, unearthed at Pompeii.

89 F. M. Snowden, *AntCl*, 25, fasc. 1 (1956): 114, considers this figure an Ethiopian.

90 *L'Italia in Africa*, *Le scoperte archeologiche (1911-1943)*: S. Aurigemma, *Tripolitania*, vol. I, *I Monumenti d'Arte decorativa*, pt. 1, *I Mosaici* (Rome, 1960), pl. 86; Bonneau, *La crue du Nil*, pp. 344-45, pl. VI. On the Egyptian and black flute-players in the Greco-Roman world, cf. Propertius 4. 8. 39. See *supra*, fig. 346.

91 Suetonius *Caligula* 57. 4: *parabatur in noctem spectaculum, quo argumenta inferorum per Aegyptios et Aethiopes explicarentur*.

92 E. Köberlein, *Caligula und die ägyptischen Kulte*, Beiträge zur Klassischen Philologie, 3 (Meisenheim am Glan, 1962), p. 32.

93 See, e.g., J. Baltrušaitis, *Essai sur la légende d'un mythe. La quête d'Isis. Introduction à l'égyptomanie*, Collection Jeu Savant (Paris, 1967); S. Morenz, *Die Begegnung Europas mit Ägypten*, Sitzungsberichte der sächsischen Akademie der Wissenschaften zu Leipzig, Band 113, Heft 5 (Berlin, 1968); J. Leclant, "En quête de l'Egyptomanie," *Revue de l'Art* 5(1969): 82-88.

94 J. Huynen, *L'énigme des Vierges noires*, Collection Les énigmes de l'univers (Paris, 1972).

95 E. Mâle, *La fin du paganisme en Gaule et les plus anciennes basiliques chrétiennes* (Paris, 1950), p. 320, thinks they derive from terracottas, blackened by time, which represented Gallo-Roman goddess-mothers holding a child.

96 H. W. Müller, "Isis mit dem Horuskinde. Ein Beitrag zur Ikonographie der stillenden Gottesmutter im hellenistischen und römischen Ägypten," *MJB* 14(1963): 7-38.

97 Vatican, Museo Gregoriano Egizio; G. Botti and P. Romanelli, *Le Sculture del Museo Gregoriano Egizio*, Monumenti Vaticani di Archeologia e d'Arte, vol. IX (Vatican City, 1951), pp. 97-98, no. 147; Malaise, *Inventaire des documents égyptiens*, pp. 104-105.

98 Vatican, Museo Gregoriano Egizio; Botti and Romanelli, *Le Sculture del Museo Gregoriano Egizio*, pp. 99-100, no. 148; Malaise, *Inventaire des documents égyptiens*, p. 105, pl. 100 b.

19 Tribute scene (detail): African women with children. Dynasty XVIII, about 1557-1504 B.C. Mural painting. Thebes, necropolis of Sheikh Abdel Qurna, tomb of Inene: pillared court, north wall, west of the passage.

20 Tribute scene (detail): group of black women with children. Dynasty XVIII, about 1425-1408 B.C. Mural painting. Thebes, necropolis of Sheikh Abdel Qurna, tomb of Horemheb: hall, east wing, north wall.

21, 22 Stela of Amenhotep III: black prisoners bound to the pharaoh's war chariot. From Thebes. Dynasty XVIII, about 1408-1372 B.C. Limestone. 207 × 110 cm. Cairo, Egyptian Museum, JE 31409 (= CG 34026).

23-27 Bearing tribute from the South to Tutankhamun. Details: ship loaded with cargo; princes and princesses accompanied by servants and Chieftains of the Land of Kush; the prince of Miam and the Chieftains of the "Wawat"; black prisoners followed by women and children; herd of cattle. Dynasty XVIII, about 1342-1333 B.C. Mural painting. Thebes, necropolis of Qurnet Murai, tomb of Huy: hall, north wall, west of the passage.

28-31 Egyptian military expedition returning to Egypt from the Upper Nile. Details of low relief: rhinoceros; black dancers; prisoners bearing products from the South; drummers. Dynasty XVIII, about 1504-1450 B.C. Stone. Armant, Temple of Monthu: pylon of Tuthmosis III, east pier.

32 Procession of Amun (detail): black dancers and trumpet players. Dynasty XVIII, about 1342-1333 B.C. Low relief, stone. Luxor, Temple: Processional Colonnade, east wall.

33, 34 Athletic contest presented before the court and foreign ambassadors. Details of low relief: a black and an Egyptian wresting; black man among the spectators. Dynasty XX, about 1198-1166 B.C. Stone. Medinet Habu, Great Temple: first court, inner face of south wall, lower register.

35 Fragment of column base: escutcheon of a conquered people from the South. Dynasty XVIII, about 1408-1372 B.C. Stone. Soleb, Temple of Amenhotep III: Hypostyle Hall IV, south side.

36 Base of a colossus of Ramesses II: list of the conquered Southern peoples. Dynasty XIX, about 1301-1235 B.C. Stone. Luxor, Temple: court of Ramesses II, statue west of entrance passage to the Great Colonnade.

37 Footstool: black and Asiatic captives in chains. From Thebes, tomb of Tutankhamun. Dynasty XVIII, about 1342-1333 B.C. Wood overlaid with gilt stucco and blue glass. Cairo, Egyptian Museum, JE 62045.

38 List of the conquered Southern peoples (detail): three escutcheons. Dynasty XIX, about 1301-1235 B.C. Low relief, stone. Abydos, Temple of Ramesses II: portico, south wall.

39, 40 Base of a colossus of Ramesses II: list of the conquered Southern peoples (details). Dynasty XIX, about 1301-1235 B.C. Stone. Luxor, Temple: court of Ramesses II, statue west of entrance passage to the Great Colonnade.

41 Kneeling black captive; detail of the socle of an Osiride pillar of Ramesses III. Dynasty XX, about 1198-1166 B.C. Stone. Medinet Habu, Great Temple: first court, north portico, seventh statue from east.

42 Sub-base of a colossus of Ramesses II: row of kneeling prisoners. Dynasty XIX, about 1301-1235 B.C. Stone. Abu Simbel, Temple of Ra-Harakhte: facade, south wall of entrance, sub-base of the second statue.

43 Amenhotep as a sphinx trampling his enemies; side panel of the pharaoh's throne. Dynasty XVIII, about 1408-1372 B.C. Stone. Thebes, necropolis of El Khokha, tomb of Amenemhat-Sourer: portico, west wall, north of the passage.

44 Architectural inlays: black prisoners. From Medinet Habu, Palace-Temple of Ramesses III, doorpost. Dynasty XX, about 1198-1166 B.C. Polychrome faïence. H: approx. 25 cm. Cairo, Egyptian Museum, JE 36457 and JE 36457 H.

71 Head of Shabaka, fragment of a colossal statue. From depository at Karnak. Dynasty XXV, about 716-701 B.C. Pink granite. H: 97 cm. Cairo, Egyptian Museum, JE 36677 (CG 42010).

72 Head of Shabaka (?). Dynasty XXV, about 716-701 B.C. Green schist. H: 7 cm. Brooklyn, The Brooklyn Museum, Department of Ancient Art, 60.74.

73, 74 Statuette of Shabaka kneeling. Dynasty XXV, about 716-701 B.C. Bronze. H: 15.5 cm. Athens, National Museum, 632.

75 Shabaka opposite a falcon-headed god, low relief on a reused block of stone. Dynasty XXV, about 716-701 B.C. Karnak, Osireion of Taharqa of the Lake.

76 Shabaka opposite a god, low relief on a reused block of stone. Dynasty XXV, about 716-701 B.C. Karnak, Osireion of Taharqa of the Lake: east wall, outer face.

77 Statuette of Harmakhis. From depository at Karnak. Dynasty XXV, about 716-701 B.C. Red sandstone. H: 66 cm. Cairo, Egyptian Museum, JE 38580 (=CG 42204).

78 Shabataka before the god Amun (detail). Dynasty XXV, about 701-690 B.C. Low relief, stone. Karnak, chapel of Osiris-Heqa-djet: facade, eastern side.

79, 80 Colossal statue of Taharqa, treading on several bows. From Gebel Barkal. Dynasty XXV, 690-664 B.C. Black granite. H: 382 cm. Khartum, Sudan National Museum, 1841.

81 Head of Taharqa. Dynasty XXV, 690-664 B.C. Black granite. H: 35 cm. Cairo, Egyptian Museum, CG 560.

82 Head of Taharqa. Dynasty XXV, 690-664 B.C. Black basalt. H: 14 cm. Copenhagen, Ny Carlsberg Glyptotek, AEIN 1538.

83, 84 Taharqa facing Hemen the falcon god. Dynasty XXV, 690-664 B.C. Bronze, gold-plated schist. H: 19.7 cm. Paris, Musée du Louvre, Département des Antiquités égyptiennes, E 25276.

85, 86 Sphinx of Taharqa. From Kawa. Dynasty XXV, 690-664 B.C. Granite. L: 74.5 cm. London, British Museum, Department of Egyptian Antiquities, 1770.

87 Taharqa protected by a ram. From Kawa. Dynasty XXV, 690-664 B.C. Gray granite. H: 100 cm. Khartum, Sudan National Museum, 24002.

88 Taharqa making an offering of milk, low relief on a reused column drum. (From Colonnade of Taharqa.) Dynasty XXV, 690-664 B.C. Stone. Karnak North.

89 Portrait of Taharqa, detail of low relief. Dynasty XXV, 690-664 B.C. Sandstone. Gebel Barkal, temple called Typhonium: Room 3, north of passage leading to the sanctuary.

90 Portrait of Taharqa, fragment of low relief. Dynasty XXV, 690-664 B.C. Sandstone. 28 × 25.5 cm. Paris, Private Collection.

91 Portrait of Taharqa, detail of low relief. Dynasty XXV, 690-664 B.C. Stone. Karnak, Edifice of Taharqa of the Lake: doorpost of outer court.

92 Portrait of Taharqa, detail of low relief. Dynasty XXV, 690-664 B.C. Sandstone. Sedeinga, west necropolis, doorpost of a tomb.

93 Shawabti of Taharqa. From Nuri. Dynasty XXV, 690-664 B.C. Alabaster. H: 33.3 cm. Khartum, Sudan National Museum, 1389.

94, 95 Shawabti of Taharqa. From Nuri. Dynasty XXV, 690-664 B.C. Ankerite. H: 33.1 m. Boston, Museum of Fine Arts, 21.11748.

96 Carved ivory plaquette: royal lion-cub devouring a Kushite. From Nimrud. VIII century B.C. Ivory, gold, colored paste. H: 6 cm. London, British Museum, Department of Western Asiatic Antiquities, 127412.

97 Shawabti of Taharqa. From Nuri. Dynasty XXV, 690-664 B.C. Black serpentine. H: 23 cm. Khartum, Sudan National Museum, 1421.

98 Inlay fragment: head of a black. From El Kurru, tomb of Shabataka. Dynasty XXV, about 701-690 B.C. Ivory. H: 1.8 cm. Boston, Museum of Fine Arts, 21.308.

123 Stela of Nastasen (detail). Probably from Gebel Barkal; found at Dongola. Second half IV century B.C. Granite. Over-all Dims: 163 × 127 cm. East Berlin, Staatliche Museen, Ägyptisches Museum, 2268.

124 Head of the god Sbomeker, detail of low relief. Late III century B.C. Sandstone. Musawwarat es-Sufra, Lion Temple: south wall, outer face.

125 Queen Amanitore and King Natakamani opposite the lion god, four-armed Apedemak. Late I century B.C.-early I century A.D. Low relief, sandstone. Naga, Lion Temple: west wall, outer face.

126 King Natakamani dominating his enemies. Late I century B.C.-early I century A.D. Low relief, sandstone. Naga, Lion Temple: pylon, south pier.

127 Cargill plaquette: Prince Arikankharer defeating his enemies. Early I century A.D. Sandstone. 20 × 25.4 cm. Worcester (Mass.), Worcester Art Museum, 1922.145.

128 "Negro goddess," detail of low relief. Late I century B.C.-early I century A.D. Sandstone. Naga, Lion Temple: north wall, outer face.

129 Group perhaps representing Queen Shanakdakhete and her son. II century B.C. High relief, basalt or gray granite. H: 161 cm. Cairo, Egyptian Museum, CG 684.

130 Triad with the ram of Amun flanked by Sbomeker and Arsenuphis. From Musawwarat es-Sufra, Great Enclosure. III century B.C. High relief, sandstone. 51.5 × 72.5 cm. Khartum, Sudan National Museum, 24003.

131 Colossal statue. From Argo Island, Temple of Tabo. II century B.C. Gray granite. H: approx. 700 cm. Khartum, Sudan National Museum, 23983.

132 Pillar statue of a god. From Meroë, Temple of Isis. I century A.D. (?). Sandstone. H: 223 cm. Copenhagen, Ny Carlsberg Glyptotek, AEIN 1082.

133 Statuette of Osiris. Bronze. Sedeinga, necropolis.

134 Funerary stela. From Dabarosa. Sandstone. 52 × 33 cm. Khartum, Sudan National Museum, 5587.

135 Statuette of a *ba*-bird. From Karanog, necropolis. Sandstone. H: 74.1 cm. Cairo, Egyptian Museum, JE 40232.

136 Head of a *ba*-bird (fragment). From Sedeinga, necropolis. Sandstone. Khartum, Sudan National Museum.

137 Head of a *ba*-bird. From Nag Gamus, necropolis. Sandstone. 9 × 16 cm. Madrid, Museo Arqueológico Nacional, no inventory number.

138 Head of a *ba*-bird. From Argin. Sandstone. H: 20 cm. Khartum, Sudan National Museum, 13365.

139 Head of a *ba*-bird (fragment). From Nag Gamus, necropolis. Sandstone. H: 7 cm. Madrid, Museo Arqueológico Nacional, no inventory number.

140 Anthropomorphic sarcophagus. From Argin. Terracotta. H: 22 cm.; L: 177 cm. Khartum, Sudan National Museum, 10045.

141 Pendant: three African prisoners overpowered by a vulture. From Sedeinga, necropolis of the western tombs. Lead. Approx. 5.5 × 6 cm. Khartum, Sudan National Museum, 20391.

142 Negroid profile carved in shell. From Ayious Onouphrios. Early second millennium B.C. L: 4.5 cm. Oxford, Ashmolean Museum of Art and Archeology, Department of Antiquities, 1938.537.

143 *Jewel Fresco* fragment: pendants in the form of heads of blacks wearing earrings. From Knossos. Middle Minoan III, about 1600 B.C. Painted stucco. H: 8 cm. Herakleion, Archeological Museum, Room XV.

144 Nubian archer (detail). From Assiut, tomb of Prince Mesehty. Dynasty XI or XII, about 2000 B.C. Model in painted wood. Over-all L: 193 cm. Cairo, Egyptian Museum, JE 30969 (= CG 257).

145 *The Captain of the Blacks*. Fresco fragment (reconstruction). From Knossos. Late Minoan II, about 1550-1500 B.C. 24 × 20 cm. Herakleion, Archeological Museum, Room XVI.

170 Hydria (detail): Heracles and Busiris' servants. From Vulci. V century B.C. Terracotta. Over-all H: 36 cm. Munich, Staatliche Antikensammlungen, 2428.

171 Busiris in flight, interior of a cup. From Spina, necropolis. Early V century B.C. Terracotta. Diam of cup: 28 cm. Ferrara, Museo Archeologico Nazionale, 609.

172 Altamura Painter, stamnos: Heracles and Busiris. V century B.C. Terracotta. H: 37.5 cm. Bologna, Museo Civico Archeologico, 174.

173 Ethiop Painter, pelike (detail): the prisoner Heracles followed by one of Busiris' servants. From Nola. Late V century B.C. Terracotta. Over-all H: 22.8 cm. Paris, Bibliothèque Nationale, Cabinet des Médailles. A. de Ridder, *Catalogue des vases peints* (Paris, 1902), no. 393.

174, 175 Workshop of the Niobid Painter, pelike: tying of Andromeda who is supported by a black servant. V century B.C. Terracotta. H: 44 cm. Boston, Museum of Fine Arts, 63.2663.

176, 177 Calyx-krater: scene from the *Andromeda* of Euripides (?) with a figure personifying Ethiopia. From Capua. Late V century B.C. Terracotta. H: 37.7 cm. East Berlin, Staatliche Museen, Antikensammlung, 3237.

178, 179 Kantharos in the shape of conjoined heads of a white woman and a satyr. From Corchiano. V century B.C. Terracotta. H: 23.6 cm. San Simeon (Calif.), Hearst San Simeon State Historical Monument, 5715(SSW 9904).

180 Plastic vase: Andromeda (?). Early IV century B.C. Terracotta. H: 21.2 cm. Oxford, Ashmolean Museum of Art and Archaeology, Department of Antiquities, G 227.

181 Antefix: mask of a Negro. From Cerveteri. First half V century B.C. Terracotta. H: 20 cm. Houston, D. and J. de Menil Collection, CA 7009.

182 Antefix: mask of a Negro. From Campania. Late VI century B.C. Terracotta. H: 14.6 cm. Hamburg, Museum für Kunst und Gewerbe, 1917,1002.

183 Antefix: mask of a Negro. From Pyrgi. Early V century B.C. Terracotta. H: 20 cm. Rome, Museo Nazionale Etrusco di Villa Giulia, scavo no. 203.

184 Negroid Victory driving Heracles' chariot, detail of an oinochoe. From Cyrenaica. Early IV century B.C. Terracotta. Over-all H: 22.3 cm. Paris, Musée du Louvre, Département des Antiquités grecques et romaines, N 3408.

185 Negroid Circe offering a magic potion to Odysseus, detail of a skyphos. From Kabeirion. Late V or early IV century B.C. Terracotta. Over-all H: 19 cm. London, British Museum, Department of Greek and Roman Antiquities, 1893.3-3.1.

186, 187 Triobol. Obverse: helmeted goddess. Reverse: head of a Negro. From Athens. About 502 B.C. Silver. Diam: 1.2 cm. East Berlin, Staatliche Museen, Münzkabinett, Prokesch-Osten coll. (acquired 1875).

188 Coin. Obverse: head of a Negro. Reverse (not reproduced): letters AC. From Delphi. V century B.C., about 490-479. Silver. Boston, Museum of Fine Arts, 04.804.

189 Coin. Obverse: head of a Negro. Reverse (not reproduced): head of a goat. From Delphi. V century B.C., about 490-479. Silver. Boston, Museum of Fine Arts, 04.803.

190 Coin. Obverse: head of a Negro. Reverse (not reproduced): head of a ram. From Delphi. V century B.C. Silver. Diam: 0.9 cm. London, British Museum, Department of Coins and Medals, E.H.P.375.N.5(=B.M.C. Delphi 7).

191 Coin. Obverse: head of a Negro. Reverse (not reproduced): head of a ram. From Delphi. V century B.C. Silver. Diam: 0.8 cm. London, British Museum, Department of Coins and Medals, E.H.P.375.N.6(=B.M.C. Delphi 8).

192 Coin. Obverse: head of a Negro. Reverse (not reproduced): head of a ram. From Delphi. V century B.C. Silver. Diam: 0.9 cm. London, British Museum, Department of Coins and Medals, E.H.P.375.N.7(=B.M.C. Delphi 9).

193 Kantharos: conjoined heads of Heracles and a Negro. V century B.C. Terracotta. H: 20 cm. Vatican, Museo Gregoriano Etrusco, 16539.

218 Brooklyn-Budapest Painter, krater: unidentified scene (Lynceus cutting the throat of Danaus?). From Taranto. Second quarter IV century B.C. Terracotta. H: 49 cm. Bonn, Akademisches Kunstmuseum der Universität, 2667.

219, 220 Askos: black woman dancing between a maenad and a satyr. From Ruvo. IV century B.C. Terracotta. H: 23 cm. Ruvo, Museo Jatta, 1402.

221, 222 Phiale decorated in relief with three concentric rows of Negro heads and one row of acorns. From Panagyurishte. Late IV century B.C. Gold repoussé. Diam: 25 cm. Plovdiv, National Archeological Museum, 3204.

223 Askos in the form of a child crouching beside a vase. From Capua. IV century B.C. Terracotta. H: 8.9 cm. London, British Museum, Department of Greek and Roman Antiquities, 1873.8-20.285.

224 Lekythos in the form of a crouching child, hands clasped around his knees which are drawn to his chest. From Ruvo. IV century B.C. Terracotta. H: 24 cm. London, British Museum, Department of Greek and Roman Antiquities, 1873.8-20.287.

225 Askos with a mask of a Negro in relief. From Cyprus, Poli (formerly Marion). Late IV century B.C. Terracotta. H: 8 cm.; Diam: 8.75 cm. Cambridge, Fitzwilliam Museum, GR.102.1890.

226 Askos in the form of a child seizing a goose. From South Italy. IV century B.C. Terracotta. H: 8.4 cm. New York, Metropolitan Museum of Art, 41.162.45.

227 Fragment of a rhyton in the form of a Negro head. From Olynthus. IV century B.C. Terracotta. H: 14.2 cm. Cambridge (Mass.), Fogg Art Museum, Harvard University, 1960.404.

228 Boxing match, detail of a fresco. From Paestum. Second half IV century B.C. Paestum, Museo Archeologico Nazionale, 21522.

229 Tetradrachm. Obverse: Zeus Ammon. From Cyrene. About 400 B.C. Silver. Diam: 2.7 cm. East Berlin, Staatliche Museen, Münzkabinett, 996/1872.

230 Portrait of a North African of mixed type. From Cyrene, Temple of Apollo. Mid-IV century B.C. Bronze. H: 30 cm. London, British Museum, Department of Greek and Roman Antiquities, 1861.11-27.13.

231, 232 Young black groom steadying a horse, statue base (?). From Athens. Late IV or early III century B.C. Marble. 200 × 190 cm. Athens, National Museum, 4464.

233 Young mulatto groom, fragment of a funerary relief. Late IV century B.C. Marble. 88 × 57 cm. Copenhagen, Ny Carlsberg Glyptotek, IN 2807.

234, 235 Mosaic of the Nile in flood: landscape of the Upper Nile with two black hunters. From Praeneste, Temple of the Fortuna. I century B.C. Over-all dims. approx. 400 × 500 cm. Palestrina, Museo Archeologico Nazionale.

236 Head of a Negro. Early III century B.C. Terracotta. H: 9.2 cm. Oxford, Ashmolean Museum of Art and Archaeology, Department of Antiquities, G 97.

237 Fragment of a balsamarium in the form of a Negro head. Late III or early II century B.C. Bronze. H: 7.7 cm. Houston, D. and J. de Menil Collection, CA 6387.

238 Mask of a Negro. From Sicily (?). III or II century B.C. Terracotta (with traces of red pigment). H: 15.2 cm. Houston, D. and J. de Menil Collection, CA 6911.

239 Perfume vase: bust of a Negro youth. From Samannûd (Egypt). II or I century B.C. Bronze. H: 12.8 cm. Providence, Museum of Art, Rhode Island School of Design, 11.035.

240 Lamp in the form of a Negro head. From Athens, Agora. II century B.C. Terracotta. H: 6.7 cm.; L: 8.9 cm. Athens, Agora Museum, L 2207.

241 Perfume vase: head of an adolescent of Nilotic type. About 100 B.C. Bronze. H: 10 cm. London, British Museum, Department of Greek and Roman Antiquities, 1955.10-8.1.

242 Balsamarium: head of an adolescent of Nilotic type. III or II century B.C. Bronze. H: 7.2 cm. Florence, Museo Archeologico, 2288.

272 Etruscan coin. Obverse: head of a black mahout. III century B.C. Bronze. Diam: 1.9 cm. London, British Museum, Department of Coins and Medals, S.N.G. II (Lloyd) 31.

273 Etruscan coin. Reverse of the coin in figure 271: elephant. III century B.C. Bronze. Diam: 1.8 cm. London, British Museum, Department of Coins and Medals, R.P.K. 1 P. 218 (=B.M.C. Etrurian uncertain 17).

274 Etruscan coin. Reverse of the coin in figure 272: elephant. III century B.C. Bronze. Diam: 1.9 cm. London, British Museum, Department of Coins and Medals, S.N.G. II (Lloyd) 31.

275 Statue of a jockey, detail of head. From Cape Artemisium. Late III century B.C. Bronze. H of figure: 84 cm. Athens, National Museum, 15177.

276 Statuette of a captive. Late I century B.C. Bronze. H: 11 cm. East Berlin, Staatliche Museen, Antikensammlung, Br. 10486.

277 Statuette of a captive. Late I century B.C. Bronze. H: 13.3 cm. East Berlin, Staatliche Museen, Antikensammlung, Br. 10485.

278 Statuette of a warrior carrying a double-edged ax. From Fayum. II or III century A.D. Terracotta. H: 21.5 cm. Houston, Menil Foundation Collection, 72-62 DJ(4).

279 Statuette of a warrior carrying an ax and a shield. From Egypt. Roman Period. Terracotta. H: 19 cm. Amsterdam, Allard Pierson Museum, 7316.

280 Bust of an Ethiopian. I century A.D. Grayblack marble. Diam of medallion: 140 cm. Rome, Museo Torlonia, 209.

281 Sarcophagus fragment: barbarians before a Roman general surrounded by soldiers. First half III century A.D. Marble. 57×82 cm. Rome, Palazzo Rondinini.

282 Apotheosis of Alexandria enthroned between Asia and Africa. From Pompeii, House of Meleager. I century A.D. Mural painting. 98×141 cm. Naples, Museo Archeologico Nazionale, 8898.

283 *Great Hunt Mosaic*. Detail: Ethiopian leading a team of oxen. IV century A.D. Piazza Armerina, Imperial Villa: Great Corridor.

284 Mosaic: black bath-attendant. I century A.D. 100×60 cm. Pompeii, House of the Menander: entrance to the caldarium.

285 Head of a woman representing Libya. From vicinity of Rome (Ostia?). I century A.D. Marble. H: 14.5 cm. Private Collection.

286 Statuette: allegory of Africa. From Lower Egypt. I century A.D. Marble. H: 72 cm. Whereabouts unknown.

287 Vase in the form of a Negro head. From Pompeii. I century A.D. Enamelled red glass. H: 10.5 cm. Naples, Museo Archeologico Nazionale, 129404.

288 Isiac ceremonial with several black officiating priests. From Herculaneum. I century A.D. Mural painting. 81×82 cm. Naples, Museo Archeologico Nazionale, 8924.

289 Isiac ceremonial: sacred dance performed by a black. From Herculaneum. I century A.D. Mural painting. 87×83 cm. Naples, Museo Archeologico Nazionale, 8919.

290 Statue of a youth standing with arms extended forward. From Tarragona. I century A.D. Bronze. H: 82 cm. Tarragona, Museo Arqueológico Provincial, 527.

291, 292 Statue of a singer or actor. From vicinity of Naples. II century A.D. White marble. H: 167 cm. Naples, Museo Archeologico Nazionale, no inventory number.

293 Statuette of a draped Ethiopian. From Augusta Raurica. Roman Period. Bronze. H: 6.8 cm. Augst, Römermuseum, 61.6532.

294 Statuette of a draped Ethiopian. From Avignon. Roman Period. Bronze. H: 6.1 cm. Saint-Germain-en-Laye, Musée des Antiquités Nationales, 32.542.

295, 296 Statuette of a nude, black youth. From Reims. Roman Period. Bronze. H without base: 16 cm. Saint-Germain-en-Laye, Musée des Antiquités Nationales, 818.

297, 298 Statuette of a phlyax-actor. I century B.C. or I century A.D. Bronze. H: 17 cm. Houston, D. and J. de Menil Collection, X 608.

299 Statue of an acrobat balancing on a crocodile. Roman Period. Marble. H: 75 cm. London, British Museum, Department of Greek and Roman Antiquities, 1768.

320 Lamp in the form of a Negro head with facial cicatrices. From Egypt. Roman Period. Terracotta. Cairo, Egyptian Museum, 42110.

321 Head of a youth. From Athens, Agora. First half III century A.D. Terracotta. H: 5 cm. Athens, Agora Museum, T 873.

322 Head of a man. From Athens, Agora. Mid-III century A.D. Marble. H: 31.5 cm. Athens, Agora Museum, S 435.

323 Head of a laughing Negro. From Cologne. III century A.D. Terracotta. H: 9.3 cm. Cologne, Römisch-Germanisches Museum, 25,396.

324 Lamp in the form of a Negro youth seated, wearing a *cucullus*. From Athens, Agora. First half III century A.D. Terracotta. H: 11.8 cm. Athens, Agora Museum, L 3457.

325 Pepper pot in the form of an old man napping. From Chaourse-Montcornet (Aisne). Roman Period. Silver. H: 9 cm. London, British Museum, Department of Greek and Roman Antiquities, 1889.10-19.16.

326 Intaglio: Negro head. II or I century B.C. Glass paste. 0.8 × 1.1 cm. Geneva, Musée d'Art et d'Histoire, MF 2858.

327 Plastic vase: Negro head. II or III century A.D. Terracotta. H: 15.2 cm. Houston, D. and J. de Menil Collection, CA 6714.

328 Plastic vase: Negro head. From Asia Minor (?). II or III century A.D. Terracotta (green glaze). H: 30 cm. Houston, D. and J. de Menil Collection, CA 6920.

329 Head of an African (?) priest. I century B.C. Limestone. H: 34 cm. Syracuse, Museo Archeologico Nazionale, 747.

330 Head of an Isiac priest. From Athens. Late I century B.C. or early I century A.D. Marble. H: 30 cm. Copenhagen, Ny Carlsberg Glyptotek, IN 2032.

331, 332 Head of an African. From Egypt. Between 50 B.C. and A.D. 50. Marble. H: 22 cm. Amsterdam, Allard Pierson Museum, 7872.

333 Head of a woman. From Athens, Agora. Early II century A.D. Marble. H: 11.6 cm. Athens, Agora Museum, S 1268.

334 Head of a young girl. From Corinth. II century A.D. Marble. H: 22.5 cm. Boston, Museum of Fine Arts, 96.698.

335 Head of a black youth. I century A.D. Marble. H: 25 cm. Vatican, Museo Gregoriano Profano, 10155.

336-338 Portrait of Memnon, disciple of Herodes Atticus. From Thyreatis (Peloponnesus). II century A.D. Marble. H: 27.3 cm. East Berlin, Staatliche Museen, Antikensammlung, SK 1503.

339 Mosaic of the Gladiators (detail of east border): torture of Garamantes attacked by wild beasts. From Zliten, House of Dar Buc Ammera. Late I century A.D. Tripoli, Archaeological Museum.

340 Mosaic of the Black Camel-riders. From Thuburbo Maius, House of the Camel-riding Blacks. IV century A.D. 84 × 98 cm. Tunis, Musée National du Bardo, 2996.

341 Amulet in the form of a head of a black. Black glass paste. H: 1.6 cm. Constantine, Musée Gustave Mercier.

342 Scarab with head of a black. From Carthage. Jasper. H: 2.7 cm. Tunis, Musée National du Bardo.

343 Mask of a man. From Carthage, Dermech, tomb 10(6). VII or VI century B.C. Terracotta. H: 19 cm. Tunis, Musée National du Bardo, 1558 Pd.

344 Nilotic mosaic (detail): Pygmy armed with a stick. From el Alia. Late I or early II century A.D. Over-all Dims: 570 × 485 cm. Sousse, Musée Archéologique, 10438.

345 Fragment of a Nilotic mosaic: Pygmies and a hippopotamus. From Sousse, triclinium of a villa. First half III century A.D. 145 × 215 cm. Sousse, Musée Archéologique, 10457.

346 Mosaic: Allegory of the Life-giving Nile (detail): black musicians in front of a nilometer. From Lepcis Magna, House of the Nile. II century A.D. Over-all Dims: 118 × 322 cm. Tripoli, Archaeological Museum.

373 Statuette of a draped Pygmy standing beside a vase. From Fayum. II-III century A.D. Terracotta. H: 13.8 cm. Houston, Menil Foundation Collection, 72-62 DJ(3).

374 Mosaic of the Nile in flood (detail): Nubian hunters pursuing a monkey. From Praeneste, Temple of the Fortuna. I century B.C. Over-all Dims: approx. 400 × 500 cm. Palestrina, Museo Archeologico Nazionale.

375 Sarcophagus decorated with a Nilotic scene (detail). From Rome, via Ostiensis. Mid-III century A.D. Over-all Dims: 46 × 195 cm. Marble. Rome, Museo Nazionale Romano, 113065.

376 Terracotta plaque: Nilotic landscape with Pygmies in a boat. From Latium. I century A.D. 50.5 × 48 cm. Rome, Museo Nazionale Romano, 62662.

377 Pygmies fighting crocodiles and a hippopotamus. From Pompeii, Casa del Gallo, garden. I century A.D. Detail of a mural painting. Over-all Dims: 76 × 126 cm. Naples, Museo Archeologico Nazionale, 113195.

378 Nilotic scene (detail): Pygmies protecting themselves from a crocodile with crossed sticks. I century A.D. Mural painting. Pompeii, Casa dei Pigmei, oecus.

379 Statuette of **Harpocrates** on horseback. From Fayum. II-III century A.D. Terracotta. H: 16.2 cm. Paris, Musée du Louvre, Département des Antiquités grecques et romaines, S 1640.

380 "Grand Bès" seated. Saïtic Period. Faïence, black glass, and carnelian. H: 17.7 cm. Paris, Musée du Louvre, Département des Antiquités égyptiennes, E 10929.

381, 382 Handle of a sistrum with a Bes and an Isis dancing back to back. From Rome, Temple of Isis. Roman Period. Bronze. H of sistrum: 24.3 cm. Paris, Musée du Louvre, Département des Antiquités égyptiennes, 8076.

383, 384 Funerary relief: sacred dance performed during an Isiac ceremony (Negroid musicians and dancers). From tomb on the Via Appia near Ariccia. Early II century A.D. Marble. 50 × 110 cm. Rome, Museo Nazionale Romano, 77255.

385 Statue of Isis. From Tivoli, Hadrian's villa. I century A.D. Black basalt. H: 143 cm. Vatican, Museo Gregoriano Egizio. G. Botti and P. Romanelli, *Le Sculture del Museo Gregoriano Egizio* (Vatican City, 1951), no. 148.

PERMISSIONS

PHOTO CREDITS

Munich H. Koppermann: *69*
 Staatl. Antikensammlungen und Glyptothek: *170*
New York André Emmerich Gallery Inc.: *208, 209*
Paris Photo. Bibl. nat. Paris: *173*
 Editions du Centre National de la Recherche Scientifique, reprinted from G. Ville, "Essai de datation de la mosaïque des Gladiateurs de Zliten," in *La mosaïque gréco-romaine* (Paris, 1965): *339, 348*
 Photo Archive Prof. J. Leclant: *111, 136*
 Mission M. S. Giorgini: *35, 92, 133*
 Reprinted from *Monuments et Mémoires publiés par l'Académie des Inscriptions et Belles-Lettres, Fondation Eugène Piot* 22(1916), pl. XVI: *286;* 32(1932), pl. IV: *285*
 Courtesy of the Musée du Louvre, Department of Greek and Roman Antiquities, photographer Chuzeville: *158, 370*
 Courtesy Prof. J. Vercoutter: *49, 342*
Philadelphia The University Museum of the University of Pennsylvania: *155*
Princeton, N. J. The Negro in the Male Procession in Vol. II *The Frescoes* of Mabel L. Lang *The Palace of Nestor at Pylos in Western Messenia* (copyright (c) 1969 by Princeton University Press), Plate 129, no. 59 Hnws. Reprinted by permission of Princeton University Press and the University of Cincinnati: *146*
Rome Deutsches Archäologisches Institut, Rom: *280, 346, 366*
 F. Orefici: *28, 29, 30, 31, 38*
St. Louis The St. Louis Art Museum: *59*
Syracuse Museo Archeologico Nazionale: *161, 162*
Tunis Musée du Bardo: *360*
University, Miss. University of Mississippi: *243*
Vienna Kunsthistorisches Museum: *150, 151, 200*
Worcester, Mass. Worcester Art Museum: *127*

MAPS

1-2. Nile Valley

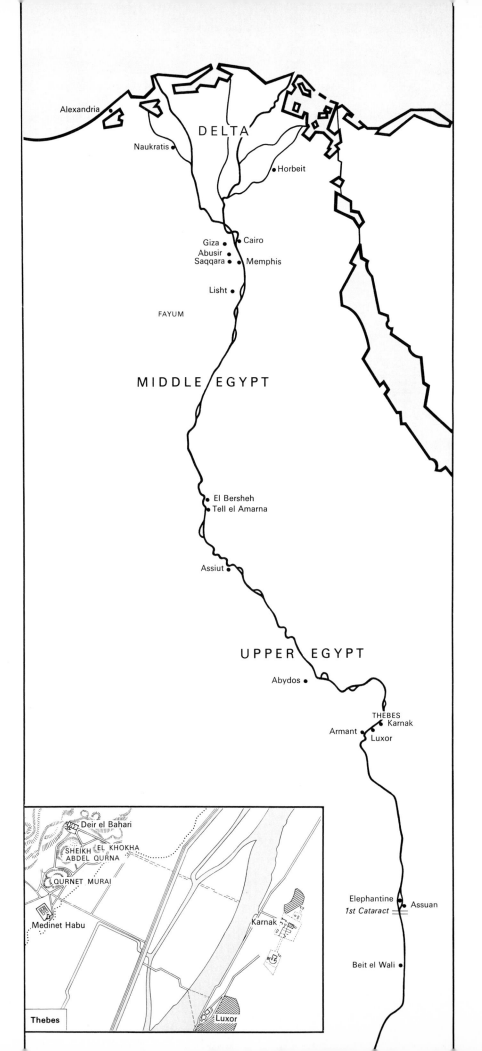

DELTA

Alexandria

Naukratis

Horbeit

Giza • Cairo
Abusir
Saqqara • Memphis

Lisht

FAYUM

MIDDLE EGYPT

El Bersheh
Tell el Amarna

Assiut

UPPER EGYPT

Abydos

THEBES
Armant • Karnak
Luxor

Deir el Bahari
EL KHOKHA
SHEIKH
ABDEL QURNA
QURNET MURAI

Medinet Habu

Karnak

Luxor

Thebes

Elephantine • Assuan
1st Cataract

Beit el Wali

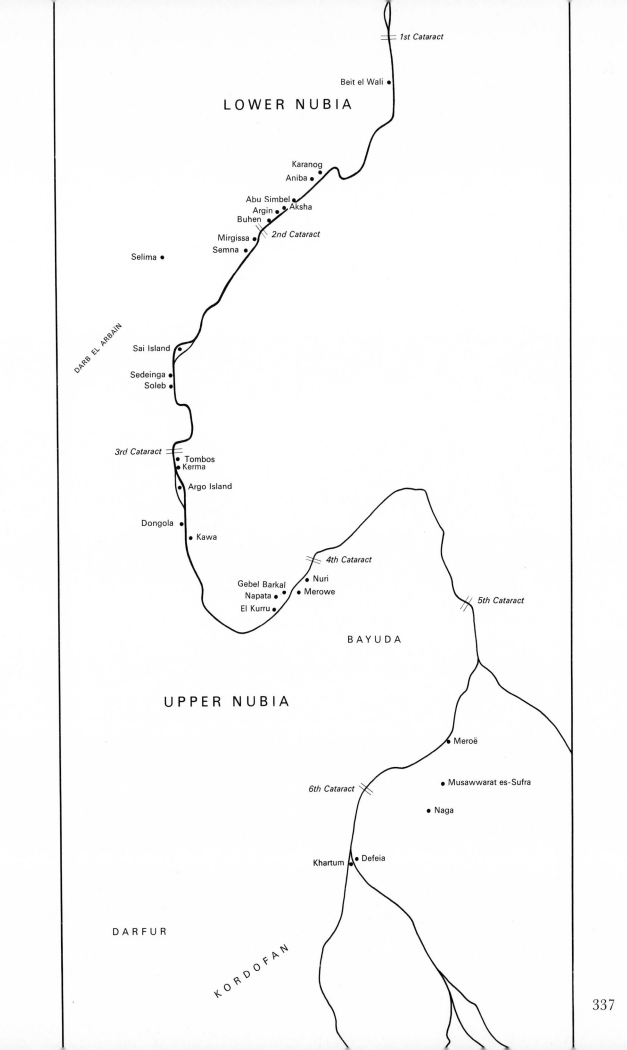

1st Cataract

Beit el Wali

LOWER NUBIA

Karanog
Aniba
Abu Simbel
Argin Aksha
Buhen
Mirgissa 2nd Cataract
Semna

Selima

DARB EL ARBAIN

Sai Island

Sedeinga
Soleb

3rd Cataract
Tombos
Kerma
Argo Island

Dongola
Kawa

4th Cataract
Gebel Barkal Nuri
Napata Merowe
El Kurru

5th Cataract

BAYUDA

UPPER NUBIA

Meroë

Musawwarat es-Sufra

6th Cataract

Naga

Khartum Defeia

DARFUR

KORDOFAN

337

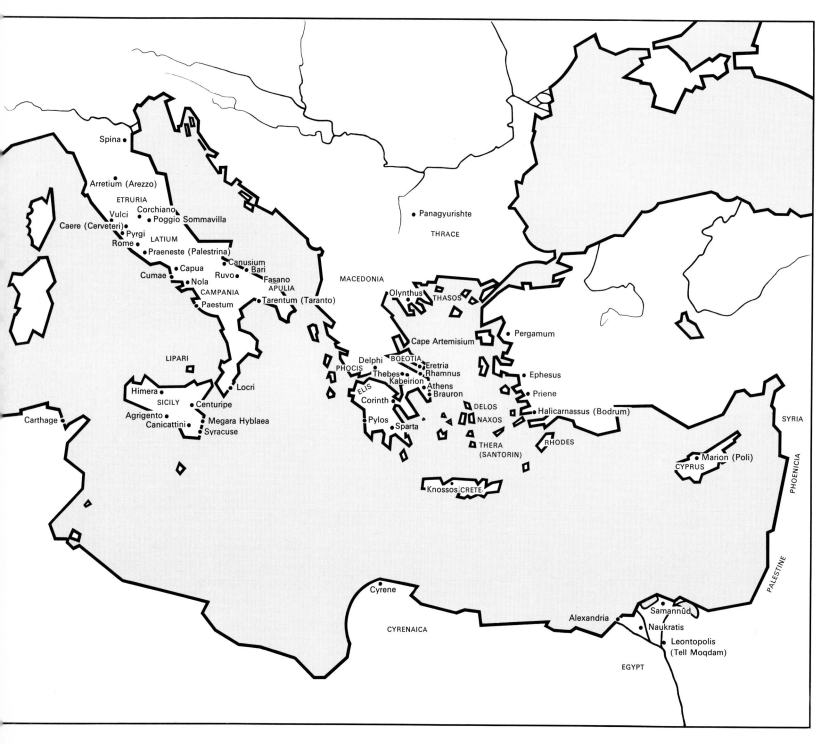

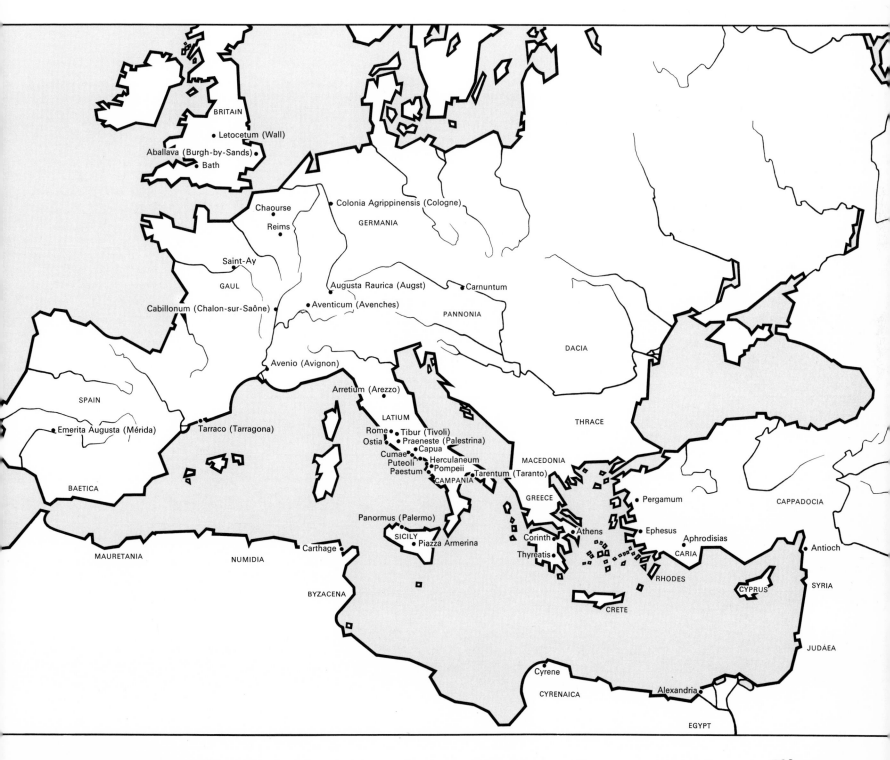

BRITAIN

Letocetum (Wall)

Aballava (Burgh-by-Sands)
Bath

Chaourse
Colonia Agrippinensis (Cologne)
Reims
GERMANIA

Saint-Ay

GAUL
Augusta Raurica (Augst)
Carnuntum

Cabillonum (Chalon-sur-Saône)
Aventicum (Avenches)
PANNONIA

DACIA

Avenio (Avignon)

SPAIN
Arretium (Arezzo)
THRACE
LATIUM

Emerita Augusta (Mérida)
Tarraco (Tarragona)
Rome Tibur (Tivoli)
Ostia Praeneste (Palestrina)
Capua
Cumae Herculaneum
MACEDONIA
Puteoli Pompeii
Pergamum
Paestum Tarentum (Taranto)
CAPPADOCIA
BAETICA
CAMPANIA
GREECE

Panormus (Palermo)
Athens Ephesus
Aphrodisias
SICILY Corinth
Antioch
MAURETANIA NUMIDIA Carthage Piazza Armerina
Thyreatis CARIA
RHODES
SYRIA
BYZACENA
CYPRUS
CRETE

JUDAEA

Cyrene

CYRENAICA Alexandria

EGYPT

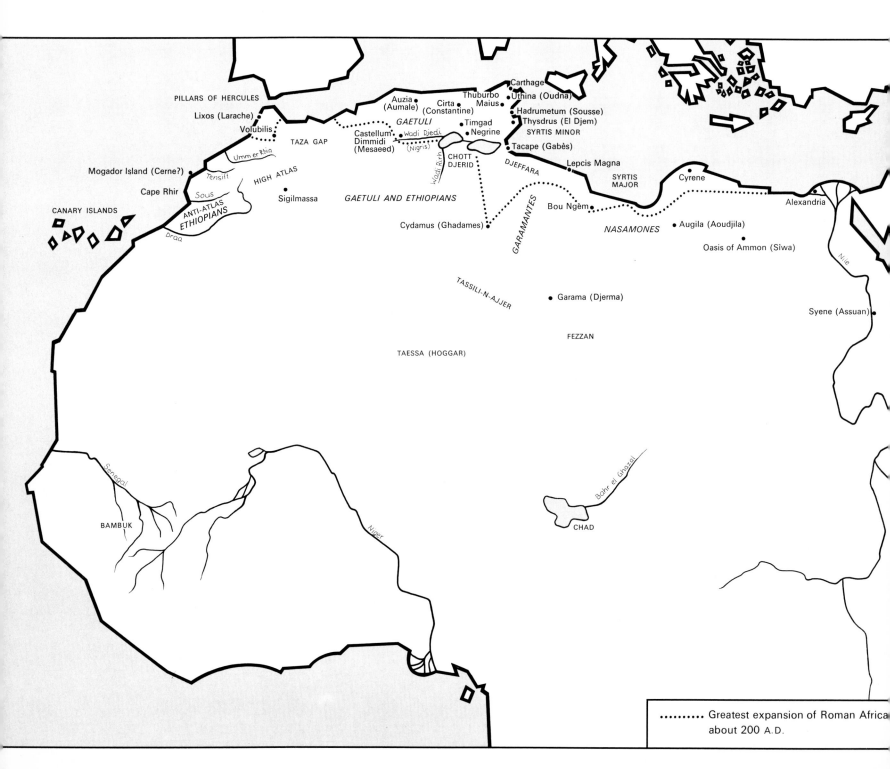

PILLARS OF HERCULES

Lixos (Larache)

Volubilis

TAZA GAP

GAETULI

Auzia (Aumale)

Cirta (Constantine)

Castellum Dimmidi (Mesaeed)

Wadi Djedi (Nigris)

Timgad

Negrine

Thuburbo Maius

Carthage

Uthina (Oudna)

Hadrumetum (Sousse)

Thysdrus (El Djem)

SYRTIS MINOR

Tacape (Gabès)

CHOTT DJERID

Wadi Rirh

DJEFFARA

Lepcis Magna

SYRTIS MAJOR

Cyrene

Alexandria

Mogador Island (Cerne?)

Tensift

HIGH ATLAS

Umm er Rbia

Cape Rhir

Sous

CANARY ISLANDS

ANTI-ATLAS *ETHIOPIANS*

Draa

Sigilmassa

GAETULI AND ETHIOPIANS

Cydamus (Ghadames)

GARAMANTES

Bou Ngèm

NASAMONES

Augila (Aoudjila)

Oasis of Ammon (Siwa)

TASSILI-N-AJJER

Garama (Djerma)

Nile

Syene (Assuan)

FEZZAN

TAESSA (HOGGAR)

Senegal

BAMBUK

Niger

Bahr el Ghazal

CHAD

·········· Greatest expansion of Roman Africa
about 200 A.D.

Bovill, E. W., 299 n. 59, 310 n. 96

Braemer, F., 306 nn. 277, 296

Brauron, 167

Breasted, J. H., Jr., 34, 299 n. 27

Breccia, E., 305 n. 231, 306 n. 298, 314 n. 43

Brett, A. B., 301 n. 97

Briggs, L. C., 303 n. 185, 308 n. 1

Brilliant, R., 305 n. 238

Brinkerhoff, D. M., 303 n. 167

Britain, 214, 305 n. 266, 310 n. 81

Broadhead, H. D., 299 n. 61

Brooklyn-Budapest Painter, 176, *fig. 218*

Brooklyn, The Brooklyn Museum, 80, 88, 92, 111, 194, 292 nn. 68, 69, 77, 293 n. 21, 294 n. 46, 295 n. 63, 303 nn. 180, 182, *figs. 52, 53, 64, 65, 72, 249-52*

Bruneau, P., 304 n. 211, 312 n. 130

Brunton, W., 294 n. 38

Brussels, Musées Royaux d'Art et d'Histoire, 144, 146, 294 n. 46, 296 n. 86, 299 nn. 47, 52, *fig. 159*

Bücheler, F., 302 n. 156, 311 n. 108

Buhen, 63

Bulgaria, 183

Burckhardt, J. L., 292 n. 47

Burgh-by-Sands. *See* ancient name Aballava

Burn, A. R., 136, 298 n. 20

Burney, E., 291 n. 38, 292 n. 51, 295 n. 68

Buschor, E., 299 n. 36, 302 n. 130, 314 n. 37

Busiris, 140, 152, 160, 167, 176, 271, 300 nn. 70, 72, 301 n. 98, 302 n. 139, *figs. 168, 171, 172*

Butana, 89

Butzer, K. W., 308 n. 2

Buzara, Mount, 309 n. 31

Byzacena, 216

Caere (Cerveteri), 140. *See also* Cerveteri

Caesar, 252

Cagnat, R., 308 n. 11, 312 n. 129

Cahn, H. A., 302 n. 126

Cairo, 291 n. 3, 303 n. 162
 Egyptian Museum, 47, 56, 92, 98, 111, 126, 138, 291 nn. 10, 11, 20, 31, 41, 292 nn. 56, 62, 72, 293 nn. 7, 12, 20, 28, 294 nn. 38, 40, 42, 46, 295 nn. 51, 61, 296 nn. 71, 74, 83, 297 nn. 107, 115, 299 n. 27, 306 n. 300, *figs. 3, 4, 10, 11, 13, 21, 22, 37, 44, 55, 56, 67, 71, 77, 81, 107, 115, 129, 135, 144, 320*

Calaeno, 164

Caligula, 285, 314 n. 62

Cambridge, Fitzwilliam Museum, •183, 302 nn. 130, 151, 306 n. 294, 315 n. 73, *figs. 214, 225, 314*

Cambridge (Mass.), Fogg Art Museum, Harvard University, 161, 183, 299 n. 63, 301 n. 93, 302 n. 152, *figs. 164, 227*

Cameroon, 310 n. 63

Campania, 160, 221, 224, 315 n. 88

Camps-Fabrer, H., 310 n. 93

Camps, G., 308 n. 3, 309 n. 47

Canary Islands, 250

Canicattini, 171

Canusium, 167

Capua, 176

Carcopino, J., 309 n. 26, 310 nn. 63, 65, 74

Caria, 273

Carnuntum, 210, 229

Carpenter, R., 309 n. 52

Carter, H., 291 n. 37

Carthage, 146, 251, 254, 258, 269, 270, 302 n. 156, 310 nn. 65, 90, 311 nn. 97, 113
 Antiquarium, 312 n. 132, *figs. 358, 359*
 Baths of Antoninus Pius, 260, 312 n. 132
 Dermech, 258, 311 n. 115
 House of the Seasons, 312 n. 133
 Musée de Carthage, 260, 312 n. 133, *fig. 360*

Carthaginians, 148, 171, 212, 252

Caskey, L. D., 307 n. 316

Castellum Dimmidi (Mesaeed), 248

Caucasians, 242

Cavalier, M., 301 n. 119

Cèbe, J.-P., 300 n. 68, 311 nn. 109, 121, 312 n. 131, 314 n. 54, 315 n. 64

Celt, 304 n. 194

Centuripe, 148

Cepheus, 155, 167, 300 n. 81, 301 n. 98, 302 n. 139

Cerne, island of, 248, 299 n. 29, 310 n. 74, 312 n. 148

Cerveteri, 160, 167. *See also* ancient name Caere

Chabeuf, M., 308 n. 3

Chad, 33, 47, 250

Chadwick, J., 298 n. 24

Chalon-sur-Saône, 199, 224, 303 n. 183

Chamla, M.-Cl., 296 n. 97, 308 n. 3

Chantre, E., 135, 298 n. 10

Chaource Treasure, 236

Chaplain, J., 300 n. 71

Chapman, S. E., 296 nn. 91, 93, 94

Ch.-Picard, G., 224, 260, 295 n. 47, 305 n. 260, 308 n. 17, 309 nn. 24, 34, 310 n. 87, 312 nn. 130, 132, 133

Chase, G. H., 300 n. 87

Cheops, 38

Cherchell, Musée Archéologique, 312 n. 146, *figs. 363, 364*

China, 270

Chiusi, 314 n. 48

Chora, Archaeological Museum, 298 n. 23, *cf. fig. 146*

Chovin, G., 309 n. 62

Cicero, 310 n. 91

Cintas, P., 246, 258, 308 n. 5, 311 n. 113

Circe, 161, 301 nn. 92, 98, *fig. 185*

Cirta (Constantine), 248

Claudian, 247, 258, 308 n. 23, 309 n. 31, 311 n. 111

Claudius, 252, 310 n. 81

Cleopatra, 310 n. 91

Cleveland, Cleveland Museum of Art, 303 n. 183, 304 n. 198

Collignon, M., 305 n. 252

Collignon, R., 308 n. 20

Collingwood, R. G., 305 n. 236

Cologne, 236
 Römisch-Germanisches Museum, 306 n. 303, *fig. 323*

Colonna, G., 300 n. 86

Comstock, M., 304 n. 191

Condamin, J., 314 n. 52

Congo, 33

Constantine. *See also* ancient name Cirta
 Musée Gustave Mercier, 258, 260, 311 nn. 113, 126, 129, 312 nn. 130, 145, *figs. 341, 351, 353, 356, 357*

Cook, S. A., 304 n. 213

Cooney, J. D., 291 n. 40, 303 n. 183, 304 n. 198

Copenhagen
 Nationalmuseet, 166, 176, 294 n. 46, 301 n. 107, 302 n. 129, *figs. 198, 212*
 Ny Carlsberg Glyptotek, 98, 126, 184, 206, 214, 238, 294 nn. 41, 46, 296 nn. 77, 81, 297 n. 108, 303 n. 157, 304 nn. 199, 200, 305 n. 234, 307 n. 313, *figs. 82, 109, 114, 132, 233, 330*

Corchiano, 160

Corinth, 229
 Archaeological Museum, 306 n. 280, *fig. 302*

Crassus, 310 n. 91

Crete, 136, 138, 146, 164

Croissant, F., 299 n. 43

Cumae, 144

Cumont, F., 217, 305 n. 253

Curto, S., 315 n. 73

Cydamus (Ghadames), 247, 308 n. 12

Cyprus, 136, 140, 183

Cyrenaica, 258, 302 n. 153

Cyrene, 183, 217, 254, 302 n. 154
 Temple of Apollo, 183

Dabarosa, 297 n. 113

Dacia, 252

345

Simon, E., 301 n. 98

Simpson, W. K., 297 n. 114

Sirte, Gulf of, 254, 308 n. 19, 309 nn. 54, 57, 311 n. 125

Siwa. *See* Ammon, oasis of

Slane, M. G. de, 308 n. 19

Smith, A. H., 306 n. 275

Smith, C. H., 300 n. 78

Smith, W. S., 294 n. 37, 296 n. 86

Snowden, F. M., Jr., 270, 282, 291 n. 36, 298 nn. 5, 7, 13, 299 nn. 25, 26, 45-47, 49, 54, 58, 300 nn. 64, 78, 88, 301 nn. 92, 95, 100, 106, 302 nn. 125, 128, 132, 134, 139, 142, 143, 147, 149, 303 n. 168, 304 nn. 189, 193, 199-201, 207, 209, 224, 305 nn. 234, 238, 258, 261-63, 267, 306 nn. 282, 300, 307 nn. 311, 319, 328, 312 n. 148, 313 nn. 23, 25, 30, 314 nn. 39, 47, 315 nn. 74, 76, 79, 80, 82, 83, 86, 89

Soleb, Temple of Amenhotep III, 68, 70, *fig. 35*

Somali, 34

Somalia, 270

Sonrhay, 252

Sophocles, 155

Sotades, 152, 176, 271, 272, 300 nn. 66, 69, 302 n. 138, *figs. 165, 369, 370*

Sous, 248, 252

Sousse. *See also* ancient name Hadrumetum
 Musée Archéologique, 265, 310 n. 116, 311 n. 120, 312 n. 143, *figs. 344, 345, 365*

Spain, 224, 251, 278, 310 n. 70
 Citerior, 310 n. 81

Sparta, 315 n. 75

Speier, H., 306 n. 275

Spina, 152

Stamp, L. D., 308 n. 2

Steiger, R., 306 n. 271

Stella, L. A., 298 n. 24

Strabo, 213, 252, 304 n. 228, 305 n. 230, 309 nn. 38, 39, 310 nn. 70, 78, 79, 91, 311 nn. 97, 124, 313 n. 5

Strong, D. E., 306 n. 307

Strouhal, E., 297 n. 97

Strouthophagi, 258

Sudan, 54, 56, 70, 98, 104, 128, 257, 293 n. 18, 295 n. 67, 297 n. 120, 313 n. 16

Sudanese, 258, 260, 303 n. 162

Suetonius, 285, 310 n. 82, 315 n. 91

Suse, 314 n. 34

Swindler, M. H., 314 n. 46

Swing Painter, 144

Switzerland, 232

Sydney, Nicholson Museum of Antiquities, University of Sydney, 295 n. 68

Syene (Assuan), 247. *See also* Assuan

Syracuse, Museo Archeologico Nazionale, 148, 171, 238, 299 n. 57, 302 n. 122, 307 n. 312, *figs. 161, 162, 206, 329*

Syria, 109

Syriskos Painter, 150

Székesfehérvar, 278

Tabo, Temple of. *See* Argo Island

Tacape (Gabès), 254, 310 n. 92

Tacitus, 310 n. 77

Taessa (Hoggar), 308 n. 2

Tafraout, 310 n. 69

Taharqa, 96, 98, 104, 109, 111, 148, 294 nn. 35, 36, 38, 43, 46, 295 nn. 51, 67, 69, 313 n. 5, *figs. 79-95, 97*
 of the Lake, Edifice of. *See* Karnak

Tanutamun, 111, 294 n. 43, 295 nn. 64, 66, 67, *figs. 101-105*
 tomb of. *See* El Kurru

Taranto. *See also* ancient name Tarentum
 Museo Nazionale, 183, 302 n. 147

Tarentum (Taranto), 204

Tarradell, M., 310 n. 75

Tarragona, Museo Arqueológico Provincial, 224, 306 n. 268, *figs. 290, 303*

Tartarus, 257

Tassili-n-Ajjer, 252, 254

Taza Gap, 252

Tazeroualt, 310 n. 69

Teixidor, J., 297 n. 118

Tell el Amarna, 292 n. 69

Tell Moqdam. *See* ancient name Leontopolis

Telmine, 308 n. 11

Temporini, H., 314 n. 39

Tensift, river, 309 n. 38

Terence, 210, 304 n. 215

Terrace, E. L. B., 294 n. 46

Thanuny, tomb of. *See* Thebes, necropolis of Sheikh Abdel Qurna

Thasos, 272, 273, 300 n. 67

Thebes (Egypt), 43, 269, 291 n. 41
 necropolis of El Khokha, tomb of Amenemhat-Sourer, 292 n. 59, *fig. 43*
 necropolis of Qurnet Murai, 56
 tomb of Huy, 56, 58, 62, 63, 80, 88, 291 n. 43, *figs. 23-27*
 necropolis of Sheikh Abdel Qurna
 tomb of Horemheb, 56, 80, 291 n. 40, *figs. 20, 54*
 tomb of Inene, 54, 56, 291 n. 39, *fig. 19*
 tomb of Rekhmire, 47, 50, 51, 54, 56, 291 n. 34, *figs. 14-16*
 tomb of Sebekhotep, 54, 56, 62, 64, 88, 291 n. 38
 tomb of Thanuny, 140, 299 n. 41, *fig. 152*
 tomb of Wah, 80, 292 n. 65, *fig. 51*
 Valley of the Kings, tomb of Tutankhamun, 70, 292 n. 72

Thebes (Greece), 210, 273

Theodectes, 302 n. 138

Theodorus, 140

Theodosius, Count, 247, 308 n. 23

Theophrastus, 164, 301 n. 102

Thera, 138, 298 nn. 21, 22

Thibilis (Announa), 312 n. 145

Thiersch, H., 304 n. 213

Thilo, G., 301 n. 101

Thimme, J., 313 n. 32

Thina, necropolis, 260

Thomasson, B. E., 311 n. 118

Thompson, L. A., 305 n. 237

Thoth, 282

Thouvenot, R., 303 n. 187

Thracian(s), 146, 312 n. 148, 313 n. 30

Thuburbo Maius, House of the Camel-riding Blacks, 248, 260, 309 n. 34

Thugga, 308 n. 7

Thureau-Dangin, F., 295 n. 59

Thyia, 164

Thysdrus (El Djem), 260

Tidamensii, 308 n. 12

Tiddis, 311 n. 129

Til Barsib, 109, 295 n. 59

Timesgadiouine, 310 n. 69

Timgad
 Musée Archéologique, 312 nn. 129, 131, *figs. 347, 352*
 northwestern baths, 260, 312 n. 131

Tipasa, 311 n. 113

Tiridates, 221

Tivoli, Hadrian's villa, 285

Todi, 312 n. 130

Tod, M. N., 299 n. 32

Tokai, 308 n. 7

Tomâs (Nubia), 315 n. 65

Tombos, quarry, 294 n. 43

Toynbee, J. M. C., 306 nn. 278, 279, 293

Trajan, 247, 252

Tran Tam Tinh, V., 305 n. 254, 315 nn. 84, 87, 88

Trebba, Valle, necropolis, 300 n. 72

Trendall, A. D., 300 nn. 77-79, 90, 302 nn. 121, 122, 134, 138

Triakontaschoinos, 247

Trieste, Museo Civico di Storia e d'Arte, 204, 303 n. 185

Trimalchio, 221

Tripoli, Archaeological Museum, 308 n. 16, 311 nn. 121-23, *figs. 339, 346, 348, 366*

Tripolis, 258. *See also* Tripolitania

Printed in Switzerland